DESIGN BASICS 2D AND 3D

EIGHTH EDITION

STEPHEN PENTAK
The Ohio State University

RICHARD ROTH
Virginia Commonwealth University

DAVID A. LAUER

WADSWORTH
CENGAGE Learning

Australia • Brazil • Japan • Korea • Mexico • Singapore • Spain • United Kingdom • United States

Design Basics: 2D and 3D, Eighth Edition
Stephen Pentak, Richard Roth, David A. Lauer

Publisher: Clark Baxter

Senior Development Editor: Sharon Adams Poore

Assistant Editor: Ashley Bargende

Editorial Assistant: Elizabeth Newell

Associate Media Editor: Kimberly Apfelbaum

Marketing Program Manager: Gurpreet S. Saran

Senior Content Project Manager: Lianne Ames

Senior Art Director: Cate Rickard Barr

Senior Print Buyer: Mary Beth Hennebury

Rights Acquisition Specialist, Image: Amanda Groszko

Production Service: Lachina Publishing Services

Text Designer: Anne Carter

Cover Designer: Anne Carter

Cover Image: Ann Hamilton, *corpus*. 2003. Mixed-media installation at Massachusetts Museum of Contemporary Art. Photograph Thibault Jeanson © Ann Hamilton Studio.

Compositor: Lachina Publishing Services

For product information and technology assistance, contact us at
Cengage Learning Customer & Sales Support, 1-800-354-9706

For permission to use material from this text or product, submit all requests online at **www.cengage.com/permissions**. Further permissions questions can be emailed to **permissionrequest@cengage.com**.

Library of Congress Control Number: 2011939009

ISBN-13: 978-0-495-90997-2
ISBN-10: 0-495-90997-1

Wadsworth
20 Channel Center Street
Boston, MA 02210
USA

Cengage Learning is a leading provider of customized learning solutions with office locations around the globe, including Singapore, the United Kingdom, Australia, Mexico, Brazil and Japan. Locate your local office at **international.cengage.com/region**.

Cengage Learning products are represented in Canada by Nelson Education, Ltd.

For your course and learning solutions, visit **www.cengage.com**.

Purchase any of our products at your local college store or at our preferred online store **www.cengagebrain.com**.

Instructors: Please visit **login.cengage.com** and log in to access instructor-specific resources.

Printed in the United States of America
1 2 3 4 5 6 7 15 14 13 12 11

ABOUT THE COVER ART

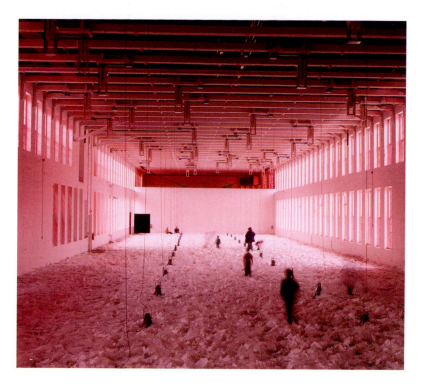

ANN HAMILTON

corpus. 2003. Mixed-media installation at the
Massachusetts Museum of Contemporary Art

Ann Hamilton is internationally recognized for large-scale installations
that respond to the architecture and social history of the site and
immerse the viewer in a multi-sensory experience. The cover art for this
book shows *corpus,* an installation at Mass MoCA that encompassed
a room the length of a football field, in this museum that was once a vast
New England mill.

 The cavernous space was transformed by several subtle interventions.
The windows (thousands of window panes) were individually covered
with a fine silk organza that filtered the light casting a pink glow in the
vast interior space. A rubber foot on each of 50 ceiling-mounted pneumatic
mechanisms suctioned a single sheet of paper from a stack, carried it to
the end of a short track, paused, and then released the paper to fall freely
to the floor 23 feet below. This slimmest of two-dimensional materials
accumulated over time on the gallery floor creating the soft environment
you see in the photograph and animated the space with the rhythm of the
dropping paper.

 The detail photograph on the back cover shows the lowering of bell-
shaped speakers, which intoned a 26-person recorded recitation. And, if
you look closely you will see a piece of paper descending from the ceiling.

 The summary experience transcended the formal elements of 2D or
3D design and included sound and time as well. We thought this would
be a compelling image to convey our aspiration that *Design Basics: 2D
and 3D* should also offer a reading experience greater than the sum of
its parts.

CONTENTS

Part 1
DESIGN PRINCIPLES

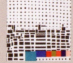

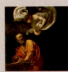

Part 2
DESIGN ELEMENTS

CHAPTER
9

PATTERN AND TEXTURE 178

CHAPTER
10

ILLUSION OF SPACE 194

CHAPTER
11

ILLUSION OF MOTION 228

Part 3

THREE-DIMENSIONAL DESIGN

CHAPTER 15

IDEAS AND APPROACHES 312

CHAPTER 16

3D DESIGN ELEMENTS 356

CHAPTER
17

3D DESIGN PRINCIPLES 378

CHAPTER
18

MATERIAL 416

CHAPTER
19

STRUCTURE 428

PREFACE

Design Basics: 2D and 3D offers a comprehensive introduction to design across a wide spectrum of media and practices. The original *Design Basics* (now in its eighth edition) presents the transcendent elements and principals of design as we find them in a universe of examples from drawing to architecture, human made objects, and nature. From these sources ideas are extrapolated for application with a primarily two-dimensional emphasis. It is fair to say that design and composition are nearly interchangeable terms in this case. When we talk of a painting's design we are talking about composition. Similarly, when we compose, we design.

Entering into a discussion of the three-dimensional realm is by its very nature a move from the abstract, the cerebral, and the optical into the world of objects, spaces, materials, and the tactile. So, then the "3D" text makes a leap into the physical world we occupy and with that the messiness of materials and processes involved in making things.

A wise guy (probably a painter) once said that "sculpture is something you back into while looking at a painting." This crack is a low brow version of the old duality that sets intellect or imagination against craft or process. We think you will discover in this expanded offering of *Design Basics* a synthesis of these imagined polarities. The creative nature of art and design requires a "both/and" view of the world in place of an "either/or" world view.

Josef Albers once said that for the artist, one plus one creates something *greater than* two. We hope you find that phenomenon in the joint edition of these two texts.

Stephen Pentak
Professor Emeritus, The Ohio State University

Richard Roth
Professor, Virginia Commonwealth University

FLEXIBILITY

Get the resources you need the way you want …

| Lauer/Pentak, *Design Basics*, 8e 978-0-495-91577-5 | Roth/Pentak, *Design Basics: 3D* 978-0-495-91578-2 | Pentak/Roth, *Color Basics* 978-0-534-61389-1 |

RESOURCES

Art CourseMate brings design concepts to life with interactive learning, study tools, and an ebook. The interactive ebook allows students to take notes, highlight, and search, and links directly to the interactive foundations tutorials for review.

ArtStudio provides a secure, password-protected online image and video upload and grading program that enables you to critique students' assignments as well as facilitating student peer-review, allowing students to see and respond to the work of others in an interactive, non-judgmental environment. ArtStudio includes pre-built assignments and grading rubrics in core topic areas, which you can choose to use or modify—or, you can build entirely new assignments.

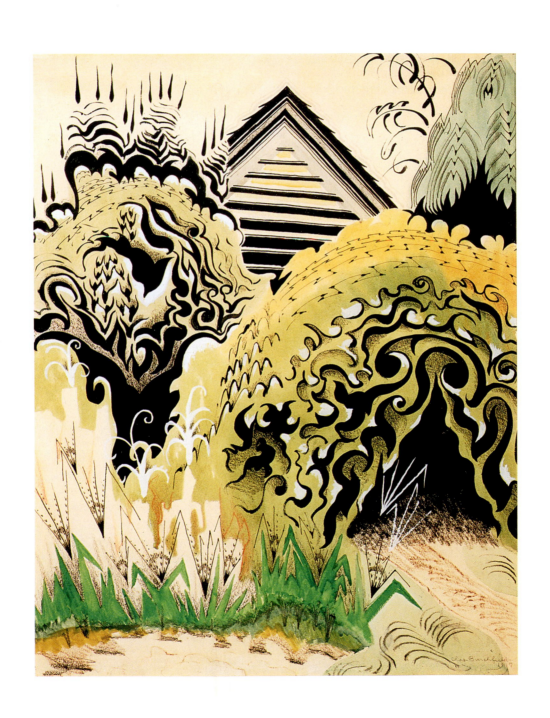

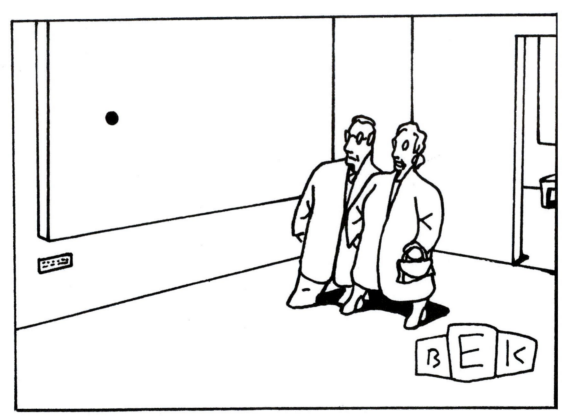

"Where does he get all his ideas?"

1 DESIGN PROCESS

DESIGN DEFINED

What do you think of when you hear the word *design*? Do you associate design with fashion, graphics, furniture, or automotive style? Design has a more universal meaning than the commercial applications that might first come to mind. A dictionary definition uses the synonym *plan*: To **design** indeed means to plan, to organize. Design is inherent in the full range of art disciplines from painting and drawing to sculpture, photography, and time-based media such as film, video, computer graphics, and animation. It is integral to crafts such as ceramics, textiles, and glass. Architecture, landscape architecture, and urban planning all apply visual design principles. The list could go on. Virtually the entire realm of two- and three-dimensional human production involves design, whether consciously applied, well executed, or ill considered.

Visual Organization

Design is essentially the opposite of chance. In ordinary conversation, when we say "it happened by design," we mean something was planned—it did not occur just by accident. People in all occupations plan, but the artist or designer plans the arrangement of elements to form a visual pattern. Depending on the field, these elements will vary—from painted symbols to written words to scenic flats to bowls to furniture to windows and doors. But the result is always a visual organization. Art, like other careers and occupations, is concerned with seeking answers to problems. Art, however, seeks visual solutions in what is often called the design process.

The poster shown in **A** is an excellent example of a visual solution. *How* the letters are arranged is an essential part of communicating the idea. Two other posters offer a comparison

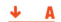

A

John Kuchera. *It's Time to Get Organized.* 1986. Poster. Art Director and Designer, Hutchins/Y&R.

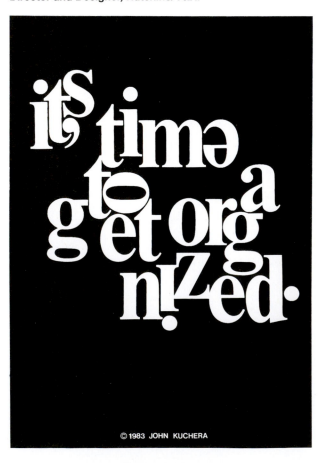

© 1983 JOHN KUCHERA

B

Steve Mehalo. *Make Jobs Not War.* **Poster design.** Copyright: free art for public use.

and contrast of how text can be organized to create a visual message from what could be a merely verbal message. *Make Jobs Not War* **(B)** is composed to communicate a simple and unambiguous statement. "War" is given a special focus through the color red, but the message is primarily verbal, not visual. In **C** red is again used for emphasis, but in this case the design of the text is more critical to the creation of a *visual* statement. The red that brings forward the word "war" from the text "what is it good for?" appears to have been crudely brushed on with drips and rough edges accentuating a violent urgency. This stands in contrast to the graceful formality of the text in black. This contrast conveys the message via a visual solution. If we recall the message in **C**, it will be because we will recall how the elements are organized.

Creative Problem Solving

The arts are called *creative* fields because there are no predetermined correct answers to the problems. Infinite variations in individual interpretations and applications are possible. Problems in art vary in specifics and complexity. Independent painters or sculptors usually create their own "problems" or avenues they wish to explore. The artist can choose as wide or narrow a scope as he or she wishes. The architect or graphic and industrial designer is usually given a problem, often with very specific options and clearly defined limitations. Students in art classes are often in this "problem-solving" category—they execute a series of assignments devised by the instructor that require rather specific solutions. However, all art or visual problems are similar in that a creative solution is desired.

The creative aspect of art also includes the often-heard phrase "there are no rules in art." This is true. In solving problems visually, there is no list of strict or absolute dos and don'ts to follow. Given the varied objectives of visual art throughout the ages, definite laws are impossible. However, "no rules" may seem to imply that all designs are equally valid and visually successful. This is not true. Artistic practices and criteria have been developed from successful works, of which an artist or designer

should be aware. Thus, guidelines (not rules) exist that usually will assist in the creation of successful designs. These guidelines certainly do not mean the artist is limited to any specific solution.

Form and Content Defined

Discussions of art often distinguish between two aspects, **form** and **content**. Form is the purely visual aspect, the manipulation of the various elements and principles of design. Content implies the subject matter, story, or information that the artwork seeks to communicate to the viewer. Content is what artists want to say; form is how they say it. The poster in **C** can be appreciated for a successful relationship between form and content.

Sometimes the aim of a work of art or design is purely **aesthetic.** Take, for example, adornment such as jewelry where the only "problem" is one of creating visual pleasure. However, even art and design of a decorative nature have the potential to reveal new ways of seeing and communicate a point of view. Art is and always has been a means of visual communication.

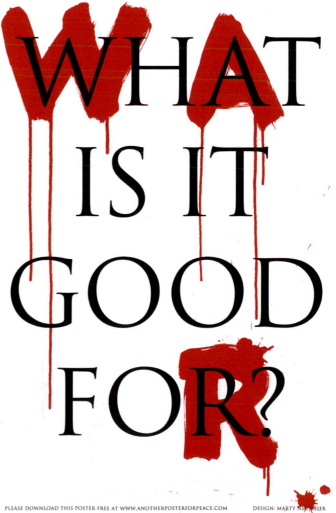

Marty Neumeier. *War: What is it Good For?* **Poster design.** PLEASE DOWNLOAD THIS POSTER FREE AT WWW.ANOTHERPOSTERFORPEACE.COM DESIGN: MARTY NEUMEIER

STEPS IN THE PROCESS

We have all heard the cliché "a picture is worth a thousand words." This is true. There is no way to calculate how much each of us has learned through pictures. Communication has always been an essential role for art. Indeed, before letters were invented, written communication consisted of simple pictorial symbols. Today, pictures can function as a sort of international language. A picture can be understood when written words may be unintelligible to the foreigner or the illiterate. We do not need to understand German to grasp immediately that the message of the poster in **A** is pain, suffering, and torture.

Art as Communication

In art, as in communication, the artist or designer is saying something to the viewer. Here the successful solution not only is visually compelling but also communicates an idea. Any of the elements of art can be used in communication. Purely abstract lines, color, and shapes can very effectively express ideas or feelings. Many times communication is achieved through symbols, pictorial images that suggest to the viewer the theme or message. The ingenuity of creative imagination exercised in selecting these images can be important in the finished work's success.

Countless pictures demonstrate that words are not necessary for communication. We can see that in two examples that suggest the idea of balance. In the photograph *Balanced Rock* **(B)** no words are needed to communicate the idea. In **C** we read the word, but the concept is conveyed visually. The uppercase *E* provides a visual balance to the capital *B*, and the dropped *A* is used as a visual fulcrum. As in **A** the concept comes across independent of language.

So we are led to wonder how these artists arrived at their conclusions. Both **B** and **C** are good ideas, but how were they generated? We can appreciate that the process of trial and error would differ between working with rocks and text! Examples on the coming pages will demystify the work behind the results we admire in accomplished artworks.

The Creative Process

These successful design solutions are due, of course, to good ideas. Students often wonder, "How do I get an idea?" Almost everyone shares this dilemma from time to time. Even the professional artist can stare at an empty canvas, the successful writer at a blank page. An idea in art can take many forms, varying from a specific visual effect to an intellectual communication of a definite message. Ideas encompass both content and form.

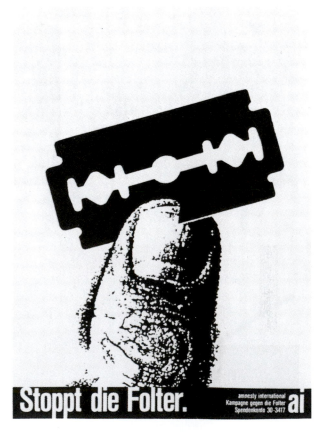

A

Stop Torture. 1985. **Poster for Amnesty International.**

It is doubtful that anyone can truly explain why or how an answer to something we've been puzzling over appears out of the blue. Our ideas can occur when we are in the shower, mowing the lawn, or in countless other seemingly unlikely situations. But we need not be concerned here with sudden solutions. They will continue to occur, but what happens when we have a deadline? What can we consciously do to stimulate the creative process? What sort of activities can promote the likelihood that a solution to a problem will present itself?

The media and the message can vary dramatically, but a process of development can transcend the differences. We suggest three very simple activities with very simple names:

Thinking
Looking
Doing

These activities are not sequential steps and certainly are not independent procedures. They overlap and may be performed almost simultaneously or by jumping back and forth from one to another. One thing is certain however: a moment of sudden insight (like the idea in the shower) rarely occurs without an investment of energy into the problem. Louis Pasteur said that "chance favors the prepared mind," and the painter Chuck Close tells it like it is: "Inspiration is for amateurs. The rest of us get to work."

Andy Goldsworthy. *Balanced Rock* **(Misty, Langdale, Cumbria, May 1977).** *Andy Goldsworthy: A Collaboration with Nature.*

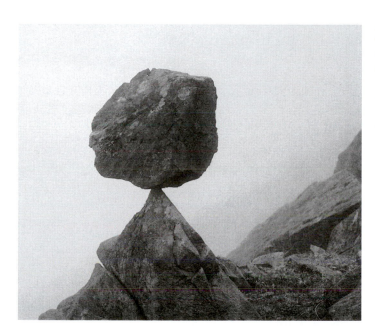

→ C

The layout of the letters matches the word's meaning to convey the idea.

BALANCE

GETTING STARTED

The well-known French artist Georges Braque wrote in his *Cahiers* (notebooks) that "one must not think up a picture." His point is valid; a painting is often a long process that should not be forced or created by formulas to order. However, each day countless designers must indeed "think up" solutions to design problems. Thinking is an essential part of this solution. When confronted by a problem in any aspect of life, the usual first step is to think about it.

Thinking is applicable also to art and visual problems. It is involved in all aspects of the creative process. Every step in creating a design involves choices, and the selections are determined by thinking. Chance or accident is also an element in art. But art cannot be created mindlessly, although some art movements have attempted to eliminate rational thought as a factor in creating art and to stress intuitive or subconscious thought. Even then it is thinking that decides whether the spontaneously created result is worthwhile or acceptable. To say that thinking is somehow outside the artistic process is truly illogical.

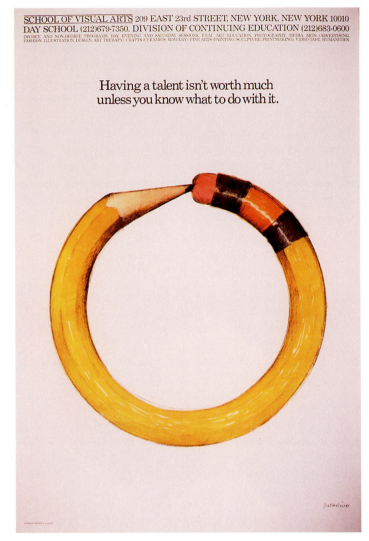

 B

"Having a talent isn't worth much unless you know what to do with it." Poster for the School of Visual Arts. 1978.

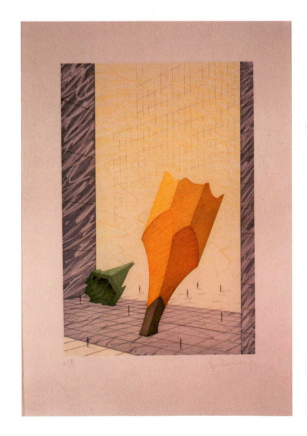

 A

Claes Oldenburg. *Proposal for a Colossal Monument in Downtown New York City: Sharpened Pencil Stub with Broken-off Tip of the Woolworth Building.* **1993. Etching with aquatint, 2' 8½" × 1' 10". Collection of Claes Oldenberg and Coosje van Bruggen.**

Thinking about the Problem

Knowing what you are doing must precede your doing it. So thinking starts with understanding the problem at hand:

Precisely what is to be achieved? (What specific visual or intellectual effect is desired?)

Are there visual stylistic requirements (illustrative, abstract, nonobjective, and so on)?

What physical limitations (size, color, media, and so on) are imposed?

When is the solution needed?

These questions may all seem self-evident, but effort spent on solutions outside the range of these specifications will not be productive. So-called failures can occur simply because the problem was not fully understood at the very beginning.

Tom Friedman. *Untitled.* 1992. Pencil shaving, 1' 11½" × 1½" × 1½", from an edition of two.

Thinking about the Solution

Thinking can be especially important in art that has a specific theme or message. How can the concept be communicated in visual terms? A first step is to think logically of which images or pictures could represent this theme and to list them or, better yet, sketch them quickly, because a visual answer is what you're seeking. Let's take a specific example: What could visually represent the idea of art or design? Some obvious **symbols** appear in the designs on these pages, and you will easily think of more. You might expand the idea by discussing it with others. They may offer suggestions you have not considered. Professional designers often consult reports from market surveys that reveal the ideas of vast numbers of people.

Sketch your ideas to see immediately the visual potential. At this point you do not necessarily decide on one idea. But it's better to narrow a broad list to a few ideas worthy of development. Choosing a visual image is only the first step. How will you use your choice? Three examples shown here all start with a pencil, but take that to unique and memorable conclusions:

A fragment of a pencil becomes the subject of a monumental sculpture. **(A)**

Wasted talent is symbolized by a distorted and useless pencil. **(B)**

A carefully sharpened pencil becomes a spiraling ribbon demonstrating art's ability to transform our understanding of form. **(C)**

These designs are imaginative and eye-catching. The image was just the first step. How that image or form was used provided the unique and successful solution.

Thinking about the Audience

Selecting a particular symbol may depend on limitations of size, medium, color, and so on. Even thinking of future viewers may provide an influence. To whom is this visual message addressed? An enormous pencil fragment as a piece of sculpture might serve as a monument to the legions of "pencil pushers" in an office complex. The same sculpture located at an art school could pay tribute to the humblest of art-making tools. The ribbon of pencil shaving **(C)** may not engage an audience as a symbol so much as a simple but extraordinary fact.

FORM AND CONTENT

What will be presented, and how will it be presented? The thinking stage of the design process is often a contest to define this relationship of *form* and *content*. The contest may play itself out in additions and subtractions as a painting is revised or in the drafts and sketches of an evolving design concept. The solution may be found intuitively or may be influenced by cultural values, previous art, or the expectations of clients.

Selecting Content

Raymond Loewy's revised logo for the Greyhound Bus Company is an example of content being clearly communicated by the appropriate image or form. The existing logo in 1933 **(A)** looked fat to Loewy, and the chief executive at Greyhound agreed. His revised version **(B)** (based on a thoroughbred greyhound) conveys the concept of speed, and the company adopted the new logo.

Selecting Form

The form an artist or designer selects is brought to an elemental simplicity in the challenge of designing **icons** or **pictograms** for signs, buttons, and web or desktop applications. For these purposes the image must be as simple and unambiguous as possible. The examples shown in **C** communicate a number of activities associated with a picnic area in a park and do so in a playful manner. Beneath the fun appearance though we can recognize that simple shapes such as circles and ovals predominate, and that the number of elements are as few as possible to communicate with an image and no text.

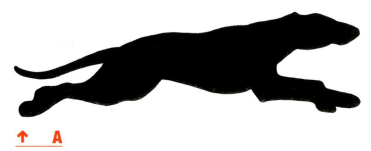

↑ **A**

Raymond Loewy. Original logo for Greyhound Bus Co.

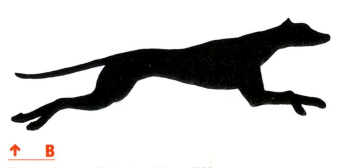

↑ **B**

Raymond Loewy. Redesigned logo, 1933.

Form and content issues would certainly be easier to summarize in a monocultural society. Specific symbols may lose meaning when they cross national, ethnic, or religious borders. The *Navigational Chart* from the Marshall Islands shown in **D** communicated currents and navigational landmarks to the island people who knew how to read this. For the rest of us it is a mysterious web of bamboo lines and shells marking a number of points. We may infer a meaning from an impression that the construction is not an arbitrary arrangement, but without more information the visual clues would not communicate to us. We can only guess how successfully the signs in **C** would communicate to the islanders who used the navigational map.

Given these obstacles to understanding, it is a powerful testimony to the meaning inherent in form when artworks *do* communicate successfully across time and distance. Raymond Loewy's design solution conveys speed and grace with an image that can be understood by many generations and many cultures.

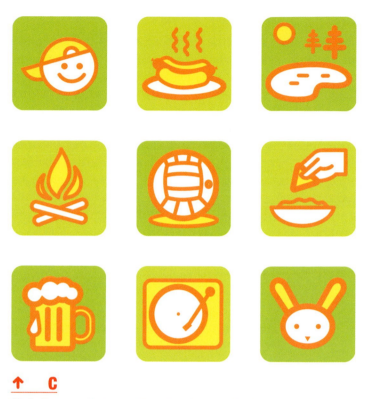

↑ **C**

Chris Rooney. *Picnic Icons.* **From Blackcoffee Design Inc., editor,** *1,000 Icons, Symbols, and Pictograms: Visual Communication for Every Language* **(1000 Series) (Beverly, Mass.: Rockport Publishers, 2009).**

 → **D**

Navigational Chart. Micronesian, Marshall Islands, Late 19th–early 20th century. Findspot: Marshall Islands. Bamboo, cowrie shells, and twine, 66 × 63 cm (2' 2" × 2' 13/16"). Chart consisting of thin bamboo rods, tied together into roughly square form, with diagonally-oriented elements and cowrie shells at some intersections. The bamboo elements represent currents; the cowries represent land masses. On view in the Richard B. Carter Gallery (Oceanic Art), Museum of Fine Arts, Boston. Gift of Governor Carlton Skinner and Solange Skinner, 2002.

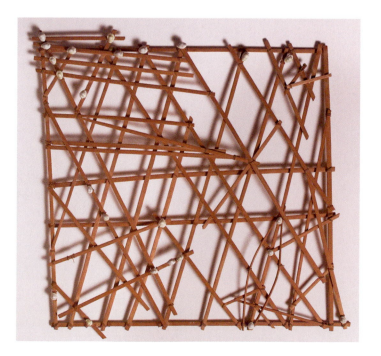

FORM AND FUNCTION

The seaplane shown in **A** shares a similarity of form to the whale shown in **B**. We can probably assume that the designers of the seaplane did not copy the form of this whale; however, both the plane and whale are streamlined for easy movement through the water. In each case the form follows function.

When we say that form follows function, we say that purpose defines the look and shape of an object, and that efficiency is obvious. This relationship is often easiest to see and acknowledge in utilitarian design, such as the furniture design of the American Shaker movement. The interior presented in **C** reveals a simple, straightforward attitude toward furniture and space design. All the furnishings are functional and free from extraneous decoration. The ladder back of the chair exhibits a second utility when the chair is hung on the wall. Everything in this space communicates the Shaker value of simplicity.

The meandering bookshelf and curved furniture shown in **D** are also functional but in a playful and surprising way. The forms are not dictated by a strict form-follows-function design approach. The design solution is simple but the forms express a sense of visual delight and humor as well. This may seem whimsical in contrast to the austerity of Shaker design but in fact both offer a satisfying economy and unadorned clarity.

 A

Grumman HU–16 Albatross, post-WWII "utility and rescue amphibian." Bill Gunston, consultant editor, *The Encyclopedia of World Air Power* (London: Aerospace Publishing Limited, 1980), p. 165.

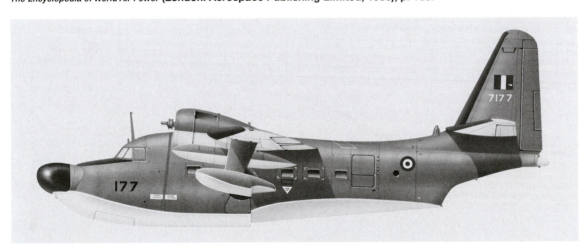

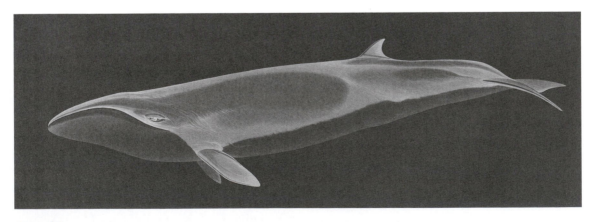

↑ **B**

Pygmy Right Whale *(Caperea marginata)*, Southern Hemisphere, 18'–21½' (5.5–6.5 m). From Mark Cawardine and Martin Camm, *Whales, Dolphins, and Porpoises* (London: Dorling Kindersley, 1995), p. 48.

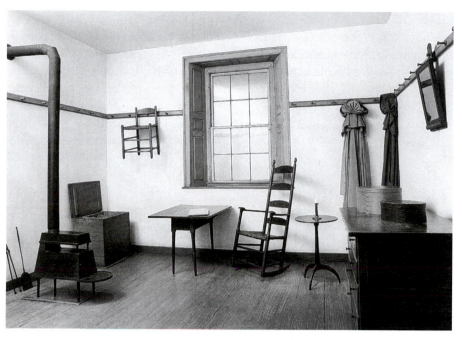

 C

Shaker interior. Reproduced by permission of the American Museum in Britain, Bath, U.K. ©

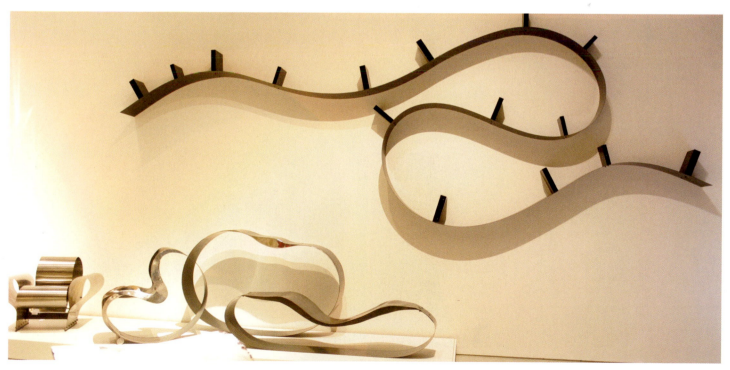

↑ **D**

Ron Arad. "Restless" Exhibition. The Barbican Centre, London, England.

SOURCES: NATURE

Looking is probably the primary education of any artist. This process includes studying both the natural world and human artifacts. Observing nature reveals the elegant adaptations of plants and animals to their environment. The structures of nature, from beehives to birds' wings, offer models for efficient design and beautiful art.

Source versus Subject

Sources in nature are clearly identifiable in the works of some artists, while less obvious in the works of others—perhaps revealed only when we see drawings or preparatory work. In any case a distinction should be made between source and subject. The source is a stimulus for an image or idea. For example, Arthur Dove's oil painting **(A)** is titled *Tree Composition*, but the source of this image is significantly abstracted and the subject of the painting is apparently a spiral form and energy that Dove saw in the tree.

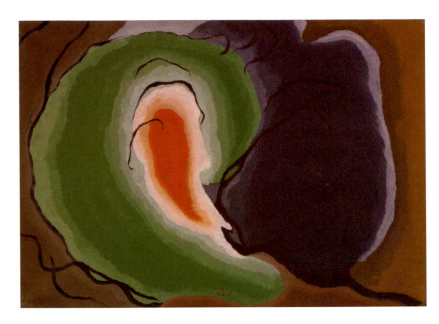

← **A**

Arthur Dove. *Tree Composition.* **1937. Oil on canvas, 1' 3¼" x 1' 9". Edward W. Root Bequest (57.136). Munson-Williams-Proctor Arts Institute, Utica, New York.**

→ **B**

Georgia O'Keeffe. *Shell No. 1.* **1928. Oil on canvas, overall: 17.8 × 17.8 cm (7" × 7"), framed: 20.3 × 20.3 × 3.3 cm (8" × 8" × 1⁵⁄₁₆").**

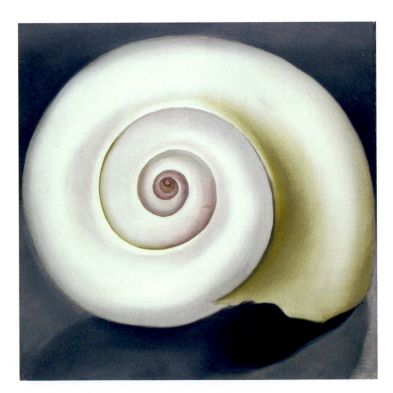

← **C**

Leonardo da Vinci. *Studies of Flowers.* **c.1509–1511. Drawings, Watercolours and Prints. The Royal Collection. London.**

→ **D**

Leonardo da Vinci. *Study of Flowing Water.* **c. 1509–1511. The Royal Collection, London.**

Georgia O'Keefe's painting of a shell **(B)** is a more realistic depiction of its source or model in the natural world, but clearly she too was interested in the spiral, and in this way her painting has a kinship to that of Arthur Dove (her friend and colleague).

The two sketchbook drawings by Leonardo **(C** and **D)** show how the artist found similar spiral patterns in the way a plant grows and the turbulence of water. Drawing is an artist's means for active looking and learning from the natural world. Leonardo drew upon these observations in both his paintings and machine designs. The plant appears in the painting *Virgin of the Rocks*, and the study of water turbulence was relevant to his ideas on bridge design. For Leonardo "design" was relevant to both painting and engineering.

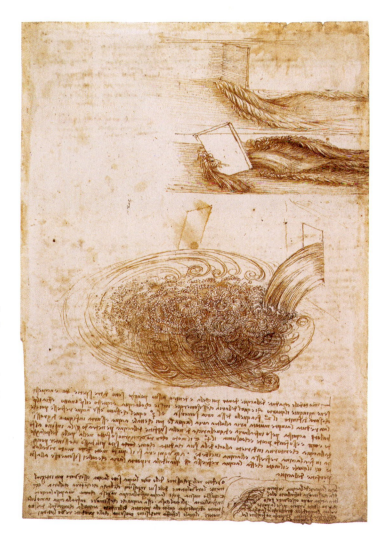

SOURCES: ARTIFACTS

We expect artists and designers to be visually sensitive people who see things in the world that others might overlook and who look with special interest at the history of art and design. Studying art, architecture, craft, and design from all periods, regions, and cultures introduces you to a wealth of visual creations, better equipping you to discover your own solutions.

The painter Sean Scully has long been interested in the arrangements of walls and windows and the light that falls on these surfaces. In fact, he often photographs these subjects. This informs our understanding of the installation of his paintings shown in **A**. What is Scully looking at when he looks at these architectural structures? Evidently he sees a rich world of color and light and surprising arrangements of rectangles and stripes that challenge him to compose subtle but complex compositions . . . inspired from a seemingly neutral or ordinary source.

This process of looking is extended in the photograph by a Dartmouth College student shown in **B**. This photo is a response to Scully's paintings and is one of a series of "stripes" found in the campus environment.

For better or worse we do not create our design solutions in an information vacuum. We have the benefit of an abundance of visual information coming at us through various media, from books to television, websites, and films. On the plus side, we are treated to images one would previously have had to travel to see.

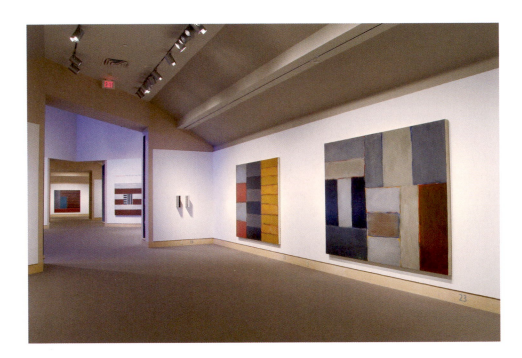

 A

Sean Scully. *Installation View.* **Hood Museum, Dartmouth College, New Hampshire.**

 B

Dartmouth College student Lauren Orr. 2008. Hood Museum, Dartmouth College, New Hampshire.

On the minus side, it is easy to overlook that we are often seeing a limited (or altered) aspect of the original artwork in a reproduction. The influence of reproduced images is enriching but potentially superficial. Artists and designers will often travel and study influences firsthand for a deeper understanding of their influences.

Nancy Crow is an artist who mines a rich treasure of cultural influences and creates unique works that are not simply copies gleaned from other cultures. Her travels and research connect her work to artifacts such as Mexican masks **(C)**. The impact can be seen in her quilt shown in **D**.

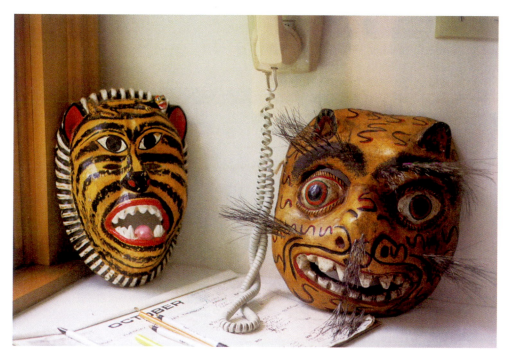

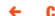 **C**

Nancy Crow. *Mexican Tiger Masks.* **From the Collection of Nancy Crow.**

→ D

Nancy Crow. *Mexican Wheels II.* **1988. Quilt, 7' 6" × 7' 6". From the Collection of Nancy Crow.**

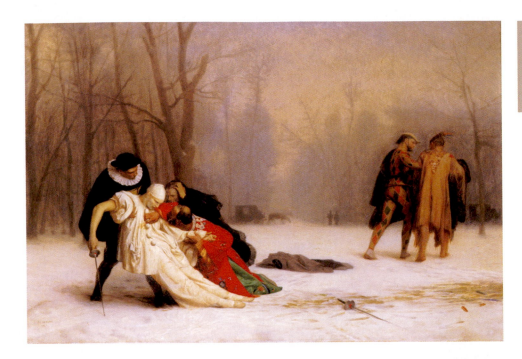

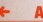

A

Jean-Léon Gérôme. *The Duel after the Masquerade.* **1857–1859. Oil on canvas, 1' 3⅜" × 1' 10¾₆" (39.1 × 56.3 cm).**

SOURCES: HISTORY AND CULTURE

Visual Training and Retraining

The art of looking is not entirely innocent. Long before the training in seeing we get in art and design classes, we are trained by our exposure to mass media. Television, film, Internet, and print images provide examples that can influence our self-image and our personal relationships. The distinction between "news" and "docudrama" is often a blurry one, and viewers are often absorbed into the "reality" of a movie.

At times it seems that visual training demands a retraining of looking on slower, more conscious terms. "Look again" and "see the relationships" are often heard in a beginning drawing class. Part of this looking process involves examining works of art and considering the images of mass media that shape our culture. Many artists actively address these issues in their art by using familiar images or "quoting" past artworks. Although this may seem like an esoteric exercise to the beginning student, an awareness of the power of familiar images is fundamental to understanding visual communication.

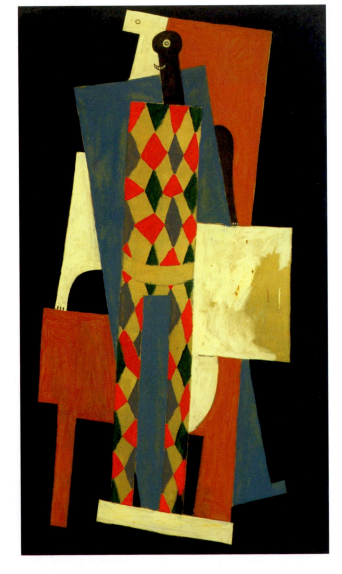

B

Pablo Picasso. *Harlequin.* **Paris, late 1915. Oil on canvas, 6' ¼" × 3' 5⅝" (183.5 × 105.1 cm).**

Two paintings separated by a century in time have a common "character" in the Harlequin. The Harlequin pattern can be seen in both **A** and **B**, but the visual language of these two paintings is in stark contrast. Picasso references earlier artwork even as he constructs a radically different composition. We will engage both of these images throughout the chapters of this book as we compare and contrast their attributes.

Certain so-called high art images manage to become commonly known, or **vernacular**, through frequent reproduction. In the case of a painting like *Washington Crossing the Delaware*, the image is almost as universally recognized as a religious icon once was. There is a long tradition of artists paying homage to the masters, and we can understand how an artist might study this or other paintings in an attempt to learn techniques. However, *George Washington Carver Crossing the Delaware* **(C)**, by the African American artist Robert Colescott, strikes a different relationship to the well-known painting we recognize as a source. Colescott plays with the familiarity of this patriotic image and startles us with a presentation of negative black stereotypes. One American stereotype is laid on top of another, leading the viewer to confront preconceptions about both.

In contrast to the previous fine art examples, the example shown in **D** comes from the world of commercial art. The evolving image of "Betty Crocker" reveals how this icon was visualized at different times. This then reflects where the illustrator looked for a visual model of "American female." Looking, then, can be influenced by commercial and societal forces, which are as real an aspect of our lives as the elements of nature.

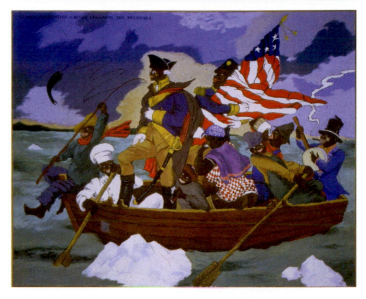

↑ **C**

Robert Colescott. *George Washington Carver Crossing the Delaware.* **1975. Acrylic on canvas, 4' 6" × 9'. Phyllis Kind Gallery, New York.**

Looking is a complex blend of conscious searching and visual recollections. This searching includes looking at art, nature, and the vernacular images from the world around us, as well as doing formal research into new or unfamiliar subjects. What we hope to find are the elements that shape our own visual language.

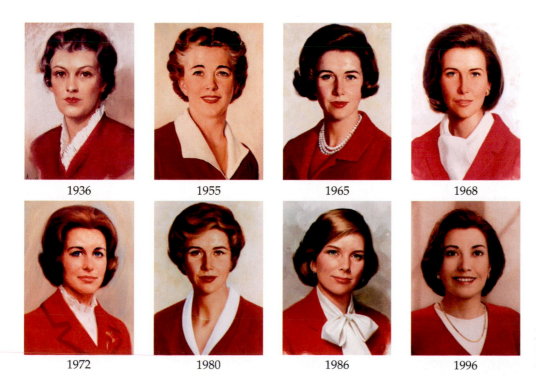

1936 1955 1965 1968

1972 1980 1986 1996

← **D**

Betty Crocker through the years. Courtesy General Mills (Canada).

THINKING WITH MATERIALS

Doing starts with visual experimentation. For most artists and designers, this means thinking with the materials. Trial and error, intuition, or deliberate application of a system is set into motion. At this point an idea starts to take form, whether in a sketch or in final materials. The artist Eva Hesse got right to the point with her observation on materials:

Two points of view—
a. *Materials are lifeless til given shape by creator.*
b. *Materials by their own potential created their end.**

Eva Hesse is known for embracing apparent contradictions in her work. The studio view **(A)** presents a number of her sculptural works that embody both of the preceding points of view. Hesse gave shape to materials such as papier-mâché, cloth, and wood. Other elements, such as the hanging, looping, and connecting ropes and cords, reflect the inherent potential of the materials.

Sarah Weinstock's drawing shown in **B** is the result both of the forces at play with ink spread on soap bubbles and of the artist's coaxing and encouragement of those materials on the paper. The result suggests two organic forms with one reaching out toward the other.

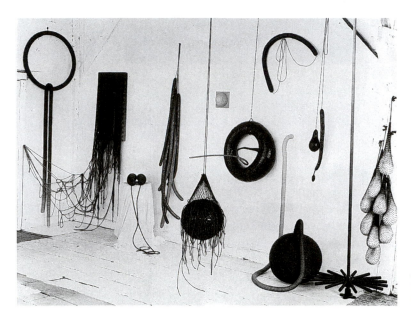

 A

Eva Hesse. *Studio.* **1966. Installation photograph by Gretchen Lambert. Courtesy Robert Miller Gallery.**

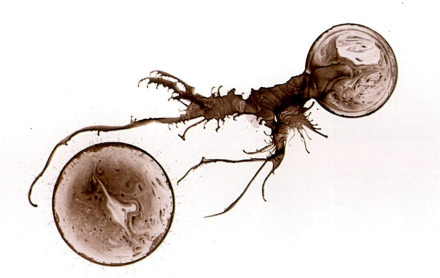

 B

Sarah Weinstock. *Untitled Drawing.* **2006. Ink and soap bubbles on paper, 6½" × 9½" (detail).**

*Lucy R. Lippard, *Eva Hesse* (New York: New York University Press, 1976/Da Capo Press, Inc., 1992), 13.

The sculptor David Smith composed spray paintings, and these resemble the stacked arrangements of his sculptures. The playfulness in his approach is obvious and direct in these paintings. We can easily imagine him arranging and rearranging shapes before deciding to accept a certain arrangement and capture that with an over-spray (**C** and **D**). When we see his stainless steel sculptures, we may not be aware that such physically heavy and abstract work has a playful side—a necessary step in the doing process for this artist.

↑ C

David Smith. *Untitled.* **1964. Spray enamel on canvas, 1' 7" × 1' 4".
Art © Estate of David Smith. Licensed by VAGA, New York,
New York. Courtesy Gagosian Gallery. Photography by
Robert McKeever.**

→ D

David Smith. *DS 1958.* **1958. Spray and stenciled enamel on paper,
1' 5 ½" × 11½" (44.5 × 29.2 cm). Gift of Candida and Rebecca
Smith, 1994. Art © Estate of David Smith/Licensed by VAGA, New
York, New York. Image copyright © The Metropolitan Museum of
Art/Art Resource, New York.**

DOING AND REDOING

The art historian Irving Sandler recounts the occasion of watching the painter Willem De Kooning being filmed at work in his studio.

> Our camera followed his movements avidly, the flailing brush, the dancing feet. It couldn't be better as film. A few days later I met de Kooning on the street and asked how the painting was going. He said that he had junked it the moment we left. I asked why. "I lost it," he said. "I don't paint that way." Then why the charade? He answered, "You saw that chair in the back of the studio. Well, I spend most of my time sitting on it, studying the picture, and trying to figure out what to do next. You guys bring up all that equipment . . . what was I supposed to do, sit in a chair all night?" "But Bill," I said, "in the future, they'll look at our film and think that's how you painted." He laughed.*

Students tend to underestimate this part of the creative process (the sitting and reflecting) and the value of doing and redoing. Often we have to overcome our attachment to a first idea or reluctance to change, revise, or wipe out first efforts. The painter Henri Matisse did us a favor in recording many stages **(A)** of his painting *The Pink Nude* **(B)**. Here is an artist at the height of his career. Perhaps any one of the variants would have satisfied an eager collector, but for Matisse, the painting process was a search for a new and striking version of a familiar painting subject. The search by Matisse led to a painting where the whole composition is the subject . . . not just the more obvious focal point that a nude presents.

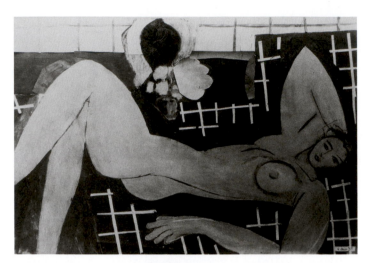

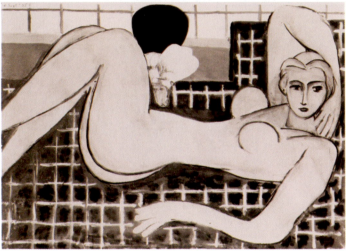

 A

Henri Matisse. *Large Reclining Nude/The Pink Nude: Two Stages in Process* **(two of seventeen photographed by the artist). 1935. Oil on canvas (with cut paper), 2' 2" × 3' ½" (66 × 92.7 cm).**

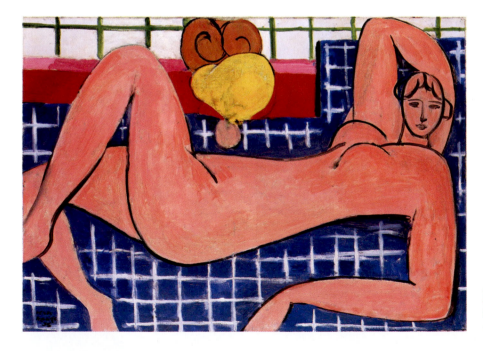

 B

Henri Matisse. *Large Reclining Nude/The Pink Nude.* **1935. Oil on canvas, 2' 2" × 3' ½" (66 × 92.7 cm).**

*Irving Sandler, "Willem de Kooning, 1904–1997" (obituary), *Art in America* (May 1997).

The process board shown in **C** exhibits all the aspects of thinking, looking, and doing. Considerations of marketing are recorded, sources and other symbol solutions are acknowledged, and, finally, the initial idea is shown moving through stages of doing and redoing, leading to finished refinement.

A graphic designer is more likely than a painter to communicate the considerations and steps in the process to a client. A film of the painter Philip Guston at work ends with him covering his picture with white to begin again. Guston accepted such a setback along the way as normal and even necessary. His experience told him that revision would allow an idea to grow beyond an obvious or familiar starting point. If we examine paintings carefully, we often discover **pentimenti**, or traces of the artist's revisions. This Latin term means "the artist repents."

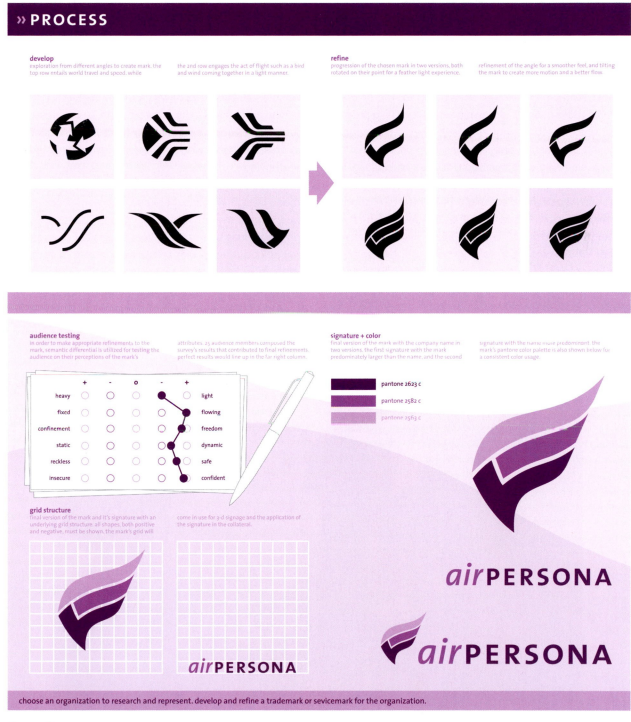

» PROGRESS

develop
exploration from different angles to create mark. the top row entails world travel and speed, while

the 2nd row engages the act of flight such as a bird and wind coming together in a light manner.

refine
progression of the chosen mark in two versions, both rotated on their point for a feather light experience.

refinement of the angle for a smoother feel, and tilting the mark to create more motion and a better flow.

audience testing
in order to make appropriate refinements to the mark, semantic differential is utilized for testing the audience on their perceptions of the mark's

attributes. 25 audience members composed the survey's results that contributed to final refinements. perfect results would line up in the far right column.

	+	-	o	-	+	
heavy	○	○	○	●	○	light
fixed	○	○	○	●	○	flowing
confinement	○	○	○	●	○	freedom
static	○	○	○	●	○	dynamic
reckless	○	○	●	○	○	safe
insecure	○	○	○	●	○	confident

signature + color
final version of the mark with the company name in two versions. the first signature with the mark predominately larger than the name, and the second

signature with the name more predominant. the mark's pantone color palette is also shown below for a consistent color usage.

pantone 2623 c
pantone 2582 c
pantone 2563 c

grid structure
final version of the mark and it's signature with an underlying grid structure. all shapes, both positive and negative, must be shown. the mark's grid will

come in use for 3-d signage and the application of the signature in the collateral.

*air*PERSONA

*air*PERSONA

choose an organization to research and represent. develop and refine a trademark or sevicemark for the organization.

↑ **C**

Meredith Rueter. *Process Board: air PERSONA.*

CONSTRUCTIVE CRITICISM

Critique is an integral component of studio education for art students and can take several forms. You could have direct dialogue with a professor in front of a work in progress, or your entire class could review a completed work **(A** and **B)**. Critique can also be a self-critique and take the form of a journal entry. The goal of a critique is increased understanding through examination of the project's successes and shortcomings. Various creative people, from artists to composers to authors, generally affirm that criticism is best left for *after* the completion of a design or composition. A free and flexible approach to any studio work can be stifled by too much criticism too soon.

The components of a constructive critique can vary, but a critique is most valid when linked to the criteria for the artwork, design, or studio assignment. If a drawing's objective is to present an unusual or unexpected view of an object, then it is appropriate to critique the perspective, size, emphasis, and contrast of the drawing—those elements that contribute to communicating the point of view. Such a critique could also include cultural or historic precedents for how such an object might be depicted. A drawing of an apple that has been sliced in half and is seen from above would offer an unusual point of view. An apple presented alongside a serpent would present a second point of view charged with religious meaning for Jews and Christians. Both approaches would be more than a simple representation and would offer contrasting points of view. Nevertheless, both drawings may be subject to a critique of their composition.

A Model for Critique

A constructive model for critique would include the following:

Description: A verbal account of what is there.

Analysis: A discussion of how things are presented with an emphasis on relationships (for example, "bigger than," "brighter than," "to the left of").

Interpretation: A sense of the meaning, implication, or effect of the piece.

A simple description of a drawing that includes a snake and an apple might lead us to conclude that the drawing is an **illustration** for a biology text. Further description, analysis, and interpretation could lead us to understand other meanings and the emphasis of the drawing. And, in the case of a critique, thoughtful description, analysis, and interpretation might help the artist (or the viewer) see other, more dynamic possibilities for the drawing.

The many sections devoted to principles and elements of art and design in this text are each a potential component for critique. In fact, the authors' observations about an image could be complemented by further critical analysis. For example, the text may point out how color brings emphasis to a composition, and further discussion could reveal the impact of other aspects such as size, placement, and cultural context.

The critique process is an introduction to the critical context in which artists and designers work. Mature artworks are subject

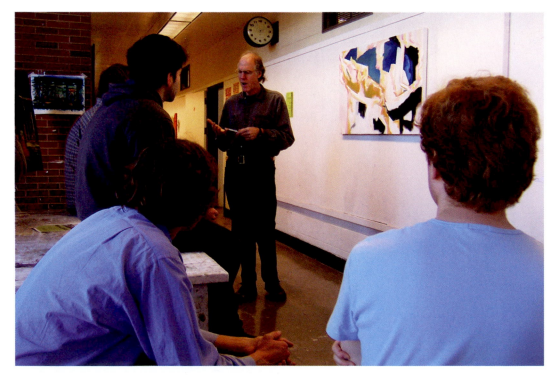

↑　**A**

A professor critiques a work in progress.

to critical review, and professional designers submit to the review of clients and members of their design teams. Future theory and criticism are pushed along by new designs and artworks.

On a lighter note, the critique process can include the range of responses suggested by Mark Tansey's painting shown in **C**:

You may feel your work has been subjected to an aggressive cleansing process.

You may feel you are butting your head against a wall.

And don't forget that what someone takes from an image or design is a product of what he or she brings to it!

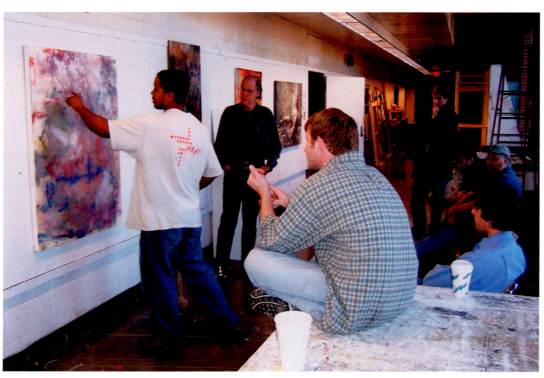

 B

Students review and critique each other's work.

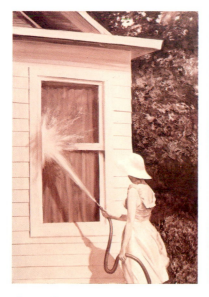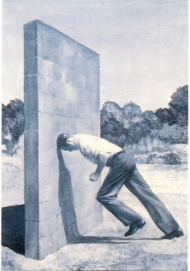

 C

Mark Tansey. *A Short History of Modernism.* **1982. Oil on canvas, three panels, 4' 10" × 10' overall. Collection: Steve and Maura Shapiro. Courtesy Gagosian Gallery, New York, with permission from the estate of Mark Tansey.**

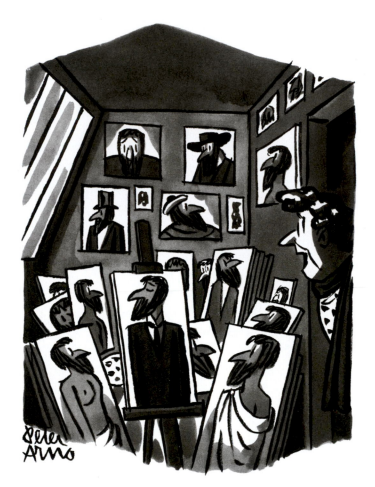

"George! Are you in there?"

Peter Arno. 1970.
© *The New Yorker Album of Art and Artists.*
All Rights Reserved.

CHAPTER **2** UNITY

HARMONY

Unity, the presentation of an integrated image, is perhaps as close to a rule as art can approach. Unity means that a congruity or agreement exists among the elements in a design; they look as though they belong together, as though some visual connection beyond mere chance has caused them to come together. Another term for the same idea is **harmony**. If the various elements are not harmonious, if they appear separate or unrelated, your composition falls apart and lacks unity.

The image in **A** illustrates a high degree of unity. When we look at the elements in this design, we immediately see that they are all somewhat similar. This harmony, or unity, arises not merely from our recognition that all the objects are paint cans. Unity is achieved through the repetition of the oval shapes of the cans. Linear elements such as the diagonal shadows and paint sticks are also repeated. The subtle grays of the metal cans unify a composition accented by a few bright colors. Such a unity can exist with either **representational** imagery or abstract forms.

The landscape photograph in **B** consists of varied shapes with no exact repetitions, yet all the shapes have a similar irregular jigsaw puzzle quality. The harmonious unity of the shapes is reinforced by a similarity of color throughout this **monochromatic** picture.

Seen simply as cutout shapes, the variety of silhouettes in **C** would be apparent. Alex Katz balances this variation with the unity of the repeated portrait of his wife, Ada. This approach of theme and variation is the essence of the concept of unity.

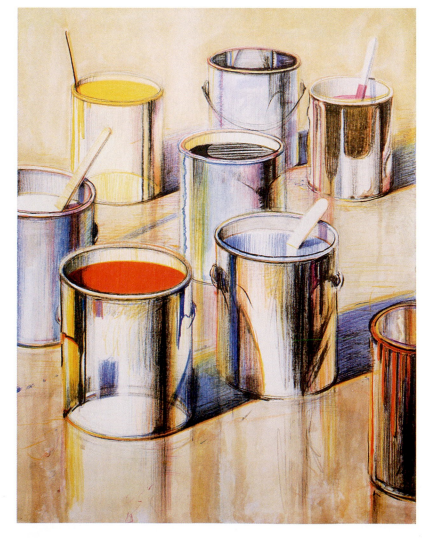

 A

Wayne Thiebaud. *Paint Cans.* **1990. Lithograph, hand-worked proof, 75.7 × 58.8 cm. DeYoung Museum (gift of the Thiebaud Family, 1995.99.12). Art © Wayne Thiebaud/ Licensed by VAGA, New York, New York.**

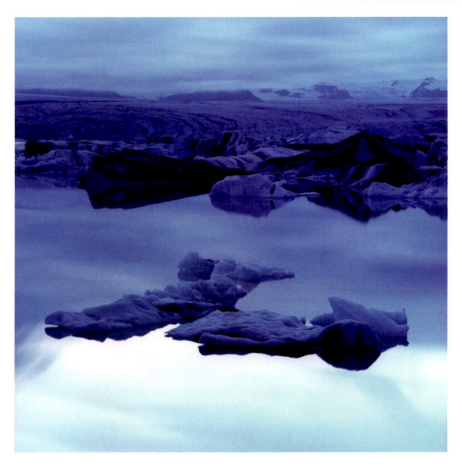

 B

Damon Winter. Personal photograph from Iceland.
Communication Arts, **May/June 2005.**

Where Does Unity Come From?

Unity of design is planned and controlled by an artist. Sometimes it stems naturally from the elements chosen, as in these examples. But more often it reflects the skill of the designer in creating a unified pattern from varied elements. Another term for *design* is **composition**, which implies the same feeling of organization. Just as a composition in a writing class is not merely a haphazard collection of words and punctuation marks, so too a visual composition is not a careless scattering of random items around a format.

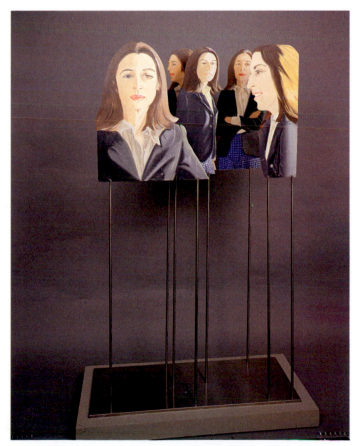

 C

Alex Katz. *Black Jacket.* **1972. Oil on aluminum (cutout), 5' 2⅝" × 3' ¼"
(159 × 92 cm). Des Moines Art Center (gift in honor of Mrs. E. T.
Meredith, Permanent Collection, 1978.7). Art © Alex Katz/Licensed
by VAGA, New York, New York.**

VISUAL UNITY

An important aspect of visual unity is that the whole must predominate over the parts: you must first see the whole pattern before you notice the individual elements. Each item may have a meaning and certainly add to the total effect, but if the viewer sees merely a collection of bits and pieces, then visual unity doesn't exist.

This concept differentiates a design from the typical scrapbook page. In a scrapbook each item is meant to be observed and studied individually, to be enjoyed and then forgotten as your eye moves on to the next souvenir. The result may be interesting, but it is not a unified design.

Exploring Visual Unity

The **collage** in **A** is similar to a scrapbook in that it contains many individual images. However, unlike a scrapbook, we are aware first of the pattern the elements make together, and then we begin to enjoy the items separately. A visual unity dominates.

Do not confuse intellectual unity with visual unity. Visual unity denotes some harmony or agreement between the items that is apparent to the eye. To say that a scrapbook page is unified because all the items have a common theme (your family, your wedding, your vacation at the beach) is unity of idea—that is, a conceptual unity not observable by the eye. A unifying idea will not necessarily produce a unified visual composition. The fact that all the elements in **A** are plant forms is interesting, but it is the repetition of curling lines and similarity of color that creates the unity. Within that obvious unity we are invited to compare and contrast the numerous specimens.

The unity in **B** does not derive from the fact that the four girls are sisters (a fact we can take from the title). The repetition of white smocks and a white dress tie the figures together. A recurring blue-gray also unifies the composition. Even an apparently singular element like the red screen has an echo in one girl's red dress. This painting has many individual elements that capture our attention, but the entirety of the composition is unified.

The need for visual unity is nowhere more apparent than in the design of a typeface or **font**. Whether bold, or regular, or italic, the unity of design must be foremost. Letters as divergent as "Q" and "Z" must have a family resemblance. The sample shown in **C** demonstrates one such successful design.

↓ **A**

Karl Blossfeldt. *Pumpkin Tendrils.* **Works of Karl Blossfeldt by Karl Blossfeldt Archive. Ann and Jürgen Wilde, eds.,** *Karl Blossfeldt: Working Collages* **(Cambridge: MIT Press, 2001), p. 54.**

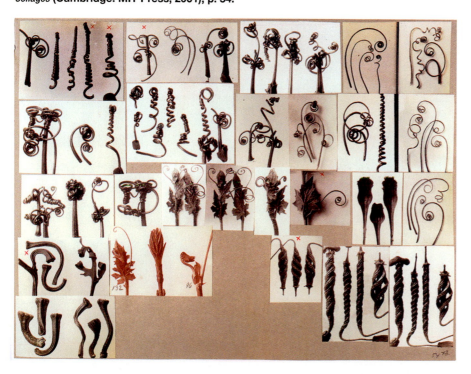

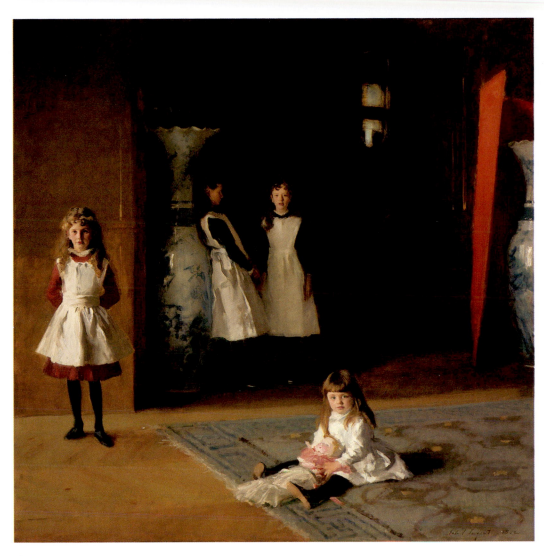

 B

John Singer Sargent, *The Daughters of Edward Darley Boit.* **1882. Oil on canvas, 221.93 × 222.57 cm (7' 3⅜" × 7' 3⅜"). MFA, Boston.**

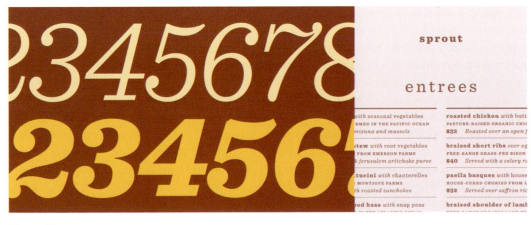

↑ **C**

Hoefler & Frere-Jones. Sentinel Font.

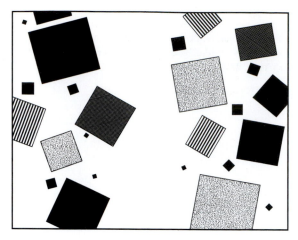

↑ A

We instantly see two groups of shapes.

↑ B

The white diagonal is as obvious as the two groups of rectangles.

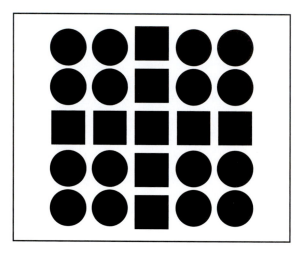

↑ C

Grouping similar shapes makes us see a plus sign in the center.

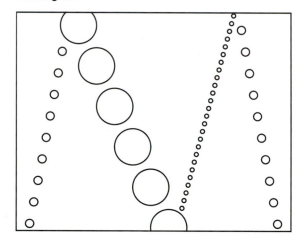

↑ D

The circles seem to form "lines," and we see an M shape.

VISUAL PERCEPTION

The designer's job in creating a visual unity is made easier by the fact that the viewer is actually looking for some sort of organization, something to relate the various elements. The viewer does not want to see confusion or unrelated chaos. The designer must provide some clues, but the viewer is already attempting to find some coherent pattern and unity. Indeed, when such a pattern cannot be found, chances are the viewer will simply ignore the image.

Studies in the area of perception have shown this phenomenon. Since early in the twentieth century, psychologists have done a great deal of research on visual perception, attempting to discover just how the eye and brain function together. Much of this research is, of course, very technical and scientific, but some of the basic findings are useful for the artist or designer. The most widely known of these perception studies is called the **gestalt** theory of visual psychology.

How We Look for Unity

Consider a few elementary concepts, which only begin to suggest the range of studies in perception. Researchers have concluded that viewers tend to group objects that are close to each other into a larger unit. Our first impression of **A** is not merely some random squares but two groups of smaller elements.

Negative (or empty) **spaces** will likewise appear organized. In **B** viewers immediately see the many elements as two groups. However, with all the shapes ending on two common boundaries, the impression of the slanted white diagonal shape is as strong as the various rectangles.

Also, our brain will tend to relate and group objects of a similar shape. Hence, in **C** a cross or plus sign is more obvious than the allover pattern of small shapes. In **D** the pattern is not merely many circles of various sizes. Instead our eye will close the spaces between similar circles to form a design of "lines."

These diagonal lines organize themselves to give the impression of an M shape.

We easily identify the elements that make up the Richard Prince painting shown in **E** as three ellipses and a circle in a white field. The proximity of the four black shapes forms a constellation, and the smaller parts give way to the organization of the larger pattern. In this case it is possible to see this configuration as a startled clownlike face. This reading is assisted by the title (*My Funny Valentine*) but also reveals how easily we project a "face" onto a pattern.

The impulse to form unity or a visual whole out of a collection of parts can also work on an architectural scale. The Beaubourg **(F)** is a contemporary art center in Paris. The outer shell of the building is formed from conduits and structural features that are usually hidden. The constant repetition of vertical ducts, square structural framing, and circular openings gives visual unity to a potentially chaotic assortment of pipes and scaffolding. This building's distinct appearance stands in contrast to other buildings in the area, further strengthening its visual identity. Our brain looks for similar elements, and when we recognize them, we see a cohesive design rather than unorganized chaos.

E

Richard Prince. *My Funny Valentine.* **2001. Acrylic on silk screen frame, 7' 2½" × 5' 8½". Courtesy Barbara Gladstone Gallery, New York. © Richard Prince.**

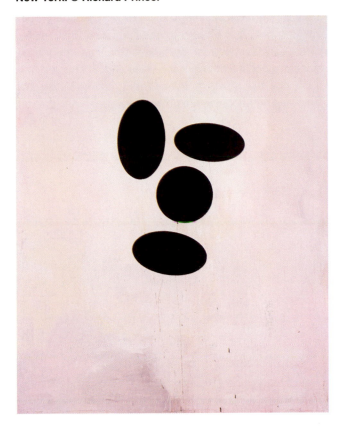

F

Piano & Rogers; Ova Arup & Partners. Centre National d'Art et de Culture Georges Pompidou (Beaubourg) Paris, 1971–1977.

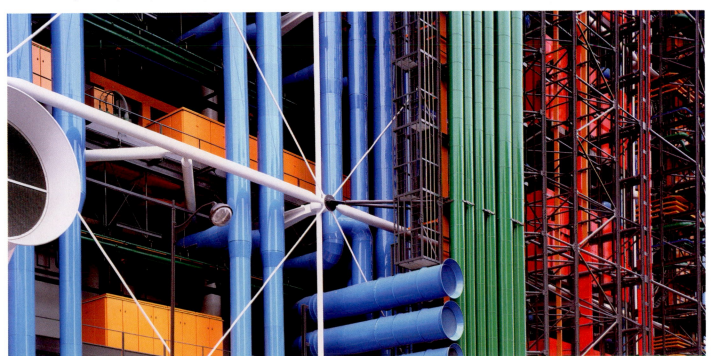

PROXIMITY

An easy way to gain unity—to make separate elements look as if they belong together—is by **proximity,** simply putting the elements close together. The four elements in **A** appear isolated, as floating bits with no relationship to each other. By putting them close together, as in **B**, we begin to see them as a total, related pattern. Proximity is a common unifying factor. Through proximity we recognize constellations in the skies and, in fact, are able to read. Change the proximity scheme that makes letters into words, and reading becomes next to impossible.

Proximity in Composition

Thomas Eakins's painting **(C)** of bathers at a swimming hole shows the idea of proximity in composition. The lighter elements of the swimmers' bodies contrast with the generally darker background. However, these light elements are not placed aimlessly around the composition but, by proximity, are arranged carefully to unite visually. Four of the figures form the apex of an equilateral triangle at the center of the painting. This triangle provides a stable unifying effect.

El Lissitzky's *Here are Two Squares* **(D)** is a **nonobjective** "construction" from a series of related designs. They tell the story of a radical approach to visual communication from early in the twentieth century. In this example (one of six in the series) the black square, tilted red square, and text below the frame are tied together by proximity. Lissitzky takes the principle shown in **B** to unify three parts into a unified cast of characters. This keeps the brash red square in check.

Proximity is the simplest way to achieve unity, and many artworks employ this technique. Without proximity (with largely isolated elements), the artist must put greater stress on other methods to unify an image.

 A

If they are isolated from one another, elements appear unrelated.

 B

Placing items close together makes us see them first as a group.

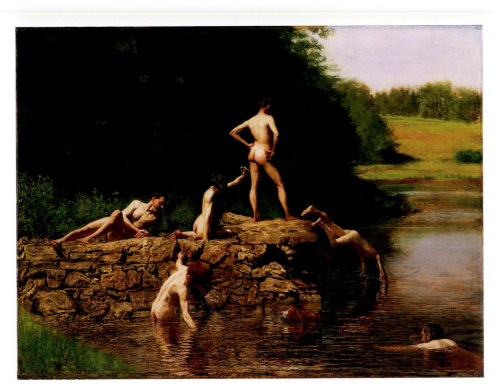

← **C**

Thomas Eakins. *Swimming.* **1885. Oil on canvas, 2' 3⅜" × 3' ⅜". Collection of Amon Carter Museum, Fort Worth, Texas.**

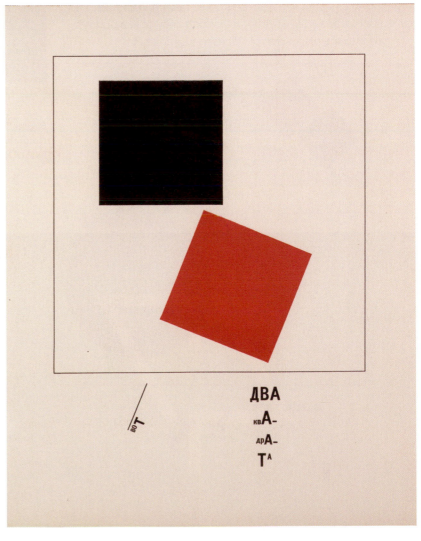

→ **D**

Shapes and text follow a line of continuation. El Lissitzky.
Of Two Squares: A Suprematist Tale in Six Constructions. **1922.**

REPETITION

A valuable and widely used device for achieving visual unity is **repetition.** As the term implies, something simply repeats in various parts of the design to relate the parts to each other. The element that repeats may be almost anything: a color, a shape, a texture, a direction, or an angle. In the painting by Sophie Taeuber-Arp **(A)**, the composition is based on one shape: a circle with two circular "bites" removed. This shape is repeated in different sizes and positions. The result is a composition that is unified but not predictable.

Joe Miller's logo design for *space 47* **(B)** also shows unity by repetition. In this case it is not multiple repetitions, but a simple repeat with a twist that differentiates the "4" from the "7." The puzzle created by this is striking and engaging to the viewer resulting in a memorable logo.

Repetition as an element of unity is not limited to geometric shapes. In the ink drawing shown in **C** we see many marks of a similar fast and dynamic stroke. These marks define hair, jacket surface, furrowed brow, and so forth, but their similarity of character unites them into a distinct language. Imagine how different this image would be if these lines were replaced in part with dots in one area and a photographic realism in another. The three approaches would disrupt the strong unity of this portrait.

See also the discussion of *Rhythm* in Chapter 6.

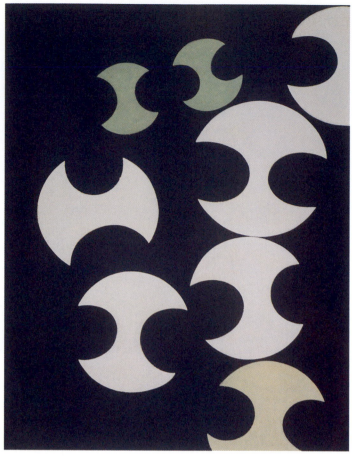

 A

Sophie Taeuber-Arp. *Composition with Circles Shaped by Curves.* **1935. Gouache on paper, 1' 1⅞" × 10⅝" (35 × 27 cm). Kunstmuseum Bern (gift of Mrs. Marguerite Arp-Hagenbach).**

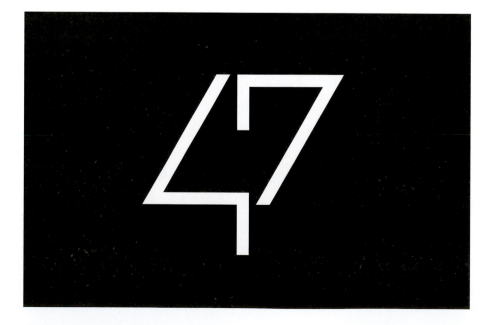

 B

Joe Miller's Design Co. Logo design for space 47. 47 East William Street, San José, California 95112.

 C

Don Bachardy. *UNTITLED II.* August 19, 1985. Works on paper (drawings, watercolors, etc.). Acrylic on paper, 2' 5.9" × 1' 10.4" (75.9 × 56.9 cm).

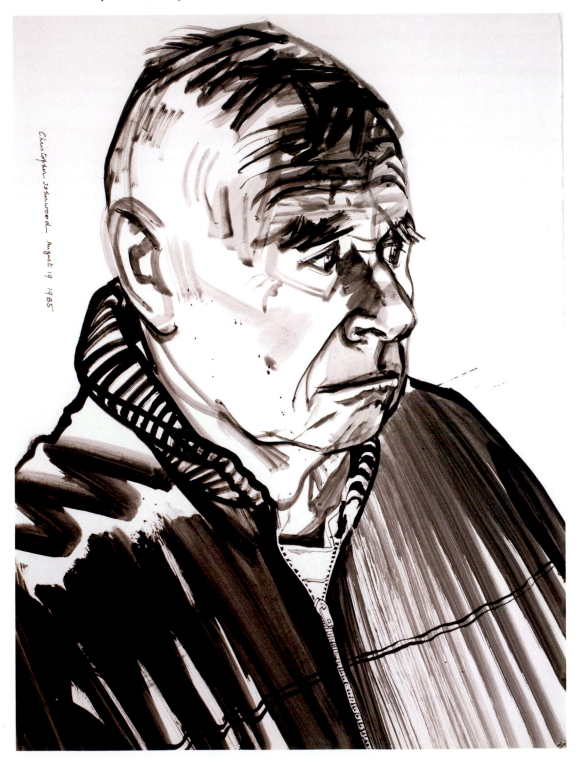

CONTINUATION

A third way to achieve unity is by **continuation,** a more subtle device than proximity or repetition, which are fairly obvious. Continuation, naturally, means that something "continues"—usually a line, an edge, or a direction from one form to another. The viewer's eye is carried smoothly from one element to the next.

The design in **A** is unified by the closeness and the character of the elements. In **B**, though, the shapes seem even more of a unit because they are arranged in such a way that one's vision flows easily from one element to the next. The shapes no longer float casually. They are now organized into a definite, set pattern.

Continuation Can Be Subtle or Deliberate

The edge of the sleeping girl's head and her outstretched arm connect to the curving line of the sofa, forming one line of continuity in *The Living Room* **(C)**. Other subtle lines of continuation visually unite the many shapes and colors of what might otherwise be a chaotic composition.

A deliberate or more obvious form of continuation is a striking aspect in many of Jan Groover's photographs. In one series of photographs, she caught passing trucks as an edge of each truck aligned visually with a distant roofline or a foreground pole. This alignment connected these disparate elements for an instant, resulting in a unified image. In **D** Groover employs a more subtle form of continuation, which results in a fluid eye movement around the picture. One shape leads to the next, and alignments are part of this flow.

Three-Dimensional Design

Continuation is an aspect not only of two-dimensional composition. Three-dimensional forms such as the automobile shown in **E** can utilize this design principle. In this case the line of the windshield continues in a downward angle as a line across the fender. A sweeping curve along the top of the fender also connects the headlight and a crease leading to the door handle.

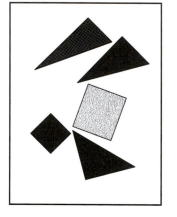

 A

Proximity and similarity unify a design.

↑ B

The unity of the same elements is intensified.

↓ C

Balthus (Balthasar Klossowski de Rola). *The Living Room.* 1941–1943. Oil on canvas, 3' 8½" × 4' 9¾". The Minneapolis Institute of Arts.

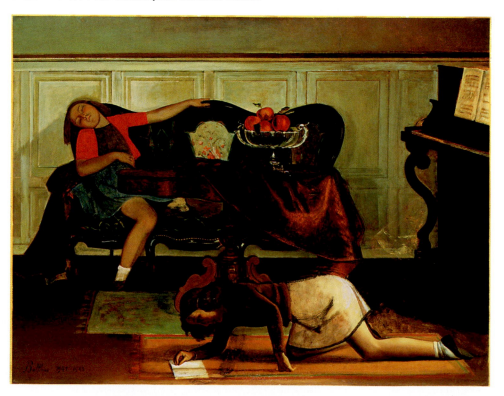

↑ **D**

Jan Groover. *Untitled.* **1987. Gelatin-silver print, 11¹⁵⁄₁₆" × 1' 2¹⁵⁄₁₆" (30 × 38 cm). Janet Borden, Inc.**

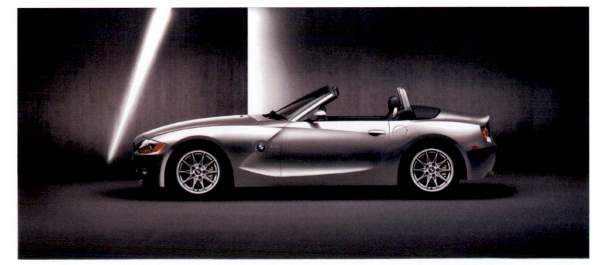

→ **E**

**2003 BMW Z4 Roadster.
Courtesy BMW of North
America, LLC.**

CONTINUITY AND THE GRID

As we have learned, continuation is the planned arrangement of various forms so that their edges are lined up—hence, forms are "continuous" from one element to another within a design.

 A

A grid determines page margins and divides the format into areas used on successive layouts.

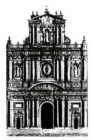
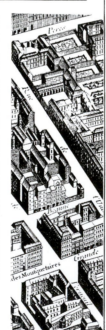

ARCHITECTURE

 B

A grid need not lead to boring regularity in page design.

Serial Design

The artist has almost unlimited choice in how to apply the concept of continuation in a single design. The task changes, however, when there are multiple units. The artist's job now is not only to unify one design but to create several designs that somehow seem to relate to each other. In other words, all the designs must seem part of a "series." In a series the same unifying theme continues in successive designs. This is not an unusual job for a designer. Countless books, catalogs, magazines, pamphlets, and the like all require this designing skill.

Using a Grid

Continuity is the term often used to denote the visual relationship between two or more individual designs. An aid often used in such serial designs is the grid. The artist begins by designing a **grid**, a network of horizontal and vertical intersecting lines that divide the page and create a framework of areas, such as in **A**. Then this same "skeleton" is used on all succeeding pages for a consistency of spacing and design results throughout all the units. To divide any format into areas or **modules** permits, of course, innumerable possibilities, so there is no predetermined pattern or solution. In creating the original grid, there are often numerous technical considerations that would determine the solution. But the basic idea is easily understood.

Using the same grid (or space division) on each successive page might suggest that sameness, and, hence, boring regularity, would result from repetition. This, however, is not necessarily true. A great deal of variety is possible within any framework, as the varied page layouts in **B** show.

Web Design

The grid alone is no guarantee of a successful composition, as can be seen in the range of quality in web page designs. In many cases the grid offers a bland display. On the other hand, **C** is a simple but refreshing take on the restraining format of banner at the top and columns below. In this case the fluid shape of the company's logo is repeated in the column headings. When you click on a heading, a column drops down (as expected), but it pours out of the heading. The repetition of this fluid theme builds on the unity inherent in the underlying grid.

→ C

Wood/Philips web page.

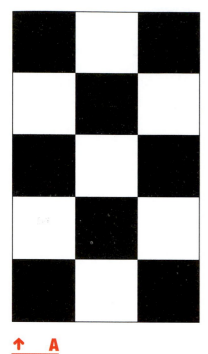

↑ **A**

A checkerboard shows perfect unity.

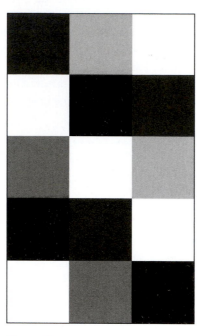

↑ **B**

Some variations in the basic pattern increase interest.

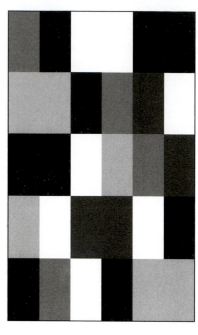

↑ **C**

More variation possibilities are endless.

THE GRID

The word *design* implies that the various components of a visual image are organized into a cohesive composition. A design must have visual unity.

Using the Grid Effectively

The checkerboard pattern in **A** has complete unity. We can easily see the constant repetition of shape and the obvious continuation of lined-up edges. Unhappily, the result is also quite boring. The design in **B** has the same repetitive division of space, but it doesn't seem quite as dull. Some changes (or variations) now make this design a bit more interesting to the eye. In **C** the variations have been enlarged, so we can almost forget the dull checkerboard in **A**, but the same underlying elements of unity are still present. This is the basis of the principle of unity with variety. An obvious, underlying feeling of unity exists, yet variations enliven the pattern. Shapes may repeat, but perhaps in different sizes; colors may repeat, but perhaps in different values.

In the painting by Paul Klee **(D)**, an underlying feeling of a checkerboard is again the basic space division. The feeling now is more composed, and the arrangement of colors sets up a predictable **rhythm** of light and dark patches unlike **C**. The complexity of color relationships transforms a structure that could be boring into a painting that has both vivid and subtle passages.

Robert Rauschenberg's lithograph **(E)** also conveys an underlying checkerboard, but the arrangement is deliberately messier with overlaps and colors bleeding through, disrupting the pattern. The format provides a unity to a collage of varied historical art images that seem to compete for attention.

The watercolor depiction of animal designs shown in **F** is organized in a grid but does not resemble a checkerboard. Each design is unique but is unified by similar style and the compositional structure of the grid.

A point to remember is that, with a great variety of elements, a simple layout idea can give needed unity and be very effective.

Paul Klee. *New Harmony.* 1936. Oil on canvas, 3' ⅞" × 2' 2⅛".
Solomon R. Guggenheim Museum, New York. 71.1960.

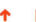

Robert Rauschenberg, *Centennial Certificate.* 1969. Color
lithograph. Art © Robert Rauschenberg/Licensed by VAGA,
New York, New York. Digital image © The Metropolitan
Museum of Art/Art Resource, New York.

Awa Tsireh. *Animal Designs.* c. 1917–1920.
Watercolor on paper sheet, 1' 8¹⁄₁₆" ×
2' 2⅛" (50.9 × 66.2 cm). Smithsonian
American Art Museum, Corbin-Henderson
Collection (gift of Alice H. Rossin).

VARIED REPETITION

Is the principle of unity with variety a conscious, planned ingredient supplied by the artist or designer, or is it simply produced automatically by a confident designer? There is no real answer. The only certainty is that we can see the principle in art from every period, culture, and geographic area.

Variety Adds Visual Interest

Charley Harper's painting of a bird working on a sunflower seed **(A)** employs repetition in two distinct ways. The head repeats in a sequence with geometric clarity. This humorously depicts the characteristic pecking habit of the Tufted Titmouse. The leaves also repeat and are geometric, but in this case variety is emphasized as the shapes fold and pivot. This artwork is typical of Harper's illustrations that are easily recognized because of a geometric unity that is enriched by surprising variations on a theme.

The use of unity with variety displayed in the collection of photographs **(B)** suggests a more rigid approach. The individual subject of industrial buildings might not catch our attention, but the variety displayed in the grid format immediately invites comparison and contrast. The idea of related variations seems to satisfy a basic human need for visual interest that can be achieved without theoretical discussions of aesthetics.

A conscious (or obvious) use of unity with variety does not necessarily lessen our pleasure as viewers. An obvious use of the principle is not a drawback. Unity is immediately apparent in the set of functional ceramicware in **C**. Eva Zeisel's vessels seem to have evolved their forms as naturally as unfurling leaves or swelling seed pods. A similar small element at the top of each piece works to close a handle in one case and provide a spout in another.

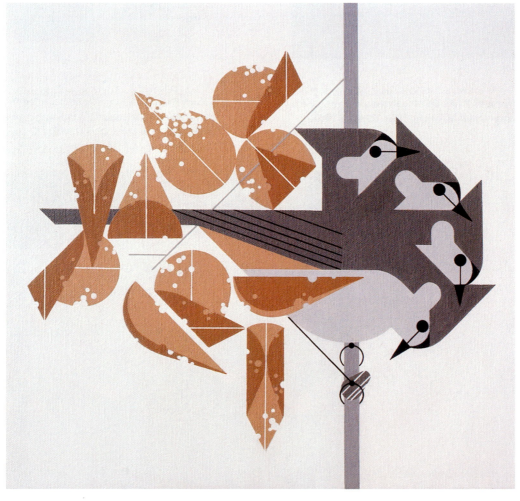

↑ **A**

Charley Harper. *Original painting for Titmouse Tidbit (Tufted Titmouse).* 1975. Acrylic on canvas, 1' 1" × 1' 2".

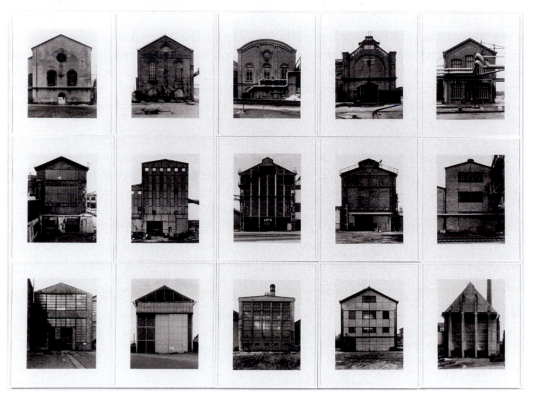

 B

Bernd and Hilla Becher.
Industrial Facades. 1970–1992.
Fifteen black-and-white
photographs, overall:
5' 8¾" × 7' 11" (installed as
a group). Albright-Knox Art
Gallery, Buffalo, New York
(Sarah Norton Goodyear
Fund, 1995).

← **C**

Eva Zeisel. Classic Century:
oil pourer, sauce boat,
salt and pepper. Ceramic.
Produced by Royal Stafford,
England.

EMPHASIS ON UNITY

In the application of any art principle, wide flexibility is possible within the general framework of the guideline. So it is in unity with variety. To say a design must contain both the ordered quality of unity and the lively quality of variety does not limit or inhibit the artist. The principle can encompass a wide variety of extremely different visual images and can even be contradicted for expressive purposes.

Unity through Repetition

These pages show successful examples of emphasis on the unifying element of repetition. Variety is present, but admittedly in a subtle, understated way. Photograph **A** shows thousands of pilgrims in Mecca during the Hajj. The multitude of humanity from all races, nations, and walks of life is united by simple white garments.

We know at a glance that all the plants depicted in **B** are irises. As with other Japanese screens from this period, the composition is strongly unified by repetition of natural forms. But this is not wallpaper. No two leaves or flowers are identical, and the eye is rewarded with subtle variation on a constant theme.

The visual unity gained by repetition is obvious in a depiction of twins. In Loretta Lux's photograph **(C)** it is reinforced by the identical polka dot dress. This cliché of twins dressed alike is heightened by the virtually blank background. We are left to search for the subtlest of clues to discern any difference between the two girls. In this case a strong unity produces a strange, even disturbing, challenge to any desire to see these two as individuals.

↑ **A**

Grand Mosque, Mecca, Saudi Arabia. More than two million Moslems prostrate themselves at the Grand Mosque in Mecca each year during the Hajj. National Geographic Society.

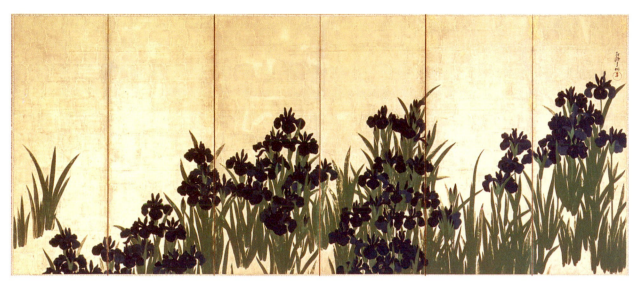

↑ **B**

Ogata Korin. *Irises.* **Edo period, c. 1705. Sixfold screen (one of pair), 150.9 × 338.8 cm. Nezu Art Museum, Tokyo.**

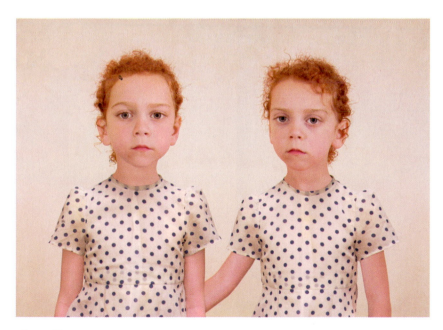

↑ **C**

Loretta Lux. *Sasha and Ruby.* **2005. Ilfochrome print.**

EMPHASIS ON VARIETY

Two artists argue over a painting:

"This painting is great because of the unity of similar shapes," says the first.

"You're crazy! It is the variety and contrasts that make it great!" says the second.

And both might be right.

Life is not always orderly or rational. To express this aspect of life, many artists have chosen to underplay the unifying components of their work and let the elements appear at least superficially uncontrolled and free of any formal design restraints. The examples here show works in which the element of variety is strong.

Variety in Form, Size, Color, and Gesture

The painting shown in **A** demonstrates unity by an emphasis on serpentine curves flowing through the *Deposition from the Cross*. Continuation is a strong feature as the viewer's eye is led through the complex arrangement of draped clothing and the bodies. Variety is emphasized through color and the almost infinite subtle differences possible in the human form.

 B

Elizabeth Murray. *Painter's Progress.* **Spring 1981. Oil on canvas, 19 panels, 9' 8" × 7' 9". Acquired through the Bernhill Fund and gift of Agnes Gund. The Museum of Modern Art, New York, New York.**

 A

Jacopo Pontormo. *Deposition from the Cross.* **Capponi Chapel. Location: S. Felicita, Florence, Italy.**

Elizabeth Murray's whimsical depiction of an artist's palette shown in **B** offers up an unlikely comparison to Pontormo's painting **(A)**. Murray's painting is like an ill-fitting jigsaw puzzle trying to come together. Piercing triangular spaces left over in this assembly and the angular shapes of the pieces offer a contrast to the fluid shape of the palette. A simple arrangement of curves and angles is punctuated by vivid color set off against the surrounding black areas. Seen in this way *both* artists express dynamism through variety and rely on unifying elements to hold it all together.

An aggressive near ugliness pervades the chaotic jumble of battered texts in George Herms's **assemblage** sculpture **(C)**. A first impression might be of materials out of control and barely hanging together. One can find, however, a visual unity is at work in the strong cross-like structure and a limited range of colors dominated by brown, black, and white.

↑ **C**

George Herms. *The Librarian.* **1960. Assemblage: wood box, papers, brass bell, books, painted stool, 4' 9" × 5' 3" × 21"
(1.4 m × 1.6 m × 53 cm). Norton Simon Museum, Pasadena (gift of Molly Barnes, 1969).**

CHAOS AND CONTROL

Without some aspect of unity, an image or design becomes chaotic and quickly "unreadable." Without some elements of variety, an image is lifeless and dull and becomes uninteresting. Neither utter confusion nor utter regularity is satisfying.

The photograph of a commercial strip shown in **A** reveals a conflicting jumble of **graphic** images, each vying for our attention. In this case information overload cancels out the novelty or variety of any single sign and leaves us confused with the chaotic results.

The photo in **B** reveals the bland unity of a housing subdivision. There is an attempt at variety in the facades, but the backs of the homes are identical. After a number of years, personal variations may show in paint color, landscaping, and sometimes eccentric renovations. Such expressions can bring about conflict between conformity and individuality.

The model for the Frank Gehry–designed Guggenheim Museum at Bilbao **(C)** offers a dramatic but coherent emphasis on variety. The various sweeping curves provide a contrast to the straight and angular architectural features and to the surrounding built environment. Within the curves are various directions, sizes, and shapes. In this case a variety of architectural forms was made possible by the use of computer design software developed for airplane design. Here you can see the power of variety to offer contrast within a unified whole.

↑ **A**

Signs create a visual clutter along old Route 66 in Kingman, Arizona.

 B

The bland unity of a housing subdivision.

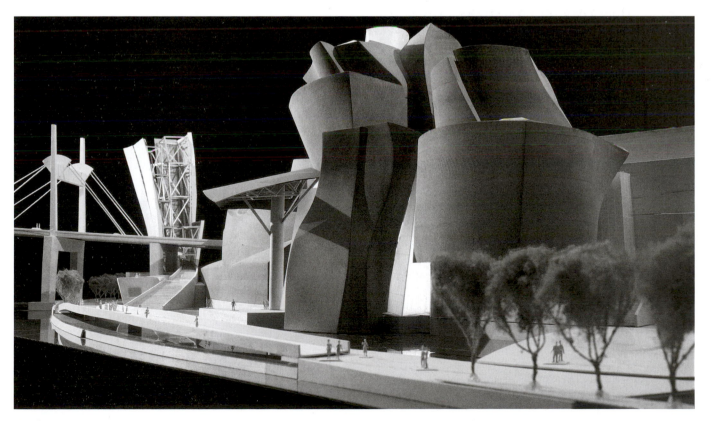

↑ **C**

Frank Gehry. Model of Guggenheim Museum. Bilbao, Spain.

FIGURATIVE AND ABSTRACT

The earlier discussion of the works by Pontormo and Murray (see **A** and **B** on page 48) examined unity and variety within both figurative and abstract artworks. Unity is not simply a property of related organic shapes or of related geometric elements. An apprehension of unity is a simple and immediate sense of connections resonating throughout a composition. The elements that build that unity may be simple as well, or they may be subtle and more complex.

Gérôme's painting **(A)** presents a story: a duel after a masquerade party. The characters are set on a stage-like space of a snowy field. The distant landscape and waiting carriage are as diffuse and simplified as theatrical backdrop. Unity is largely achieved by a narrow range of **analogous colors** that allows the tragic figures to stand out in contrast. Unity is also at work in the proximity of characters and a line of continuity that flows from the fallen Pierrot to the departing Harlequin. A **narrative** artwork such as this requires the artist to act much like a movie director, and a deft handling of unity is decisive in holding the story together.

Picasso's version of *Harlequin* **(B)** could hardly be more different from Gérôme's. Here is a painting that seems to only share a character, but by no means a style of painting. The Picasso picture appears to be layers of flat geometric shapes more akin to a crazy quilt than Gérôme's idea of a painting. A longer examination of the two paintings will afford us a chance to see more that they have in common, but for now we will confine the discussion to how Picasso achieves his version of a unified composition.

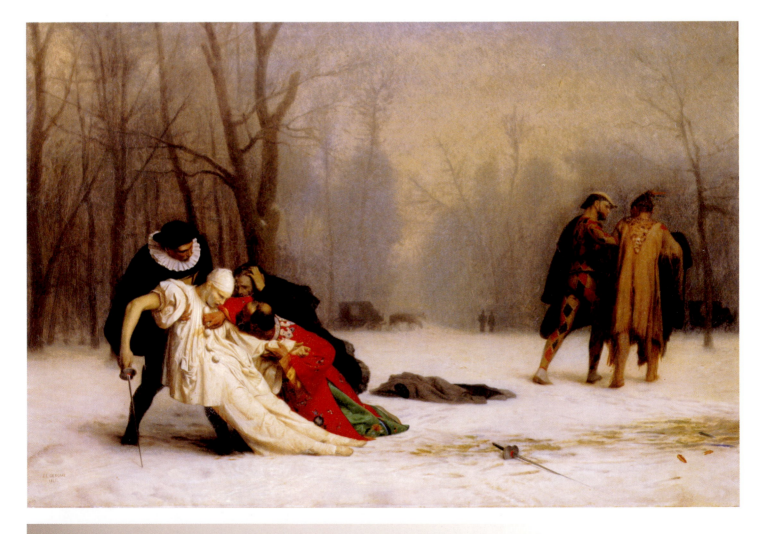

↑ A

Jean-Léon Gérôme. *The Duel after the Masquerade.* **1857–1859. Oil on canvas, 1' 3⅜" × 1' 10³⁄₁₆" (39.1 × 56.3 cm).**

Harlequin may be quilt-like, but it is not crazy. The singular nature of the harlequin pattern (red, blue, and beige diamonds) is integrated into the design by a repetition of the blue color. In fact, every shape and color has an echo or repeats elsewhere in the painting. Repeated directional lines (angles to the left balanced by angles to the right) also unify the arrangement.

Whatever your personal preference between these two contrasting painting styles, one has to acknowledge that both artists composed with an eye for unity.

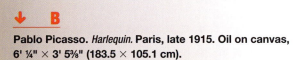

↓ B

Pablo Picasso. *Harlequin.* **Paris, late 1915. Oil on canvas, 6' ¼" × 3' 5⅝" (183.5 × 105.1 cm).**

"Oh, look! I think I see a little bunny."

3 EMPHASIS AND FOCAL POINT

ATTRACTING ATTENTION

Very few artists or designers do not want people to look at their work. In past centuries, when pictures were rare, almost any image was guaranteed attention. Today, with photography and an abundance of books, magazines, newspapers, signs, and so on, all of us are confronted daily with hundreds of pictures. We take this abundance for granted, but it makes the artist's job more difficult. Without an audience's attention, any messages, any artistic or aesthetic values, are lost.

How does a designer catch a viewer's attention? How does the artist provide a pattern that attracts the eye? Nothing will guarantee success, but one device that can help is a point of emphasis or **focal point.** This emphasized element initially can attract attention and encourage the viewer to look closer.

Using Focal Point for Emphasis

Every aspect of the composition in **A** emphasizes the grapefruit at center stage. The grapefruit shape is large, centered, light, and yellow (compared with darker gray surroundings), and even the lines of the sections point to the center. All these elements bring our focus to the main character or subject. This is the concept of a focal point.

The painting by Henri Matisse (**B**) does not have the central, obvious target that is evident in **A**, but the focal point is unambiguous and even humorous. The small red turtle is emphasized by contrast of size, unique color, and isolation. The figures direct our attention as well as we follow their gaze to the focal point. In this case even a very small area of emphasis is powerful enough to need balancing counterpoints such as the bright hair of the left-hand figure and the abstracted blue stripe of water at the top of the painting.

The photograph in **C** is a view of an ordinary street scene. The large pine tree might go unnoticed in a stroll through the neighborhood. Several things contribute to the emphasis on this tree in the photograph: placement near the center, large size, irregular shape, and dark value against the light sky.

There can be more than one focal point. Sometimes an artwork contains secondary points of emphasis that have less attention value than the focal point. These serve as accents or counterpoints as in the Matisse picture. However, the designer must be careful. Several focal points of equal emphasis can turn the design into a three-ring circus in which the viewer does not know where to look first. Interest is replaced by confusion: When everything is emphasized, nothing is emphasized.

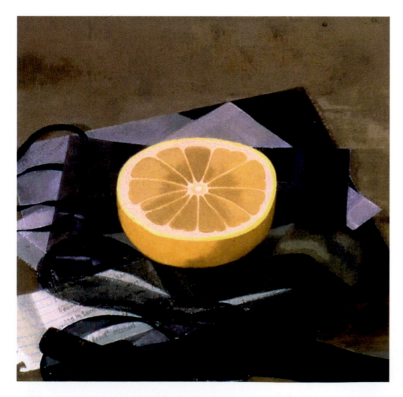

 A

Susan Jane Walp. *Grapefruit with Black Ribbons.* **2000. Oil on linen, 8" × 8¼". Tibor de Nagy Gallery, New York.**

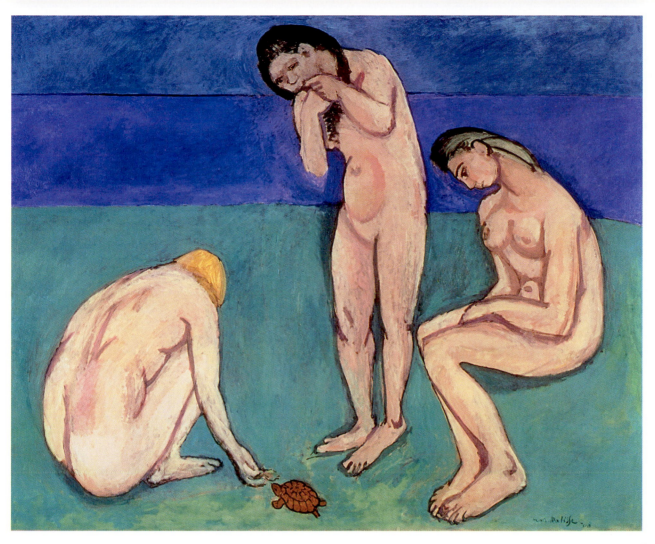

↑　**B**

Henri Matisse. *Bathers with a Turtle.* **1908. Oil on canvas, 179 × 220 cm. The St. Louis Museum of Art, Missouri.**

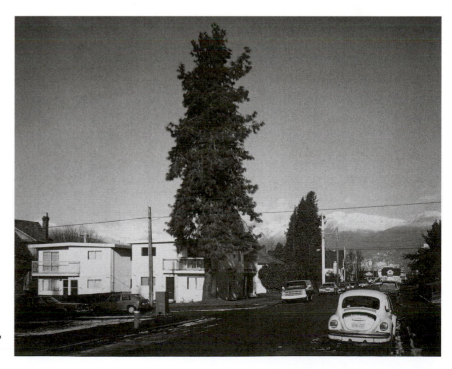

→　**C**

Jeff Wall. *The Pine on the Corner.* **1990. 3' 10¾" × 3' 10¼" (1.19 × 1.48 m). Edition of 3. Marian Goodman Gallery, New York.**

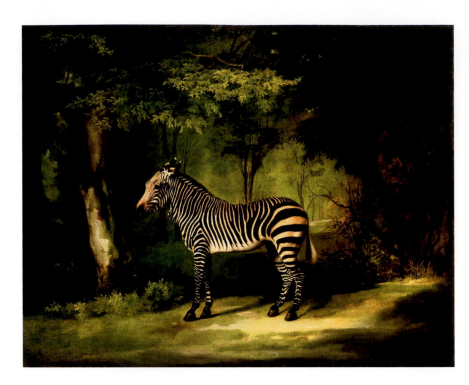

← A

George Stubbs. *Zebra.* **1763. Oil on canvas, 3' 4½" × 4' 2¼".**

EMPHASIS BY CONTRAST

Very often in art the pictorial emphasis is clear, and in simple compositions (such as a portrait) the focal point is obvious. But the more complicated the pattern, the more necessary or helpful a focal point may become in organizing the design.

Creating a Focal Point through Contrast

As a rule, a focal point results when one element differs from the others. Whatever interrupts an overall feeling or pattern automatically attracts the eye by this difference. The possibilities are almost endless:

> When most of the elements are dark, a light form breaks the pattern and becomes a focal point.
>
> When most of the elements are muted or soft-edged, a bold contrasting pattern will become a focal point **(A)**.
>
> In an overall design of distorted expressionistic forms, the sudden introduction of a naturalistic image **(B)** will draw the eye for its very different style.
>
> Text or graphic symbols will be a focal point (in this case, the eye is drawn to the number 16) **(C)**.
>
> When the majority of elements are black and white, color will stand out as in **D**.

This list could go on and on; many other possibilities will occur to you. Sometimes this idea is called *emphasis by contrast.* The element that contrasts with, rather than continues, the prevailing design scheme becomes the focal point.

See also *Devices to Show Depth: Size,* page 198; *Value as Emphasis,* page 248; and *Color as Emphasis,* page 272.

↓ B

James Ensor. *Self-Portrait Surrounded by Masks.* **1899. Oil, 3' 11½" × 2' 7½" (121 × 80 cm). Sammlung Cleomir Jussiant, Antwerp.**

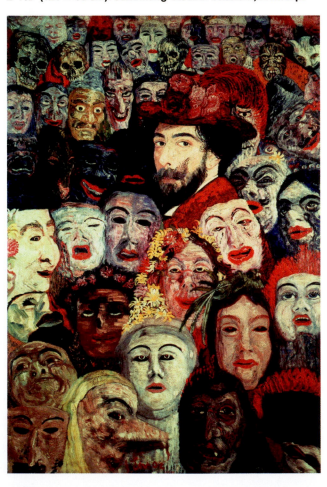

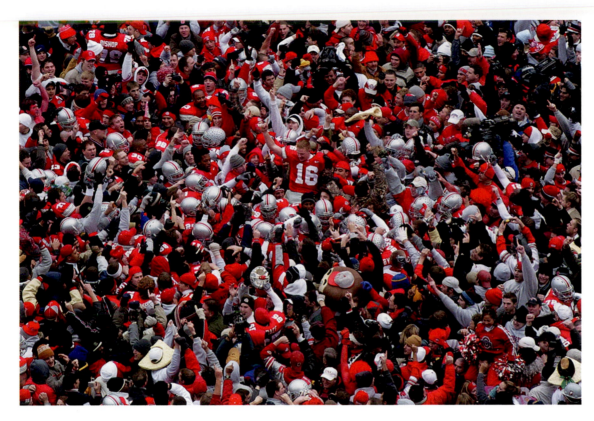

← C

Karl Kuntz (photographer).
Columbus Dispatch. **Sunday,
November 24, 2002.**

→ D

Thomas Nozkowski. *Untitled.* **2006. Aquatint
etching, 1' 9½" × 2' 3½".**

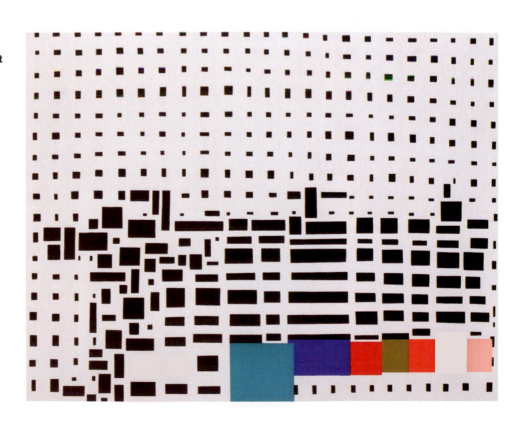

EMPHASIS BY ISOLATION

A variation on the device of emphasis by contrast is the useful technique of emphasis by isolation. There is no way we can look at the design in **A** and not focus our attention on that element at the bottom. It is identical to all the elements above. But simply by being set off by itself, it grabs our attention. This is contrast, of course, but it is contrast of placement, not form. In such a case, the element, as here, need not be any different from the other elements in the work.

Creating a Focal Point through Isolation

In the painting by Eakins **(B)** the doctor at left repeats the light **value** of the other figures in the operating arena. All the figures in this oval stand out in contrast to the darker figures in the background. Isolation gives extra emphasis to this doctor at the left.

Gérôme's painting **(C)** uses isolation to create a hierarchy of emphasis. The cluster of figures around the dying Pierrot is isolated to the left, the departing Harlequin to the right, and the awaiting carriage in the center background.

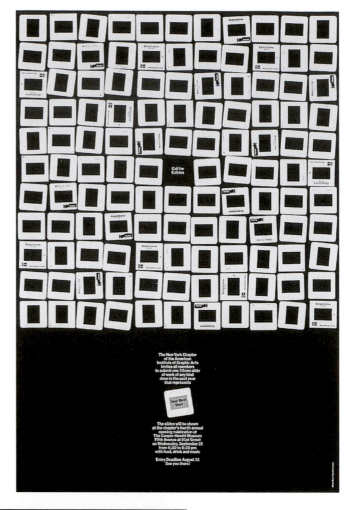

→ **A**

Call for entries for AIGA/New York show. "Take Your Best Shot." Designer: Michael Beirut, Vignelli Associates, New York.

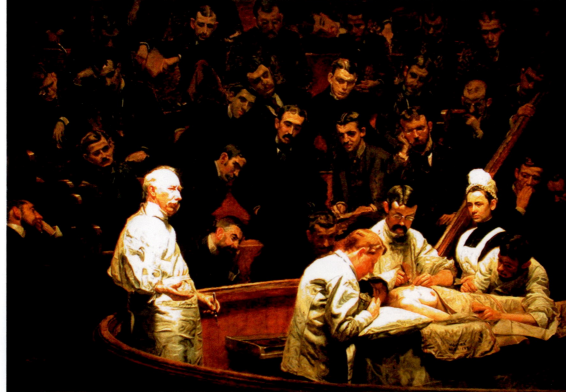

← **B**

Thomas Eakins. *The Agnew Clinic.* **1889. Oil on canvas, 6' 2½" × 10' 10½" (1.9 × 3.3 m). University of Pennsylvania Art Collection, Philadelphia.**

In neither of these examples is the focal point directly in the center of the composition. This placement could appear too obvious and contrived. However, it is wise to remember that a focal point placed too close to an edge will tend to pull the viewer's eye right out of the picture. Notice in Eakins's painting **(B)** how the curve of the oval on the left side and the doctor looking toward the action at right keep the isolated figure from directing our gaze out of the picture. In **C** the dramatic cluster of figures on the left is balanced by the departing characters on the right. Even the sword is isolated on the ground for emphasis.

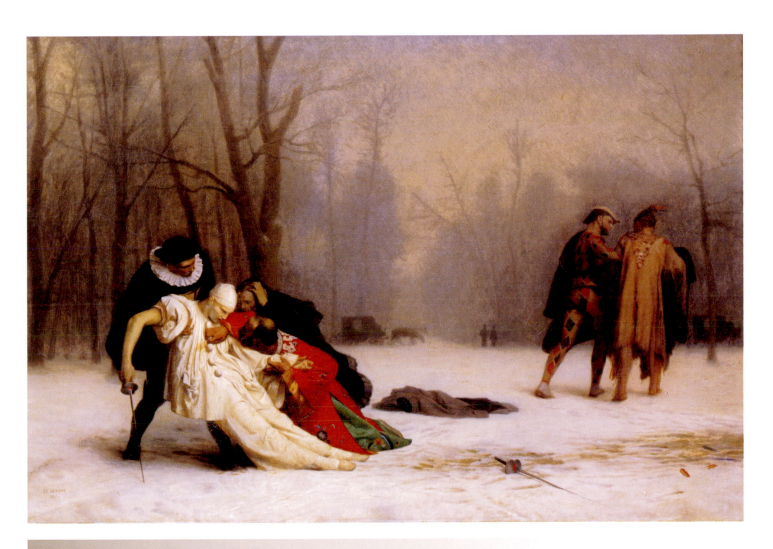

↑ **C**

Jean-Léon Gérôme. *The Duel after the Masquerade.* 1857–1859. Oil on canvas, 1' 3⅜" × 1' 10³⁄₁₆" (39.1 × 56.3 cm).

EMPHASIS BY PLACEMENT

It does not require much in the way of proof to say that putting something at the center of a composition creates emphasis. In fact, it is often a criticism of naïve or boring compositions to notice that the subject is plopped down smack in the center. So then it becomes interesting to see how the center can be used in a subtle way to achieve emphasis.

Susan Moore's portrait of her daughter **(A)** offers a three-quarter view and avoids a frontal "mug shot" composition. The center of the painting is not the center of her face. The central vertical axis of the painting *does* intersect her right eye and acts to draw attention to her gaze at us. We make eye contact through this placement.

The position of the most famous apple of all time is also near the center of **B**. The painting is busy and crowded, and the passing of the apple takes place at the intersection of the tree trunk and the lines formed by the arms of Adam and Eve. The composition has an equal balance to the left and right of this focal point, and the key element is emphasized. Both **A** and **B** succeed because the focal point for each does not have to compete with other elements for prominence.

The bull's-eye of a dartboard would be the simplest illustration of an absolute focal point. This is the essence of a radial design: the center of a circle from which all elements radiate. Radial designs are more common in architecture (temples) or the craft areas (quilts and ceramics) than in two-dimensional art. In pictures, perspective lines can lead to a point of emphasis, and the result can be a radial design. In Vermeer's painting **(C)** the girl is the focal point, and the perspective lines of the interior

A

Susan Moore. *Vanity (Portrait 1)*. 2000. Oil stick on canvas, 4' × 3' 11".

B

Lucas Cranach the Elder. *Adam and Eve*. 1526. Oil on panel, 3' 10⅛" × 2' 7¾" (117 × 80 cm). Courtauld Gallery, Courtauld Institute, London.

all direct our eyes back to the figure. It is a mark of the subtlety and complexity of Vermeer's work that the painting is not simply constructed to point to the main figure but also unfolds other areas of interest and keeps our attention and involvement. Notice how the one line on the floor that would lead straight from the viewer's position to the girl is obscured by the tapestry and the cello. Vermeer employs the power of a radial design without overstating it.

See also *Symmetrical Balance*, pages 92 and 94, and *Radial Balance*, page 106.

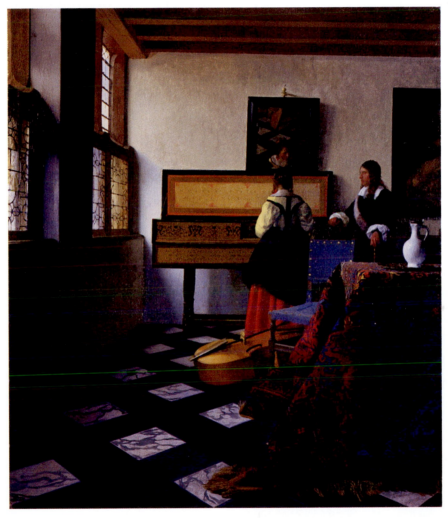

Jan Vermeer. *A Lady at the Virginals with a Gentleman (The Music Lesson).* **1662–1664. Oil on canvas, 2' 5" × 2' 1". The Royal Collection, London.**

ONE ELEMENT

A specific theme may at times call for a dominant, even visually overwhelming focal point. The use of a strong visual emphasis on one element is not unusual.

In the graphic design of newspaper advertisements, billboards, magazine covers, and the like, we often see an obvious emphasis on one element. This emphasis can be necessary to attract the viewer's eye and present the theme (or product) in the few seconds most people look casually at such material. Such increased focus is also needed when an idea is being promoted, as in the illustration for an editorial shown in **A**. Here the intent is to grab our attention in the hope that we will read the commentary. The striking red circle creates a mouth and gives voice to the marginalized subject in a plea for peace.

 A

Lino. *Communication Arts*, May/June 2005, p. 115. Editorial for *Courier International* (France). Art Director: Pascal Phillipe.

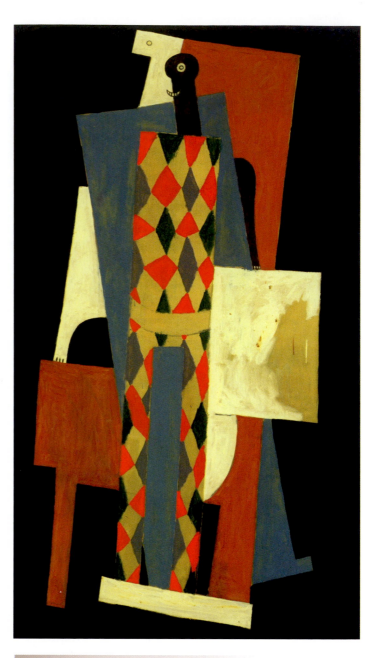

 B

Pablo Picasso. *Harlequin*. Paris, late 1915. Oil on canvas, 6' ¼" × 3' 5⅝" (183.5 × 105.1 cm).

blue figure and background. The figure dissolves into the blue, and the dress literally pops! The strength of this focal point is integrated into the unity of the total composition. The established focal point is not a completely unrelated element. The curving shapes are balanced by other similar shapes, and the orange is echoed by the brown of the man's suit.

The concept of a focal point is not limited to two-dimensional compositions. The hearth as a focal point for a room is a standard feature in many homes. The fireplace shown in **D** is eye-catching in form and accentuated by the sparseness of the space. Nevertheless it is not a domineering focal point since it is placed off center and allows the view through the window to be an alternative focus. The curving lines of the seating echo the curves of the fireplace and help to integrate it into the otherwise rectangular space.

↓ **D**

UrbanLab. *X House.* **Urban. Hennepin, Illinois.**

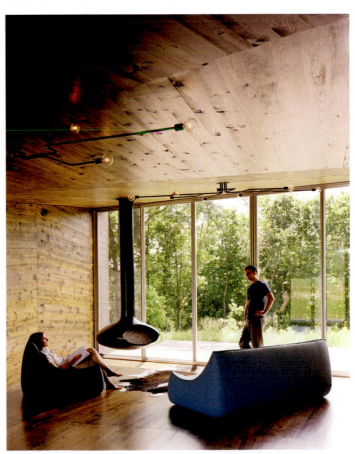

↑ **C**

Maurice Vellekoop. *Christian Dior Boutique, Valentino.* **November/December 1997. Watercolor on paper. Wallpaper.**

Maintaining Unity with a Focal Point

A focal point, however strong, should remain related to and a part of the overall design. The red circle in **A** is visually strong yet is related to other elements of strong contrast: the black head and white doves. Contrast the effect in **A** with that in **B**. In Picasso's painting **(B)** the singular treatment of the masklike "face" contrasts with the shapes and planes that unify the rest of the painting. In this case the contrast is less robust than in **A**. Two very small circles and an arc are the only elements needed to snap our attention to the "face" of this abstract figure. The position of the white eye as a pivot point for the seesawing planes below it serves to integrate the face into the overall composition.

In general, the principle of unity and the creation of a harmonious pattern with related elements are more important than the injection of a focal point if this point would jeopardize the design's unity. In the playful illustration by Maurice Vellekoop **(C)**, the unusual shape of the orange dress is accentuated by the

EMPHASIZING THE WHOLE OVER THE PARTS

A definite focal point is not a necessity in creating a successful design. It is a tool that artists may or may not use, depending on their aims. An artist may wish to emphasize the entire surface of a composition over any individual elements. Lee Krasner's painting **(A)** is an example. Similar shapes and textures are repeated throughout the painting. These shapes and textures form loose rows and columns and a kind of grid. The artist creates an ambiguous visual environment that is puzzling. Dark and light areas repeat over the surface in an even distribution, and no one area stands out. The painting has no real starting point or visual climax. It has the effect of a surface in nature: a rock face, waves on the water, or leaves scattered in the ground.

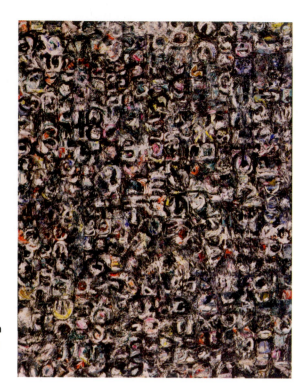

→ **A**

Lee Krasner. *Untitled.* **1949. Oil on composition board, 4' × 3' 1" (122 × 94 cm). The Museum of Modern Art, New York (gift of Alfonso A. Ossorio).**

→ **B**

Mark Keffer. *Altered Map. Esopus,* **Number 3 (Fall 2004).**

The **collage** painting by Mark Keffer shown in **B** is less dense than **A**, and by comparison it seems open and airy. Here the grid is that of a street map. The added elements of pink shapes and circles punctuate different intersections. If only one shape or circle had been added, it would create a focal point, but the repetition and suggested continuation beyond the edge of the composition emphasize the whole over the parts.

The cover design **(C)** shows that an emphasis of the whole over any one part is not limited to geometric repeat patterns or something as simple as autumn leaves scattered evenly across a lawn. In this case the very graphic thumbprint serves to absorb or camouflage the zebra. The purpose for this carefully composed alignment of the thumbprint and zebra stripe pattern is to emphasize not the animal, but our effect on its environment. Note how different this is from the zebra in **A** on page 58!

See also *Crystallographic Balance*, page 108.

↑ **C**

Chaz Maviyane-Davies. IUCN Annual Report 1998.

"You must be terribly proud. It's the finest thing you've done."

4 SCALE AND PROPORTION

SCALE AND PROPORTION

Scale and *proportion* are related terms: both basically refer to size. Scale is essentially another word for size. "Large scale" is a way of saying big, and "small scale" means small. Big and small, however, are relative. What is big? "Big" is meaningless unless we have some standard of reference. A "big" dog means nothing if we do not know the size of an average dog. This is what distinguishes the two terms. **Proportion** refers to relative size—size measured against other elements or against some mental norm or standard.

The small stool and the clues given by the architecture of the space provide a scale reference for judging the size of the sphere in **A**. Because a sphere has no inherent scale reference, we depend on the context to judge its size. In **A** the sphere is almost oppressively large in proportion to the setting. Imagine the same sphere outdoors seen from an airplane. It might have the same visual impact as a period on this page.

We often think of the word *proportion* in connection with mathematical systems of numerical ratios. It is true that many such systems have been developed over the centuries. Artists have attempted to define the most pleasing size relationships in items as diverse as the width and length of sides of a rectangle to parts of the human body.

Using Scale and Proportion for Emphasis

Scale and proportion are closely tied to emphasis and focal point. The lemon and strawberry depicted in Glen Holland's painting **(B)** are at a one-to-one (1:1) scale, so the painting is obviously small. However, the proportion of these subjects to the rest of the painting and the unusual point of view lend a monumental feeling to these humble subjects.

In past centuries visual scale was often related to thematic importance. The size of figures was based on their symbolic importance in the subject being presented. This use of scale is called **hieratic scaling**. Saint Lawrence is unnaturally large compared with the other figures in the fifteenth-century painting in **C**. The artist thus immediately not only establishes an obvious focal point but also indicates the relative importance of Saint Lawrence to the other figures.

See also *Devices to Show Depth: Size*, page 198.

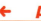 **A**

Richard Roth. *Untitled.* **1983. Installation: 11' diameter (3.4 m) sphere with red stool. © 1993 Richard Roth. Photo: Fredrik Marsh.**

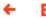 **B**

Glen Holland. *Sweet & Sour.* **1998.**
Oil on wood, actual size 4' 6" × 7'.
Fischbach Gallery, New York.

→ **C**

Fra Filippo Lippi. *Saint Lawrence Enthroned with Saints*
and Donors. **c. late 1440s. Altarpiece from the church**
of the Villa Alessandri, Vincigliata Fiesole, central
panel only. Tempera on wood, gold ground; overall,
with arched top and added strips: 3' 11¾" × 3' 9½"
(121.3 × 115.6 cm). The Metropolitan Museum of Art,
Rogers Fund, 1935.

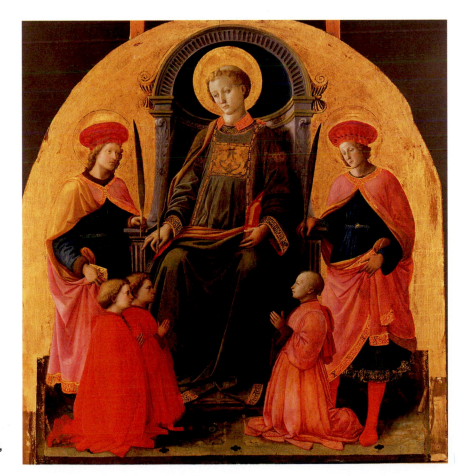

→ A

Chinese medallion. Ming Dynasty, late 16th–early 17th century. Front view: carved in high relief with scene of the return by moonlight of a party from a "spring outing." Ivory, diameter: 3⅜" (8.6 cm). The Metropolitan Museum of Art, purchase, Friends of Asian Art Gifts, 1993.

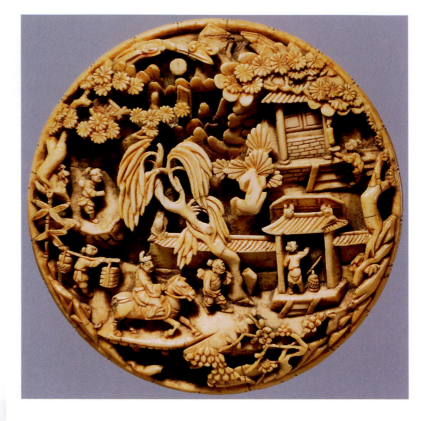

↑ B

Limbourg Brothers. *Multiplication of the Loaves and Fishes*, from the Book of Hours *Les Très Riches Heures du Duc de Berry*. 1416. Manuscript illumination, 6¼" × 4⅜" (16 × 11 cm). Musée Condé, Chantilly.

HUMAN SCALE REFERENCE

One way to think of artistic scale is to consider the scale of the work itself—its size in relation to other art, in relation to its surroundings, or in relation to human size. Unhappily, book illustrations cannot show art in its original size or scale. Unusual or unexpected scale is arresting and attention-getting. Sheer size does impress us.

When we are confronted by **frescoes** such as the Sistine Chapel ceiling, our first reaction is simply awe at the enormous scope of the work. Later we study and admire details, but first we are overwhelmed by the magnitude. The reverse effect is illustrated in the Chinese medallion in **A**. A world of details—figures, landscape, and architecture—is compressed into a three-and-one-half-inch-diameter circle. An immensity of information is rendered with delicate precision on an intimate scale.

The Power of Unusual Scale

If large or small size springs naturally from the function, theme, or purpose of a work, an unusual scale is justified. We are acquainted with many such cases. The gigantic pyramids made a political statement of the pharaohs' eternal power. The elegant miniatures of the religious *Book of Hours* **(B)** served as inspirational illustrations for the private devotionals of medieval nobility. The small scale is appropriate to private reflection.

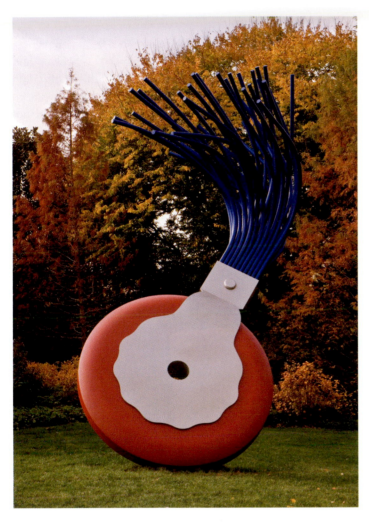

The scale of **C** illustrates the opposite approach. Claes Oldenburg has made use of a leap of scale in his *Typewriter Eraser* **(C)**. As with the work of other **pop artists**, this piece calls attention to an everyday object not previously considered worthy of aesthetic consideration. Oldenburg transforms the object by elevating it to a monumental scale. A magnification such as this allows us to see the form with fresh eyes, and, as a result, we might discover new associations, such as the graceful strands of the brush, which project upward like a fountain. The children in the photo give us a scale reference, and also an understanding how the object is transformed into a playground feature, perhaps for a game of hide-and-seek. As typewriters and their eraser have faded from use, the eraser form becomes even more abstract to a new generation of viewers.

Earthworks are unique in the grandeur of their scale. The Nazca earth drawing **(D)** is pre-Columbian in origin. Its original function or meaning has been lost and is the subject of much speculation. With a length of 150 feet it can really only be seen properly from the air! A sense of scale can be determined by the tire tracks around the perimeter of the spider. We can only speculate whether the large scale had a religious importance, or was playful like the Oldenburg.

← **C**

Claes Oldenburg and Coosje van Bruggen. *Typewriter Eraser, Scale X.* **1999. Stainless steel and cement, approximately 20' tall. National Gallery of Art, Sculpture Garden, Washington, DC. Gift of The Morris and Gwendolyn Cafritz Foundation.**

→ **D**

Nazca earth drawing. *Spider.* **Approximately 150' long.**

INTERNAL REFERENCES

The scale of artworks can impress or hold our attention through their actual size. Scale within a work of art provides meaning, context, and often a clue to how it is made or how we are meant to interpret the image or object. As we have seen, the most powerful point of reference is our own size. Is it bigger than I am? Is it smaller than I am? Are we the same? Psychologically this can be very powerful.

The painting shown in **A** has no point of reference in terms of imagery or pictorial elements. It is simply composed of brushstrokes. This is a very literal presentation of the elements of painting. These marks organize the surface and even carry over onto the frame. In one sense we can see the brushstrokes as actors on a stage. As we identify the marks as brush strokes we also identify a scale: the size of the tool that made them and the length or reach of the artist's arm. Now we have connected to the creation of this painting.

Andreas Gursky's photograph shown in **B** is, at first glance, as abstract as Howard Hodgkin's painting **(A)**. The black and gray curves resemble inky brush strokes. In fact this photograph is larger than Hodgkin's painting. This is a point that might be overlooked in the context of this book where one might not question the intended size of a photograph.

A second photograph from the series **(C)** gives us more information regarding the context of these striking curves and lines. The inclusion of buildings on the horizon sets the scale within this composition, and our understanding is transformed. The source of these undulating lines and shapes is a desert racetrack. Without the internal scale references, we are left with a puzzle.

↑　**A**

Howard Hodgkin. *Menswear.* **1980–1985.**

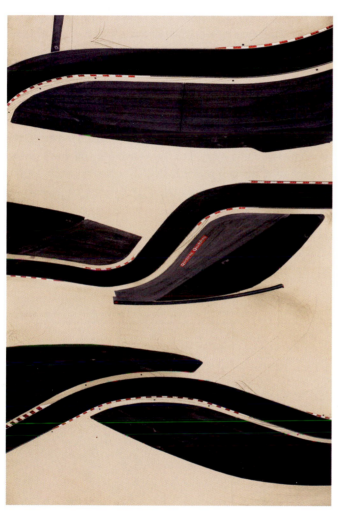

 B

Andreas Gursky. *Bahrain II.* **2005. C-Print, 306 × 221.5 cm.**

 C

Andreas Gursky. *Bahrain I.* **2005. C-Print, 306 × 221.5 cm.**

INTERNAL PROPORTIONS

The second way to discuss artistic scale is to consider the size and scale of elements within the design or pattern. The scale here, of course, is relative to the overall area of the format—a big element in one painting might be small in a larger work. Again, we often use the term *proportion* to describe the size relationships between various parts of a unit. To say an element in a composition is "out of proportion" carries a negative feeling, and it is true that such a visual effect is often startling or unsettling. However, it is possible that this reaction is precisely what some artists desire.

The three examples in **A** contain the same elements. But in each design the scale of the items is different, thus altering the proportional relationships between the parts. This variation results in very different visual effects in the same way that altering the proportion of ingredients in a recipe changes the final dish. Which design is best or which we prefer can be argued. The answer would depend on what effect we wish to create.

Using Scale to Effect

Look at the difference scale can make in a painting. The images in **B** and **C** both deal with the same topic: the well-known story of Christ's last supper with His disciples before the crucifixion. In Ghirlandaio's painting **(B)** all the figures are quite small relative to a large, airy, and open space. The figures are life-size in a 25-foot-long architectural painting. The regular placement of the figures at the table and the geometric, repeating elements of the architecture give a feeling of calm and quiet order. *The Last Supper* by Nolde **(C)** is, indeed, in a different style of painting, but a major difference between the two works is the use of scale within the picture. In fact the figures in both paintings are similar in size! However, Nolde's figures are crammed together and overlap in the constricting space of a modest canvas. The result is crowded and claustrophobic. Nolde focuses our attention on the intense emotions of the event. The harsh drawing, agitated brushwork, and distortion of the figures enforce the feeling. Both artists relate the same story, but they have very different goals. The choice of scale is a major factor in achieving each artist's intention.

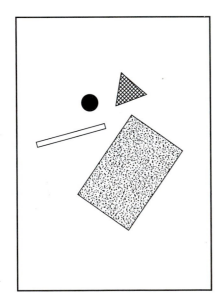

↑ **A**

Changes in scale within a design also change the total effect.

 B

Domenico Ghirlandaio. *Last Supper.* c. 1480. Fresco, 25' 7" (8 m) wide. San Marco, Florence.

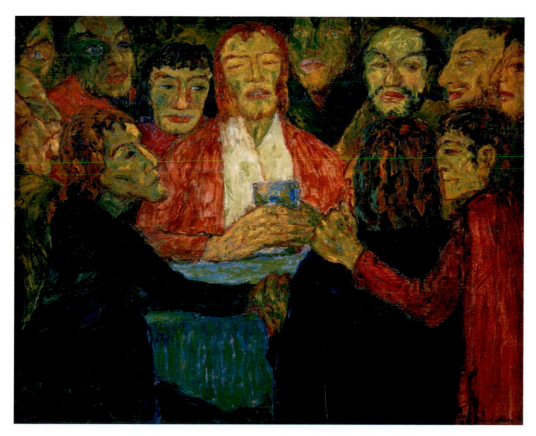

 C

Emil Nolde. *The Last Supper.* 1909. Oil on canvas, 2' 10⅝" × 3' 6½" (88 × 108 cm). Statens Museum for Kunst, Copenhagen.

A

Mark Fennessey. *Insects IV.* 1965–1966. Wash, 2' 5" × 1' 8" (73.6 × 50.7 cm). Yale University Art Gallery (transfer from the Yale Art School).

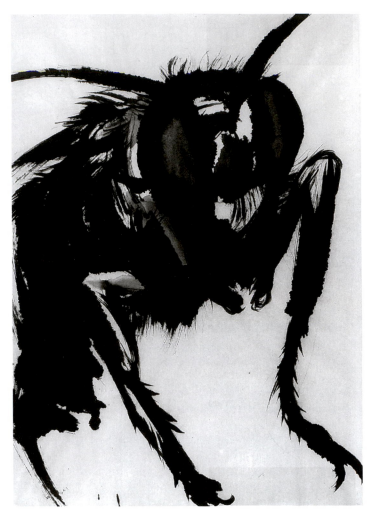

B

Gilbert Li. *Social Insecurity.* 2001. 7⅜" × 10⅞". Design Firm: Up Inc. (Toronto, Canada). Client: Alphabet City, Inc.

CONTRAST OF SCALE

Unexpected or Exaggerated Scale

An artist may purposely use scale to attract our attention in different ways. For example, we notice the unexpected or exaggerated, as when small objects are magnified or large ones are reduced. The wash drawing in **A** is startling, here seen enlarged to page-filling size. Just the extreme change in scale attracts our attention. The opposite approach is shown in **B**. Here the purposeful use of the very tiny figures contrasts with a vast space, evoking anxiety.

Pavel Pepperstein employs the same device found in **B** to satirical effect in his wash drawing titled *Landscapes of Future* **(C)**. This rendition of monumental images pokes fun at the utopian ideology of an earlier age, which can be seen in "pure" form in an earlier illustration in this book (page 34, **B**). Elements that really have no inherent scale (a rectangle, a curve . . . these can be any size) are treated here as symbols of monumental importance, really for the sake of showing the humor in that.

↑ **C**

Pavel Pepperstein. *Landscapes of Future.* **2009. Drawings, watercolor, different sizes. Artist's collection, Courtesy of the Multimedia Art Museum, Moscow.**

Large and Small Scale Together

Either large or small scale is often employed in painting or design. However, a more common practice is to combine the two for a dramatic contrast. In John Moore's *Blue Stairway* **(D)**, a foreground plant is presented in front of a distant building. This juxtaposition results in their similarity of size within the painting and encourages a visual dialogue between these otherwise contrasting forms.

→ **D**

John Moore. *Blue Stairway.* **1998. Oil on canvas, 2' 4" × 2'.**

 A

René Magritte. *Personal Values (Les Valeurs Personnelles).* **1952.** Oil on canvas, 2' 7½" × 3' 3⅜" (80.01 × 100.01 cm).

 B

New York–New York Hotel & Casino. **Las Vegas, Nevada.**

SURREALISM AND FANTASY

The deliberate changing of natural scale is not unusual in painting. In religious paintings many artists have arbitrarily increased the size of the Christ or Virgin Mary figure to emphasize philosophic and religious importance.

Some artists, however, use scale changes intentionally to intrigue or mystify us rather than to clarify the focal point. **Surrealism** is an art form based on paradox, on images that cannot be explained in rational terms. Artists who work in this manner present the irrational world of the dream or nightmare—recognizable elements in impossible situations. The **enigmatic** painting by Magritte **(A)** challenges the viewer with a confusion of scale. We identify the various elements easily enough, but they are all the wrong size and strange in proportion to each

→ **C**

Charles Ray. *Family Romance.* **1993. Mixed
media, 4' 6" × 8' × 2" (137 × 244 ×
61 cm). Edition of 3. Regen Projects,
Los Angeles.**

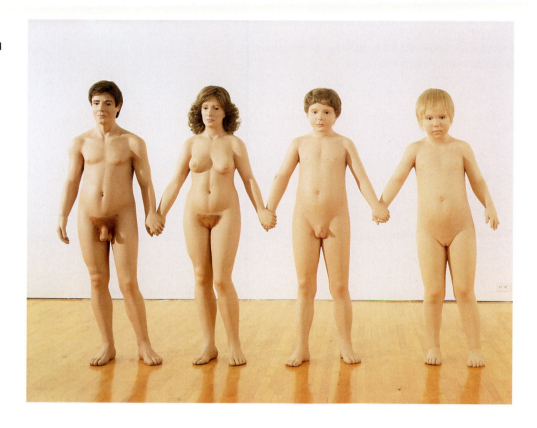

↓ **D**

Fernando Botero. *Mona Lisa.* **1977. Oil on canvas, 6' × 5' 5⅖"
(183 × 166 cm). © Fernando Botero, courtesy Marlborough Gallery,
New York.**

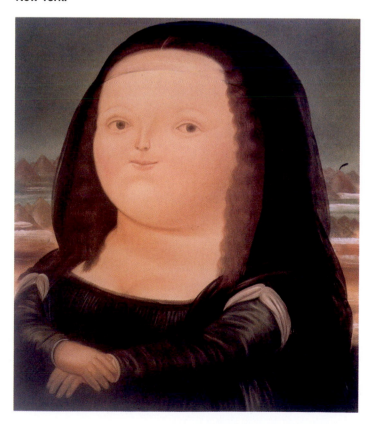

other. Does the painting show an impossibly large comb, shav-
ing brush, bar of soap, and other items, or are these normal-
size items placed in a dollhouse? Neither explanation makes
rational sense.

A scale change can be an element of fantasy like the small
door that Alice can't fit through until she shrinks in *Alice in Won-
derland*. The city skyline shown in **B** is almost convincing but
also more than just a bit "off." In fact, it is the New York–New
York Hotel in Las Vegas. The cars in the photograph betray the
actual size of this Vegas fantasy.

Charles Ray's *Family Romance* **(C)** radically demonstrates
the impact of a side-by-side scale change. In this case the adult
figures are reduced in scale, and the children are presented at
closer to actual scale. This comparison reveals the difference in
bodily proportions for adults and children.

A similar manipulation can be observed in Botero's version
of *Mona Lisa* **(D)**. The familiarity of this image accounts in part
for our reaction to the distortions in proportion. A large head-
to-body relationship suggests childlike proportions. However, in
this case an iconic image has been inflated like a cheap balloon.

Magritte would say that such artworks provoke a "crisis
of the object." They cause us to pause and reconsider how we
know things.

→ **A**

A golden rectangle can be created by rotating the diagonal of the half-square.

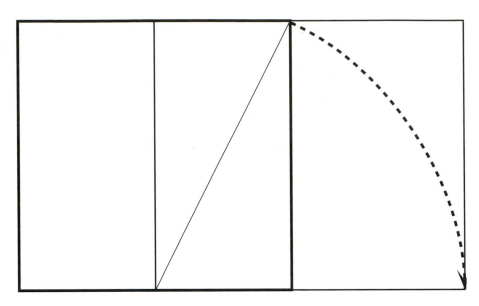

GEOMETRY AND NOTIONS OF THE IDEAL

Proportion is linked to ratio. That is to say, we judge the proportions of something to be correct if the ratio of one element to another is correct. For example, the ratio of a baby's head to its body is in proportion for an infant but would strike us as out of proportion for an adult. In a life drawing class, you might learn that an adult is about seven and one-half heads tall. Formulas for the ideal figure have at times had the authority of a rule or **canon**. Contemporary art or design seldom seems based on such canons, but you may have noticed the apparent standard of "ten heads tall" in the exaggerated proportions of fashion illustration.

The ancient Greeks desired to discover ideal proportions, and these took the form of mathematical ratios. The Greeks found the perfect body to be seven heads tall and even idealized the proportions of the parts of the body. In a similar fashion they sought perfect proportions in rectangles employed in architectural design. Among these rectangles the one most often cited as perfect is the **golden rectangle**. Although this is certainly a **subjective** judgment, the golden rectangle has influenced art and design throughout the centuries. The fact that this proportion is found in growth patterns in nature (such as the chambered nautilus shell, plants, and even human anatomy) and lends itself to a modular repetition has given it some authority in the history of design.

← **B**

George Inness. *View of the Tiber near Perugia.* **1872–1874. Oil on canvas, 3' 2⁹⁄₁₆" × 5' 3⁹⁄₁₆" (98 × 161.5 cm). National Gallery of Art, Washington, DC (Ailsa Mellon Bruce Fund).**

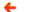

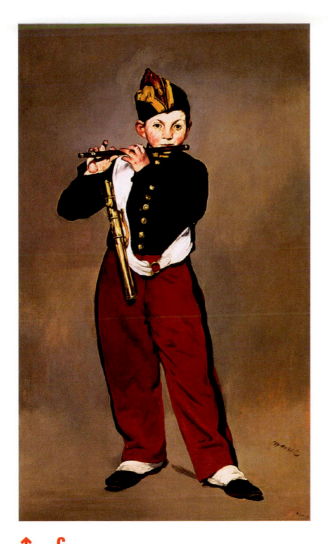

↑ **C**

Édouard Manet. *The Fifer.* 1866. Oil on canvas, 5' 3" × 3' 2⅝"
(160 × 98 cm). Signed lower right: Manet. Musée d'Orsay,
Paris (bequest of Count Isaac de Camondo.

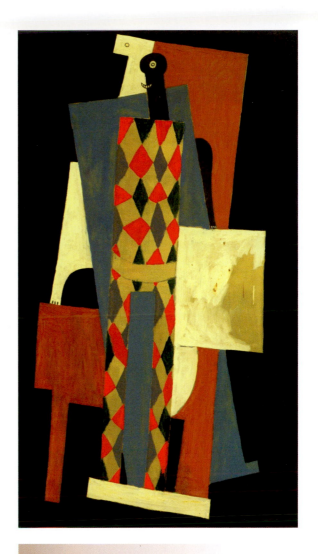

↑ **D**

Pablo Picasso. *Harlequin.* Paris, late 1915. Oil on
canvas, 6' ¼" × 3' 5⅜" (183.5 × 105.1 cm).

Finding the Golden Rectangle

The proportions of the golden rectangle can be expressed in the
ratio of the parts to the whole. This ratio (called the ratio of the
golden mean) is width is to length as length is to length plus
width (w:l as l:l + w). This rectangle can be created by rotating
the diagonal of a half-square, as shown in **A**. Both the entire
rectangle created and the smaller rectangle attached to the orig-
inal square are golden rectangles in their proportions.

The ratio of the golden mean can be found in the Fibonacci
sequence, a counting series where each new number is the sum
of the previous two: 1, 1, 2, 3, 5, 8, 13, 21, 34, and so on. The
irrational number 21/34 is approximately 0.618 and is repre-
sented by the Greek letter F.

In a horizontal orientation the format is classic in landscape
painting. In a painting by Inness **(B)**, we can see how the square
within the golden rectangle opens up a vista of deep space to
the left of the grove of trees.

We see this 3:5 ratio expressed in music (harmonies of
thirds, fifths, and octaves), and we find it in growth patterns in
nature. With research you can find numerous examples of these
proportions in nature, the human body, and design. In art the
3:5 proportion is well suited in a vertical format to the human
figure **(C)**. Picasso's abstraction **(D)** relies in part on a vertical
rectangle (a "root 3" rectangle: that is a proportion of 1:√3) to
evoke the figure.

ROOT RECTANGLES

Like the golden rectangle, other rectangles are derived from the square. These are called root rectangles and have proportions such as $1:\sqrt{2}$, $1:\sqrt{3}$, and $1:\sqrt{5}$. Exploring the dynamics of these shapes and finding their expression in art and design is interesting.

Rotation of the diagonal of a square produces a $\sqrt{2}$ rectangle. If the square is 1 unit long, for example, the diagonal will be 1.414 or $\sqrt{2}$. Drop this diagonal to create the long side of a new rectangle that is 1:1.414 **(A)**. This is a unique rectangle in that each half of the rectangle is also a $\sqrt{2}$ proportion. In **B** you can see how these two halves create an equal space for the two combatants in *The Duel after the Masquerade*. Each half has the same proportion (but in a vertical orientation) as the whole painting.

Root Five Rectangles

Rotation of the diagonal of the half-square describes a half-circle and creates a new rectangle with a square at the center flanked by two golden rectangles.

This rectangle, a derivative of the golden rectangle, is called a root five ($\sqrt{5}$) rectangle because its proportions are $1:\sqrt{5}$. This proportion is often observed in the architecture of antiquity such as the façade of the Parthenon. Masaccio's *The Tribute Money* **(C)** exploits the properties of this rectangle in depict-

↑ **A**

The root 2 rectangle can be created by rotating the diagonal of a square.

ing a three-part narrative with grace and subtlety. In the center area (the square), the tax collector demands the tribute money from Christ, who instructs Peter to get the money from the fish's mouth. On the left Peter kneels to get the money, and on the right he pays the tax collector.

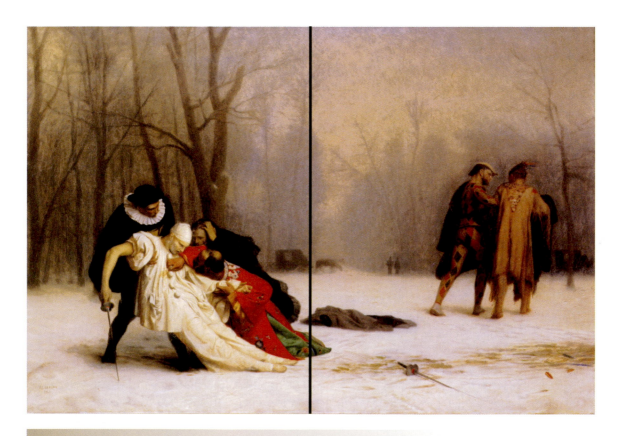

↑ **B**

Jean-Léon Gérôme. *The Duel after the Masquerade.* **1857–1859. Oil on canvas, 1' 3⅜" × 1' 10⁹⁄₁₆" (39.1 x 56.3 cm).**

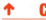 **C**

The geometry of root five and golden rectangles divides this three-part painting at significant locations. Masaccio. *The Tribute Money.* **c. 1427. Fresco, 8' 4" × 19' 8" (2.54 x 5.99 m). Santa Maria del Carmine, Florence, Italy.**

Exploring Geometry in Art and Design

The inherent geometry of rectangles such as the golden rectangle and root five rectangle not only provides an agreeable proportion; the diagonals and other interior structural lines often conform to significant features in a composition as is evident in **C**. These proportions do not provide a formula for design success, however. As with other visual principles, the attributes of the golden mean offer an option for design exploration.

The altered appearance of the "street rod" shown in **D** may seem odd after looking at Masaccio's fresco, and the car was probably not designed with the golden mean in mind. What it does reveal is the power of altered proportions to get our attention and cause us to notice a form. The roofline of this street rod is immediately recognizable as altered in proportion from our expected image of a car. In fact the roof-line bears a striking resemblance to the diagram in **C**.

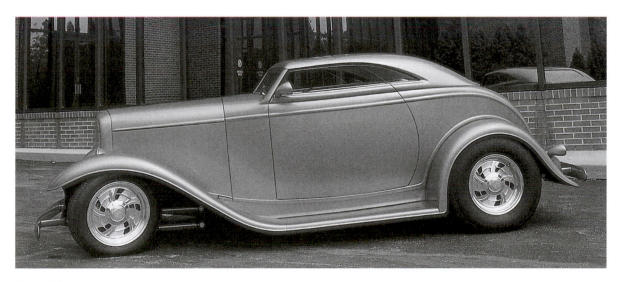

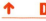 **D**

Modified 1932 Ford ("Deuce") Street Rod. **Designer: Thom Taylor. Source: Timothy Remus,** *Ford '32 Deuce Hot Rods and Hiboys: The Classic American Street Rod 1950s–1990s* **(Motorbooks International Publishers and Wholesalers).**

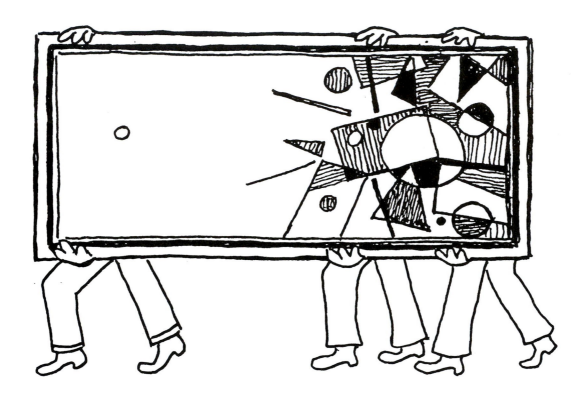

David Lauer.

5 BALANCE

INTRODUCTION

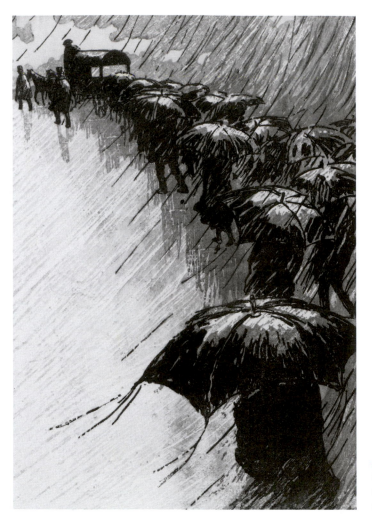

Funeral under Umbrellas (**A**) is a striking picture. What makes it unusual concerns the principle of **balance** or distribution of visual weight within a composition. Here all the figures and visual attention seem concentrated on the right-hand side. The left-hand side is basically empty. The diagonal sweep of the funeral procession is subtly balanced by the driving rain that follows the other diagonal. The effect seems natural and unposed. The result looks like many of the photographs we might see in newspapers or magazines.

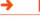 **A**

Henri Rivière. *Funeral under Umbrellas.* **c. 1895. Etching, 8½" × 7" (21.5 × 17.7 cm). Paris, Bibliothèque Nationale de France, Cabinet des Estampes.**

→ **B**

Josef Albers. Bookshelf. 1923. Reproduction by Rupert Deese (1999). Baltic birch, 4' 9⅛" × 5' 8⅜" × 11⅜". The Josef and Anni Albers Foundation.

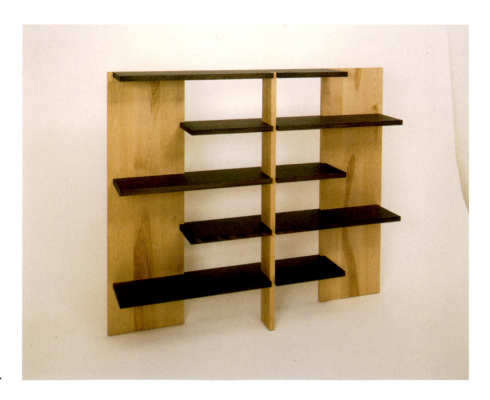

A sense of balance is innate; as children we develop a sense of balance in our bodies and observe balance in the world around us. Lack of balance, or imbalance, disturbs us. We observe momentary imbalance such as bodies engaged in active sports that quickly right themselves or fall. We carefully avoid dangerously leaning trees, rocks, furniture, and ladders. But even where no physical danger is present, as in a design or painting, we still feel more comfortable with a balanced composition. The bookshelf designed by Josef Albers **(B)** is lively in design as the shelves alternate in their extension left and right. The overall pattern is balanced and lends a sense of stability to the design.

Pictorial Balance

In assessing pictorial balance, we always assume a center vertical **axis** and usually expect to see some kind of equal weight (visual weight) distribution on either side. This axis functions as the fulcrum on a scale or seesaw, and the two sides should achieve a sense of **equilibrium**. When this equilibrium is not present, as in **C**, a certain vague uneasiness or dissatisfaction results. We feel a need to rearrange the elements in the same way that we automatically straighten a tilted picture on the wall. In **D** we can see how a line drawn over the middle of the picture (running through the "eye") reveals the fulcrum of a pendulum-like composition. It is as if the shapes were hung from this point ("the eye") and settled into an equilibrium.

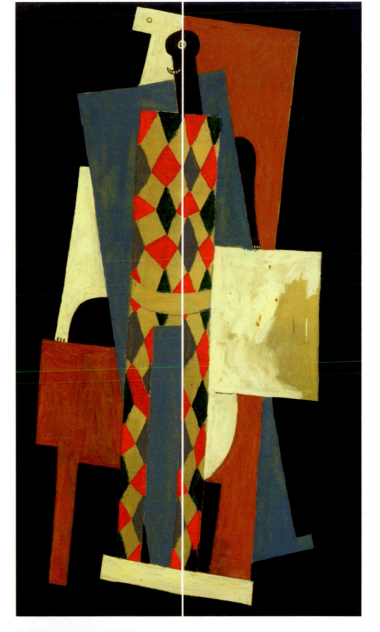

 C

An unbalanced design leaves the viewer with a vague uneasiness.

 D

Pablo Picasso. *Harlequin.* **Paris, late 1915. Oil on canvas, 6' ¼" × 3' 5⅜" (183.5 × 105.1 cm).**

HORIZONTAL AND VERTICAL PLACEMENT

Balance—some equal distribution of visual weight—is a universal aim of composition. The vast majority of pictures we see have been consciously balanced by the artist. However, this does not mean there is no place in art for purposeful **imbalance**. An artist may, because of a particular theme or topic, expressly desire that a picture raise uneasy, disquieting responses in the viewer. In this instance imbalance can be a useful tool.

Using Imbalance to Create Tension

Philip Guston's *Transition* **(A)** is weighted to the right-hand side of the painting. Even the hands of the clock seem to point to the mass of enigmatic forms. The off-balance shift in weight seems in keeping with the title: a body off balance tends to be in transition until balance is reached. This effect is also achieved in **B**, where our attention is focused on the dying figure, and secondarily, our attention turns to the departing figures in a counterpoint to this tension.

In speaking of pictorial balance, we are almost always referring to horizontal balance, the right and left sides of the image.

↑ **A**

Philip Guston. *Transition.* 1975. Oil on canvas, 5' 6" × 6' 8½" **(167.6 × 204.5 cm). Smithsonian American Art Museum, Washington, DC. Bequest of Musa Guston.**

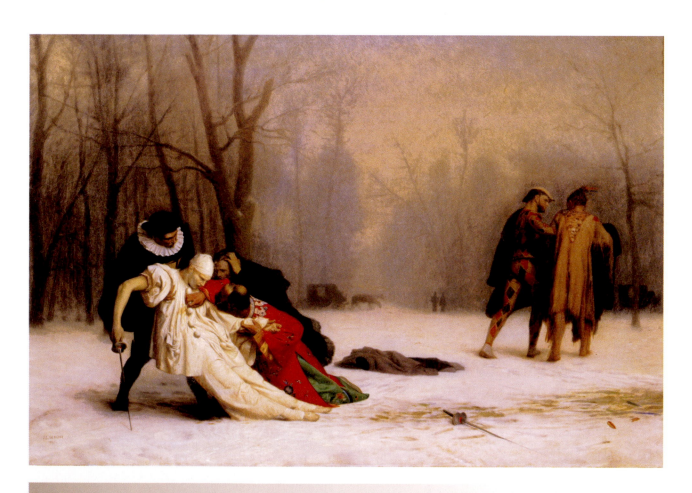

↑ **B**

Jean-Léon Gérôme. *The Duel after the Masquerade.* 1857–1859. Oil on canvas, 1' 3⅜" × 1' 10³⁄₁₆" (39.1 × 56.3 cm).

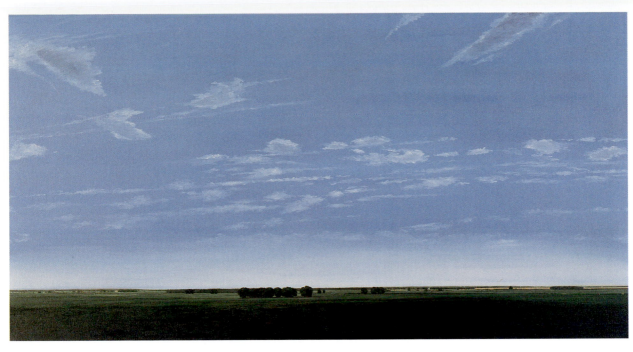

↑ **C**

Keith Jacobshagen. *In the Platte River Valley.* **1983. Oil on canvas, 2' 6" × 4' 8¼". Sheldon Memorial Art Gallery and Sculpture Garden, University of Nebraska–Lincoln (gift of Wallis, Jaime, Sheri, and Kay in memory of their parents, Joan Farrar Swanson and James Hovland Swanson, 1984.U-3729). Photo: © Sheldon Memorial Art Gallery.**

But artists consider vertical balance as well. An imagined horizontal axis divides a work top and bottom. Again, a certain general equilibrium is usually desirable. However, because of our sense of gravity, we are accustomed to seeing more weight toward the bottom, with a resulting stability and calmness. In the landscape painting by Keith Jacobshagen **(C)**, the darkness of the strip of land at the bottom creates this sense of weight. The farther up in the format the main distribution of weight or visual interest occurs, the more unstable and dynamic the image becomes.

The effect of a high center of visual interest can be seen in Guston's *Transition* **(A)**, where the heaviest grouping of shapes is at the top of the painting. In this picture, weight to the right and the top creates the effect of a "transition."

At first glance, **D** appears to be imbalanced with an awkward void in the center and right side of the composition. Our attention is drawn to the graceful white handle depicted on the left and the white lettering in the text at top and bottom. The "empty" area reveals a subtle shadow of the pitcher suggesting that what we see first and most emphatically is not the whole story.

→ **D**

William Bailey. Detail from *TURNING.* **2003. Oil on linen, 5' 10" × 4' 7" (177.8 × 139.7 cm). WB10092. Advertisement for Betty Cunningham Gallery.** *Art in America,* **April 2005.**

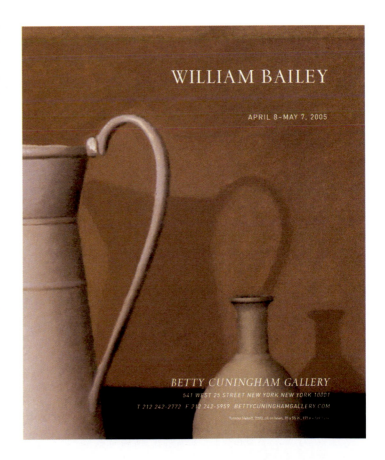

WILLIAM BAILEY

APRIL 8–MAY 7, 2005

BETTY CUNINGHAM GALLERY
541 WEST 25 STREET NEW YORK NEW YORK 10001
T 212 242-2772 F 212 242-5959 BETTYCUNINGHAMGALLERY.COM

BILATERAL SYMMETRY

The simplest type of balance, both to create and to recognize, is called *symmetrical balance*. In symmetrical balance, like shapes are repeated in the same positions on either side of a vertical axis. This type of **symmetry** is also called **bilateral symmetry**. One side, in effect, becomes the mirror image of the other side. Symmetrical balance seems to have a basic appeal for us that can be ascribed to the awareness of our bodies' essential symmetry.

Symmetry is high on the list of universally recognized attributes ascribed to beauty. Across cultures, a symmetrical face is perceived as agreeable. This is independent of ethnic or racial characteristics. The photograph of Audrey Hepburn **(A)** is manipulated in **B**. Her right side is flipped and replaces her left side (this is apparent in the artificial appearance of her hair). This reveals the near symmetry of her natural features and one reason she was an icon of beauty.

The painting shown in **C** shows a similar facial symmetry … *almost*. While the hairstyle is symmetrical, the facial features are regular, and the placement of the figure is centered, there is nonetheless an odd tension to this stiff formal pose. Everything is quite beautiful, and just a bit off. On the one hand this is more natural than a perfect symmetry, but in this case it calls into question the very notion of perfection. The sitter in this portrait is the editor in chief of *Vogue*, a magazine noted for displaying standards of fashion and beauty.

Formal Balance

Conscious symmetrical repetition, while clearly creating perfect balance, can be undeniably **static**, so the term *formal balance* is used to describe the same idea. There is nothing wrong with quiet formality. In fact, this characteristic is often desired in some art, notably in architecture. Countless examples of architecture with symmetrical balance can be found throughout the world, dating from most periods of art history. The continuous popularity of symmetrical design is not hard to understand. The formal quality in symmetry imparts an immediate feeling of permanence, strength, and stability. Such qualities are important in public buildings to suggest the dignity and power of a government. So statehouses, city halls, palaces, courthouses, and other government monuments often exploit the properties of symmetrical balance.

The high altar created by Bernini for St. Peter's **(D)** is situated in perfect symmetry within the architecture of the basilica. Symmetry is often associated with altars and religious artworks where stability and order reinforce enduring values.

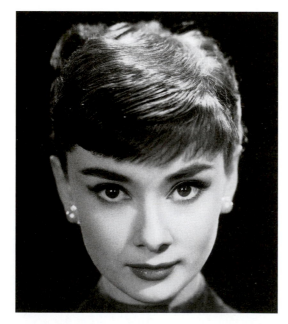

↑ **A**
Audrey Hepburn. Cropped.

↑ **B**
Audrey Hepburn. Symmetry.

Symmetry Unifies

The elements of the altar and architecture shown in **D** create an exciting, ornate space. Imagine the effect *without* symmetrical organization molding the masses of niches, columns, and statuary into a unified and coherent visual pattern. There are undoubtedly countless examples of bilateral symmetry in religious and municipal architecture, and the results range from banal or oppressive, to spectacular and beautiful. Symmetry provides an order but does not guarantee an appreciative human response.

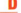 **D**

Giovanni Lorenzo Bernini. The Baldacchino, the high altar
and the chair of St. Peter. St. Peter's, Vatican, Rome, Italy.

↑ **A**

Ed Ruscha. *Step on No Pets.* **2002. Acrylic on canvas, 5' 4⅛" × 6' ⅛". Gagosian Gallery, New York.**

EXAMPLES FROM VARIOUS ART FORMS

Symmetrical balance is rarer in painting, photography, or graphic design than in architecture. In fact, relatively few two- or three-dimensional artworks would fit a strict definition of symmetry. When successfully employed, symmetry is used to reinforce the subject, not merely as a crutch for a simple solution.

Symmetry for Emphasis

Symmetry can be found in nature—in the reflected images of a pond, or crystalline structures. However, most images of the landscape reveal a more chaotic world where order emerges in nonlinear patterns like the complexity of a forest or mountain range. An ordered or symmetrical landscape brings to mind formal gardens or an imposition of human intervention. Ed Ruscha turns a mountain landscape **(A)** into a symmetrical shape like a Rorschach test. Superimposed over this artificial image is a palindrome, the verbal equivalent of bilateral symmetry.

Hiroshi Sugimoto exploits the symmetry of a movie theater to keep the focus on the luminosity of the movie screen **(B)**. This luminosity is achieved by a long exposure while a film is running. The bilateral symmetry reinforces the quiet glow of the image as the interior is subtly illuminated.

Margaret Wharton transforms a wooden chair into a *Mocking Bird* **(C)** through a process of slicing and reassembling. In this case we can, once again, trace the origins of the sculpture's symmetry back to the human figure. The symmetry of the chair derives from the human body for which it is designed. Wharton's cut and reassembled version takes on the winged symmetry of a birdlike form.

↑ B

Hiroshi Sugimoto. *U.A. Play House.* **1978.**

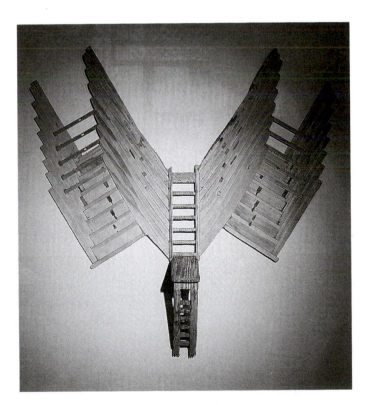

↑ C

Margaret Wharton. *Mocking Bird.* **1981. Partially stained wooden chair, epoxy glue, paint, wooden dowels, 5' × 5' × 1' 1" (152 × 152 × 33 cm). Courtesy of the artist and Jean Albano Gallery, Chicago.**

ASYMMETRICAL BALANCE

INTRODUCTION

The second type of balance is called **asymmetrical balance**. In this case balance is achieved with dissimilar objects that have equal visual weight or equal eye attraction. Remember the children's riddle, "Which weighs more, a pound of feathers or a pound of lead"? Of course, they both weigh a pound, but the amount and mass of each vary radically. This, then, is the essence of asymmetrical balance.

Informal Balance

In Nan Goldin's photograph **(A)** the figure gazes out at us from the right side of the picture. But the composition is not off balance. Left of center are the hand and cigarette, which balance the face as a natural point of interest. Balance is maintained as the two sides of the picture each provide a visual emphasis.

← **A**

Nan Goldin. *Siobhan with a Cigarette.*
Berlin. 1994. Photograph.

↑ **B**

Ham Steinbach. *supremely black.* **1985. Plastic laminated wood shelf, ceramic pitchers, cardboard detergent boxes,
2' 5" × 5' 6" × 1' 1" (74 × 168 × 33 cm). Sonnabend Gallery and Jay Gorney Modern Art, New York.**

Goldin's photograph shows one advantage of asymmetrical balance: the feeling is more casual than that of a formal symmetrical portrait. Another term for asymmetrical balance is, appropriately, **informal balance**. The human face is a strong target for our attention. Presented in absolute symmetry, the result can be a static or boring portrait. Goldin's use of a more informal balance is in keeping with the delicate sense of balance in the lives of real people.

Symmetry can appear artificial, as our visual experiences in life are rarely symmetrically arranged. Some buildings and interiors are so designed, but even here, unless we stand quietly at dead center, our views are always asymmetrical.

Carefully Planning Asymmetry

Asymmetry appears casual and less planned, although obviously this characteristic is misleading. Asymmetrical balance is actually more intricate and complicated to use than symmetrical balance. Merely repeating similar elements in a mirror image on either side of the center is not a difficult design task. But attempting to balance dissimilar items involves more complex considerations and more subtle factors.

The sculpture by Ham Steinbach **(B)** shows how two can balance three in an asymmetric arrangement. Two black pitchers sit on a red shelf adjacent to three red Bold 3 detergent boxes on a black shelf. This asymmetric pairing invites us to find the visual rhymes and contrasts that exist across the dividing line. The visual interest in comparing the unequal sides results in a balanced composition, and the number of elements feels correct.

Careful planning takes on a different level of significance in the engineering and design of a bridge where function and safety are paramount. The expressive asymmetry of Calatrava's bridge **(C)** confounds our usual expectation of stability, and the result is a dynamic, unforgettable design.

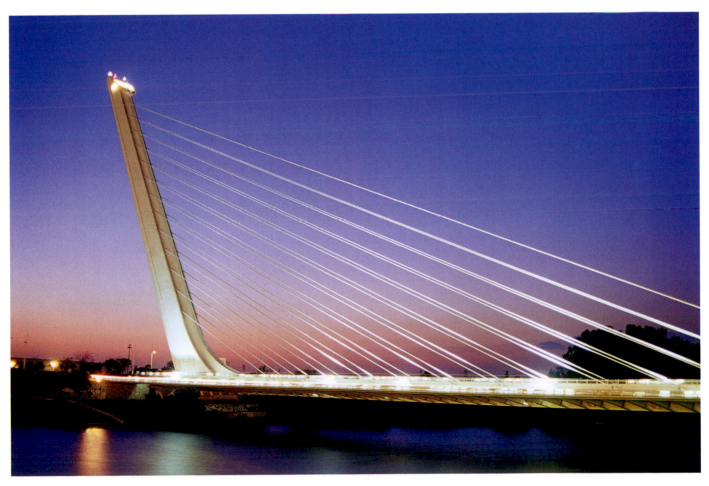

↑ **C**

Alamillo Bridge/Cartuja Viaduct, Seville, Spain. Architect: Santiago Calatrava.

BALANCE BY VALUE AND COLOR

Value

Asymmetrical balance is based on equal eye attraction—dissimilar objects are equally interesting to the eye. One element that attracts our attention is **value** difference, a contrast of light and dark. As **A** illustrates, black against white gives a stronger contrast than gray against white; therefore, a smaller amount of black is needed to visually balance a larger amount of gray.

The photograph of the cathedral at York (**B**) reverses the values but shows the same balance technique. The left side of the composition shows many details of the angled wall of the church nave. However, the receding arches, piers, columns, and so on are shown in subtle gradations of gray, all very close and related in value. In contrast, on the right side is the large black **silhouette** of a foreground column and the small window area

 A

A darker, smaller element is visually equal to a lighter, larger one.

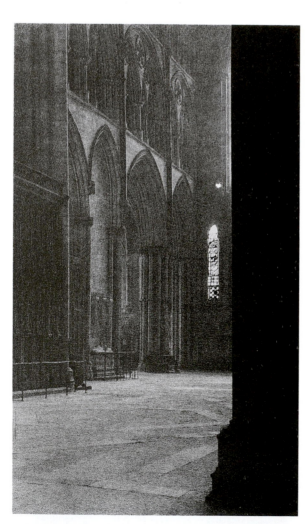

 B

Frederic H. Evans. *York Minister, Into the South Transept.* 1900. Platinum print, 8¼" × 4¾" (20.9 × 12.1 cm). The Metropolitan Museum of Art, Alfred Stieglitz Collection, 1933.

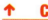 **C**

Kristian Russell, Art Department. 1998.

of bright white. These two sharp visual accents of white and black balance the many essentially gray elements on the left.

Color

The illustration in **C** suggests motion as the figure exits the left side of the composition. The design is quite abstract and breaks into jigsaw puzzle–like shapes. This dynamic arrangement is countered by the bold expanse of yellow that dominates the right half of the image.

Mary Cassatt's painting **(D)** balances the value of the striking white blouse with a vivid red cape. This shows how value and color are both powerful in creating emphasis and balance in a composition. Balance by value or color is a great tool, allowing a large difference of shapes on either side of the center axis and still achieving equal eye attraction.

See also *Color and Balance*, page 274, and *Ways to Suggest Motion*, pages 234, 236, and 238.

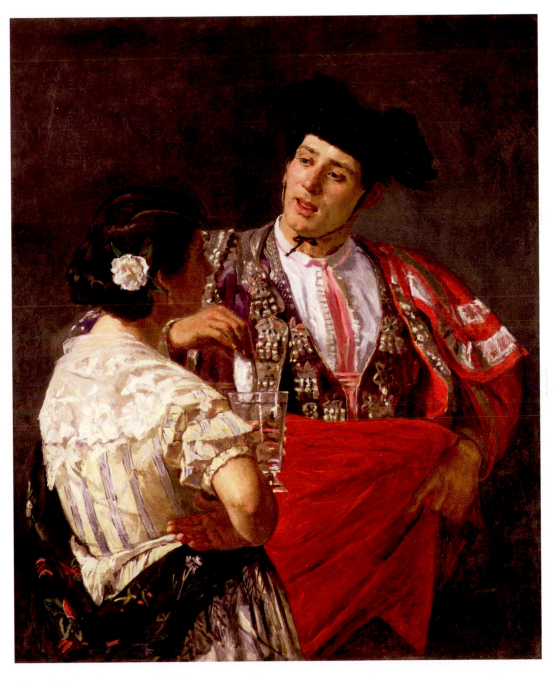

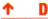 **D**

Mary Stevenson Cassatt. *Offering the Panale to the Bullfighter.* **1873. Oil on canvas, 100.6 × 85.1 cm. 1955.1. Sterling and Francine Clark Art Institute.**

BALANCE BY TEXTURE AND PATTERN

The diagram in **A** illustrates balance by shape. Here the two elements are exactly the same value and texture. The only difference is their shape. The smaller form attracts the eye because of its more complicated contours. Though small, it is more interesting than the much larger, but duller, rectangle.

Texture Adds Interest

Any visual **texture** with a variegated dark and light pattern holds more interest for the eye than does a smooth, unrelieved surface. The drawing in **B** presents this idea: the smaller, rough-textured area balances the larger, basically untextured area (smoothness is, in a sense, a texture).

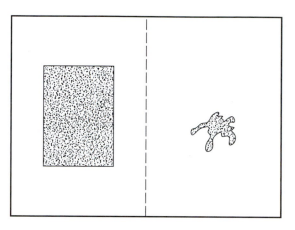

 A

A small, complicated shape is balanced by a larger, more stable shape.

↑ **B**

A small, textured shape can balance a larger, untextured one.

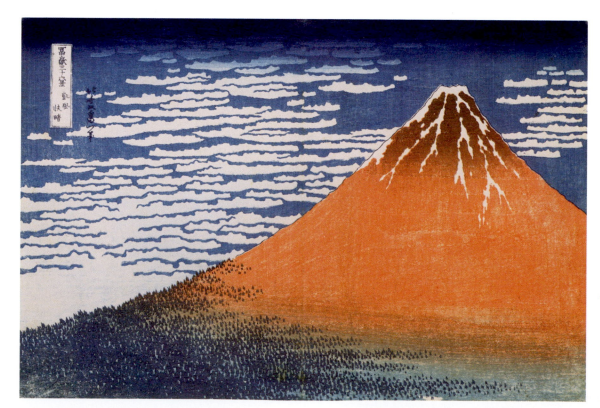

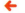 **C**

Katsushika Hokusai. *South Wind, Clear Dawn* from *Thirty-Six Views of Mount Fuji.* **Woodblock print, 10" × 1' 2⅞". The Metropolitan Museum of Art, bequest of Henry L. Phillips, 1939.**

Using Texture and Pattern for Balance

The balance of the elements in the Japanese woodcut **(C)** shows how a large, simple form can be balanced by an intricate pattern or texture. The large, simple triangular mass of the mountain is positioned to the right. The left side is balanced by the pattern of clouds and sky and by a texture that suggests a forest of trees. Pattern and texture balance the strength of the large red mountain shape.

The still-life painting by Henri Fantin-Latour **(D)** offers a surprising composition. A pitcher sits on top of a broad expanse of white linen, and this focal point is balanced by the intricate pattern of foliage on the right.

Texture in Commercial Design

Printed text consisting of letters and words in effect creates a visual texture. The information is in symbols that we can read, but the visual effect is nothing more than a gray-patterned shape. Depending on the typeface and the layout, this gray area varies in darkness, density, and character, but it is visually textured. Very often in advertisements or editorial page layouts, an area of "textured" printed matter will balance photographs or graphics. The pages of this text are similarly composed.

 D

Henri Fantin-Latour. *Still Life: Corner of a Table.* **1873. Oil on canvas, 3' 1⁵⁄₁₆" × 4' 1³⁄₁₆" (96.4 × 125 cm). The Art Institute of Chicago (Ada Turnbull Hertle Endowment).**

BALANCE BY POSITION AND EYE DIRECTION

A well-known principle in physics says that two items of unequal weight can be brought to equilibrium by moving the heavier inward toward the fulcrum. In design this means that a large item placed closer to the center can be balanced by a smaller item placed out toward the edge. The two seesaw diagrams in **A** illustrate this idea of balance by position.

Achieving Casual Balance

Balance by position often lends an unusual, unexpected quality to the composition. The effect not only appears casual and unplanned but also can make the composition seem, at first glance, to be in imbalance. This casual impression is evident in the illustration by Aubrey Beardsley **(B)**. The three "garçons" are grouped in the left-hand portion of the composition. Notice how much of these figures is actually the white aprons, which lighten the weight of the figure grouping. Two tables, one stacked with plates, on the right-hand edge of the picture provide sufficient balancing lines and shapes to this informal group.

Connecting the Eyes

At first glance, the Annunciation fresco by Fra Angelico **(C)** seems heavily weighted to the left side of the composition. The angel has prominent wings with bright color and darker values. The figure of Mary, on the other hand, is pale, almost dissolving into the background. This imbalance is offset by subtle eye direction. We connect the figures through the line of their gaze and the arches sweeping across the top of the painting.

Although not usually the only technique of balance employed by artists, eye direction is a commonly used device. Eye direction is carefully plotted, not only for balance but also for general compositional unity.

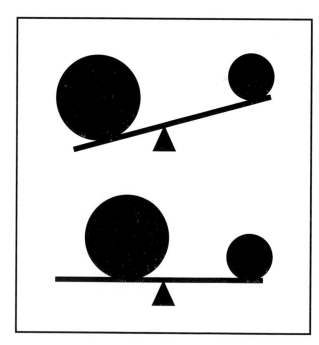

 A

A large shape placed near the middle of a design can be balanced by a smaller shape placed toward the outer edge.

 B

Aubrey Beardsley. *Garçons de Café.* **1894. Line block drawing originally published in** *The Yellow Book,* **vol. II, July.**

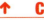

Fra Angelico. *The Annunciation.* 1442. Fresco, 6' 1½" × 5' 1¾" (187 × 157 cm). Museo di San Marco dell'Angelico.
Florence, Italy/The Bridgeman Art Library.

ANALYSIS SUMMARY

In looking at works of art, you will realize that isolating one technique of asymmetrical balance as we have done is a bit misleading because the vast majority of works employ several of the methods simultaneously. For the sake of clarity, we discuss these methods separately, but the principles often overlap and are frequently used together. Let us look at just a few examples that use several of the factors involved in asymmetrical balance.

Awareness of Asymmetry

Van Gogh's *Portrait of Dr. Gachet (Man with a Pipe)* **(A)** shows a marked asymmetry and a pronounced slant running along the diagonal from upper left to lower right. This is a print, so the image is reversed. The original drawing on the etching plate would have slanted in the opposite direction. Such a slant or drag is often an indication as to whether the artist is right- or left-handed (a slant to the right indicating a right-handed artist). When working on a portrait (or any composition for that matter), it can be useful to hold the image to a mirror to see the image reversed. This can reveal a tilted bias to the composition that is otherwise "invisible" to your eye.

 A

Vincent van Gogh. *Portrait of Dr. Gachet (Man with a Pipe).* **May 15, 1890. Etching, plate: 7⅛" × 5¹⁵⁄₁₆" (18.1 × 15.1 cm). Gift of Abby Aldrich Rockefeller. The Museum of Modern Art, New York.**

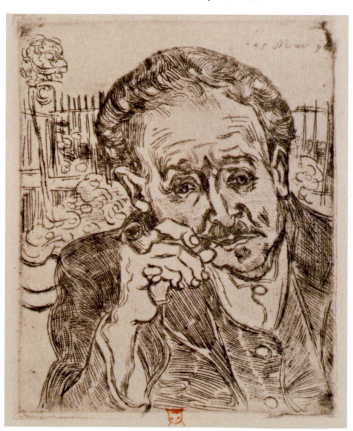

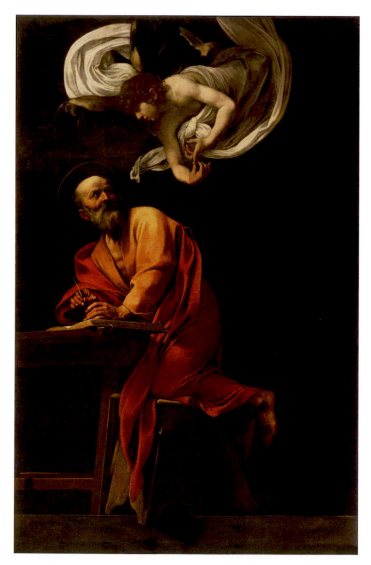

 B

Caravaggio (Michelangelo Merisi da). *The Inspiration of Saint Matthew.* **1600–1602. Oil on canvas, 9' 7" × 6' 1" (292 cm x 186 cm). San Luigi dei Francesi, Rome.**

Dynamic Combinations of Elements

Caravaggio's *The Calling of St. Matthew* **(B)** presents an example of dynamic asymmetry. The focus is on St. Matthew's face on the left side of the painting in an apparently radical imbalance. The activity is unfurled in a reverse "S" curve, which provides a path for the eye to follow. The almost abstract white and red support a precarious balance between above and below in the composition. The painting depicts a moment of an epiphany for St. Matthew, which is best expressed by a composition that is not in repose or strict balance. In fact, the stool his knee rests on tips precariously as if about to tumble.

Garry Winogrand's photograph **(C)** appears to be essentially symmetrical with elements balanced to the left and right of the center. In fact, it is the asymmetrical aspects of the composition that keep us engaged:

The white car on the left blends into the light sand, while the blue picnic stand on the right echoes the sky.

The open door and figure on the left balance two figures on the right.

The clouds are distributed equally left and right, but the shapes vary.

The Winogrand photograph seems remarkably symmetrical for an unposed, spontaneous moment. The picture is, in fact, a play between the asymmetrical balance of lively casual elements and a symmetry that evokes a staged or artificial quality.

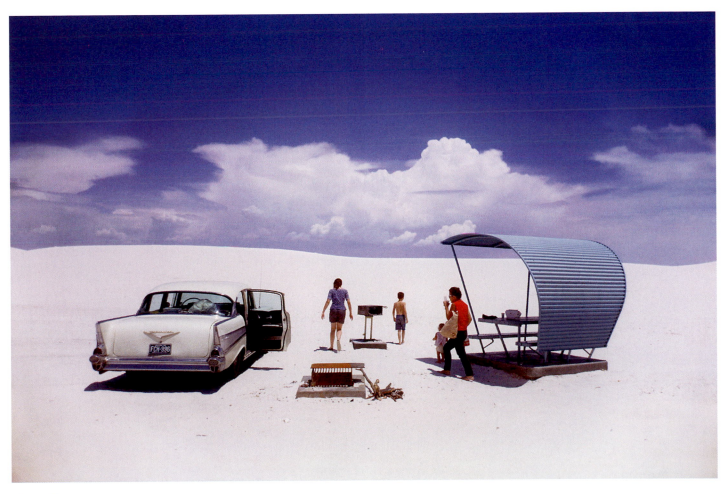

↑ **C**

Garry Winogrand. *White Sands National Monument.* **1964. Courtesy of Estate of Garry Winogrand, Center for Creative Photography, University of Arizona.**

EXAMPLES IN NATURE AND ART

A third variety of balance is called **radial balance**. Here all the elements radiate or circle out from a common central point. The sun with its emanating rays is a familiar symbol that expresses the basic idea. Radial balance is not entirely distinct from symmetrical or asymmetrical balance. It is merely a refinement of one or the other, depending on whether the focus occurs in the middle or off center.

Radial patterns are abundant in the natural world. The form of the flower shown in **A** is a visual expression of its growth outward from the stem. Each small floret echoes this pattern. This same pattern is seen in Josiah McElheny's sculpture **(B)**, which is modeled on what physicists understand about a certain stage of the big bang.

Circular forms abound in craft areas, where the round shapes of ceramics, basketry, and jewelry often make radial balance a natural choice in decorating such objects. Radial balance can be found in the playful design based on a bicycle wheel in **C**. This whirligig, fashioned from a wheel and funnels to catch the wind, exemplifies a rotational structure also seen in the weather patterns of a hurricane or the vortex of water in a whirlpool.

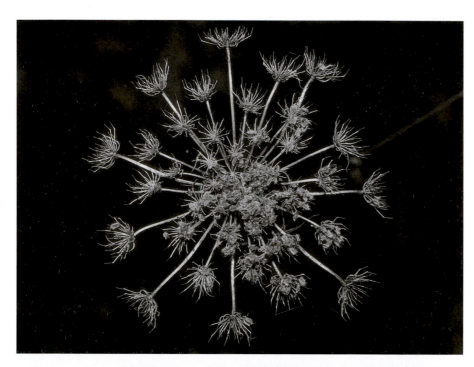

← **A**

Queen Anne's Lace.

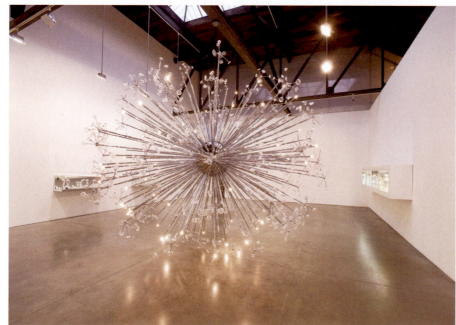

← **B**

Josiah McElheny. *An End to Modernity.* **2005. Chrome-plated aluminum, electric lighting, hand-blown glass, 12' × 15' × 15'. Courtesy Donald Yound Gallery, Chicago, and Andrea Rosen Gallery, New York.**

Cultural Symbols

Radial balance has been used frequently in architecture. The round form of domed buildings such as the Roman Pantheon or our nation's Capitol will almost automatically give a radial feeling to the interior. Such a design has a symbolic function of giving emphasis to the center as a place of cultural significance. Many cultures employ radial balance as part of their spiritual imagery and designs. These range from Tibetan **mandalas** to the rose windows of Gothic cathedrals. The advantage of such a design is the clear emphasis on the center and the unity that this form of design suggests.

The pull of a radial design even extends to urban planning. The Piazza del Popolo ("literally the plaza of the people") in Rome **(D)** is a center of activity in the city. Streets radiate from the piazza, and a monument at the center is visible from a distance. Such nodes of emphasis give order to a large city.

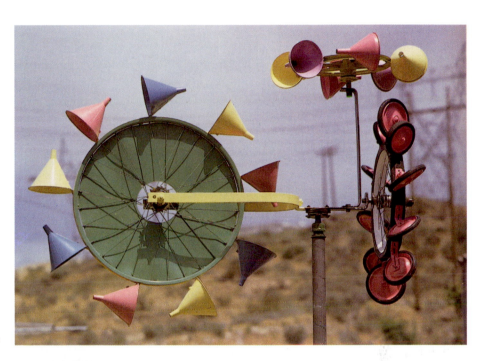

→ **C**
Anonymous. "Whirligig."

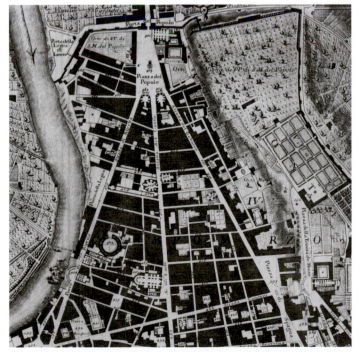

← **D**
Piazza del Popolo.

ALLOVER PATTERN

One more specific type of visual effect is often designated as a fourth variety of balance. The examples here illustrate the idea. These works all exhibit an equal emphasis over the whole format—the same weight or eye attraction literally everywhere.

This technique is officially called **crystallographic balance**. Because few people can remember this term—and even fewer can spell it—the more common name is **allover pattern**. This technique is, of course, a rather special refinement of symmetrical balance. The constant repetition of the same quality everywhere on the surface, however, creates an impression truly different from our usual concept of symmetrical balance.

Allover Pattern in Art and Design

In the *Signature Quilt* **(A)**, emphasis is uniform throughout. The many blocks are the same size, with each defined in the same degree of contrast to the black background. Each signature on each block is accorded the same value, whether that of a president (Lincoln, for example) or a lesser-known individual. There is no beginning, no end, and no focal point—unless, indeed, the whole quilt is the focal point.

An allover pattern may suggest the geometry of a quilt, but the same effect can be achieved with a more irregular structure such as a map. A map may lead us to look for a point of emphasis such as a major city; however, Jasper Johns's map **(B)** has no such emphasis. Shattered patches of color are distributed in similar amounts and defy most boundaries of the map. The result is more raucous than **A** but similarly suggests that the whole composition is the focus.

The wall of photographs shown in **C** is intended for quiet reflection or contemplation. Here are photos of many of the predominantly Jewish residents of an eastern European town. The Jewish community was eliminated by the Nazis, and this wall gives testimony to the loss with each individual having an equal place of commemoration. A balance is present between the unique nature of each photograph and frame, emphasizing the loss of distinct individuals, and the whole collection, which gives some sense of the larger community.

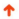 **A**

Adeline Harris Sears. *Signature Quilt.* 1856–1863. Silk with inked signatures, 6' 5" × 6' 8" (195.6 × 203.2 cm). The Metropolitan Museum of Art, purchase, William Cullen Bryant Fellow Gifts, 1996.

 B

Jasper Johns. *Map.* 1961. Oil on canvas, 6' 6" × 10' 3⅛" (198.2 × 314.7 cm). Gift of Mr. and Mrs. Robert C. Scull. The Museum of Modern Art, New York. Art © Jasper Johns/licensed by VAGA, New York, New York. Digital Image © The Museum of Modern Art/Licensed by SCALA/Art Resource, New York.

 C

Ralph Appelbaum. Hallway in the United States Holocaust/Memorial Museum, Washington, DC.

Frankly, Martha, NO!! It does NOT make me feel like dancing!
David Lauer.

CHAPTER 6 RHYTHM

ENGAGING THE SENSES

Rhythmic structures in visual art and design are often described (as they have been here) in terms borrowed from music vocabulary. The connection between visual rhythms and musical rhythms can be more than a simile or metaphor. In some cases the visual rhythms composed by an artist seem to resonate with memories or associations in our other senses. When a visual experience actually stimulates one of our other senses, the effect is called **kinesthetic empathy**.

Evoking Sight, Sound, and Touch

Charles Burchfield's painting **(A)** is, on one level, a depiction of the roofline of a building set among trees and plants. This description does not tell us the subject of *The Insect Chorus*, however. A description of the painting's many rhythmic patterns would come closer to explaining the title. Repeated curves, zig-zags, and straight linear elements throughout the picture literally buzz and create the sensation of a hot summer afternoon alive with the sound of cicadas. Even the sensation of heat is evoked by the rhythm of wavering lines above the rooftop.

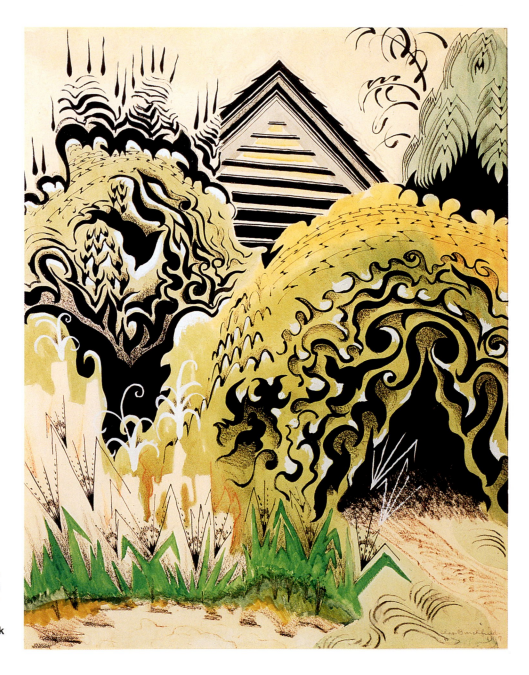

 A

Charles Burchfield. *The Insect Chorus.* **1917. Opaque and transparent watercolor with ink and crayon on paper, 1' 7⅞" × 1' 3⅞" (50 × 40 cm). Munson-Williams-Proctor Institute. Museum of Art, Utica, New York (Edward W. Root Bequest).**

The drawing shown in **B** attempts to convey the sensation of "metallic" sounds. This early experiment in Russian **Suprematism** from 1915 reflects the interest in industrial subjects of that era. The jumpy arrangement of shapes, almost lacking in any rhythmic pattern, seems to echo the harsh, dynamic sounds of a factory.

A second drawing by Malevich **(C)** is titled *Sensation of Movement and Resistance*. In this case our physical experiences of moving through the world are simulated. The drawing appeals to our sense of touch and "muscle memory" by repeating horizontal lines of varying weight along a curved path. The rhythmic interruption of the heavier, darker rectangles offers the "resistance" referred to in the title.

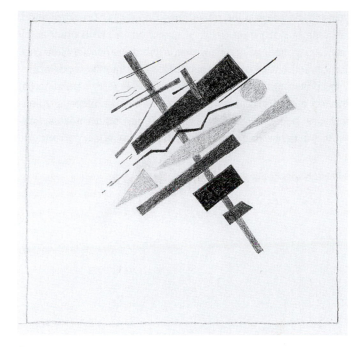

↑ **B**

Kasimir Malevich. *Suprematist Composition: Sensation of Metallic Sounds.* **1916–1918. Crayon on paper, 8" × 6½" (20.9 × 16.4 cm). Kupferstichkabinett, Oeffentliche Kunstsammlung Basel.**

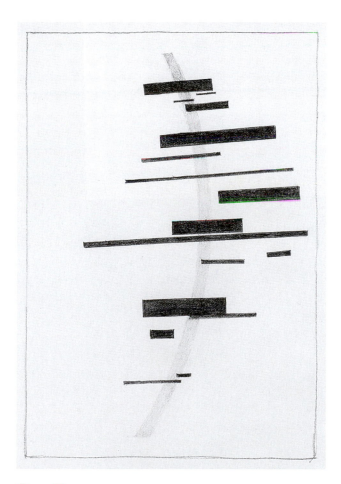

↑ **C**

Kasimir Malevich. *Suprematist Composition: Sensation of Movement and Resistance.* **Crayon on paper, 10½" × 8" (26.5 x 20.5 cm). Kupferstichkabinett, Oeffentliche Kunstsammlung Basel.**

VISUAL RHYTHM

Rhythm as a design principle is based on repetition. Repetition, as an element of visual unity, is exhibited in some manner by almost every work of art. However, rhythm involves a clear repetition of elements that are the same or only slightly modified.

In conversation we might refer to Bridget Riley's painting **(A)** as having a rhythmic feeling. This might seem a strange adjective to use because **rhythm** is a term we most often associate with the sense of hearing. Without words, music can intrigue us by its pulsating beat, inducing us to tap a foot or perhaps dance. Poetry often has meter, which is a term for measurable rhythm. The pace of words can establish a cadence, a repetitive flow of syllables that makes reading poems aloud a pleasure. But rhythm can also be a visual sensation. We commonly speak of rhythm when watching the movement displayed by athletes, dancers, or some workers performing manual tasks. In a similar way the quality of rhythm can be applied to the visual arts, in which it is again basically related to movement. Here the concept refers to the movement of the viewer's eye, a movement across recurrent motifs providing the repetition inherent in the idea of rhythm.

The painting in **A** has this feeling of repetition in the curved vertical stripes that vary from thick to thin. The contrasts of color enhance the sense of undulation. The senses of sight and hearing are indeed so closely allied that we often relate them by interchanging adjectives (such as "vibrating" colors). Certainly this relationship is shown in Riley's visual rhythm.

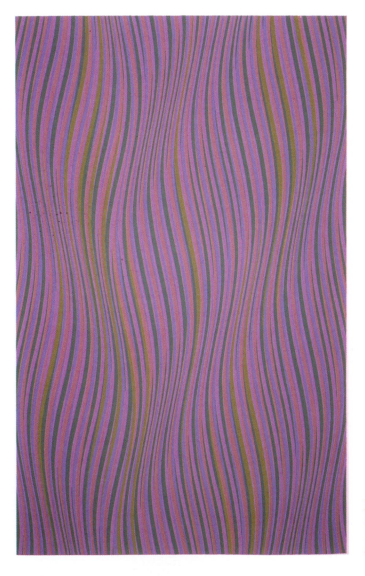

 A

Bridget Riley. Series 35. *Olive Added to Red and Blue, Violet and Green, Single Reversed Diagonal.* **1979. Gouache on paper, 3' 2⅛" × 2' ⅜".**

Not only **nonobjective** shapes are capable of producing an undulating rhythm. A similar effect is present in the photograph shown in **B**. Here tree trunks produce a sinuous rhythm, but one that is a bit more awkward or "herky-jerky" than that in **A**.

The chair shown in **C** offers a contrast to **A** and **B**. The chair design has a crisp rhythm in the repetition of vertical slats. The squares formed by crossing horizontals create a rhythmic pattern as well. This second rhythm gains emphasis toward the top of the chair. The curve of the chair's back subtly alters these patterns. In this case a few simple design elements work together to make a dramatic, more complex rhythm.

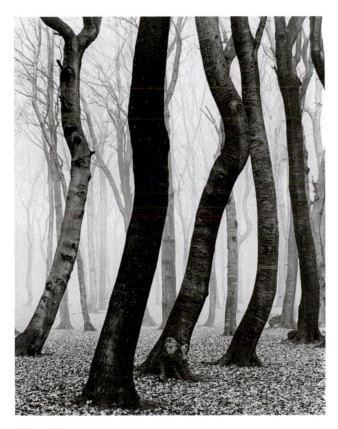

 B

Albert Renger-Patzsch. *Buchenwald in Herbst (Beech Forest in Autumn).* **1936. Silver gelatin print, 8¾" × 6⅜" (22.2 × 16.2 cm). The Metropolitan Museum of Art, Warner Communications, Inc., purchase fund, 1980.**

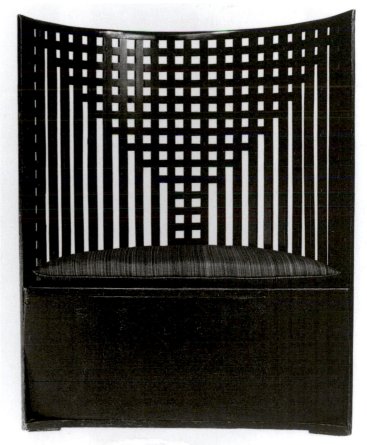

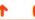 **C**

Charles Rennie Mackintosh. *Chair.* **1904. Ebonized oak, reupholstered with horsehair, 3' 10⁹⁄₁₆" × 3' 1" × 1' 4½" (118 × 94 × 42 cm). Collection of Glasgow School of Art, Glasgow.**

SHAPES AND REPETITION

We may speak of the rhythmic repetition of colors or textures, but most often we think of rhythm in the context of shapes and their arrangement. In music, some rhythms are called **legato**, or connecting and flowing. The same word could easily be applied to the visual effect in **A**. The photograph of Death Valley shows the sand dune ridges in undulating, flowing, horizontal curves. The dark and light contrast is quite dramatic, but in several places the changes are soft with smooth transitions. The feeling is relaxed and calm.

A similar rhythm occurs in the sixteenth-century illuminated manuscript by Hoefnagel (**B**). Here the rhythm is faster with more repetitions and more regularity or consistency in the repeated curves. The fluid strokes carry our eye across the text and mark both the beginning and end of the passage with a flourish.

Manipulating Rhythm

If the rhythm of **B** conjures up a baroque fugue, then the poster shown in **C** is well suited to conveying a jittery jazz rift. But, of course, not all jazz can be summarized on one such pattern, and so, **D** expresses another kind of jazz rhythm, perhaps more synthetic in expression. Niklaus Troxler has done many jazz posters, and the variety is remarkable: each has a unique rhythm.

The rhythms of **C** and **D** are indeed different, but the two examples are also alike in that the rhythm initially established is then consistent and regular throughout the composition. This regularity is not present in Alan Crockett's painting *Doodle de Do* (**E**); however, even the title suggests a playful rhythm. Elements repeat, but in less-predictable ways and always with some variation. This painting is not an illustration for a jazz poster like the previous two, but an analogy can still be made to the dynamic but often unsettling rhythms of improvised jazz.

 B

Joris Hoefnagel (illuminator) and Georg Bocskay (scribe). *Dianthis and Almond* from *Mira Calligraphiae Monumenta (Model Book of Calligraphy)*, **folio 21r. 1561–1562. Pen and ink, watercolors on vellum and paper, 6⁹⁄₁₆" × 4¹³⁄₁₆" (16.6 × 12.3 cm). The J. Paul Getty Museum, Los Angeles.**

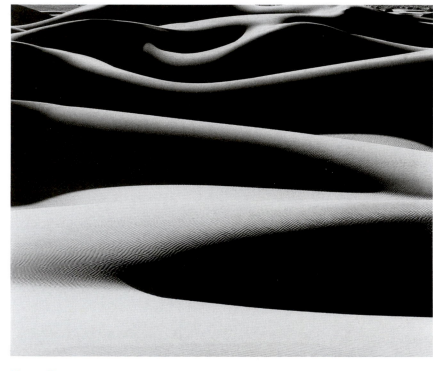

 A

Bruce Barnbaum. *Dune Ridges at Sunrise, Death Valley.* **1976. Silver gelatin print, 10¾" × 1' 1¼" (27.3 × 33.6 cm). Courtesy of the photographer.**

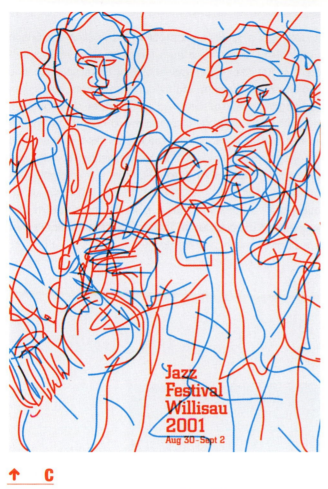

↑ C

Niklaus Troxler. *Poster: Jazz Festival Willisau.* **2001.**

↑ D

Niklaus Troxler. *Poster: Jazz Festival Willsau.* **2004.**

→ E

Alan Crockett. *Doodle de Do.* **2006. Oil on canvas, 5' × 6'.**

PATTERNS AND SEQUENCE

Rhythm is a basic characteristic of nature. The pattern of the seasons, of day and night, of the tides, and even of the movements of the planets, all exhibit a regular rhythm. This rhythm consists of successive patterns in which the same elements reappear in a regular order. In a design or painting, this would be termed an **alternating rhythm**, as motifs alternate consistently with one another to produce a regular (and anticipated) sequence. This predictable quality of the pattern is necessary, for unless the repetition is fairly obvious, the whole idea of visual rhythm becomes obscure.

The pattern in Edna Andrade's *Interchange* **(A)** produces a bouncy alternating rhythm. Our eye flips back and forth due to the **vibrating colors** and alternating direction of diagonal lines and circles. A musical term for the "bouncing bow" applied to the violin is *spiccato*. If Troxler's poster (**D** on page 117) is staccato, then Andrade's is spiccato.

We can see a familiar example of alternating rhythm in a building with columns, such as a Greek temple. The repeating pattern of light columns against darker negative spaces is clearly an alternating rhythm. Architectural critics often speak of the rhythmic placement of windows on a facade. The light and dark areas alternate consistently along the top band of the brick cornice shown in **B**. The lowest decorative band presents an alternating rhythm of X and O blocks. Alternating rhythms and rhythmic variety can relieve the large surface of predictable patterns such as a brick wall.

Notice that exactly the same description of alternating themes could be used for the painting in **C**. The artist, Robert Delaunay, titled this work, appropriately, *Rhythm without End*.

↑ **A**

Edna Andrade. *Interchange.* **1976. Acrylic on canvas, 3' 4¾" × 3' 4¾".**

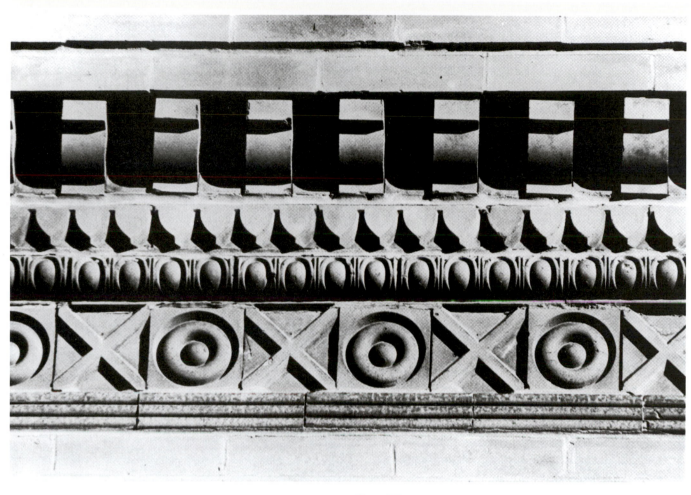

↑ **B**

Brick cornice. Published in James Stokoe, *Decorative and Ornamental*
Brickwork **(New York: Dover Publications, 1982).**

← **C**

Robert Delaunay. *"Rhythme sans fin"* *(Rhythm without End).* **1934. Gouache, brush and**
ink, on paper, 10⅝" × 8⅝" (27 × 21 cm). The Museum of Modern Art, New York
(given anonymously).

CONVERGING PATTERNS

Another type of rhythm is called progression, or **progressive rhythm**. Again, the rhythm involves repetition, but repetition of a shape that changes in a regular manner. There is a feeling of a sequential pattern. This type of rhythm is most often achieved with a progressive variation of the size of a shape, though its color, value, or texture could be the varying element. Progressive rhythm is extremely familiar to us; we experience it daily when we look at buildings from an angle. The perspective changes the horizontals and verticals into a converging pattern that creates a regular sequence of shapes gradually diminishing in size.

Inherent Rhythm

In **A** the rhythmic sequence of lines moving vertically across the format is immediately obvious. A more subtle progressive rhythm appears when we notice the dark shapes of the oil stains in the parking spaces. These change in size, becoming progressively smaller farther away from the building. In this photograph from an aerial vantage point, a rhythm is revealed in the ordinary pattern of human habits.

Progressive rhythms are rather commonplace in nature, although they may not always be readily apparent. Edward Weston's extreme close-up of an artichoke cut in half **(B)** shows a growth pattern. The gradual increase in size and weight creates a visual movement upward and outward. Other natural forms (such as chambered nautilus shells) cut in cross section would also reveal progressive rhythms.

The photographs in **A** and **B** are quite different, yet they both make visible progressive rhythms from the world around us, whether in the pattern of human activity or in natural forms. It is not surprising, then, that we should sense a growth-like pattern in the abstract sculpture by Louise Bourgeois **(C)**. This piece is more architectural than organic in its individual parts, yet the progression upward and outward from smaller to larger forms is similar to **B**.

 A

Ed Ruscha. *Goodyear Tires, 6610 Laurel Canyon, North Hollywood.* **1967. Photograph, 8¼" × 3⅞" (21 × 10 cm). From the book** *Thirty-Four Parking Lots in Los Angeles* **(1974), published by the author.**

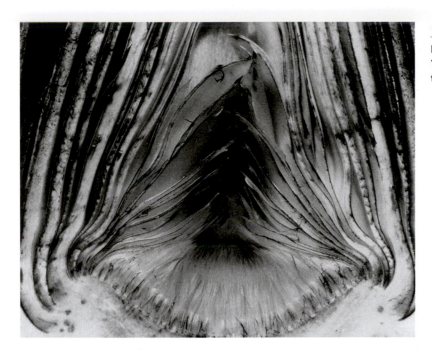

← **B**

Edward Weston. *Artichoke, Halved.* **1930. Silver gelatin print, 7½" × 9½" (19 × 24.1 cm). 1981. Center for Creative Photography, Arizona Board of Regents.**

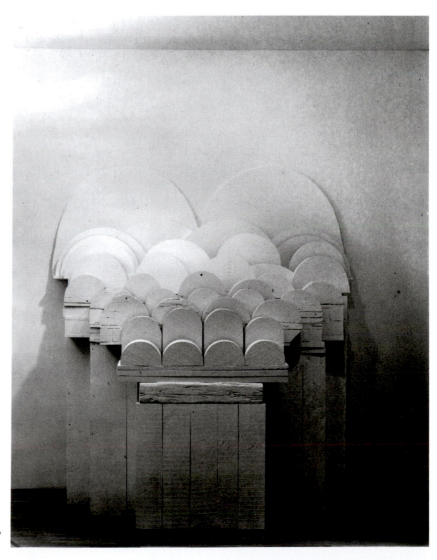

→ **C**

Louise Bourgeois. *Partial Recall.* **1979. Wood, 9' × 7' 6" × 5' 6" (274.3 × 228.5 × 167.6 cm). Private collection. Art © Louise Bourgeois/Licensed by VAGA, New York, New York/Photo © Peter Moore.**

POLYRHYTHMIC STRUCTURES

A STUDY IN CONTRAST

The most complex rhythmic structure we can ascribe to an artwork, or musical piece for that matter, is a **polyrhythmic structure**. This overlay of perhaps several rhythmic patterns produces a complex result, even if the parts are simple.

The painting by Gérôme **(A)** shows just such a juxtaposition of different rhythms. The foreground is loud and simple at the left: one strong beat (the cluster of figures), that is then repeated in a diminishing volume with the two figures on the right. The background presents a much softer, subtle rhythm: the quiet beat of the trees on the left, fading to a muffled tone on the right. This background rhythm is like supporting orchestration behind a duet of voices.

The painting by Picasso **(B)** presents a contrast between the regular motif of the harlequin pattern and a more irregular repetition of brown, black, and white in the other planes of this collage-like composition. The contrast in rhythm provides a visual contest between dueling parts . . . more like an argument than a duet.

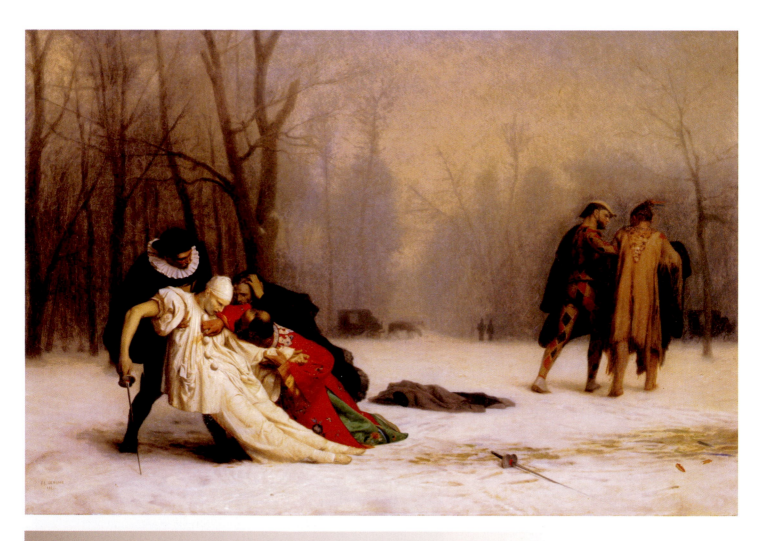

↑ **A**

Jean-Léon Gérôme. *The Duel after the Masquerade.* 1857–1859. Oil on canvas, 1' 3⅜" × 1' 10⁹⁄₁₆" (39.1 × 56.3 cm).

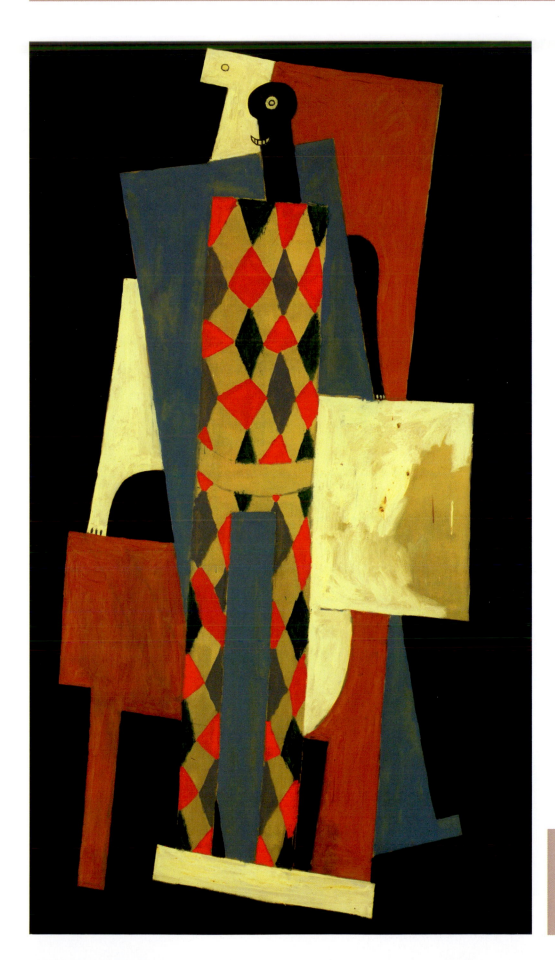

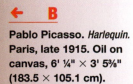

Pablo Picasso. *Harlequin.*
Paris, late 1915. Oil on
canvas, 6' ¼" × 3' 5⅜"
(183.5 × 105.1 cm).

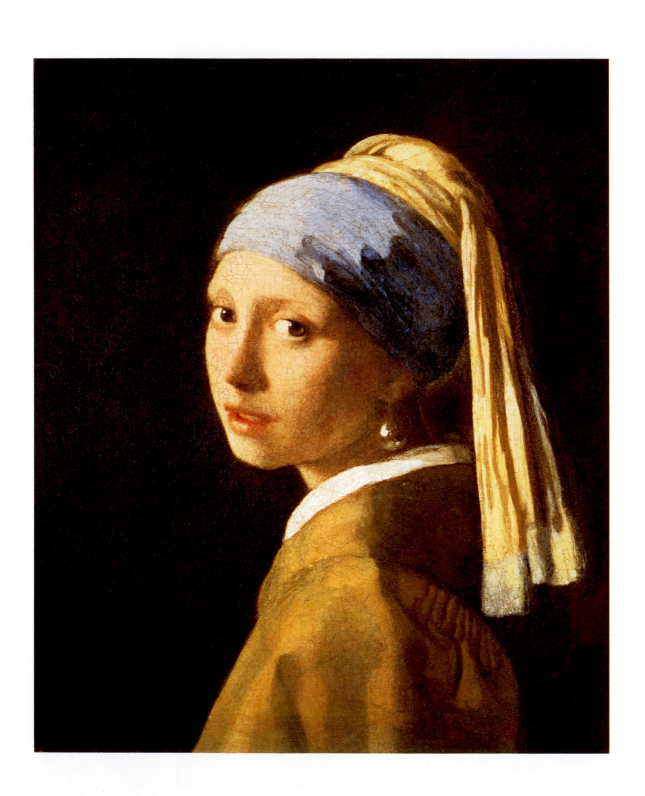

PART **2** **DESIGN ELEMENTS**

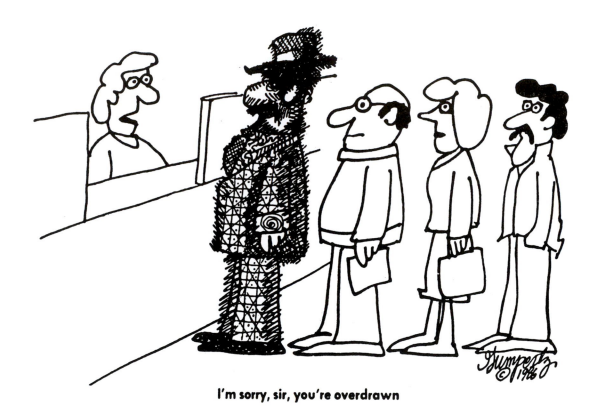

I'm sorry, sir, you're overdrawn

Robert Gumpertz. 1986.
© Robert Gumpertz, Mill Valley, California.

CHAPTER **7** LINE

A POINT SET IN MOTION

What is a **line**? If we think of a point as having no dimensions (neither height nor width), and then we set that point in motion, we create the first dimension: line. This is demonstrated vividly in a famous photograph of Pablo Picasso drawing a centaur in the air with a flashlight **(A)**.

In theory, line consists only of the dimension of its length, but, in terms of art and design, we know line can have varying width as well. The pathways in **B** are fashioned from irregular rocks, yet we instantly perceive the meandering paths as lines. In contrast to the speed expressed in **A**, Richard Long's *Five Paths* marks a slow progress across the terrain.

Of all the elements in art, line is perhaps the most familiar. Most of our writing and drawing tools are pointed, and we have been making lines constantly since we were young children. Our simplest notion of line comes from our first experiences with outlines such as those in coloring books. But line is more than mere border or boundary. Figure **C** is a line drawing describing the many items in the artist's studio and even the view out the window. The use of line is sufficiently descriptive so that we understand the whole scene. We see the brushstrokes as vivid paths in search of the edges of the forms. These lines are loose and free in the spirit of Paul Klee's idea that a line "is a point set in motion."

↑　　**A**

Artist Pablo Picasso drawing a centaur in the air with a flashlight at Madoura Pottery. Pablo Picasso. *Flashlight Centaur.* **1948.**

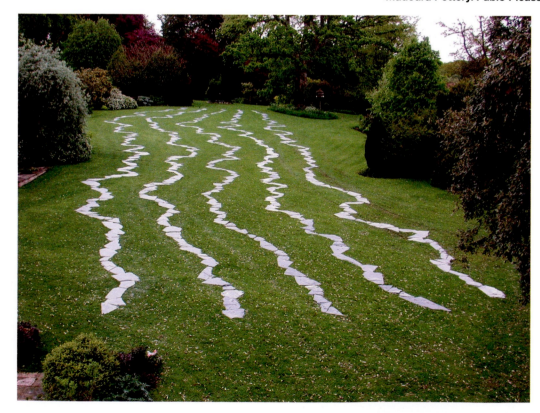

←　　**B**

Richard Long. *Five Paths.* **2002. Delabole slate, 61.1 × 17.4 m. New Art Centre Sculpture Park & Gallery, Wiltshire, UK.**

Lines Convey Mood and Feeling

A curious feature of line is its power of suggestion. What an expressive tool it can be for the artist! Think of all the adjectives we can apply to lines. We often describe lines as being nervous, angry, happy, free, quiet, excited, calm, graceful, or dancing and as having many other qualities. The pathways in **B** are jittery and nervous compared with the fluid grace of Picasso's drawing in the air **(A)**. The power of suggestion of this basic element is great, as **D** makes obvious with a delightful wit.

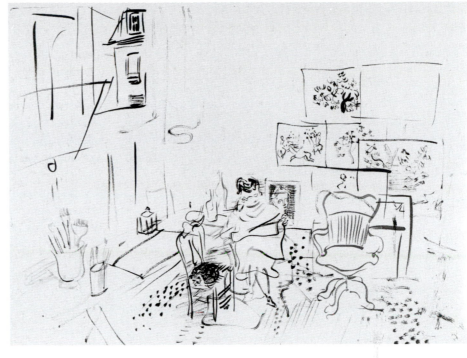

↑ **C**

Raoul Dufy. *The Artist's Studio.* **c.** 1942. Brush and ink on paper, 1' 7⅝" × 2' 2" (49.7 × 66 cm). **The Museum of Modern Art, New York (gift of Mr. and Mrs. Peter A. Rubel).**

← **D**

Saul Steinberg. *Untitled.* **c.** 1959. Ink on paper. Originally published in *The New Yorker*, **March 14, 1959. © The Saul Steinberg Foundation/ Artists Rights Society (ARS), New York.**

DEFINING SHAPE AND FORM

Artistic Shorthand

Example **A** is a line drawing—a drawing of lines that are not present in the photograph **(B)** or in the original collection of objects. In the photograph, of course, no black line runs around each object. The lines in the drawing actually show edges, whereas in **B** areas of different value (or color) meet, showing the end of one object and the beginning of another. Line is, therefore, artistic shorthand, useful because with comparatively few strokes, an artist can describe and identify shapes through outline and contour.

Cross Contour Describes Form

Contour description in **A** is obvious and defines the visible boundary of the forms and shapes. Contour line can also define a form though **cross contour**, as if following the boundaries of a slice or cross section of a three-dimensional form. This is most obvious in the familiar contour lines of a topographical map **(C)**.The white lines of the fabric billowing in the wind **(D)** similarly reveal the flowing topography of the material. The textural stretch marks on the bark of a gray birch **(E)** suggest lines that go around the limb of this tree. This photograph reveals the cross-contour lines inherent in the cylindrical forms. In these two examples, line defines form by means other than mere outline.

 A

Line, as artistic shorthand, depicts the edges of shapes.

 B

Advertisement from *New York Times* Advertising Supplement, Sunday, November 11, 1998, p. 14A. Photo: Thomas Card. Fashion direction: Donna Berg and Heidi Godoff for Twist Productions. Prop styling: Caroline Morrison. Advertorial produced by Comer & Company.

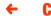

Grand Teton Quadrangle map (detail). U.S. Geological Survey.

Jack Lenor Larsen. *Seascape.* 1977. *Nest Magazine*, Winter 2002–2003.
Special Section: Jack Lenor Larsen.

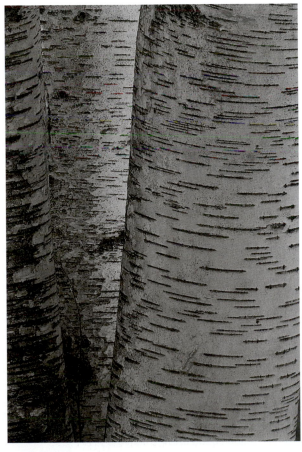

Lines in the bark reveal the cross contours of the tree.

ACTUAL, IMPLIED, AND PSYCHIC LINES

Line has served artists as a basic tool ever since cave dwellers drew with charred sticks on the cave walls. In addition to this language of descriptive contour drawing, two other types of line also figure importantly in pictorial composition.

An **implied line** is created by positioning a series of points so that the eye tends automatically to connect them. "Follow the dotted line" is an example familiar to us all. Our eye connects the dots to follow the graceful line of a suspension bridge in **A**.

 A

kptyson. *George Washington Bridge.*

→ B

Germany's goalkeeper Rene Adler points toward England's Jermain Defoe during the Germany versus England international friendly football match at the Olympic stadium in Berlin on November 19, 2008. England won 1–2. AFP Photo/John MacDougall.

A **psychic line** is illustrated in **B**. There is no real line, not even intermittent points, yet we feel a line, a mental connection between the two players. Our eyes invariably follow the direction a figure is pointing, and a psychic line results.

Interpreting Lines

All three types of line are present in Georges de La Tour's *Fortune Teller* (**C**). Actual lines clearly delineate the edges of figures and garments. An implied line is created between the victim's hand on his hip and the fortune-teller's left hand. Along this line we spy (in the shadows) hands at work relieving the victim of his valuables (**D**). A second such line is created by the continuation of the pickpocket's arm on the left through the bottom of the victim's jacket and along to the fortune-teller on the right. Psychic lines occur as our eyes follow the direction in which each figure is looking.

Artists have the potential to lead a viewer's eye movement, and the various types of lines can be a valuable tool to that end.

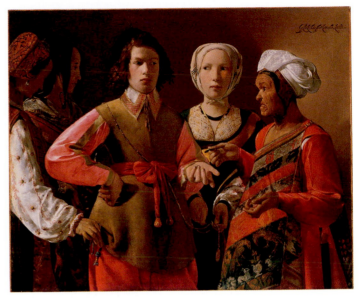

↑ **C**

Georges de La Tour. *The Fortune Teller.* **Probably 1630s. Oil on canvas, 3' 4⅛" × 4' ⅝" (102 × 123.5 cm). The Metropolitan Museum of Art, Rogers Fund, 1960.**

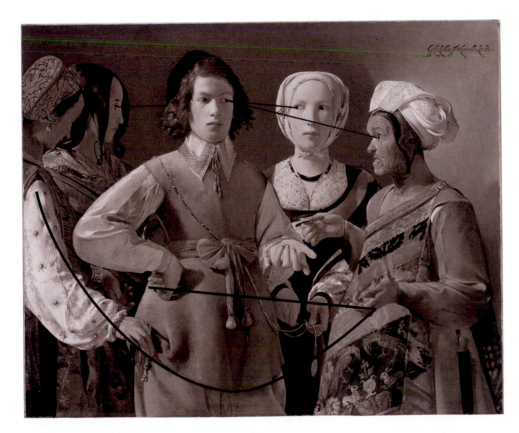

← **D**

Actual, implied, and psychic lines organize the composition.

HORIZONTAL, VERTICAL, AND DIAGONAL LINES

One important characteristic of line that should be remembered is its direction. A horizontal line implies quiet and repose, probably because we associate a horizontal body posture with rest or sleep. A vertical line, such as a standing body, has more potential of activity. But the diagonal line most strongly suggests motion. In so many of the active movements of life (skiing, running, swimming, skating) the body is leaning, so we automatically see diagonals as indicating movement. Whereas **A** is a static, calm pattern, **B** is changing and exciting.

↑ **A**

Horizontal lines usually imply rest or lack of motion.

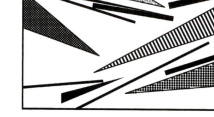

↑ **B**

Diagonal lines usually imply movement and action.

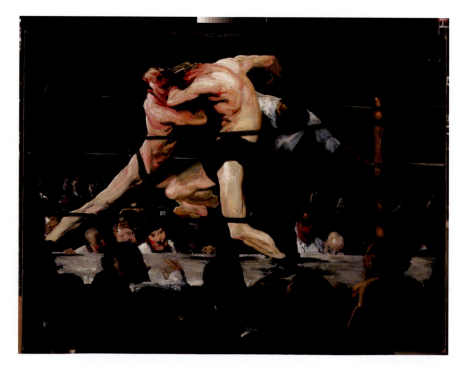

→ **C**

George Bellows. *Stag at Sharkey's.* **1909. Oil on canvas, 110 × 140.5 × 8.5 cm. © The Cleveland Museum of Art (Hinman B. Hurlbut Collection).**

Reinforcing the Format

One other factor is involved in the quality of line direction. The outside format of the vast majority of drawings, designs, paintings, and so forth is rectangular. Therefore, any horizontal or vertical line within the work is parallel to, and repetitive of, an edge of the format. The horizontal and vertical lines within a design are stabilizing elements that reduce any feeling of movement. The lines in **A** are parallel to the top and bottom, but none of the lines in **B** is parallel to any of the edges.

Analyzing Lines in Paintings

George Bellows's painting **(C)** is dominated by a diagonal line that begins with the one fighter's leg on the left and continues through the second fighter's shoulder and arm. Other diagonals within the figures create the dynamism of the fight scene. The diagonal gesture of the referee balances the group of three figures and completes a triangle. The verticals and horizontals of the fight ring stabilize the composition and provide a counterpoint to the action depicted.

John Moore's *Evangeliste* **(D)** has a subtle but strong underlying structure of verticals and horizontals that lend a calm serenity to the scene. The window frame provides the anchor to this pattern, but the table and building seen outside the window repeat vertical and horizontal lines. The more chaotic line directions on the tabletop and other curved and diagonal lines provide a lyric variety within the dominant order of vertical and horizontal.

The painting shown in **D** does not suggest the kind of dynamic movement of the Bellows work **(C)**, but it does show that a composition based on verticals and horizontals does not have to be boring!

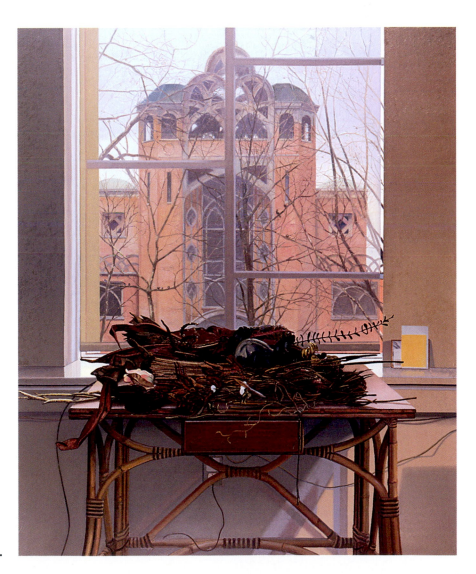

➜ D

John Moore. *Evangeliste.* **2001. Oil on canvas, 5' × 4' 2". Hirschl & Adler Modern, New York.**

PRECISION OR SPONTANEITY

Regardless of the chosen medium, when line is the main element of an image, the result is called a drawing. There are two general types of drawings: **contour** and **gesture**.

Contour Drawing

When line is used to follow the edges of forms, to describe their outlines, the result is called a contour drawing. This is probably the most common use of line in art; **A** is an example: simple, economical, and elegant. Ingres's drawing **(B)** is also a contour drawing; however, in this case a variety of line weight tells us more about the subject. This portrait by Ingres is a precise drawing with extremely delicate lines carefully describing the features and the folds of the clothing. The slightly darker emphasis of the head establishes the focal point. We cannot help admiring the sureness of the drawing, the absolute accuracy of observation.

↑　A

Ellsworth Kelly. *Fig Branch (Figue)*. **1965–1966. Lithograph on Rives BFK paper, 87.6 × 61 cm. Edition of 75.**

↑　B

Jean-Auguste-Dominique Ingres. *Portrait of Mme. Hayard and Her Daughter Caroline*. **1815. Graphite on white wove paper, 11½" × 8¹¹⁄₁₆" (29.2 × 22 cm). University of Harvard Art Museums, Fogg Art Museum (bequest of Grenville L. Winthrop) (1943.843).**

↑　C

Alberto Giacometti. *Self-Portrait*. **1954. Pencil, 1' 4" × 1' (40.5 × 31 cm).**

The self-portrait by Giacometti **(C)** is not composed of the precise contours we find in **A** or **C**. Instead, we see many lines that, taken together, suggest the mass and volume of the head. The result is more active, and we can more readily observe the artist's process of looking and recording. Many of Giacometti's lines follow the topography of the head and find surface contours within the form of the head, not merely at the outer edge.

Gesture Drawings

The other common type of drawing is called a gesture drawing. In this instance, describing shapes is less important than showing the action or the dynamics of a pose. Line does not stay at the edges but moves freely within forms. Gesture drawings are not drawings of objects so much as drawings of movement, weight, and posture. Because of its very nature, this type of drawing is almost always created quickly and spontaneously. It captures the momentary changing aspect of the subject rather than recording nuances of form. Rembrandt's *Christ Carrying the Cross* **(D)** is a gesture drawing. Some quickly drawn lines suggest the contours, but most of the lines are concerned with the action of the falling, moving figures.

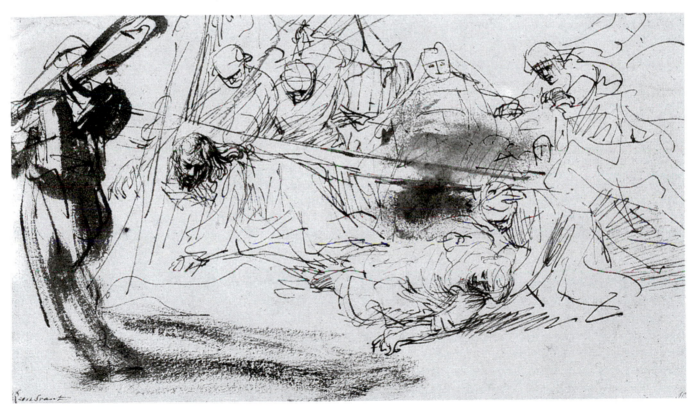

 D

Rembrandt. *Christ Carrying the Cross.* c. 1635. Pen and ink with wash, 5⅝" × 10⅛" (14 × 26 cm). Kupferstichkabinett, Staatliche Museen, Berlin.

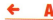

Deborah Butterfield. *Tango.* **1987. Steel, 2' 4½" × 3' 6½" × 1' 3" (72 × 107 × 38 cm). Art © Deborah Butterfield/Licensed by VAGA, New York, New York. Courtesy, Edward Thorp Gallery, New York.**

CREATING VARIETY AND EMPHASIS

To state that an artist uses line is not very descriptive of the art-ist's work because line is capable of infinite variety. To imagine the qualities that a line may have, just think of an adjective you can place before the word *line*, such as *thin*, *thick*, *rough*, or *smooth*. The illustrations on these two pages give only a sam-pling of the linear possibilities available to the artist or designer.

Volume

Deborah Butterfield's *Tango* **(A)** is a sculpture that conveys a sense of drawing in three dimensions. The found objects and steel scraps suggest the presence of a horse with almost scribble-like lines. These lines largely define the horse from the inside of the form and the gesture of the pose. Butterfield's work has a spontaneous appearance we would more likely associate with brush and ink than welded steel. When seen in a photograph such as **A**, the welded pieces work like a line drawing to convey the volume of the form.

Expressing Mood and Motion

The untitled drawing by Susan Rothenberg shown in **B** also depicts a horse, but here the similarity to **A** ends. Rothenberg's drawing is characterized by heavy, blunt contours echoed by thinner, coarse lines. The brutal line quality that describes dis-membered horse shapes creates a markedly different expres-sion than we might find in a graceful illustration of a racehorse.

↓ B

Susan Rothenberg. *Untitled.* **1978. Acrylic, flashe, pencil on paper, 1' 8" × 1' 8" (51 × 51 cm). Collection of Walker Art Center, Minne-apolis (Art Center Acquisition Fund, 1979).**

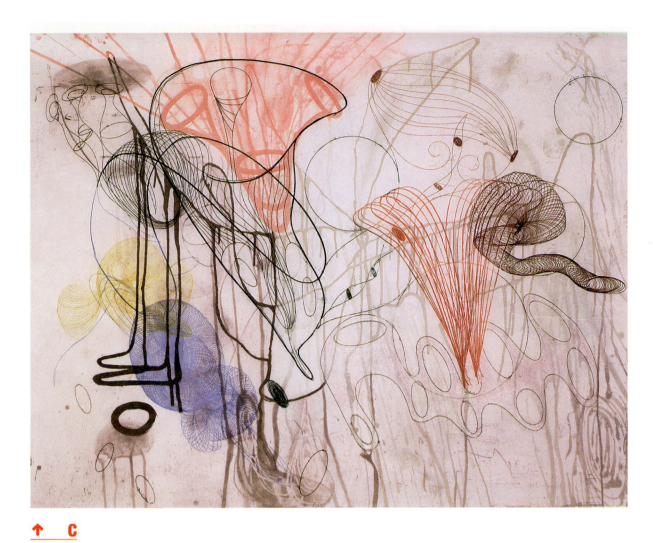

↑ **C**

Judy Pfaff. *Che Cosa è Acqua* **from** *Half a Dozen of the Other.* **1992. Color drypoint with spit bite and sugar lift aquatints, and soft ground etching, 3' × 3' 9" on 3' 6⅞" × 4' 2¾" sheet. Edition of 20. Printed by Lawrence Hamlin.**

The print by Judy Pfaff **(C)** takes advantage of a variety in line quality from bold to light, from elegant to awkward. Some thin lines perform figures like an ice skater, while the heavier lines sag like the drips of spilled paint. This print does not use line as **calligraphy**, nor is it representational. In this case, line exists for its own expressive qualities.

The lines in **D** quiver and reverberate, suggesting movement. Notice how difference in line weight suggests motion.

The linear technique you choose can produce emotional or expressive qualities in the final pattern. Solid and bold, quiet and flowing, delicate and dainty, jagged and nervous, or countless other possibilities influence the effect on the viewer of your drawing or design.

→ **D**

Honoré Daumier. *Frightened Woman.* **1828–1879. Charcoal with black crayon, on ivory laid paper, 8" × 9½" (21 × 23.9 cm). The Art Institute of Chicago (gift of Robert Allerton).**

↑ **A**

USING LINES TO CREATE DARK AND LIGHT

A single line can show the shape of objects. But an outlined shape is essentially flat; it does not suggest the volume of the original subject. The artist can, by placing a series of lines close together, create visual areas of gray. By varying the number of lines and their proximity, the artist can produce an almost limitless number of grays. These resulting areas of dark and light (called areas of value) can begin to give the three-dimensional quality lacking in a pure contour line. Again, the specific linear technique and the quality of line can vary a great deal among different artists.

Cross-Hatching

Traditionally, editorial cartoonists have had to make the most of the limitations imposed by black ink on newsprint. This constraint challenged the artists to be inventive in all aspects of their design. Hatching and cross-hatching are techniques often employed by these artists to suggest a broad gamut of **values**.

Pat Oliphant's cartoon in **A** shows a light-to-dark gradation on the right side of the composition created by a series of parallel ("hatching") lines that increase in density. To the left, Uncle Sam casts a shadow made up of intersecting patterns of pen strokes—or cross-hatching.

The same cross-hatching technique is clear in **B**. But in this etching, the artist, Rembrandt, has used the lines in a looser manner. The various densities of line suggest the values and textures of sky and landscape.

Applying Line as Value to Textiles

These techniques are by no means limited to drawings and prints. The woven fabric in **C** uses fibers as lines to create different values out of differing densities of the dark threads. Our eye reads the weave of darks and lights to create optical mixtures of various values.

See also *Value: Techniques*, page 252.

↑ **B**

Rembrandt. *The Three Trees.* 1643. Etching with drypoint and burin, only state. Courtesy of Wetmore Print Collection of Connecticut College.

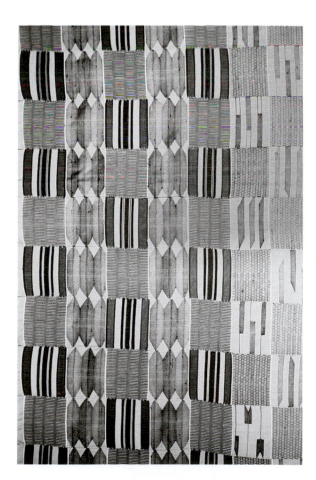

→ **C**

West African Kente cloth. No date. Cotton, 6' 10¼" × 11' ½" (23 × 3.5 m). Anacostia Community Museum, Smithsonian Institution, Washington, DC.

OUTLINE OF FORMS

Line can be an important element in painting. Because painting basically deals with areas of color, its effect is different from that of drawing, which limits the elements involved. Line becomes important to painting when the artist purposely chooses to outline forms, as Alice Neel does in her portrait **(A)**. Dark lines define the edges of the figure and the sofa. The lines are bold and quite obvious.

Line can be seen in the detail of Venus from Botticelli's famous painting **(B)**. The goddess's hair is a beautiful pattern of flowing, graceful, swirling lines. The hand is delineated from the breast by only the slightest value difference; a dark, now quite delicate line clearly outlines the hand.

Adapting Technique to Theme

Compare the use of line in Botticelli's painting with that in **C**. Both works stress the use of line, but the similarity ends there. *Crying Girl*, by Roy Lichtenstein **(C)**, employs the extremely heavy, bold line—almost a crude line typical of the drawing in comic books. Each artist has adapted his technique to his theme. Compare the treatment of the hair. Venus **(B)** is portrayed as the embodiment of all grace and beauty, her hair a mass of elegant lines in a delicate arabesque pattern. The *Crying Girl's* hair **(C)**, by contrast, is a flat, colored area boldly outlined, with a few slashing heavy strokes to define its texture.

Dark Line Technique

The use of a black or dark line in a design is often belittled as a crutch. There is no doubt that a dark linear structure can often lend desirable emphasis when the initial color or value pattern seems to provide little excitement. Many artists, both past and present, have purposely chosen to exploit the impact of dark lines to enhance their work. The heavy lines support the theme of construction in *The Builders* **(D)**. Both **C** and **D** balance the dark lines with an equally bold red, yellow, and blue color structure.

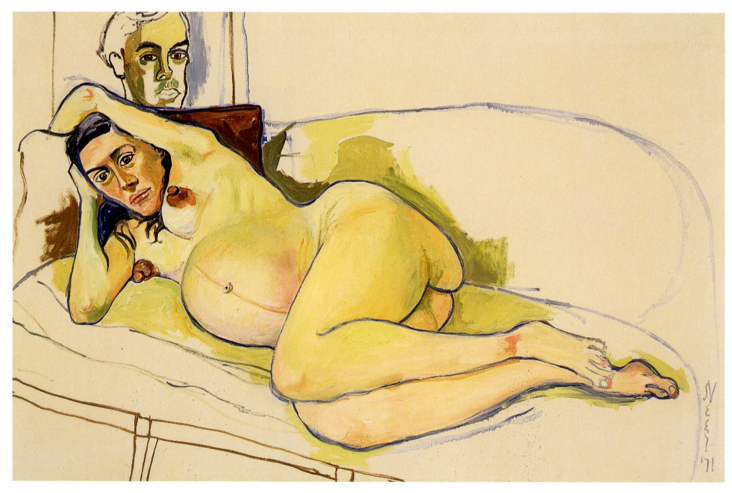

↑ **A**

Alice Neel. *The Pregnant Woman.* 1971. Oil on canvas, 3' 4" × 5'. © The Estate of Alice Neel.

 B

Sandro Botticelli. *The Birth of Venus.* (Detail), c. 1480. Oil on canvas; entire work: 5' 8⅞" × 9' 1⅞" (1.75 × 2.79 m). Galleria degli Uffizi, Florence.

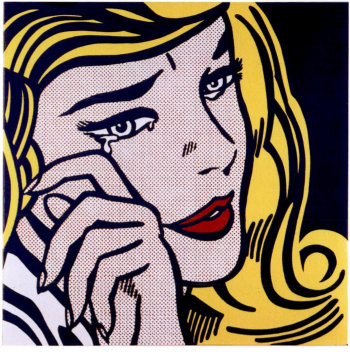

↑ **C**

Roy Lichtenstein. *Crying Girl.* 1964. Enamel on steel, 3' 10" square. © Roy Lichtenstein.

 D

Fernand Leger. *The Builders.* 1950. Oil on canvas, 9' 10" × 6' 7" (3 × 2 m). Musée National Fernand Leger, Biot, France.

 A

Ronald Davis. *Arch Duo and Vented Star.* **1976. Painting: acrylic on canvas, 9' 6" in. × 14' 6¾" (289.56 cm × 443.87 cm). Acquired 1977. Collection SFMOMA. Purchased with the aid of funds from the National Endowment for the Arts and the New Future Fund Drive, © Ronald Davis.**

EXPLICIT LINE

Explicit line is obvious in an image such as the acrylic painting by Ron Davis shown in **A**. This painting is as much drawing in color as it is painting. The perspective lines are explicit and left to tell the story of how the colored planes were generated.

Defining Shape and Form

Line becomes important in a painting when the contours of the forms are sharply defined and the viewer's eye is drawn to the edges of the various shapes. The painting by Francesco Salviati **(B)** contains no actual outlines as we can see in **A**. However, the contour edges of the figures, clothing, and landscape not only define those elements but are also critical to moving the eye through the painting. The detail shown in **C** illustrates how these serpentine lines flow from figure to background.

Karin Davie's painting **(D)** is also composed of serpentine lines that create a complex pattern. In this case they are brushstrokes that act as independent elements devoid of any representational function. The varying color of the lines creates different spatial levels and shifting areas of interest or emphasis. Although these "lines" are wide brushstrokes, they still convey Paul Klee's idea of a "point set in motion."

↑ **B**

Francesco Salviati. *Virgin and Child with an Angel.* **(1535–1539). Oil on wood,112.3 × 83 cm. National Gallery of Canada.**

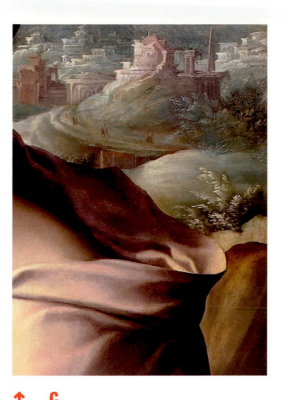

↑ **C**

Francesco Salviati. *Virgin and Child with an Angel.* **(1535–1539). Detail. Oil on wood.112.3 × 83 cm. National Gallery of Canada.**

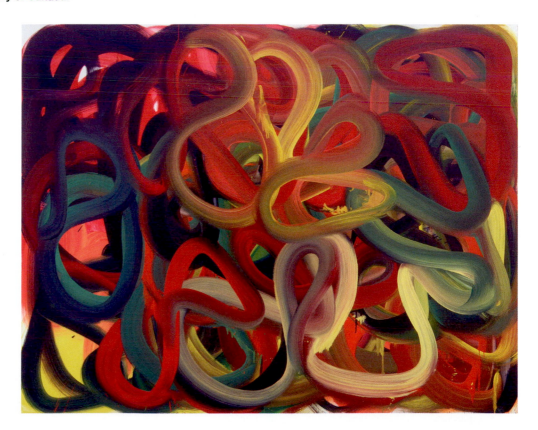

→ **D**

Karin Davie. *Between My Eye and Heart No. 12.* **2005. Oil on canvas, 5' 6" × 7'. Margulies Warehouse Collection, Miami, Florida.**

SUGGESTIONS OF FORM

Salome with the Head of John the Baptist **(A)** is a painting by Caravaggio that puts more emphasis on color and value than on line. In each of the figures, only part of the body is revealed by a sharp contour, but the edge then disappears into a mysterious darkness. This is termed **lost-and-found contour**: now you see it, now you don't. The artist gives us a few clues, and we fill in the rest. For example, when we see a sharply defined profile, we will automatically assume the rest of the head is there, although we do not see it. A line interpretation **(B)** of this painting proves that we do not get a complete scene but merely suggestions of form. Bits and pieces float, and it is more difficult to understand the image presented.

Relative Clarity

A strong linear contour structure in a painting provides clarity. Lost-and-found contour gives only relative clarity but is in fact closer to our natural perception of things. Seldom do we see everything before us in equal and vivid contrast. The relief shown in **C** presents a rhythmic linear composition created by only those edges cast in shadow. In this case of a white-on-white relief, it is the illuminated edges that disappear. We can get a better idea of the "lost" contours from the study drawing shown in **D**.

Selected Lighting

Photographers often choose the lighting for a subject to exploit the emotional and expressive effects of lost-and-found contour. Illustration **E** is just one of the countless photographs that have used the technique. Here a very beautiful and dramatic image has been produced from a simple architectural detail.

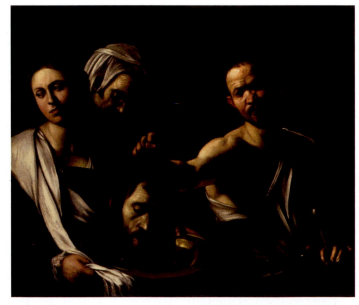

Caravaggio. *Salome with the Head of John the Baptist.* c. 1609. Oil on canvas, 116 × 140 cm. National Gallery, London, Great Britain.

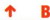

Only some contours are visible in the painting.

 C

Sophie Taeuber-Arp. *Parasols.* 1938. Painted wood relief, 2' 10" × 2' (86 × 61 cm). Rijksmuseum Kroller-Muller, Otterlo.

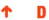 **D**

Sophie Taeuber-Arp. *Untitled (Study for Parasols).* 1937. Black crayon, 1' 1½" × 10" (34 × 25 cm). Foundation Jean Arp and Sophie Taeuber-Arp, Rolandseck, Germany.

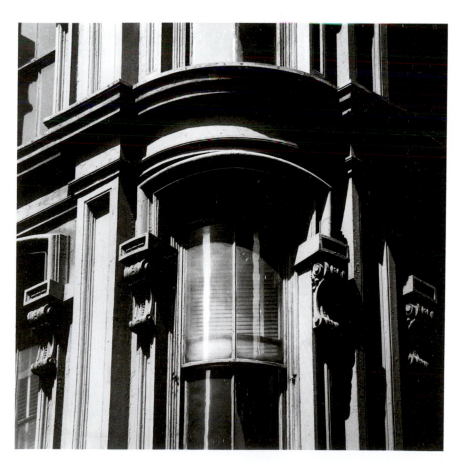

E

Mark Feldstein. *Untitled.* Photograph.

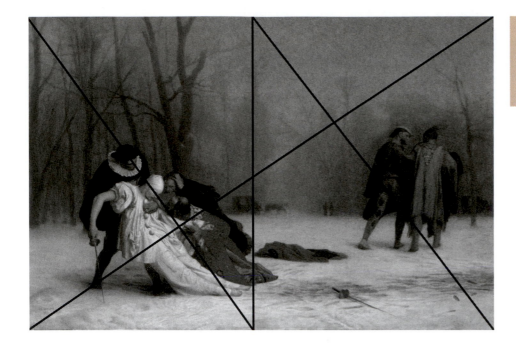

Jean-Léon Gérôme. *The Duel after the Masquerade.* 1857–1859. Oil on canvas, 1' 3⅜" × 1' 10⁹⁄₁₆" (39.1 × 56.3 cm).

STRUCTURE OF THE RECTANGLE

Any rectangular composition has inherent in its format a whole series of lines tied to the geometry of that shape. Take any rectangular piece of paper; fold it in half, then fold it in half again. Now fold from corner to corner, and again from the opposite corners. A whole web of lines will appear, dividing quadrants and tracing diagonals. The intersections of these lines suggest further possible folds and lines. Whether explicitly drawn or implicitly left unmarked, these lines form an underlying structure that can create a foundation for a visual composition.

Returning to our familiar examples, we can see that such a substructure of inherent compositional lines can exist in both figurative and nonfigurative artworks. The vertical midline divides the Gérôme painting **(A)** in such a way that the diagonals of each half intersect the main diagonal as perpendicular lines. The diagonals of these two halves reinforce the story that is depicted, and this is most prominent along the diagonal of the dying Pierrot.

Picasso's *Harlequin* **(B)** is balanced around the various diagonals that intersect the center of the painting creating a radial balance.

Pablo Picasso. *Harlequin.* **Paris, late 1915. Oil on canvas, 6' ¼" × 3' 5⅜"** (183.5 × 105.1 cm).

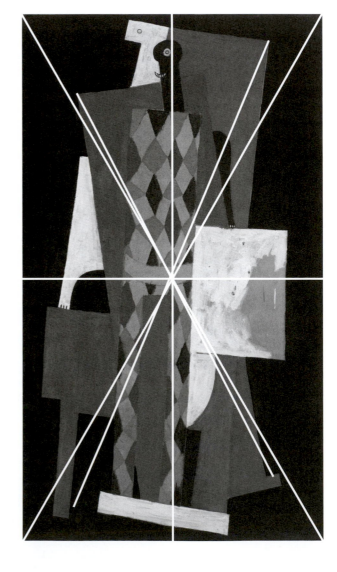

Some artists will consciously employ an awareness of geometry. Sol Lewitt's site-specific drawing **(C)** is nothing more than that—a revelation of the complex web of lines that exist between all of the points in the architectural features of a wall.

Others prefer a more intuitive, less conscious approach. In either case we will often find that a riveting composition owes much to the arrangement of elements within the web of inherent lines.

See also *Proportion: Root Rectangles*, page 84.

↑ **C**

Sol Lewitt. *Wall Drawing 51.* **All architectural points connected by straight lines (detail view). June 1970. Blue snap lines. LeWitt Collection, Chester, Connecticut.**

"Nancy!"

CHAPTER **8** SHAPE

A **shape** is a visually perceived area created either by an enclosing line or by color or value changes defining the outer edge. A shape can also be called a **form**. The two terms are generally synonymous and are often used interchangeably. *Shape* is a more precise term because *form* has other meanings in art. For example, *form* may be used in a broad sense to describe the total visual organization of a work, including color, texture, and composition. Thus, to avoid confusion, the term *shape* is more specific.

SHAPING PERCEPTION

Our visual perception is dependent on our ability to recognize borders and boundaries that separate **figure** from **ground**. The shapes we see are either

> a figure: an object or foreground element, or
> the ground: the space or volume between figures or forms.

A watercolor by Ellsworth Kelly **(A)** shows an arrangement of apples. The oval shape is emphasized by one isolated apple, and the constellation of eight apples forms a triangle. Often we can find, even in more complicated subjects, the simple shapes of circle, square, and triangle underlying a composition.

A second artwork by Ellsworth Kelly shows that his eye for shape is not drawn only to the object or "figure," but also to the ground. The black relief shown in **B** seems to have been found in the spaces or "ground" in **A**. The slender shape of **B** offers an unexpected "figure" and in fact bears the title *Black Venus*.

A general rule of perception states that (all other things being equal) our eye tends to read *convex* shapes as figure and *concave* shapes as ground. This is affirmed in **A** by the plump convex shapes of the fruit. The shape featured in **B** surprises us by contradicting our expectations: in this case the shape, or figure, is largely concave.

→ **A**

Ellsworth Kelly. *Apples.* **1949. Watercolor and pencil on paper, 2' ¾" × 1' 7⅜" (62.9 × 49.2 cm). Collection of the artist. © Ellsworth Kelly from the exhibition Cezanne and Beyond, 2009.**

The jacket and skirt design seen in **C** is eye catching and reminiscent of Kelly's relief. It also contradicts our expectation of convex shapes defining a figure. The human figure, even a slender person, is defined by the convex forms of muscle and bone. In the case of **C**, however, most of the edges of the suit are seen as concave black shapes against a lighter background. Both **B** and **C** emphasize the figure by contrast of a black shape against a white ground. This is true of the typography of this page as the shapes of the letters are easily read against the white page.

In each of these examples, shape is the defining element. Other elements are simple: a contrast of black and white or a limited color scheme. With few other distractions we can experience our perception of shape at a very elemental level. In the following sections of this chapter, we will see more complex aspects of shape and figure/ground contrasts, also defined as shape and negative shape.

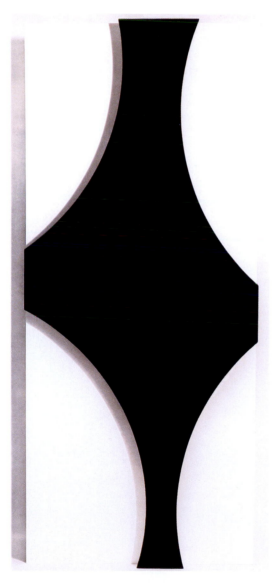

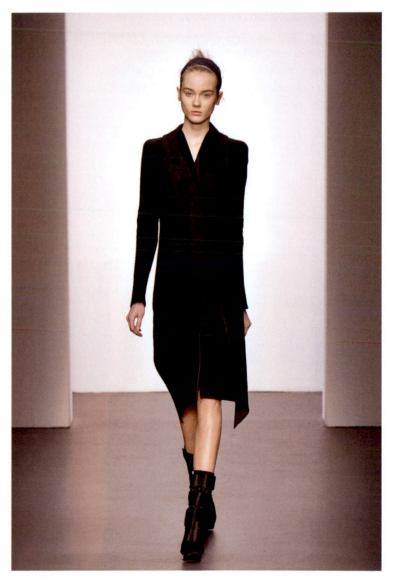

 B

Ellsworth Kelly. *Black Venus.* **1959. Painted aluminum, 7' 1" × 3' × 2⅝" (1" off wall) (215.9 × 91.4 × 6.7 cm). Private collection.**

 C

Francisco Costa for Calvin Klein.

Two-dimensional design, or composition, is basically the arrangement of shapes. Scott Noel's painting *Orpheus and Eurydice* **(A)**, with its depiction of objects, a mirror, and a painting within a painting, presents the viewer with a near-overwhelming complexity. Despite this complication, the composition can ultimately be seen as a jigsaw-puzzle-like array of many shapes—some simple and geometric, others more complicated. By contrast Mark Rothko's *Four Darks in Red* **(B)** has the dramatic impact of a large field of color, but it is first of all a canvas, rectangular in shape. The soft-edged color bars that emerge in this red field are also rectangles.

In representational pictures, only the most diffuse atmospheric images of light can be said to almost dispense with shape. The image in **C** is based on one of Claude Monet's impressions of the Rouen Cathedral that emphasizes light and atmosphere over shape. The artist Roy Lichtenstein further exaggerates these qualities in **C**. The shape of the cathedral barely flickers into focus, and the hundreds of dots compete with the shapes of the architectural elements for our attention. If you look closely, you can see that the dots in **C** are small circles, so this image is, after all, composed of shapes.

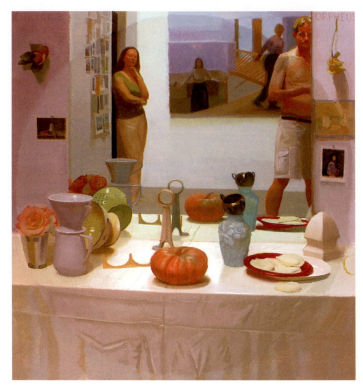

 A

Scott Noel. *Orpheus and Eurydice.* **Oil on linen, 4' 6" × 4' 2".**

→ **B**

Mark Rothko. *Four Darks in Red.* **1958. 8' 6" × 9' 8".**
Whitney Museum of American Art.

The still life painted by the contemporary painter Sydney Licht (**D**) is also composed of round shapes, but in various sizes and combinations. Of course, the color, texture, and value of these shapes are important, but the basic element is shape. The pattern on the tablecloth serves as a simple and more abstract echo of the shapes and negative shapes found in the asparagus bundles. The overall effect may be quite different, but at the level of shape, the two artworks shown in **C** and **D** have a common element.

← **C**

Roy Lichtenstein. *Cathedral #2 from the Cathedral Series.* 1969. Color lithograph and screen print in red and blue, 4' ⁵⁄₁₆" × 2' 8⅜" (123 × 82.5 cm). Fine Arts Museums of San Francisco, Anderson Graphic Arts Collection (gift of Harry W. and Margaret Anderson Charitable Foundation, 1996.74.239).

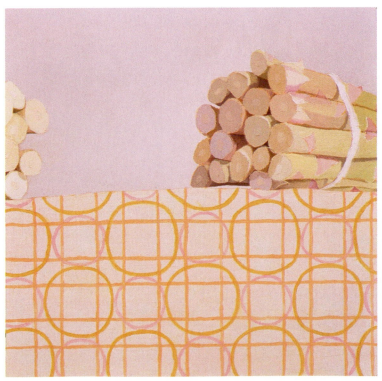

→ **D**

Sydney Licht. *Still Life with Two Bunches.* Oil on linen, 1' × 1'. Lyons Wier Gallery, New York.

WORKING IN TWO AND THREE DIMENSIONS

Shape usually is considered a two-dimensional element, and the words *volume* and *mass* are applied to the three-dimensional equivalent. In simplest terms, paintings have shapes and sculptures have masses. The same terms and distinctions applied to shapes apply to three-dimensional volumes or masses. Although the two concepts are closely related, the design considerations of the artist can differ considerably when working in two- or three-dimensional media.

Angle of Perception

A flat work, such as a painting, is essentially designed for viewing from a single point of view, but three-dimensional works change each time we move: the forms are constantly seen in different relationships. *Fifteen Pairs of Hands* by Bruce Nauman **(A)** demonstrates that a three-dimensional form such as the human figure offers countless variety of shapes that change with position and point of view.

A painting by Robert Moskowitz **(B)** contrasts the sculptural experience of form and volume with the painter's concern with shape. In Moskowitz's painting, Rodin's *Thinker* is seen as a silhouette. This shape is a recognizable image of the famous sculpture, but only one of the many possible silhouette shapes that could be seen.

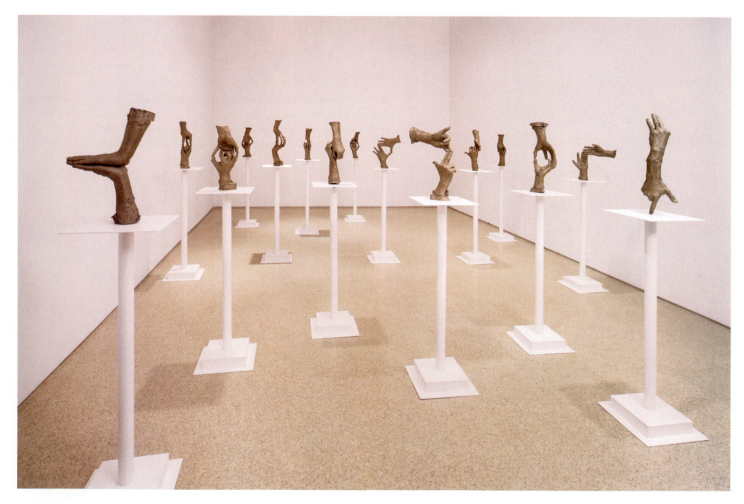

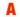 **A**

Bruce Nauman. *Fifteen Pairs of Hands.* **1996. White bronze with painted steel base, 15 parts, each approximately 4' 4" × 1' × 1'.**

Combining Two- and Three-Dimensional Work

Many artists today attempt to break down the dividing barriers between painting, drawing, sculpture, and architecture. Julian Opie's *Shahnoza* **(C)** accomplishes just this and goes further in breaking down distinctions between "highbrow" and "lowbrow." The vinyl line drawings of a "pole dancer" were placed to interact in a witty dialogue with an installation of Henry Moore's abstracted figures. The Opie drawings are also quite abstract: note the circles for heads. The position of the drawings aligns the poles with the architectural grid of the ceiling, humorously suggesting that, like ancient **caryatids**, they are holding up the building. Opie accomplishes all this with drawings that emphasize flat shapes, not three-dimensional volumes.

↑　**B**

Robert Moskowitz. *Thinker.* **1982. Pastel on paper, 9' × 5' 3". Collection of Joslyn Art Museum, Omaha, Nebraska.**

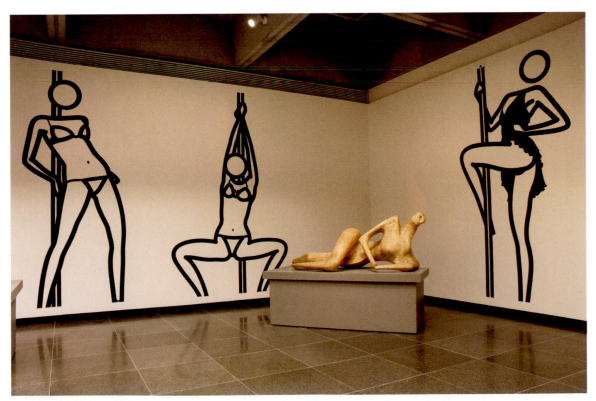

←　**C**

Installation: Henry Moore and Julian Opie.

EXAGGERATED SHAPES

Naturalism is self-evident. A portrait painting from the nineteenth century will convince us that it is a likeness even though we have never seen the subject or a photograph of the subject. Reasonable proportion of shapes and attention to the shapes of features such as the eyes and the mouth will create a sense of credibility, and we believe the image.

Distortion, or exaggerated shapes, are familiar to us through caricatures and even the playful effects possible on your laptop's camera. Shapes are stretched and altered in proportion. The deft caricaturist does this and maintains a strong resemblance to the natural subject. The funhouse mirror effect on your computer distorts or exaggerates beyond recognition.

The caricature of President Bill Clinton provides a study of exaggerated shapes that still offers a resemblance to a natural image. The natural proportions have been altered in a way that exaggerates features we easily recognize including a general puffiness and pursed lips. The body is very small to emphasize the face. It would be possible to place a grid over a photograph of Bill Clinton and distort the grid (narrower or wider spaces) to alter the shapes and see how far that can stretch or compress and still be recognizable.

The caricatures in **B** are also recognizable as John Travolta and Samuel L. Jackson from *Pulp Fiction*. Here the distortion and exaggeration is translated to the simplest possible nearly geometric shapes. This vocabulary of shapes allows the artist, Noma Bar, to use the shapes of guns as stand-ins for features such as eye and eyebrow, nose, mouth, and moustache. An attentive eye for shape allows these distortions and manipulations.

↑ **A**

Bill Clinton #3. **The Kerry Waghorn Studios.**

Distortion and Expression

We can see in **A** and **B** that distortion and exaggeration are employed for expressive effect relative to the character of the subject. As in literature, exaggeration may have dramatic or humorous effect, or come across as overstatement and hyperbole. A visual example of hyperbole might be the illustrations of puppies with oversized eyes. Such cheap manipulation is the hallmark of **kitch**.

The illustration for a Nike advertisement **(C)** employs exaggeration for expressive effect. The form of the human body is distorted through elongation. The result is an image that communicates visually the stretching, leaping, and reaching that are the nature of a basketball game. The distortion puts an emphasis on the action over a naturalistic view of the body. Picasso once said that "art is a lie that reveals the truth," and that can be seen in the manipulated shapes of these examples.

See also *Chapter 4: Scale and Proportion*.

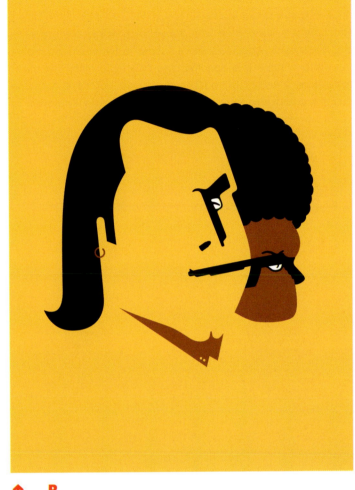

↑　**B**

Noma Bar. *Pulp Fiction.* **Three-color screenprint, 59.4 cm height ×
42 cm width. Limited edition of 10. Printed in Jerusalem.**

←　**C**

**Advertisement for Nike Sportswear. 1995. NYC Campaign. Art Director:
John C. Jay. Designer: Pao. Illustrator: Javier Michaelski. Creative Directors: Dan Wieden, Susan Hoffman. Source:** *Print,* **March/April 1996, p. 87.**

NATURE AND ASPIRING TO PERFECTION

Naturalism is concerned with appearance. It gives the true-to-life, honest visual appearance of shapes in the world around us. In contrast, there is a specific type of artistic distortion called **idealism**. Idealism reproduces the world not as it is but as cultural worldview says it should be. Nature is improved on based upon an artificial standard of perfect form. These notions of perfection may come from a geometric order, or an image of perfect health and youth in the human body. All the flaws, accidents, and incongruities of the visual world are corrected.

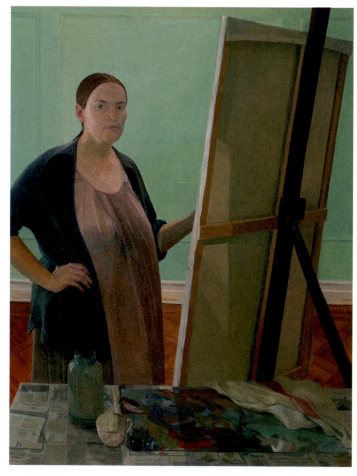

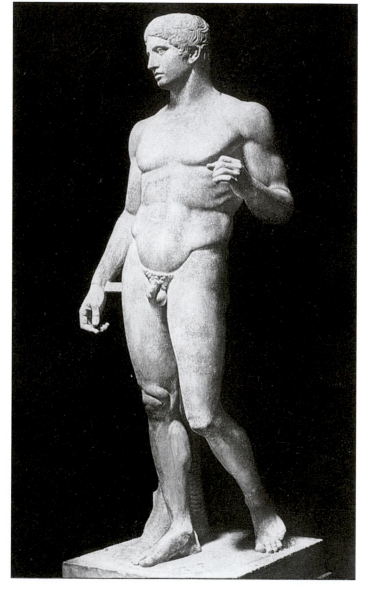

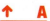 **A**

Catherine Murphy. *Self-Portrait.* 1970. Oil on canvas, 4' 1½" × 3' 1⅛" (125.7 × 94.3 cm). Museum of Fine Arts, Boston (gift of Michael and Gail Mazur, 1998).

 B

Polyclitus. *Doryphorus (Spear Bearer).* Roman copy after Greek original of c. 450–440 BC. Marble, height 6' 11" (1.98 m). Museo Archeologico Nazionale, Naples, Italy.

Idealism in Art

The self-portrait by Catherine Murphy **(A)** is naturalistic. Even in painting herself, the artist has indulged in no flattery. The artist's face is in shadow, and the emphasis is less on the portrait than the naturalistic presentation of the artist's studio. The fifth-century-BC statue **(B)** illustrates the opposite approach—idealism. This statue was a conscious attempt to discover the ideal proportions of the human body. No human figure was copied for this sculpture. The statue represents a visual paragon, a conceptual image of perfection that nature simply does not produce.

Idealism is a recurrent theme in art, as it is in civilized society. We are all idealistic; we all strive for perfection. Despite overwhelming historical evidence, we continue to believe we can create a world without war, poverty, sickness, or social injustice. Obviously, art will periodically reflect this dream of a utopia.

Idealism in Advertising and Propaganda

Today, we are all familiar with a prevalent, if mundane, form of idealism. Large numbers of the advertisements we see daily are basically idealistic. Beautiful people in romantically lit and luxurious settings evoke an atmosphere that is far different from the daily lives of most of us. Fashion illustration suggests body types that are rare or unreal. Governments also often employ idealistic images to convince the world (or themselves) that their particular political system is superior. The heroic "worker" shown in **C** has the idealized muscles of a comic superhero.

↑ **C**

Completely Smash the Liu-Deng Counter-Revolutionary Line. Collection: The University of Westminster.

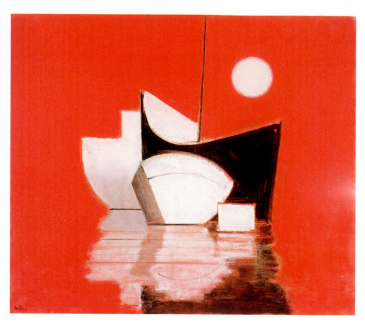

↑ **A**

Paul Resika. *July.* 2001. Oil on canvas, 4' 4" × 5'. Alpha Gallery, Boston.

ESSENCE OF SHAPE

A specific kind of artistic distortion is called **abstraction**. Abstraction implies a simplification of natural shapes to their essential, basic character. Details are ignored as the shapes are reduced to their simplest terms. The painting in **A** is an example of abstraction.

Abstraction for Effect

Because no artist, no matter how skilled or careful, can possibly reproduce every detail of a natural subject, any painting could be called an abstraction. But the term *abstraction* is most often applied to works in which simplification is visually obvious and important to the final pictorial effect. Of course, the degree of abstraction can vary. In **A** all the elements have been abstracted to some extent. Most details have been omitted in reducing the boats to basic geometric shapes (primarily sections of circles, triangles, and rectangles). Still, the subject matter is immediately recognizable, even though we are several steps removed from a naturalistic image. This form of abstraction, where elements are simplified to building blocks, is sometimes called "reductive."

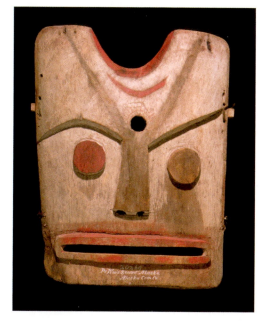

↑ **B**

Alutiiq mask. c. 1875. Painted wood, 38 cm high. National Museum of Natural History, Smithsonian Institution.

↑ **C**

Rebecca Harvey. *Systema Naturae.* **1998.**

For the Love of Shapes

Abstraction is not a new technique; artists have employed this device for centuries. If anything, the desire for naturalism in art is the more recent development. The Alutiiq mask in **B** clearly shows abstracted forms. Although the result is quite different from **A**, many of the shapes in this mask are similar. This aspect illustrates a widely accepted principle: all form, however complex, is essentially based on, and can be reduced to, a few geometric shapes.

Abstracted form does not always lead simply to an alternative representation of a naturalistic form. Abstraction often arises from a love of shape and form for its own sake and from a delight in manipulating form. The teapot shown in **C** transforms a given mold form of a duck in an unexpected way. This reflects the artist's ability to see the potential in a shape or form *beyond* its literal name. That is the essence of abstract thinking and seeing.

Biomorphic Shapes

Not all abstraction necessarily results in a geometric conclusion, and abstraction can result in imagery that is not as directly derived from natural references as the previous examples. The simple petal-like shapes in Arshile Gorky's *Garden in Sochi* **(D)** suggest plants, and even human anatomy, without explicitly resembling anything nameable. Abstract shapes such as these, which allude to natural, organic forms, are called **biomorphic**.

↓ **D**

Arshile Gorky. *Garden in Sochi.* **c. 1943. Oil on canvas, 2' 7" × 3' 3" (78.7 × 99 cm). The Museum of Modern Art, New York (acquired through the Lillie P. Bliss Bequest, 1969).**

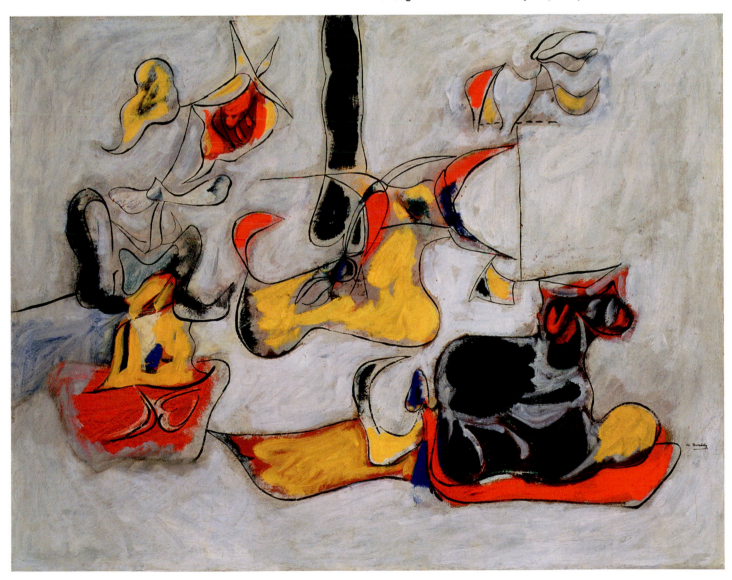

PURE FORMS

According to common usage, the term *abstraction* might be applied to Auguste Herbin's painting *Jour (Day)* **(A)**. This would be misleading, however, because the shapes in this work are not natural forms that have been artistically simplified. They do not represent anything other than the geometric forms we see. Rather, they are pure forms. A better term to describe these shapes is **nonobjective**—that is, shapes with no object reference and no subject matter suggestion.

Visual Design

Most of the original design drawings in this book are nonobjective patterns. Often, it is easier to see an artistic principle or element without a distracting veneer of subject matter. In a similar way, many twenty-first-century artists are forcing us to observe their works as visual patterns, not storytelling narratives. Without a story, subject, or even identifiable shapes, a painting must be appreciated solely as a visual design. Paintings such as **A** present purely nonobjective, geometric shapes that are, as Plato said, "free from the sting of desire."

↑ A

Auguste Herbin. *Jour (Day).* 1953. Gouache on paper, 1' 1⅛" × 10½" (33.4 × 26.6 cm).

The collage by Anne Ryan **(B)** is nearly a geometric as Herbin's painting, yet we sense another factor at play. Ryan's shapes seem to come naturally from the scraps of a sewing room floor. Helen Frankenthaler's painting **(C)** is equally non-objective, but the shapes are not geometric and seem to have developed from the inherently fluid quality of the paint. The canvas seems to be a record of the paint flowing and pooling under the artist's direction. In both of these examples, the shapes are nonobjective but derive from the process.

Lack of a referent subject matter does not necessarily eliminate emotional content in the image. Compare the three examples on these two pages for the tone that they convey from serious to playful to dramatic.

 B

Anne Ryan. *No. 74.* **Between 1948 and 1954. Fabric and paper collage, 8" × 7" unframed. Walker Art Center (gift of Elizabeth McFadden, 1979).**

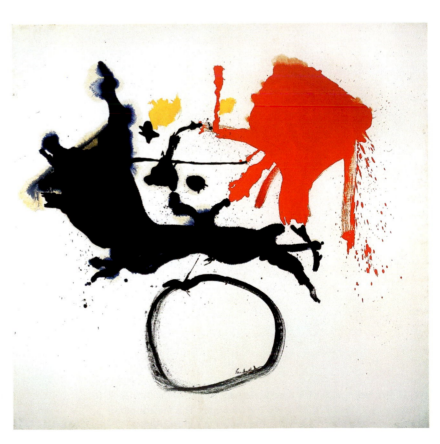

 C

Helen Frankenthaler. *Over the Circle.* **1961. Oil on canvas, 7' 1⁄8" × 7' 3⁷⁄₁₆" (2.13 × 2.21 m). Jack S. Blanton Museum of Art, The University of Texas at Austin (gift of Mari and James A. Michener, 1991).**

The Miata roadster shown in **A** is a form composed of many compound curves. It is said that there is nowhere for a drop of water to rest on the surface: it will flow along a curved plane. Such a **curvilinear** design may be functional and aerodynamic, but it is not the only possibility for a car. More recent cars affect the chiseled angles of a stealth fighter. Style sometimes trumps function in consumer products.

The poster in **B** shows a similar emphasis on curvilinear shapes. There is barely a straight line to be found. This poster is a product of a late nineteenth-century style called **art nouveau**, which put total pictorial emphasis on curvilinear or natural shapes.

We have seen previous examples of curvilinear shapes in fine art examples such as the paintings shown earlier in this chapter. Such shapes will obviously be found in still life and figure painting but are also ubiquitous in pop culture, animation, and illustration. The Walt Disney preparatory drawings for the film *Snow White* **(C)** show the underlying ovals that create the curvilinear shapes of the character. Such shapes predominate in Disney animation and can be found at the root of every character.

The artwork shown in **D** is a witty contemporary deconstruction of another Disney character that displays the curvilinear elements as separate pieces. Even in this condition, Mickey is still recognizable! Like much of pop art, this artwork reveals the visual language shared by fine art, graphic design, and popular forms.

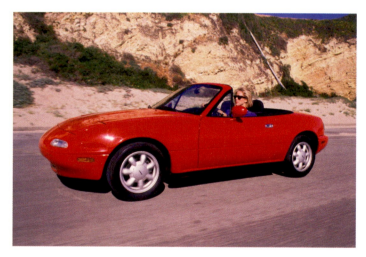

↑ **A**

Mazda Miata. 1990

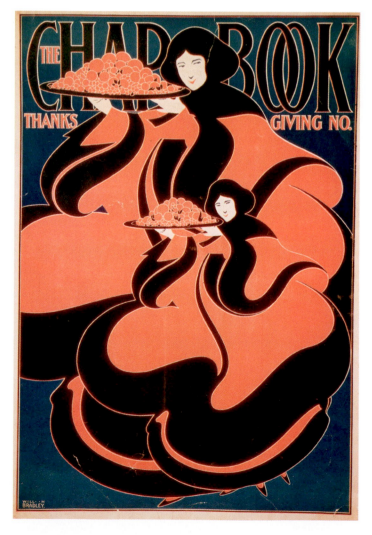

→ **B**

Will H. Bradley. Poster for the *Thanksgiving Number of The Chap-Book.* **1895. Lithograph, 1' 7⅝" × 1' 6⁵⁄₁₆" (49.7 × 33.5 cm). The Metropolitan Museum of Art, New York (gift of Leonard A. Lauder, 1984).**

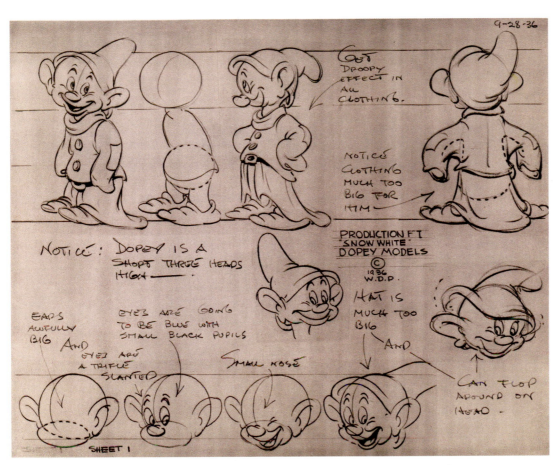

← C
Walt Disney Studios.
Snow White Models.

→ D
Markus Hofko. *Mickey Mouse*
of the series *Cartoon Particles.*

RECTILINEAR SHAPES AND COMBINATIONS

The prefabricated house **(A)** offers a sharp contrast to the examples of the preceding section on curvilinear shapes. The architecture emphasizes right angles and rectangular planes—all the forms have straight edges, giving a sharp, angular feeling. **Rectilinear** is the term to describe this visual effect. This may be a practical concern transporting and fabricating the components to the house, but it is certainly not the only form possible. A clean rectilinear design offers a simplicity and clarity that has been a modernist ideal.

The painting by Yeardley Leonard **(B)** is clearly a rectilinear design. The emphasis of this painting is on color intervals and relationships. A rectilinear composition keeps the focus on planes of color, and these planes repeat the overall format of a rectangular painting.

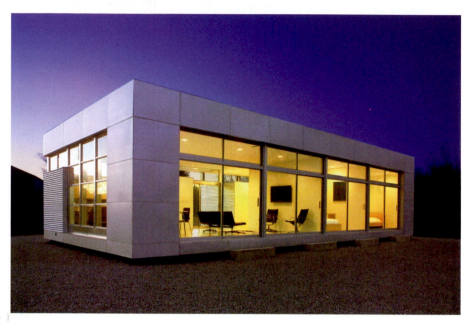

↑ **A**

Rocio Romero. *Prefabricated Home* (**"LV Home," designed as a second vacation home).**

↑ **B**

Yeardley Leonard. *Sita.* **2001. Acrylic on linen on panel, 1' 4½" × 2' 9". Elizabeth Dee Gallery, New York.**

We do think of curvilinear shapes as natural, reflecting the soft, flowing shapes found in nature. Rectilinear shapes, being more regular and precise, suggest geometry and, hence, appear more rational and manufactured. Of course, these are very broad conclusions. In fact, rectilinear shapes abound in nature, for example in crystalline minerals, and the curvilinear architecture of a city like Barcelona reflects a sensuous environment and culture.

Shapes in Combination

These rectilinear examples and the curvilinear examples shown in the previous section all concentrate exclusively on a single type of shape. Most art and design combine both curvilinear and rectilinear shapes. In architecture we may think of rectilinear design dominating, with the verticals and horizontals of doors, windows, and walls. The simple curve of an arch can provide visual relief. Or, as in **C**, a dramatically curved section of the building seems to send a ripple or wave through the design of the rest of the building, even affecting the pattern of rectangular windows.

→ C

Nationale-Nederlanden Building. Prague. 1996. Architects: Vladimir Milunic, Frank Gehry. The Metropolitan Museum of Art (1984). Photo: Tim Griffith/Esto.

INTRODUCTION

The four examples in **A** illustrate an important design consideration that is sometimes overlooked. In each of these patterns, the black shape is identical. The very different visual effects are caused solely by its placement within the format—the location of the black shape immediately organizes the empty space into various shapes. We often refer to these as **positive** and **negative shapes**. The black shape is a positive element; the white empty space is the negative shape or shapes. *Figure* and *ground* are other terms used to describe the same idea, the black shape being the figure.

Negative Spaces Are Carefully Planned

In representational paintings, the distinction between object and background is usually clear. It is important to remember that both elements have been thoughtfully designed and planned by the artist. The subject is the focal point, but the negative areas created are equally important in the final pictorial effect. Japanese art often intrigues the Western viewer because of its unusual design of negative spaces. In the Japanese print **(B)**, the unusual bend of the central figure and the flow of the robes to touch the edges of the picture create two varied and interesting negative spaces. A more usual vertical pose for this figure would have formed more regular, symmetrical shapes in the negative areas. In this composition the dominant shapes are actually the hair and black borders on the robe. The light ground blends with the face and head; only a delicate line marks the boundary of figure and ground here.

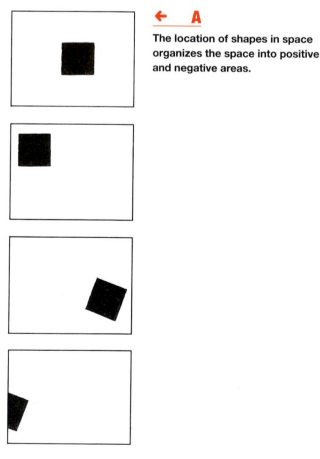

← **A**

The location of shapes in space organizes the space into positive and negative areas.

 ↑ **B**

Kitagawa Utamaro. *Ten looks of women's physiognomy/enjoyable looks.* **The Japan Ukiyo-e Museum, Matsumoto, Japan.**

Negative shapes are also an aspect of letter design and typography. In this case a black letter may be the "figure" and the white page, the "ground." Aaron Siskind's photograph *Chicago 30* (**C**) is apparently a sideways letter *R*. By cropping in on his subject, Siskind has given almost equal weight to the white negative areas, thus giving emphasis to the shapes of both. The play of light and dark or figure and ground is similar to the print by Utamaro (**B**).

Using Negative Space in Three Dimensions

The same positive/negative concept is applicable to three-dimensional art forms. The sculpture shown in **D** is first perceived as large arcs of steel. As you move about the labyrinth-like arrangement, the space becomes not a mere leftover but a positive component of the composition. A view skyward reveals the power of the negative shapes.

← **C**

Aaron Siskind. *Chicago 30.* **1949. Silver gelatin, 1' 1⅞" × 1' 5⅝". International Center of Photography, New York.**

→ **D**

Richard Serra. *Joe.* **The Pulitzer Foundation, St. Louis.**

ISOLATION OR INTEGRATION

Design themes and purposes vary, but some integration between positive and negative shapes is generally thought desirable. In **A** the shapes and their placement are interesting enough, but they seem to float aimlessly within the format. They also have what we call a "pasted-on" look, because there is little back-and-forth visual movement between the positive shapes and the negative white background. An unrelieved silhouette of every shape is usually not the most interesting spatial solution.

The image in **B** shows similar shapes in the same positions as those in **A**, but the "background" is now broken into areas of value that lend interest as well as greater positive/negative integration. The division into positive and negative is flexible—that is, some squares serve *both* as a ground (negative) that hosts smaller square shapes and as a figure (positive) within the larger ground of the entire composition.

Picasso's *Harlequin* **(C)** closely resembles the dynamics of **B**. Although black surrounds the central shapes on four sides, there is a variety of overlap in the central shapes and variety in the size and shape of the black areas around the perimeter. Furthermore, black shapes also appear with the interior of the composition, and the pendulum-like black shape at center top moves to the foreground as other black shapes retreat. In fact, all the planes or shapes of color advance in some areas and retreat in others. This weaving of the shapes creates an integrated composition.

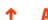 **A**

When positive and negative spaces are too rigidly defined, the result can be rather uninteresting.

 B

If the negative areas are made more interesting, the positive-negative integration improves.

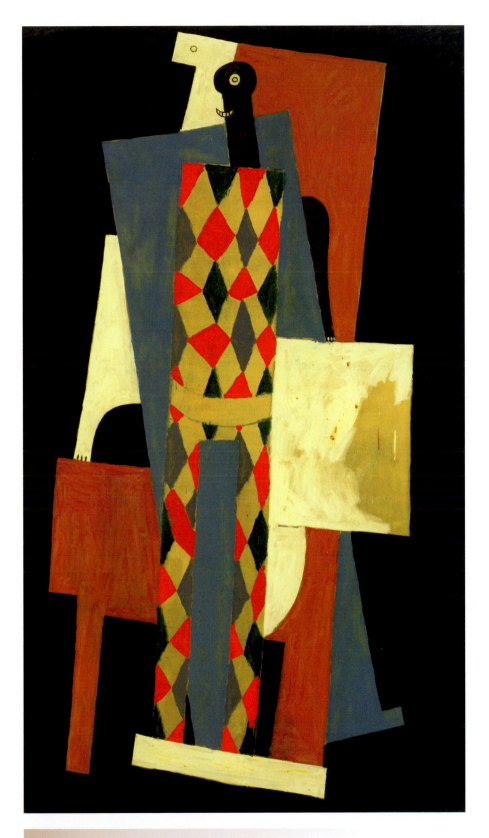

↑ C

Pablo Picasso. *Harlequin.* **Paris, late 1915. Oil on canvas, 6' ¼" × 3' 5⅜" (183.5 ×
105.1 cm).**

EMPHASIS ON INTEGRATION

Three drawings by Georges Seurat demonstrate three degrees of positive/negative integration. The drawing of the female figure shown in **A** presents the figure as a dark shape against a lighter background. For the most part this is a silhouette; positive and negative (figure and ground) are presented as a simple contrast.

The relationship of positive and negative is more complex in **B**. The left side of the figure is dark against a lighter ground, and the right side of the figure is light against a darker ground. This alternation of dark and light makes us aware of the negative shapes, and they take on a stronger visual interest than in **A**.

The composition of **C** presents the most complex integration of positive and negative shapes of the three Seurat drawings. Here, dark, light, and middle values are present as both figure and ground. There are areas of sharp distinction, such as the edge of the arm against the background, and there are areas of soft or melting transitions where the eye moves smoothly from foreground to middle ground to background. The soft boundaries of the hair melt into the surrounding background shapes.

Gérôme's painting **(D)** offers a very rich example of figure/ground or positive/negative integration. At first glance it is a simplistic presentation: the snowy field provides a stage for the actors, and the landscape provides a rather flat backdrop. To make matters "worse," the focus is the dying Pierrot—a white figure against a white (snowy) ground! Sounds like a recipe for a failed composition. But look again. Pierrot is framed by figures in black and red, which serve to advance the dying figure. In a reciprocal fashion the white Pierrot pushes back the red figure. So attention is drawn to the main actor while not overwhelming the composition. We don't fixate on the red. Meanwhile the departing Harlequin resides more subtly within the surrounding space. Gérôme deftly integrates shape and negative shape in a theatrical but complex composition.

See also *Lost-and-Found Contour*, page 146.

 A

Georges Seurat. *Silhouette of a Woman.* 1882–1884. Conté crayon on paper, 1' × 8⅞" (30.5 × 22.5 cm). Collection of McNay Art Museum, San Antonio, Texas (bequest of Marion Koogler McNay).

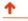 **B**

Georges Seurat. *The Black Bow.* c. 1882. Conté crayon, 1' 3/16" × 9 1/16" (31 × 23 cm). **Musée d'Orsay, Paris.**

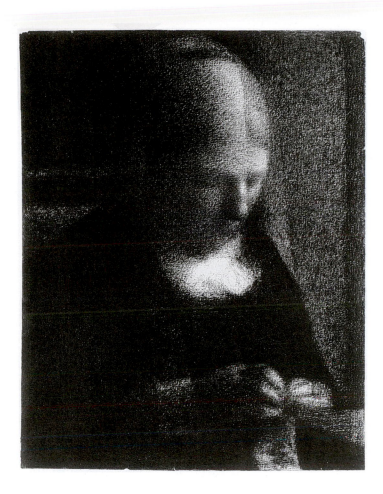

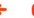

← **C**

Georges Seurat. *Embroidery: The Artist's Mother (Woman Sewing).* **1882–1883. Conté crayon, 1' ⅝" × 9⁷⁄₁₆" (31.2 × 24 cm). Metropolitan Museum of Art (Purchase, Joseph Pulitzer Bequest, 1951; acquired from The Museum of Modern Art, Lillie P. Bliss Collection).**

→ **D**

Jean-Léon Gérôme. *The Duel after the Masquerade.* **1857–1859. Oil on canvas, 1' 3 ⅜" × 1' 10³⁄₁₆" (39.1 × 56.3 cm).**

AMBIGUITY

Sometimes positive and negative shapes are integrated to such an extent that there is truly no visual distinction. When we look at the painting in **A**, we are conflicted in our response to the bulbous central shape. The convex curves suggest a positive form or figure framed by a yellow border. The small wedges of dark color along the edge of the painting can visually connect with the dark center shape, and then it becomes possible to see the dark area as a space, like a dark entryway. The artist has purposely made the positive/negative relationship ambiguous. The big shape can be *both* figure and ground.

The film poster in **B** has this same quality, as our eyes must shift back and forth from dark to light in seeking the positive element. We may at first see two black heads, one in top hat, silhouetted against a light shape. Then we notice the light area is a woman's profile. The image is appropriate for the title, *The Bartered Bride*.

Deliberate Blending of Positive/Negative Shapes

In most paintings of the past, the separation of object and background was easily seen, even if selected areas merged visually. But several twentieth-century styles literally did away with the distinction. We can see that the subject matter of the painting in **C** is a figure. Despite the **cubist** abstractions of natural forms into geometric planes, we can discern the theme. But it is difficult to determine just which areas are part of the figure and which are background. The artist, Picasso, also broke up the space in the same cubist manner. There is no clear delineation of the positive from the negative.

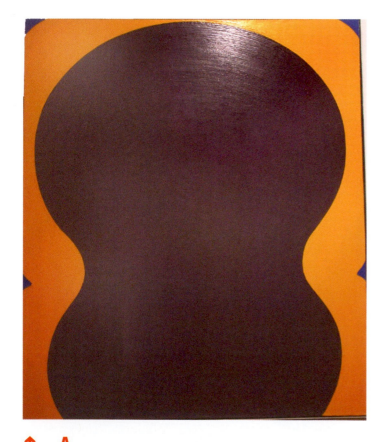

↑ **A**

Al Held. *Helena.* **1963. Acrylic on canvas, 7' × 6'. Art © Al Held Foundation/Licensed by VAGA, New York, New York.**

↑ **B**

Hans Hillmann. Poster for the film *The Bartered Bride.* **1972. Source:** *Print,* **March/April 1988, p. 105.**

Deliberate Delineation of Positive/ Negative Shapes

Picasso's painting invites the viewer to a slow reading of figure and ground relationships. In graphic design the goal more often is to make a quicker impact. An integration of positive and negative shapes not only is a way to get a viewer's attention with high-contrast simple forms, but often it can present surprising or memorable results. The logo for Multicanal, an Argentine cable company **(D)**, takes advantage of an alternating figure ground reading. Our attention is captured by the back-and-forth reading of stars and *M*.

↑ C

Pablo Picasso. *Daniel-Henry Kahnweiler.* **1910. Oil on canvas, 3' 3⅝" × 2' 4⅝" (101.1 × 73.3 cm). Photograph courtesy of The Art Institute of Chicago (gift of Mrs. Gilbert W. Chapman, 1948).**

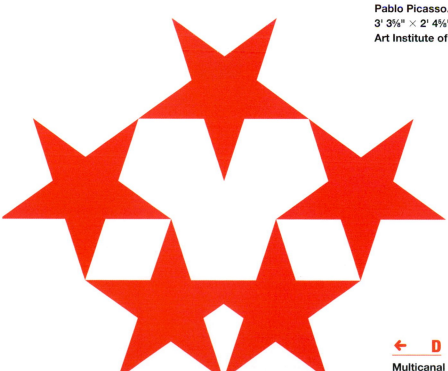

← D

Multicanal (logo design for cable television company, Buenos Aires, Argentina). Chermayeff & Geismar, Inc., New York.

"Oh, for Pete's sake, lady! Go ahead and touch it."

9 PATTERN AND TEXTURE

CREATING VISUAL INTEREST

Pattern is a term ubiquitous to design. It has one meaning when we think of a "dress pattern" or template, and it has another, more general meaning referring to repetition of a design motif. This latter meaning is intrinsic to the human thought process. We say we need to change our patterns of thought or actions when we want to break a habit. We speak of "pattern recognition" when we search for meaning in facts or information. Humankind's earliest discoveries relating to the cosmos came with the recognition of the patterns of seasons and lunar cycles. Though "pattern"—in the visual sense of the word—is often linked to a superficial idea of decoration, our very human interest in pattern clearly has deeper roots.

Psychologists speak of "*horror vacui*" or a need to fill up empty spaces, and that is a basic human impulse. This explains a desire to add visual interest to an empty surface or space. When this surface activation is accomplished through repeated marks or shapes, we have the beginnings of pattern. The photograph in **A** shows the walls of a young man's room filled with photos similar enough to create a "wallpaper" effect and form an ad hoc pattern.

Pattern can be intricate or simple. The pattern being created in **B** is both simple and bold. Further, it echoes the pattern of the woman's dress, suggesting her preference for such motifs.

 A

Adrienne Salinger. *Fred H.* Photograph from *Teenagers in Their Bedrooms* (Chronicle Books, 1995).

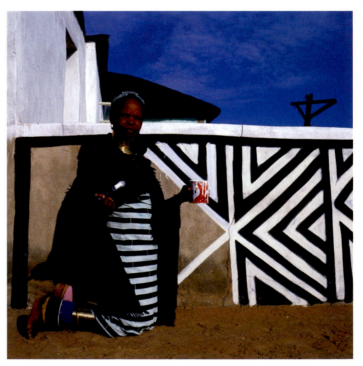

 B

Margaret Courtney-Clarke. *Anna Mahlangu Painting Her Home for a Ceremonial Occasion.* 1985. Photograph. Mabhokho, Kwandebele, South Africa.

Pattern is a dynamic way of capturing visual interest as we can appreciate in Picasso's *Harlequin* painting. The detail shown in **C** is from the center of the painting, and seen in isolation we see how striking it is. The red diamonds fairly pop and create a jazzy rhythm.

The pattern worn by the harlequin character in Gérôme's painting **(D)** is the same as the Picasso version, but notice how toned down it is as the figure retreats into the fog. This pattern would surely compete for attention with the dying figure (not shown in this detail) if Gérôme did not use this device to diminish the effect.

See also *Introduction: Visual Rhythm, Rhythm and Motion*, and *Alternating Rhythm*, pages 114, 116, and 118.

D

Jean-Léon Gérôme. *The Duel after the Masquerade* (detail). 1857–1859. Oil on canvas, 1' 3⅜" × 1' 10³⁄₁₆" (39.1 × 56.3 cm).

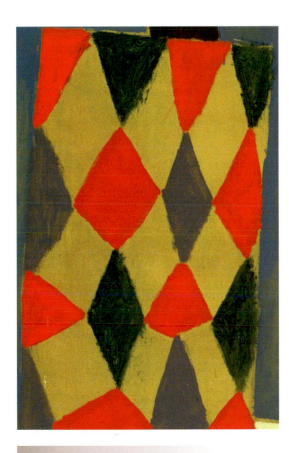

C

Pablo Picasso. *Harlequin* (detail). Paris, late 1915. Oil on canvas, 6' ¼" × 3' 5⅜" (183.5 × 105.1 cm).

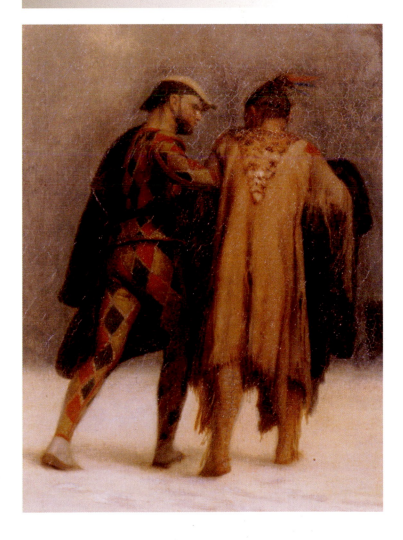

ORDER AND VARIETY

Pattern begins with a unit or shape that is repeated. It is common to find pattern based on floral designs evoking the richness of a garden. Such floral motifs can be representational and flow like a rambling vine, or more abstract and geometric as in example **A**.

Most patterns can be reduced to a grid of some sort, and the result is a crystallographic balance or order. A highly disciplined version of this is seen in the Alhambra tiles shown in **B**. Here we can see both the individual units or tiles and the larger expanse of the patterns. Such elaborate patterns are built on complex symmetries, repetitions, and rotations.

The drawings of M.C. Escher continue the tradition of highly mathematical pattern-making we see in the Alhambra. Figure **C** shows the basic triangular unit that is the core of one such pattern. Notice the order along lines formed by each side of the triangle. Each curve or shape has an equal and opposite curve or shape balanced by radial symmetry around the midpoint of the line. Example **D** reveals the hexagon that orders the pattern of fish shapes. Slide the hexagon down and to the right on a thirty-degree axis, and the pattern is created. Each point of pinwheel-like rotation conforms to a radial symmetry. The magic of such a pattern is a complete unity of figure and ground. Every space is also a fish!

The examples we have seen thus far are closely related to architecture or graphics. In painting, an artist may include pattern as one element among others such as line or shape or color. Gustav Klimt gains some of the dazzle of the Alhambra in his juxtaposition of two patterns in the painting *Hope, II* **(E)**. The patterns in this case are distinct from each other and do not conform to a strict order (you can find variety in each).

See also *Positive/Negative Shapes*, pages 170, 172, 174, and 176, and *Radial Balance*, page 106.

↓ A

Yellow and blue ceramic tiles (azulejos) from Portugal.

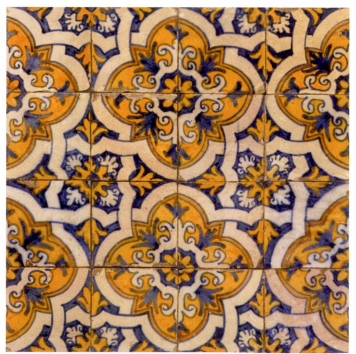

↑ B

Tile patterns from the Alhambra, Granada, Spain. Close-up of ornamental mosaic.

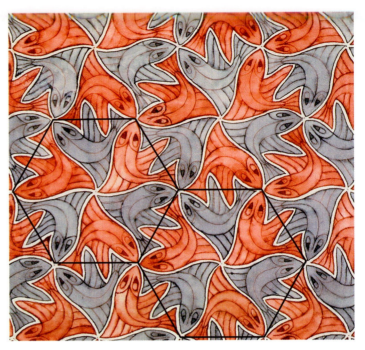

← **E**

Gustav Klimt. *Die Hoffnung II* (*Hope, II*). 1907–1908.
**Oil and gold paint on canvas, 3' 7½" × 3' 7½"
(110.5 × 110.5 cm). Museum of Modern Art.**

SIMILARITIES AND DIFFERENCES

It would be difficult to draw a strict line between texture and pattern. Pattern is usually defined as a repetitive design, with the same motif appearing again and again. Texture, too, often repeats, but its variations usually do not involve such perfect regularity. The difference in the two terms is admittedly slight. The texture of a material such as burlap would be readily identified by touch, yet the surface design is repetitive enough that a photograph of burlap could be called pattern.

The essential distinction between texture and pattern seems to be whether the surface arouses our sense of touch or merely provides designs appealing to the eye. In other words, although every texture makes a sort of pattern, not every pattern could be considered a texture. Some suggestion of a three-dimensional aspect to the surface, such as shadows or glossiness, no matter how subtle, will visually evoke texture.

Evoking Our Sense of Touch

This distinction between what the eye takes to be simply pattern and the qualities that evoke our sense of touch can be seen in the three examples beginning with **A**. This decorative motif is regular, high in contrast, and representational of a plant. It is clearly a pattern. The image in **B** is also a Victorian-era decorative motif, but its irregular pattern and lack of a representational image allow it to be read as a series of ridges, and thus it has some textural associations. The image in **C** is a close-up of pleated silk. The pattern is again rippled, but there is also a variety of grays. It is more complex than **B** and more suggestive of texture. An irony is that the resulting image in **C** is rather like tree bark and might not be recognized as silk due to this close-up view.

The small, intricate designs that dominate the illustration in **D** create both patterns and textures. The peacock's tail offers a pattern of repeated shapes and the texture of the feathers. The many small marks in the background suggest the texture of foliage. This illustration shows a rich vocabulary of pattern and texture possible with just black and white.

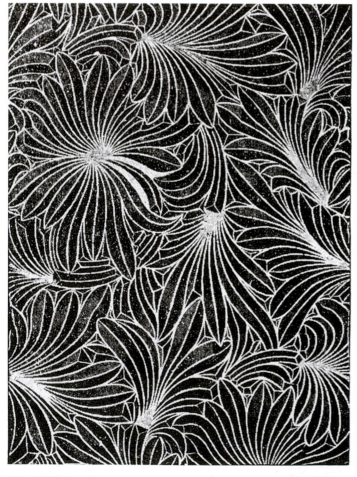

↑ **A**

Figured glass.

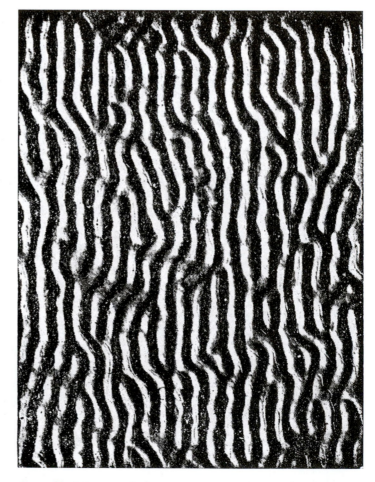

↑ **B**

Figured glass.

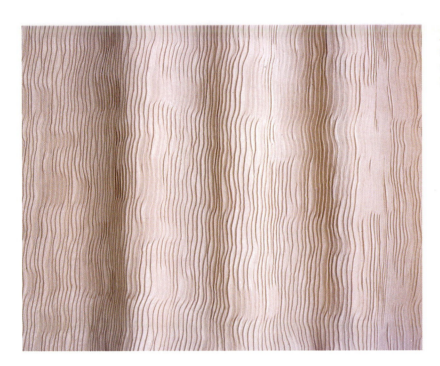

← **C**
Gretchen Belinger (textile designer). *Isadora*® **(pleated silk). 1981. From** *Contemporary Designers* **(London: St. James Press, 1990).**

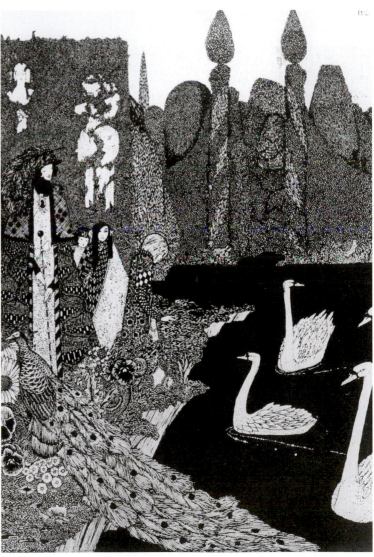

→ **D**
Harry Clarke. *The Most Beautiful of All,* **illustration for "The Ugly Duckling" from** *Fairy Tales* **by Hans Christian Andersen. c.1910. Half-tone engraving.**

CREATING VISUAL INTEREST

Texture refers to the surface quality of objects. Texture appeals to our sense of touch. Even when we do not actually feel an object, our memory provides a sensory reaction or sensation of touch. In effect, the various light and dark patterns of different textures give visual clues so that we can enjoy the textures vicariously. Of course, all objects have some surface quality, even if it is only an unrelieved smooth flatness. The element of texture is illustrated in art when an artist purposely exploits contrasts in surface to provide visual interest.

Texture in Craft Forms

Many art forms have a basic concern with texture and its visual effects. In most of the craft areas, texture is an important consideration. Ceramics, jewelry, and furniture design often rely heavily on the texture of the materials to enhance the design effect. In weaving and the textile arts, texture is a primary consideration. The interior designer must be sensitive to the visual effects that textural contrasts can achieve.

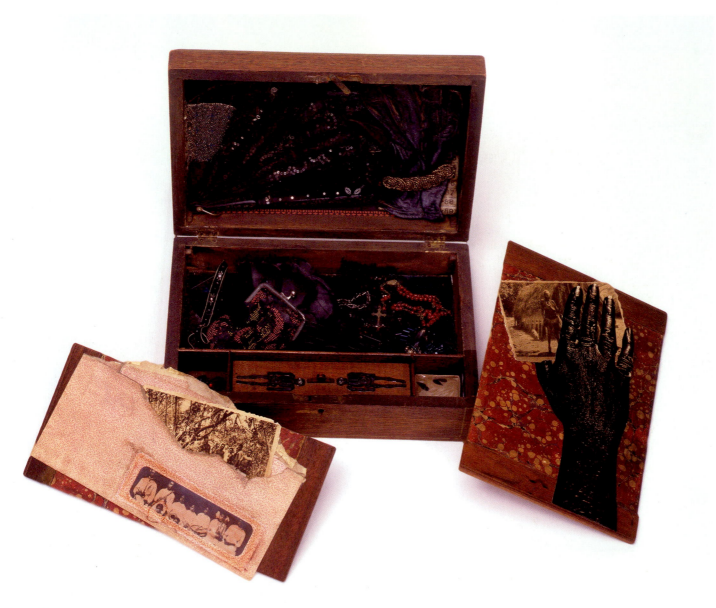

 A

Betye Saar. *The Time Inbetween.* **1974. Sculpture, wooden box containing photographs, magazine illustrations, paint, envelope, etc., 3½" × 11⅝" × 8⅛" (8.89 cm × 29.53 cm × 20.64 cm). San Francisco Museum of Modern Art (purchase). © Betye Saar.**

Texture in Sculpture

In sculpture exhibits, Do Not Touch signs are a practical (if unhappy) necessity, for so many sculptures appeal to our enjoyment of texture that we almost instinctively want to touch. The smooth translucence of marble, the rough grain of wood, the polish or patina of bronze, the irregular drop of molten solder— each adds a distinctive textural quality.

Textural Variety

Betye Saar's *The Time Inbetween* **(A)** contains a variety of textures and seems to invite us to explore this intimate collection by handling it. Beads, feathers, bone, and velvet provide a variety of tactile sensations. A photocopy of the artist's hand underscores the primacy of the sense of touch for this artwork.

The photograph in **B** shows how a variety of textures create sustained interest in the image. Our eye may be initially drawn to the red architectural details, but our attention would soon fade were it not for the contrasts of stone, shingle, and wood. The photographer's decision to crop the image keeps our focus on these details.

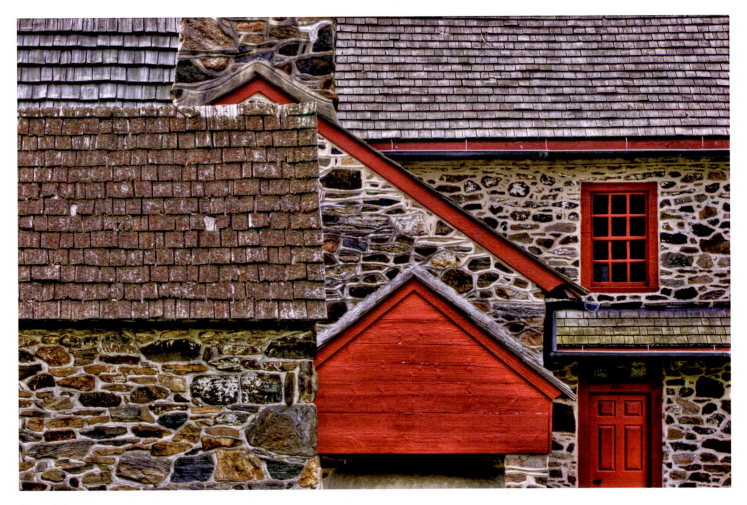

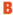 **B**

Elliot Barnathan. *Brandywine I.* **Digital photograph.**

ACTUAL AND IMPLIED

There are two categories of artistic texture—tactile and visual. Architecture and sculpture have what is called **tactile texture**—texture that can actually be felt. In painting, the same term describes an uneven paint surface, produced when an artist uses thick pigment (a technique called **impasto**) to create a rough, three-dimensional paint surface.

Texture as Paint on Canvas

As the need and desire for illusionism in art faded, tactile texture became a more common aspect of painting. Paintings now could look like what they truly were—paint on canvas. Calling attention to the painting's surface became another option available to the artist. Van Gogh was an early proponent of the application of paint as an expressive element. The detail in **A** shows how short brushstrokes of thick, undiluted paint are used. The ridges and raised edges of the paint strokes are obvious to the viewer's eye. On the figure they follow the form, and in the background these strokes form a more abstract pattern akin to the sky and cypress trees of his landscape paintings.

The Next Step

The "relief painting" by Thornton Dial **(B)** shows a next step in bringing tactile texture into a painting. This painting is so complex with contrasts of value (light and dark) and added materials that we have to look closely at some parts to determine what is tactile texture and what is implied texture. In this case materials include cans, bottles, and a desiccated cat! The surprising result is one of paint and other materials working together to create a unified composition. The dividing line between painting and sculpture disappears in many such contemporary works when physical items are attached to the painted surface.

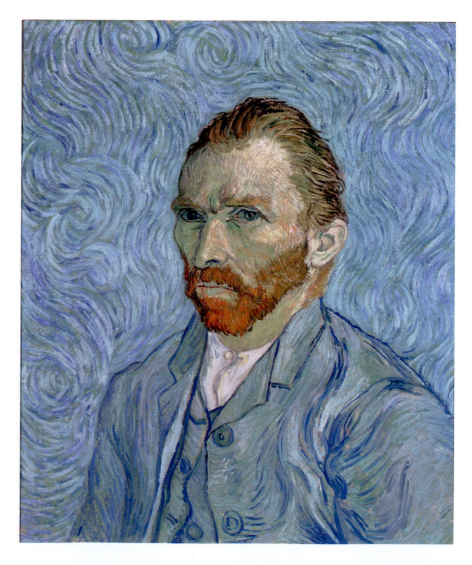

→ **A**

Vincent van Gogh. *Portrait of the Artist.* **1889. Oil on canvas, 65 × 54.5 cm. Musée d'Orsay, Paris.**

Implied Texture

The actual texture of thick strokes records the process of van Gogh's portrait. Texture becomes a visual history of the painting's creation. In contrast to this, the image of brushstrokes in Lichtenstein's print **(C)** is only an implied texture. In fact, the texture of a screen print is as flat and smooth as can be.

 B

Thornton Dial. *Contaminated Drifting Blues.* **1994.** Desiccated cat, driftwood, aluminum cans, glass bottle, found metal, canvas, enamel, spray paint, industrial sealing compound on surplus plywood, 5' 7" × 4' 1" × 1' 5½" (170 × 124 × 44 cm). Collection of William S. Arnett.

 C

Roy Lichtenstein, *Brushstrokes.* **1967.** Color screen print, 1' 10" × 2' 6" (55.88 × 76.2 cm) (image) 1' 11" × 2' 7" (58.42 × 78.74 cm). © Estate of Roy Lichtenstein.

COLLAGE

Creating a design by pasting down bits and pieces of colored and textured papers, cloth, or other materials is called **collage**. This artistic technique has been popular for centuries, mainly in the area of **folk art**. Only since the twentieth century has collage been seriously considered a legitimate medium of the fine arts.

Why Collage?

The collage method is a very serviceable one. It saves the artist the painstaking, often tedious task of carefully reproducing textures in paint. Collage is an excellent **medium** for beginners. Forms can be altered or reshaped quickly and easily with scissors. Also, compositional arrangements can more easily be tested (before pasting) than when the design is indelibly rendered in paint.

Creating a Range of Tactile Sensations

Mary Bauermeister's collage titled *Progressions* **(A)** is composed of stones and sand on board. Even in the reproduction, one can imagine a range of tactile sensations, from bumpy to rough. Bauermeister has emphasized the textural qualities of her materials by reducing the composition to a few squares of progressively larger size. Within two of the squares there is also a progression in the size of the pebbles, creating a gradation in texture from fine to coarse. The physical presence of the materials can be seen in the shadows cast by this collage.

Anne Ryan, an American, worked mainly in collages of cloth. Her untitled collage in **B** shows various bits of cloth in contrasting weaves and textures interspersed with some scraps of printed papers. The dark and light pattern is interesting, but our attention is drawn mainly to the contrast of tactile textures.

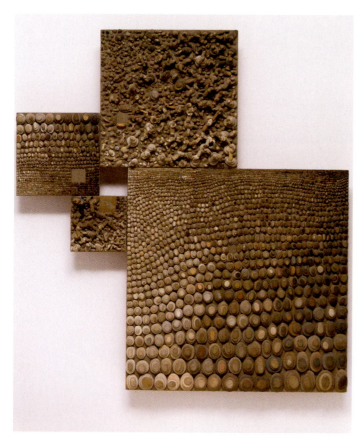

 A

Mary Bauermeister. *Progressions.* **1963. Pebbles and sand on four plywood panes, 4' 3¼" × 3' 11⅜" × 4¾" (130.1 × 120.4 × 12 cm). The Museum of Modern Art, New York (Matthew T. Mellon Foundation Fund).**

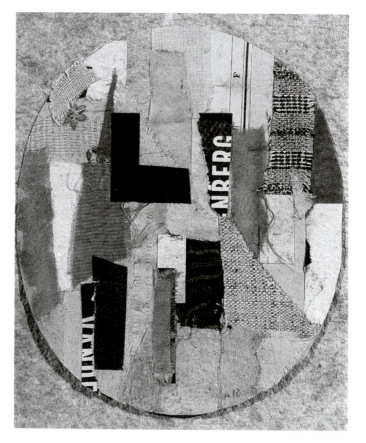

 B

Anne Ryan. *Untitled, No. 129.* **c. 1948–1954. Collage on paper, 4¾" × 4¼" (12.1 × 10.8 cm). Courtesy Joan T. Washburn Gallery, New York.**

Using Found Materials

Folk art is often characterized by an inventive use of found materials and may be considered one of the oldest forms of collage. Such a spirit is also seen in a necklace created from found materials **(C)**. We instinctively sense the metallic feel of clips and chain and tea strainer that were transformed into jewelry. The same artist, Anni Albers, also anticipated (many decades ago) our current interest in recycling materials for new uses. Her wall covering material shown in **D** consists of cotton and cellophane. Today we may be surprised that a soft shopping bag may be made from recycled plastic bottles. In these examples a potentially unpleasant material is transformed into a pleasing texture.

↓ **D**

Anni Albers. Wall covering material. 1929. Cotton and cellophane, 9" × 5" (22.9 × 12.7 cm). © 2003 The Josef and Anni Albers Foundation/Artists Rights Society (ARS), New York. The Josef and Anni Albers Foundation, Bethany, Connecticut.

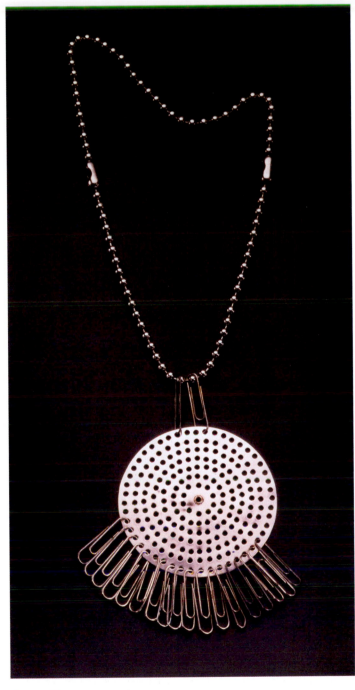

↑ **C**

Anni Albers and Alex Reed. *Neck piece.* **c. 1940. Aluminum strainer, paper clips, and chain, 4¼" × 3⅛" (10.8 × 8 cm). © 2003 The Josef and Anni Albers Foundation/Artists Rights Society (ARS), New York. The Josef and Anni Albers Foundation, Bethany, Connecticut.**

VERISIMILITUDE AND TROMPE L'OEIL

In painting, artists can create the impression of texture on a flat, smooth painted surface. This is called **verisimilitude**, or an appearance that is "truly the same." By reproducing the color and value patterns of familiar textures, painters encourage us to see textures where none actually exist. **Visual texture** is the impression of texture as purely visual; it cannot be felt or enjoyed by touch. It is only suggested to our eyes.

Choosing Subject Matter Rich in Texture

One of the pleasures of still-life paintings is the contrast of visual textures. These works, even when they lack symbolism or emotional content, can be purely visual delights as the artist plays one simulated texture against another. Pieter Claesz's painting **(A)** evokes the cold hardness of stone, the moist surface of fruit, and the feel of metal and glass. This painting appears to have been painted with fluid paint and a soft brush. No physical mark is made by the paint.

In contrast to the method used by Peter Claesz, Max Ernst creates an eerie landscape texture through processes like **frottage** or rubbings **(B)**. This **surrealist** artist exploits equivalence between the depicted texture and the technique that creates it. Leonardo da Vinci observed that the prepared mind is capable of seeing a battle scene in the stains on a wall. This describes an artist's ability to convert smears, stains, and marks into implied textures and representations.

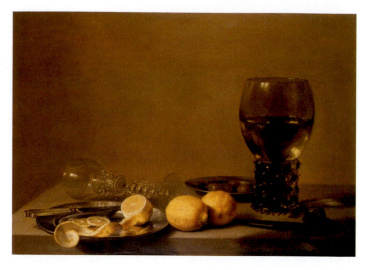

 A

Pieter Claesz. *Still Life with Two Lemons, a Façon de Venise Glass, Roemer, Knife and Olives on a Table.* **1629. Oil on panel, 1' 4⅞" × 1' 11⅜" (42.8 × 59.3 cm). Anonymous loan.**

 B

Ernst, Max. *Europe After the Rain (Europa nach dem Regen).* **1940–1942. Oil on canvas, 1' 9⁹⁄₁₆" × 4' 10³⁄₁₆" (54.8 x 147.8 cm). The Ella Gallup Sumner and Mary Catlin Sumner Collection Fund. Wadsworth Atheneum Museum of Art, Hartford, Connecticut.**

Trompe L'oeil

The ultimate point in portraying visual texture is called **trompe l'oeil**, a French term meaning "to fool the eye." This style is commonly defined as "deceptive painting." In trompe l'oeil, the objects, in sharp focus, are delineated with meticulous care. The artist copies the exact visual color and value pattern of each surface.

What is meant by visual color as the term is used here? The artist Neil Welliver once observed that the color he mixes to represent a rock in his landscape painting is *not* the color of the rock, but the color the rock *appears* to be when presented in the context of the painting. Perhaps it has to be lighter or bluer, for example. This will look right in the painting, but if the paint was applied to the rock, it would not match it. Set painters understand this as they exaggerate contrast in painting sets for the theater so that implied texture can be perceived from a distance. A deception occurs because the *appearance* of objects is so skillfully reproduced that we are momentarily fooled. We look closer, even though our rational brain identifies the image as a painting and not the actual object.

Textural trompe l'oeil is most convincing when the image is shallow or almost two dimensional. When a three-dimensional object is represented in a painting, no matter how skillfully, our binocular vision will soon betray the deception. Both **C** and **D** succeed in their deception, not only because of a skillful attention to detail but also because the subjects depicted are low relief textures. An ordinary bridge underpass is transformed into elaborate masonry through trompe l'oeil painting in **D**.

↑ **C**

Ed Ruscha. *Rancho.* **1968. Oil on canvas, 5' height × 4' 6" width.**

↑ **D**

Jan-Marie Spanard. *Broadway Gateway Mural* **(north wall detail). 1999–2000. Albany, New York.**

"JUST GO DOWN TO THE VANISHING POINT AND TAKE A LEFT."

CHAPTER 10 ILLUSION OF SPACE

TRANSLATING SPACE TO TWO DIMENSIONS

Many art forms are three-dimensional and therefore occupy space: ceramics, jewelry and metalwork, and sculpture, to name a few. In creating or viewing traditional figurative sculpture or in purely abstract forms, it is important for us to move about to fully take in the changing spatial experience from various angles. Architecture, of course, is an art form mainly preoccupied with the enclosure of three-dimensional space and our movement within those spaces.

In art forms, such as drawings, paintings, and prints, the artist who wants to convey a feeling of space or depth must translate clues from a three-dimensional experience to a two-dimensional plane. In this case space is an illusion, for the images rendered on paper, canvas, or boards are essentially flat.

↑　A

Michel Taupin. *Rhythm Study*. 2006. Digital photograph.

Surface and Depth

Many artists throughout the centuries have accepted an essential flatness and worked with primarily surface considerations of design. In contrast to that approach, some periods and cultures have emphasized spatial illusion. The contemporary artist and designer is conscious of *both* the two-dimensional plane and the many ways to suggest three-dimensional space. The photograph in **A** emphasizes the rhythm of trees on a hillside and is most interesting as a flat pattern. A different photograph by the same photographer taken the same day in the same region emphasizes the space of the Western landscape **(B)**. *Gros Ventre #3* **(B)** creates a sense of this space with many spatial clues: overlap, diminishing size, and effects of atmosphere.

The photograph in **A** and the painting in **C** have a surprising commonality: a vertical line at the center, which taken alone would tend to flatten the space. In **A** this line is suggested by the continuation of a few light tree trunks. In **C** a lamppost divides the painting into two rectangular areas. Nevertheless, Gustave Caillebotte's painting **(C)** pierces the **picture plane**. We are encouraged to forget that a painting is merely a flat piece of canvas. Instead, we are almost standing with the figures in the painting, and our eyes are led to the distant buildings across the plaza and down the streets that radiate from the intersection. Caillebotte's images suggest three-dimensional forms in a real space. The picture plane no longer exists as a plane, but becomes a window into a simulated three-dimensional world created by the artist. A very convincing illusion is created.

Artists throughout the centuries have studied this problem of presenting a visual illusion of space and depth. The engraving by Albrecht Durer from the sixteenth century **(D)** offers an early explanation of how the image we see in space—as if through a window—can be plotted as a series of points on the picture plane that records the view from a single, fixed vantage point. This establishes the meaning of "picture plane" and a basis for dealing with **foreshortening**, depth and space.

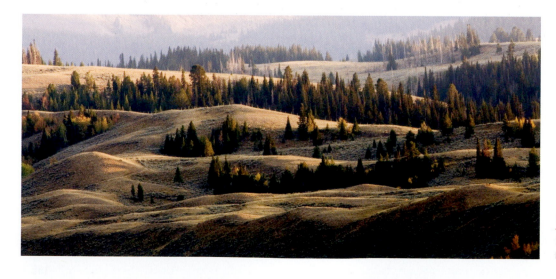

←　B

Michel Taupin. *Gros Ventre #3*. 2006. Digital photograph.

 C

Gustave Caillebotte. *Rue de Paris; Temps de Pluie (Paris Street, Rainy Day).* 1877. Oil on canvas, 6' 11½" x 9' ¾" (212.2 × 276.2 cm). The Art Institute of Chicago (Charles H. and Mary F. S. Worcester Fund Collection, 1964).

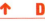 **D**

Albrecht Durer. *Method of Perspective Drawing.* c. 1530. Published in an 1878 history of the Middle Ages. Digital restoration by Steven Wynn Photography.

SIZE

The easiest way to create an illusion of space or distance is through size. Very early in life we observe the visual phenomenon that as objects get farther away they appear to become smaller. Complex naturalistic artworks will employ many spatial clues, but it is possible to find artworks that choose a more limited vocabulary effectively. Abraham Walkowitz's painting **(A)** relies primarily on contrast of size. In this case the elements of the landscape are painted as flatter shapes; however, the foreground figures are larger than those in the middle and far distance. Size difference conforms with our understanding of how we perceive space, yet the artist is able to emphasize the shapes of rocks and figures and even glimpses of the ocean by playing down other effects of space.

Spatial Effect with Abstract Shapes

Notice that the size factor can be effective even with abstract shapes, when the forms have no literal meaning or representational quality **(B)**. The smaller squares automatically begin to recede, and we see a spatial pattern. With abstract figures, the spatial effect is more pronounced if the same shape is repeated in various sizes. The device is less effective when different shapes are used. The repetition of figures and rocks in **A** is consistent with the example shown in **B**.

Exaggerated Scale

Using relative sizes to give a feeling of space or depth is very common to many periods and styles of art. Some artists have taken this basic idea and exaggerated it by increasing the size differences. In the Japanese woodcut **(C)**, the one fish kite is very large and hence seems quite close. By contrast, the other smaller kites and the tiny figures, trees, and hills seem far in the distance. There are two advantages to this practice. First, seeing a kite drawn larger than human figures automatically forces us to imagine the great distance involved. Second, this very contrast of large and tiny elements can create a dynamic visual pattern.

The circus scene by Demuth **(D)** uses the same idea. One performer is shown very large and, hence, is in the foreground. The other trapeze artists are shown smaller and, therefore, recede into the background.

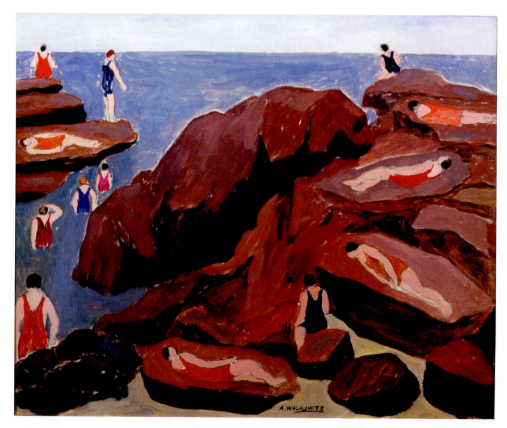

↑ **A**

Abraham Walkowitz. *Bathers on the Rocks.* 1935. Oil on canvas, 2' 1" × 2' 6⅛". Tampa Museum of Art Collection, Museum Purchase (1984).

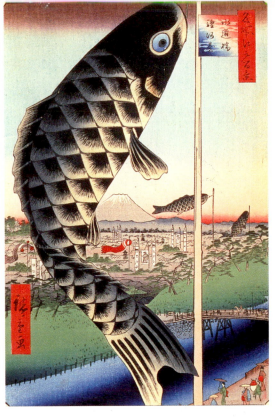

 C

Ando Hiroshige. *Suido Bridge and Surugadai (Suidobashi Surugadai) No. 48 from Famous Views of Edo.* **Edo Period, Ansei Era, published May 1857. Color woodblock print. Hiroshige, Ando or Utagawa (1797–1858). Brooklyn Museum of Art, New York, gift of Anna Ferris/The Bridgeman Art Library.**

 B

El Lissitzky. *Of Two Squares: A Suprematist Tale in Six Constructions.* **1922. Illustrated book with letterpress cover and six letter-press illustrations, 10¹⁵⁄₁₆" × 8⅞" (27.8 × 22.5 cm). Publisher: Skify, Berlin. Gift of the Judith Rothschild Foundation.**

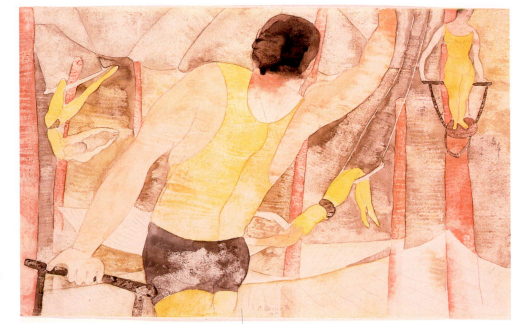

 D

Charles Henry Demuth. *Circus.* **1917. Watercolor and pencil on paper, 8¹⁄₁₆" × 1' 1" (20.5 × 33 cm). Hirshhorn Museum and Sculpture Garden, Smithsonian Institution, gift of Joseph H. Hirshhorn Foundation, 1966.**

OVERLAPPING

Overlapping is a simple device for creating an illusion of depth. When we look at the design in **A**, we see four elements and have no way to judge their spatial relationships. In **B** the relationships are immediately clear due to overlapping. Each shape hides part of another because it is on top of or in front of the other. A sense of depth is established.

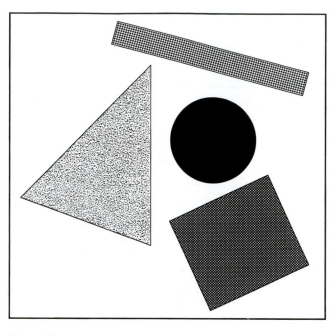

 A

No real feeling of space or depth can be discerned.

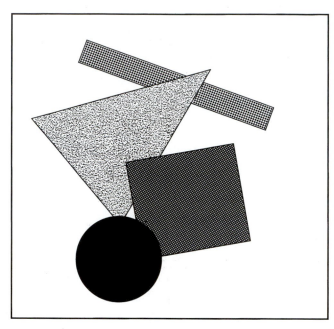

 B

Simple overlapping of the shapes establishes the spatial relationships.

→ C

Jacob Lawrence. *Cabinet Makers.* 1946. Gouache with pencil underdrawing on paper; sheet: 1' 10" × 2' 6³⁄₁₆" (55.9 × 76.6 cm), image: 1' 9¾" × 2' 6" (55.2 × 76.1 cm). Hirshhorn Museum and Sculpture Garden, Smithsonian Institution, gift of Joseph H. Hirshhorn, 1966.

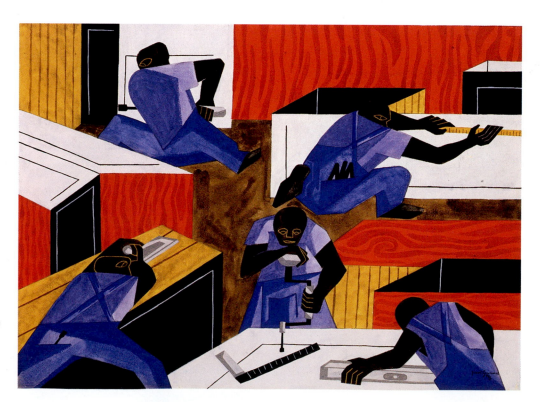

Overlapping with and without Size Differences

In Jacob Lawrence's painting **(C)**, there is no size difference between the cabinetmakers in the front and those in back. But we do understand their respective positions because of the overlapping that hides portions of the figures. Because overlapping is the primary spatial device used, the space created is admittedly very shallow. The pattern of two-dimensional shapes is stronger than an illusion of depth. Notice that when overlapping is combined with size differences, as in Hayllar's painting **(D)**, the spatial sensation is greatly increased.

Spatial Depth with Abstract Shapes

The same principle can be illustrated with abstract shapes, as the designs in **E** show. The design on top, which combines overlapping and size differences, gives a much more effective feeling of spatial recession.

See also *Transparency*, page 224.

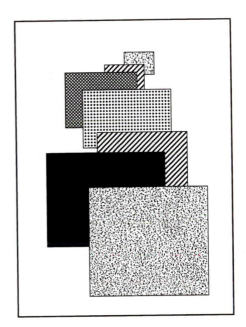

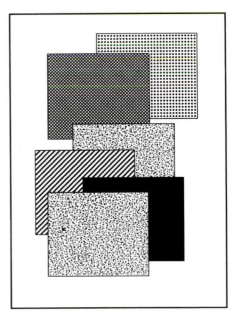

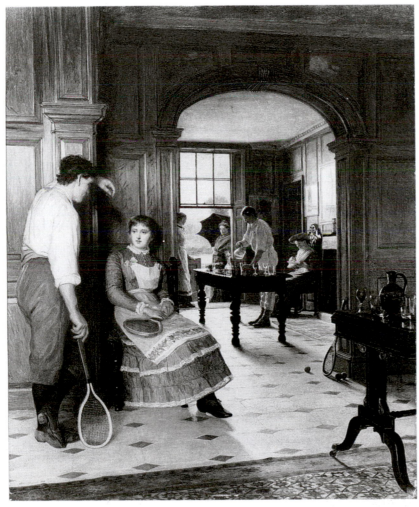

 D

Edith Hayllar. *A Summer Shower.* **1883. Oil on panel, 1' 9" × 1' 5⅝" (53.4 × 44.2 cm). The Bridgeman Art Library.**

 E

The design on the bottom does not give as much feeling of spatial depth as the one on top.

VERTICAL LOCATION

Vertical location is a spatial device in which elevation on the page or format indicates a recession into depth. The higher an object, the farther back it is assumed to be. In the painting shown in **A**, the artist is relying mainly on vertical location to give us a sense of recession into depth. To our eyes, the effect, though charming and decorative, seems to have little suggestion of depth. The figures appear to sit almost on top of each other all in one plane. However, this device was used widely in Near Eastern and Asian Art and was immediately understandable in those cultures.

Emphasizing Figures and Objects

As the image in **B** shows, the use of vertical location in a composition can emphasize the figures, objects, and architectural features. These elements—the figures on a blanket, the card table, and the bridge—are given more importance than an accurate depiction of spatial relationships. This format is well suited for quilts, where other decorative elements may have significance along with the pictorial elements (for example, the text in the quilt's border).

The painting and collage by Tom Wesselmann **(C)** shows that this device can be effective even when aspects of the work are photo-realistic. In this painting we can see an arrangement based on a flat grid evident in the tablecloth pattern and other verticals and horizontals. Objects are arranged within this grid, and we sense the space presented based mainly on vertical location.

 A

Miskina. *The Disputing Physicians* (or *Philosophers*). 1593–1595. From the Khamsa of Nizami, f.23v. Painting on paper, 30 × 19.5 cm.

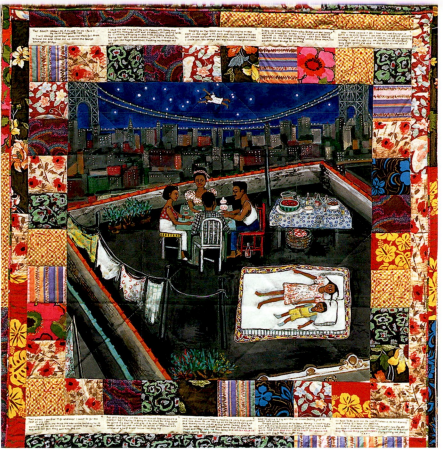

↑ **B**

Faith Ringgold. *Tar Beach.* **1988. Acrylic paint on canvas and pieced tie-dyed fabric, 6' 2" × 5' 8½". Collection of the Solomon R. Guggenheim Museum, New York.**

← **C**

Tom Wesselmann. *Still Life #12.* **1962. Acrylic and collage of fabric, photogravure, metal, etc., on fiberboard, 4" × 4" (1.22 × 1.22 m). Art © Estate of Tom Wesselmann. Licensed by VAGA, New York, New York. Smithsonian American Art Museum, Washington, DC/Art Resource, New York.**

AERIAL PERSPECTIVE

Aerial, or atmospheric, **perspective** describes the use of color or value (dark and light) to show depth. The photograph in **A** illustrates the idea: The value contrast between distant objects gradually lessens, and contours become less distinct. Greater contrast advances, diminished contrast retreats. Color changes also, with objects that are far away appearing less distinct and showing less contrast. The distant hills take on the bluish hue of the sky **(B)**.

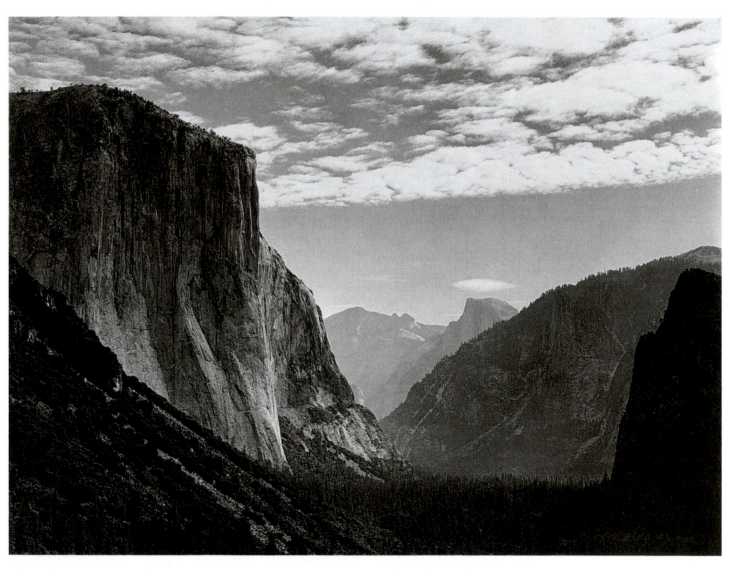

↑ **A**

Ansel Adams. *Yosemite Valley from Inspiration Point.* c. 1936. Photograph. Copyright © 1993 by the Trustees of the Ansel Adams Publishing Rights Trust. All rights reserved.

Rockwell Kent. *Asgaard.* **1950. Oil on canvas, 86 × 112 cm.**

Mary Cassatt. *The Fitting.* **1890–1891. Drypoint and aquatint on laid paper; plate: 1' 2¾" × 10" (37.5 × 25.4 cm), sheet: 1' 6¹³⁄₁₆" × 1' 1⁄₈" (47.8 × 30.8 cm). National Gallery of Art, Washington, DC, (Chester Dale Collection, 1963).**

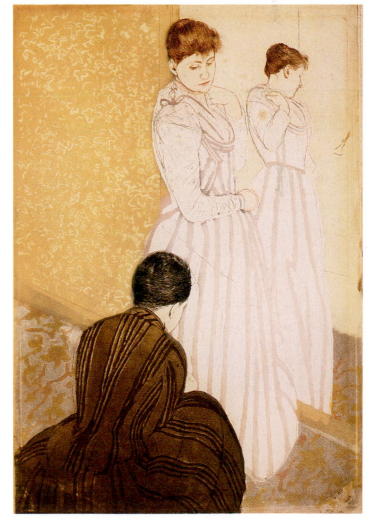

We ordinarily think of aerial perspective and value changes to show distance as applied to vast landscapes with distant hills. But look at **C**. Of course, the overlapping immediately establishes that the standing woman is behind the figure in the foreground. But notice how the sense of depth is increased because the light dress is similar to the light mirror and wall (similar to the recession of hills in the photo **A**). If the standing figure were dark, she would tend to merge with the crouching figure, creating a flatter composition. Mary Cassatt shows both an awareness of flat shapes *and* elements that create space.

See also *Value and Space*, page 250, and *Color and Space*, page 276.

PLAN, ELEVATION, PERSPECTIVE

The architect's job includes communicating a proposed building to a client so that the spatial relationships can be understood. It is not surprising that many aspects of spatial illusion were first utilized by architects and then adapted by painters and other artists. The necessity for more than one way to describe a space (or the inadequacy of any one method to tell a complete story) is the reason for three different kinds of drawing being used for communication.

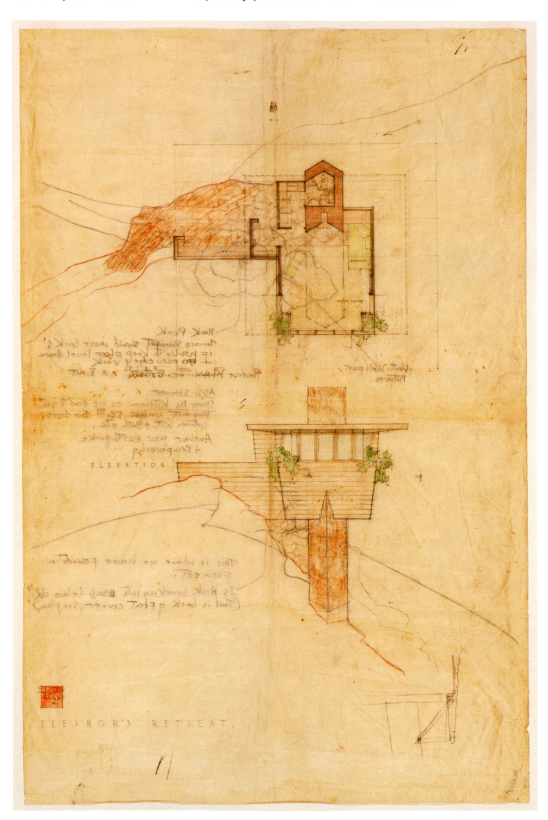

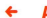 **A**

Frank Lloyd Wright. Arch Oboler Guest House (Eleanor's Retreat), project, Malibu, California, plan and elevation. 1941. Graphite and colored pencil on tracing paper, 2' 6¾" × 2' ⅛" (78.1 × 51.1 cm). Arthur Drexler Fund. © 2009 Frank Lloyd Wright Foundation/Artists Rights Society (ARS), New York. 111.1992. The Museum of Modern Art, New York.

↑ **B**

Frank Lloyd Wright. Arch Oboler Guest House (Eleanor's Retreat), project, Malibu, California, perspective. 1941. Colored pencil, graphite, and color ink on tracing paper, 1' 4¹⁵⁄₁₆" × 1' 7¼" (43.1 × 48.9 cm). Arthur Drexler Fund. © 2009 Frank Lloyd Wright Foundation/Artists Rights Society (ARS), New York. The Museum of Modern Art, New York.

A drawing from Frank Lloyd Wright actually shows two kinds of drawing; **A** includes both a **plan** and an **elevation**. The plan shows a map of the floor and wall arrangement and is a scale interpretation of the placement of features such as doors and windows. The elevation shows one facade of the structure or the appearance from the outside from one viewpoint (again, to scale).

The **perspective** view in **B** allows us to visualize the building from a unique vantage point. This illustrates the fore-shortened planes and recession in space we would observe. A perspective drawing may be more accurate in describing appearance, but without the other two views our understanding of this structure in space would be incomplete.

LINEAR PERSPECTIVE

Linear perspective is a complex spatial system based on a relatively simple visual phenomenon: as parallel lines recede, they appear to converge and to meet on an imaginary line called the horizon, or eye level. We have all noticed this effect with railroad tracks or a highway stretching away into the distance. From this everyday visual effect, the whole science of linear perspective has developed. Artists had long noted this convergence of receding parallel lines, but not until the Renaissance was the idea introduced that parallel lines on parallel planes all converge at the same place (a **vanishing point**) on the horizon. Piero della Francesca was an early proponent of this spatial system, which can be seen in **A**. The perfection of this ideal city shown in perspective shows the origins of this method in architecture and the arts of that period.

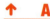 **A**

Piero della Francesca. *View of an Ideal City.* Galleria Nazionale delle Marche, Urbino, Italy.

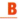 **B**

Kitagawa Utamaro. *Moonlight Revelry at the Dozo Sagami.* Edo Period, Japan. Ink and color on paper, 147.0 × 318.6 cm. Freer Gallery of Art, Smithsonian Institution, Washington, DC, (gift of Charles Lang Freer).

Although linear perspective is based on our perception, it is limited to a single fixed vantage point, or a **monocular** depth clue. It is not based on the **parallax** of our two-eyed perception of depth. A strong use of linear perspective can therefore have an artificial quality as seen both in the della Francesca and the Japanese woodcut in **B**. The edges of the room's floor, walls, and ceiling are clearly receding to a common vanishing point, and the setting is like a stage presented directly in front of us. This print combines a Western system of spatial depiction with the Japanese emphasis on two-dimensional shapes and patterns.

The distance between horizontal lines that are parallel to the picture plane also show a consistent pattern of recession **(B)**. The spaces between them appear to diminish as we look back into the space. This is evident in an obvious and simple way as we notice the foreshortening of spaces between horizontal lines in **C**, which demonstrates another effect of linear perspective. Circles foreshorten to ellipses as we can see with the center circle of the playing field. The height and width of this ellipse are parallel to the vertical and horizontal borders of the picture plane.

Still life paintings, drawings, and photographs are often anchored by elliptical shapes. Our mind understands that the bowl depicted in **D** is circular although the shape we see is actually an ellipse.

Linear perspective tells us our angle of perception and our position as an observer. In this regard perspective is credited with recognizing the viewer as a specific unique individual in a distinct place with a point of view.

↑ **C**

Andreas Gursky. *EM Arena II.* **2000, C-print, 9' ⅓" × 6' 9¹⁄₁₀" (275 × 206 cm).**

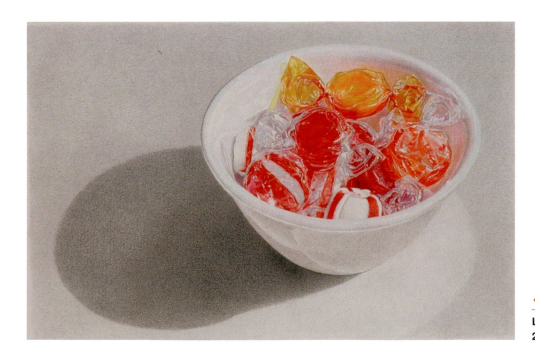

← **D**

Lowell Tolstedt. *Bowl with Candy and Shadow.* **2008. Color pencil, 6⅞" × 10⅜".**

↑ **A**

Leonardo da Vinci. *Adoration of the Magi.* **1482. Unfinished. Tempura mixed with oil on wood, 8' 1" × 8' (246 cm × 243 cm). Uffizi, Florence, Italy.**

ONE-POINT PERSPECTIVE

The complete study of linear perspective is a complicated task. Entire books are devoted to this one subject alone, and it cannot be fully described here. The procedures for using linear perspective were rediscovered and developed during the Renaissance. From drawings, we see that in the fifteenth and sixteenth centuries many artists preceded paintings with careful perspective studies of the space involved.

Few recent painters have made such a strict use of linear perspective. For the architect, city planner, interior designer, set designer, and so on, an ability to do perspective drawing is essential for presenting their ideas. But it is important for any designer or artist to know the general principles of linear perspective, for it is a valuable tool for representing an illusion of depth.

Positioning the Horizon

The concept of linear perspective starts with the placement of a horizontal line, the "horizon," that corresponds to the "eye level" of the artist. On this line is located the needed number of vanishing points to which lines or edges will be directed. It might seem that working by a "formula" such as linear perspective provides would lead to a certain sameness and monotony in pictures. This is not true, because the artist's choice in the placement of

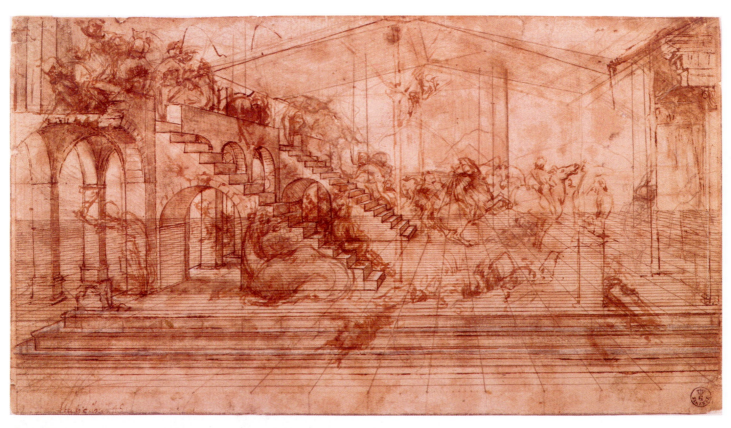

↑ **B**

Leonardo da Vinci. Architectural study for the background of *Adoration of the Magi.* **ca. 1480. Gabinetto dei Disegni e delle Stampe, Uffizi, Florence, Italy.**

the horizon and vanishing points within the picture (or outside it) is almost unlimited. The same scene drawn by the same artist would result in radically different visual compositions by altering these initial choices. This is simply the artist choosing the point of view, whether at a predictable eye level, or perhaps from below or above.

Exploring One-Point Perspective

Leonardo's unfinished painting **(A)** is an example of **one-point perspective**. The preparatory drawing **(B)** shows how a single point has been placed on the horizon line, and all the lines at right angles to the plane of the canvas converge toward that point. The drawing and the unfinished painting taken together offer us the chance to see the artist's process of placing the figures within the space created for them.

The horizon is another term for eye level. Often the eye level is coincident with the eyes in the depicted figures. In the Leonardo painting, we can observe that our vantage point is slightly elevated (the horizon line is higher than the eyes of the foreground figures), and we are looking down on the scene of the Madonna and the surrounding figures. It is informative to see that Leonardo took care to structure this space in strict one-point perspective even though the architecture is relegated to the background and most of the painting is a landscape setting.

No diagram is needed to illustrate the one-point perspective used in **C**. This poster, commemorating the flight of Danish Jews to Sweden, transforms one triangle of the Star of David into receding lines suggestive of movement to the distance.

The rules of one-point perspective can also be used to manipulate our experience of actual space. This is the case with Borromini's Arcade for the Palazzo Spada in Rome **(D)**. The columns decrease in size, their spacing gets shorter, and the pavement narrows down the arcade. This very short corridor appears longer due to these systematic reductions in size, shape, and spacing all focused on a single vanishing point of one-point perspective.

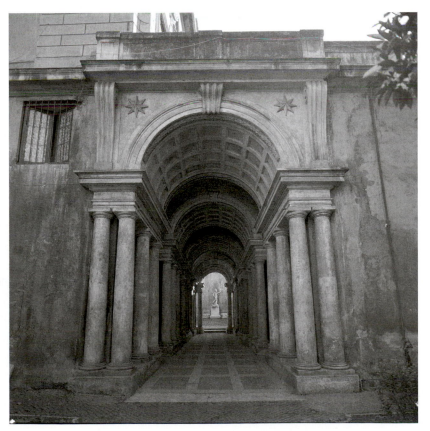

↓ **D**

Francesco Borromini. Arcade, Palazzo Spada, Rome. c. 1635–1650.

↑ **C**

Per Arnoldi (Denmark). **Poster commemorating the 50th anniversary of the Danish Jews' flight to Sweden. 1993. Client: Thanks to Scandinavia, New York.**

TWO-POINT PERSPECTIVE

One-point perspective presents a very organized and unified spatial image. **Two-point perspective** probably appears to us as more natural and lifelike. Here we are not looking head-on at the scene. Now, it is being viewed from an angle. No objects are parallel to the picture plane, and all edges recede to two points on the horizon line. This more nearly approximates our usual visual experience.

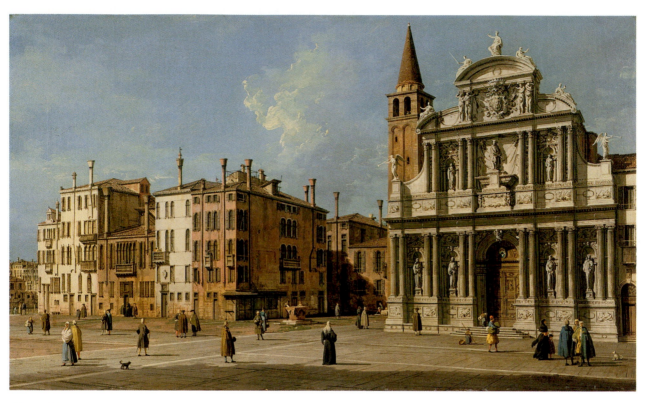

↑ **A**

Giovanni Antonio Canal, known as Canaletto (1697–1798). Campo Santa Maria Zobenigo. Venice, Italy. Oil on canvas, 1' 6½" × 2' 6⅝" (47 × 78.1 cm). Private collection, New York.

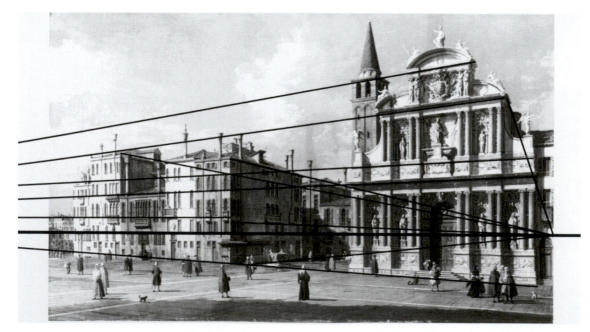

← **B**

Diagram superimposed over painting A. The angled lines of the architecture would meet at two points on the horizon.

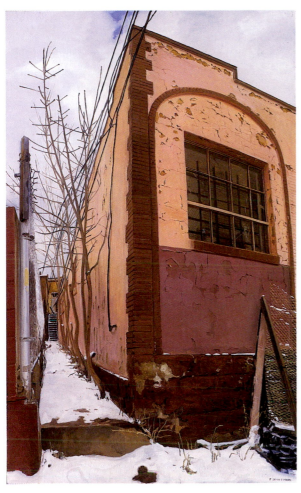

 C

Felix de la Concha. *Así en el cielo (As in Heaven).* **2001. Oil on canvas on board, 4' × 2' 5½" (121.9 × 74.9 cm). Karl and Jennifer Salatka Collection, Concept Art Gallery, Pittsburgh, Pennsylvania.**

The painting by Canaletto **(A)** illustrates the idea. In the diagram **(B)** the horizon line is shown on which there are two points, and the various architectural lines of the different buildings recede to them.

A Static Effect Can Be a Dramatic Element

In a perspective drawing or painting, strict two-point perspective can appear a bit posed and artificial. It assumes we are standing still and looking without moving. This is possible and does happen but is not typical of our daily lives. Our visual knowledge is gained by looking at objects or scenes from many changing viewpoints. Photography can capture a still view, and film and video have conditioned us to rapidly changing points of view. Perhaps for these reasons linear perspective is not as frequently used in painting today as it was for centuries.

However, painting and drawing still have the power to share a still and careful observation. The contemporary painting by Felix de la Concha **(C)** shows how two-point perspective can be a dramatic element of composition and can resonate with our daily experience. An alleyway may seem to be a banal subject, but de la Concha's attention to the narrow space and surprising facade is extraordinary.

Ed Ruscha's *Standard Station, Amarillo, Texas* **(D)** exploits the more artificial aspect of two-point perspective to give drama to the subject and celebrate highway culture. Billboard architecture seeks our attention, and in the American west we are offered a view to infinity across the vast, flat landscape.

→ D

Ed Ruscha. *Standard Station, Amarillo, Texas.* **1963. Oil on canvas, 5' 4⁵⁄₁₆" × 10' 11³⁄₁₆" (1.65 × 3.09 m). Hood Museum of Art, Dartmouth College, Hanover, NH (gift of James J. Meeker, Class of 1958, in memory of Lee English).**

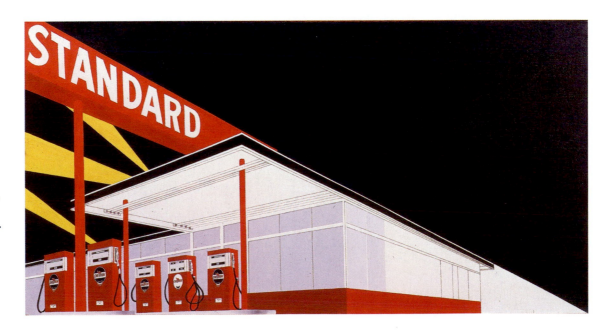

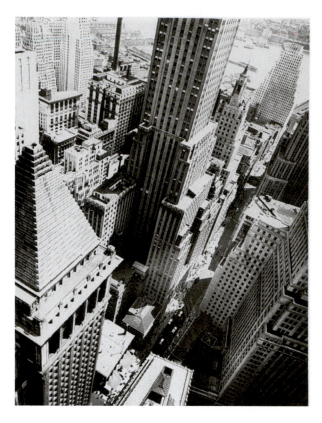

MULTIPOINT PERSPECTIVE

In perspective drawing the vertical edges of forms generally remain vertical. Sometimes a third vanishing point is added above (or below) the horizon so that the vertical parallels also taper and converge. This technique is useful to suggest great height, such as looking up at (or down from) a city skyscraper **(A)**.

Although city streets or a line of buildings might be laid out in orderly rectangular rows of parallel lines, often in real life a variety of angles will be present. This entails the use of **multipoint perspective**. Different objects will have separate

 A

Berenice Abbott. *Wall Street, Showing East River from Roof of Irving Trust Company.* **1938. Photograph. Museum of the City of New York.**

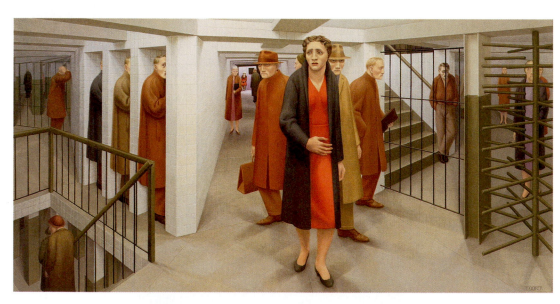

 B

George Tooker. *The Subway.* **1950. Egg tempera on composition board; sight: 1' 6⅛" × 3' ⅛" (46 × 91.8 cm), frame: 2' 2" × 3' 8" (66 × 111.8 cm). Whitney Museum of American Art, New York, 50.23. By permission of the artist c/o DC Moore Gallery, New York.**

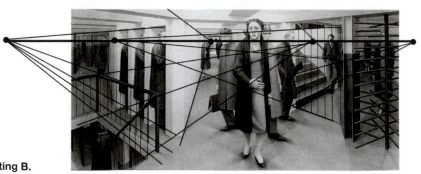

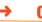 **C**

Diagram superimposed over painting B.

sets of vanishing points if they are not parallel to each other. If they are all on a plane parallel to the ground plane, all vanishing points will still be on a common horizon line. This can reproduce our visual experience where rarely in any scene are all the elements in neat, parallel placement. In the painting by Tooker **(B)**, the long corridors of the subway recede at several different angles from the center foreground. Each area thus has a different vanishing point **(C)**. The anxiety-producing feeling of the subway as a maze is clearly presented.

For Dynamic Spatial Effect

Multiple vanishing points create a dynamic spatial effect in a two-dimensional composition even when the composition is as abstract as the example seen in **D**. The source of this image may be architectural, but there are no representational details. The linear perspective leading to three vanishing points conveys the sense of space. Two vanishing points are on the horizon line. A third vanishing point (below the bottom of the picture) is implied by the converging vertical lines, suggesting a downward view.

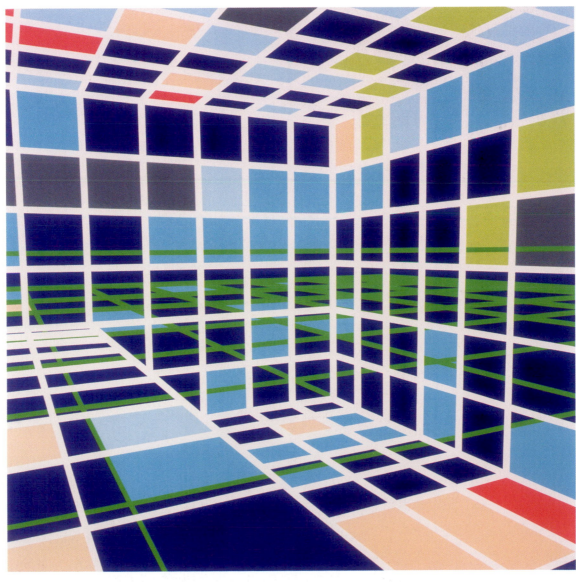

 D

Sarah Morris. *Pools–Crystal House (Miami).* **2002. Gloss household paint on canvas, 7' ¼" × 7' ¼" (214 × 214 cm). Courtesy Friedrich Petzel Gallery, New York.**

A DIFFERENT POINT OF VIEW

To introduce a dramatic, dynamic quality into their pictures, many artists have used what is called **amplified perspective**. This device reproduces the visual image but in the very special view that occurs when an item is pointed directly at the viewer.

Playing with Perspective

A familiar example is the old Army recruiting poster in which Uncle Sam's pointing finger is thrust forward ("I Want You") and right at the viewer. The same effect can be seen in **A**, in which the figure's legs are thrust directly at us. In this exaggerated example we are presented with the image of the feet being unbelievably large in **juxtaposition** with the body. The photograph heightens a phenomenon that we see in less-dramatic terms every day but to which we unconsciously adjust to conform to our knowledge of the human figure.

In Tony Mendoza's photograph **(B)**, we are presented with an unusual vantage point on a familiar subject. Here the stems of the plants, rather than the flowers, come toward the viewer. This camera angle from below gives us a fresh view and a "bug's-eye" glimpse of the garden.

The contrast of size we see in Yvonne Jacquette's painting in **C** creates an amplified space in a composition that might first capture our attention for its color, pattern, or shapes. The river and harbor make a large, essentially flat shape. The pattern of lights and shadows creates a jewel-like decorative effect. Against this surface composition an amplified perspective evokes a deep space. Individual windows on the foreground tower are as large as the distant image of the Statue of Liberty. This juxtaposition might be hard to hold in one view in actual experience, but a painting can render it visible.

→ A

Ad for Din Sko shoe store, Sweden. Agency: Inform Advertising Agency, Gothenburg. Art Director: Tommy Ostberg. Photo: Christian Coinberg.

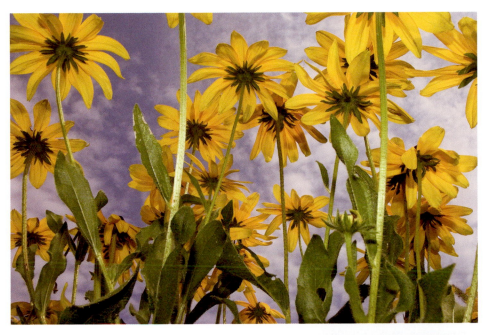

 B

Tony Mendoza. *Yellow Flowers.* **Photograph on 100% rag paper, 1' 9" × 2' 8".**

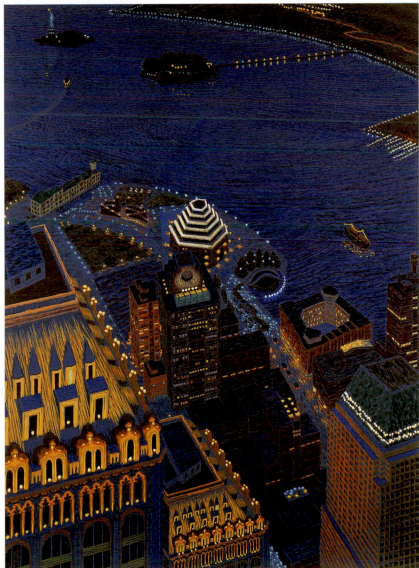

 C

Yvonne Jacquette. *Mixed Heights and Harbor from World Trade Center II.* **1998. Oil on canvas, 5' 10¼" × 4' 10⅜". Private collection, courtesy of DC Moore Gallery, New York.**

A PICTORIAL DEVICE

Looking at a figure or object from more than one vantage point simultaneously is called **multiple perspective**. Several different views are combined in one image. This device has been used widely in twentieth- and twenty-first-century art, although the idea is centuries old.

Multiple Perspective in Ancient Art

Multiple perspective was a basic pictorial device in Egyptian art, as illustrated in a typical Egyptian painted figure **(A)**. The artist's aim was not necessarily to reproduce the visual image but to give a composite image, combining the most descriptive or characteristic view of each part of the body. The Egyptians solved this problem by combining a side view of the head with a front view of the eye. Each body part is thus presented in its most characteristic aspect: a front view of the torso, a side view of the legs, and so forth.

The cubist painting by Ozenfant **(B)** is a more recent example of this approach. This modernist interpretation of a still life offers both the characteristic view of an oval opening for a cylindrical container, and the silhouette or "profile" view of a pot or decanter. Both views would not be possible from a single vantage point.

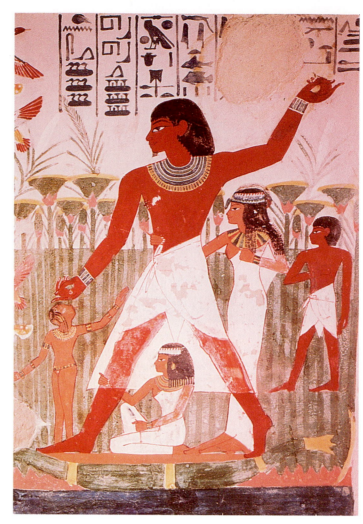

**Detail of Wall Painting in the Tomb of Nakht, Thebes. c. 1410 BC.
Victor R. Boswell, Jr., National Geographic photographer.**

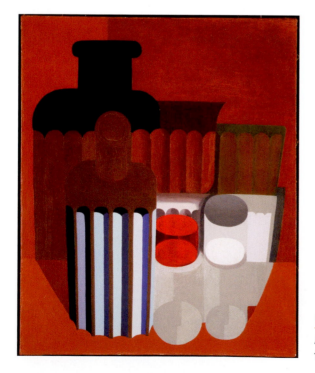

Amédée Ozenfant. *Glasses and Bottles.* **c. 1922–1926. Oil on canvas, 72.7 × 60.3 cm, frame: 90.5 × 78.4 × 6 cm.**

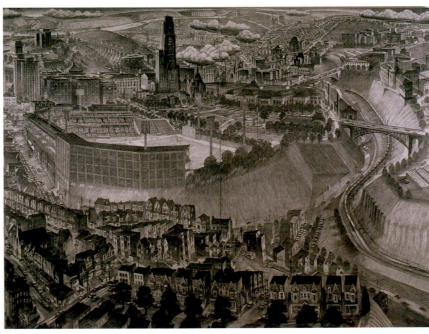

← **C**

Douglas Cooper. Portion of *Senator John Heinz Regional History Center Mural.* **(1992–1993). Courtesy of the artist.**

↓ **D**

David Hockney. *Brooklyn Bridge, November 28, 1982.* **Photographic collage, 9' 1" × 4' 10". Collection © David Hockney.**

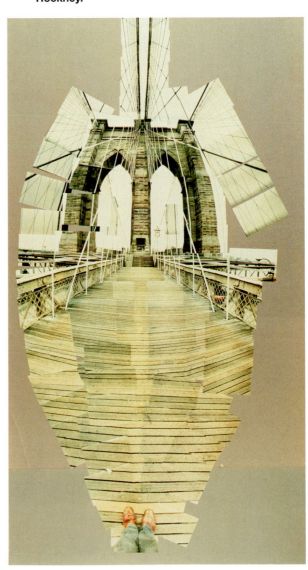

Since the twentieth century, with the camera able to effortlessly give the fixed visual ("realistic") view, artists have been free to explore other avenues of perception, including multiple perspective. Douglas Cooper employs multiple perspectives to capture a dramatic breadth of experiences in one two-dimensional composition **(C)**. The hilly, winding river valley of Pittsburgh is brought together in a mural where the space seems to bend and curve. The straight lines of linear perspective curve when a two-dimensional picture expands to hold more than the view of a single picture plane.

Straight lines yielding to a curved pattern are evident in David Hockney's photographic **montage** of the Brooklyn Bridge **(D)**. The point of view shifts from downward to forward to upward, creating multiple picture planes and multiple perspectives.

As you have noticed, multiple perspective does not give a clear spatial pattern of the position occupied by each element. This aspect has been sacrificed to give a more subjective, **conceptual** view of forms.

A SPATIAL ILLUSION

For centuries Asian artists did not make wide use of linear perspective. Another spatial convention was satisfactory for their pictorial purposes. In Oriental art, planes recede on the diagonal, but the lines, instead of converging to a vanishing point, remain parallel. Traditional Japanese prints such as **A** illustrate this device. The effect is different from Western perspective but certainly not disturbing. The order of parallel diagonals and many parallelogram shapes complements the flowing lines of the figures and robes. The space is clear to us with the use of overlap to reinforce our view.

↑ **A**

Nishikawa Sukenobu. *Woman and Child beside a Mirror Stand.* **c. 1740. Color woodblock print, sheet: 10¹⁄₁₆" × 14¹¹⁄₁₆" (25.6 cm × 37.4 cm).**

← **B**

Richard Meier. The Atheneum, New Harmony, Indiana. Axonometric. Graphite on tracing paper, 1' 9¼" × 1' 9" (54 × 53.3 cm). Gift of the architect. © 2009 Richard Meier.

Isometric Projection in the West

Isometric projection is used extensively in engineering and mechanical drawings. The drawing by Richard Meier **(B)** shows how an isometric drawing can give a sense of the three-dimensional form and space without the foreshortening or converging lines of perspective. Here the goal is to present the measurements along three axes. The lines do not recede to vanishing points (they remain parallel), and the spatial intervals do not foreshorten. So this gives some sense of three-dimensional space while maintaining the dimensions we would see in a plan or elevation.

An isometric projection is less commonly used among contemporary artists. The self-portrait by David Hockney **(C)** uses this device, and the change from the linear perspective is fresh and intriguing. Hockney has explored virtually every method of spatial organization mentioned in this chapter in prints, drawings, paintings, and photography.

The work by Josef Albers **(D)** uses this idea in a purely abstract way. The artist creates a geometric shape drawn in an isometric-type view. The interesting aspect of the design, however, is the shifting, puzzling spatial pattern that emerges. The direction of any plane seems to advance, then recede, then to be flat in a fascinating **ambiguity**.

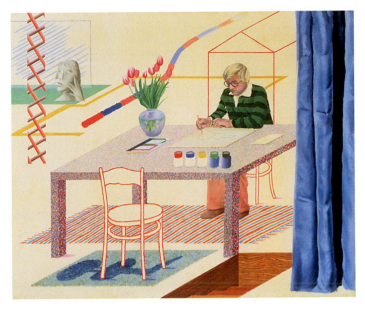

↑ **C**

David Hockney. *Self-Portrait with Blue Guitar.* **1977. Oil on canvas, 5' × 6' (1.52 × 1.83 m).**

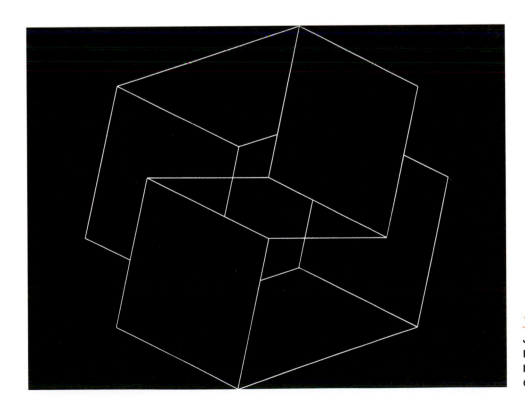

← **D**

Josef Albers. *Structural Constellation II.* **c. 1950. Machine-engraved vinylite mounted on board, 1' 5" × 1' 10½" (43.2 × 57.1 cm). Collection, The Josef Albers Foundation.**

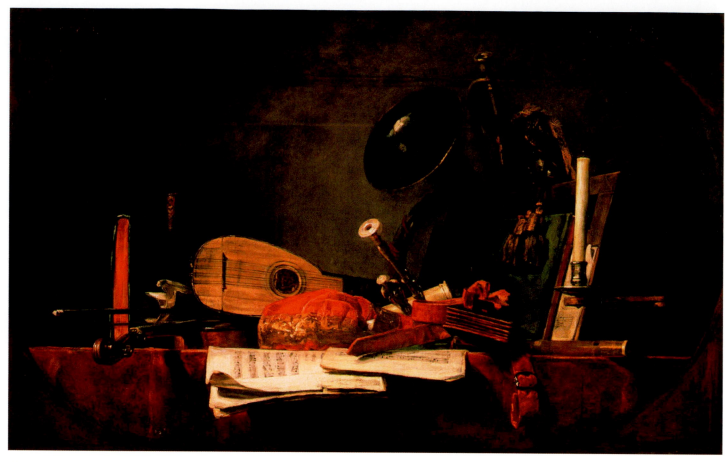

↑

Jean-Baptiste-Siméon Chardin. *The Attributes of Music.* **1765. Oil on canvas, 2' 11⅞" × 4' 8⅞" (91 × 145 cm). Musée du Louvre, Paris, France.**

THE CONCEPT OF ENCLOSURE

One other aspect of pictorial space is of concern to the artist or designer. This is the concept of enclosure, the use of what is referred to as **open form** or **closed form**. The artist has the choice of giving us a complete scene or merely a partial glimpse of a portion of a scene that continues beyond the format.

Exploring Closed Form

In **A** Chardin puts the focal point in the center of the composition; thus our eyes are not led out of the painting. The still life of musical instruments and sheet music is effectively framed by the curved border of the picture, which echoes the many ovals in the composition. The book on the left and the candle on the right bracket the composition and keep our attention within the picture. This is called closed form.

Picasso demonstrates that closed form is not a concept limited to representational subject matter. All of the shapes are contained within **B**, and just as Chardin's painting is composed of oval shapes within an oval frame, Picasso's is dominated by rectilinear shapes within a rectilinear frame.

Exploring Open Form

The ultimate extension of the open-form concept is illustrated in **C**. This painting breaks out of a rectangular format and effectively destroys any framed, or contained, feeling. In fact, shapes within the painting extend outward, and the white wall creates shapes that cut into the painting but also expand to include a field well beyond the painting's boundary. This painting has much in common with Picasso's but seems to have burst out of conventional containment.

It may be most surprising to encounter open form when the subject is the human figure. Figures are often cropped in the action photographs of athletes, and this suggests the dynamics of sports. A cropped figure can also simply suggest a unique point of view. The print by Alex Katz shown in **D** is cropped to form an unexpected composition. The open form implies a figure beyond the picture, while emphasis is given to an unusual focus on the feet.

As you can see, closed form generally gives a rather formal, structured appearance, whereas open form creates a casual, momentary feeling, with elements moving on and off the format in an informal manner.

 C

Elizabeth Murray. *Keyhole.* 1982. Oil on canvas, 8' 3½" × 9' 2½". Agnes Gund Collection, New York.

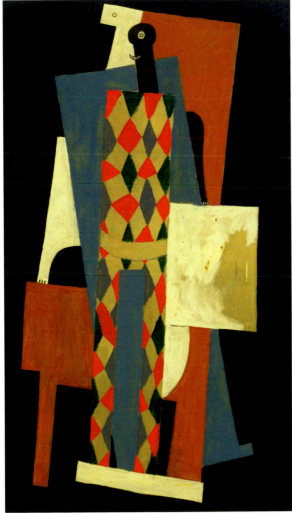

 B

Pablo Picasso. *Harlequin.* Paris, late 1915. Oil on canvas, 6' ¼" × 3' 5⅜" (183.5 × 105.1 cm).

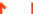 D

Alex Katz. *Ada's Red Sandals.* 1987. Oil on canvas, 4' × 5'. Alex Katz Studio II, New York. Art © Alex Katz/Licensed by VAGA, New York, New York.

EQUIVOCAL SPACE

Most art in the twentieth and twenty-first centuries has not been concerned with a purely naturalistic reproduction of the world around us. Photography has provided a way we can all record appearance in a picture. This is true in the area of spatial and depth representation also. Many artists have chosen to ignore the device of overlapping. Instead, they have used what is called **transparency**. When two forms overlap and both are seen completely, the figures are assumed to be "transparent" **(A)**.

Interest in Ambiguity

Transparency does not give us a clear spatial pattern. In **B** we are not sure which plane is on top and which behind. The spatial pattern can change as we look at it. This purposeful ambiguity is called **equivocal space**, and many artists find it a more interesting visual pattern than the immediately clear spatial organization provided by overlapping in a design.

There is another rationale for the use of transparency. Just because one item is in front of and hides another object does not mean the item in back has ceased to exist. In **B** a bowl of fruit is depicted with the customary visual device of overlapping. In **C** the same bowl of fruit is shown with transparency, and we discover another piece of fruit in the bottom of the bowl. It was always there, simply hidden from our view. So, which design is more realistic? By what standards do you decide?

 A

The use of overlapping with transparency confuses our perception of depth.

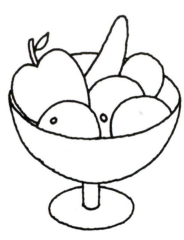

 B

Overlapping sometimes can be deceptive.

 C

The use of transparency reveals what is hidden by overlapping.

Exploring Equivocal Space

The sweatshirt design in **D** was created to celebrate a fifth anniversary. The letters spelling "Five" are clear, but they overlap and become transparent with differing patterns and values. The design takes a simple theme and creates an interesting pattern from a few elements.

Spatial ambiguity can also be suggested through the use of open form. A large *X* seems to expand beyond the boundaries of the rectangle in **E**. The same composition can be seen in a moment of figure/ground reversal to be four small triangular shapes against a yellow ground. A spatial ambiguity is created in this reversal.

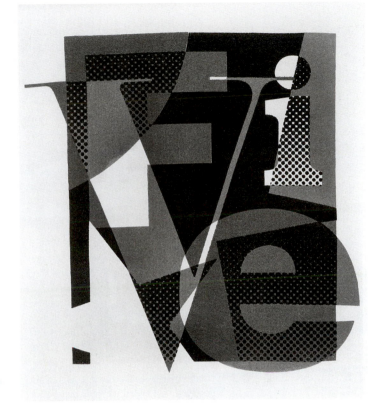

 D

Sweatshirt design for a fifth anniversary. 1990. Designer: Jennifer C. Bartlett. Design firm: Vickerman-Zachary-Miller (VZM Transystems), Oakland, California.

 E

Al Held. *Yellow.* 1956. Acrylic on paper mounted on board, 57.5 × 77.5 cm. Kunstmuseum Basel, Kupferstichkabinett. (Legat Anne-Marie and Ernst Vischer-Wadler, 1995). Art © Al Held Foundation/Licensed by VAGA, New York, New York. Photo: Oeffentliche Kunstsaammlung Basel, Martin Buhler.

↑ **A**

Pieter Bruegel the Elder. *The Harvesters.* **1565. Oil on wood; overall, including added strips at top, bottom, and right: 3' 10⅞" × 5' 3¾" (119 × 162 cm), original painted surface: 3' 9⅞" × 5' 2⅞" (116.5 × 159.5 cm). The Metropolitan Museum of Art, Rogers Fund, 1919.**

COMPLEXITY AND SUBTLETY

Two-dimensional art and design are by definition flat. Unlike the realms of sculpture and architecture, space in two-dimensional art forms can only be implied. This leaves the artist and designer with a range of spatial clues and techniques with a similar range of expressive potential. A flat graphic design may pack a punch for a poster or abstract painting. A complex space may lead a viewer into the subtle depths of a landscape painting.

When we look at the painting by Bruegel **(A)**, we are drawn into space that moves from intimate to vast and deep. In the foreground we observe the details of a scene of workers at leisure. Nearly every spatial device we can think of leads us back through an unfolding and interesting landscape:

As we move up the picture plane we also move back in space. Foreground figures and trees are larger.
The trimmed edges of the hayfield follow the rules of linear perspective.
The rolling ground plane offers many instances of overlapping.
The atmosphere softens forms in the distance: value contrast diminishes, and colors become cool and subtle.

Bruegel's painting tells us much about life in the sixteenth century, but it also tells us much about the potential for painting to evoke space.

Gérôme's painting **(B)** offers a similar list of spatial devices but in a much more staged tableau. In fact we sense this deliberate orchestration of the space, as though a director is at work on his production. The use of red to grab foreground attention is theatrical and almost abstract. We may even sense some kinship between this figurative painting and the nonobjective painting **C** in the way that black, white, and red contrast with muted grays.

John McLaughlin's painting **(C)** offers a stunning contrast to pictorial representation. By the mid-twentieth century, painting had been long liberated from illustrative space by photography. That does not mean that a crisply two-dimensional and geometric composition can't offer an experience akin to that of space and depth. The planes can suggest overlap, horizon, boldly advancing color, subtly dissolving values, and a shifting sense of which plane advances or retreats. This reading of the relationships occurs over time, and movement or change over time implies space.

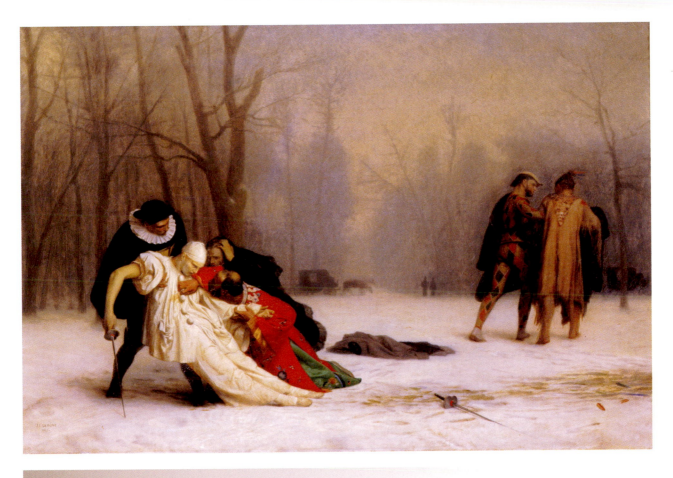

 B

Jean-Léon Gérôme. *The Duel after the Masquerade.* 1857–1859. Oil on canvas, 1' 3⅜" × 1' 10⅜" (39.1 × 56.3 cm).

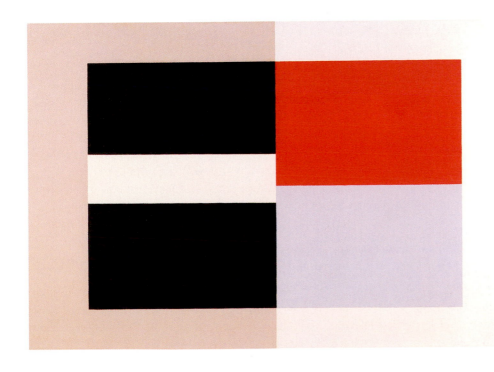

 C

John McLaughlin. *Y-1958.* 1958. Oil on canvas, 2' 8" × 4'. Addison Gallery of American Art, Phillips Academy, Andover, Massachusetts (1995).

Sam Gross.
The Museum of Modern Art Book of Cartoons. In association with
The Cartoon Bank: A New Yorker Magazine Company.

CHAPTER 11 ILLUSION OF MOTION

STILLNESS AND ARRESTED ACTION

Relative Stillness

Almost every aspect of life involves constant change. We humans cannot sit or stand motionless for more than a moment or so; even in sleep we turn and change position. But if we could stop our body movements, the world about us would continue to change. Thus motion is an important consideration in art.

A deceptive stillness characterizes Vermeer's painting *Kitchen Maid* **(A)**. This might (at first glance) be seen as the equivalent of a photograph taken at a fast shutter speed, say, 125th of a second. Now consider that the milk is *moving* as the woman pours it, and we sense that the duration of the picture might be a brief interval of time longer than a split second.

Gérôme's painting **(B)** is certainly not a quiet moment shared by the viewer. In this stage-like tableau the artist picks an important moment from an unfolding drama that encapsulates the story. The Harlequin character and his companion move off, while Pierrot is caught as he collapses.

↑ **A**

Johannes Vermeer. *The Kitchen Maid.* **c. 1658. Oil on canvas, 45.5 × 41 cm. Rijksmuseum, Amsterdam.**

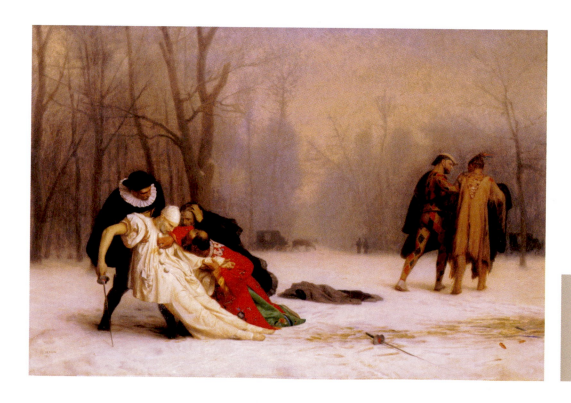

← **B**

Jean-Léon Gérôme. *The Duel after the Masquerade.* **1857–1859. Oil on canvas, 1′ 3⅜″ × 1′ 10³⁄₁₆″ (39.1 × 56.3 cm).**

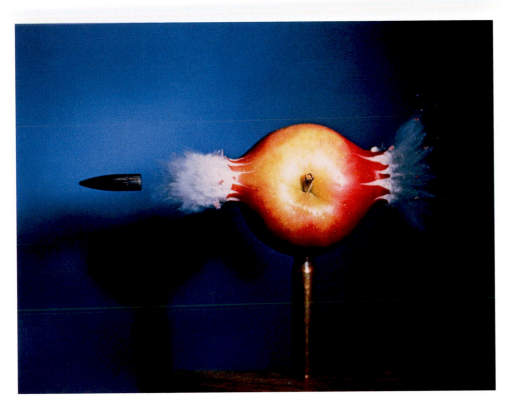

Harold Edgerton. *Making Applesauce at MIT (.30 Bullet Piercing an Apple).* **1964. Photograph.** © Harold & Ester Edgerton Foundation, 2007, courtesy of Palm Press, Inc.

→ **D**

Henri Cartier-Bresson. 1932. Paris, France. Place de l'Europe. Gare Saint Lazare.

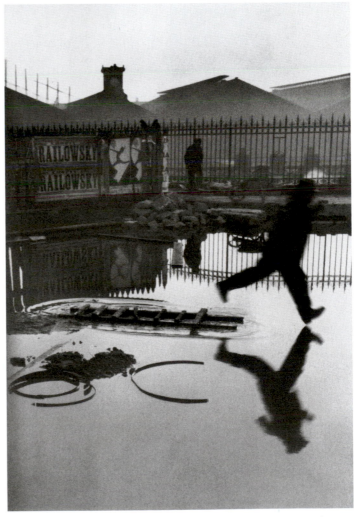

Depicting the Transient

Photography has made visible images that are otherwise invisible to us due to a motion too rapid for the eye to perceive. Now an event that exists for a millisecond can be revealed to us. Harold Edgerton's photograph of a bullet piercing an apple **(C)** is one such example. Edgerton pioneered techniques of strobe lighting, which coordinates the camera with an instant of light to capture such images.

Photography also makes possible the imagery of a "decisive moment." This is the term Henri Cartier-Bresson used to describe the moment captured in photographs such as **D**. While film and video may satisfy our desire for experiencing rapid or graceful movement, painting and photography offer a singular moment—one that lingers on for our continued inspection and appreciation.

SEEING AND FEELING IMPENDING ACTION

Much of the implication of movement present in art is caused by our memory and experience. We recognize temporary, unstable body positions and realize that change must be imminent. This anticipation is not limited to images of the human figure. The red square in **A** is in a dynamic position poised at an angle as if ready to tumble. Example **B** (a later step in Lissitzky's series) shows that this is what the artist had in mind as all the forms have changed or moved and new ones have entered the space.

Kinesthetic Empathy

In a process called **kinesthetic empathy**, we tend to re-create unconsciously in our own bodies the actions we observe. We actually "feel" in our muscles the exertions of the athlete or dancer; we simultaneously stretch, push, or lean, though we are only watching. This involuntary reaction also applies to static images in art, where it can enhance the feeling of movement.

A feeling of **anticipated movement** can be enhanced by implied lines and gestures. Thus in **C** the figures are about to complete their actions, and the dynamics are accentuated by the diagonal (active) lines in the composition.

In each of the preceding examples, a tense space is left unresolved. A small space separates the tumbling square in **A**, and a similar small space separates foot-from-base, and ball-from-glove in **C**. A desire for resolution triggers our response.

↑ **A**

El Lissitzky. *Of Two Squares: A Suprematist Tale in Six Constructions.* **1922. Illustrated book with letterpress cover and six letterpress illustrations, 10¹⁵⁄₁₆" × 8⅞" (27.8 × 22.5 cm). Publisher: Skify, Berlin.**

↑ **B**

El Lissitzky. *Of Two Squares: A Suprematist Tale in Six Constructions.* **1922. Illustrated book with letterpress cover and six letterpress illustrations, 10¹⁵⁄₁₆" × 8⅞" (27.8 × 22.5 cm). Publisher: Skify, Berlin.**

Baseball photo.

← **A**

Krishna Revealing His Nature as Vishnu. Miniature from Malwa, India. c. 1730. Gouache or watercolor on paper, 8" × 1' 2¾" (20 × 38 cm). Victoria and Albert Museum, London. Crown Copyright.

FIGURE REPEATED, FIGURE CROPPED

Figure Repeated

Over the centuries artists have devised various conventions to present an illusion of motion in art. One of the oldest devices is the **repeated figure**. The figure of Krishna appears over and over in different positions and situations in the Indian miniature **(A)**. This convention has been used in many cultures to form a "storyboard" that conveys a narrative over time (and the implied movement.) In fact, storyboards are still used by filmmakers and animators as a step in planning a production. One such contemporary example is **B** where the artist not only repeats the figure but varies our viewpoint to heighten the sense of movement.

↑ **B**

Lola Moreno and Ramon Rosanas. *Coca Cola Storyboard.*

Figure Cropped

A second dramatic way to express motion is by cropping the figure. The composition in **C** effectively crops the lunging basketball player to enhance the feeling of movement. The head and basketball are barely contained in the frame and form a tense line spanning the picture. The forward leg is cropped, heightening the sense of the player bursting through the confines of the frame. In this case the framing rectangle is essential to the suggestion of motion.

Comic strips employ both techniques of figure repetition and figure cropping to create a sense of motion. Bill Watterson's *Calvin and Hobbes* was rich and varied in the application of these devices to bring life to Calvin's real and imagined worlds **(D)**.

↑ **C**

Taliek Brown of the University of Connecticut. December 10, 2002. Photograph.

↑ **D**

Bill Watterson. *Calvin and Hobbes.* **© 1985. Reprinted with permission of Universal Press Syndicate. **

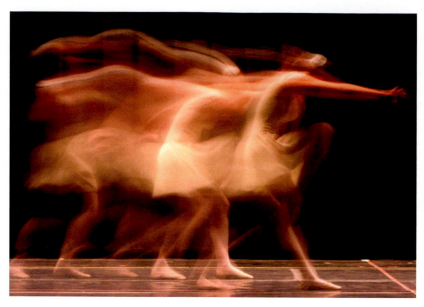

 A

Elliot Barnathan. *Study in Motion.* **Digital photograph.**

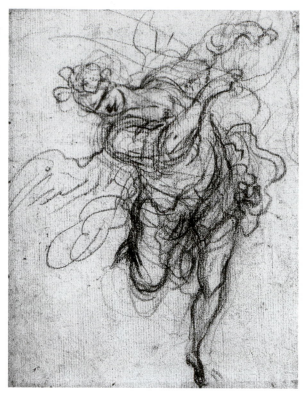

 B

Anonymous (Italian or Spanish). *Angel (Dancing Figure).* **16th century. Red chalk on cream paper, 6¾" × 5⁵⁄₁₆" (17.1 × 13.5 cm). The Metropolitan Museum of Art, gift of Cornelius Vanderbilt, 1880.**

BLURRED OUTLINES AND FAST SHAPES

We readily interpret a photograph such as **A** to be signifying movement because of the **blurred outlines**. With a fast shutter speed, moving images are frozen in "stop-action" photographs. When the shutter speed is relatively slow, the figure becomes a blurred image that we read as an indication of the subject's movement. This is an everyday visual experience. When objects move through our field of vision quickly, we do not get a clear mental picture of them. A car will pass us on the highway so fast that we perceive only a colored blur. Details and edges of the form are lost in the rapidity of the movement. In the case of **A**, this effect is used to convey a sense of grace associated with dance.

 C

Siena.

 D

Patriots logo.

The figure in the sixteenth-century Italian drawing in **B** also suggests movement in this way. The dancing figure is drawn with sketchy, incomplete, and overlapping lines to define her form and evoke the gestures of the movements.

Graphic design is also compelled to suggest movement in two dimensional and static media. Not all solutions are for the TV, film, or touch-screen audiences. Posters and print media still require solutions that evoke movement and a sense of strong visual dynamics. One obvious client requiring such solutions is a sports team. Both **C** and **D** convey speed through shapes that tail off like a streaking comet. In this case the mascots do not suggest speed (a Saint Bernard or a Patriot) but the shapes do!

Shapes that evoke speed are a staple of car design—especially the exaggerated features of a custom car (**E**). The Italian Futurists, as early as the 1920s, said that the speeding automobile had replaced Venus de Milo as a standard of beauty. Even when parked at the curb, a "street rod" such as the one in **E** expresses speed through its long, sweeping lines. Positioning the car on the diagonal in this photograph emphasizes these lines. This romance with movement and technology led to the streamlining of even utilitarian objects such as toasters and telephones, which would never speed down a highway or fly through the sky.

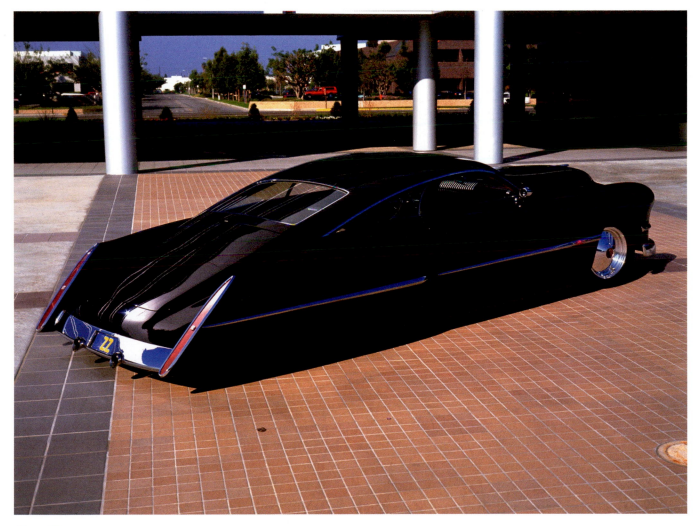

↑ **E**

Larry Erickson and Billy F. Gibbons (designers). *CadZZilla.* **1989. Custom automobile.**

MULTIPLE IMAGE

Another device for suggesting movement, called **multiple image**, is illustrated in **A**. When we see one figure in an overlapping sequence of poses, the slight change in each successive position suggests movement taking place. The photograph in **A** is from the 1880s. The photographer, Thomas Eakins, was intrigued with the camera's capabilities for answering the visual problem of showing movement and analyzing it.

In **B** multiple figures suggest motion in a single instant. In this case the repetition and overlap of many very similar and synchronized figures create the illusion. The foreground figures seem to emerge from the light, and the rhythm of repeated shadows and faces sets a pulse or beat to the parade.

Lines of Force

Painters of the twentieth and twenty-first centuries have often been concerned with finding a visual language to express the increasingly dynamic quality of the world around us. Although at first glance very different, Duchamp's famous *Nude Descending a Staircase* (**C**) is much like the two photographs. Again, multiple images of a figure are shown to suggest a body's movement in progress. Now the body forms are abstracted into simple geometric forms that repeat diagonally down the canvas as the nude "descends." Many curved lines (called **lines of force**) are added to show the pathway of movement.

Grouping Multiple Images

The group of photographs in **D** is a collection of six similar subjects from different sources. They have the effect of a "multiple image" and create movement across the grid. A sense of motion is created like that of an old film or a flicker book.

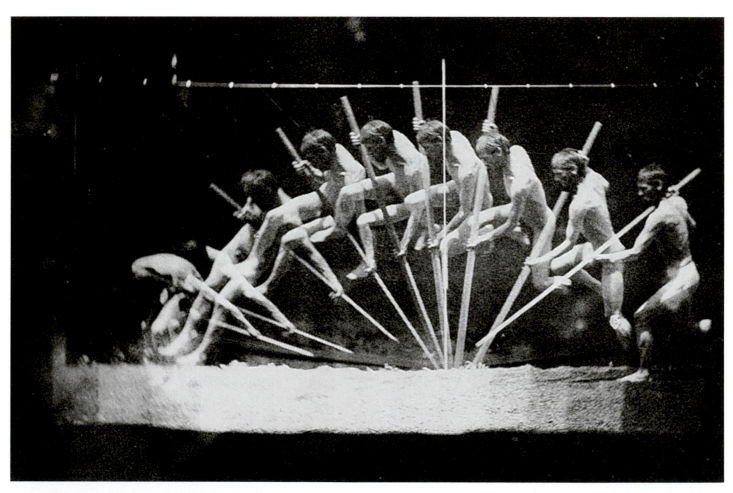

 A

Thomas Eakins. *Pole Vaulter: Multiple Exposure of George Reynolds.* **c. 1884. Photograph, 9.5 × 12.3 cm. The Metropolitan Museum of Art, New York (gift of Charles Bregler, 1941).**

 B

Feng Li. *Beijing Celebrates the 60th Anniversary of New China.*

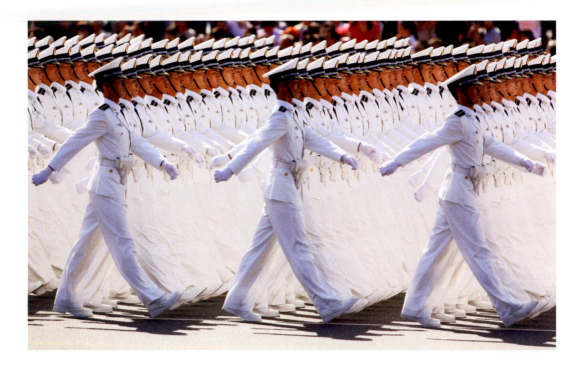

 C

Marcel Duchamp. *Nude Descending a Staircase, No. 2.* 1912. Oil on canvas, 4' 10" × 2' 11" (1.47 × 0.89 m). Philadelphia Museum of Art (Louise and Walter Arensberg Collection).

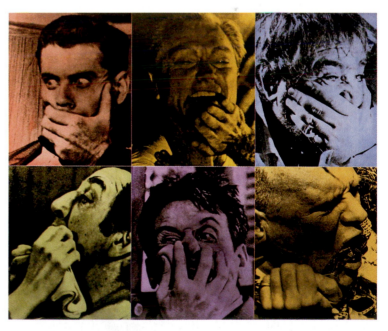

 D

John Baldessari. *Six Colorful Gags (Male).* 1991. Photogravure with color aquatint and spit bite aquatint, 3' 11" × 4' 6". Edition 25. Crown Point Press, San Francisco.

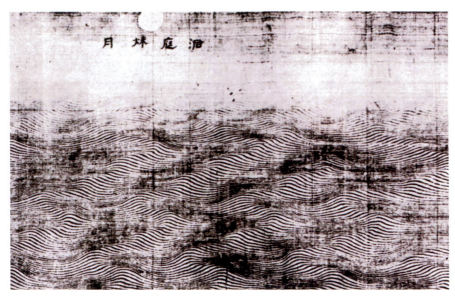

↑ **A**

Unknown Chinese artist. *A Wave under the Moon.* **12th century. Ink on silk, detail of a scroll.**

AFTERIMAGE AND EYE MOVEMENT

Several techniques have been presented for capturing movement or depicting it in two-dimensional media. The understanding is that static art and design forms such as drawing, painting, prints, and graphic design *can't* actually move—*but* the eye can move, or the image on the retina can flicker, and graphic elements can induce these movements.

As early as the twelfth century, a Chinese artist understood how to create movement for the restless eye. The tapering and undulating lines and spaces in **A** trigger just such a visual effect. Flowing water and other natural forces are part of a rich vocabulary for Chinese landscape art.

A poster for a jazz festival **(B)** is a striking example of optical movement through the flickering effects of afterimage. The intersections of the grid are literally light circles. So why does our eye jump around in search of black circles we *think* we are seeing? The intersections of a grid create a flashbulb-like afterimage. This effect is well suited to the scale of the pages of this book and should be easy to see.

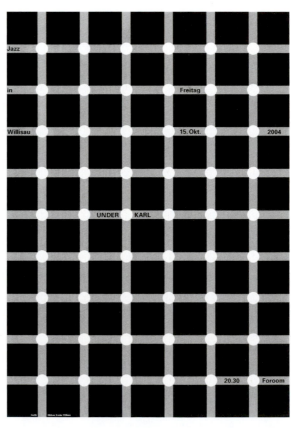

↑ **B**

Niklaus Troxler. *Underkarl.* **2004. Jazz concert poster.**

Intense colors can also induce such eye movement as our eye struggles to focus on different colors simultaneously. In addition to that, the retina will fatigue from exposure to a strong color, and as we glance away an afterimage will flicker. This creates a jumpy movement in the quilt shown in **C**. Since this is a crib quilt we can only hope the baby wasn't looking at it while trying to fall asleep! Picasso's painting **(D)** bears a striking similarity to the quilt, and we can imagine the tumbling movement set off by the harlequin pattern were we standing in front of the painting at full size.

See also *Chapter 6: Rhythm*.

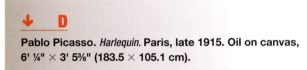

↓ D

Pablo Picasso. *Harlequin.* **Paris, late 1915. Oil on canvas, 6' ¼" × 3' 5⅜" (183.5 × 105.1 cm).**

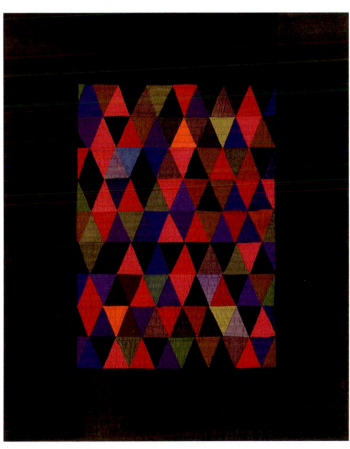

 C

Triangles crib quilt. c. 1930. 3' 5" × 2' 9". Kalona, Iowa.

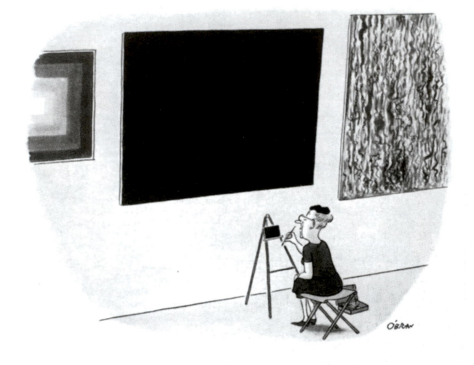

William O'Brian.
The Museum of Modern Art Book of Cartoons. In association with
The Cartoon Bank: A New Yorker Magazine Company.

CHAPTER **12** VALUE

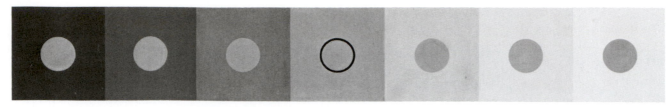

↑ **A**

A value scale of gray. The center circles are identical in value.

↑ **B**

Ardine Nelson. *DoubleFrame Diana #2103.* **Hand colored black and white silver print, 1' 8" × 2' 6".**

LIGHT AND DARK

Value is simply the art and design term for light and dark. Our perception of figure and ground depends on relationships of light and dark. The page you are reading now is legible only because the darkness of the type contrasts with the lightness of the background paper. In reduced light our visual perception is more dependent on value than color.

Illustration **A** is a scale of seven values of gray. These are termed **achromatic** grays, as they are mixtures of only black and white; no color is used.

The Relationship between Light and Dark Areas

The term **value contrast** refers to the relationship between areas of dark and light. Because the scale in **A** is sequential, the contrast between any two adjoining areas is rather slight and is termed low-value contrast. The center gray circles are all the same middle value. It is interesting to note how this consistent center gray *seems* to change depending on the background. Indeed, it is hard to believe that the circles on the far left and

far right are precisely the same value. The surrounding value influences our perception of the middle gray: against the light it appears relatively dark, and against the dark it appears relatively light.

The scale in **A** shows only seven steps. Theoretically, between black and white there could be an almost unlimited number of steps. Studies have shown that the average eye can discern about forty variations in value. The artist may use as many or as few values as her or his artistic purposes dictate, though at times the nature of the chosen medium may influence the result. The photograph of architectural details by Ardine Nelson **(B)** demonstrates a rich range of values between the extremes of light and dark. This is the result of the right subject perceived under optimum lighting and the artist's skills. The exposure, the relationship between the limits of the film and the lens, and the developing process all are controlled. To achieve such a rich value range (possible with even a simple camera), a photograph is not merely "taken"; it is made.

The wash drawing shown in **C** reveals the artist's hand through evident brushstrokes. A full range of values and many subtle transitions as well as strong contrasts are registered. The white paper acts as both light on the figure and the space enveloping the figure. The values of wash pull the figure out of the surrounding ground.

Notice the striking contrast **D** offers to **C**. Here the value contrasts are extremely close and at the limits of our perception. This sets a different tone demanding an attentive audience and slow viewing in keeping with this artist's lifelong project. Earlier paintings from this series offered more contrast. The series has evolved over the decades and the white numbers are now painted on a nearly white ground as he continues the counting sequence. Roman Opalka considers all of the paintings to be one work in many parts. When seen this way, the artwork actually embraces a full range of values with perhaps *more* steps and gradations than **B**, or **C**.

→ **C**

Susan Moore. Mixed media on paper, 1' 2" × 11".

↑ **D**

Roman Opalka. 1965. Acrylic on canvas. 6' 5⅛" × 4' 5⅒" (196 × 135 cm).

VARIATIONS IN LIGHT AND DARK

In describing paintings or designs, we speak often of their **value pattern**. This term refers to the arrangement and the amount of variation in light and dark, independent of the colors used.

For the purpose of seeing the dramatic value pattern in Artemisia Gentileschi's painting **(A)**, a black and white photograph is revealing. The emphasis on a dark ground and slashing diagonal light shapes is perfectly tuned to the dramatic subject matter and consistent with the theatricality of Baroque painting.

Balance by Value Distribution

Despite their obvious difference in style, the paintings we have been returning to by Gérôme and Picasso **(B** and **C)** have a common value range. Both run the scale from nearly white to black. Gérôme's *Duel after the Masquerade* **(B)** seems to play each note of the scale, where Picasso's *Harlequin* **(C)** offers fewer (but relatively equal) steps between the extremes. The Picasso painting is very balanced in the distribution of values, and the Gérôme painting is weighted to the left where the greatest contrast exists. Picasso's painting does not feel unbalanced, however, as the action depicted moves from left to right and diminishes like a piece of music that ends quietly rather than with a bang. What a difference this pattern makes in contrast with the drama of **A**!

↑ **A**

Artemisia Gentileschi. *Judith Decapitating Holofernes.* **c. 1620. Oil on canvas, 5' 10" × 5' (199 × 152.5 cm). Galleria degli Uffizi, Florence, Italy.**

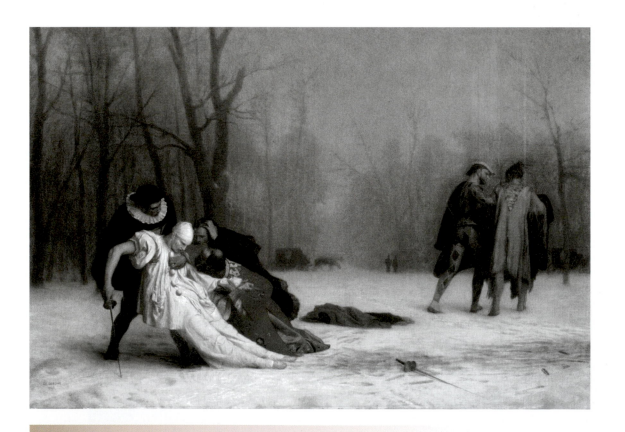

↑ **B**

Jean-Léon Gérôme. *The Duel after the Masquerade.* **1857–1859. Oil on canvas, 1' 3⅜" × 1' 10⁹⁄₁₆" (39.1 × 56.3 cm).**

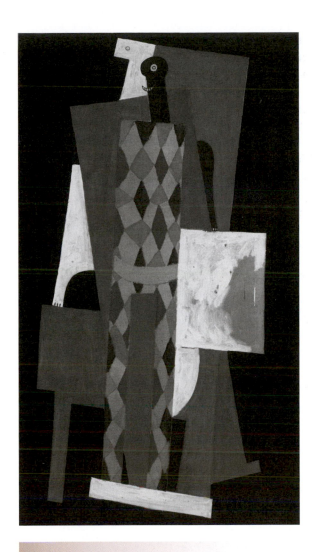

↑ **C**
Pablo Picasso. *Harlequin.* **Paris, late 1915. Oil
on canvas, 6' ¼" × 3' 5⅝" (183.5 × 105.1 cm).**

↑ **D**
**The values of the pink and green shapes are close to the value of
the expanse of gray.**

The Relationship between Value and Color

Value and color are related. Every color is, in itself, also simultaneously a certain value. Pure yellow is a light (high-value) color corresponding to a very light gray in terms of light reflection. Purple is basically a dark, low-value color that would match a very dark gray. A pure red will fall in the middle of the value scale.

The painting by Henri Matisse appears to be decidedly unbalanced if we view it in black and white **(D)**. A large part of the painting melts into middle gray. The color reproduction **(E)** reveals strong greens and pinks and a balanced composition. These contrasts disappear in the black and white photograph because of the colors' similar middle values.

See also *Properties of Color: Value*, page 262.

↑ **E**
Henri Matisse. *The Piano Lesson.* **1916. 8' ½" × 6' 11¾"
(245.1 × 212.7 cm).The Museum of Modern Art, New York.**

CREATING A FOCAL POINT

A valuable use of dark-and-light contrast is to create a focal point or center of attention in a design. A visual emphasis or "starting point" is often desired. A thematically important character or feature can be visually emphasized by value contrast. High dark-and-light contrast instantly attracts our attention because of **value emphasis**. By planning high contrast in one area and subdued contrast elsewhere, the artist can ensure where the viewer's eye will be directed first.

Homer's watercolor of a leaping trout **(A)** emphasizes the trout through value contrast. The light underbelly stands out against the dark background, and the darker tail stands out against the backdrop of reflected light on the water.

The etching in **B** places emphasis on the light window at the right-hand side of the composition. Our eye follows the path of the gentle light to the softly illuminated figure grouping of the Holy Family. All other features of the interior melt into the darkness as we move away from that spot.

An Experiment in Value Contrast

Strong contrast of value creates an equal emphasis in both **C** and **D**. These photographs have precisely the same vantage point and appear almost like a positive and negative of the same image. In reality the artist has collaborated with nature to produce two striking images of contrast. In **C** a wet sycamore stick is seen against the snow. The photograph in **D** shows the same stick the next day, stripped of its bark, against the ground after the snow has melted away. In each case the form of the branch stands in contrast to the ground, but for very different reasons!

↑ **A**

Winslow Homer. *Leaping Trout.* **1889. Watercolor on paper, 1' 1⅞" × 1' 7". Portland Museum of Art, Portland, Maine (bequest of Charles Shipman Payson).**

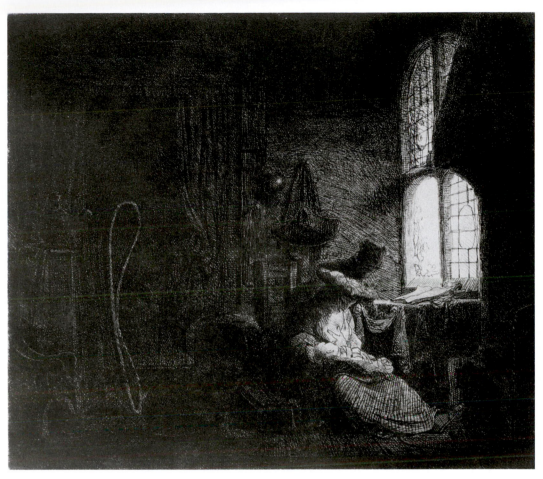

↑ **B**

Ferdinand Bol. *Holy Family in an Interior.* **1643. Etching, drypoint and engraving; sheet: 7³⁄₁₆" × 8½"**
(18.21 × 21.59 cm). The Metropolitan Museum of Art, The Elisha Whittelsey Collection, The Elisha
Whittelsey Fund, 1995.

↑ **C**

Andy Goldsworthy. Photograph, January 1981. *Sycamore stick*
placed on snow/raining heavily. **Middleton Woods, Yorkshire. From**
Andy Goldsworthy: A Collaboration with Nature **(New York: Harry N.**
Abrams, 1990).

↑ **D**

Andy Goldsworthy. Photograph, January 1981. *Snow gone by next*
day, bark stripped, chewed and scraped off. **Middleton Woods, York-**
shire. From *Andy Goldsworthy: A Collaboration with Nature* **(New York:**
Harry N. Abrams, 1990).

USING VALUE TO SUGGEST SPACE

One of the most important uses of gradations of dark and light is to suggest volume or space.

On a flat surface, value can be used to impart a three-dimensional quality to shapes. During the Renaissance the word **chiaroscuro** was coined to describe the artistic device of using light and dark to imply depth and volume in a painting or drawing. Chiaroscuro is a combination of the Italian words for "light" and "dark." A drawing using only line is very effective in showing shapes. By varying the weight of the line, an artist may imply dimension or solidity, but the effect is subtle. When areas of dark and light are added, we begin to feel the three-dimensional quality of forms. This is apparent in Sidney Goodman's figure drawing **(A)**. The top portion of the figure is fully modeled with the light falling across the upraised arms revealing a roundness of form in contrast to the flat linear quality of the lower portion of the drawing. The watercolor in **B** shows how effectively the feeling of volume and space can be presented. Here the representational source is undulating paper, but the subject is space and light. Paper and wall interchange in relationships of lighter-than and darker-than.

Value and Atmospheric Perspective

Far-off objects visually become less distinct and are absorbed into the atmosphere as the distance increases. In art this is called **aerial**, or atmospheric, **perspective**. High-value contrast seems to come forward, to be actually closer, whereas areas of lesser contrast recede or stay back, suggesting distance. This effect is commonly illustrated with sweeping landscape paintings (as it is in this book in other sections), but the photograph seen in **C** shows this effect to be true in other more unconventional circumstances. Notice how the foreground objects have very dark values unlike those in the middle and far distances as objects are affected by the white haze.

Physical Space and Psychological Space

In **D** the artist Sue Coe has used the values to create zones of light and darkness. Coe creates both the literal space of the hotel room and the troubled psychological space that Charlie Parker occupied in his short life. Although the composition is divided into two contrasting areas, there is a remarkable range of values in each.

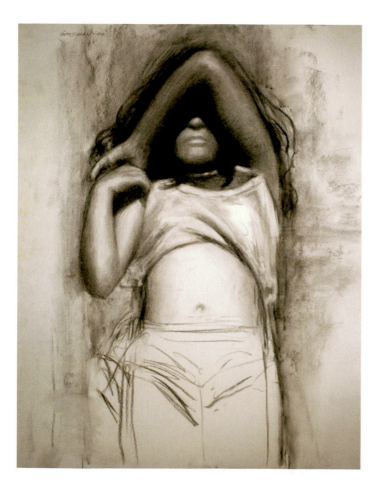

 A

Sidney Goodman. *Maia with Raised Arm.* **2000. Charcoal on paper, 2' 5" × 1' 11".**

 B

Sue Hettmansperger. *Untitled Drawing.* **1975. Watercolor and pencil, 1' 11" × 2' 1" (58 × 64 cm). Collection of North Carolina National Bank.**

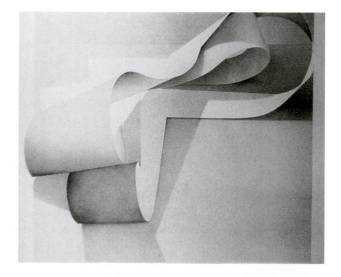

← C

Edward Burtynsky. *Shipbreaking #10, Chittagong, Bangladesh.* **2000. Photograph. Charles Cowles Gallery, New York.**

→ D

Sue Coe. *Charlie Parker Watches His Hotel Room Burn.* **1984. Photo etching, 10½" × 1' 2". © 1984 Sue Coe. Courtesy Galerie St. Etienne, New York.**

AN OVERVIEW

The use of value in a work of representational art is commonly called **shading**. However, to say that an artist uses shading does little to describe the final work, as there are so many techniques and hence many visual effects available. Artistic aims vary from producing a naturalistic rendition of some visual image to creating a completely nonobjective work that uses dark and light simply to provide added visual interest to the design. Even with a similar purpose, works about the same subject done by the same artist will be very different depending on the chosen medium and technique. These examples can show you just a few of the almost unlimited possibilities.

↑ **A**

Walter Hatke. *Self-Portrait.* 1973. Graphite on paper.

↑ **B**

Giorgio Morandi. *Striped Vase with Flowers.* 1924. Etching on zinc, 23.9 × 20.4 cm. Museo Morandi, Bologna, Italy.

→ **C**

Giovanni Domenico Tiepolo. *St. Ambrose Addressing the Young St. Augustine.* c. 1747–1750. Black chalk, pen, and brown ink with brown wash on paper, 7⅝" × 10⅞". Arkansas Arts Center Foundation Collection: Purchased with a gift from Helen Porter and James T. Dyke, 1993.

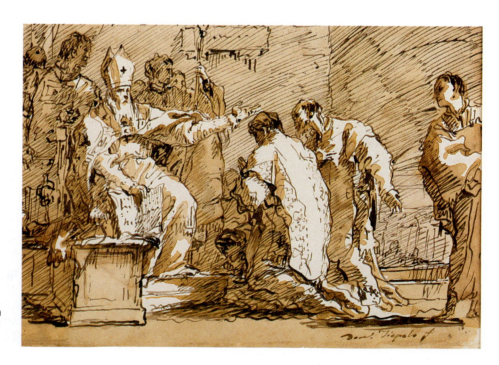

Choosing the Medium

Pencil, charcoal, chalk, and Conté crayon are familiar media to art students. Being soft media, they are capable of providing (if desired) gradual changes of dark to light. The Walter Hatke drawing **(A)** shows the subtle and gradual transitions possible. Areas of contrast sit alongside subtle shifts in value, and the artist leads us gracefully from a predominantly light ground to the darkest values in the shadow.

Experimenting with Technique

A medium such as black ink, by its nature, gives decidedly sharp value contrast. But this can be altered in several ways. The artist may use what is called **cross-hatching** (black lines of various densities that, seen against the white background, can give the impression of different grays). Again, variations are possible. These lines may be done with careful, repetitive precision or in a more atmospheric manner as in **B**.

An artist may also choose the technique of wash drawing, in which dark ink or watercolor is mixed with water, diluting the medium to produce desired shades of gray (or brown). The **mixed-media** drawing shown in **C** creates value shapes in this manner. The value created by the wash contrasts with the bright lighter values. Darker values are created by combining parallel hatching of dark ink lines within the middle value wash.

Visual Grays

The use of dots to create visual grays is a very common procedure, though we may not realize it. All the black-and-white halftones we see daily in newspapers, books, and magazines are actually areas of tiny black dots in various concentrations to produce visual grays. This is a photomechanical process, but the same effect can be seen in Seurat's drawing **(D)**. Here the dots are created by the artist scraping a soft Conté crayon over a heavily textured white paper. Again, dots of black produce visual grays.

Using the same concept, **E** presents a definite visual feeling of grays and, hence, dimension and volume. But this "drawing" is accomplished by digital manipulation of a photograph. The grays are created by the positioning of hundreds of small numerals of various densities that combine with the white background to give us the impression of many different grays.

In past centuries visual media was dominated by black and white: prints, drawings, photography, even film and video were essentially black and white at one time. In contemporary media such a limited palette is a creative choice, but a sensitivity to value relationships remains an important skill for the artist and designer.

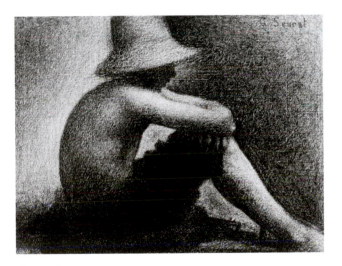

 D

Georges Seurat. *Seated Boy with Straw Hat (Study for The Bathers).* 1882. Conté crayon, 9½" × 1' ¼" (24.13 × 31.1 cm). Yale University Art Gallery, New Haven (Everett V. Meeks Fund).

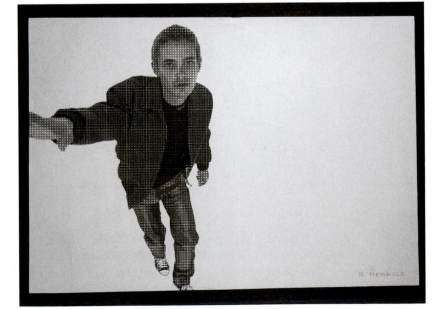

 E

Spread from catalog featuring fashion by R. Newbold, a Paul Smith subsidiary, Autumn/Winter 1996. Art Director: Alan Aboud. Photographer: Sandro Sodano. Computer Manipulation: Nick Livesey, Alan Aboud, Sandro Sodano.

"Damn it, man, do I look like I have any yellow ochre?"

Jack Ziegler.
The Museum of Modern Art Book of Cartoons. In association with
The Cartoon Bank: A New Yorker Magazine Company.

COLOR THEORY

It is not only the professional artist or designer who deals with color. All of us make color decisions almost every day. We constantly choose items to purchase of which the color is a major factor. Our world today is marked by bold uses of color in every area of ordinary living. We can make color choices for everything from home appliances to bank checks—it seems that most things we use have blossomed into bright colors. Fashion design, interior design, architecture, industrial design—all fields in art are now increasingly concerned with color.

Therefore, everyone can profit by knowing some basic color principles. Unfortunately, the study of color can be rather complex. The word *color* has so many aspects that it means different things to a physicist, optician, psychiatrist, poet, lighting engineer, and painter; and the analysis of color becomes a multifaceted report in which many experts competently describe their findings. Shelves of books in the library on the topic attest that a comprehensive study of color from all viewpoints is impossible in a limited space.

The Essentials

However, any study of color must start with a few important, basic facts. The essential fact of color theory is that color is a property of light, not an object itself. Sir Isaac Newton illustrated this property of light in the seventeenth century when he put white light through a prism. The prism broke up white light into the familiar rainbow of hues **(A)**. This presents the spectrum of wavelengths visible to the human eye. Objects have no color of their own but merely the ability to reflect certain wavelengths of light. Blue objects absorb all the wavelengths except the blue ones, and these are reflected to our eyes. Black objects absorb all the wavelengths; white objects reflect all of them. The significance of this fact for the artist is that as light changes, color will change.

Color Mixing

But although color indeed comes from light, the guidelines of color mixing and usage are different depending on whether the color source is light or pigments and dyes. Rays of light are direct light, whereas the color of paint is reflected light. Color from light combines and forms new visual sensations based on what is called the **additive system**. On the other hand, pigments combine in the **subtractive system**. This term is appropriate. Blue paint is "blue" because when light hits its surface, the pigment absorbs (or "subtracts") all the color components except the blue that is reflected to our eyes. Artists should be aware of both systems. The painter, of course, will be mainly concerned with the subtractive, whereas the stage lighting designer, photographer, and often the interior designer will be concerned with the additive.

Lights projected from different sources mix according to the additive method. The diagram in **B** shows the three **primary colors** of light—red, green, and blue—and the colors produced where two hues overlap. The three primaries combined will produce white light. Complementary (or opposite) hues in light (red/cyan, blue/yellow, green/magenta) when mixed will again produce an achromatic (neutral) gray or white. Where light from a cyan (blue-green) spotlight overlaps with light from a red spotlight, the visual sensation is basically white. Combining these two colors in paint would produce a dark neutral gray or black, anything but white.

This latter mixture of pigments functions according to the subtractive system. The red paint reflects little or no "blue-green" (or cyan), and the blue-green paint reflects little or no red. When mixed together, they act like two filters that now combine to reflect less light, thus approaching black (or a dark neutral) as the result. All paint mixture is to some degree subtractive; that is, the mixture is always weaker than at least one of the parent colors.

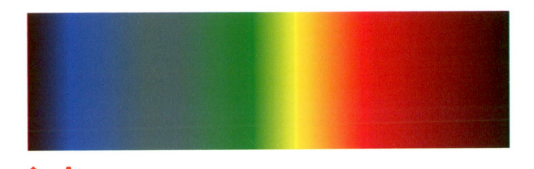

↑ A

The spectrum of colors is created by passing white light through a prism.

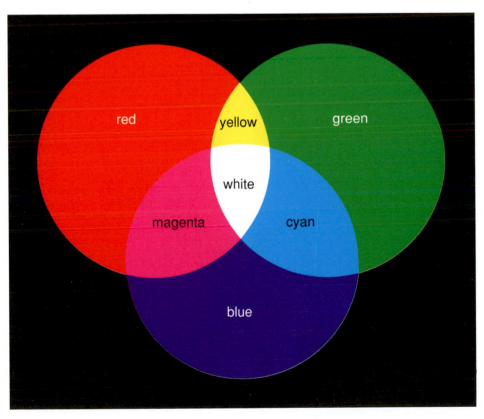

↑ B

Colors of light mix according to the additive process.

COLOR PERCEPTION

Light

In any discussion of color, it is important to acknowledge that color is a product of light. Therefore, as light changes, the color we observe will change. What color is grass? Green? Grass may be almost gray at dawn, yellow-green at noon, and blue-black at midnight. The colors of things are constantly changing with the light. Though this is a simple visual fact, our mind insists that the grass is green despite the visual evidence to the contrary, a psychological compensation called **color constancy**. This **constancy effect** is useful from the standpoint of human adaptation and survival. Imagine the problems if we questioned the colors of things with each new perception. Yet it is just this kind of questioning that has led artists such as Monet to reveal the range of color sensations around us. Monet's two paintings of poplars along the River Epte (**A** and **B**) are typical of this artist's reinvestigation of the same setting under different circumstances. Season, time of day, and weather conditions all contribute to different light and a difference in the color we perceive.

Influence of Context

Today's artists and students (and authors) owe a great debt to the twentieth-century artist Josef Albers, who as a painter and teacher devoted a career to the study of color and color relationships. His books and paintings have contributed invaluably to our knowledge of color. Many of the concepts in this discussion are reflections of his research and teaching.

 A

Claude Monet. *Poplars on the Epte.* 1891. Oil on canvas, 92.4 × 73.7 cm. Tate Gallery, London, England.

 B

Claude Monet. *Poplars.* 1891. Oil on canvas, 3' 3⅜" × 2' 1⅝" (100 × 65 cm). Philadelphia Museum of Art.

Color and Its Surroundings

Related to the concept of color changing with the light is one other important color phenomenon: our perception of colors changes according to their surroundings. Even in the same light, a color will appear different depending on the colors that are adjacent to it. Rarely do we see a color by itself. Normally colors are seen in conjunction with others, and the visual differences are often amazing. The impact of context on perception is dramatically demonstrated in a situation like that seen in **C**. The

simultaneous contrast of a nearly neutral color with a magenta and a green background alters our perception of this "muddy" color. We see it appear more pink against the green and more green against the pink.

These manipulations of our perception are not mere "tricks." Illustration **C** is not an exception to our everyday experience: this is an example of contextual influences that surround our every perception (and we will see others in coming sections).

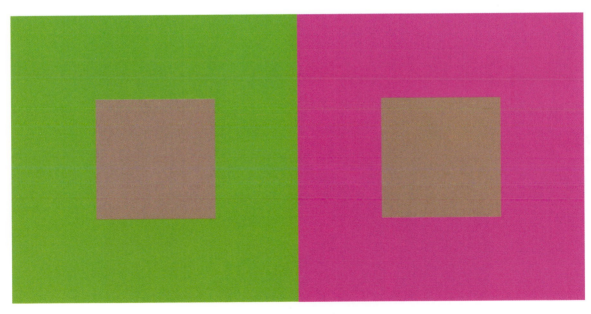

↑ C

The gray sample looks different against the two background colors.

HUE AND THE THREE DIMENSIONS OF COLOR PERCEPTION

The first property of color is what we call **hue**. Hue simply refers to the name of the color. Red, orange, green, and purple are hues. Although the words *hue* and *color* are often used as synonyms, there is a distinction between the two terms. *Hue* describes the visual sensation of the different parts of the color **spectrum**. However, one hue can be varied to produce many colors. So even though there are relatively few hues, there can be an almost unlimited number of colors. Pink, rose, scarlet, maroon, and crimson are all colors, but the hue in each case is red. We are all aware that in the world of commercial products, color names abound; plum, adobe, colonial blue, desert sunset, Mayan gold, and avocado are a few examples. These often romantic images are extremely inexact terms that mean only what the manufacturers think they mean. The same hue (or color) can have dozens of different commercial names. You will even notice that the same hue can have different names in different color systems. "Blue," for instance, may be a blue-violet in one system and a cyan in another. One system may use the term *purple* and another *violet*. Try to see past the names given to the colors and look instead at the relationships.

The Color Wheel

The most common organization for the relationships of the basic colors is the **color wheel** shown in **A**. The wheel system dates to the early eighteenth century, and this version is one updated by Johannes Itten in the twentieth century. This particular organization uses twelve hues, which are divided into three categories.

The three **primary** colors are red, yellow, and blue. From these, all other colors can *theoretically* be mixed. The three **secondary colors** are mixtures of the two primaries: red and yellow make orange; yellow and blue make green; blue and red make violet. The six **tertiary colors** are mixtures of a primary and an adjacent secondary: blue and green make blue-green, red and violet make red-violet, and so on. This offers the most basic starting point for understanding the relationships of the color wheel, but we may recall childhood experiences of mixing such simple primaries and being disappointed at the muddy results. We will see that in application cyan, yellow, and magenta are the closest to pigment primaries, and as we have noted red, blue, and green are the primaries of light.

The color wheel of twelve hues is the one still most commonly used. If you look closely, however, you will notice that the complements are not perfectly consistent with those shown in

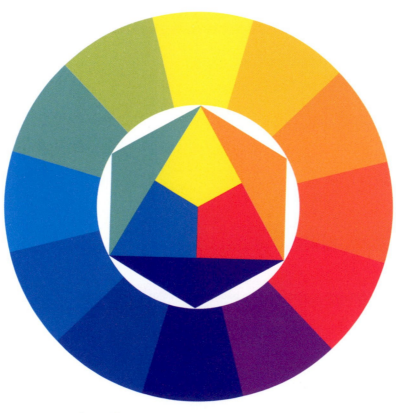

↑ **A**

The twelve-step color wheel of Johannes Itten.

the illustration of additive and subtractive primaries seen earlier. Furthermore, if you try mixing colors based on this wheel (such as blue and red to make violet), you will find the results to be dull and unsatisfactory.

Color in Three Dimensions

The color wheel shown in **B** is from the Munsell Color System and is based on equal visual steps. Mixtures of complements on this wheel will more closely produce neutrals (when tested as light mixtures, for example), and the positions of the colors are more useful in predicting paint mixtures as well. The other charts show the full dimension of perceived color relationships:

Hue: The colors of the spectrum or color wheel
Value: The relative lightness or darkness of a color
Intensity (or **chroma** as it is called by Munsell): the relative saturation of hue perceived in a color

These three attributes of color ultimately form a three-dimensional model or color space, which has been constructed by Munsell as a complete color reference.

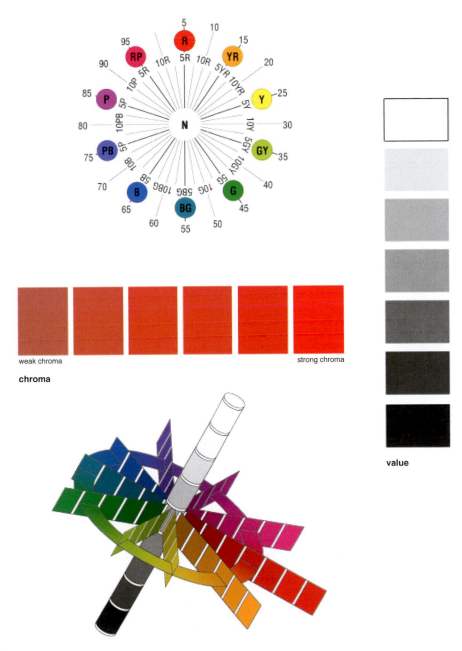

chroma

weak chroma · strong chroma

value

↑ B

Section from Munsell System, Munsell Chroma. Courtesy of Gretag Macbeth, New Windsor, New York.

VALUE

The second property of color is **value**, which refers to the lightness or darkness of the hue. In pigment, adding white or black paint to the color alters value. Adding white lightens the color and produces a **tint**, or high-value color. Adding black darkens the color and produces a **shade**, or low-value color. Individual perception varies, but most people can distinguish at least forty tints and shades of any color.

"Normal" Color Values Differ

The colors on the color wheel are shown at their inherent values. This inherent, or normal, value is the pure color unmixed and undiluted. The normal values of yellow and of blue, for example, are radically different **(A)**. Because yellow is a light, or high-value, color, a yellow value scale shows many more shades than tints. The blue scale shows more tints, because normal blue is darker than a middle value. The inherent value of a hue is based on our perception—that is, the way the human eye reads the values of colors. We can see this as we compare the value scales for blue and yellow to the adjacent gray scale.

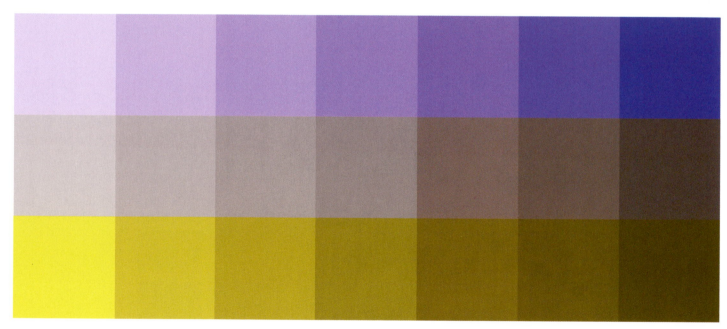

↑ **A**

Value scales for blue, gray, and yellow with equal visual steps.

Changing Color Values

When working with paint and pigments, the value of a color can be altered by thinning the color with medium. The more transparent color will be a lighter value when applied over a white background. The value of a color can also be altered by mixture with other hues: a naturally dark violet will darken a yellow, for example.

Value, like color itself, is variable and depends on surrounding hues for its visual sensation. In **B** the center green area appears much lighter and more luminous on the black background than on the white.

Color Interaction

It is well known that colors are changed by their context. Amounts and repetition are also critical factors in color interaction. The same green shown in **B** takes on a different complexion when it is "woven" through the black or white as shown in **C**. In this case the white and green interact in a mixture effect (best perceived from a distance), producing a lighter value field of color than the green and black pattern.

 B

The same color will appear to change in value, depending upon the surrounding color.

 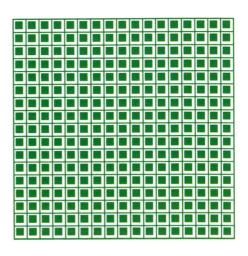

 C

The visual mixture of green with black and white.

INTENSITY/ COMPLEMENTARY COLORS

The third property of color is **intensity** (sometimes called chroma), which refers to the saturation of a color. Because a color is at full intensity only when pure and unmixed, a relationship exists between value and intensity. Mixing black or white with a color changes its value and at the same time affects its intensity. To see the distinction between the two terms, look at the two tints (high value) of red in example **A**. The tints have about the same degree of lightness, yet one might be called "rose," the other "shocking pink." The two colors have very different visual effects, and the difference we perceive is their relative intensity.

 A

Two tints of red at the same value have different intensities.

 B

Complementary colors neutralize each other in mixture.

 C

Casanova table and side chairs. Domus Design Collection, New York.

Mixtures Lower Intensity

There are two ways to lower the intensity of a color, to make a color less saturated, more neutral, or duller. One way is to mix gray with the color. Depending on the gray used, you can dull a color without changing its value. The second way is to mix a color with its **complement**—the color directly across from it on the color wheel. Illustration **B** shows an intensity scale involving complementary colors blue and orange. Neutralized (low-intensity) versions of a color are often called *tones*. In **B** we see two intensity levels of blue and two intensity levels of orange with gray in the middle. As progressively more orange is added to the blue, the blue becomes duller, more grayed. The same is true of the orange, which becomes browner when blue is added. Note this effect in the photograph of orange chairs seen through the blue glass table **(C)**. In paint mixtures, complements neutralize toward gray or black, acting in a filter-like effect akin to viewing the chair through colored glass (a subtractive mixture.) In light mixtures, complements mix to produce white light (an additive mixture). In both cases the effect is neutralizing.

The Degas painting in **D** is characterized by varying intensities of a single hue. The warm red-orange ranges in intensity to include flesh tones and browns. When other hues are not present, the effect of intensity is even more obvious.

Afterimage and Simultaneous Contrast

Another phenomenon that defines complementary color is the **afterimage** effect. Stare at an area of intense color for a minute or so, and then glance away at a white piece of paper or wall. Suddenly, an area of the complementary color will seem to appear. For example, when you look at a white wall after staring at a red shape, a blue-green shape will seem to appear. This is a result of **retinal fatigue**. Prolonged exposure to a single strong hue will cause the receptors for that hue to fatigue while the complement is still perceived.

Mixing complementary colors together neutralizes them, as we have seen. But, when complementary colors are placed next to each other, they intensify each other's appearance through simultaneous contrast. Artists use this visual effect when they wish to emphasize brilliant color.

See also *Color Schemes. Complementary/Triadic*, page 280.

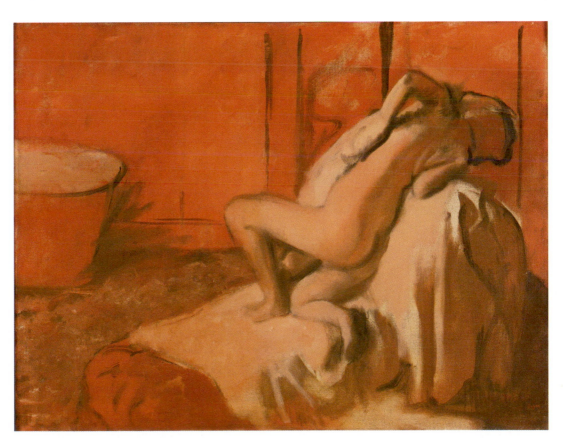

 D

Edgar Degas. *After the Bath, Woman Drying Herself.* c.1896. Oil on canvas, 2' 11" × 3' 9⅔" (89 × 116 cm).
Philadelphia Museum of Art (Purchased, Estate of the late George D. Widener, 1980).

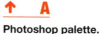

↑ **A**

Photoshop palette.

MIXING LIGHT AND MIXING PIGMENTS

It is probably as common for a young art student to have had some experience with a digital palette as a painter's palette (perhaps more likely!). This relatively recent development brings light into the discussion right alongside traditional pigments.

The mixing window from Adobe Photoshop shown in **A** lays out all of the elements we have discussed previously. The continuous scale of hues could be closed in a circle to make the color wheel, and complements would be opposite on this wheel. This relationship is noted by the 360 degrees of hue difference; 180 degrees (or half a circle) separates complements. The hue is given a position number on this scale (letter *H*) and a lightness level (letter *B*) and a saturation or intensity (letter *S*). Mixture amounts are shown for red, blue, and green (R, B, G) as well as cyan, magenta, yellow, and black (C, M, Y, K). The first set of numbers is relevant to the screen, and the second set is relevant for the printer and inks. This palette can be used to identify a color by sampling from a picture, or for altering a color through manipulation of the variables.

Three palettes are shown (courtesy of Gamblin Paints) that chart the evolution of the painter's palette. The image in **B** shows the mineral pigments available to artists from the period of the Renaissance and on into the nineteenth century. We can appreciate the exotic appeal of those rare minerals that produced intense hues! These were the "special effects" of an earlier era.

The second image (**C**) shows how that palette grew with the addition of cadmiums and other heavy metals. This enhanced the opportunity for the Impressionists to develop more saturated paintings with a greater variety of hues and attempts to capture luminous and fugitive color sensations. Finally, **D** is a modern palette that has grown greatly to include organic dyes. These new pigments offer more saturated hues and more steps on the color wheel. The result is the potential for more saturated mixtures: the closer the colors on the wheel, the more intense their mixture.

Some modern paint producers offer the artist information regarding the hue, value, and intensity (or chroma) of a color. It is important to realize that a paint's pigment saturation is not synonymous with *visual* saturation. In fact, a paint that looks black coming out of the tube (such as a dioxazine purple) and is very saturated with pigment will actually become more *visually* saturated when it is thinned with a transparent medium. This is because light can then enter the paint and illuminate it like stained glass. A color that looks saturated right from the tube (with a name like "bright purple" typical of some student-grade paints) may in fact be a mixture of more than one pigment and white. This color will have more limited mixing potential since you can always add white to a dioxazine purple, but you can't remove it from the "bright purple."

The increased steps available to the painter's palette, and the palette employed by digital applications such as Photoshop, present the student with a more sophisticated and interrelated understanding of color mixing than that available to past generations. It is important to observe that this does not guarantee success in the application of color. In fact, it appears that Vermeer and Rembrandt did quite well with their limited palettes.

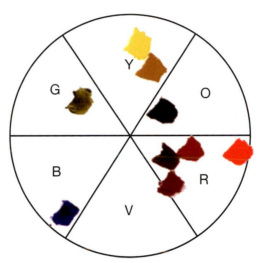

Classical Palette in Color Space

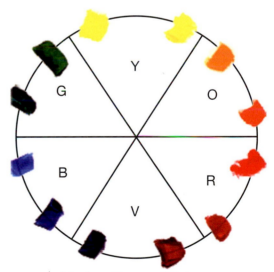

← **B**

Classic artist's palette: Naples Yellow (Hue), Yellow Ochre, Raw Umber, Vermillion (Napthol Scarlet shown here), Venetian Red, Burnt Sienna, Indian Red, Ultramarine Blue (lapis), and Terre Verte. Courtesy Gamblin Paints.

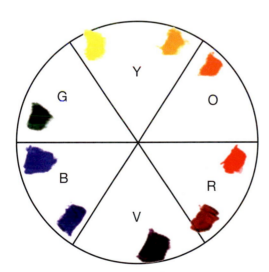

Impressionist Palette
in Color Space

Modern/Spectral Palette
in Color Space

↑ **C**

Impressionist's palette: Cadmium Yellow Light, Cadmium Yellow Deep, Cadmium Orange, Cadmium Red Light, Alizarin Crimson, Cobalt Violet, Ultramarine Blue, Cerulean Blue, and Viridian. Courtesy Gamblin Paints.

↑ **D**

Modern/Spectral Palette: Hansa Yellow Light, Hansa Yellow Medium, Hansa Yellow Deep, Mono Orange, Napthol Scarlet, Quinacridone Red, Quinacridone Violet, Dioxazine Purple, Phthalo Blue, Manganese Blue Hue, Phthalo Green, and Phthalo Emerald. Courtesy Gamblin Paints.

TECHNIQUES THAT SUGGEST LIGHT

Pigments combine along certain guidelines to create new colors. However, muddy or dull colors are often the result. Even when mixing adjacent colors on the color wheel, you may find the results to be less intense than you anticipated, and the farther apart the hues, the more subtractive (darker and duller) the mixture. To understand this process, think of the pigments as acting like filters, which in combination (or mixture) allow less light or color to reflect off the colored surface to the viewer's eye.

Visual Color Mixing Techniques

Pigment simply will never reproduce the luminous and brilliant quality of light. Recognizing this, artists (painters, printmakers, and fiber artists) have struggled with the problem and tried various techniques to overcome it. One attempt is called **visual color mixing** or **optical mixture**. Rather than mixing two colors on the palette, artists place two pure colors side by side in small areas so the viewer's eye (at a certain distance) will do the mixing. Or perhaps they drag a brush of thick pigment of one color loosely across a field of another color. The uneven paint application allows bits and pieces of the background to show through. Again, the pure colors are mixed in our perception, not on the canvas.

Visual mixing is often associated with the post-Impressionist era of the late nineteenth century and can be observed in the works of artists such as Seurat and van Gogh. The techniques of **pointillism** and *divisionism* both use small bits of juxtaposed color to produce different color sensations. In a way, these artists anticipated the truly additive color mixing that occurs on a screen. Your laptop's screen is composed of thousands of luminous

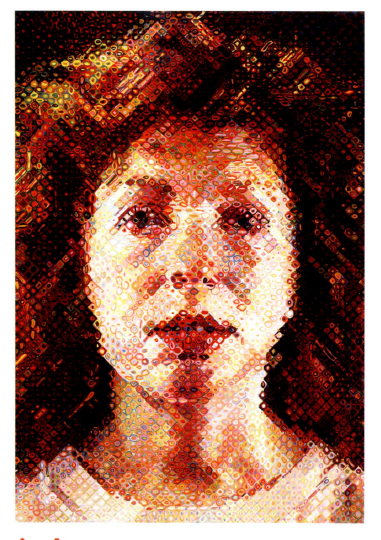

 A

Chuck Close. *April.* **1990–1991. Oil on canvas, 8' 4" × 7'. Courtesy Pace Wildenstein, New York.**

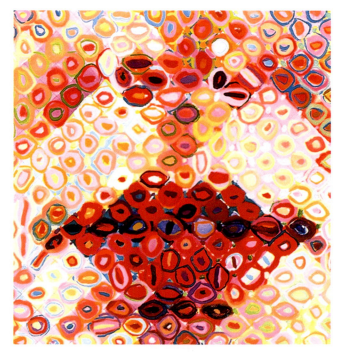

 B

Chuck Close. *April (detail).* **1990–1991. Oil on canvas, 8' 4" × 7'. Courtesy Pace Wildenstein, New York.**

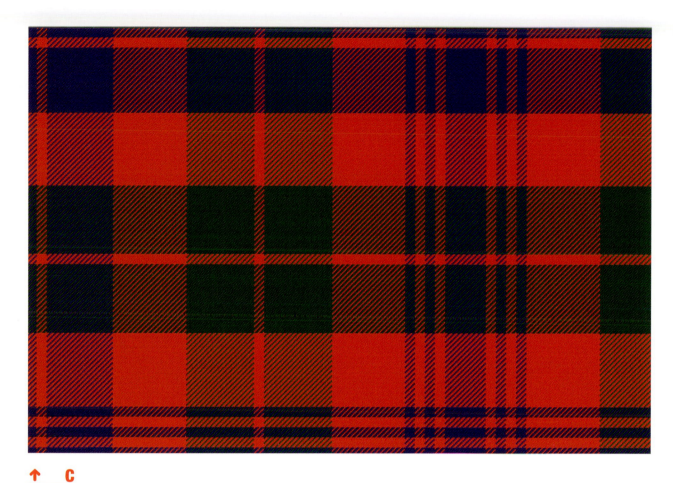

↑ **C**

Black Watch Plaid for Band Regimental Tartan (#396). House of Tartan, Ltd., Perthshire, Scotland.

pixels. The colors we see are a visual mix of the light primaries red, blue, and green. Such luminosity is not possible with the surface of painting. Still, artists continue to explore the possibilities of visual mixture, as can be seen in *April* **(A)** by the contemporary painter Chuck Close. The large scale of this portrait assures that we will always be aware of the pattern of color bits and that they will not absolutely merge into a mixture. In fact, this technique is usually most luminous when that is the case.

This particular painting by Close has large, obvious units of color, as can be seen in the detail **(B)**. Earlier paintings by the artist employed smaller, more subtle dots and dashes. The larger marks in the newer work allow us to easily see the components of the "mixture." It is evident that the closer the value of the color bits, the more easily they merge.

Visual Mixing in Other Art Forms

The basic idea of visual mixing is used in many areas. In creating mosaics, stirring a bowl of red and blue tiles will not, of course, produce purple tesserae. Instead, small pieces of pure-colored tiles are interspersed to produce the effect of many other intermediate colors. The same process is employed in creating tapestries. Weavers working with a limited number of colored yarns or threads can intermingle them so that at a distance the eye merges them and creates an impression of many hues, values, or intensities. Illustration **C** is a plaid, or tartan, fabric that demonstrates this phenomenon. From a distance the material can seem to be a pattern of many colors and values. Close inspection might reveal that just three colored threads have been woven in various densities to produce all the visual variations.

A version of the pointillist technique is now used every day in a photomechanical adaptation in the printing of color pictures. The numerous colors we see in printed reproductions, such as those on these pages, are usually produced by just four basic colors in a small dot pattern. The dots in this case are so tiny that we are totally unaware of them unless we use a magnifying glass to visually enlarge them.

COOL/WARM COLORS

IDENTIFYING COLOR WITH THE SENSES

"Cool" colors? "Warm" colors? These may seem odd adjectives to apply to the visual sensation of color, as cool and warm are sensations of touch, not sight. Nevertheless, we are all familiar with the terms and continually refer to colors this way. Because of the learned association of color with objects, we continue to relate colors to physical sensations. Hence, red and orange (fire) and yellow (sunlight) become identified as warm colors. Similarly, blue and sea-green colors (sky, water) evoke coolness.

A Psychological Effect

Touching an area of red will assuredly not burn your hand, but looking at red will indeed induce a feeling of warmth. The effect may be purely psychological, but the results are very real. Perhaps you have read of the workers in an office painted blue complaining of the chill and actually getting colds. The problem was solved not by raising the thermostat but by repainting the office in warm tones of brown.

An architectural installation by James Turrell **(A)** shows such a striking warm/cool contrast. The cutaway in the roof that opens to the sky is subtle and reveals none of the expected architectural details, only the expanse of sky. This blue contrasts with the warm interior lighting. Incandescent lighting, for example, has such a warm glow (associated with "hearth and home") that it has been a psychological obstacle for people to accept the more neutral florescent lighting despite the economic and environmental benefits.

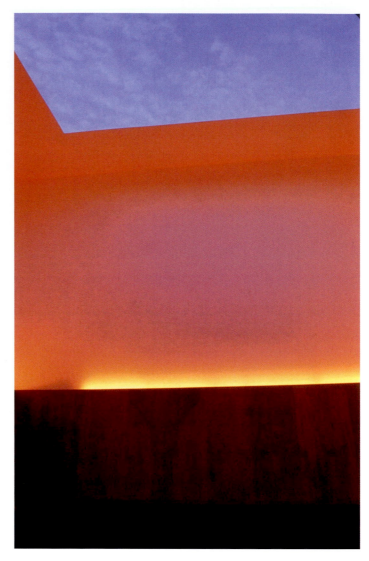

↑ **A**

James Turrell. *Meeting.* **1986.**

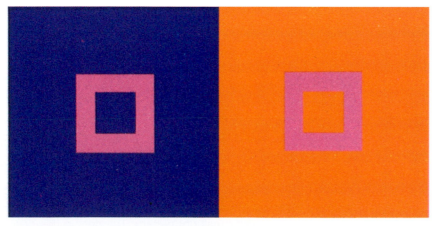

↑ **B**

The red-purple squares, although seemingly different, are identical.

Color Context Makes a Difference

We generally think of the colors yellow through red-violet as the warm side of the color wheel and yellow-green through violet as the cool segment. The visual effects are quite variable, however, and again depend a great deal on the context in which we see the color. In **B** the magenta shape appears very warm surrounded by a background of blue, but this same hue appears very cool against the orange background. Josef Albers described it like this: When you take your hands from hot water and place them in room-temperature water, it feels cool. When you take your hands from ice water and place them in the same room-temperature water, it feels warm—same water, different sensation.

Light and Shadow

Because warm colors tend to advance whereas cool colors seem to recede, the artist may use the warm/cool relationship to establish a feeling of depth and volume. This is most evident in the receding blue hills of a landscape. The influence of the blue sky can also be seen in the shadows on a sunny day. Neil Welliver's winter landscape shown in **C** makes this evident. The bright snow is illuminated by the intense sunlight, and the shadows reflect the blue sky. In fact, these shadows are close in color to the bit of sky reflected in the pool of water.

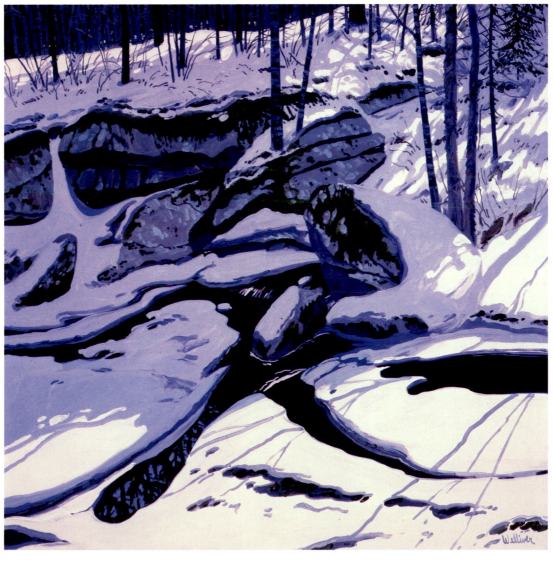

↑ **C**

Neil Welliver. *Thawed Ledge.* **1988. Oil on canvas, 5' × 5' (152.4 × 152.4 cm).**

COLOR DOMINANCE

Areas of emphasis in a work of art create visual interest and, naturally, have been carefully planned by the artist. Color is very often the means chosen to provide this emphasis—color is probably the most direct device to use. When planning emphasis, we might think of using a larger size somewhere, or perhaps changing a shape, or isolating one element by itself. As the diagrams in **A** show, the use of color dominates these other devices. You will notice that the accented color is not a radically different hue or very different in value or intensity. Such contrasts, of course, would heighten the effect. But **A** shows that color by its very character commands attention.

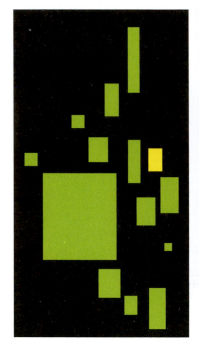
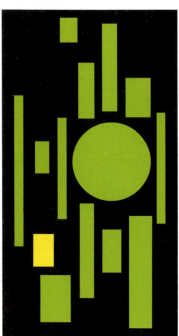
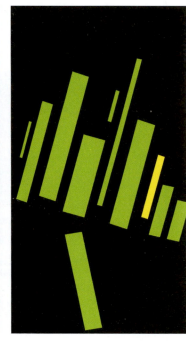

← **A**

Color is so strong a visual element that it will dominate other devices to establish emphasis.

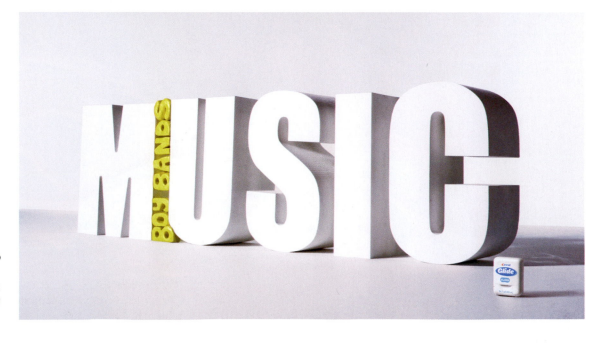

→ **B**

"Music." P&G Glide Dental Floss Campaign. Saatchi & Saatchi, New York. Creative director: Tony Granger, Jan Jacobs, Leo Premutico. Art director: Menno Kluin. Copywriter: Icaro Doria. Photo: Jenny van Sommers.

Color as Attention-Grabber

Sometimes the artist or designer may wish to create a definite focal point or center of attention that the observer will see first. A bright or vivid color, such as the yellow in the dental floss advertisement **(B)** creates an emphasis that the shape or position of the words "boy bands" would not achieve in black and white. In this case the focus is not on the product, which is more subtly presented in the foreground. A memorable and humorous reference to dental floss is suggested by emphasizing an irritant to be flossed out.

The unusual arrangement of autumn leaves in *Elm* by Andy Goldsworthy in **C** shows how color can create an emphasis so strong that it dominates other elements. In this case Goldsworthy tore similar dark and yellow leaves and mated a dark half to a yellow half of another similarly shaped leaf. These mated leaves form the boundary, which contains many other yellow leaves set off against the field of darker and duller leaves. The result emphasizes the yellow shape and gives the appearance of the dark leaves having been painted within that rough circle.

In each of the preceding examples, yellow is the dominant hue and attention grabber. In **A** yellow provides emphasis in a cluster of green shapes. In **B** yellow dominates a predominantly light valued composition, and in **C** the fact that yellow is a light hue asserts dominance in an otherwise dark composition.

← **C**

Andy Goldsworthy. *Elm.* **Middleton Woods, Yorkshire. 1980. From** *Andy Goldsworthy: A Collaboration with Nature* **(New York: Harry N. Abrams, 1990).**

ACHIEVING BALANCE WITHIN ASYMMETRICAL COMPOSITION

Unlike symmetrical balance, asymmetry is based on the concept of using differing elements on either side of the center axis. But to create visual balance, these elements must have equal weight or attraction. Color is often used to achieve this effect.

The use of color to balance a composition is very common and seen in many different periods and different styles of art. Wayne Thiebaud's *Rabbit* **(A)** is at first glance the simplest of compositions: a white rabbit placed in the center of a white field. The rabbit's head is the natural focus of the composition, and this directs our attention to the left side of the painting. The intense blue shadow on the right-hand side of the composition provides the balance.

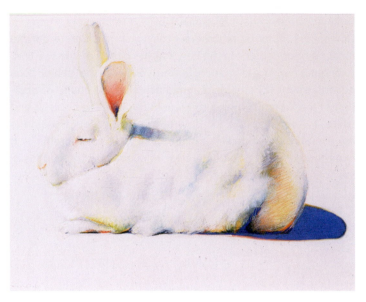

↑ **A**

Wayne Thiebaud. *Rabbit.* **1966. Pastel on paper, 1' 2¾" × 1' 7½" (37 × 50 cm). Courtesy collection of Mrs. Edwin A. Bergman and the artist. Art © Wayne Thiebaud/Licensed by VAGA, New York, New York.**

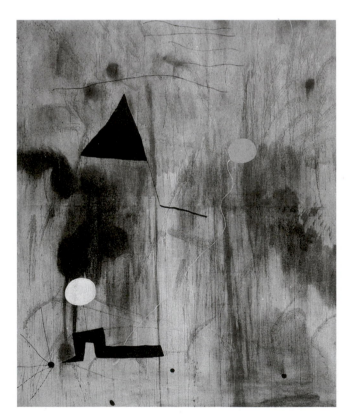

↑ **B**

Joan Miró. *The Birth of the World.* **Montroig, summer 1925. Oil on canvas, 8' 2¾" × 6' 6¾" (250.8 × 200 cm). The Museum of Modern Art, New York (acquired through an anonymous fund, the Mr. and Mrs. Joseph Slifka and Armand G. Erpf funds, and by gift of the artist).**

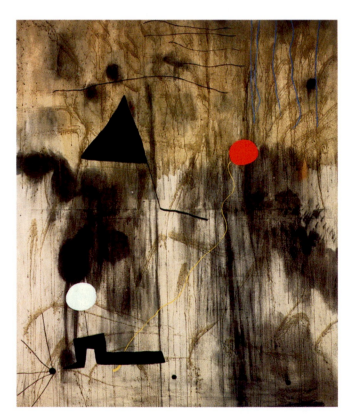

↑ **C**

Seeing B in color shows us how color achieves the balance.

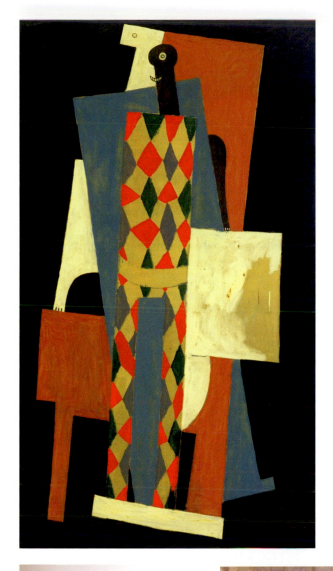

Color in Balance with Value

A comparison of **B** and **C** will illustrate the idea. In **B** Joan Miró's painting is shown just in black and white. In this reproduction, the composition might appear off balance. The left side, with the contrasting white circle, solid black triangle, and notched rectangle, seems to have more visual interest than the right side where there is less delineation of the shapes and little value contrast. But when the same painting is seen in color **(C)**, the balance is immediately clear. The circular shape on the right is actually a brilliant red. This very vivid color note in a predominantly neutral painting attracts our eye and can balance the elements on the left.

Dynamics of Balance and Imbalance

Picasso's *Harlequin* **(D)** demonstrates a particular kind of balancing act. The two sides of the composition seem to rock back and forth around a vertical axis that runs through the "eye" or pivot point at the center and top of the painting. The opposing tilt of the brown and blue planes also suggests a radial balance. The alternating colors (including black and white) are repeated in a balanced but asymmetrical pattern.

The Gérôme painting **(E)** shows an opposite effect to that of Miró's painting **(C)**. The small amount of red that provides balance for Miro creates a dynamic imbalance for Gérôme. In **E** red brings emphasis to the culmination of the drama on the left. Although this composition is balanced by the interest created in the departing figures on the right, there is no question that the red contributes to a weighted emphasis on the left.

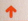 **D**

Pablo Picasso. *Harlequin.* **Paris, late 1915. Oil on canvas, 6' ¼" × 3' 5⅜" (183.5 × 105.1 cm).**

 E

Jean-Léon Gérôme. *The Duel after the Masquerade.* **1857–1859. Oil on canvas, 1' 3⅜" × 1' 10⁹⁄₁₆" (39.1 × 56.3 cm).**

COLOR'S SPATIAL PROPERTIES

Atmospheric Perspective

The earth's atmosphere disperses the shorter wavelengths of blue coloring the sky and objects that recede into the atmosphere **(A)**. As objects recede, any brilliance of color becomes more neutral, finally seeming to be gray-blue. Value and color contrasts are more pronounced in the foreground and more subtle in the distance. This is such a common experience in our lives that we are inclined to interpret cool colors as receding even in abstract designs.

Spatial experience is not limited to the clues of a representational subject such as the landscape. Alan Cotes's diptych painting **(B)** presents two spatial realities side-by-side in a nonobjective composition. The left panel has greater hue variety: tints of red and blue against a yellow ground. The right panel is limited in hue but varied in value and intensity. The red parallelograms on the right float and appear to advance from the darker space. On the left, the pinks and pale blues exist in a shallow space and seem to vibrate against the yellow ground. It may take a moment to notice that there are two yellows on the left and two dark reds on the right. These subtle distinctions that emerge slowly in our perception enhance the spatial experience. For example, the dark red behind the floating shapes is cooler and emphasizes the warmth of the parallelograms.

Using Color to Emphasize Flatness

David Hockney in *Mulholland Drive: The Road to the Studio* **(C)** offers a contrast to both **A** and **B**. Hockney consciously flattens and compresses space by his use of color. Hills, groves of trees, and the towers of power lines are obvious images from the landscape, but the shapes, colors, and patterns are laid out like a crazy quilt. Even the map-like patterns at the top add emphasis to the essential flatness of the arrangement. In this case, hot oranges work as both foreground and background. You can see blue along the bottom or "foreground" of the painting as well as farther up or "back" in the landscape.

See also *Devices to Show Depth: Aerial Perspective*, page 204, and *Value and Space*, page 250.

→ A

Asher B. Durand. *Kindred Spirits.* **1849. Oil on canvas, 3' 8" × 3'. Courtesy Crystal Bridges Museum of American Art, Bentonville, Arkansas.**

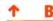 **B**

Alan Cote. *Untitled.* **2007. Acrylic on canvas, 6' 9" x 8'.**

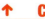 **C**

David Hockney. *Mulholland Drive: The Road to the Studio.* **1980. Acrylic on canvas, 7' 2" × 20' 3" (218.44 × 617.22 cm). Los Angeles County Museum of Art (purchased with funds from the F. Patrick Burns Bequest).**

MONOCHROMATIC/ANALOGOUS

Certain color schemes are thought of as **color harmonies**. These schemes are organized by simple color relationships. They may explain relationships and often recur in nature, but they are not *the* formula for design success that the word harmony might imply. In fact, music that relies only on harmony as an element usually makes us think of "elevator music." Similarly, color harmony can be simplistic or part of a more complex composition.

Monochromatic Color Scheme

A **monochromatic** color scheme involves the use of only one hue. The hue can vary in value, and pure black or white may be included. The image in **A** is a monochromatic painting. Mark Tansey explains that his use of monochrome unifies an image that is created from a montage of photographs. The disparate sources are united by a palette of just one hue. Monochrome also serves to heighten an emphasis on shape and texture. In Tansey's case it also evokes a photographic quality suggesting a cyanotype or sepia-toned photograph.

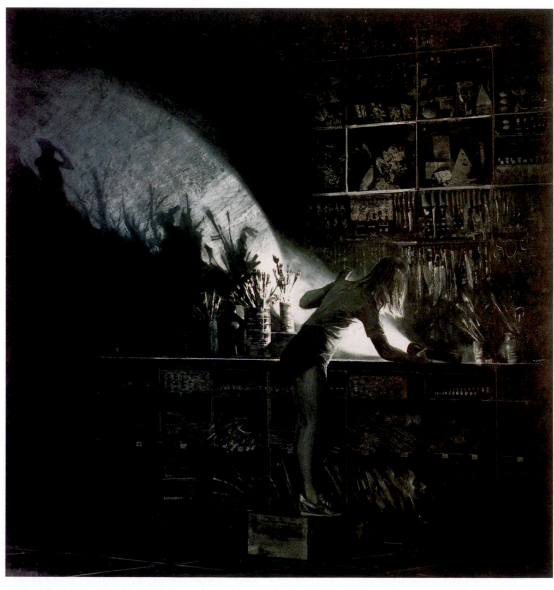

 A

Mark Tansey. *The Bricoleur's Daughter.* 1987. Oil on canvas, 5' 8" × 5' 7". Collection Emily Fisher Landau, New York.

Analogous Color Scheme

An **analogous** color scheme combines several hues that sit next to each other on the color wheel. Again, the hues may vary in value. The Navajo textile **(B)** shows the related, harmonious feeling that analogous color lends to a design. This blanket includes colors adjacent to red on the color wheel.

Tonality

Color unity is described by another term. We often speak of the *tonality* of a design or painting. **Tonality** refers to the dominance of a single color or the visual importance of a hue that seems to pervade the whole color structure despite the presence of other colors. Analogous color schemes can produce a dominant tonality, as **C** shows. In this case the tonality suggests a strong red light source.

Elizabeth Peyton. *Julian.* **2005–2006. Fifty-five-color handprinted ukiyo-e woodcut, 1' 5" × 1' 9⁄10" (43.2 × 32.8 cm).**

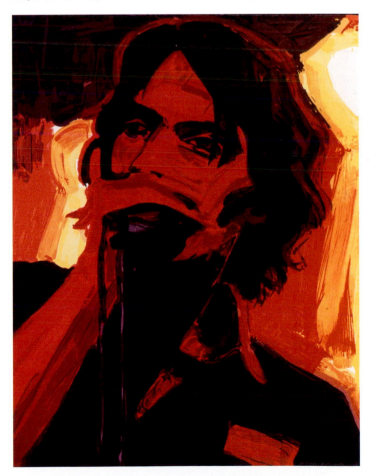

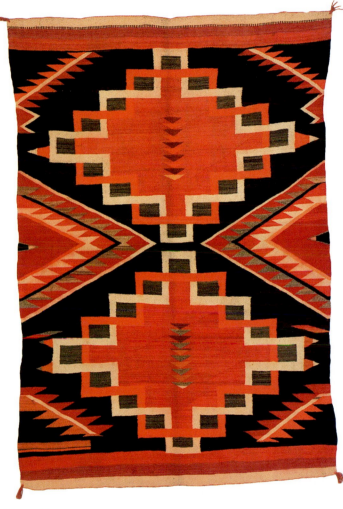

Navajo blanket/rug. c. 1885–1895. 4' 7" × 6' 10" (140.5 × 207.8 cm). Natural History Museum of Los Angeles County (William Randolph Hearst Collection).

COMPLEMENTARY/TRIADIC

A **complementary** color scheme, as the term implies, joins colors opposite each other on the color wheel. This combination produces a heightened sense of contrast, as in Stuart Davis's painting titled *Visa* **(A)**. This painting has the graphic qualities of a billboard or sign. The complementary contrast of magenta letters and green background makes use of the eye-catching devices of advertising.

Split Complementary Color Scheme

A split complementary color scheme is related to the complementary scheme but employs colors adjacent to one of the complementary pairs. For example, the sky in **B** is balanced by a range of yellows and oranges near the complementary opposite of the blue. It is more common to find a complex solution such as **B** than a simple complementary pair.

Triadic Color Scheme

A **triadic** color scheme involves three hues equally spaced on the color wheel. Red, yellow, and blue would be the most common example. These hues form a triangle on the color wheel and suggest balance. This is true even when the red, yellow, and blue are subtle as in Vermeer's painting *Girl with a Pearl Earring* **(C)**. Red, yellow, and blue often appear in combination with the simple contrast of black and white as they do in this picture.

Planning Color Schemes

These color schemes or harmonies are probably more common to such design areas as interiors, posters, and packaging than to painting. In painting, color often is used intuitively, and many artists would reject the idea that they work by formula. But knowing these harmonies can help designers consciously plan the visual effects they want a finished pattern to have. Moreover, color can easily provide a visual unity that might not be obvious in the initial pattern of shapes. Even though design aims vary, often the more complicated and busy the pattern of shapes is, the more useful will be a strict control of the color. The reverse is also true.

 A

Stuart Davis. *Visa.* 1951. Oil on canvas, 3' 4" × 4' 4". The Museum of Modern Art, New York (gift of Mrs. Gertrud A. Mellon). Art © Estate of Stuart Davis/Licensed by VAGA, New York, New York. Digital Image © The Museum of Modern Art/Licensed by SCALA/Art Resource, New York.

 B

Vincent van Gogh. *The Yellow House.* 1888. Oil on canvas, 72 × 91.5 cm. © Van Gogh Museum, Amsterdam, The Netherlands/The Bridgeman Art Library.

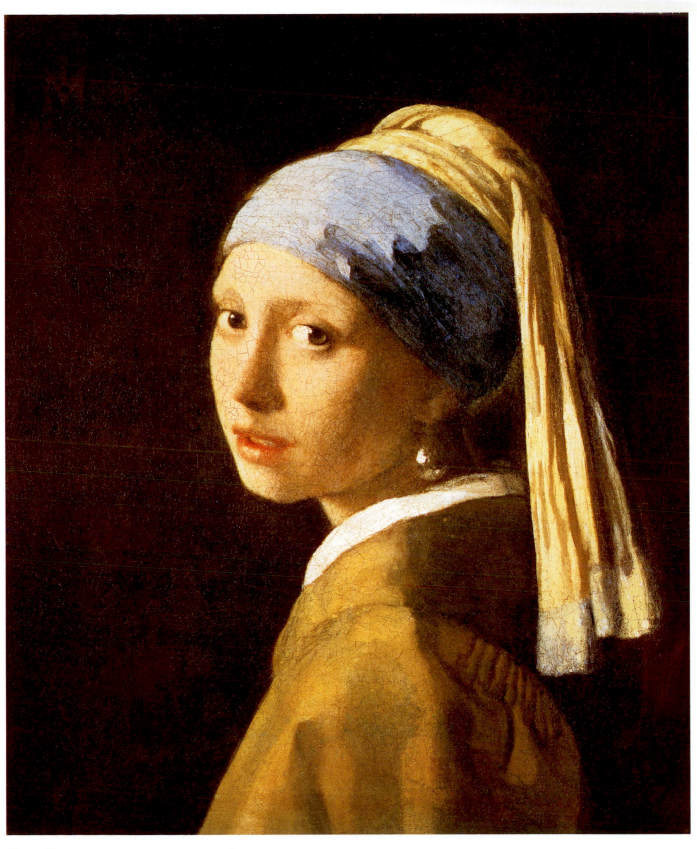

Jan Vermeer. *Girl with a Pearl Earring.* **c. 1665–1666. Oil on canvas, 1' 5½" × 1' 3⅜" (44.5 × 39 cm).
Royal Cabinet of Paintings, Mauritshuis, The Hague.**

UNEXPECTED COMBINATIONS

Color discord is the opposite of color harmony. A combination of discordant colors can be visually disturbing. Discordant colors have no basic affinity for each other (as you would find with analogous colors) nor do they seem to balance each other (as with a complementary contrast).

The term *discord* conveys an immediate negative impression. Discord in life, in a personal relationship, for example, may not be pleasant, but it often provides a stimulus or excitement. In the same manner, discord can be extremely useful in art and design.

Using Discord to Add Interest

Mild discord results in exciting, eye-catching color combinations. The world of fashion has exploited the idea to the point that mildly discordant combinations are almost commonplace. A discordant color note in a painting or design may contribute visual surprise and also may better express certain themes or ideas. A poster may better attract attention by its startling colors.

Once, rules were taught about just which color combinations were harmonious and which were definitely to be avoided because the colors did not "go together." A combination of pink and orange was unthinkable; even blue and green patterns were suspect. Today these rules seem silly, and we approach color more freely, seeking unexpected combinations.

 A

Pure orange and red-purple.

 B

The same colors with closer values.

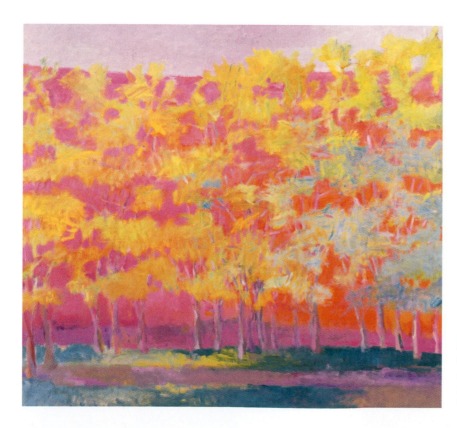

 C

Wolf Kahn. *Color/Tree Symphony.* 1994. Oil on canvas, 4' 3½" × 4' 8½". Grace Borgenicht Gallery, New York. Art © Estate of Wolf Kahn/Licensed by VAGA, New York, New York.

The color pair of orange and red-purple shown in **A** is one that has been called discordant. This is typical of color pairings that are widely separated on the color wheel but not complements. In **B** the effect is even more discordant when the red-purple is lightened to the same value as the orange.

Wolf Kahn (**C**) takes full advantage of this red-purple and orange color pairing to create *Color/Tree Symphony*. The colors conjure the intense impact of autumn foliage and seem to create light.

Colors in Conflict

Certain color pairings are almost difficult to look at. In fact, our eye experiences a conflict in trying to perceive them simultaneously. Red and cyan literally have a vibrating edge when their values are equal and their intensities are high (**D**). You will find this to be true for a range of colors when they are paired at equal value, but the **vibrating color** effect is strongest with reds opposed to blues and greens. Note that the quilt shown in **E** is an homage to Paul Klee, whose painting is reproduced on page 43 in Chapter 2. Paul Klee's painting pairs a red and a green. It is interesting to compare the two color worlds of the similar grid designs.

↑ **D**

Red and cyan will have a vibrating edge when values are equal and intensities are high.

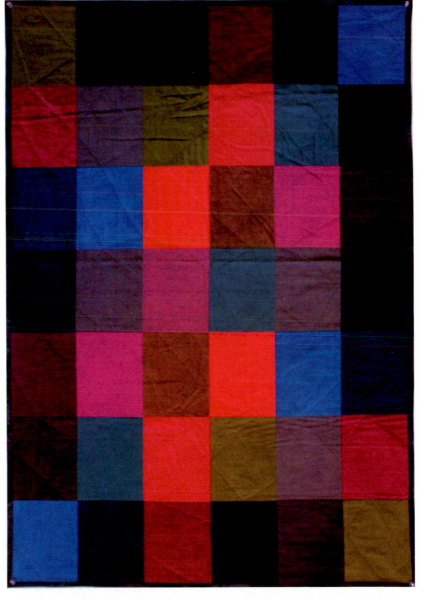

↑ **E**

Deborah Pentak. *Klee Squares, II.* **1995. Hand-dyed cotton quilt, 4' 1½" × 2' 9½".**

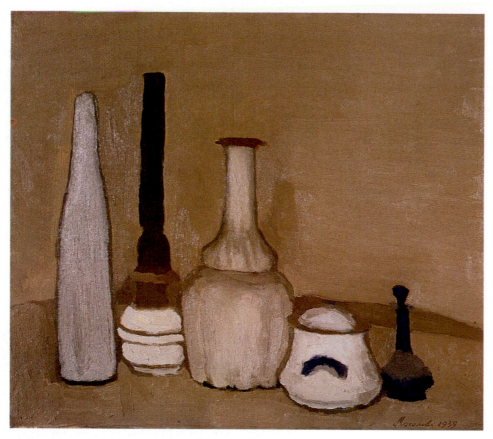

 A

Giorgio Morandi. *Still Life.* **1939. Oil on canvas, 41.5 × 47.3 cm. Museo Morandi, Bologna.**

LOCAL, OPTICAL, ARBITRARY

There are three basic ways in which color can be used in painting. An artist may use what is called **local color**. This refers to identifying the color of an object under ordinary daylight. Local color is the **objective** color that we "know" objects are: grass is green, bananas are yellow, apples are red. The use of local color reinforces, or takes advantage of, our preconceptions of an object's color, and because of this we associate this approach with children's books, naïve painting, and other simple presentations.

Light Affects Color

Visually, the red of an apple can change radically, depending on the illumination. Because color is a property of light, the color of any object changes at sunset, under moonlight, or by artificial lighting. An artist reproducing these visual effects is using optical color, that is, what we *see*, not what we *think* we see.

Giorgio Morandi was acutely sensitive to the color he actually saw. A number of the objects in **A** might be dismissed as merely "white" when seen in isolation. In this still life grouping we are invited to notice subtle hues within these neutrals. Under a different lighting this might all change as we would see in his other paintings. Morandi shows that a colorist is not someone bound to the vividness of the spectrum or color wheel.

Lighting directors for theater and dance consciously manipulate lighting to evoke mood, create space, and give emphasis to principal actors as in **B**. Lighting can compensate for the lack of visual information an audience can see at a distance from the stage. Local color is consumed in the lighting seen in **B**.

Subjective Use of Color

In arbitrary color, the color choices are subjective rather than based on the colors seen in nature. The artist selects colors for design, aesthetic, or emotional reasons. Large patches of color make up the composition of Milton Avery's *White Rooster* **(C)**. The blue tree and salmon-colored sky are bold subjective color choices. Arbitrary color is sometimes difficult to pinpoint, because many painters take some artistic liberties in using color. Has the artist disregarded the colors he saw, or has he merely intensified and exaggerated the visual reference? This latter use is termed **heightened color**. The pink hills and green tree line might be heightened color while the blue tree may be the subjective decision to move blue from the sky and place it in the foliage.

 B

Scene from *Candide* by Leonard Bernstein and Richard Wilbur. The Ohio State University Department of Theatre.

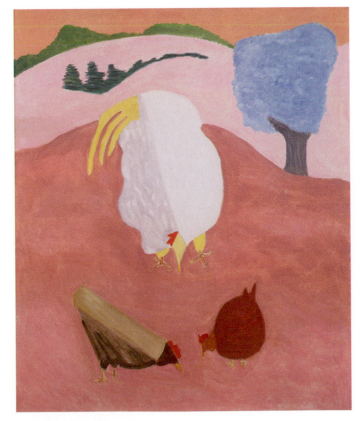

 C

Milton Avery. *White Rooster.* 1947. Oil on canvas, 5' 1½" × 4' 2¾". The Metropolitan Museum of Art (gift of Joyce Blaffer von Bothmer, 1975).

COLOR EVOKES A RESPONSE

"Ever since our argument, I've been blue."
"I saw red when she lied to me."
"You're certainly in a black mood today."
"I was green with envy when I saw their new house."

These statements are emotional. The speakers are expressing an emotional reaction, and somehow a color reference makes the meaning clearer, because color appeals to our emotions and feelings. For artists who wish to arouse an emotional response in the viewer, **emotional color** is the most effective device. Even before we "read" the subject matter or identify the forms, the color creates an atmosphere to which we respond.

Colors Evoke Emotions

In a very basic instance, we commonly recognize so-called warm and cool colors. Yellows, oranges, and reds give us an instinctive feeling of warmth and evoke warm, happy, cheerful reactions. Cooler blues and greens are automatically associated with quieter, less-outgoing feelings and can express melancholy **(A)** or depression. These examples are generalities, of course, for the combination of colors is vital, and the artist can also influence our reactions by the values and intensities of the colors selected. Archibald Motley's *Gettin' Religion* **(B)** shows how a predominantly blue painting can suggest a festival at night.

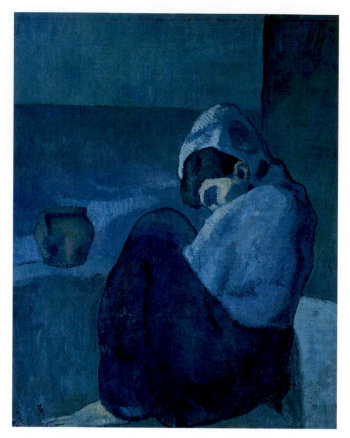

 A

Pablo Picasso. *Crouching Woman.* **1902. Oil on canvas, 2' 11" × 2' 4" (90 × 71 cm). Staatsgalerie, Stuttgart.**

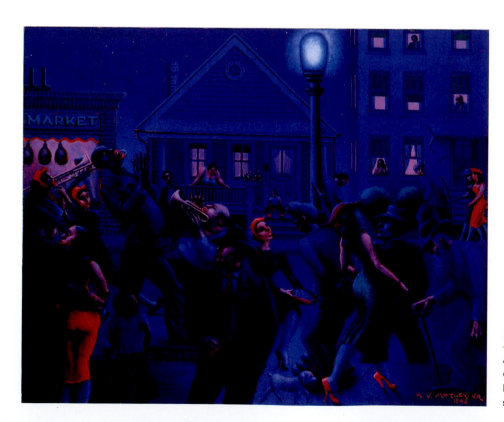

 B

Archibald J. Motley Jr. *Gettin' Religion.* **1948. Oil on canvas, 2' 7⅞" × 3' 3¼". Collection Archie Motley and Valerie Gerrard Browne, Evanston, Illinois. Chicago History Museum.**

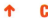 **C**

Leon Golub. *Mercenaries IV.* 1980. Acrylic on linen, 10' × 19' 2½" (3 × 6 m). Private collection, courtesy of the artist. Art © Estate of Leon Golub/ Licensed by VAGA, New York, New York. Photo, Courtesy Ronald Feldman Fine Arts.

Theme and Context

Paintings in which color causes an emotional reaction and relates to the thematic subject matter are very common. The flat red background in Leon Golub's *Mercenaries IV* **(C)** is evocative of blood and impending violence associated with the threatening image of the mercenaries. The intense red seems to push these figures at us, heightening our emotional response to the subject matter. The "dirty" colors and complementary greens also contribute to the emphasis on conflict and violence.

With a change of context, the same hue can evoke a different response. Red is also a dominant color in Hans Hofmann's *The Golden Wall* **(D)**, and once again the red seems to push the other shapes toward us. The nonobjective shapes of intense color and modulations in the red field create a vibrant, joyous quality in this painting quite different from Golub's *Mercenaries IV*.

The power of color to evoke an emotional response is undeniable. The context or situation the artist creates in a composition determines whether the effect is inventive or merely a cliché.

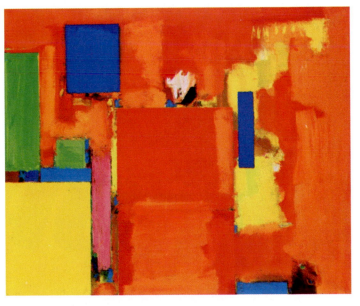

 D

Hans Hofmann. *The Golden Wall.* 1961. Oil on canvas, 5' × 6' ½" (151 × 182 cm). Photograph © 1993. The Art Institute of Chicago (Mr. and Mrs. Frank G. Logan Prize Fund, 1962).

CONCEPTUAL QUALITIES OF COLOR

"Don't worry, he's true-blue."
"I caught him red-handed."
"So I told her a little white lie."
"Why not just admit you're too yellow to do it?"

We frequently utter statements that employ color references to describe character traits or human behavior. These color references are symbolic. The colors in the preceding statements symbolize abstract concepts or ideas: fidelity, sin, innocence, and cowardice. The colors do not stand for tangibles like fire, grass, water, or even sunlight. They represent mental, conceptual qualities. The colors chosen to symbolize various ideas are often arbitrary, or the initial reasons for their choice have become so deeply buried in history we no longer remember them. Can we really explain why green means "go" and red signifies "stop"?

Cultural Differences

A main point to remember is that symbolic color references are cultural; they are not the same worldwide but vary from one society to another. What is the color of mourning that one associates with a funeral? Our reply might be black, but the answer would be white in India, violet in Turkey, brown in Ethiopia, and yellow in Burma. What is the color of royalty? We think of purple (dating back to the Egyptians), but the royal color was yellow in dynastic China and red in ancient Rome (a custom continued today in the cardinals' robes of the Catholic Church). What color does a bride wear? White is our response, but yellow is the choice in Hindu India, and red is the choice in China.

Different eras and different cultures invent different color symbols. The symbolic use of color was very important in ancient art for identifying specific figures or deities to an illiterate public. Not only the ancients used color in this manner—in the countless pictures of the Virgin Mary throughout centuries of Western art, she is almost always shown in a blue robe over a red or white garment.

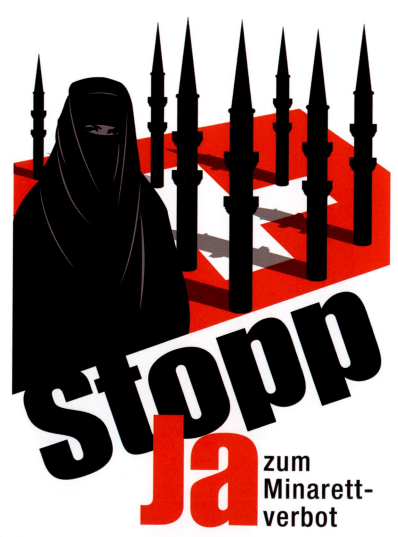

 A

Stopp: Ja zur Minarett verbots-initiative. Poster.

Symbolic Color Today

Symbolic color designations are associated with political, religious, and commercial messages in the current era. In advertising, green may evoke an association with environmental responsibility, or black is often used to connote sophistication. Until recently black was taboo for food packaging—now it may suggest a premium product.

Color symbolism can still be powerful. Think of Ukraine's "Orange Revolution" or the millions of people from all countries on a pilgrimage to Mecca for the Hajj, all dressed in white.

The poster shown in **A** uses the color of the Swiss flag in a xenophobic message seeking to outlaw the presence of minarets in Switzerland. A contrary message **(B)** depicts the presence of white light evoking a divine illumination to express the message "The sky above Switzerland is big enough."

↑ **B**

Der Himmel über der Schweiz ist gross genug. Poster.

F/A-18 Hornet aircraft breaking the sound barrier.

ORGANIZING FORM

Artists, designers, and architects organize form, placing elements in relationship to each other in order to make useful products, meaningful objects, and ordered experiences.

To some extent, everyone is a designer, and if we think of **design** as an organizing activity, everything in the built world has been designed. Daily life requires that each individual shape his or her environment, order priorities, and organize time. If you arrange the furniture in your living room or adjust the handlebars on your bicycle to get a better position—you are organizing form. Through education and experience, artists and designers become sensitive to nuance and engage more serious and complex issues, expanding on everyday aspects of design, like a master chef who creates sophisticated dishes that celebrate and elaborate on basic home cooking.

All the Senses

While vision is the primary sense involved in art and design, three-dimensional design concerns all the senses—visual, **haptic**, acoustic, and olfactory. Your computer might imitate the sound of crinkling paper when you toss a document into the trash icon, giving you important acoustic feedback confirming that the task has been completed. Your appreciation of a good hammer **(A)** is likely to be more tactile than visual. Does it fit your hand? Is it the right weight for you? Does its balance permit a comfortable and accurate swing?

Attention

There is perhaps no frame of mind more important to design thinking than attention! Without interest and care, nothing will happen. The writer Guy Davenport said, "Art is always the replacement of indifference by attention." Excitement with things in the world enables us to see and understand more. Attention propels invention.

Good Design

While we all aspire to create good design, we must recognize that there are no simple recipes to follow—and if there were, design wouldn't be the challenging and exhilarating activity it is. Good design and quality in the arts are notions that are forever in flux. Those who simply learn rules and recipes will inevitably be left behind, producing objects that might have been considered good in an earlier time or another place. Good design, provocative sculpture, and magnificent architecture are achieved by those who are passionate, visually sensitive, informed, open-minded, and inventive. It is toward the development of these qualities that this book is directed. As artists and designers of the future, it is up to you to determine the values of your time and to create its significant objects.

(Art) is the impress of those who live in full play of their faculties. The individual passes, living his life, and the things he touches receive his kind of impress, and they afterwards bear the trace of his passing. They give evidence of the quality of his growth.

Art appears in many forms. To some degree every human being is an artist, dependent on the quality of his growth. Art need not be intended. It comes inevitably as the tree from the root, the branch from the trunk, the blossom from the twig. None of these forget the present in looking backward or forward. They are occupied wholly with the fulfillment of their own existence. The branch does not boast of the relation it bears to its great ancestor the trunk, and does not claim attention to itself for this honor, nor does it call your attention to the magnificent red apple it is about to bear. Because it is engaged in the full play of its own existence, because it is full in its own growth, its fruit is inevitable.

—*Robert Henri*

→ A

S2 Framing Hammer. 18 oz., length 1' 6". Vaughan, manufacturer.

DESIGN DEFINED

The word design has many meanings. Design is often used as a noun: *the design* (referring to the result of the process of design) or *design*—the professional discipline of design, as in product design, graphic design, information design, interior design, and so forth. It is also used as a verb: *to design*—referring to the activity of designing, planning, or organizing. Design, as primarily used in this book, refers to design's more general definition—design as an organizing activity.

Basic Design

To complicate matters, there is also *basic design*—the course of study that most art and design students take in their foundation year before majoring in a specific discipline. The basic design course is, traditionally, a series of visual exercises that teaches the fundamental concepts of visual form and organization, and develops sensitivity to visual phenomena. Basic design is usually subdivided into three parts: two-dimensional design, three-dimensional design, and time design, sometimes called 4D. Two-dimensional design deals with all that is flat—such as composition, pattern, illusion, and color. Time design involves phenomena that exist in time; it deals with movement and the sequential. Three-dimensional design covers all concepts relating to 3D form and structure, as well as related spatial issues.

Origins

Many of the seminal ideas taught today in art, design, and architecture foundation programs around the world were developed in the revolutionary, experimental German design school, the **Bauhaus (A)**, during the years 1919–1933.

The Bauhaus brought architecture, art, craft, design, and technology together under one roof. Artists and designers were encouraged to utilize machines, mass production, new materials, and technology in order to create design for their own time. The Bauhaus existed during a crippling economic depression; it made utility and economy of means paramount, and promoted the belief that design should arise from first principles and experiment, not from precedent. Though the school was eventually disbanded by the Nazis, the Bauhaus spirit and philosophy are very much alive in contemporary art, architecture, and design as well as in their pedagogical underpinnings. Prior to the Bauhaus, the training of artists and designers was an apprenticeship system: students learned their masters' techniques. The "new" approach emphasized student discovery, which remains relevant in this era of digital design, rapid prototyping, and new materials.

The paper-folding project at the Bauhaus aimed to teach students to understand the structural possibilities of paper and to utilize its unique properties—its paperness! In **B**, artist and instructor Josef Albers conducts a critique of student work.

One of the most important and decisive experiences for me was the Vorkurs (foundation course) conducted by Josef Albers. Every student had to go through this preliminary course to prove his abilities, before he was accepted.

I remember vividly the first day of Vorkurs, Josef Albers entered the room, carrying with him a bunch of newspapers, which were distributed among the students. He then addressed us, saying something like this: "Ladies and gentlemen, we are poor, not rich. We can't afford to waste materials or time. We have to make the most out of the least. All art starts with material, and therefore we have first to investigate what our material can do. So, at the beginning we will experiment without aiming at making a product. At the moment we prefer cleverness to beauty. Economy of form depends on the material we are working with. Notice that often you will have more by doing less.

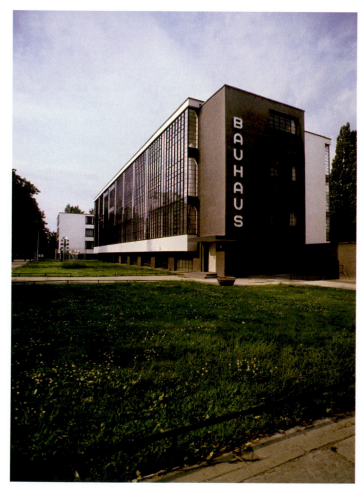

↑ **A**

Walter Gropius. 1925–1926. Bauhaus Building, Dessau, Germany.
© 2011 Artists Rights Society (ARS), New York/VG Bild-Kunst, Bonn.

Our *studies should lead to constructive thinking. All right? I want you to take the newspapers you got and try to make something out of them that is more than you have now. I want you to respect the material and use it in a way that makes sense—preserve its inherent characteristics. If you can do without tools like knives and scissors, and without glue, the better. Good luck."* And with these words he left the room, leaving us quite flabbergasted. He returned hours later and asked us to put the results of our efforts on the floor.

There were masks, boats, castles, airplanes, and all kinds of cute little figurines. He referred to all this as kindergarten products which could often have been made better in other materials. He pointed then at a study of extreme simplicity, made by a young Hungarian architect. He simply had taken the newspaper and folded it lengthwise so it was standing up like a folding screen. Josef Albers explained to us how well the material was understood and utilized— how the folding process was natural to paper, because

it resulted in making a pliable material stiff, so stiff that it could stand up on its smallest part: the border of the paper. He further pointed out to us that a newspaper lying on the table would only have one page visually active, where as the rest would be hidden. Now that the paper was standing up, both sides had become visually active.

. . . Through the Vorkurs a whole new world of seeing and thinking opened up to us. Most students had come to the Bauhaus with set ideas about art and design. They were usually romantic cliché ideas. But we soon learned that habitual thinking was in the way of creative thinking. The Vorkurs was a kind of group therapy. Seeing the solutions made by other students, we learned quickly to recognize the most elegant solution to a given problem. We also learned to exercise self-criticism, which was considered more important than criticism.

—Hannes Beckmann, on his experience in Josef Albers's Bauhaus, basic design course

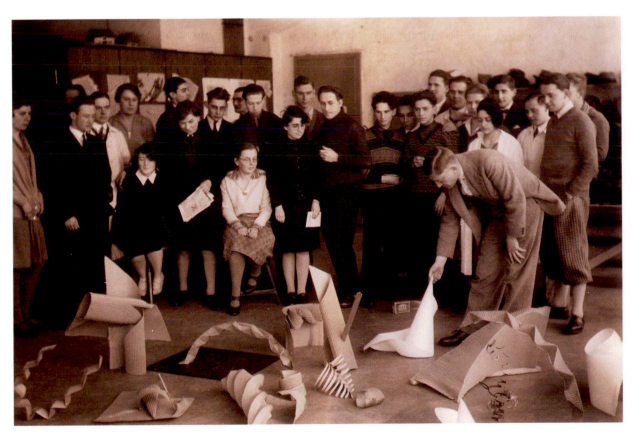

 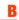

Josef Albers assessing work from his Preliminary Course at the Bauhaus. 1928–1929.
© 2011 The Josef and Anni Albers Foundation/Artists Rights Society (ARS), New York.

William Wegman. *Contemplating the Bust of Man Ray.* **1978. Photograph. JPMorgan Art Collection.**

ATTENTIVE OBSERVATION

We are moved by the beauty of the natural world, devoted to the face of a loved one, and inspired by art, design, and architecture. In all these instances, observation is essential. It is at the very heart of art and design. Attentive observation is also a survival skill. Artists and designers are voyeurs—the entire world elicits fascination.

Sensitivity

We often look without really seeing. Try drawing the front of a one-dollar bill from memory. You will find that although you have looked at the dollar bill countless times, you have not really seen it. Most people can recall only a few rudimentary aspects—George Washington in the center, numeral ones on some corners, and a border of sorts. The proportions, the text, the ornate scrollwork, and the colors are usually missing or incorrect. Don't even try to recall the back of the dollar bill! Rigorous observation demands effort. Art and design require seeing with sensitivity—they are disciplines that help develop analytical and insightful powers of observation. Drawing and sculpting from observation, for example, teach us to see more and to see with greater sensitivity.

Viewpoint

Looking implies a vantage point. To observe, you must situate yourself somewhere in space. The same object (**A** and **B**), a section of vertebra, viewed from two different angles appears completely different. Does a viewpoint suggest that you must also have a point of view? Cezanne said, "Here on the edge of the river, the motifs are very plentiful, the same object seen from a different angle gives a subject for study of the highest interest and so varied that I think I could be occupied for months without changing my place, simply bending a little more to the right or left."

↑ **A**
Vertebra section, view 1.

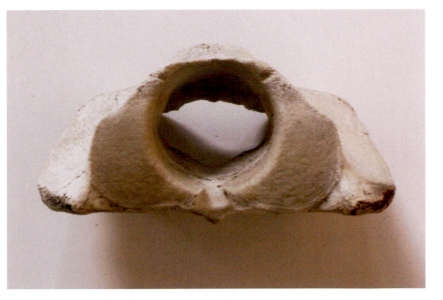

↑ **B**
Vertebra section, view 2.

SIMILARITIES AND DIFFERENCES

When observing two or more things, it is natural to perceive how similar or different they might be. This tendency, when thoughtfully utilized, is an extremely useful aid to sensitive seeing. Comparison helps us see in context and make insightful observations that inform our understanding of both objects.

Compare the sculpture *Bird in Space* **(A)** to the **functional** bird decoy, *Blue Heron* **(B)**. Most significantly, they share

extremely **reductive** form—they depict only essential features, eliminate detail, and utilize a radical economy of means. Both express a very modern sense of lightness, appropriate to their subject matter. We may also observe that *Bird in Space* is polished bronze and represents a bird in flight, and therefore the movement and freedom of flight are also expressed. *Blue Heron* depicts a heron standing motionless and is made of

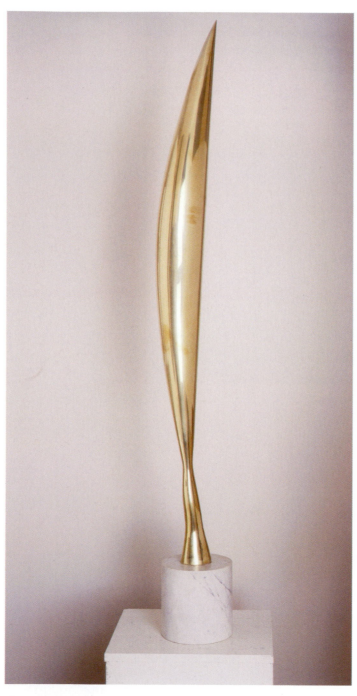

↑　A

Constantin Brancusi. *Bird in Space.* **1924. Bronze, 4' 2⁵⁄₁₆" high.**
© 2011 Artists Rights Society (ARS), New York/ADAGP, Paris.

carved wood. *Bird in Space* is a single discrete form mounted on a pedestal (which may be considered part of the work). *Blue Heron* is composed of five parts and is intended to be placed directly in the ground.

We could continue in this manner for quite a while; comparing similarities and differences is a most useful technique for observation. It is interesting to note that Brancusi's sculpture was groundbreaking in its use of reductive form—*Bird in Space*, created in 1928, is an icon of modern art. *Blue Heron* was made by an anonymous craftsperson as a functional object, a humble decoy. Its primary purpose was simply to attract herons for hunting. It is, nonetheless, a completely delightful object that transcends its simple function. *Blue Heron* was created in New Jersey in 1907.

↑ **B**

Blue Heron **Decoy. 1907.**

CONNECTIONS

To appreciate and understand the world of 3D form and to make sense of experience in general, we make connections. We see or sense a commonality between one shape and another, or between one underlying concept or structure and another. Memory plays a role when we make connections between shapes or structures seen long ago. The mind is always seeking patterns and attempting to make sense of the world. Artists and designers work to nurture and heighten this natural inclination in order to invent new and useful configurations.

Underlying Patterns in Nature

The eminent Scottish biologist D'arcy Wentworth Thompson is revered for his observations that revealed the physical and mathematical laws that determine the forms of living things. The poet Edith Sitwell found numerous related structures in nature. She marveled at "the immense design of the world, one image of wonder mirrored by another image of wonder—the pattern of fern and of feather by the frost on the window-pane, the six-rays of the snowflake mirrored in the rock-crystal's six-rayed eternity—seeing the pattern on the scaly legs of birds mirrored in the pattern of knotgrass . . ."

↑ **A**

Afghanistan Markhor (*Capra falconeri megaceros*). Male.

↑ **B**

Double Helix DNA model.

Such structural resemblances are seen everywhere in nature—from the ordinary to the majestic. The markhor's horn **(A)** and the double helix of DNA **(B)** share helical configurations. A spiral nebula that is more than 60,000 light years across **(C)** has the same fundamental form as the chambered nautilus **(D)**.

Artists and designers, much like scientists, are always on the lookout for resemblances and hidden patterns connecting the world and their work, and within the work itself. How many spiral structures can you find in a day?

C

Spiral Nebula (M51). NASA, Hubble Heritage Team. 2010. Photo.

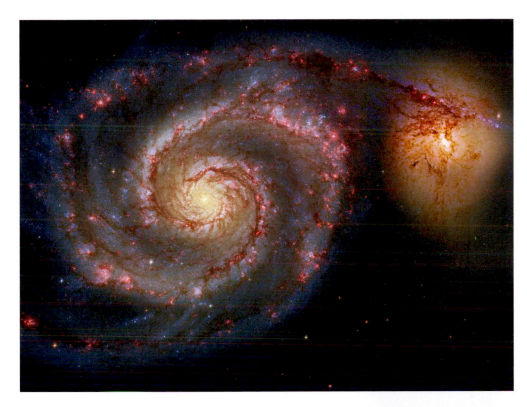

D

Chambered nautilus, cross section.

TACTILE SENSATION

The sense of touch (tactile sensation) plays an important role in experiencing the 3D world. Though vision may be the primary mode of human perceptual experience, all the senses contribute to our ongoing need to decipher, navigate, and manipulate the three-dimensional realm.

Imagine that you are in a house, blindfolded, and need to find your way to another room. You would undoubtedly do so with your arms extended in front of you. Your two hands, probing for obstacles, serve as antennae and function as a primitive form of sight.

Vision and Touch

Vision and the sense of touch, working in tandem, constitute a partnership that is an extremely successful perceptual agent. The woodcarver in **A** must observe visually and sense with his hands, simultaneously. The craftsperson sanding a piece of wood will visually examine the completed work to make sure the surface is adequately smooth. Next, he or she will inevitably feel the wood, lightly sliding a hand across the surface in order to ascertain the accuracy of the initial visual observation. The use of touch in this manner is an example of feedback. The sensitive hand communicates specific information concerning surface imperfections, enabling one to sand efficiently and complete the task. When it comes to judging texture or the gracefulness of a curving surface, whether in the making or the appreciation, the hand is an extraordinary sensory tool.

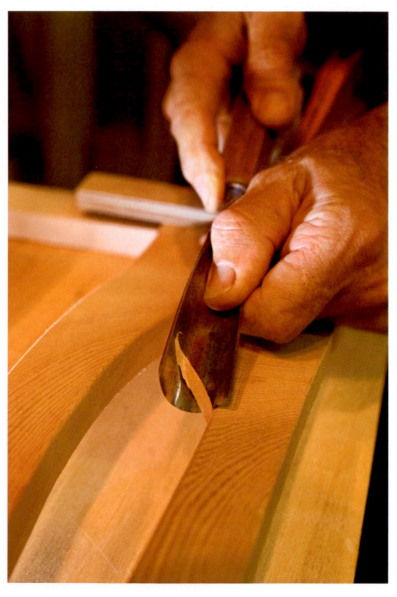

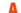 **A**

Hands carving wood.

The Hand

Though touching art in museums is widely forbidden, it is not unusual to see a particular spot, a beautiful curved form on an accessible bronze sculpture, that has had its **patina** rubbed off and its surface polished by museum visitors who could not resist reaching out to touch it as they walked by. While museums, of necessity, must forbid touching, most sculptors are extremely engaged with the tactile qualities of their work.

The industrial designer Raymond Loewy believed that judging an automobile's design required running one's hands over it.

The automobile is but one of the numerous objects and structures that engage the tactile. The clay car model **(B)** involves shaping complex curves and necessitates using the hand to test for gracefully flowing form. Many functional objects engage the viewer's touch. How does the cup feel in your hand? How does it engage your lips when drinking? Does the cup when filled with tea get too hot to hold?

↑ **B**

Clay model, 2010 BMW 550I Gran Turismo. © BMW PressClub.

A SHAPING FORCE

Objects communicate their characteristics and take on meaning not in isolation but in context. All objects exist in relationship to other objects and to their environments. The perceived qualities of objects change when other objects are placed in proximity or when placed in a new environment. Such changes affect both form and meaning. We cannot help comparing the formal characteristics of objects, as we always see each in comparison to the other. A small book may seem large when it sits next to an even smaller book. Every object-group and site also involves complex social and psychological effects that are, like form, relative and contextual. Artists and designers must be sensitive to the formal, social, and psychological implications of context. Spaces and situations are never neutral.

Artist Haim Steinbach is a master of context. His practice has for many years consisted of placing groups of found objects on shelves. The Ajax can in the sculpture in **A** is a component of a work of art. Transporting objects from one social context to another is now a commonly understood art strategy. Under your kitchen sink, the Ajax can means something quite different than it would in an art gallery. This work, though, deals with context in another way as well; it pits one found object against another. It also raises the important issue of the pedestal in sculpture. The Ajax can is elevated in status due to its place of honor on the subservient shelf; but the shelf, a rustic handmade object, possesses more qualities associated with traditional art than does the Ajax can. Steinbach's sculpture gives us a glimpse of shifting contextual relationships between two mute objects.

↑ **A**

Haim Steinbach. *Shelf with Ajax.* **1980. Mixed mediums. Fisher Fine Arts Library Image Collection.**

Recontextualizing

The artist Fred Wilson was invited to the Maryland Historical Society in 1992 to rearrange the collection. The resulting exhibition, "Mining the Museum," **recontextualized** the art and artifacts in the museum collection by creating provocative new **juxtapositions**. One pairing—*Slave Shackles* (never previously exhibited) and *Silver Vessels in Baltimore Repoussé Style* **(B)**—critiques the ideological biases of institutions as well as history.

See also *Scale: Comparative Size*, page 410.

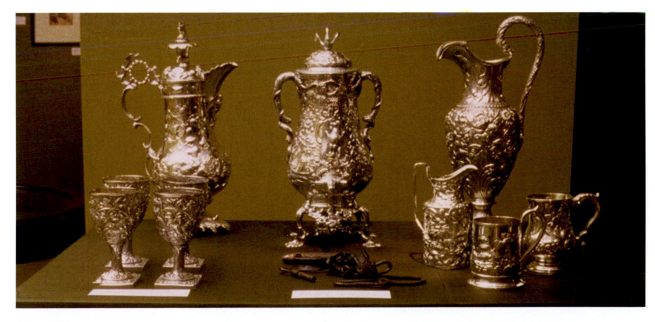

 B

Fred Wilson. *Mining the Museum: An Installation.* **1992. Detail: Silver Vessels in Baltimore Repoussé Style, 1830–1880, and Slave Shackles, maker unknown. c. 1793–1872. Baltimore.**

SITE SPECIFIC

All objects exist in context, but artworks, architecture, and design installations that make context essential are called **site specific**. Such works are made for particular places. If moved from their intended sites, they become unintelligible or acquire new meaning.

Architecture is especially involved with issues of site. A new building must contend with the landscape it resides in, as well as neighboring structures. Site issues can become contentious when high-rise buildings are planned for low-rise residential neighborhoods or pristine natural sites, or when an extension is planned for a building that happens to be an architectural landmark.

Frank Lloyd Wright's *Fallingwater* **(A)**, a house in rural Pennsylvania, makes a waterfall its central feature. *Fallingwater* appears to become an extension of the overhanging rock formations of the landscape. Using natural materials and sandstone from a local quarry further reinforced its site-specific spirit.

Surrounded Islands **(B)** is a sculpture installation that used 6.5 million square feet of woven polypropylene fabric to surround eleven islands in Biscayne Bay. The intense pink fabric floated on the surface of the water for the two-week duration of this temporary work. The flamboyant gesture that is *Surrounded Islands*, removed from its site, would be nothing, just a pile of fabric. In fact, what is *Surrounded Islands* really? Is it simply the fabric, which the artists had fabricated, or does it encompass all of Biscayne Bay, including its islands, boats, people, and weather?

In a digital print **(C)**, Wim Delvoye simulates an amusing site-specific installation. The message, "Out walking the dog, back soon. Tina," would, of course, not be funny if it were on an ephemeral Post-it attached to a door; it would just be another daily bit of information. By recontextualizing the note, putting this mundane sentence into a wildly inappropriate context, one more suitable for a monument or a presidential memorial, Delvoye disrupts our expectations.

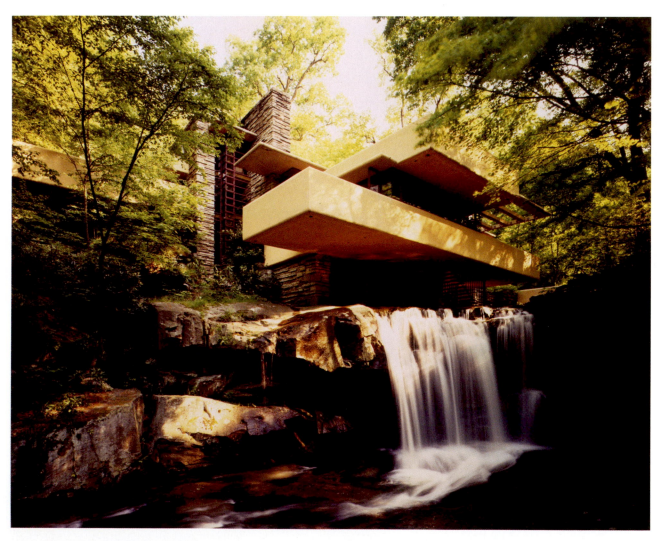

↑ A

Frank Lloyd Wright. Kaufmann House (*Fallingwater*). 1937. Bear Run, Pennsylvania. © 2011 Frank Lloyd Wright Foundation, Scottsdale, AZ/Artists Rights Society (ARS), New York.

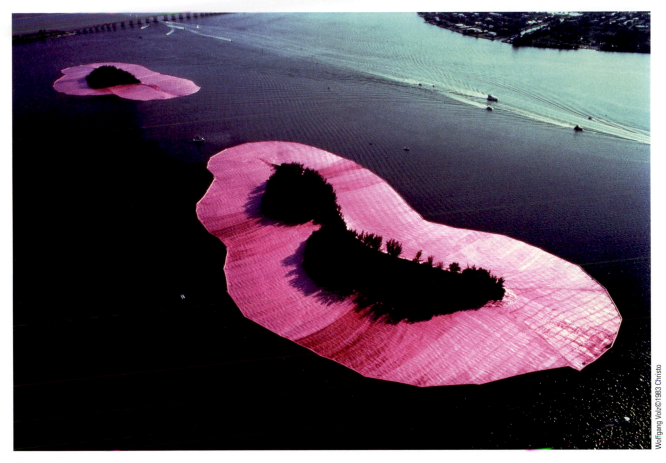

Wolfgang Volz©1983 Christo

 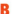 **B**

Christo and Jeanne-Claude.
Surrounded Islands, Biscayne Bay,
Greater Miami, Florida, 1980–83.
**Copyright Christo & Jeanne-
Claude.**

 C

Wim Delvoye. *Out Walking the Dog.* **2000.**
C-print on aluminum, 3' 3" × 4'.

BECOMING INFORMED AND AWARE

In art and design, as well as life in general, few activities are more important than learning. Many of the things we do in the arts are intended to enrich and inform the maker, not simply to arrive at a product . . . or perhaps, the maker can also be considered a product to be shaped. Artists and designers are fortunate to have practices that require perpetual learning.

Art and design foundation programs (first-year programs) are created to teach students the basics of visual form, introduce materials and structural principles, develop technical skills and the ability to research and articulate ideas, foster visual sensitivity, communicate effectively, and above all, become informed, inventive, thinking makers who are beginning to develop an awareness of the history and the nature of the disciplines of art and design, against a global backdrop.

Problem-Solving in the Art Foundation

Problem-solving assignments have been created to accomplish these formidable educational tasks. We have inherited many assignment ideas from the Bauhaus. Successful projects have been passed along from teacher to teacher, often adjusted to create variations on the original, and some are completely new. In 3D classes projects range from the highly structured to the expressive, and from the observational—depicting various displayed objects in clay, cardboard, or wire, perhaps—to studies in structure (towers or bridges constructed of wood dowels that must support a brick or other weight, for example).

Box Beam Workshop

Every assignment is designed to teach a lesson or a bundle of lessons. Let's examine one project in order to gain some insight into the workings of the 3D foundation experience.

In the art foundation program of the School of the Arts at Virginia Commonwealth University (a foundation program that includes both art and design students), Professor Matt King has assigned the "One-Week Box Beam Workshop" **(A** and **B)**. He states the problem: "Using box beam construction, create a cardboard structure that suggests an extraordinary or unexpected relationship to gravity." With only corrugated cardboard, hot glue, and brown paper tape, the students work in groups of three to four. Professor King sets some of the following parameters: "The piece must be taller than the tallest person in the group; the cardboard may only have three points of contact (two on the floor and one on a stool or chair); the stool must remain unattached to the cardboard structure." Student solutions are accomplished in accordance with a specific procedure, requiring the creation of 1:8 scale preliminary models, investigation of the stresses involved, and finally translating the scale model into a full-size structure.

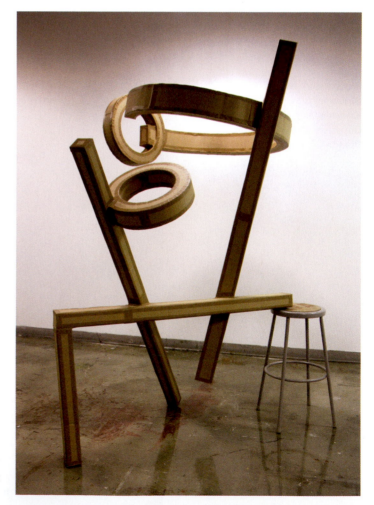

→ A

Student project. Professor Matt King, instructor. Virginia Commonwealth University, Art Foundation Program.

However delightful the students' solutions may be, they are, more importantly, the vehicle for significant lessons. Students learn to work collaboratively, requiring them to put their ideas into words. They learn to be inventive, generate ideas through the use of models, think in scale, measure, and develop fabri-cation skills. Their structures must be carefully balanced; thus they learn to deal with issues of gravity and **cantilever**, as well as structure. By means of the instructor's criticism and the final group **crit**, students learn to be articulate about things visual and structural, and they learn the importance of self-criticism.

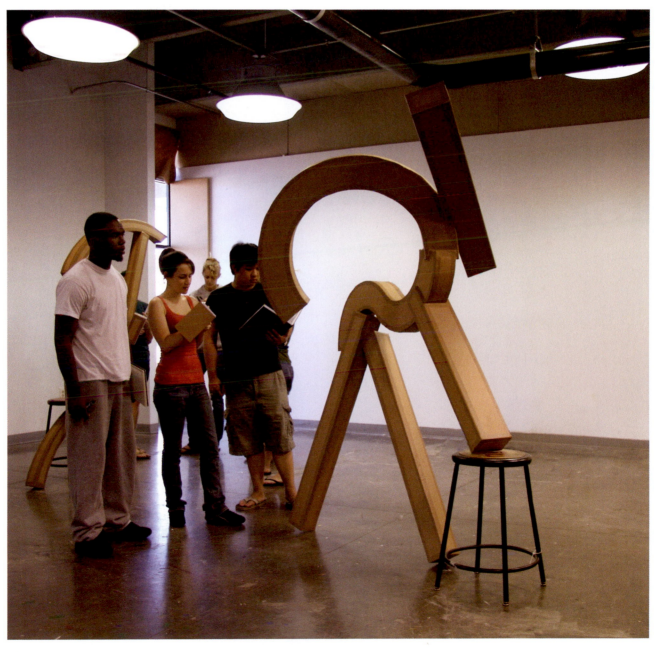

↑ **B**

Student project. Professor Matt King, instructor. Virginia Commonwealth University, Art Foundation Program.

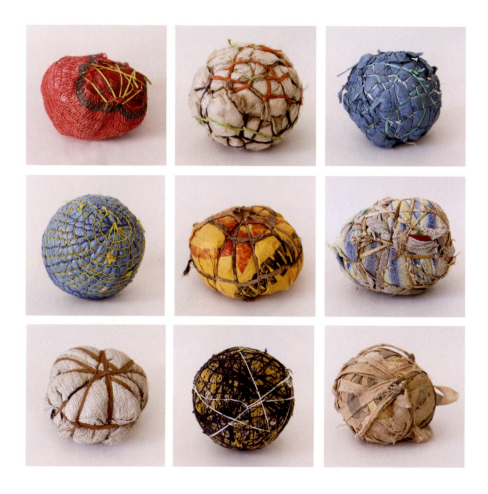

Jessica Hiltout, photographer. Nine homemade soccer balls, Africa.
From the book *Amen: Grassroots Football*, 2010.

CHAPTER 15 IDEAS AND APPROACHES

RESEARCH

Artists, designers, and architects utilize research in numerous ways. On one level, research in design is similar to research in the humanities. An artist/designer might go to the library or the web, or travel to find out more about the history of the Civil War, if intending to design a commemorative monument in Richmond, Virginia. Research in the arts sometimes resembles play, but, just as often, it can be similar to scientific investigation.

Biomimicry

Biomimicry is a discipline in which engineers, scientists, and product designers research and emulate nature's designs and

processes to create products, solutions, and strategies to solve human problems. The sandcastle worm builds its dwelling **(A)** by gluing sand and bits of shell together underwater. Scientists are studying this phenomenon in order to develop adhesives that will be able to bond broken bones and seal incisions in the moist environment of the human body. Self-cleaning surfaces, such as glass and paint used in architecture, are examples of bioinspired products developed by studying the self-cleaning properties of plant leaves. The design process and research are inseparable.

Experiments and Questions

Another type of research in art and design takes the informal path. In this research mode, the artist/designer asks a series of questions: What will happen if I put the structural elements of my building on the outside instead of hidden internally? What will happen if I design a product that spoofs "good" design? What will happen if I construct a chair with the least amount of material possible? What will happen if I place a round, wood form above a faceted steel polyhedron? Then, after enacting a response (altering material) and answering the question, more questions follow: That doesn't work, but what if I split it in half? Then the designer attempts that, and so forth. Whether this process is highly structured or simply involves exploring material properties, this kind of research can lead the designer on a journey of connected discoveries leading to a new, original and unexplored terrain.

Testing

A racing bicycle **(B)** is tested in a wind tunnel to arrive at the most **aerodynamic** and efficient form. The Cervélo Baracchi **(C)** was designed from scratch and subjected to an intense testing regimen that involved real-life road racing, as well as wind tunnel analysis, to create the ultimate aerodynamic racing bike.

↑　**A**

Tube-shaped dwelling of sandcastle worm (top); two beads of a worm's home microscopically enlarged (bottom). © Russell Stewart.

→　**B**

Cervélo bicycle in wind-tunnel test.

Design Research

Subjecting **prototypes** of aircraft, automobiles, sports equipment, and most other products to testing provides valuable information for improving performance. Wind tunnel testing, structural stress testing, real-world use, and interviewing and videotaping users of new products are just some of the many modes of contemporary product testing. It is useful to all makers, on every level, to subject the objects they create to testing.

Research Methodology in Art

The working method of some contemporary artists resembles that of the scientist. Natalie Jeremijenko created a sculpture installation, *Tree Logic* **(D)**, in which she suspended six live trees upside down from an armature. This was an experiment to examine the effects of gravity and phototropism on the growth and shape of trees.

← **C**

Cervélo Baracchi bicycle.

→ **D**

Natalie Jeremijenko.
Tree Logic. **1999. MASS MoCA, North Adams, Massachusetts.**

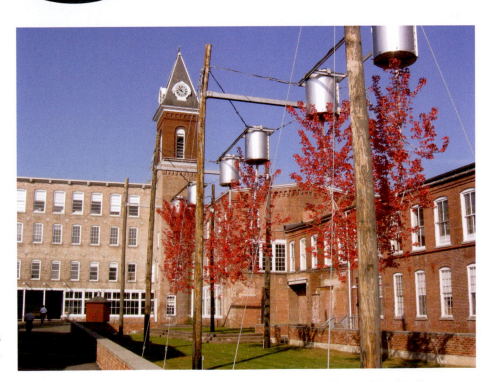

PROCESS

To one who has watched the potter at his wheel, it is plain that the potter's thumb, like the glass-blower's blast of air, depends for its efficacy upon the physical properties of the clay or 'slip' it works on, which for the time being is essentially a fluid. The cup and the saucer, like the tube and the bulb, display (in their simple and primitive forms) beautiful surfaces of equilibrium as manifested under certain limiting conditions. They are neither more nor less than glorified 'splashes,' formed slowly, under conditions of restraint which enhance or reveal their mathematical symmetry.

—D'Arcy Wentworth Thompson,
On Growth and Form, *1917*

The Relationship of Process, Material, and Form

While the form of many objects, products, and structures today is to a great extent determined by function, form is also significantly the result of its fabrication process and material. A chair constructed of wood and steel **(A)** and one of resin and fiberglass **(B)** might share the same function—to seat diners around a table. The formal difference between two such chairs can be attributed to factors that include the dissimilar processes and materials involved in their fabrication and the designer's values and sensibility.

Form Is a Diagram of Forces

The industrial process of extrusion is an example of a fabrication procedure that determines very specific kinds of forms. As heated aluminum, rubber, or other malleable material is forced

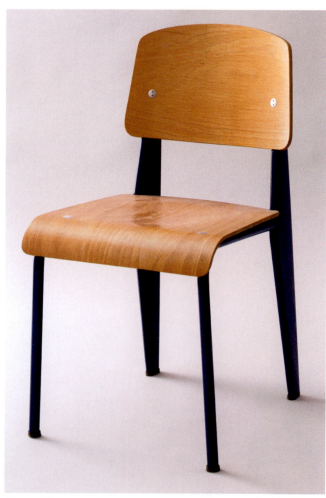

 A
Jean Prouvé. Standard chair. 1950. The Museum of Modern Art, New York.

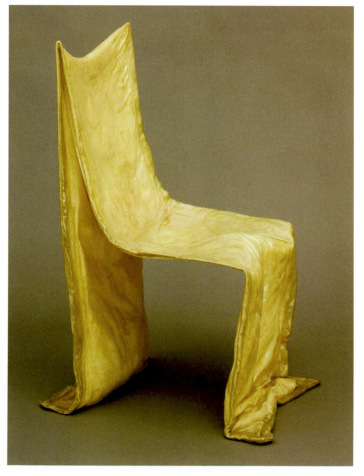

 B
Gaetano Pesce. *Golgotha Chair.* **1972. Dacron filled and resin soaked fiberglass cloth, 3' 3" × 1' 6½" × 2' 3¾". The Museum of Modern Art, New York.**

through an aperture of specific shape, it achieves the form of a long rod or tube with a configuration derived from the shape of the aperture. In **C**, a pliable, flour paste is extruded to form rigatoni, one of the many pasta shapes that may be determined by the simple change of aperture.

Biologist D'Arcy Wentworth Thompson said, "In short, the form of an object is a diagram of forces; in this sense, at least, that from it we can judge of or deduce the forces that are acting or have acted upon it; in this strict and particular sense, it is a diagram." The extrusion process is a good example of Thompson's proposition: it produces forms that are easily identifiable as extrusions and illustrates developmental forces.

Process and Feedback

Feedback is an important component of many fabrication processes. Consider the work of a potter **(D)**. The potter's wheel predetermines fundamental formal qualities—it naturally and efficiently produces round and cylindrical shapes. As the potter squeezes the pliable wall of a spinning clay vessel, he or she is constantly sensing the thickness of the wall. This ongoing feedback is essential to the achievement of the desired outcome. Feedback and process are interactive partners.

Process and Invention

Artists and designers often utilize process as a research tool. The exploration of materials and their properties can result in useful and surprising discoveries. Gaetano Pesce is an Italian designer known for his freewheeling experimentation with new materials. Looking again at **B**, note how Pesce combines unlikely materials—Dacron-filled, resin-soaked fiberglass cloth—to invent a playful, **anthropomorphic** chair.

← **C**

Rigatoni extrusion in pasta machine.

→ **D**

Ceramic artist at potter's wheel.

THE VESSEL

It is significant that in speaking of craft objects, people use terms such as savor and style. The beauty of such objects is not so much of the noble, the huge, or the lofty as a beauty of the warm and familiar. Here one may detect a striking difference between the crafts and the arts. People hang their pictures high up on walls, but they place their objects for everyday use close to them and take them in their hands.

—Sōetsu Yanagi

The tradition of the vessel (a receptacle or container) extends back to prehistory; it is an **archetypal** form, worthy of our special attention. From the cups, glasses, pots, and bowls we use every day, to highly technical scientific and industrial vats, the vessel is born of utility. Vessels are everywhere around us: paper cups, glass and plastic bottles, and cookware; even cardboard boxes, cabinets, and dressers may be considered vessels, and so too, rooms and buildings. While we are thinking broadly, let's not forget the bathtub, the toilet bowl, and the swimming pool. Boats and ships are also referred to as vessels; they contain cargo and people and volumes of air that displace water.

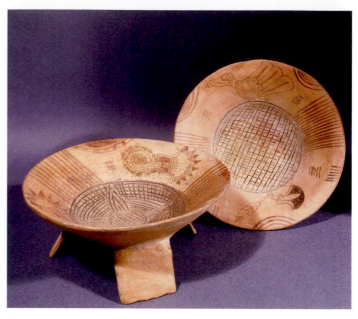

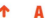 **A**

Aztec hand-coiled domestic pottery. 16th century. Mexico.

Glass and Ceramics

The disciplines of glass and ceramics hold an esteemed place for the vessel, ranging from the purely functional to vessels that primarily explore form and disregard utility. The potter may take flat slabs of clay, pinching them together at the seams, to create a vessel, or roll out long lines of clay and coil them in circles, one above the other, to construct a bowl **(A)**. Of course, pots are most commonly thrown on the potter's wheel, harnessing the spinning forces and the potter's hand, used as an instrument of extrusion, to naturally produce spherical and cylindrical forms. Similarly, the glassblower's breath and the spinning of the molten glass at the end of the blowpipe produce round and cylindrical vessels—byproducts of the process **(B)**.

Another way of producing ceramic vessels **(C)** is by pouring slip (liquid clay) into molds. As with all ceramic objects, after drying, the vessels are fired in kilns. In a related manner, glass may be blown into forms to produce precise shapes.

New Processes

Designer Stefan Lindfors re-imagines and elevates the humble motor oil can **(D)**. The blow-molded polyethylene container is produced by an industrial process in which air is blown into polyethylene plastic. The air pressure forces the plastic against the walls of a mold where the container's shape is determined.

See also *Replication Technologies: New Approaches*, page 484.

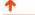 **B**

Glassblower at Waterford Crystal, Ireland.

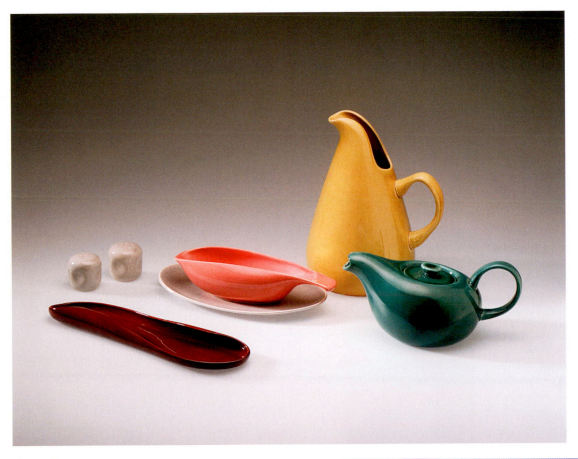

↑ **C**

Russel Wright. American modern dinnerware. 1937. Manufacturer: Steubenville Pottery, East Liverpool, Ohio. The Museum of Modern Art, New York.

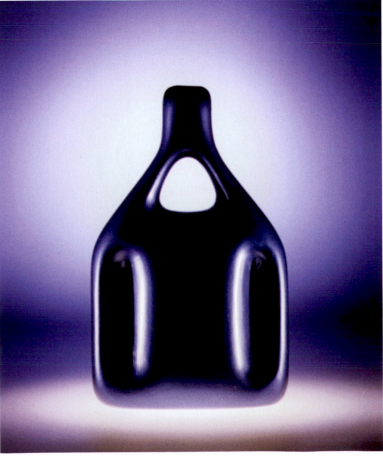

→ **D**

Stefan Lindfors. *Oil.* Four-liter motor oil container prototype for Neste Oil. 1994. Blow-molded polyethylene.

NATURE

We might not think of nature as designed, but the fact is, all form and matter, whether organic or inorganic, must of necessity be generated and shaped by forces, conditions, and processes. In this sense, nature might be seen as the ultimate designer as well as the first and foremost source of design inspiration—the design school without equal.

The Grand Canyon **(A)** is one of the most awe-inspiring natural monuments. The rock of the Colorado Plateau was carved away bit by bit for a duration spanning millions of years by the eroding force of the Colorado River. Its form was and continues to be determined by natural processes—the creation of the plateau by forces of plate tectonics followed by the perpetual interaction of limestone and sandstone with ice, wind, gravity, and a turbulent river.

Sand and wind combine to generate spectacular dunes **(B)** in Peach Canyon, Arizona. Here, sand acts as a perfect recording device for atmospheric conditions. Wind blows, sand piles up, collapses and slides down, seeking equilibrium, then begins all over again. Every breeze is transcribed.

The Hooded Oriole nest **(C)**, made of artfully woven plant fibers, hangs attached to the underside of leaves and is perfectly suited to its purpose. The Oriole utilized not just the usual natural fibers, but much like any savvy contemporary designer, it incorporated whatever worked and was available in the vicinity—in this case, green holiday tinsel!

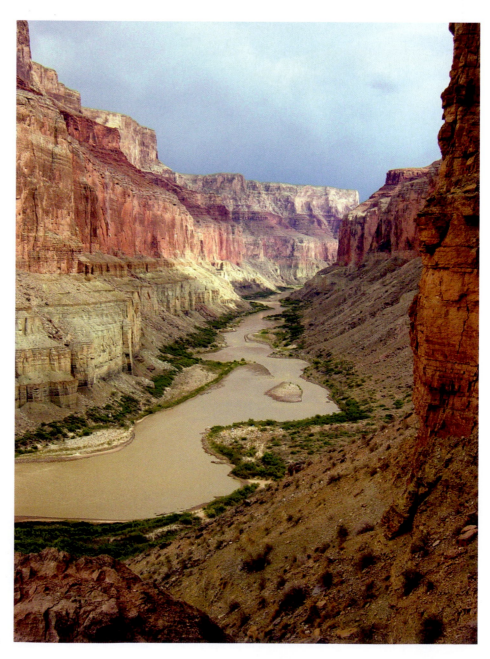

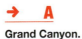 **A**

Grand Canyon.

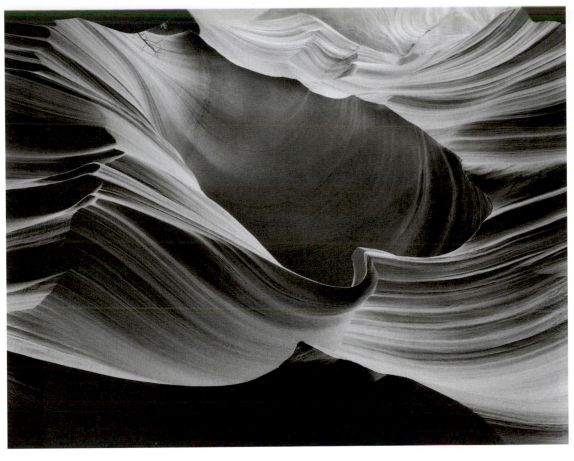

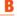 **B**

Bruce Barnbaum. *Hollows and Points, Peach Canyon.* **1984. Photograph.**

 C

Richard Barnes. Hooded Oriole nest. Photograph.

EXTENDING CAPABILITY

It was once thought that humans distinguished themselves from other animals by their use of tools. It is now common knowledge that animals also utilize tools. Some chimpanzees and bonobos use sticks as probes to extract ants and termites from their hives. To crack open mussels, flying birds drop them on rocks below. Some crows have been observed placing walnuts on roads so passing cars can break them open!

The first human tools were most likely repurposed found objects—such as shells used for digging, cutting, and drinking, and stones used as hammers and weapons. The earliest human-made prehistoric stone tools **(A)** were simple hand axes. Today, tools are everywhere and are increasingly complex. It is almost impossible to imagine life without tools.

Tools enable us to perform special and complex tasks that would otherwise be impossible. Levers and pulley systems allow us to lift heavy weights; lenses bring distant objects near and make small objects appear large; computers perform many tasks by making huge calculations instantly. Art and designed objects look as they do, in part, because tools generate particular forms. It is safe to say that many contemporary buildings would simply not exist without computer-aided design.

The traditional jack plane **(B)** is perfectly suited to its task. It is a hand tool for smoothing flat, wood surfaces, one thin shaving per stroke. It is efficient, adjustable, and exquisitely simple. From the hand ax to the ever-present and increasingly complex computer, tools continue to extend human capability. Industrial welding robots **(C)** produce perfect welds at great speed.

Today artists and designers utilize a wide array of tools. For example, sculptors use hammers and chisels to carve wood and stone, molds to replicate forms, welders and laser cutters to shape steel, and **CNC** routers (computer controlled carving machines) to shape many materials. Designers utilize **CAD** (computer aided design programs) and **rapid prototyping** (3D printers), as well as traditional hand tools. An important part of a basic 3D design course consists of mastering tools and technology.

↑ **A**

Paleolithic stone hand ax.

Now the camera, camcorder, and computer have been added to the list of essential tools.

A famous moment in the movie *2001: A Space Odyssey* neatly summed up the evolution of tools on earth when it portrayed an early, ape-like human ancestor throwing a bone high in the air after discovering that it could be used as a weapon. At the top of the bone's trajectory, bridging millions of years in an instant, the film cuts to an image of a rotating space station.

I love the tools made for mechanics. I stop at the windows of hardware stores. If I could only find an excuse to buy many more of them than I have already bought on the mere pretense that I might have a use for them! They are so beautiful, so simple and plain and straight to their meaning. There is no "Art" about them, they have not been made beautiful, they are beautiful.

—Robert Henri

↑ **B**

Traditional jack plane. Peck Tool.

 ↑ **C**

Welding robots at an auto plant in Fukuoka prefecture on Japan's southern island of Kyushu.

TRANSCENDING PHYSICALITY

The requirement that raw material be transformed, changed from mere matter to something greater, something transcendent, is a commonly accepted notion in the arts. Clay is nothing but mud. In the hands of a great sculptor, clay can be transformed into human flesh. The **aesthetic** expectation that matter be altered evokes historic myths of transformation—alchemy's transmutation of base metals into gold, as well as creation stories.

By depicting nuanced human form garnered from careful observation, Gian Lorenzo Bernini coaxed life out of cold, hard marble **(A)**. Prior to Bernini, it was rare to see indentations (due to the pressure of a grasp, for example) depicted in sculpture. This telling detail completed the illusion of the transformation of stone to flesh.

Tara Donovan stacked thousands of ordinary clear plastic drinking straws against a gallery wall to create *Haze* **(B)**. When first viewing *Haze*, one does not perceive the completely ordinary material of its construction. The initial experience is spatially disorienting and perceptually ambiguous. *Haze* appears to be a cloud-like formation, more like a mirage than an object. Upon close inspection **(C)**, seeing that it is made of drinking straws startles and amazes.

A musical instrument is a mysterious thing, inhabiting a complex sort of space: it is both an ordinary three-dimensional object and a portal to another world; it exists as a physical entity solely so that it—and, indeed, physicality—can be transcended.

—*Joyce Carol Oates*

Transformation as a Conceptual Act

In 1975, sculptor Scott Burton took an old and quite ordinary wooden chair left behind by the previous tenant of his apartment and had it cast in bronze **(D)**. He did not alter the chair in any other way. He performed one simple modification: he converted a wooden chair to a bronze chair. This simple conceptual act had profound ramifications. Identical to the original chair in every way, except material, the chair was no longer a chair; it was sculpture. As sculpture that was *about* a chair, it became philosophical. The Burton chair was profoundly transformed by a simple act. It is cold to the touch, rock hard, and extremely heavy, but it looks exactly like a chair and . . . you can sit in it!

→ **A**

Gian Lorenzo Bernini. *The Rape of Proserpina*, **detail of Pluto's hands. 1621–22. Marble, height 9' 8".
Galleria Borghese, Rome.**

 B

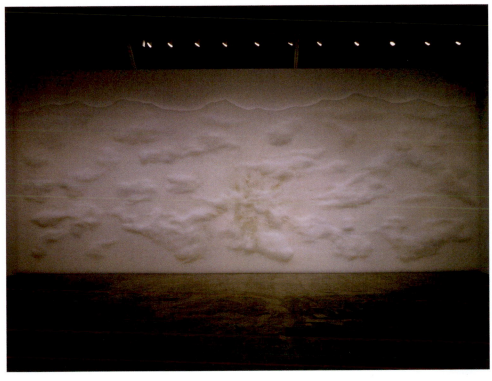

Tara Donovan. *Haze.* 2003. Installation with translucent drinking straws, dimensions variable.

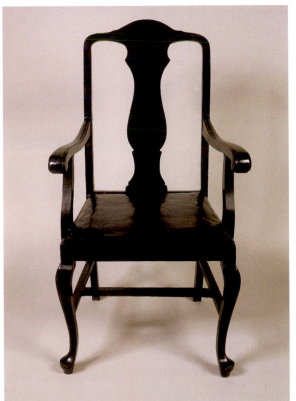

 C

Tara Donovan. *Haze*, detail. 2003. Installation with translucent drinking straws, dimensions variable.

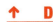 **D**

Scott Burton. *Bronze Chair.* 1979. Solid cast bronze, 3' 8⅛" × 1' 9½" × 1' 10½". © 2011 Estate of Scott Burton/Artists Rights Society (ARS), New York.

ALTERING FORM

Variation

Why do designers and artists create variations on a theme? Isn't one version enough? There are compelling reasons for this design tactic; one is—to get it right. The first, second, and third versions (also referred to as **iterations**) might not express exactly what needs to be stated, so perhaps a fourth version is required. The end result is four interesting and related objects, but with varying attributes. Another reason for working with variations is simply the fact that certain issues and themes suggest numerous responses. When a single conclusion will not suffice, different points of view are required to fully understand the subject.

Henri Matisse created four versions, in bronze relief, of the female back **(A, B, C, D)**. Matisse did not create these pieces as a series; they were generated by a theme of great interest that he returned to repeatedly during a period of more than twenty years. These monolithic reliefs allowed Matisse to use sculpture to inform his painting—relief is the flattest form of sculpture and can be rectangular—in this way, relief is painting's kindred spirit. In these four works, Matisse explored ideas of realism and pursued a development toward greater abstraction. The back in **D**, the final piece, evolved into a figure that is primarily about form—the vertical masses of the bifurcated back and their relationship to the rectangular frame.

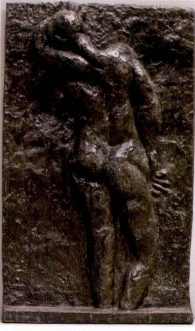

→ **A**

Henri Matisse. *The Back I.* 1909. Bronze, 6' 2½" × 3' 8" × 6". The Museum of Modern Art, New York. © 2011 Succession H. Matisse/Artists Rights Society (ARS), New York.

← **B**

Henri Matisse. *The Back II.* 1913. Bronze, 6' 2½" × 3' 8" × 6". The Museum of Modern Art, New York. © 2011 Succession H. Matisse/Artists Rights Society (ARS), New York.

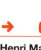 → **C**

Henri Matisse. *The Back III.* 1916–1917. Bronze, 6' 2½" × 3' 8" × 6". The Museum of Modern Art, New York. © 2011 Succession H. Matisse/ Artists Rights Society (ARS), New York.

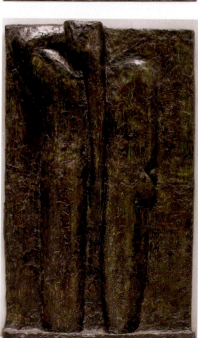

← **D**

Henri Matisse. *The Back IV.* 1930. Bronze, 6' 2½" × 3' 8" × 6". The Museum of Modern Art, New York. © 2011 Succession H. Matisse/Artists Rights Society (ARS), New York.

Images **E** and **F** are two variations of many that the architecture firm SITE designed for a company that owned numerous big-box stores in the 1970s. SITE preserved the basic, efficient box structure of the buildings but decorated the façades in inventive and destabilizing ways, riffing on antiquity and suburbia, and creating variations that once seen are never forgotten.

Deformation

Deformation plays an important role in art, design, and architecture. It involves rethinking and reinventing established forms or pre-existing elements. It can entail anything from a complete restructuring to a subtle tweak. In some way, all creation involves a deformative act, as there is always a prior format or genre.

George Ohr took a common form of **ceramic** vase and had a great deal of fun with it **(G)**. He dented the side of a freshly thrown clay vessel until its side collapsed, creating a new vase in which the original form as well as the process of its deformation remain clearly visible.

The painter Jasper Johns suggests, "Take an object. Do something to it. Do something else to it. Do something else to it."

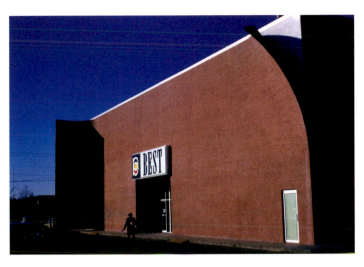

↑ **E**

Peeling Project. 1971. Richmond, Virginia. SITE architecture, art and design.

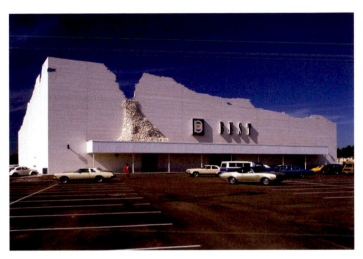

↑ **F**

Indeterminate Façade Building. 1974. Houston, Texas. SITE architecture, art and design.

↑ **G**

George Ohr. *Lighthouse pot.* **c. 1895.**

FOCUSED INVESTIGATION

Throughout history, artists and designers have worked in series. Monet painted numerous versions of water lilies, haystacks, and Rouen Cathedral. Degas returned repeatedly to ballet dancers and their classic positions. The rise of scientific method as well as modern mass production enhanced interest in the series—consider the automobile production line or the similar yet different houses in a suburban development. Nature as well loves the series—scientists estimate over 9,000 species of birds in the world. Matisse observed that every fig leaf is different, but all are always unmistakably fig leaves.

In the arts and design, a series can be based on a theme, a form, a process, or an idea. Each element in a series varies from the others while maintaining a distinct similarity. Series allow creators to investigate issues more deeply than a single work would permit.

Conceptual Series

Sol LeWitt created a **conceptual** sculpture series titled *Incomplete Open Cubes* **(A)** that included all 122 variations of an open-sided cube missing between one and nine of its edges. To create this work, LeWitt followed his initial concept rigorously—122 permutations based on a generating principle. It is exciting to see the range of formal variation and expressive form resulting from such a methodical approach.

↑ **A**

Sol LeWitt. *Incomplete Open Cubes.* **1974. Installation: painted wood structures, gelatin silver prints, and drawings on paper, sculptures: 8" × 8" × 8", framed works: 2' 2" × 1' 2", base: 1' × 10' × 18'. Collection SFMOMA. © 2011 The LeWitt Estate/Artists Rights Society (ARS), New York.**

Seriality and Process

Roxy Paine used a modified industrial extruding process and a set of computer instructions to create a sculpture series **(B)**. "Engaged ambivalence" is how he refers to his involvement in this automated fabrication process. His sculpture machine discharges piles of layered polyethylene to create a series that is at once thoroughly consistent and exuberantly diverse.

Thematic Series

Some series are based on observed reality. The goose decoys on a frozen lake **(C)** depict geese in varying positions. Only the series would allow the maker to articulate an array of archetypal positions.

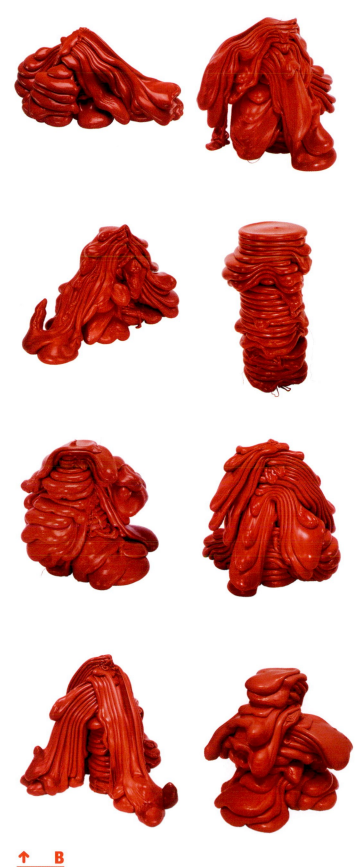

↑ **B**

Roxy Paine. Eight sculptures. All 2003 except lower left 2007. Low density polyethylene, dimensions vary from 1' 6" to 2' 6" h. Courtesy the artist and James Cohan Gallery, New York/Shanghai.

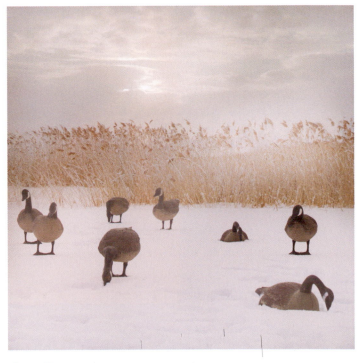

↑ **C**

Goose decoys on a frozen lake.

THE IDEA BECOMES A MACHINE THAT MAKES THE ART

"If the idea is there, the brush can spare itself the work." This Chinese painter's proverb makes it very clear that concepts have always been important to the arts. Art and design involve ideas; consequently, it might be safe to say that all art and design are conceptual. Some traditional genres, such as Realism, that have very long histories might seem devoid of concept, but this is only because we have so completely assimilated their histories and methodologies that they appear "natural," obvious, inevitable. In fact, Realism is quite a rich conceptual domain.

Let's look again at Sol LeWitt's *Incomplete Open Cubes* **(A)**. They were generated entirely by a single operational idea—construct all 122 permutations of an open-sided cube missing between one and nine of its edges. LeWitt has written, "In conceptual art the idea or concept is the most important aspect of the work. When an artist uses a conceptual form of art, it means that all of the planning and decisions are made beforehand and the execution is a perfunctory affair. The idea becomes a machine that makes the art."

Cloaca **(B)** is an installation that explores the operation of the digestive system of the human body. Though it *looks* nothing like its subject (constructed of glass vats, tubes, pumps, and digestive enzymes), it does *function* like a digestive system. Cloaca is "fed" real food; fecal matter is the end product. This sculpture, with its straightforward conceptual approach, would be equally at home in a science laboratory. It is a good example

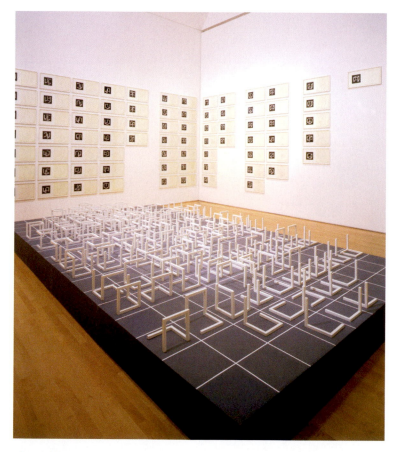

↑ **A**

Sol LeWitt. *Incomplete Open Cubes.* **1974. Installation: painted wood structures, gelatin silver prints, and drawings on paper, sculptures: 8" × 8" × 8", framed works: 2' 2" × 1' 2", base: 1' × 10' × 18'. Collection SFMOMA.**

of a work of art that completely avoids traditional aesthetic values, while perhaps suggesting a new aesthetic model.

Extreme Concept

AN OBJECT TOSSED FROM ONE COUNTRY TO ANOTHER.

Some conceptual work is all concept, no object. In the above statement (in blue text) created in 1969, artist Lawrence Weiner made language the vehicle of his art. Whether painted on a wall or printed here, the words, "an object tossed from one country to another," *are* the art. Whether this work is read or performed, and whether you consider it sculpture, theater, or literature, you must admit that, with the lightest of touches, it delivers so much. In 1968 Weiner wrote this statement of intent:

1. THE ARTIST MAY CONSTRUCT THE WORK
2. THE WORK MAY BE FABRICATED
3. THE WORK NEED NOT BE BUILT

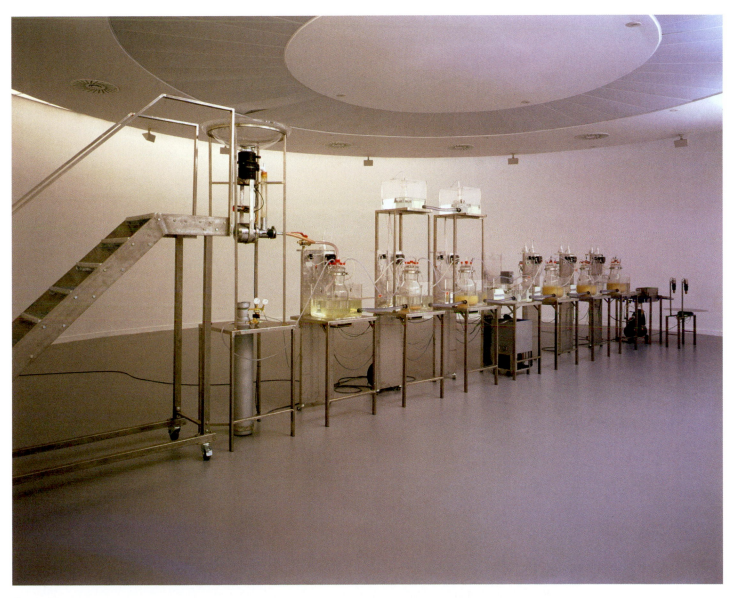

 B

Wim Delvoye. *Cloaca.* **2000.**

DISCOVERY

Let my playing be my learning, and my learning be my playing.

—Johan Huizinga

Play

In 1938 the Dutch scholar Johan Huizinga wrote the book *Homo Ludens* (Man the Player). Huizinga made a powerful case for the importance of the play element in culture. To Huizinga, play is not a cultural amusement; it is a necessity! Artists and designers perform acts of serious play in order to arrive at new discoveries.

Casually constructed of such materials as wire, wood, cork, and cloth, *Cirque Calder* **(A)** is a miniature version of a circus. *Cirque Calder* is not only a sculpture but a set of props that Alexander Calder used to enact live performances. This child-like involvement with the circus and the rudimentary nature of the craft utilized by one of the major sculptors of the twentieth century affirm the importance of play to creativity.

Both hearts and teapots are liquid-bearing vessels, but to actually construct a teapot in the form of a realistic human heart and its arteries, as Richard Notkin does in **B**, is a bold leap that renders a functional object whimsical and surreal.

Invention

Seeing similarities and differences, and playfully combining and manipulating forms, can enable us to discover objects in our environment and utilize them in new ways. In 1942 Picasso took a bicycle seat and handlebars, and through an act of great imagination created a quite realistic bull's head with horns **(C)**.

Those who simply love the language and materials of art and design, and spend countless hours playfully exploring, create a surprising amount of great work. Play need not lead only to playful creations. Play, as a methodology or a sensibility, can lead to serious discoveries.

Problem Solving

Innovation and invention are achieved via numerous paths. While the element of play is a major factor for many, more systematic problem-solving methods are also extremely valuable, especially in the design disciplines. There are many problem-solving methodologies, and the various disciplines favor specific approaches. Some principles common to a number of such systems include brainstorming (especially with an interdisciplinary team), breaking down large problems into small discrete units, lateral thinking (avoiding the obvious direct approach), and research (investigating existing solutions to related problems).

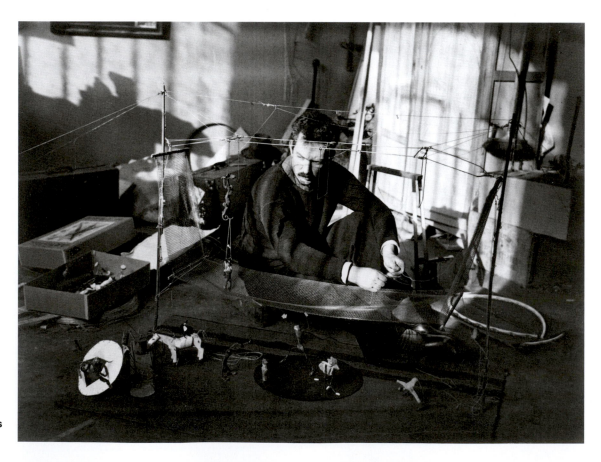

→ **A**

Alexander Calder with his
Cirque Calder **(1926–1930).**

← **B**

Richard Notkin. *Heart Teapot:*
The Pump II, **Yixing Series. 1990.**
Stoneware, 6⅛" × 10½" × 4⅞".

→ **C**

Pablo Picasso. *Bull's Head.* **Assemblage, bicycle seat**
and handle bars, 1' ½" × 1' × 7½". © 2011 Estate of
Pablo Picasso/Artists Rights Society (ARS), New York.

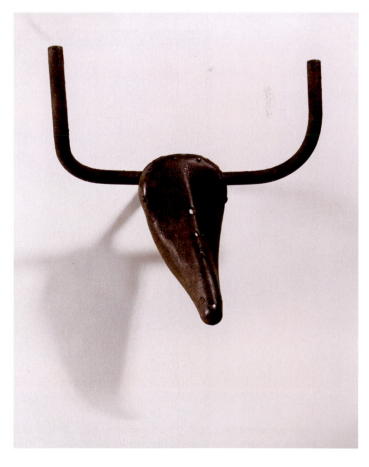

REDUCTIVE SENSIBILITY

Simplicity is not an objective in art, but one achieves simplicity despite oneself by entering into the real sense of things.

—*Constantin Brancusi*

It would be difficult to overstate the importance of reductive strategies in art and in life. When we think of reductive form, **Minimalism** and International Style architecture, with their tenet "less is more," might first come to mind. Minimalist sculptors like Donald Judd clearly made pure form—devoid of figuration and decoration—the central focus of their attention. The unadorned plywood and geometric structure of the sculpture in **A** celebrates essential, formal relationships in a severe and straightforward manner.

We may also think of reductive form as a strategy for bracketing out the world. Jettisoning the noise and cacophony of daily life, simplicity allows the viewer to experience a perceptual slowing down and heightened awareness.

Many artists, designers, and artisans throughout history have demanded that simplicity come first, but even fields removed from what we think of as conventional design disciplines can embody the general sensibility of a culture. The sushi in **B** exemplifies the reductive spirit of traditional Japanese design. Sushi is not only visually reductive, one or two elements juxtaposed, but one or two tastes are carefully balanced. And sushi is not cooked—simplicity extends even to its preparation.

One common mistake of the beginning student involves the tendency to put everything he or she *likes* into a single work. Yes, it is good to be motivated by that which excites you, but, if you made a stew, would you put in everything you like? Steak, apples, mustard, and ice cream? In art and design, as in the creation of a meal, carefully considered proportions of very specific elements are the key to success.

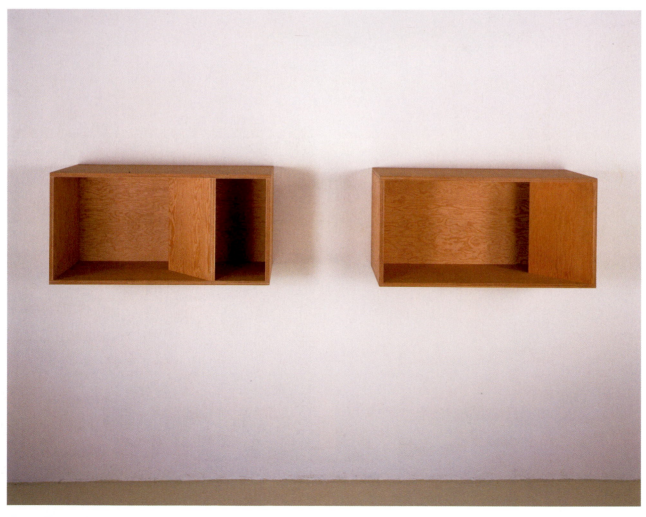

↑ **A**

Donald Judd. *Untitled.* **1989. Two plywood units, 1' 7¹¹⁄₁₆" × 3' 3⅜" × 1' 7¹¹⁄₁₆" × each. Donald Judd Photography by Ellen Page Wilson, courtesy The Pace Gallery. © Judd Foundation. Licensed by VAGA, New York.**

Economy of Means

Perhaps even more important than the appreciation of minimal form is the interconnected idea—economy of means. This idea manifests itself in both simple and complex forms; it is not a concern limited to abstract artists or designers with a geometric style. Paring down form and communication to *only that which is essential* has always been important.

Robert Maillart's barrel-vaulted shell **(C)** was a bold, early experiment in reinforced concrete construction. It spanned 53 feet with a shell thickness of a mere 2⅜", testing the structural limits of a new material (sprayed concrete and steel mesh). Maillart's shell, along with objects such as racing bicycles and jet airplanes, are pared down forms utilizing as little material as possible. You can sense the designers thinking, "How light can we go?"

Economy of means raises the question "what is essential?" It also suggests the good old-fashioned values of frugality. These ideas reverberate with new meaning as we confront the prospect of diminishing natural resources and endangered eco-systems worldwide.

On your next project, try asking yourself, "What is unnecessary? What can be eliminated?"

See also *Sustainability: Reuse and Green Design*, page 426, and *Structural Economy: Efficient Form*, page 432.

Vigorous writing is concise. A sentence should contain no unnecessary words, a paragraph no unnecessary sentences, for the same reason that a drawing should have no unnecessary lines and a machine no unnecessary parts. This requires not that the writer make all his sentences short, or that he avoid all detail and treat his subjects only in outline, but that every word tell.

—*William Strunk, in* The Elements of Style

Perfection is reached not when there is nothing more to be added but when there is nothing to be taken away.

—*Antoine de Saint Exupery*

↑ **B**

Tako Octopus Sushi (foreground).

↑ **C**

Robert Maillart. Cement Industries Hall, Swiss National Exhibition. 1939. Zurich, Switzerland. The Museum of Modern Art, New York.

IDEATION

It is hard to imagine anything more important to the design process than sketching, model making, and prototyping. Sitting still and attempting to simply *think up* ideas just isn't effective. Developing solutions to design problems and creating art require both thought and action.

Sketching and making models and prototypes are activities that facilitate successful **ideation** and invention. Making a sketch or model allows you to see and test your idea, and that prompts modifications as well as the opportunity to detect something unexpected, something that can lead to new and better ideas. Sketches and models need not be beautiful or highly crafted; in fact, many sketches seem dashed off, and models may be rough and crude—mock-ups that contain the bare bones of only that which needs to be present.

Sketching

The sketches for the Guggenheim Museum in Bilbao, Spain **(A)**, are more like energy diagrams than accurate depictions; nevertheless, they perfectly express the dynamic fluidity of the finished building (see Guggenheim, Bilbao, page 480).

As soon as I understand the scale of the building and the relationship to the site and the relationship to the client, as it becomes more and more clear to me, I start doing sketches.

—*Frank Gehry*

Model Making

The sculptor David Smith used cardboard boxes taped to his studio window **(B)** to develop ideas for his large-scale, welded steel sculpture **(C)**. In the model, he has total freedom to move his forms around, searching for the most powerful relationships, and he can do it with a speed that is simply impossible when hoisting and welding heavy stainless steel boxes. A model that is reduced in scale, like the one in **B**, is also called a **maquette**.

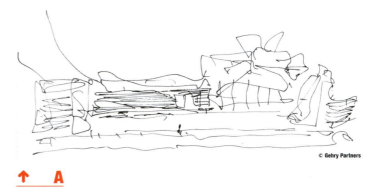

© Gehry Partners

↑　**A**

Frank Gehry. Sketch of Guggenheim Museum Bilbao. Bilbao, Spain.

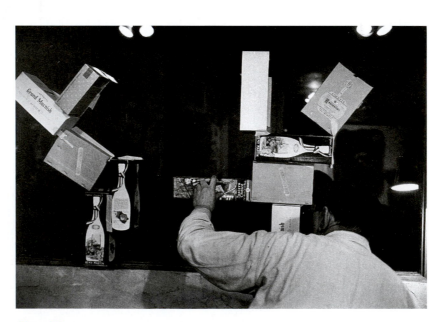

↑　**B**

David Smith assembling liquor boxes as models for his sculptures.
Art © Estate of David Smith/Licensed by VAGA, New York.

Prototypes

In **D**, the designer utilizes simple paper silhouettes to test her idea for the shape and placement of the handle on her prototype pitcher. A prototype is a unique object that is a full-scale working model of the product being designed. It can be used and tested for effectiveness. Often, a number of prototypes are produced in succession, each attempting to improve an aspect of the previ-

ous one. In the case of the pitcher **(D)**, the prototype can be used to evaluate its form (from every angle), judge the comfort of the handle in use, or ascertain the spout's pouring characteristics. After a successful pitcher prototype is arrived at, molds are made and the pitcher goes into production.

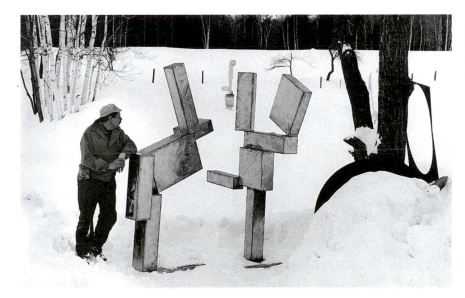

 C

David Smith with completed sculptures *Cubi IV* and *Cubi V.* **Art © Estate of David Smith/Licensed by VAGA, New York.**

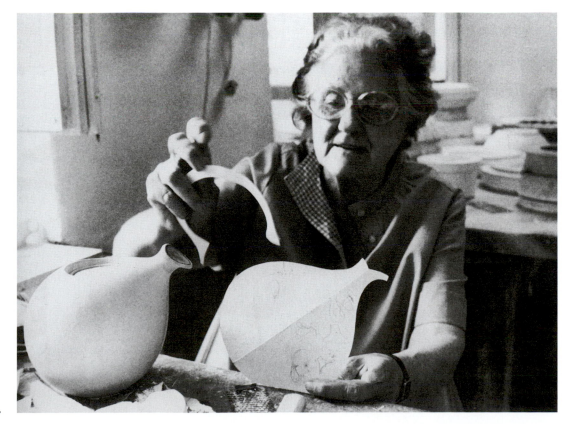

→ **D**

Eva Zeisel working on a model.

CLOSE ATTENTION

God is in the details.

—*Ludwig Mies van der Rohe*

Observing and interacting with designed objects and buildings in which primary form is in synch with minor characteristics can be exhilarating. It is not enough to have a good idea if it is executed without care.

Consider traditional handcrafted wood joinery. If the facets are not cut perfectly flat, if the corners are not clean and sharp, and if the angles are not exact, the joinery will not be structurally sound. Here, attention to detail is required for functionality.

Looking again at the chair in **A** reveals a very special attention to detail. The designer made numerous drawings, studies, and prototypes to get the details right, carefully considering the size and placement of the welds, the size and number of crimps to bend a tube, and the proportions of every element.

Totalizing Detail

The dining room interior **(B)** is defined by the primary elements of space, structure, and proportion, but the architect Frank Lloyd Wright went well beyond these elements. He designed every aspect of this room—table, chairs, lamps, and built-in seating, shelving, and decorative elements. From macro to micro, this extreme attention to detail allowed the architect to extend and amplify his design sensibility.

 A

Jean Prouvé. Standard chair. 1950.

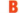 **B**

Frank Lloyd Wright. Robie House, dining room. 1910. Chicago.

Precision

Precision in the past was less available and more difficult to achieve. To a large extent, only nobility and the wealthy could afford the expert craftwork that resulted in precision products such as fine handmade watches, perfectly balanced swords, precise measuring devices, and intricate textiles. Today, technology and industrial production have made precision available to multitudes. In this regard, precision might be considered a modern phenomenon. Consider laser cutting technology, the computer, computer memory chips **(C)**, integrated circuit boards, satellites, surgical technology, digital imaging, cell phones, and the automobile engine.

Appropriate Craft

Attention to detail requires neither high craft and finish **fetishism**, nor that all aspects of a sculpture, product, or building be pristine or geometric, only that everything be considered and *appropriately* crafted.

↑ **C**

Computer memory chip, Intel Core 2010 (microscopic view).

AN INTERPRETIVE ACT

Meaning

In 1994 a four-foot-tall, bullet-shaped chunk of granite **(A)** was discovered by Hindus and New Agers in a remote section of Golden Gate Park and fast became a sacred shrine. Believed to be a symbol of the divine Siva, throngs of devotees left offerings of flower garlands, milk, and sandalwood paste. The rock, probably, originally a parking barrier, was deposited at the site by a worker practicing with heavy equipment, said a city official. It was eventually removed. A park representative said, "It is basically a piece of rubble. It's not part of the park."

The problem of meaning has long fascinated philosophers and cultural critics. In the deepest sense, meaning is now understood to be a notion assigned to objects by viewers, not simply something that is built into objects and hardwired. It is a dialogue between viewers and the properties of objects and events. Meaning is also relative—it varies from culture to culture and changes over time. It is an interpretive act, requiring effort on the part of the viewer.

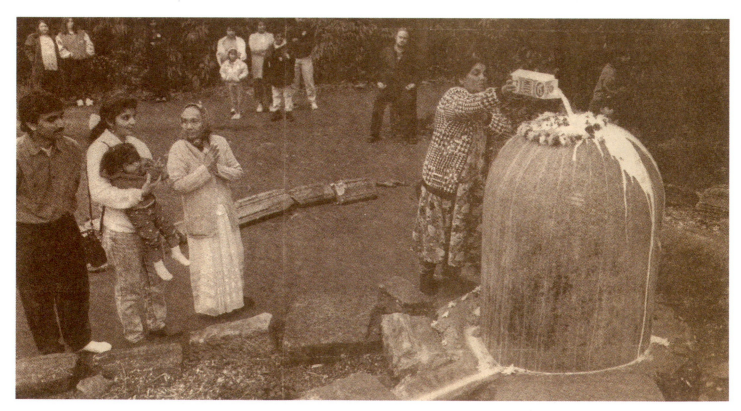

↑ **A**

Improvised shrine in Golden Gate Park. c. 1994. San Francisco. Photographer: Susan Spann.
Image scanned from January 16, 1994 _New York Times._

Value

Value (here referring to significance) is one of the most slippery and important concepts in the arts. We all need to assign value to things and ideas in the world. Failing in this would render us unable to decide how to order our lives, how to proceed, and what to make. Works of art in the museum have achieved significance over time, either by consensus or by expert opinion. One would be imprudent to ignore the wisdom that has accrued over the ages, and the values of one's time; nevertheless, it is up to every individual to formulate a personal value system, without which we would be deprived of the thrill of new ideas and condemned to remake the art and architecture of the past.

The photograph in **B** shows Nelito, a boy from an impoverished region of Mozambique, and his homemade soccer ball. He had to be resourceful, gathering and assembling scarce materials to make his own, simulated soccer ball. Compared to a new, regulation, Adidas ball, what value would you assign to Nelito's? Compared to a diamond ring?

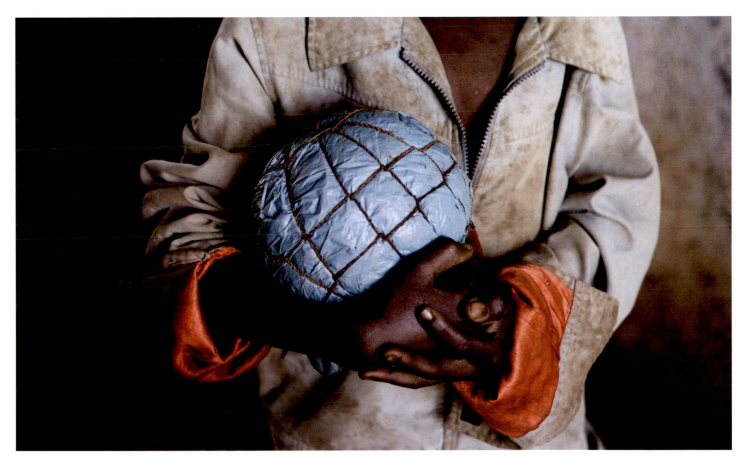

 B

Jessica Hiltout, photographer. *Nelito's Ball.* **Nhambonda, Mozambique. From the book** *Amen: Grassroots Football***, 2010.**

GENERATING CREATIVE ENERGY

Artists and designers are always on the prowl for information and inspiration. Bountiful wellsprings, repeatedly turned to, are called sources. **Source** material can come from anywhere; it only needs to inspire and generate creative energy. Artists and designers are nourished by their sources and often come to cherish them.

The source for many artists and designers is, not surprisingly, other art and design, both contemporary and historical; but nature, geometry, and culture at large are especially valuable influences as well. An artist's or designer's source may often be barely observable in the work or completely invisible—it may be a spiritual or conceptual inspiration. Sometimes the source is overt and extremely evident.

The work of Marcel Duchamp has long cast a powerful spell on countless artists. Dropping a meter-long thread from the height of one meter, three times, Duchamp created three new, meter-long templates that were all different lengths—*Three Standard Stoppages* **(A)**. Using chance operations to determine form, Duchamp commented on the arbitrary and relative nature of standards and hierarchies.

Forty-eight years later, Robert Morris created a sly, pop culture homage to Duchamp's *Three Standard Stoppages*, titled *Three Rulers*. Three found, wood, hardware store yardsticks were hung together, side by side on a wall. Such yardsticks were once given free to store patrons. Due to their cheap and sloppy fabrication, Morris's rulers are all slightly different lengths.

↑ **A**

Marcel Duchamp. *3 Standard Stoppages.* 1913–1914. © 2011 Artists Rights Society (ARS), New York/ADAGP, Paris/Succession Marcel Duchamp.

Influence

For a recent line of clothing, the designer, Raf Simons, was inspired by the French mid-century ceramist Pol Chambost (who was himself inspired by natural forms). The formal similarities between Chambost's ceramic vessel **(B)** and the soft fabric coat **(C)** are quite evident—biomorphic structure and interior/exterior color.

Obsession

Sometimes an inspiring source becomes an obsession. For example, many painters found inspiration in the work of Picasso, but Arshile Gorky was more intensely preoccupied than most. When Gorky said, referring to Picasso, "If he drips, I drip," the line between source and obsession was blurred.

References

When a visual similarity to another artwork or any built or natural form is observable in a work of art, design, or architecture, we call it a reference. When you sense natural forms, rock and bone, in the abstract sculpture of Henry Moore, you can say that the sculpture refers to nature or that nature is a reference.

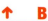 **B**

Pol Chambost. *Vase.* c. 1954. © 2011 Artists Rights Society (ARS), New York/ADAGP, Paris.

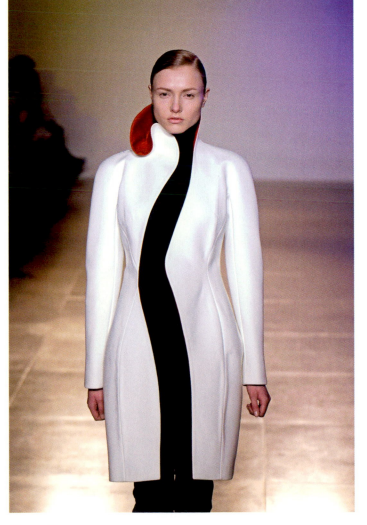

 C

Raf Simons, designer. For Jil Sander. Fall 2009 Ready to Wear.

NATURE

Nature is the ultimate source. It envelops all. Artists, designers, and architects have always looked to nature for ideas and inspiration. The scale and spectacle of its realm and its overwhelming diversity—plants, insects, fish, mammals, rock formations, oceans, weather, and the cosmos at large—render nature the source of all sources, and humbles us as we stand before its magnitude and deep mysteries. We are inspired even while knowing, as fellow creators, we will always be decisively outperformed.

Biomorphism

Nature, especially in the form of rock, shell, and bone, was a vital source and inspiration for the sculptor Henry Moore. Most of us who are inspired by nature find ourselves collecting bits and pieces of it wherever possible. Moore was no exception. A selection from his collection of bones **(A)** clearly demonstrates the reciprocal nature of collecting source material. Moore's sculpture **(B)** looks a lot like the bones he collected, and the bones he collected were those that resembled his sculpture.

Henry Moore was enamored of twisting forms, gracefully flowing forms, holes that penetrate form, and textural variation. Nature provided him with an extensive range of models. The term **biomorphic** is used to categorize design and art that, like Moore's, utilize flowing organic form reminiscent of nature.

Art Nouveau also found inspiration in organic form. The design of the Art Nouveau ornamental ironwork in **C** is derived from plant forms and the exuberant, twisting patterns of growing tendrils.

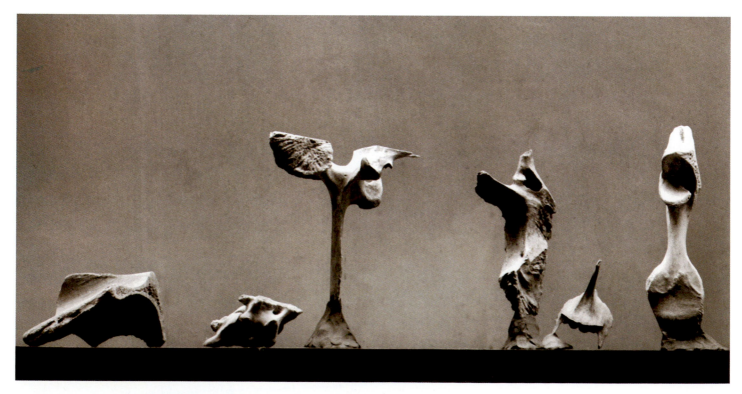

 A

Henry Moore's collection of bones. Reproduced by permission of The Henry Moore Foundation.

There is recorded in a Zen book an episode which took place a long time ago in China, when a novice came to see Shô Zenji, a Zen master who lives at Sekken, and, wishing to study under him, asked the master, "I have come to be in my novitiate for the first time. From where shall I enter into the study of Zen?" The master, thereupon, asked him in return, "Canst thou hear the sound of that mountain stream?" The novice answered, "Yes, I hear it." The master told him, "Then enter from there."

—*Zenkei Shibayama*

For the artist communication with nature remains the most essential condition. The artist is human, himself nature, part of nature within natural space.

—*Charles Biederman*

He who is in harmony with Nature hits the mark without effort and apprehends the truth without thinking.

—*Confucius*

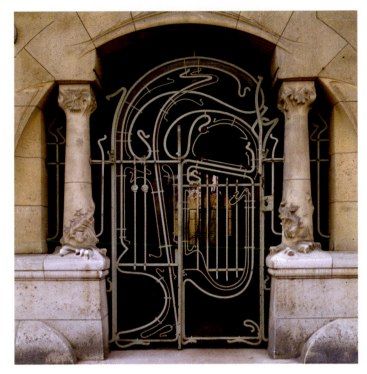

↑ C

Hector Guimard. Entrance gate of Castel Berenger, Paris. 1898.

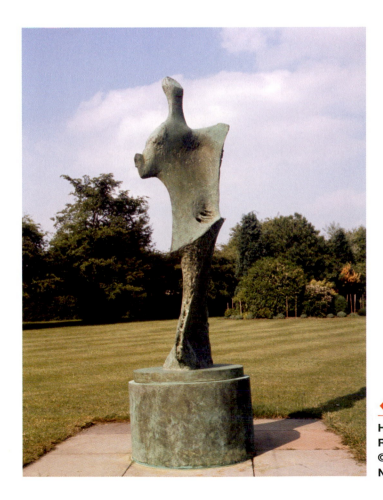

← B

Henry Moore. *Standing Figure.* **1962. Bronze height 9'4".**
Reproduced with permission of the Henry Moore Foundation.
© 2011 The Henry Moore Foundation. All Rights Reserved/ARS,
New York/DACS, London.

GEOMETRY AND MATHEMATICS

God always geometrizes.

—Plato

Mathematics and geometry are omnipresent in the built world. Look around and you will see straight lines, squares, cubes, triangles, and circles everywhere, as well as number and proportion. The vast majority of contemporary structures, from individual rooms to houses and buildings, are based on the rectangle. In bridges, towers, and other structures with strict functional requirements, the triangle reigns supreme. Triangulation results in extremely stable structures.

Geometry and Philosophy

Some 3D forms are of special historical importance, such as the five Platonic solids of geometry **(A)**. They possess special properties, unique configurations, and flawless symmetry.

In Plato's *Dialogues*, Socrates proclaims,

. . . what the argument points to, is something straight or round, and the surfaces and solids which a lathe or carpenter's rule and square produces from the straight and round. I wonder if you understand. Things of that sort, I maintain, are beautiful, not, like most things, in a relative sense; they are always beautiful in their very nature, and they offer pleasures peculiar to themselves, and quite unlike others. They have that purity which makes for truth. They are philosophical.

Geometry and Mathematics in Nature

Forms that reveal a marked mathematical and geometrical structure are also widely evident in nature. There are countless examples: crystals, sunflowers, bubbles, rainbows, growth patterns, spiral nebula, and DNA's double helix. The bee's honeycomb **(B)** is a network of hexagons, and hexagonal rods are among the twenty-two polyhedrons or combinations of polyhedrons that allow for the most efficient packing of space.

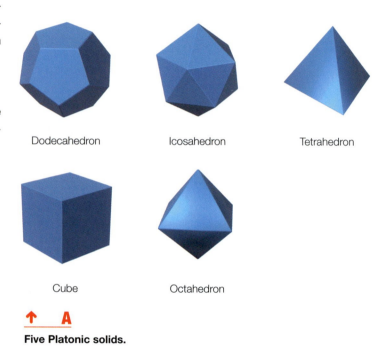

Dodecahedron Icosahedron Tetrahedron

Cube Octahedron

↑ **A**
Five Platonic solids.

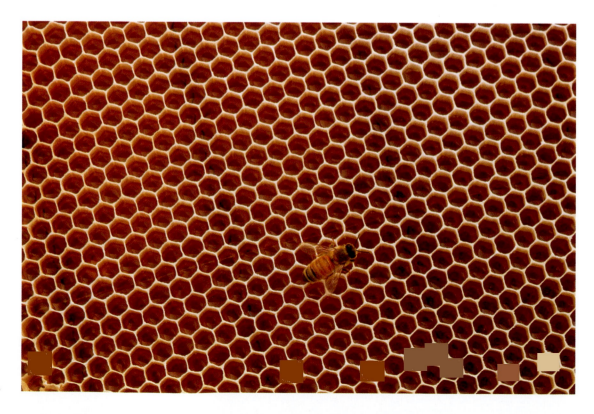

→ **B**
Honeycomb and honeybee.

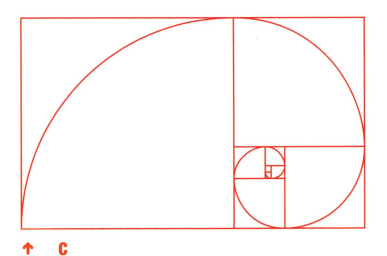

↑ **C**

Golden Spiral in golden rectangle.

No discussion of mathematics in nature could be complete without mentioning the Fibonacci series and its relationship to the golden rectangle and the spiral. The numbers of the Fibonacci series are 1, 1, 2, 3, 5, 8, 13, 21, 34, and so forth. Add two consecutive numbers together to create the next. Rectangles with a 3 to 5 ratio are known as golden rectangles, and the 3:5 ratio is the **golden mean** (symbolized by the Greek letter ø). A series of consecutively smaller golden rectangles can be placed to describe the path of a golden spiral **(C)**, and the golden spiral is the spiral of the chambered nautilus **(D)** and many other spirals found in nature. Many artists and designers have used 3:5 proportions in their work, believing that the golden rectangle has unique harmonic properties.

D'Arcy Wentworth Thompson studied the physical and mathematical laws that determine biological form. In **E** he shows how the porcupine fish on the left may appear transformed into a sunfish (right) due to a different growth pattern, a pattern that is represented by a simple deformed grid.

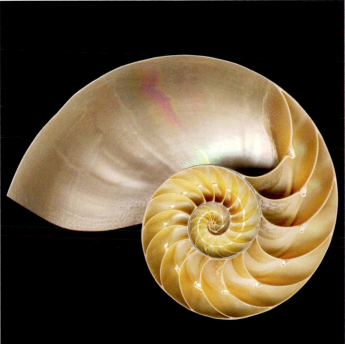

↑ **D**

Chambered nautilus, cross section.

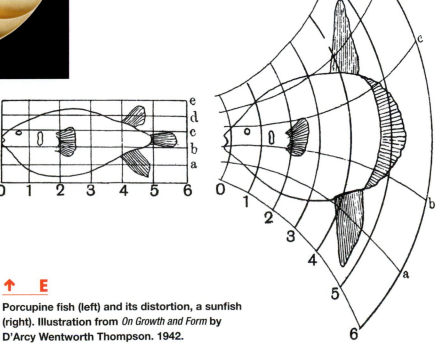

↑ **E**

Porcupine fish (left) and its distortion, a sunfish (right). Illustration from *On Growth and Form* by D'Arcy Wentworth Thompson. 1942.

CULTURE

The wide realm of culture is a source of increasing importance. Film director Werner Herzog said, "My friends are wondering why did I watch Anna Nicole Smith's show. Why do I watch Wrestlemania? My answer is . . . the poet must not avert his eyes. . . ."

Cultural anthropologists originated one of the most significant changes in our perception of art and design! In the past, the word *culture* most often implied the fine arts, classical music, the great books—the most refined esthetic forms. Today, thanks to anthropologists and the philosophers and theorists who also contributed to this paradigm shift, culture is increasingly understood to be *all* the customs and products of human beings—from everyday cooking to dating rituals. To the anthropological eye, the low is as important as the high, and maybe more important. If you were visiting Earth from another planet and you wanted to find out what human beings were all about, where do you think you would learn more—at the symphony or . . . a flea market?

 A

Andy Warhol. *Brillo Boxes.* **1964. 2011. Synthetic polymer paint and silkscreen on wood, each 1' 5⅛" × 1' 5" × 1' 2". © 2011 The Andy Warhol Foundation for the Visual Arts, Inc./Artists Rights Society (ARS), New York. The Museum of Modern Art, New York.**

The Vernacular

This change of attitude was not lost on artists, architects, and designers. Since the early twentieth century, artists and designers increasingly turned to the **vernacular**, a hallmark of both **modernism** and **postmodernism**, and in so doing, they democratized subject matter. The **ash-can school** artists went up on tenement rooftops and down to the subways to find beauty and meaning in the ordinary, the everyday, and the humble. Edward Hopper painted the gas station, and Stuart Davis the Champion spark plug logo. John Cage said, "Everything you listen to is music, everything you don't listen to is noise." Duchamp invented the "**ready-made**," and Warhol discovered the Brillo box **(A)**.

Guild House **(B)**, a housing project for the elderly, was inspired by vernacular, commercial architecture. In other words, the architects, Robert Venturi and Denise Scott Brown, looked to the "lowest," most ordinary kinds of architectural sources instead of the most sophisticated buildings. They favored "ugly and ordinary" architecture over "heroic and original." In 1977 they took a class of Yale graduate architecture students on a trip to seriously study something so vulgar most architects at the time could only sneer—Las Vegas, the ultimate commercial strip.

Guild House opened in 1964 with an oversized, gold anodized TV antenna **(C)** mounted conspicuously above the building's entrance. Not a functioning antenna, it served as sculpture, a symbol intended as a nod to its elderly occupants' involvement with television. Perceived as disparaging, eventually the antenna was removed.

← **B**

Robert Venturi and Denise Scott Brown. Guild House. 1964.

→ **C**

Robert Venturi and Denise Scott Brown. Guild House, detail of antenna/sculpture. 1964.

BELIEF SYSTEMS

The practices of art and design do not take place in a vacuum. Artists and designers are immersed, as all people are, in a particular culture and in a particular historical moment. Every culture is imprinted with numerous beliefs, philosophical inclinations, biases, infatuations. In addition, particular individuals, groups, and professional disciplines within a culture develop their own philosophical views—attitudes that shape everything they create. For example, during a period of scarcity and spiraling economic inflation in Germany, the artist/designers of the Bauhaus elevated the ideas of *doing as much as possible with the least amount of material* and *favoring efficient new industrial fabrication technologies* to fundamental design tenets. The Bauhaus chair **(A)** not only utilizes less material than the traditional stuffed chair, but its innovative use of bent steel tubing allowed hand fabrication to be replaced by mass production. Such a radical idea for a chair would have been unthinkable without the socioeconomic conditions that preceded it.

↑ **A**

Marcel Breuer. *Club chair.* **1927. The Museum of Modern Art, New York.**

Taking a Stand

It is important that contemporary artists and designers be educated in the broadest possible way. Simply being sensitive to the visual is not sufficient. An educated, critical, and impassioned worldview is a vital component of the visual disciplines. G.K. Chesterton said, "Art consists of drawing a line somewhere." This aphorism has a double meaning: yes, art must begin with an initial act, in this case drawing, but more importantly, art means taking a stand!

New Conditions = New Ideas

The abstract expressionists believed that the most important human emotions and expressions were those that were subconscious. Consequently, they avoided straightforward representation and analytical inquiry and favored the spontaneous and the accidental, which they believed were expressions of greater emotional depth. It is not surprising that the abstract expressionists were influenced by **surrealism**, **automatic writing**, Jung's ideas on myth, and Freudian psychology—the power of the unconscious, dream interpretation, and slips of the tongue. While most **abstract expressionists** were painters, there were forays into sculpture. Willem de Kooning's sculpture **(B)** displays the quick fluid gestures of its making. This process was intended to encourage aspects of the deep subconscious to bubble up and become visible. At a later stage, skilled craftspeople were required to make molds and cast them in pewter.

What ideas and events contribute to the formation of your worldview? How do your beliefs influence your approach to art and design?

↑ **B**

Willem de Kooning. *Untitled.* **1972. Pewter, 6½" × 11" × 2⅝". © 2011 The Willem de Kooning Foundation/Artists Rights Society (ARS), New York.**

MODERNISM

Modernism may sound like a synonym for "contemporary" in art or design. In fact, it is a historic period traced to the nineteenth century. It is still present as a cultural force, but most historians now agree that we are in a "postmodern" era (we will discuss the implications of this concept in the next section).

Modernism is an idea that embraced originality and progress (a love of the new), and aspired to be an international style, creating useful and beautiful products for the working masses. "Less is more" and "truth to materials" replaced decoration in architecture and design. Representation made room for abstraction in art. Built on the foundation of the Enlightenment (the global project of reason, and the rejection of superstition) and spurred by developments in science, industrialization, and photography, modernism would, it was believed, lead us to a utopian world.

During the Bauhaus years, which were critical to modernism's development, factories were producing machine-made furniture that looked like the ornate, hand-made furniture of the past. This was unacceptable to Bauhaus designers. They believed that industrially produced furniture and products should not disguise the new materials and processes of industrialization; new products should reflect their industrial fabrication and express the new era.

Rationality, the Grid, and Industrial Fabrication

The sculpture in **A** is a minimal work with high modernist inclinations. Its fabrication utilized industrial methods, its repetition of identical parts pays homage to mass production, and its composition owes a debt to rational systems. The Eames House **(B)** is based on the grid and is built primarily of off-the-shelf, prefabricated parts ordered from building catalogues. The grid ultimately became known as the signature structure of modernist design.

Utopian Modernism

A designer is an emerging synthesis of artist, inventor, mechanic, objective economist and evolutionary strategist.

—*R. Buckminster Fuller*

The visionary inventor and futurist R. Buckminster Fuller designed the model of the house in **C** (actually named the *Dymaxion Dwelling Machine*). The Dymaxion house was made of aluminum and was intended to be mass-produced. The bathroom was a sealed copper pod that included a "fog gun" for instant hygienic cleaning. In the 1940s, the Dymaxion house was far ahead of its time. Bucky Fuller went on to imagine floating cities and methods for the global distribution of food. He is the author of numerous books, including *Operating Manual for Spaceship Earth*. His utopian approach to rethinking design on a global scale, for human needs, has, over the years, become increasingly relevant.

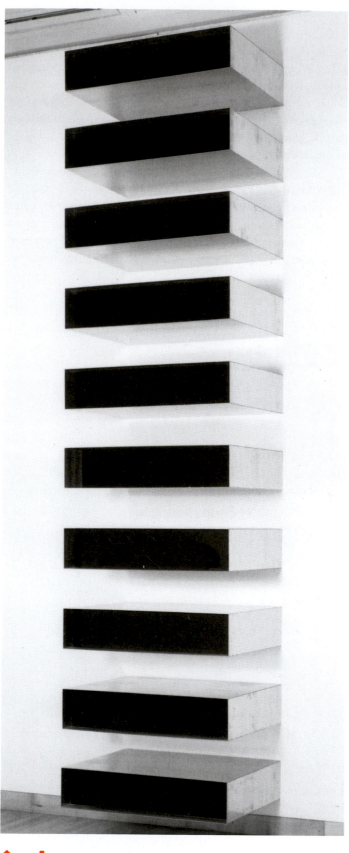

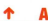 **A**

Donald Judd. *Untitled.* **1980. Steel, aluminum and perspex, 9" × 3' 4" × 2' 7". Tate, London/Art Resource, NY © Judd Foundation. Licensed by VAGA, New York.**

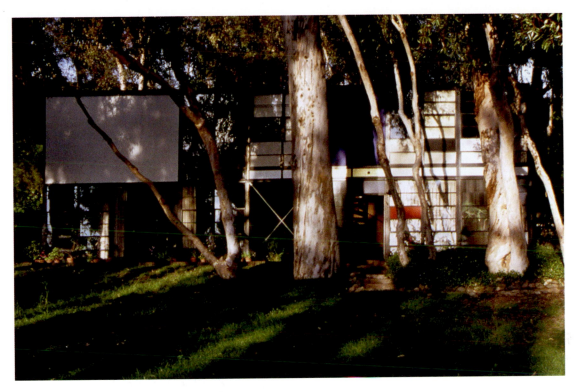

 B

Charles and Ray Eames. The Eames House. 1949.

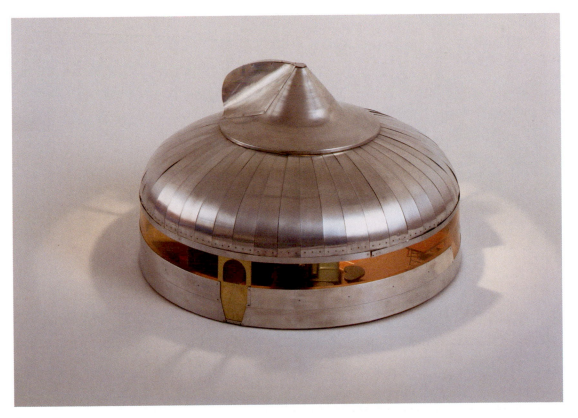

↑ **C**

R. Buckminster Fuller. *Dymaxion Dwelling Machine,* **model. 1944–1946. Aluminum and plastic, h. 1' 8", diam. 3'. The Museum of Modern Art, New York.**

POSTMODERNISM

You do not have to read and concur with contemporary theory to be postmodern; you need only to be living in the present moment. Many cultural critics believe we are all postmodern now. Although the exact nature of postmodernism remains vague, it is considered the **Zeitgeist** (defining spirit) of the contemporary world. Postmodern ideas have decisively influenced the disciplines of art, architecture, and design.

Postmodernism arose from the perceived exhaustion of modernism that for many had lost its original idealism, becoming another form of imposition by a dominant culture. This led to art and design that countered modernist principles: sincerity was replaced by **irony**, *more* became more (in answer to modernism's dictum that less is more). Multiplicity replaced an aspiration for an international style. A new generation of critics, curators, and historians gave credence to overlooked cultures and voices.

Artists and designers characterized as postmodern feel free to work in different styles simultaneously, scavenge the media, **appropriate**, quote, and playfully mix styles from past to present. The idea of **collage** has come to be known as the signature structure of postmodern design.

After Modernism

The word *post* means after—postmodernism comes after modernism. Daniel Clowes, in the comic book story *The Future* **(A)**, puts his finger on the very postmodern notion that recombining existing ideas is all that is left for us. Looking to past models, whether playfully or in earnest, is a liberating freedom for this era in contrast to modernism's striving for the new.

↑ **A**

Daniel Clowes. Frame from *The Future*, Eight Ball Comics, number four.

Multiplicity and History

The building in **B** is a postmodern classic by architect Michael Graves. It incorporates stylized design elements from the past as well as pattern and ornament. Its multiplicity of references is a far cry from modernist purity. The decorative elements are like a coat of paint, rather than being integral to the building's structure. For example, the pink keystone shape is a purely visual element here: it does not serve to anchor an arch as it once did in Roman architecture.

Jenny Holzer utilized a Spectacolor electronic sign in Times Square **(C)** to illuminate various messages, called Truisms by Holzer. Her Truisms are shape-shifters; they appear in numerous forms including T-shirts, projected light, stone benches, and websites. Often displayed in public spaces, and using commercial modes of communication, she critiques power and exposes oppression. In contrast to modernist zeal for form and function, Holzer emphasizes content and language.

Irony

The *Duct Tape Chair* in **D** is a good example of irony in design. The "duct tape" is actually fine leather, and the chair is not an old, used flea market find; it is a high-end designer chair that appropriates the look of a shabby easy chair, repaired in the most expedient manner. The humor in this is obvious to anyone who has had either fussy, design-conscious relatives or a cranky old uncle who won't give up his favorite recliner.

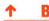 **B**

Michael Graves. The Portland Building. Portland, Oregon.

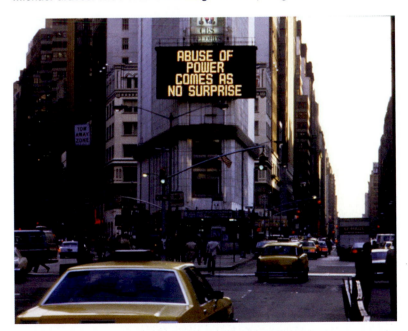

 C

Jenny Holzer. *Truisms.* **1982. Spectacolor electronic sign, 20' × 40'. Times Square, New York. © 2011 Jenny Holzer, member Artists Rights Society (ARS), New York.**

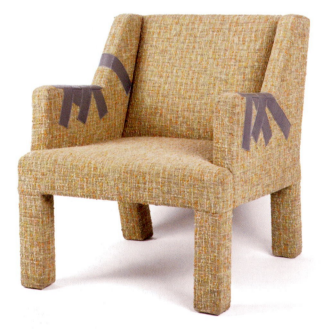

 D

Jason Miller. *Duct Tape Chair.* **2006. Cotton/wool upholstery and leather over a wood frame, 2' 5" h.**

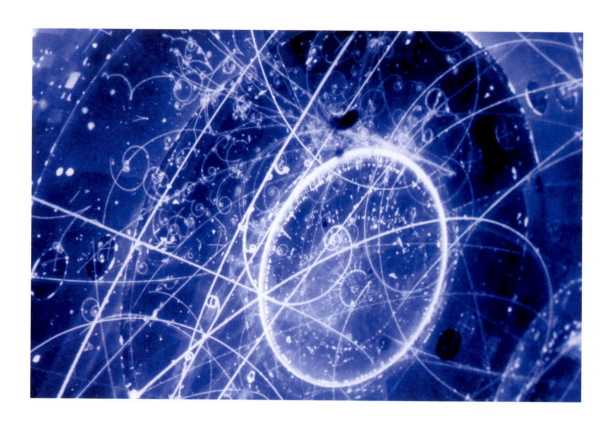

Subatomic neutrino tracks showing electrons and muons caught in a nano second. Fermi National Accelerator Laboratory in Batavia, Illinois.

FORM

Form is the overall 3D shape of an object, the complete configuration of its mass. (Shape usually refers to flat silhouette.) The word form is also is used to describe *all* visual/structural aspects (as opposed to subject matter and content) of 2D, 3D, and time-based events. When form is used in this way, it is in reference to the **formal** aspects of art and design (color, shape, composition, and so forth).

The Three in 3D

What makes 3D form different from 2D shape? It is the all-important, extra dimension that lifts three-dimensional form up and off the plane; it is the flat page of this book, compared to the page of a pop-up book. To explain three-dimensional objects, three views are required **(A)**, and these views participate in a virtual matrix with three axes, most often referred to as x, y, and z. To fully understand a 3D object, six views are best—front and back, left and right side, top and bottom.

Form and Content

The sculpture in **B** is **figurative**, and it obviously has much to say about the seated, draped human figure (its subject matter). It is also a three-dimensional form, and it has formal qualities. This sculpture, as a form, is a static, rounded **monolith**. In addition, its hooded top creates a shadowed void. This sculpture is a grave marker. What contributes more to its content (death)—its subject matter or its form?

The Visceral Experience of Form

Form is powerful. We react to form **viscerally**, experiencing it in our bodies and our minds as we empathize with such characteristics as curvilinear flow or severe right angles.

↑ A

Three views of Yoshitomo Nara's Pupcup. Bozart Toys Inc. 8½" high.

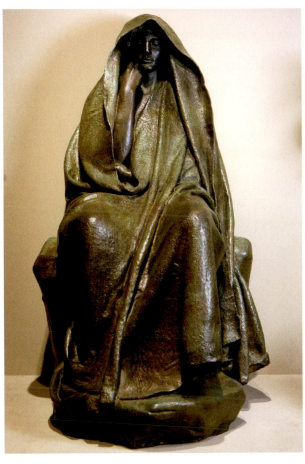

In Wolfgang Köhler's classic 1927 Gestalt psychology experiment **(C)**, subjects were asked to match two images with two made-up words. Most viewers immediately paired *takete* with the jagged geometric image and *maluma* with the curvilinear shape (*takete* sounds jagged, with sharp staccato syllables; *maluma* sounds soft and gently undulates), illustrating the human propensity to intuitively experience form as well as the ability to recognize related structural qualities in visual and auditory experience.

Aspects of 3D Form

A form is a positive element, and the space around it is **negative space**. A form can be geometric or **curvilinear**, concave or convex, **static** or **dynamic**. It can have an interior and an exterior, or pockets of negative space. It can be something that must be experienced in the round—as an object in space that one must walk around—or it might be planar, like relief sculpture, with a single frontal viewpoint. Form can embody any combination of these qualities and have numerous other properties as well.

When one walks around and in between the curved planes of oxidized steel, the full experience of Richard Serra's sculpture **(D)** unfolds. The viewer, dwarfed by steel "walls" over twelve feet high, "feels" the pressure of those tilting planes and curved paths. This is not an intellectual experience; it is a felt experience, emotional and visceral, and it is the overall form that is doing all the communicating.

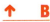 **B**

Augustus Saint-Gaudens. *Adams Memorial.* **Bronze, modeled 1886–1891, cast 1969. Bronze, 5' 9⅞" × 3' 3⅞" × 3' 8½".**

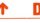 **C**

Takete and Maluma. Rendering based on an illustration in Wolfgang Köhler's *Gestalt Psychology.*

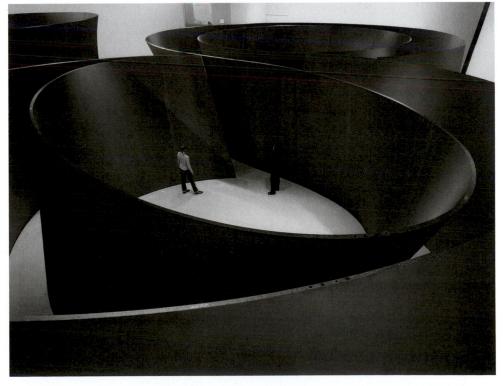

↑ **D**

Richard Serra. Installation view of the exhibition "Richard Serra Sculpture: Forty Years." 2007. Oxidized Steel. The Museum of Modern Art, New York. © 2011 Richard Serra/Artists Rights Society (ARS), New York.

THE CUBE

The cube, as a form, is so ubiquitous and so perfect that it merits special mention. One of the five Platonic solids, the cube is a form with a long history in art, design, and architecture. Like its sister, the sphere, the cube is iconic and ideal.

According to Islamic history, the Kaaba **(A)** was the first sacred structure on earth—built by Adam, rebuilt by Abraham and Ishmael and reconstructed many times in the course of its history. The present-day Kaaba is a cube approximately forty

← **A**
Pilgrims circle the Kaaba inside the Grand Mosque during the Haj. Mecca, Saudi Arabia.

→ **B**

Donald Judd. *Untitled*. 1971. Anodized aluminum. Collection Walker Art Center, Minneapolis Gift of the T.B Walker Foundation, 1971 © Judd Foundation. Licensed by VAGA, New York.

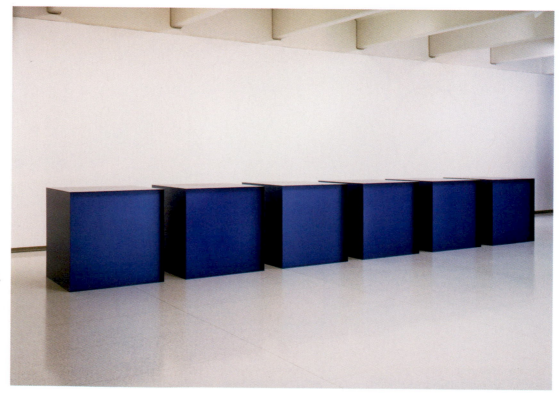

feet high. It is located in the courtyard of the Great Mosque in Mecca, Saudi Arabia. The Hajj, the annual Muslim pilgrimage, culminates at the Kaaba, the most sacred site in Islam. From the origins of Islam to the philosophy and mathematics of ancient Greece, the cube quickly achieved special status as a form among forms.

Minimal sculptors were drawn to the purity of the cube. In **B**, six cubes sit together informally on the floor. These pristinely fabricated forms resist being understood to represent anything other than their physical presence.

Minimal form, the grid and the cube are archetypes of high modernist art. Observing the staying power of these forms is interesting, even as we enter the realm of a more freewheeling postmodernism. From Andy Warhol's famous *Brillo Box*, a near cube, to Charles Ray's *Ink Box*, which is actually an open steel box filled to the brim with printer's ink, the cube sheds its "neutral" status. *Ink Box* and the sculpture in **C** have been infused with new meaning through their use of content-laden materials. The cubes of chocolate and lard in **C** were literally gnawed on by the artist as part of a complicated process in which chewing resulted in the production of candies and lipstick. Whether you might understand this work to be a primal form of carving, a statement about overabundance in the industrial world, or a feminist take on eating and cosmetics, the cube remains (however altered)—occupying space with severe dignity.

From the sublime cube of the Kaaba and Plato's philosophy, to the absurdities of popular culture, the cube has retained its value and fascination for thousands of years. The "square" watermelons of Japan (**D**) are grown in adjustable cube-shaped molds. They ship more efficiently than round watermelons, but, ultimately, they have become cult commodities because, like bonsai, they perfectly express the traditional Japanese interest in altering and idealizing living natural form.

↑　　D

Square watermelon. Japan.

→　　C

Janine Antoni. *Gnaw.* 1992. Chocolate, lard, and 150 lipsticks, overall dimensions variable. © 1992, Janine Antoni. Courtesy of Janine Antoni and Luhring Augustine, New York.

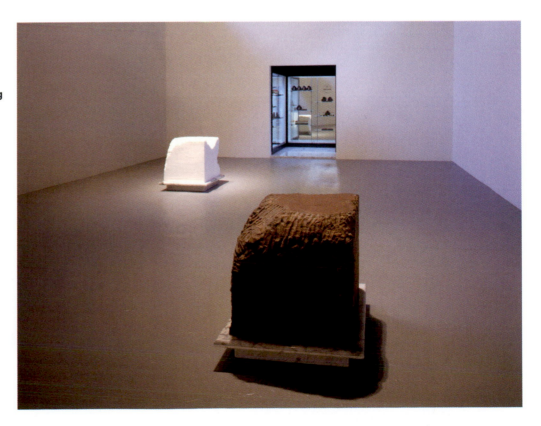

THE ART OF THE HOLE AND THE LUMP

The significance of mass and space (also referred to as positive and negative space) to three-dimensional design is perhaps best summarized in Auguste Rodin's famous dictum, "Sculpture is the art of the hole and the lump." Mass and space always exist in tandem, whether an object is pierced by voids, like a block of Swiss cheese, or is simply a solitary lump, for even the lump is surrounded by space that is altered by its intrusive form.

Mass

The sculpture in **A** is all about mass. Its intentionally funky, faux rock-like forms celebrate sheer bulk in sculpture.

Space

Louise Bourgeois's sculpture (**B**) is in many ways the opposite of **A**. Instead of using mass to occupy space, she uses mass to delineate space. Matter here embraces and defines a space. With a light touch, Bourgeois's sculpture envelops the viewer in its protective canopy. Similar to the towering interior arches of the gothic cathedral (**C**), matter is used primarily to shape meaningful spaces.

 A

Franz West. Sculpture at 52nd Venice Biennale, Arsenale. 2007.

 B

Louise Bourgeois. *Maman.* **2005. Bronze, stainless steel, and marble, 32' 10" high. © Louise Bourgeois Trust/Licensed by VAGA, New York.**

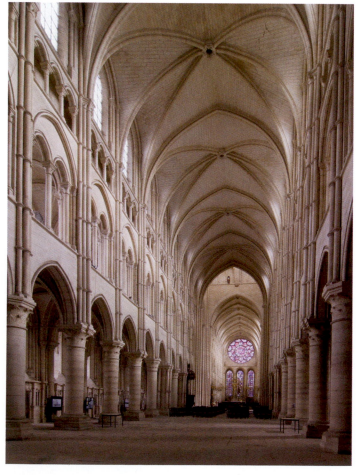

 C

Interior of Laon Cathedral (looking northeast), Laon, France. Begun c. 1190.

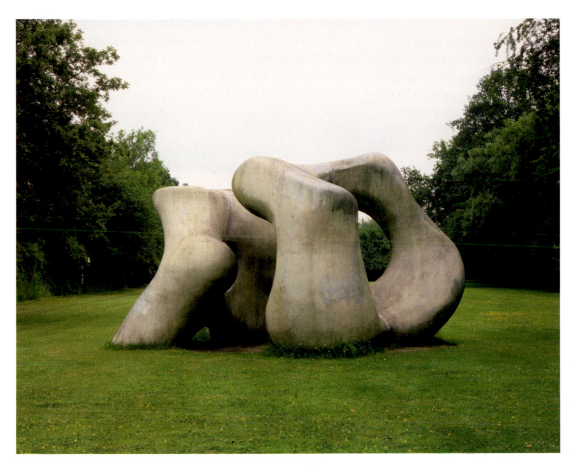

Mass/Space Interaction

Paying attention to the interaction of negative and positive space results in dynamic form. In Henry Moore's sculpture **(D)**, the two main forms are separated by a space that both divides and unites the forms. This carefully considered **interstitial** space becomes a phantom third "form" and an important player in the work. The hole in this sculpture is not an empty space created by the simple act of cutting a hole in a form; it is a hole that is the by-product of a form that appears to have organically grown around it.

The sculpture in **E** is a homage to negative space. The artist performed a simple transformative operation—she exchanged the places of mass and space. Where there was matter, there is now void; where there was space, there is now substance. The sculptor took the underside of a table and chair, and with the aid of molds, filled all the voids (the negative space) with rubber and polystyrene, then removed the table and the chair. Solid versions of the spaces beneath are all that remain.

→ **E**

A POINT SET IN MOTION

One of the simplest elements in design, line is nonetheless quite important and infinitely versatile. We look to the endpoints of a line segment and imagine them extending—in this way, lines are directional forces. Lines can be as true and straight as a laser beam or as graceful as the arc of a perfect circle; they can also form gentle irregular curves as in cursive **calligraphy**.

Charles Ray made powerful use of line in his deceptively simple sculpture **(A)**. On one hand it is a sculpture that refers to Minimalist Art and appears to be nothing more than a black line extending vertically from floor to ceiling. Understood formally in this way the sculpture encourages the viewer to perceive the entire space in a new way, as a field that revolves around a line that connects the floor to the ceiling. This simple linear element is in fact neither a wire nor a rod, but a stream of black printer's ink that literally flows downward from an aperture in the ceiling to a hole in the floor. The hapless viewer who attempts to touch this seemingly static line might be splattered with ink. Like a shooting star, this work refers to the geometric definition of line—a point set in motion.

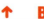 **B**

Alexander Calder. *Sow.* 1928. Wire construction, 7½" × 1' 5" × 3". The Museum of Modern Art, New York. © 2011 Calder Foundation, New York/Artists Rights Society (ARS), New York.

 A

Charles Ray. *Ink Line.* 1987. Ink and pump, dimensions variable.

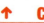 **C**

Claes Oldenburg and Coosje van Bruggen. *Ago, Filo e Nodo* (Needle, Thread and Knot), installation detail. 2000. Brushed stainless steel and fiber-reinforced plastic, height 59'. Piazzale Cadorna, Milan, Italy.

Gesture

Line can also become an expressive **gesture**, as in the delightful, bent wire pig **(B)** or playful monumental sculpture by Claes Oldenburg and Coosje van Bruggen **(C)**.

The colossal, site-specific *Running Fence* **(D)** was a 24.5-mile-long, white nylon fence (18 feet high). It was designed to be understood in relationship to the Northern California landscape that gave it its gently rolling form. Though *Running Fence* was actually a thin plane in space, due to its extreme length it read as a line in the landscape. *Running Fence* was viewed primarily from that other monumental linear earthwork, the public highway system **(E)**.

Whether actual or implied, line is a dynamic element—expressing direction and activating the space that surrounds it.

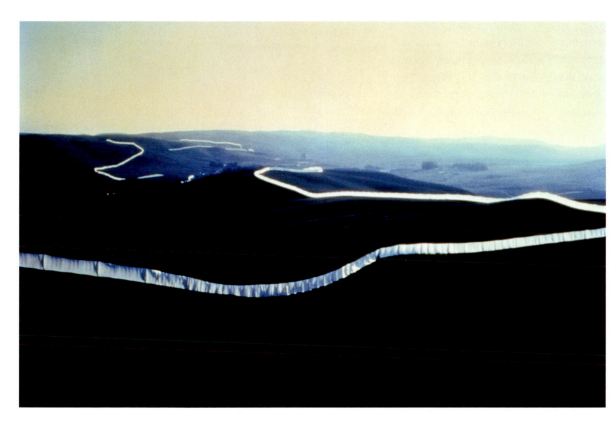

← **D**

Christo and Jeanne-Claude. *Running Fence, Sonoma and Marin Counties, California, 1972–76.* **Copyright Christo & Jeanne-Claude.**

→ **E**

Freeway interchange, aerial view.

THE TWO-DIMENSIONAL ELEMENT

Points, lines, planes, and rectangular solids are related visually and structurally in numerous ways. In geometry, a moving point generates a line, a moving line generates a plane, and a moving plane—a rectangular solid.

Planes are ubiquitous design elements: the walls of your apartment, the painting on the wall, the windowpane, and the paper you write on. The built world is planar and geometric.

Planar Representation

Picasso's *Guitar* **(A)** uses planes of metal, almost exclusively, to depict an existing object, a guitar, which is in itself built of planes. Beyond simple depiction, Picasso celebrates its essential features, its "guitarness," while also creating a more dynamic form than the original could ever hope to be. The viewer connects to the fabrication process and the material of *Guitar*, as the quite ordinary sheet metal as well as its hand-cut shapes are extremely evident.

Interpenetrating Planes

The Barcelona Pavilion **(B)** is fundamentally planar. This icon of modernism, using a strict vocabulary of horizontal and vertical elements, displays its form and structure with extreme clarity. It takes advantage of the simplicity of the plane, while exploiting its essential dynamism, interpenetrating planes slicing through space. Vertical planes are used as long, low space activators. As they enter the area defined by the horizontal roof plane, they become enclosing walls.

Curved Planes

The curved plane and the folded plane have great structural integrity. The building in **C** uses complex curves in planar form to span vast spaces, exploiting the amazing strength of the curved plane while creating a soaring, graceful visual spectacle. Richard Serra's sculpture (see page 359) shows that curved form need not be simple—curved form can be nuanced. The Serra is a ribbon of gradually changing complex curves that alter space and experience.

↑ **A**

Pablo Picasso. *Guitar.* **1912. Sheet metal and wire, 2' 6½" × 1' 1⅛" × 7⅝".**

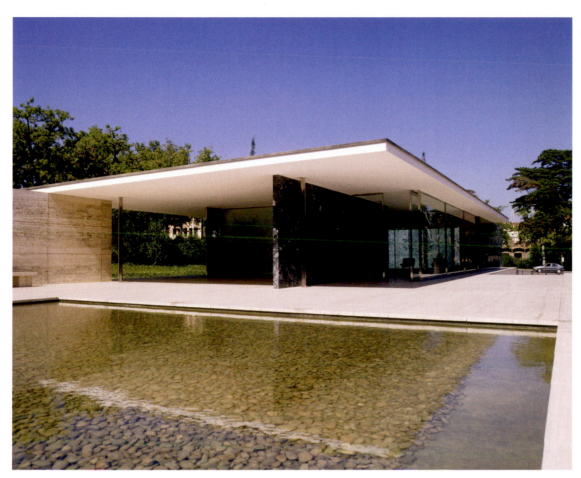

Ludwig Mies van der Rohe. Barcelona Pavilion. Barcelona, Spain. 1929.

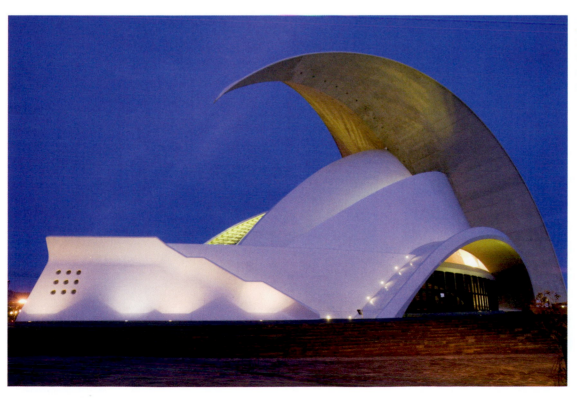

Santiago Calatrava. Tenerife Opera House. 2003. Santa Cruz de Tenerife, Canary Islands, Spain.

THE RELATIONSHIP OF THE PLANAR TO THE DIMENSIONAL

The ordinary cardboard box begins life as a flat piece of corrugated fiberboard. It is then die-cut, scored, and folded to become a fully three-dimensional container. In this way, 3D form may be generated from 2D, planar material. Flat shapes cut from steel or aluminum sheets, for example, may be folded to form many objects, from electrical utility boxes to sculpture.

Origami, the traditional Japanese craft of paper folding, similarly begins with a flat rectangle or square and proceeds, fold upon fold, until the desired configuration is obtained. In **A** instructions to make an origami praying mantis are presented in the form of a diagram. Origami is much like folding cardboard to form a box, but the forms are often extremely complicated and may even result in movable parts.

The chair in **B** folds completely flat when not in use, resembling the two-dimensional condition of its origin—a sheet of three-quarter inch plywood.

Flatland

Two-dimensional shape has long contributed to the development of three-dimensional form, and the relationship between these dimensional realms is rich and diverse. In the 1880s Edwin A. Abbott wrote *Flatland*, a mind-bending book about a fictional society that existed in two dimensions; geometric shapes such as squares and triangles lived in a completely flat, planar world. The narrator, a square, attempts to understand the third dimension—Spaceland. The drawing **(C)** illustrates how a sphere would be understood by the occupants of Flatland. The sphere would be incomprehensible, appearing simply as a circle, increasing or decreasing in size as the sphere penetrates the plane of Flatland. Abbott's book raises the interesting issue concerning our ability to understand dimensions beyond our own three-dimensional realm.

Google SketchUp is a free computer program that allows the user to easily construct 2D representations of 3D form around x, y, and z axes. Like many CAD programs, it is a useful aid to planning, understanding, and diagramming 3D structure. One SketchUp tool—*Push/Pull* **(D)**—allows the user to generate virtual three-dimensional solids, such as cubes, from squares drawn on the ground plane, with the simple move of the cursor.

↓ A

Robert J. Lang. Origami praying mantis, length 4", and fabrication instructions in the form of a diagram. The mantis is made from a single square sheet of uncut paper.

 B

Ufuk Keskin and Efecem Kutuk. *SheetSeat* **folding chair. Wood laminate, ¾" thick. Ufuk Keskin and Efecem Kutuk (efecemkutuk.com and ufukkeskin.com).**

↑ **C**

Edwin A. Abbott. Illustration from *Flatland: A Romance of Many Dimensions.* **1884.**

→ **D**

Rendering based on the push/pull icon from Google SketchUp.

TEXTURE

Surface is one of the first characteristics of form perceived by a viewer. Surface is skin on the human body, the shell of the egg, the rind of an orange, the fur of a bear, the wrinkled, gray hide of an elephant. The specific characteristics of skin, hide, and shell make a huge difference in our perception of an object. Surfaces can be soft, hard, moist, dry, smooth, rough, and any color. Determining a surface for a sculpture, product, or building has significant implications.

Texture is that aspect of a surface that we can experience tactilely. Texture is also, of course, an important visual characteristic of objects, but visual observation is not required. Rub your hand over any surface and you will experience its textural qualities—rough like gravel, sandpaper, or mown grass perhaps; soft like a kitten; or smooth like paper or glass. Seed Cathedral **(A** and **B)** is a pavilion with an extreme textural presence. Its surface is studded with 60,000 fiber-optic rods, each 24 feet, 7 inches long. The rich textural experience of Seed Cathedral is rare, even radical on this scale. It would be more familiar as a seedpod or flower blossom you could hold in your hand.

The essential form of *Cloud Gate* **(C)** is not that different from *Seed Cathedral*, but *Cloud Gate's* highly polished surface results in a completely different textural experience. The stainless steel exterior not only conveys the impression of a slippery "bean," as it is commonly referred to, but it reflects light and creates and distorts reflected images of viewers, the city, clouds, and sky.

Texture Relativity

Texture, like many design elements, is contextual. Smooth is smoother when contrasted with rough, and rough becomes rougher when in proximity to smooth. Play one off the other to heighten textural characteristics. The stone path in **D** achieves full perfection in its juxtaposition of stone and gravel.

Structural Surface Qualities

In addition to the visual and tactile, surface qualities involve other important issues. Corten steel, for example, is a steel alloy that develops a unique protective coating of rust that eliminates the need for painting. This weatherproof steel is easily identified in contemporary sculpture and architecture by its rich, velvety orange surface. Other treatments, such as anodizing, galvanizing, and etching, serve to alter surface properties. When metal is tempered by additional periods of cooling and heating during the fabrication process, the surface is hardened.

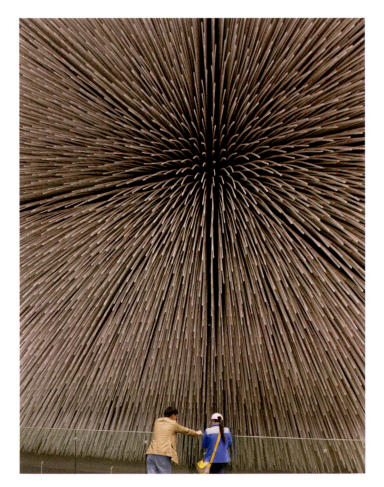

 A

Seed Cathedral. **2010 Shanghai World Expo. Thomas Heatherwick Studio.**

 B

Seed Cathedral, **detail. 2010 Shanghai World Expo. Thomas Heatherwick Studio.**

← C

Anish Kapoor. *Cloud Gate.* **2004. Polished stainless steel, height 33'. Millennium Park, Chicago.**

→ D

Stone path in Japanese garden.

COLOR

Intrinsic Color

Unpainted plaster, a raw concrete wall, a mahogany door—white, gray, and dark brown—are examples of intrinsic colors. Intrinsic color refers to objects that retain the natural color of the material that forms them. A surprisingly rich palette is available in this realm of found color. Intrinsic color was favored by modernist architects and artists interested in the notion of truth to materials.

Applied Color

Color can also be applied. Surfaces can be painted, coated, glazed, enameled, oxidized, anodized, galvanized, patinated, and so forth. Applying paint to a surface is the most common way to alter the color of an object. It is easy, inexpensive, and, in most cases, serves to protect surfaces from weather or wear. Used to decorate ancient Egyptian artifacts and Greek temples, paint is one of the oldest methods for altering objects. Historians now believe that the iconic, pure white temples of Greece that we have come to love were actually ornately painted.

Patina involves natural changes to metallic surfaces, such as when copper oxidizes over time and takes on a powdery green cast. Patination is a traditional method of altering surface color in sculpture. The ancient Greek *Charioteer* **(A)** is an example of an almost iridescent, green patina on bronze. When the natural characteristics of patination are harnessed, it becomes an art and a science, and its practitioners must know their chemistry. There are numerous methods and formulas for creating a wide array of color possibilities. A patina sample displays a mottled green surface in **B**.

Polychrome Form

Form and color are always present. Monochrome refers to objects of a single color, such as a carved marble figure, or a very close color range, like the bark of a tree. When an object displays more than one color, we call it **polychrome**. The world we live in is largely polychrome. Differentiating the parts of an object or a building, using color, is a powerful and widely utilized design tool.

In **C** (a detail of a larger installation), the artist spray-painted various objects as well as the floor. This simple application of paint resulted in profound changes to the objects and the environment. Paint becomes light and shadow, illuminating and differentiating the spheres.

Luis Barragan's architecture is enlivened by color. In **D**, color serves to make each segment of wall a unique entity with its own personality. If left unpainted, the segments would appear blandly homogeneous. Barragan united modernist architecture (that previously favored a stark intrinsic color) with the applied colors of Mexican folk traditions.

A

Charioteer of Delphi. 478–474 BCE. Bronze, 5' × 11". Greece.

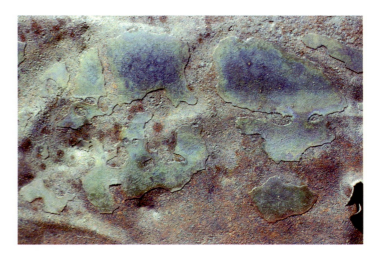

B

Patina on copper.

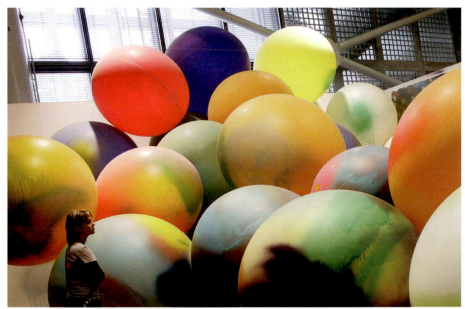

← **C**

Katharina Grosse. *Atomimage*, detail. 2007. Acrylic on wall, PVC carpeting, canvas, and latex balloons, height 13'.

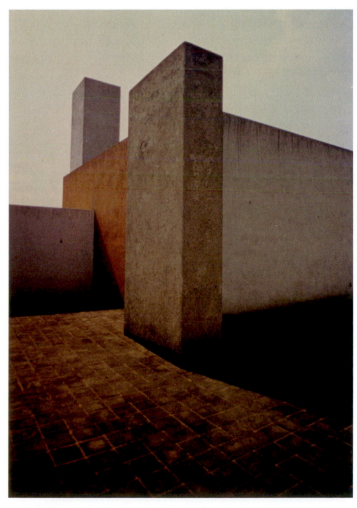

Transparency and Translucency

Color can also be transparent and translucent. The glass vessels in **E** celebrate surface color as it approaches becoming pure light. Unlike applied and intrinsic color, which are examples of reflected light, colored glass filters light directly.

↑ **D**

Luis Barragan. The architect's house. © 2011 Barragan Foundation, Switzerland/Artists Rights Society (ARS), New York.

↑ **E**

Glasswork by Venini of Murano, Italy.

CHROMATIC LUMINOSITY

Just two hundred years ago, the sun and the stars and fire and lightning were the only sources of light on Earth. Now there are numerous industrially manufactured, light-producing devices—such as incandescent bulbs, fluorescent tubes, sodium vapor lamps, lasers, neon, and LEDs.

Reflected Light

Light illuminates form and casts shadow, enabling us to perceive form. In this capacity, light is essential. The structure of the monastery in **A** is made visible by light, not just in the simple sense that we require light to see, but in the sense that these forms were intended to be defined and caressed by light. In **A**, the light source is on the right, casting shadows to the left, revealing planes and voids. Color temperature is in play as well—the shadows are cool; the illuminating light is warm.

In general, white best reveals form, as it is the most reflective color; black objects absorb most of the light that falls on them, causing them to appear less nuanced. Architecture and sculpture in the landscape share the additional challenges and opportunities of existing in a light that is continually changing—from morning till night, season to season, and in all kinds of weather.

Luminosity

Some objects emit light; they contain their own source of illumination. Such luminous objects have dual natures—they are objects with structure and they are light-emitting vehicles. The sculpture in **B** consists of standard fluorescent fixtures (its structure), and as such it might be understood to be a kind of Pop or Found/Dada sculpture, appropriating an ordinary, quotidian product. As a light-emitting object, however, this work takes on a more theatrical and ethereal presence—it transcends its humble origin, completely transforming the corner of the room with its luminosity.

Light as Pure Medium

While great use is made of light in the theater, the use of light as a sole medium devoid of objects remains a kind of utopian dream in the arts. Something approximating this ideal was created in a piece titled *Your atmospheric colour atlas* **(C)**. In a room filled with fog, housing red, green, and blue lights programmed to mix in response to viewer movement, the empty space was made visible and substantive; the dense fog became a luminous chromatic environment.

Tribute in Light **(D)** was a temporary event that took place annually for a number of years to commemorate the tragic events of September 11th. Twin beacons, representing the two towers, illuminated the night sky from a location adjacent to the World Trade Center site.

The other subject of **D** should be acknowledged—it is the City of New York. This sprawling, night photograph reminds us that light in contemporary culture often takes the form of spectacle. From the kinetic displays of Times Square to the illuminated Statue of Liberty, and the millions of illuminated windows, New York is, itself, a sublime light-work on a massive scale, and no less symbolic than the twin commemorative beacons.

A

Monastery of Panagia Hozoviotissa.
11th century. Amorgos, Greece.

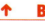

B

Dan Flavin. *Untitled (to Donna) 6.* 1971. Fluorescent lights, overall: 8' × 8' . © 2011 Stephen Flavin/Artists Rights Society (ARS), New York.

 C

Olafur Elliason. *Your atmospheric colour atlas.* **2009.
Four installation views. Fluorescent lights,
aluminum, steel, ballasts, and haze machine.
21st Century Museum of Contemporary Art,
Kanazawa, Japan. 2009–2010.**

 D

Proun Space studio. *Tribute in Light,* **9/11 Memorial, New York.
Photograph by Charlie Samuels.**

KINETIC STRUCTURE

The traditional marble sculpture on a pedestal in a museum is still and fixed in place. It is static; nevertheless, like all experiences, it involves time and motion. To perceive it in its entirety you must walk around it—in doing so, new aspects of the sculpture reveal themselves in time. Viewing the work in a different order will result in a unique unfolding of experience. In addition, this frozen, still, mute object becomes a foil against which the movement of your own body, other museum visitors, and the hum of the ventilation system, for example, become more perceptible.

The **futurist** artist Umberto Boccioni created a static sculpture, *Development of a Bottle in Space* **(A)**, in which he presented multiple views of a bottle simultaneously, simulating a walk around it. Boccioni took on the challenging task of representing time and motion in a still object.

In **kinetic** structures, artists and designers utilize time and motion directly. László Moholy-Nagy projected light on a rotating, motorized structure **(B)** in order to modulate light and reflect it onto gallery walls, creating an enveloping symphonic experience.

The contemporary artist Tony Oursler uses motion, time, and sound, combined with objects to create psychologically charged scenarios. In **C**, video images of a face are projected on two hemispheric objects, accompanied by a soundtrack of a screaming man. In spite of the complete and intentional artifice, the result is disturbingly convincing.

Robotics

A visit to a contemporary automobile factory will reveal an amazing array of robotic production technology—huge machines for transporting, welding, and painting. Robotic technology is a rapidly developing realm that already has a far-reaching impact on our lives. One playful example that reached a wide audience as a commercial product is Sony's interactive robotic dog Aibo (**A**rtificial **I**ntelligence Ro**bo**t). Aibo **(D)** is a pet that recognizes spoken commands. It has facial expressions, welcomes its master, and is capable of learning. In spite of a cold plastic exterior, Aibos are much loved by their masters.

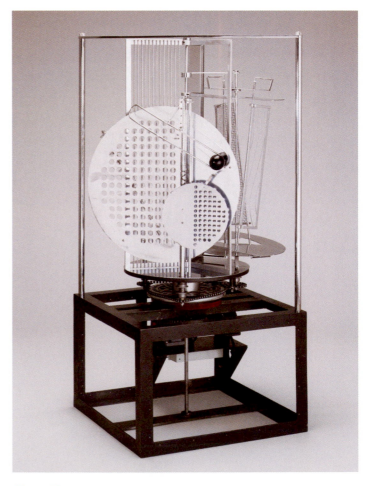

 A

Umberto Boccioni. *Development of a Bottle in Space.* **1912 (cast 1931). Silvered bronze, 1' 3" × 1' 11¾" × 1' ⅞". The Museum of Modern Art, New York.**

 B

László Moholy-Nagy. *Light Prop for an Electric Stage (Light-Space Modulator).* **1930. Aluminum, steel, nickel-plated brass, other metals, plastic, wood and electric motor, 4' 11½" × 2' 3½" × 2' 3½".**

Wonderful time/motion events also occur in everyday experience and in nature. These events await transformation by artists (they are raw material, sources of inspiration, and we can learn a great deal from them), but don't forget, they are also to be cherished just as they are.

Swarming behavior in insects and birds can create massive shifting forms that ebb and flow in a spectacular choreography. You can get a sense of the grandeur of such aerial action in the photograph of starlings over Rome **(E)**.

← **C**

Tony Oursler. *Half (Brain).* **1998. 2 Sony CPJ 200 projectors, 2 videotapes, 2 Samsung VCRs, polystyrene foam, paint, performance by: Tony Oursler. Each 1' 2" × 1' 1" × 1' 1" (plus equipment).**

↑ **D**

Aibo robotic dog. 1999. Sony Corporation.

→ **E**

Flock of Starlings. 2008. Rome, Italy. Photograph: Chris Helgren.

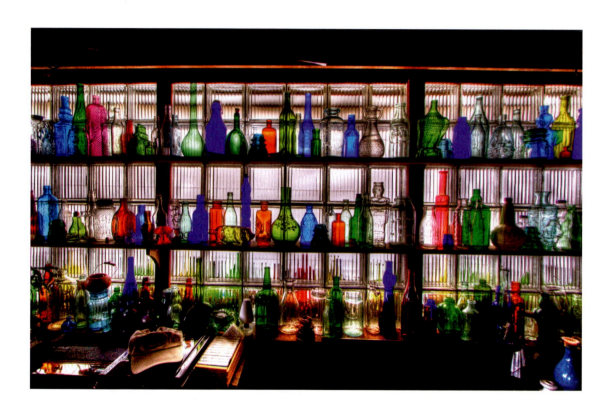

Antique bottle collection. Elliot Barnathan, photographer.

ORGANIZATION

Organization, the act of bringing separate elements together to form a unit or a structure, is a foundational component of the design process. The organization of form is facilitated by the knowledge and application of all the principles of design.

Preparing for an exhibition of Martin Puryear's sculpture, the curators and exhibition designers used small, scale models of each artwork, positioned on a diagram of the museum's floor plan **(A)**, to arrive at the best installation. Designing an exhibition is in an organizational activity.

Portia Munson created *Pink Project*, a collection of pink plastic products created for the "girl market." This collection is an artwork that has been exhibited in a number of different incarnations over the years. Let's consider three versions. The artist amassed hundreds of pink objects—the problem . . . how to present them? In **B** they are arranged neatly on a table top in groups of similar objects in a rough proximity (combs with combs, bottles with bottles). The objects in **C** are in two museum-style vitrines (with two very different approaches to display), and **D** takes the form of a chaotic pile on the floor.

Is one version of *Pink Project* better than the others? Is the pile in **D** disorganized, or is it just another kind of order? While there are no easy answers to such questions, it is worth noting that all three works have been thoughtfully organized by the artist, and in each, the objects take on an altered meaning. The subject matter of these works is as much about organization and the problem of presentation as it is about the material components. It should also be said that whatever kind of categorization or organization is used, the first principle is a visual one: all of the objects are pink, lending a commanding unity to whatever happens next.

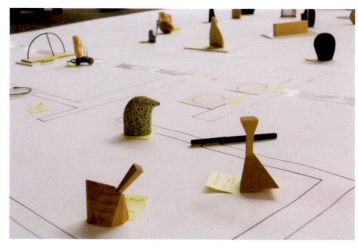

↑ **A**

Models for the Martin Puryear exhibition at the Modern Art Museum of Fort Worth.

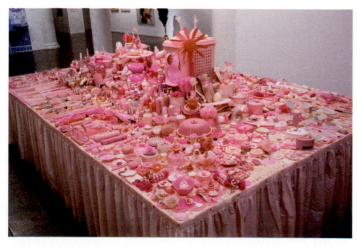

↑ **B**

Portia Munson. *Pink Project: Table.* **1995. 2' 6" × 8' × 14'.**

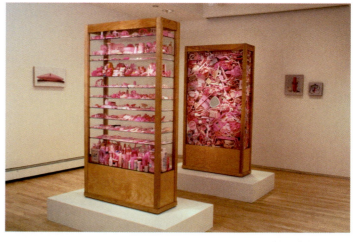

↑ **C**

Portia Munson. *Pink Project: Vitrines.* **1995. 5' 8" × 2' 8" × 1' ½".**

Organization implies order, or at least *an ordering*, but this is not to say that design must be *orderly*. Yes, organization can be highly structured and logical, but it can also be generated by a complex blend of design principles, stylistic inclinations as well as random operations. The work in **D** is an interesting combination of opposing forces: a strong organizing principle—a unifying mound, plus the casual structure of random events.

The act of organization involves just about everything we do and create; it is not, of course, relevant only to the act of arranging separate objects, such as collections. Arranging and composing the materials and elements within a single work also involve organization. The house in **E** is an arrangement of planes in space (planes of varying proportion), rectangular perforations (windows), linear elements and colors—all organized to give physical form to the architect's ideals and values. The following sections in this chapter deal with a wide array of 3D principles and their use in organizing form.

← **D**

Portia Munson. *Pink Project: Mound.* **2006–ongoing. approx. 6' × 12'.**

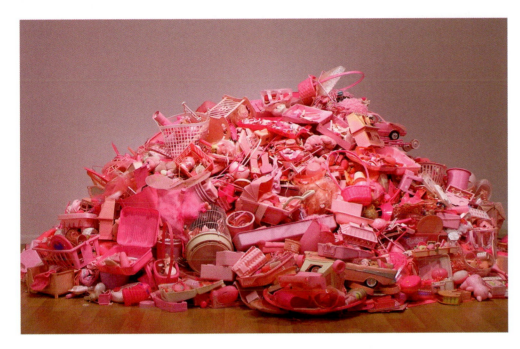

→ **E**

Gerrit Rietveld. Schröder House. 1924–1925. Utrecht, The Netherlands. © 2011 Artists Rights Society (ARS), New York.

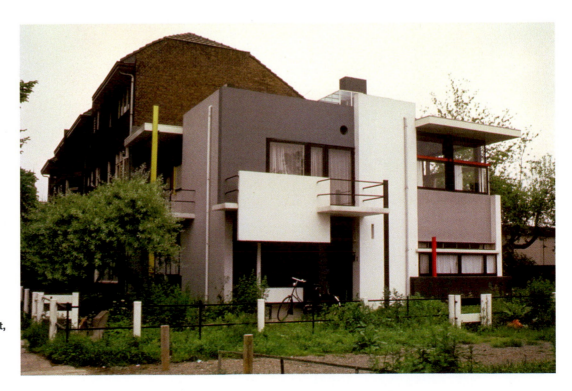

GESTALT

Unity is achieved when the whole is more important than the parts. A unified design may be, on the most basic level, a simple monolith or mass. More often, unity consists of many forms or objects brought together to construct a coherent whole.

The German word **gestalt** has proven to be quite useful for artists and designers. It is derived from the perceptual ideas of Gestalt psychology, and its full meaning has many facets. The way gestalt is most often used in art and design is a simplification, but it is a handy one. Gestalt (which means shape or form in German) suggests that experiences are greater than the sum of their parts. The individual notes of a musical tune—presented as completely separate entities—cannot provide the experience of the tune to the listener. A tune depends on the order of the notes and the intervals between them, and can only be recognized as an experienced totality. Most in the arts today use the word *gestalt* to suggest that one should experience the essence, the entire work, all at once!

Unity of the Figure

The human figure is a fundamental archetype of unity, like trees and boulders, cubes and spheres; consequently sculpture that depicts these subjects (and especially the human figure) achieves unity almost by default. So strong is the figurative image, that even the cartoon-like sculpture by Tom Friedman **(A)**, constructed of miscellaneous plastic parts, achieves unity with ease. Its monster eyeballs and loop of a mouth, however abstract and schematic, remain easily recognizable as a face.

Three-Dimensional Grid

The three-dimensional grid is a unifying force. The Seagram Building **(B)** is an example of extreme unity achieved by several contributing factors: its structure is a 3D matrix, it is a monolith, it stands isolated from other large buildings, and it has a unifying color.

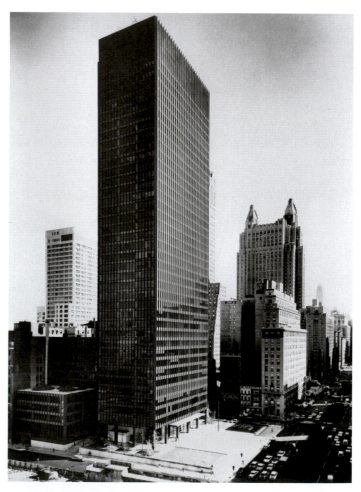

↑ **A**

Tom Friedman. *Green Demon.* **2008. Expanding insulation foam and mixed media, 7' 7" × 3' 7" × 3'. Courtesy of Tom Friedman and Luhring Augustine, New York and Stephen Friedman Gallery, London.**

↑ **B**

Ludwig Mies van der Rohe with Philip Johnson. Seagram Building. New York. 1956–1958.

Proximity

The marvelous window in **C** is the result of the architect taking two circles, decreasing the distance separating them (increasing their **proximity**) until they overlap, and forming one new and dynamic shape. This window could easily become a universal symbol of unity.

Unifying Pattern

The formal gardens of Versailles **(D)** consist of many elements: trees, bushes, paths, grass, and fountains, and all in numerous, unique shapes. One might expect such an array to be chaotic and break up into individual parts. The fact that this does not occur is the result of the garden's strong, symmetrical, unifying pattern. The whole is more important than the parts.

← **C**

Carlo Scarpa, architect. Window at Brion-Vega Cemetary. 1970–1972. San Vito d'Altivole, Italy.

→ **D**

Gardens at the Chateau de Versailles. France.

DYNAMIC PARTNERSHIP

Unity and variety is a frequently utilized and universally applied design principle—it creates rich and powerful visual events almost effortlessly. Unification provides an overall and simplifying influence; the use of variation creates nuanced events and pockets of interest. Unity and variety are the dynamic duo of design.

Ryoanji **(A)**, a Japanese Zen rock garden, is unified by a rectangular framing format, a monochrome palette, and by its consistent elements—all natural rocks. Its sameness might be deadening, but Ryoanji is full of subtle variations that bring it to life. Each rock is a different size and a unique shape. There are many places from which the viewer can experience Ryoanji, and no matter where one sits, all fifteen rocks can never be seen at once—there is always at least one rock obscured. The secret of Ryoanji is in the spaces between the rocks and the variety of those spaces—it is an acknowledged masterpiece of Japanese culture because it makes silent voids tangible.

Since **Zen** is a word you will undoubtedly hear often in the arts, this might be a good opportunity to provide a brief

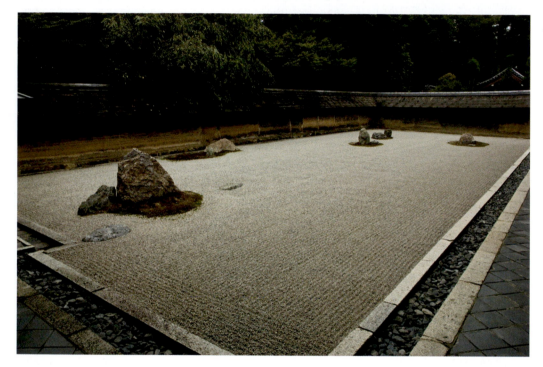

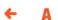 **A**

Rock Garden. Late 15th century. Ryoanji Temple, Kyoto, Japan.

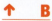 **B**

Allan McCollum. *Drawings.* **1989–1991. Pencil on museum board, each unique. Installation: Centre d' Art Contemporain, Geneva, Switzerland.**

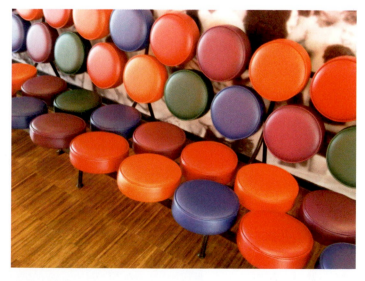

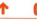 **C**

George Nelson. *Marshmallow Sofa, extended version.* **1956.**

explanation. Zen, a type of Buddhism, spread from China and India to Japan, from where it wielded most of its influence on the arts. Zen ideas are especially apparent in Abstract Expressionism, jazz, the writing of the Beat Generation, Dada, and conceptual art. Zen advocates not for things or even ideas but for the enlightened awareness of the practitioner. In this way, Zen—often called "the way of no way" and full of sassy, iconoclastic attitude—resembles the creative practices of art and design when performed at their highest levels.

The Grid

The installation in **B** is a highly ordered collection of small, framed drawings. This piece takes the form of a unifying **grid**. Its individual units are exactly the same size, and the drawings are similar—black silhouettes on white backgrounds. Its unity is clearly established. Its variety is based on the fact that every drawing is unique!

Color

The playful 1950s sofa in **C** displays an almost random variety of color disks, serving as an antidote to a unity of orderly repeated forms.

Continuation

While some work is equally balanced between unity and variety, others emphasize one quality or the other. *The Dance* in **D** leans more toward variety. It is a vigorous composition displaying a great range of forms, overlapping curves, and bodies in a wide array of configurations. Unity is evident in the symmetry of the arrangement, the monochromatic limestone, and most importantly, the use of **continuation**. The curve of an arm is visually continued by flowing drapery or by another arm, virtually making the two a single, extended curve. Continuation is used extensively in **D**, creating complex, interwoven forms that unify.

The sculpture *Study, 20 Elements* in **E** was created in response to *The Dance* in **D**, by invitation of the Musée d'Orsay for a project titled "Correspondences." Through abstract form alone, *20 Elements* perfectly captures the fusion of unity and variety in *The Dance*.

 D

Jean-Baptiste Carpeaux. *The Dance.* 1863–1869. Limestone, 13' 9" × 9' 8⁷/₃₂" × 4' 9". Musee d'Orsay, Paris.

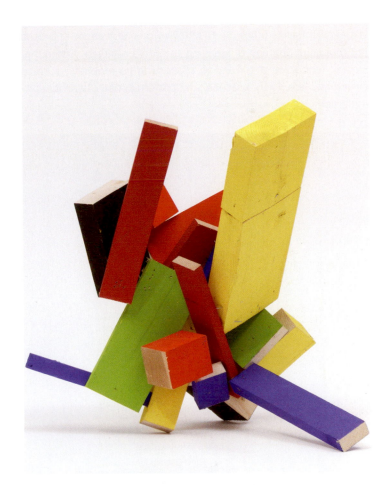

 E

Joel Shapiro. *Study, 20 Elements.* 2004.

VISUAL AND STRUCTURAL

The ornament of Reims Cathedral **(A)** consists primarily of repeating elements that radiate like ripples in water: horizontally, vertically, and radially. This repetitive motif is, to some extent, functional, adding strength to walls, but it is also a device used to decorate surfaces and emphasize form.

Rodin's *Monument to the Burghers of Calais* **(B)** builds a powerful momentum through its use of repetition. In telling the story of the burghers, Rodin amplifies the perception of their tragic destiny by depicting all six figures, creating a series of dark crevices between the figures, repeating the heavy, hanging, vertical folds of their garments and the nooses around their necks.

Brancusi's *Endless Column* **(C)**, 1938, and the *Hole in the Ice* totem pole **(D)**, created over a century ago by First Nations craftspeople of British Columbia, have completely different reasons for being. They do, however, have a great deal in common formally. Both are thin, vertical columns, and both utilize vertical repetition to transform a mere column into a gravity-defying, extreme stack, suggesting unending extension.

The seemingly perfect form of many traditional, handcrafted objects is the product of countless anonymous artisans each adding a small improvement or minor variation over long periods of time. Though function may be the primary concern, delightful visual structure is often the result. The basket weaver in **E** uses the repetitive process of weaving to create a sturdy vessel that literally embodies the weaving process in its repetitive surface structure. Here, form, process, and pattern constitute an inseparable unity.

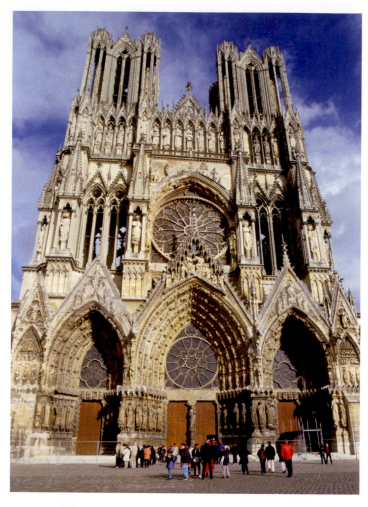

↑ **A**

West Façade of Reims Cathedral. c. 1225–1290. Reims, France.

← **B**

Auguste Rodin. *Monument to the Burghers of Calais.* **1884–1895.**

 C

Constantin Brancusi. *The Endless Column.* **1938. Târgu Jiu, Romania.**

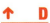 **D**

Gitxsan totem pole, *Hole in the Ice.* **c. 1900. Gitanyow (Kitwancool), British Columbia, Canada.**

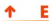 **E**

Artisan weaving a basket. Japan.

MODULARITY

A **module** is a standard unit. Modular forms such as bricks, concrete blocks, and sheets of plywood, like the tatami mats of Japan **(A)**, are not simply standardized building supplies; they have a profound influence on the design of the structures in which they are utilized. Rooms in Japanese architecture are traditionally described by the number of tatami mats required to cover the floor—a four-and-one-half-mat room is 9' × 9', for example. Due to mass production and industrial processes, the module has a large and increasing role in contemporary design.

If you played with blocks, Legos, or Tinker Toys **(B)** as a child, you already know a lot about modular systems. A diverse range of complex structures can be built from just a few basic elements—that is the value of the module! It is little wonder that the underlying structure of life and all matter is modular. With just over one hundred different kinds of atoms, an almost infinite range of molecules is possible, and that results in the incredible variety of forms in the universe. In **C**, James Watson and Francis Crick, utilizing molecular models constructed of modular elements not unlike the child's Tinker Toy, explain the structure of DNA.

Architect Moshe Safdie's Montreal building complex, Habitat '67 **(D)**, is one of the most well-known and earliest examples of modular architecture. Reminiscent of the efficient packing of the honeycomb, 354 prefabricated, individual, concrete modules are stacked and connected by steel cables—organized so that each apartment has a balcony on the roof of the apartment below. Modular architecture has clear advantages—notably the speed of on-site fabrication and the economy of prefabrication. Another kind of modular architecture is the modular house—it may be assembled from prefabricated parts at the site or shipped completely assembled as a single unit.

While architects today are increasingly involved in designing high-end, modular dwellings, it is good to remember that factory-built houses, as well as mobile homes, however maligned, are already in wide use.

↑ **A**

Tatami room in a traditional Japanese house.

↑ **B**

Tinker Toys.

 C

James Watson and Francis Crick with their DNA model at the Cavendish Laboratories in 1953.

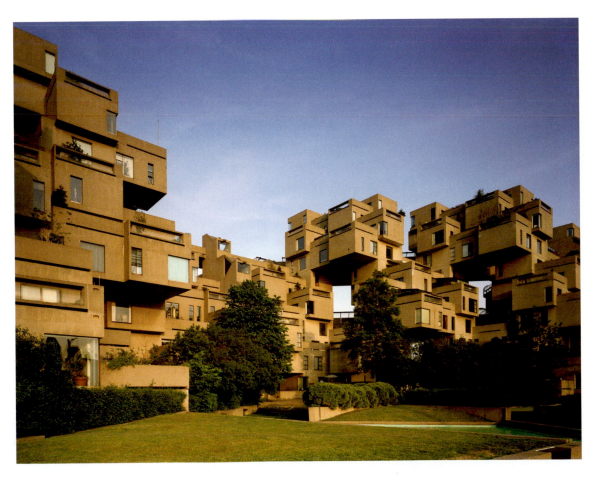

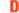 **D**

Moshe Safdie. Habitat '67. 1967. Montreal, Canada.

ORDERED REPETITION

Pattern, the ordered repetition of a visual element, is usually considered a two-dimensional issue. When pattern gets spatial, it becomes something other than what we usually consider pattern to be; it becomes more like 3D structure. Pattern is, however, an important aspect of the third dimension—especially in relief panels and when it exists on the surface of an object where it often serves to augment form.

 A

Erwin Hauer. *Continua Series Design 1.* **1950.**

3D Form as Pattern

Erwin Hauer is a master of the perforated surface. These panels **(A)** are all about pattern, and they create pattern uniquely, through three-dimensional form alone—no decorated surface here. These interwoven, organic forms result in perforations that are more like the flowing spaces under highway overpasses than simple holes. Repeated as modules, these biomorphic voids result in structures that are used architecturally in partitions, screens, and light-diffusing surfaces.

Repeat Pattern

Some patterns extend across a surface and never repeat; others utilize a modular unit, a section of pattern that may be endlessly replicated. These are called repeat patterns. The perforated surface in **A** is a repeat pattern.

Decoration

We often use the word *decoration* pejoratively, with the implication that decoration is simply a cosmetic substitute for interesting 3D form, but the exquisite detail, high craft, and range of juxtaposed patterns in the Mexican saddle **(B)** elevate the idea of decoration. Ornate embroidery, leatherwork, and embossed silver are characteristics of the artisans of Mexican cowboy culture. This saddle definitely makes one think: nothing in art and design is wrong if you do it right.

The glazed tile mihrab (niche) **(C)** in the Madrasa Imami, an Iranian mosque, is a mind-numbing display of pattern. This mihrab is considered a masterpiece of glazed ceramic tile—geometric and floral motifs are juxtaposed, calligraphic inscription and pattern are ingeniously integrated, and all edges receive special treatment—pattern delineates form.

Camouflage

Nature utilizes camouflage, dazzle patterns, and warning displays **(D and E)** to protect its creatures or to provide them with a predatory edge. Whatever the case, it must be acknowledged: nature loves pattern.

See also *Illusion: Camouflage*, page 456.

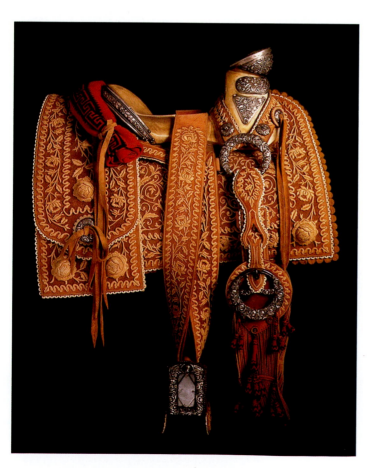

 B

Gran Gala Charro Saddle. Early twentieth century. Leather, embroidery, sterling silver. El Potro Andaluz Saddlery. Puebla, Mexico.

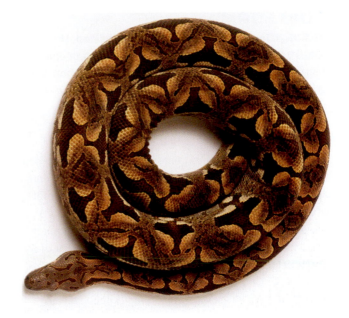

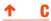 **C**

Mihrab. 1354. Mosaic of monochrome-glaze tiles on composite body set on plaster, 11' 3¹⁄₁₆" × 9' 5¹¹⁄₁₆". Isfahan, Iran.

↑ **D**

Coiled Dumeril's Boa.

 E

Grasshopper. India.

FLUID FORM

Visual **rhythm** and repetition are closely related. However, repetition is associated with a mechanical cadence of equal intervals while rhythm suggests a variation in tempo and more fluidity, not unlike rhythm in music or other time-based activities such as dance and sports.

Rhythm in Relief

The figures and drapery of the relief carving on the sarcophagus in **A** are arranged in a structure so rhythmic it appears that it might depict a dance. (The truth is far more grisly; Orestes plays out a violent Greek myth.) Different layers of rhythm are in operation, and they interact in a kind of syncopation—figures forming large wave-forms are below, and above, on the side of the lid, is a more delicate and shallow wave that is almost an echo.

Figuration and Form

A generally assumed or implicit issue in this book is worth reinforcing here. The principles of design do not just apply to abstract shapes or geometric form. Every building, sculpture, and object, even living things, have formal structures—they are forms! Within every realistic depiction, like the figures on the sarcophagus in **A**, a formal structure exists as well, and that structure affects us; it has its own independent life, regardless of the subject matter. Sometimes form and content work together, and sometimes they contradict each other. Whatever the case, there is no escaping form.

↑ **A**

Sarcophagus with the Myth of Orestes. c. 140–150 CE. Roman. Marble, 2' 7½" h.

↓ **B**

Eva Hild. *Loop Through.* **2007. Stoneware, 2' 11" × 2' 3½" × 1' ⅔". Eva Hild/© 2011 Artists Rights Society (ARS), New York/BUS, Stockholm.**

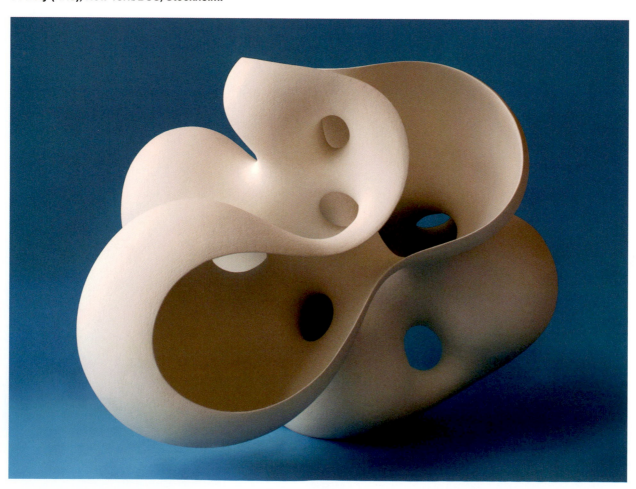

Rhythm in the Round

The rhythmic events on the sarcophagus in **A** take place on a two-dimensional surface in shallow relief. The sculpture in **B**, however, is an example of rhythm operating in full three-dimensional space. This is a fascinating and complex structure in which multiple rhythmic events occur from left to right, and top to bottom, and from inside to outside, and those rhythms continually rearrange themselves as the viewer circles the piece, assuming new vantage points.

> *Abstract sculpture now often looks like an exercise in topology, exactly because the sculptor shares the vision of the topologist.*
>
> —*Jacob Bronowski, 1970*

Staccato

In music another kind of rhythm, staccato, is about sound that changes abruptly—think drums instead of violins. The chair in **C** is a three-dimensional play on staccato rhythm. It has none of the curves we have been associating with visual rhythm; instead, there are short straight lines, planes, and points. The lines are all black, the points, yellow—this establishes a playful structure of syncopated staccato in painted wood.

→ C

Gerrit Rietveld. *Armchair Red and Blue.* **1918. Wood, paint. © 2011 Artists Rights Society (ARS), New York.**

ORIGIN AND IMPLEMENTATION

Aerodynamic Form

A three-dimensional design principle used to create the illusion of speed has its origin in a natural phenomenon: large things that move very fast are aerodynamic. We have come to associate movement and speed with such streamlined form. These forms are not simply capable of high speeds and great acceleration, they also look fast, even while standing still.

The illustration in **A** is a computer rendering of *The Bloodhound SSC*, a car being created to break the land speed record (it is expected to go 1,000 mph, faster than a bullet fired from a .44 Magnum). *The Bloodhound SSC* and the reef shark **(B)** share formal qualities associated with aerodynamic design—they are both long, pointy cylinders designed to minimize turbulence, allowing their sleek bodies to slip through the air or water. You will never see a shark, jet plane, or race car shaped like a brick.

Other ways to suggest motion are more commonly employed in two-dimensional design than in the 3D realm; they are, nonetheless, valuable principles.

Blur

The sculpture in **C** utilizes an illusion that is derived from photography. If your shutter speed is too slow when photographing a moving object, you get a blurred image. Subsequently, this fact has been used to great effect in photography and painting to express the illusion of motion. Blur is obviously more difficult to create in the realm of real objects. Sculptor Tony Cragg effectively blurs 3D form **(C)**—the bronze sculpture appears to be a figure in motion, twisting in space, and though the actual edges cannot blur, the features are vague and stretched, simulating blur and creating an illusion of motion.

Sculptors have also utilized what we now think of as the cinematic idea of representing motion—repetitive elements that appear as if they are a photographic multiple exposure. This can be effective at expressing a brief gesture, as in the Tantric figure **(D)**. Though its multiple arms are primarily symbolic, they nonetheless serve to animate this diminutive goddess.

↑ **A**

The Bloodhound SSC (Super Sonic Car) is seen traveling at speed in this artist's impression.

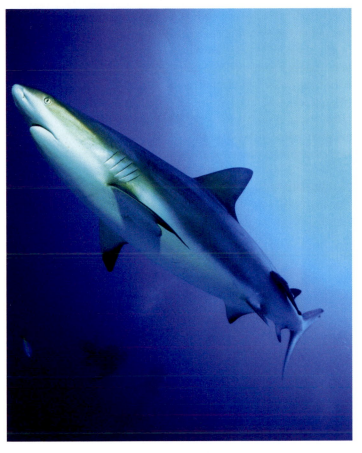

↑ B
Caribbean reef shark.

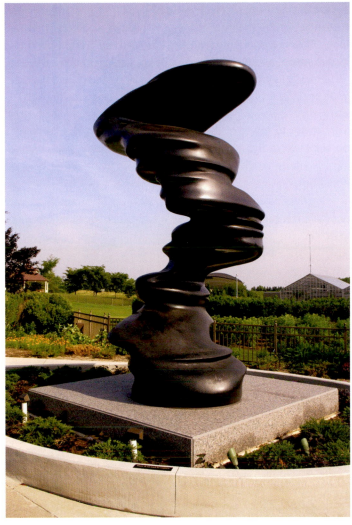

↑ C
Tony Cragg. *Bent of Mind.* 2005. Bronze. Frederik Meijer Gardens and Sculpture Park. Grand Rapids, Michigan.

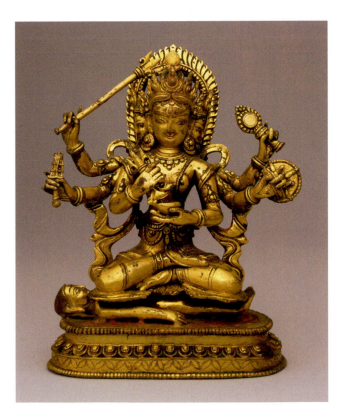

← D
Tantric Hindu Goddess. c. 17th century.
Gilt copper. 6¾" × 5¾" × 3¾". Nepal.

ACTUAL AND IMPLIED

Balance, in the realm of three-dimensional structure, has two faces: (1) it is a phenomenon of nature ruled by gravity, operating in real space, and (2) it is a virtual or implied condition.

Real balance has to do with things like leaning backwards in your chair, just past your center of gravity, and crashing downward, or . . . walking a tightrope, as did Philippe Petit in 1974, from tower to tower of the World Trade Center **(A)**. Learning to be sensitive to the stresses placed on your body while balancing will inform your understanding of stress in the structures you construct.

Implied balance involves one's awareness of actual gravity and balance, but remains a strictly visual experience that has more to do with the organizational and aesthetic factors of visual weight.

Balance—Actual

Alexander Calder's mobiles (pronounced mö-bëls) are all about matter interacting with gravity. During the process of construction, Calder had to find balancing points in order to achieve the equilibrium that would permit resolution. In *Cascading Spines* **(B)**, Calder used many lighter rods to balance the heavier, black, sheet metal disks on the left. Furthermore, this mobile appears resolved and balanced in the implied, virtual sense as well; it illustrates the fact that the origin of implied balance is balance in the physical world.

The artist, Reinhard Mucha, rearranged ordinary furniture **(C)**, much as one would before mopping a floor, just to get everything up and out of the way. This informal and precarious sculpture refers to our everyday interaction with objects,

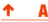 **A**

Philippe Petit walking a tightrope from tower to tower of the World Trade Center. 1974. Photograph by Jean-Louis Blondeau.

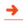 **B**

Alexander Calder. *Cascading Spines.* 1956. Sheet metal, wire, and paint, 4' 10" × 6' × 4'. © 2011 Calder Foundation, New York/Artists Rights Society (ARS), New York.

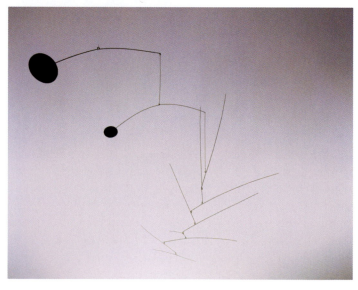

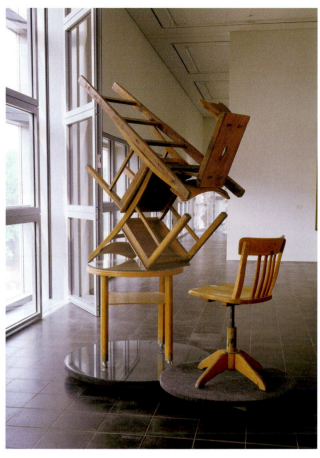

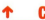 **C**

Reinhard Mucha. *Flak*. 1981. Felt, glass, and wood. Hamburger Kunsthalle, Hamburg, Germany.

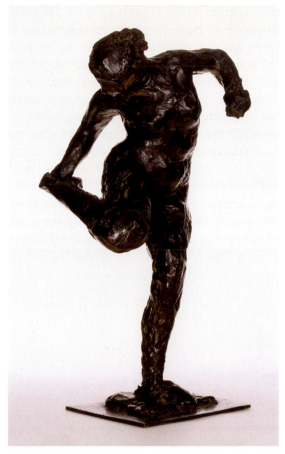

↑ **D**

Edgar Degas. *Dancer looking at the sole of her right foot*. 1919–21. Bronze.

and in its articulation of formal relationships, it continues one of sculpture's grand traditions: the exploration of gravity and balance **(D)**.

Asymmetrical Balance

While balance often implies **symmetry**, *Cascading Spines* **(B)** is clearly not symmetrical. With its visually heavy disks on one side and thin rods hanging down on the other, it is asymmetrical. It is nonetheless visually balanced—the many small elements equal the few large elements. This kind of balance is called **asymmetrical balance**.

Balance—Implied

The sculpture in **E**, from David Smith's Cubi series, does not achieve equilibrium in any classic sense; it is intended to be more dynamic than that. It doesn't need to be perfectly balanced like a Calder mobile, because it is welded together. It can initiate a conversation about gravity and balance but never has to become embroiled in gravity's relentless demands. The David Smith piece deals with the visual issues of implied balance (in 2D design this is referred to as pictorial balance).

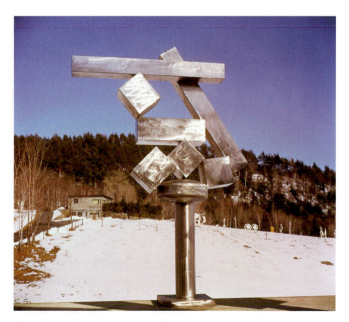

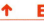 **E**

David Smith. *Cubi XVIII.* **1964. Stainless steel. Art Resource, New York © Estate of David Smith/Licensed by VAGA, New York.**

CORRESPONDENCE ACROSS A DIVIDE

Symmetry occurs when there is formal correspondence on opposite sides of an object's central dividing line—in simpler terms, when left and right sides are mirror images. This definition refers specifically to **bilateral symmetry,** but it will serve as a workable starting point. Symmetry is a widely used organizing tool closely tied to issues of balance; sometime these terms are used interchangeably. There are many distinct kinds of symmetry. We will examine some of the most common forms.

Bilateral Symmetry

Bilateral symmetry is undoubtedly the most important and ubiquitous form of symmetry. Faces, bodies, mammals, insects, and many other living things, as well as numerous built forms are all structured bilaterally. This is the symmetry of classical architecture; it is stable and familiar. Bilateral symmetry cuts one way. For example, a horse is symmetrical when looked at straight on. Imagine a plane that divides the horse from his ears down to the space between his two front hooves and projects through him to his rear. That is the dividing plane that virtually splits our horse into two symmetrical halves, but look at the horse from the side and there is no symmetry at all.

The rear view of the Silver Arrow automobile **(A)** is perfectly symmetrical, bilaterally, just like a face, which it clearly resembles. Like the horse, cars express no symmetry when viewed from the side. Seen frontally, bilateral symmetry commands our attention. It is also balanced, and most often, static (as opposed to dynamic).

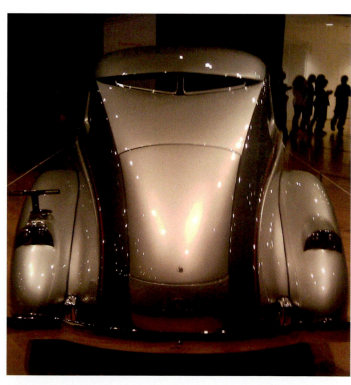

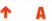 **A**

Pierce-Arrow. *Silver Arrow.* **1933. Design concept Philip Wright, body engineer James Hughes. Pierce-Arrow Motor Car Company.**

 B

Matthew Ames, designer. Spring 2010. New York Fashion Week.

The outfit worn by the model in **B** is a bit more complicated. The *form* of the jacket is symmetrical, like most jackets, but its *color* is delightfully and unexpectedly asymmetrical (devoid of symmetry). This serves to remind us that most objects are rich amalgams of more than one operating design principle—objects are bundles of forces.

Radial and Spherical Symmetry

Radial symmetry is based on symmetry around a central axis. Trees, flowers, many circular patterns, and most cylindrical configurations, such as the glass vase in **C**, are radially symmetrical.

Spherical symmetry is the condition of having similar form arranged regularly around a single point. The greatly enlarged image of a grain of pollen **(D)** is an example of spherical symmetry. Any cut that passes through the center point of the pollen grain will split it into two identical halves.

↑ **C**

Ettore Sottsass. Transparent, turquoise and yellow vase *Alioth.* **1983. For Memphis, executed by Compagnia Vetraria Muranese.**

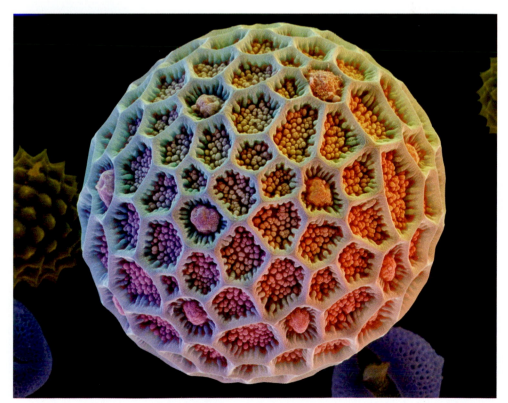

→ **D**

Knotweed pollen. Microscopic view.

DYNAMIC FORM

Every configuration that isn't symmetrical is asymmetrical. **Asymmetry** is symmetry's evil twin—it is off center, out of whack, and confrontational. Asymmetry prefers the dynamism and danger of the diagonal, to the stability of the vertical and the horizontal. If symmetry is associated with all things good, like balance and harmony, does that make asymmetry something to avoid? Absolutely not! Asymmetry is a powerful design principle, and it is in synch with contemporary ideas.

The Extension to the Denver Art Museum **(A)** is a dynamic wedge that appears as if it fell from the sky and embedded itself in the ground. This building is a high-energy cluster of abstract forms that derives power from an asymmetrical, diagonal configuration. The extreme, cantilevered triangle that hovers precariously overhead provides the spectacle that modern engineering makes possible.

 A

Daniel Libeskind. Extension to the Denver Art Museum, Frederic C. Hamilton Building.

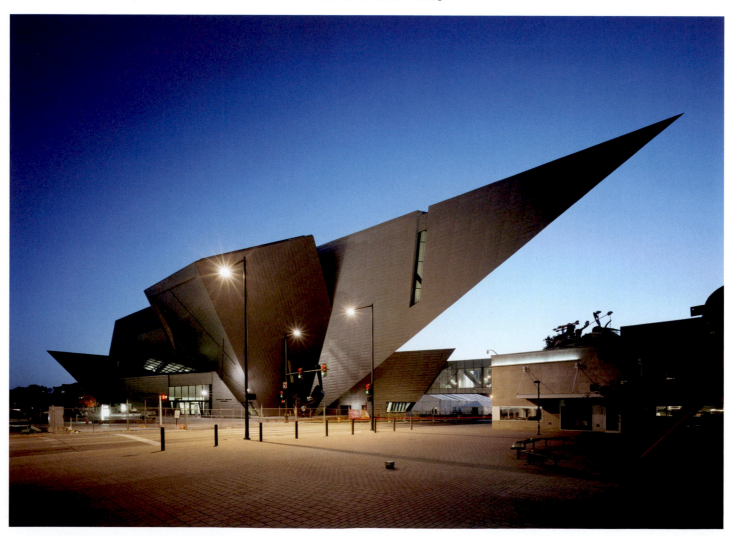

Alexander Calder's *Flamingo* **(B)** is an arching, stable sculpture that touches the ground in five places. It is nonetheless asymmetrical with most of its weight planted firmly on one side. *Flamingo* has an off-center grace that energizes a form that would otherwise be a staid, tripod-like structure. As discussed in the section on *Symmetry*, most animals have bilateral symmetry (including flamingos), but such symmetry is only apparent when viewed head-on, eye to eye. Living, moving animals assume many positions that hardly ever approach perfect symmetry—life is dynamic, rarely static.

The asymmetrical suspension bridge in **C** reminds us of the convention that all bridges and many other designed objects be symmetrical. When convention becomes rule, it is time to reconsider, as did Santiago Calatrava in designing the Campo Volantin footbridge, an inclining parabolic arch that achieves a new kind of resolution—asymmetrical equilibrium.

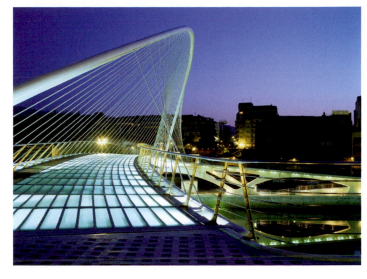

↑ **C**

Santiago Calatrava. Campo Volantin Footbridge. 1997. Bilbao, Spain.

↓ **B**

Alexander Calder. *Flamingo.* **1974. Chicago. © 2011 Calder Foundation, New York/Artists Rights Society (ARS), New York.**

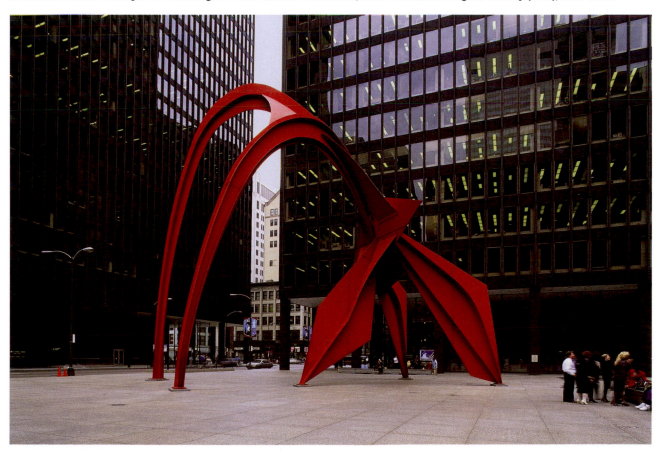

UNITY, BALANCE, ORDER

The following are some traditional definitions of harmony:

- Harmony is unity; its elements form an integrated whole.
- Harmony is balanced proportion.
- Harmony is a pleasing or orderly arrangement of parts.

Informed by aesthetics as remote as those of the ancient Greeks, ideas of harmony are still useful and continue to attract adherents. Nevertheless, harmony, as a principle of organization, has a diminished role in contemporary art and design, partly due to the vagueness of its defining principles, and, to a greater extent, because of the numerous competing ideas and principles in modern and contemporary design culture that are increasingly useful and compelling.

In any case, artists and designers interested in harmony have produced some remarkable objects. The silver decanter in **A** is a perfectly resolved object. The negative shape situated between the handle and the body of the vessel is equal in expressive form to that of the mass of the vessel itself, and it is seamlessly integrated. The decanter is holistic and biomorphic—it appears to be the result of a natural process of growth, rather than something fabricated. Its width-to-height proportion is 3:5, a proportion seen as harmonious since ancient Greece.

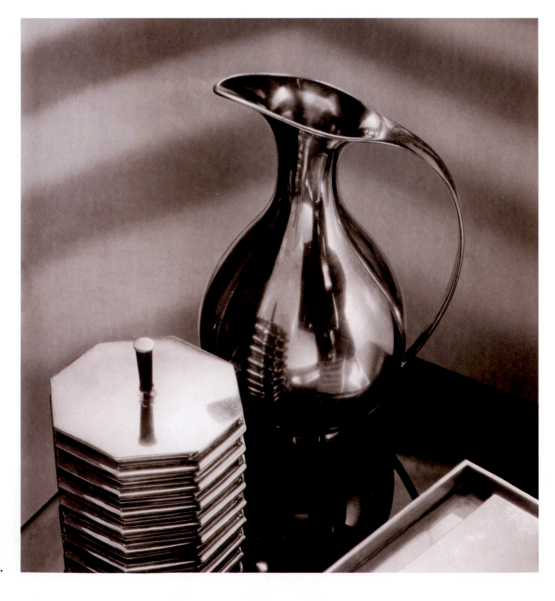

→ **A**

**Kay Fisker. Decanter. 1926. Silver.
Also octagonal tobacco jar.
Manufactured by Anton Michelsen.**

Idealism

Plato believed that objects in the world were flawed reflections of forms that were true and ideal, and these perfect forms could exist only in the mental realm of ideas. These thoughts influenced Greek artists and architects who strove for a perfection beyond mere imitation, a perfection that sought deep, essential form. This approach to form, called **idealism**, is apparent in many temples, artifacts and sculpture **(B)** of Greek antiquity.

The silver decanter **(A)** and the humble record player **(C)** both embody qualities of idealism: essential form (stripped of any unnecessary elements) and sublime proportions that would please the gods on Mount Olympus.

See also *Sources: Geometry and Mathematics*, page 346.

→ **B**

Greek, bronze statuette of a horse. Late Hellenistic, late 2nd–1st century BC. Bronze, 1' 3¹³⁄₁₆" high. The Metropolitan Museum of Art, New York.

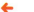

← **C**

Wilhelm Wagenfeld, Dieter Rams and Gerd Alfred Muller, designers. Braun record player. 1957.

AN ORGANIZATIONAL TOOL

Looking up at the night sky we see stars. Some groups appear formless; some appear as specific configurations; some seem to connect, appearing to form lines or triangles; and some constitute the well-known constellations. Two related phenomena contribute to these perceptions. One is the powerful pattern-forming aptitude of the human mind. The other is the principle of proximity, which visually unites things that are near one another and excludes those more distant. Venus and Jupiter in the center of the night sky in **A** are firmly locked together, perceptually, due to proximity (other configurations present themselves as terrestrial bodies and Earthly lights form distinct patterns).

Use proximity to do the important work of linking elements, forming groups and sub-groups, and creating hierarchies.

→ **A**

Night sky showing Venus and Jupiter in conjunction.

Tension

Proximity contributes to the creation and nature of visual tension. Standing too close or too far from someone you are having a conversation with significantly influences the nature of the interaction. The proximity of the two figures in **B**, a king and a falcon/god, creates an electrically charged space, like the gap between the electrodes of a spark plug. Placing the king, who is making an offering, and the falcon farther apart would completely alter our perception of this relationship.

Proximity and Function

The principle of proximity is especially important in such fields as architecture, product design, city planning, and landscape architecture. It is in these disciplines that the visual, perceptual aspects of proximity are joined by the functional. If you design a hospital or an anesthesiologist's control unit, it *must* have various rooms and equipment or instruments in close proximity.

Walking through Central Park in New York City **(C)** appears to be a walk through a bucolic, natural landscape, but this is far from the truth. Central park is a completely designed, artificial wilderness. "During the initial 20 years of construction, 10 million cartloads of dirt were shifted, 4–5 million trees of 632 species . . . were planted, and half a million cubic yards of topsoil were spread over the existing poor soil (some of it recovered from the organic refuse of the garbage dump)."*

Proximity in the park is not something you can see at a glance, but it is a carefully planned arrangement of sites that can be understood only by strolling its winding paths repeatedly over time, from the rambles to the lake (formerly a swamp), to the sheep meadow, and so on. This 843-acre park, designed by Frederick Law Olmsted, places various natural environments— woodlands, meadows, and scenic views—into a series of interconnected experiences.

*Carol von Pressentin Wright, *Blue Guide New York*. 1991, 2nd Ed.

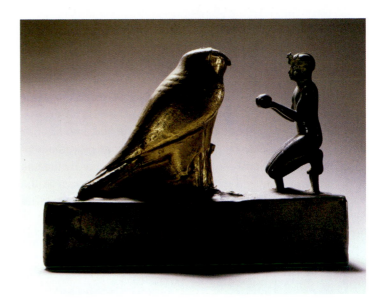

 B

King Taharga Offering a Libation. **Egypt.**

 C

Central Park. New York.

CONTRAST

Emphasis is essential in design and art, as it is in life. Try telling a story with a completely even tone of voice, and you will be reminded of the significant role emphasis plays in all forms of expression and communication. Emphasis is similar to the pictorial idea of focal point. There are numerous strategies for achieving emphasis—differences of color, texture, shape, and size, as well as isolation and placement, are commonly employed.

To differentiate one aspect of form from another by the use of contrasting elements is to emphasize both. Contrast is the underlying force behind the design principle emphasis. In Le Corbusier's celebrated chapel **(A)**, the dark cast-concrete roof appears heavier, more imposing and dramatic when juxtaposed with the whitewashed, ethereal walls that support it.

Emphasis by Color

The chest of drawers in **B** uses paint and color to emphasize unexpected parts. While primarily playful, one can imagine that the highlighted drawers might be used for special items, serving as an eccentric filing system of sorts.

→ **A**

Le Corbusier. Notre Dame du Haut. 1955. Ronchamp, France.

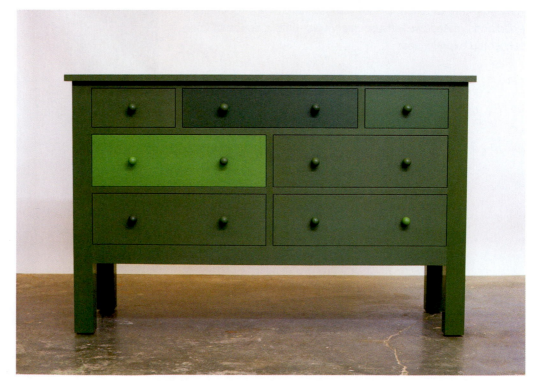

→ **B**

Roy McMakin. Dresser.

Emphasis by Size and Placement

The Palette of King Narmer **(C)**, an Egyptian relief sculpture, emphasizes the image of King Narmer by size and placement. The King is placed in the important central position, and he is larger than all the other figures depicted. In ancient Egyptian art, figures were not larger because they were closer to the viewer, as is common in perspective; size was based on status—kings, pharaohs, and other dignitaries were always the largest figures; peasants and enemies the smallest. The **ideoplastic** system of representation employed in Egyptian art is not unlike the front page of your daily newspaper, in which the largest photographs represent the most important news events.

Compound Emphasis

Ken Price creates emphasis in a number of ways in his ceramic vessel **(D)**. The penetrating hole is made prominent by surrounding it with a smooth flat shape that contrasts sharply with the bulbous forms of the vessel. In addition to texture contrast, the emphasized shape is a different color. It is also a geometric shape, a triangle, surrounded by distinctly organic form.

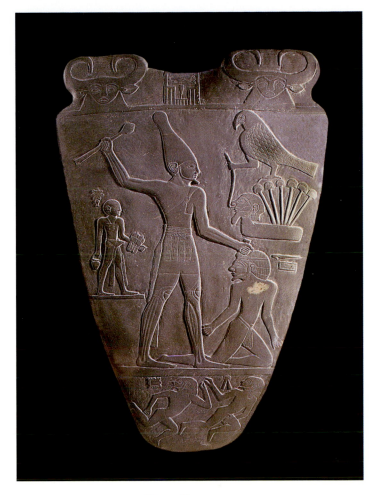

↑ **C**

Narmer Palette. 1st dynasty, 3100–2890 BC. 2' 1" high. Egypt.

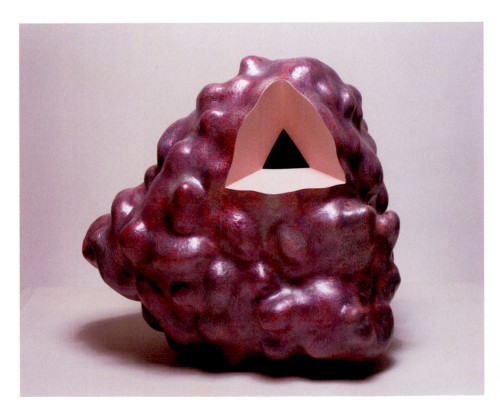

← **D**

Ken Price. *Sweet Paste.* **1994. Fired and painted clay, 1' 6" h.**

RATIO

Proportion refers to the comparative relationship of size. It can be observed by comparing one form to another, or one part to the whole, and can be expressed as a numerical ratio—for example, the ratio of a yardstick compared to a twelve-inch ruler is 3:1.

Villa Savoye **(A)** displays carefully considered variations in proportion. The height of the house to its width, the long, thin rectangle of windows in relationship to the façade, and the lightness and height of the supporting columns all contribute to a reductive sensibility made profound by the fine tuning of proportional relationships.

The Hong Kong cityscape in **B** presents itself as a kind of three-dimensional pie chart. Like most big cities, Hong Kong is an arrangement of buildings of various sizes (heights and widths), masses, and shapes; it gets almost all its visual power from its display of proportional relationships. Like many works of art and design, Hong Kong's range of proportional variation creates an invigorating visual music.

↑ B

Hong Kong cityscape.

 ↓ A

Le Corbusier. Villa Savoye. 1929–1930. Poissy, France.

Ideal Proportion and Convention

The ancient Greeks believed that certain proportions of the human body were ideal. We still have many beliefs and preconceptions concerning the contested realm of ideal physical beauty, and many of these beliefs are based on proportional standards.

We have expectations concerning the way things should look. The notion of "correct" proportion is often based on familiarity, norms, and convention. Many beliefs are well-founded; some turn out to be biases. Artists and designers take pride in their willingness to examine and challenge their preconceptions, and many use skepticism as a design strategy. The high-fashion design of the extremely oversized lace ruff collar **(C)** is not a radical work of art; it is more whimsical than that, but it does play on and subvert our expectations of what a collar should be, and it has a lot of fun with proportion along the way.

↑ **C**

Junya Nutanake. Lace ruff collar. Comme des Garçons.

COMPARATIVE SIZE

The word *scale* as used by artists, designers, and architects refers to the relative size of an object or a volume of space in relationship to the viewer, in relationship to other objects in the vicinity, or to the object's environment in general. Scale is a design principle that wields a great deal of power.

The photograph of the Kensu Valley **(A)** makes clear the contextual nature of scale. The Celestial Mountains dwarf a hunting cabin, and the mountains are understood to be immense only because we can compare them to the cabin. Scale is all about context—perceiving size depends on comparison.

From atoms with diameters of 0.1 to 0.5 nanometers, to a galaxy that is six million light-years wide, the full range of scale in the universe is exhilarating and perhaps beyond real comprehension. Human beings utilize an infinitesimal segment of the universal scale continuum.

The film *Powers of Ten* is an excellent guide to the relative nature of cosmic scale. As seen in the selection of stills from the film **(B)**, *Powers of Ten* takes the viewer on a journey from the proton of an atom in a sleeping man's hand to the outer reaches of the universe.

Human Scale

Monumental and miniature objects represent the extremes of scale in daily life. Most objects and spaces occupy a place in between these extremes. This more domestic realm is often referred to as human scale, and it is here that slight discrepancies in size or expected size can profoundly impact viewers. The human body remains the default benchmark when perceiving scale.

If you have ever sat at a table that is too high, you have experienced the disconcerting feeling that you are smaller than you actually are. The scale of the table has virtually altered your size—scale is a potent design tool. Scale's ability to make a viewer feel and appear larger or smaller brings to mind each individual's own human development—entering the world as infants and growing to adulthood, we have all experienced a wide range of scale relationships with the world. The oversize table not only alters your perception of your own body size, but it can make you feel childlike.

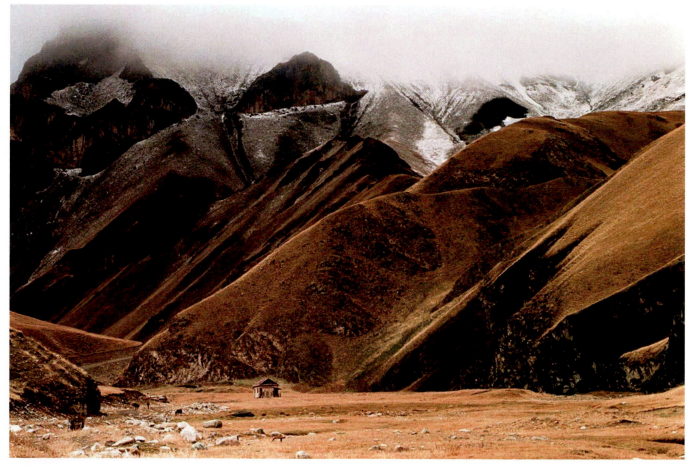

↑ **A**

Kensu Valley. Staton R. Winter, photographer. Kyrgyzstan.

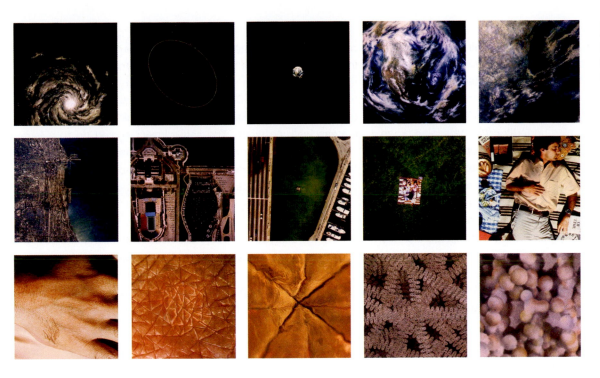

← **B**

Charles and Ray Eames. Images from the film *Powers of Ten.* **1977.**

Space

Architects are especially involved with scale. The void or volume of space contained within architectural structures influences perception. The experience of being in a room with very low ceilings can be oppressive and claustrophobic. Entering a gothic cathedral **(C)** can fill one with a sense of wonderment. The scale of the soaring space, in relationship to the viewer's body, was designed to inspire awe.

Scale Drawings

The word *scale* is also used to explain the difference in size between an object or environment and its representation. This is a vital aspect of maps, models, and diagrams. If a designer draws a chair three inches tall and determines that the scale is *one inch equals one foot*, using the drawing as a guide, the chair that is constructed from it will be three feet tall. Measuring the scale drawing will provide all of the information required to construct the chair at the intended size.

> . . . In that Empire, the Art of Cartography attained such Perfection that the map of a single Province occupied the entirety of a City, and the map of the Empire, the entirety of a Province. In time, those Unconscionable Maps no longer satisfied, and the Cartographers Guilds struck a Map of the Empire whose size was that of the Empire, and which coincided point for point with it.

—*From* On Exactitude in Science, *by Jorge Luis Borges, 1960*

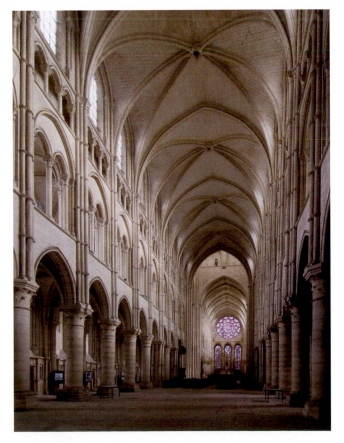

↑ **C**

Interior of Laon Cathedral (looking northeast). Begun c. 1190. Laon, France.

THE MINIATURE

Miniatures are frequently encountered in daily life—children's figurines, toys, educational models, tabletop figurative sculpture, and souvenirs are just some of the objects often produced in a scale that is smaller than life-size.

A model train set is an interesting example of an installation that can be quite large, and also understood to be scaled down many times over. Miniature scale doesn't just mean small, but small relative to a point of reference. The miniature can generate a counter perception—the operator of the train set becomes a giant with total control.

Viewing *Two Women* **(A)**, we struggle to resolve a perceptual conundrum. Have these figures been somehow shrunken and preserved by alchemy or incantation? Are they simply life-sized representations of tiny women? These figures are highly detailed representations and we can get up close and examine every wrinkle, but their diminutive size (approximately one-half life-size) leads us to feel as if we are not close, but viewing them from a distance. When scale is carefully employed, complex plays of perceptual ambiguity can be achieved. Why is **B** included? To illustrate the scale of *Two Women*, of course.

The Effects of Scale

Scale alters one's relationship to the world. The water strider **(C)** can walk on water. The same insect scaled up to a larger size would fall through the surface of the water. The relationship between the surface tension and the surface-to-weight ratio of the insect (scale!) determines successful water walking.

Extremes

How small can you go? From the minuscule to the infinitesimal, some craftspeople are pushing the envelope. Willard Wigan carves diminutive sculptures that fit in the eye of a needle **(D)**. According to his website, "Willard enters a meditative state in which his heartbeat is slowed, allowing him to reduce hand tremors and sculpt between pulse beats. Even the reverberation caused by traffic outside can affect Willard's work."

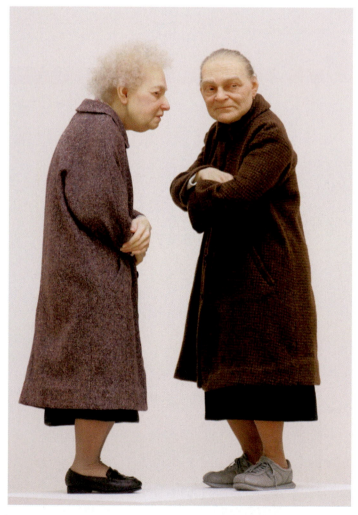

↑ **A**

Ron Mueck. *Two Women.* **2005. Mixed media, 2' 9½" high.**

↑ **B**

Ron Mueck's *Two Women* **with viewers at the Royal Scottish Academy. Edinburgh, Scotland.**

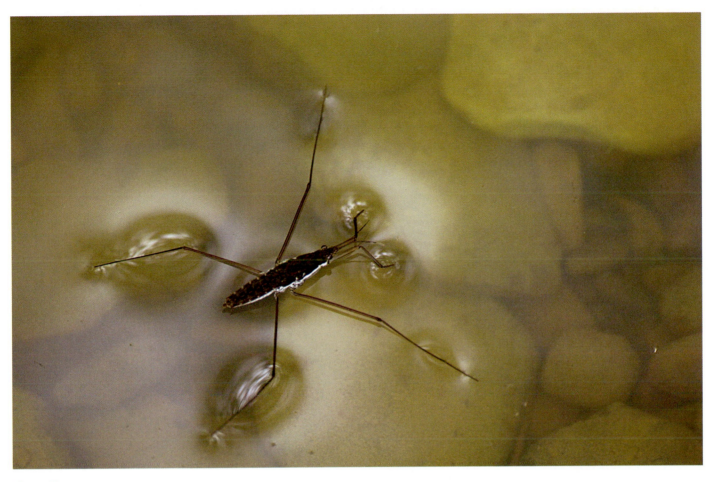

↑ **C**

Water strider.

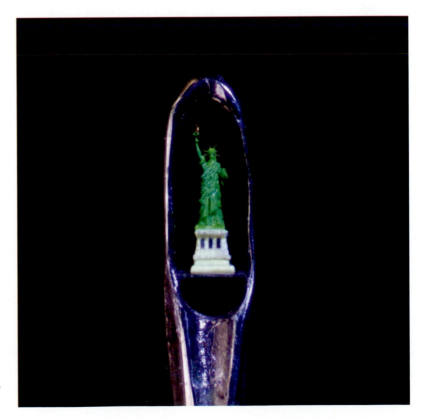

→ **D**

Willard Wigan. *Statue of Liberty*
in the eye of a needle.

MONUMENTAL

The power of scale can be well observed in monumental things. The image of the worshiper at the foot of the 70-foot-tall statue of Gomateshwara in India **(A)** clearly indicates, even in a photograph, how forcefully scale can impact observers and how that can be experienced in extremely visceral ways. The statue is at least eleven times larger than life. Scale-increases of this magnitude are humbling and exhilarating. It is for such reasons that monumental scale is often used for political and propaganda purposes. The statue of Kim Il Sung **(B)**, former prime minister of North Korea, looms over a saluting soldier, not only expressing grandeur and power but dwarfing and diminishing all viewers— we feel like mere specks in its presence.

Making the Familiar Strange

Monumental scale isn't always about power; it is often playful, as in the Claes Oldenburg/Coosje Van Bruggen binocular entrance **(C)** incorporated into the facade of a building in Venice, California. The artists utilized the classic Pop Art strategy of appropriating and super-sizing a **quotidian** object. By their choice of subject matter, they not only mock the idea of the classical facade with columns, but they use scale to breathe life into the esteemed art world **tenet**, "make the familiar strange."

Sculptor Urs Fischer also makes the familiar strange by scaling up the miniature **(D)**. After squeezing a small piece of clay in his hand, he used a 3D computer scanner to record these casual lumps, increase scale, and produce molds. The final aluminum sculpture is over thirteen feet tall. This work evokes numerous references, from cocoons and rock formations to body parts and abstract sculpture, but these readings are disrupted, ominously or hilariously—massive fingerprints are clearly visible on the surface.

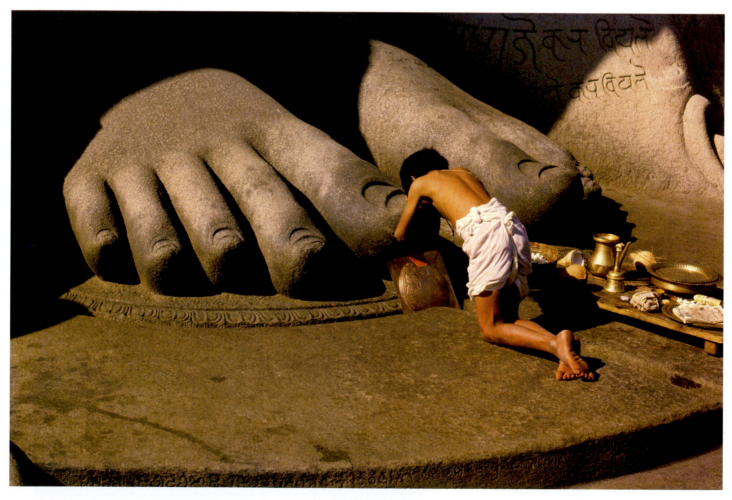

↑ **A**

Statue of Gomateshwara with worshipper. Shravanbelagola, Karnataka, India.

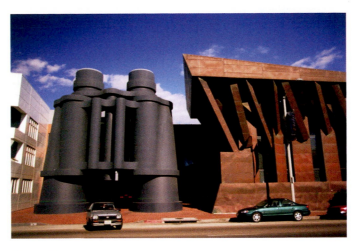

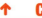 **C**

Claes Oldenburg and Coosje Van Bruggen. Binocular entrance to Chiat/Day Building designed by Frank O. Gehry. 1991. Steel frame. Exterior: concrete and cement plaster painted with elastomeric paint, 45' × 44' × 18'. Venice, California.

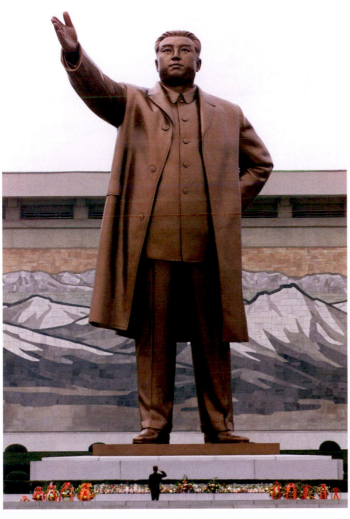

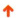 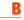 **B**

Kim Il Sung monument. North Korea.

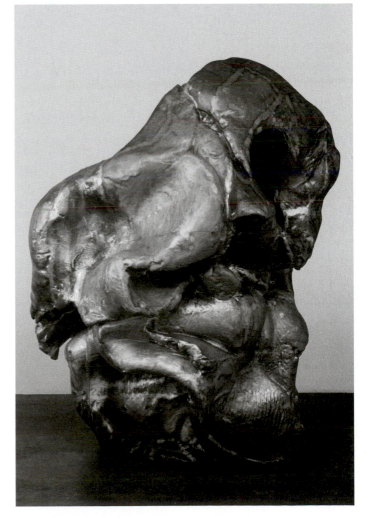

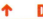 **D**

Urs Fischer. *Marguerite de Ponty.* 2006–2008. Cast aluminum, 13' 1½".

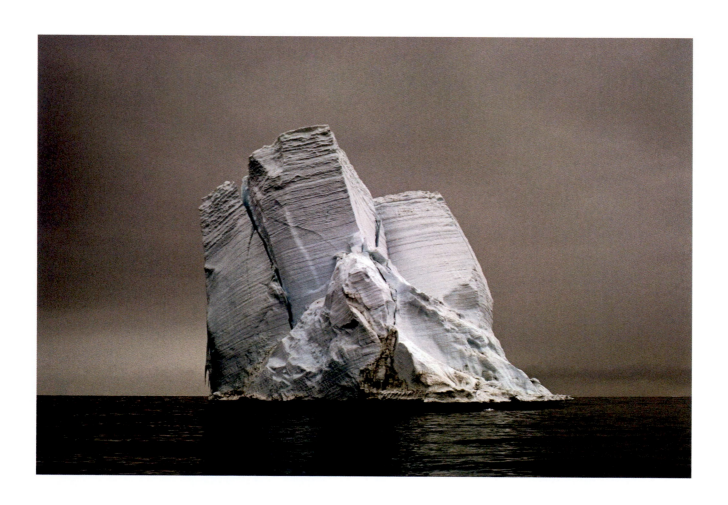

Camille Seaman. Photograph from *The Last Iceberg*. 2006.

CHAPTER 18 MATERIAL

MATERIAL CARRIES MEANING

Selecting the right materials, the appropriate materials for your purpose, is critical—it is, in itself, an art. Selecting the right stone will allow easy shaping with your chisel, the wrong wood will warp, the appropriate plastic will bend as you require, and perhaps only one metal will oxidize to become the color you require. Selecting material demands that you accumulate knowledge through research, experiment, and experience. Good ideas can be brought down by the wrong materials.

Material is not only a substance to build with; material carries meaning, contains **content**. Think how different the painting/sculpture *Corvette of My Heart* **(A)** would be if it were made of carved wood, then painted red, or if it consisted of stacked red cloth instead of its actual material, paint—layers and layers of thick, red paint. Knowing and sensing that *Corvette* is solid

paint impacts our experience of it. We can see that it was made with viscous paint, applied over time, until it became a colossal, tongue-like wedge on an industrial cart. Paint contains the weight of history, and this paint is literally and virtually heavy, dark, and loaded.

Puppy **(B)**, a public sculpture that has been installed in a number of locations since it was first created in 1992, depicts a West Highland terrier. It is constructed from approximately 70,000 living plants arranged on a stainless steel armature. Flowering plants, the basic building material, are light, colorful, and aromatic—they flutter gently in the wind. No other material would generate the same associations—formal gardens, topiary, and spring—and no other material would evoke such smiles of pure delight.

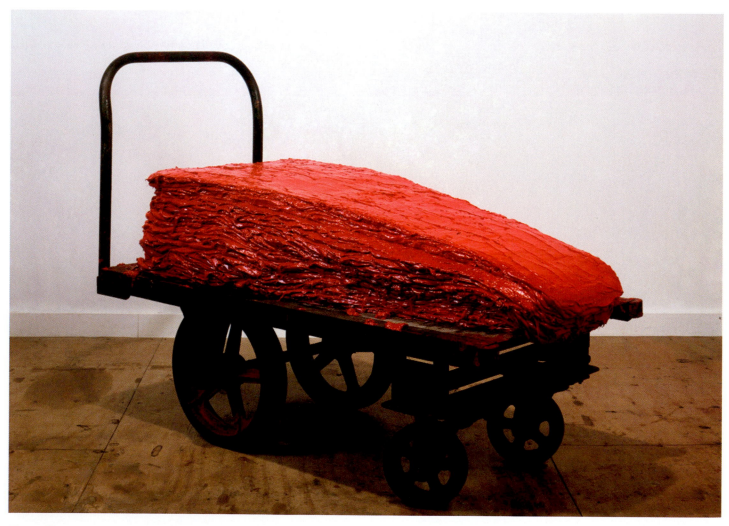

↑ **A**

Scott Richter. *Corvette of My Heart.* **2000. 3' 6" × 5' × 2' 3".**

Similarly, the sculpture *Self* in **C** derives its meaning more from its unusual material than from its form. It is made with ten pints of the artist's blood and must be kept frozen perpetually to maintain its shape. *Self* in another material is simply not an option. As Marshall McLuhan said, in a different but related context, "The medium is the message."

Truth to Materials

Truth to materials is a modernist tenet suggesting that materials should be used in ways that take advantage of their intrinsic properties. Modernist architects demanded that concrete be unpainted and unadorned, and that the process of its fabrication remain exposed on its surface. Truth to materials stands against making plastic, for example, look like wood or another material. If plastic is used, it should explore and celebrate its unique properties, its "plasticness." Today, truth to materials remains a valuable notion but it is no longer utilized systematically. The postmodernism wind has blown in more open, permissive, and playful attitudes.

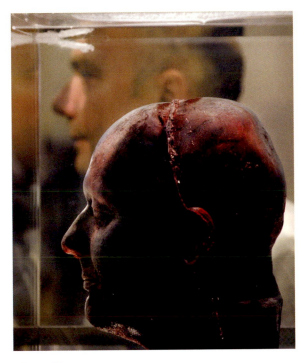

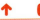 **C**

Marc Quinn. *Self.* **1966. Self-portrait. Frozen blood, vitrine, and refrigeration unit. The artist poses in background.**

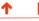 **B**

Jeff Koons. *Puppy.* **1992. Stainless steel, soil, and flowering plants, 40' 8³⁄₁₆" × 27' 2¾" × 29' 10¼".**

EASE OF USE

Most materials fall into one of these groups: wood, fiber, and paper-based products; metals; earth-based materials such as clay, stone, concrete, plaster, and glass; plastics, foams; dyes and pigments. As makers, we are fortunate to have an extensive range of widely available materials to select from.

For those who craft objects, especially beginners, one of the first requirements for selecting materials is workability. Material that is easy to form, permitting alteration of your developing ideas, allows work to proceed most effectively. Cost and availability might also be factors. It is no accident that plaster, Styrofoam, clay, wood, cardboard, and wire (**A**) are widely used in foundation programs. They are workable.

In **B**, sculptor Henry Moore is seen working on a massive polystyrene version of *Large Spindle Piece*. A small, preliminary plaster maquette served as a model for the large foam piece. Both plaster and foam are supremely adjustable and easy to form. The foam can be shaped with handsaws and rasps, allowing for quick progress on any scale. When this foam sculpture was fully resolved, molds were made and the piece was cast in bronze.

Health Hazards in Design and the Arts

It is a serious mistake to think that art and design materials, unlike industrial, workplace substances, are free of toxins or

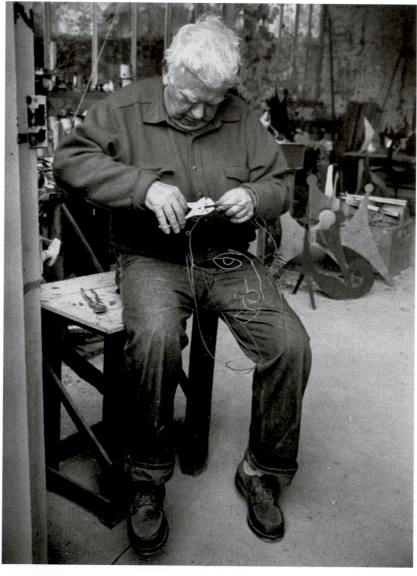

↑ A

Alexander Calder bending wire to create a self-portrait in his studio in Sache, France. 1968.

health hazards. Just about anything sprayed or sanded requires a respirator. For many processes, proper ventilation is necessary. Most activities, especially in the woodshop, require safety glasses. If you eat or smoke with various materials on your hands, such as lead or cadmium pigments, you will endanger your health. If not handled properly, art materials are dangerous—there is a lot to learn. Purchasing a good book on health hazards in the arts is a smart investment, one that will be useful as long as you continue to make things.

See also *Introduction: Making*, page 462.

Henry Moore working on polystyrene version of *Large Spindle Piece.* **1968–1969. © 2011 The Henry Moore Foundation. All Rights Reserved/ARS, New York/DACS, London.**

BAMBOO

You might think bamboo is an archaic building material, or that it is used only in developing nations, but due to its renewability, versatility, and global presence many believe it is the material of the future. Bamboo has been clocked growing up to two feet in a 24-hour period and can attain a height of eighty feet. Not actually a tree (it's in the grass family), it proliferates by spreading rhizomes and grows in abundance in warm climates all over the world.

The meeting house **(A)** illustrates the structural possibilities of large-scale bamboo construction. Here bamboo is used as a rigid support as well as a gracefully flexing network. This image shows the meeting house during its construction in New Guinea. The bamboo poles have yet to be covered with thatch. Indigenous fabrication methods developed over long periods, utilizing local materials, produce extremely sophisticated structures. Bamboo is still used in large-scale projects; it is a perfect scaffolding material and is used for this purpose worldwide. In **B** bamboo scaffolding is employed on a massive bridge construction project in China.

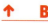 **B**

Bamboo scaffolding for bridge construction. China.

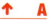 **A**

Men's clubhouse. Bamboo structure. New Guinea.

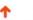 **C**

Woven bamboo fish trap anchored by a rock. Alor, Indonesia.

The range of bamboo products is astounding. The Indonesian fish trap in **C** has been used for generations. Fish swim in, but can't escape the funnel within. Here the trap is shown underwater, anchored by a rock. The ingenious tea whisk **(D)** is used in the Japanese tea ceremony and conforms to the reductive esthetic required by that Zen ritual. It is made from a single segment of bamboo, the whisk end formed by slicing the bamboo into wafer-thin tines.

The contemporary bicycle in **E** is made from bamboo that has been smoked and heat-treated; it is not just a novelty product—it's a high-performance bike for daily use as well as racing. It is strong and light, and its production process claims an extremely small **carbon footprint**. The company that produces this bicycle is now helping entrepreneurs in Ghana build their own bikes from locally sourced bamboo.

↑ **D**

Bamboo tea whisk. Japan.

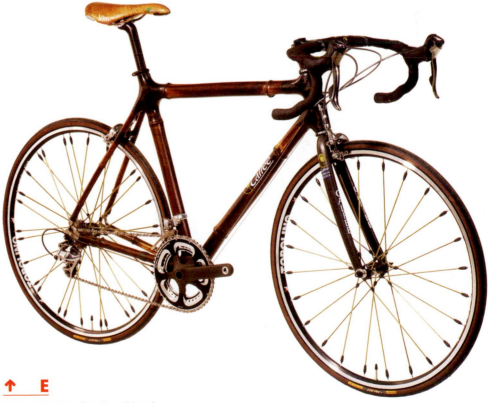

↑ **E**

Calfee Design. Bamboo bicycle.

TECHNOLOGICAL DEVELOPMENT

The evolution of material for sculpture, products, and structures has a long and interesting history. Reinforced concrete (concrete with embedded steel rods or wire) was a new and exciting material in the late 1800s, and it contributed to the development of modernist architecture, allowing ever larger, lighter, and more daring structures to be built. Today, technology has accelerated the development of new materials. An interesting company, Material ConneXion, is responding to the deluge of new materials entering the field. It houses a fast-growing library of materials that designers can actually see and touch.

Aerogel

A .07-ounce piece of aerogel supports a five-and-one-half-pound brick in **A**. A human body, if composed of aerogel, would weigh approximately one pound. Aerogel, the lightest known solid, nicknamed solid blue smoke, is a new material with many special properties. Aerogel was used on the *Stardust* spacecraft to capture particles from Comet Wild 2. Aside from the esoteric task of trapping comet particles, it is being used as a thermal insulator; other uses continue to be discovered.

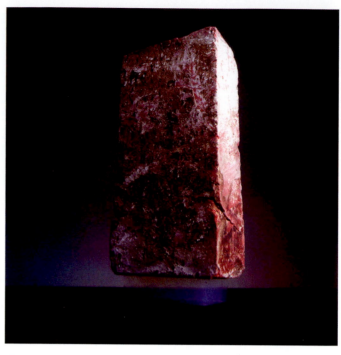

↑ **A**

Aerogel supporting a brick. A 2.5-kg brick is supported on top of a piece of aerogel weighing only 2 grams.

↑ **B**

Alinghi 5 and *USA 17* (on left) during the 33rd America's Cup.

Carbon Fiber

Carbon fiber and epoxy resin have been revolutionizing the fields of boatbuilding, aeronautical engineering, and sports and racing equipment for many years. Carbon fiber is a threadlike material with a very high strength-to-weight ratio. It can be woven, wound, or used as a composite (in combination with other materials). Carbon fiber is replacing fiberglass, which is heavy and bulky in comparison, in many high-performance products and vehicles. The thirty—third America's Cup was won by *USA 17* **(B)**, a ninety—foot trimaran sailboat that utilized cutting-edge design and carbon fiber construction.

Synthetic Skin

Many laboratories are working to perfect living, synthetic skin, and a number of skin substitutes are already available. They are effective in healing burn victims, for example. The artificial skin in **C** is INTEGRA® Dermal Regeneration Template. It provides a scaffold for skin growth. Skin replacement technology is concurrent with exciting developments in tissue engineering, the cultivation of replacement body parts from living human cells.

Designing Material

Composite materials, laminates, new polymers, nanotechnology, biotechnology, fiber optics, new textiles, porous ceramics, super-hard materials, and specialized adhesives are just some of the exciting developments in material science. Materials are no longer simply raw stuff awaiting the designer's hand. Today, materials themselves are being designed, the result—smart materials.

↑ **C**

Synthetic skin. Integra® Dermal Regeneration Template. Integra LifeSciences Corporation.

REUSE AND GREEN DESIGN

Sustainability is an important idea with worldwide significance. Sustainable or green materials refer to products such as sorghum plywood made from reclaimed agricultural fiber, or bamboo (discussed in a previous section), which grows rapidly and can be renewed or regrown as fast as it is consumed. A green material may also be one that has a local source, or has been made from recycled material, or is itself recyclable. The concept of designing the sustainable aspects of the complete life span of a building or a product is referred to as **cradle to cradle** design. Reductive design, the old idea of doing more with less, takes on new life in this context.

It is good that plastic bottles and aluminum cans have been getting thinner and thinner—many have had so much material eliminated, it seems more appropriate to call them bags. Some designers are seeking solutions to global problems in the social and behavioral realm—if we simply didn't buy bottled water, those bottles, no matter how thin, would neither have to be manufactured, nor, as often is the case, shipped across the Atlantic.

Sustainability is a critical issue in the field of design, where mass production magnifies even small incidents of wastefulness, and in architecture, where the scale of projects can involve mass quantities of building materials. Artists, as makers of unique objects, have tended to view these issues less urgently. Today, however, they are becoming more engaged.

Reuse

El Anatsui, a Ghanaian artist, uses aluminum screw-tops from discarded liquor bottles and copper wire to create enormous sculptures **(A** and **B)** that resemble metallic textiles. These abstract configurations are loaded with meaning, from the traditions of kente cloth to the history of liquor and slavery in Africa. Artists have long realized the value of found and discarded objects, but today the added idea of reuse is an important sustainability issue.

The WOBO or world bottle **(C)** was an attempt in the 1960s by the Heineken Brewing Company to make bottles that would have a second life, in this case as bricks! It was an idea that was ahead of its time; no beer was ever sold in the world bottle.

Green Design

Cook+Fox Architects, advocates of **green design**, created an energy-efficient, environmentally sustainable house **(D)**. Inspired by natural systems, the architects employed a reactive skin (an outer screen designed to interact with changes in daylight), as well as pivoting interior screens, moveable partitions to collect and block light, and skylight tubes.

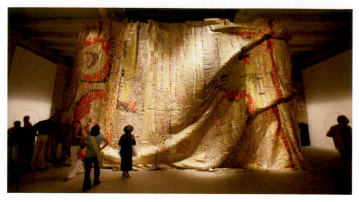

 A

El Anatsui. *Dusasa I.* 2007. Aluminum liquor bottle caps and copper wire, 20' × 30'. Venice Biennale.

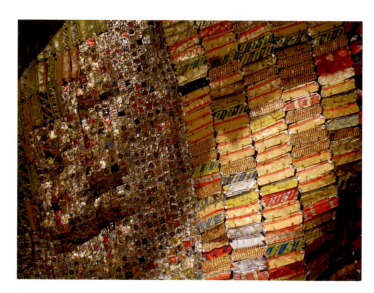

 B

El Anatsui. *Dusasa I.* Detail. 2007. Aluminum liquor bottle caps and copper wire, 20' × 30'. Venice Biennale.

 C

John Habraken, designer. Heineken WOBO (world bottle).

Environmental Guardianship

Some cultures deserve an A+ in environmental guardianship. Here, Vietnamese fishermen transport their bamboo fish traps on bicycles **(E)**.

Ideas of sustainability, sustainable materials, and conservation are issues that are changing the face of design, art, and architecture. Even if there were no global warming and resources were endless, we would still have to dispose of massive amounts of waste every day, and we would have to worry about its impact on the environment. So . . . the things your grandmother taught you remain valuable in life and design—don't be wasteful!

See also *Simplicity: Reductive Sensibility*, page 334.

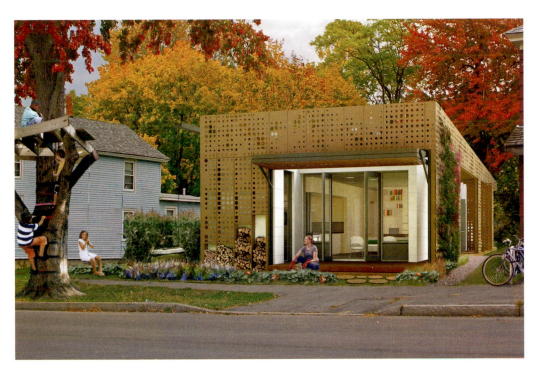

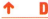 **D**

Cook + Fox Architects. *LiveWorkHome* **house.**
Eco-friendly house.

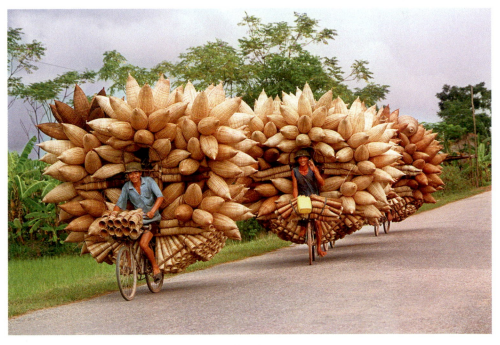

 E

Fishermen carry several bamboo fish traps on their bicycles on a road in Hai Hung province, Northern Vietnam.

Crab Nebula. Photograph from NASA Hubble Space Telescope.

STRUCTURAL PRINCIPLES

If you create sculpture, build a table, or design a house, your first obligation is, inevitably, structural. The ever-present force of gravity must be dealt with in order to achieve structural integrity. No matter how wonderful your table design may be, if it wobbles, sags, or leans over like a parallelogram when you place a load on it, it will fail to be a viable structure.

The Inherent Strength of Forms

Some forms are inherently weak, such as squares, rectangles, and rectangular solids; others, like triangles, pyramids, arches, cylinders, domes, and spheres, achieve stability quite naturally. One of the earliest types of construction is **post and lintel**; it is a building system in which a lintel (horizontal beam) is supported by two posts (columns). Stonehenge and Greek Temples are constructed in this manner, and since right angles have inher-

ent structural deficiencies, the columns must be substantial. When post and lintel construction (also referred to as post and beam) is utilized in contemporary, wood frame houses, corners are always reinforced by bracing that forms triangles. The old, leaning barn in **A** has taken on the familiar shape of the stressed, unstable rectangle—a parallelogram.

The Arch

If the lintel, resting on its supporting columns, is too long, it will bend or break. The length of a lintel is limited. If you want to create a span with an exceptionally long lintel, such as a bridge, for example, you must resort to another structural type—the arch. An arched bridge can span approximately four times the distance and support more weight than a flat beam bridge, and a suspension bridge is far more efficient than an arch.

↑ **A**

Leaning barn.

↑ **B**

**Shigeru Ban. Paper Bridge. Remoulin,
France. 2007.**

The Arch and the Truss

The architect Shigeru Ban and his students built a bridge of paper and cardboard that could hold up to twenty people **(B)**. For this amazing feat, they utilized the power of the arch. To make this bridge even stronger, another stable form was also employed—triangular structure. When triangles are repeated to form an extended configuration, an extremely sturdy structure, the **truss**, is formed; and in this case the truss is curved. In the background of **B** there is a Roman aqueduct that, though an ancient masonry structure, utilizes the same efficient arch.

The Truss

The longest continuous truss bridge in North America **(C)** harnesses the strength of the triangle—try to count the number of diagonal braces and triangles in this structure. The truss is a widely used structural configuration that adds rigidity to beams and prevents such unwelcome deformation as the parallelograming of the old barn.

↑ **C**

**Astoria-Megler Bridge, detail. Connects Astoria, Oregon, and
Megler, Washington.**

EFFICIENT FORM

The line of beauty is the result of perfect economy. The cell of the bee is built at that angle which gives the most strength with the least wax. The bone or the quill of the bird gives the most alar (wing) strength with the least weight. . . . There is not a particle to spare in natural structures.

—Ralph Waldo Emerson

From the galaxy to a crystal of salt, the exuberance of nature takes billions of forms, but study discloses that stupefying variety has been achieved with stringent economy of means. All things both great and small evolve in a few simple patterns—among them spirals, meanders, branchings, angles of 120 degrees. Why the preference for elegant simplicity? In three-dimensional space, only a few basic shapes will combine to build stable structures or do useful work. These patterns prevail because they make the most efficient use of energy. They are purposeful.

—Horace Freeland Judson

Towers

The radio transmission tower in **A**, the tallest structure in Louisiana, at close to 2,000 feet, is an example of extreme structural economy. It is an efficient vertical truss (under **compression**) that must be kept perfectly upright to remain stable. Most towers, like the Eiffel Tower in Paris, remain perpendicular to the surface of the earth by virtue of being considerably wider at the bottom, thus creating the necessary stability. Exceptionally tall towers, like the one in **A**, are often a consistent width from the top to the bottom. Guy wires are the key to keeping these improbably thin towers straight up. Observe the numerous cables (under **tension**) connecting the tower to the ground.

Domes

From igloos to cathedrals, the dome is a stable structure widely used in architecture, design, and the arts. The **geodesic dome (B)** designed by Buckminster Fuller, takes advantage of the inherent strength of both the dome and the triangle. Fuller strove to use the smallest quantity of material to span the greatest area. The weight of the dome is distributed by its web of triangles, spreading the load evenly and efficiently throughout the entire structure. Efficient and cost-effective, geodesic domes have been constructed worldwide for purposes ranging from world's fairs to emergency shelter.

Extreme Economy

Flying for about nine days, the *Voyager* **(C)** was the first aircraft to circumnavigate the world nonstop without refueling. To do this it had to have low drag, be light in weight, and carry an enormous amount of fuel. Formed by a composite material consisting of graphite, Kevlar, and fiberglass, the *Voyager* weighed approximately 2,250 pounds, incredibly light considering its wingspan of 110 feet. When it took off, fully fueled, it weighed 9,700 pounds! To obtain maximum lift, the *Voyager* utilized a double-wing design, not unlike the designs of the Wright brothers. Aeronautical design has always required stringent attention to structural economy; it is an area of design in which there is no place for the superfluous.

← **A**
Radio transmission tower near Houma, Louisiana.

↑ B

Buckminster Fuller. Biosphere of Environment Canada. 1967. Montreal, Quebec, Canada.

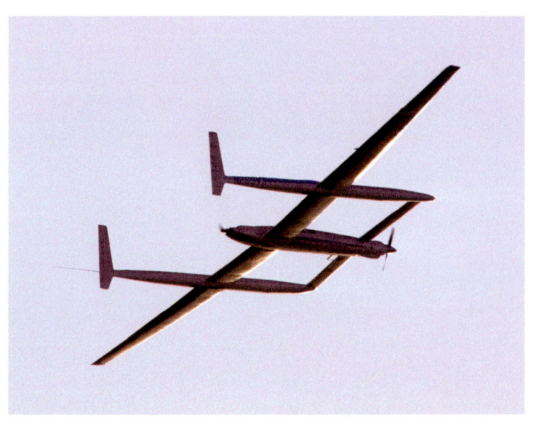

↑ C

Burt Rutan, designer. *Voyager* aircraft. Built by Rutan Aircraft Factory, Inc., 1984.

PHYSICAL FORCES

The increased understanding of the applied physical forces of tension and compression resulted in important advances in structural engineering and design. Tension is the force that stretches. Pulling each end of a rubber band places it under tension—tension acts to expand. Compression is the application of pressure. If you stand on a stack of books, squeezing it downward, it is being compressed.

The sculpture in **A** was designed by the engineer/architect Santiago Calatrava who is renowned for elevating engineering to a high art. It is no surprise, therefore, that this sculpture happens to be an extremely clear demonstration of the principles of tension and compression. The two tall cones at the base are under compression; the weight of the entire sculpture rests upon them.

What kind of force is acting on the supporting cables? They are not being compressed, they are being pulled from one end to the other; they are under tension, like our example of the rubber band. Cut these cables, and the sculpture will come crashing down.

↑ **A**

Santiago Calatrava. *Bou.* 2007. Palma, Spain.

The Suspension Bridge

This structural system that keeps the Calatrava sculpture upright is closely related to the design principles of suspension bridges. The Brooklyn Bridge **(B)**, one of the earliest suspension bridges, is an interesting case. It was built with twin masonry towers. Today, steel is commonly used for suspension bridge towers. If you compare the Brooklyn Bridge towers to the more modern suspension bridges you have seen, you can't help noticing how squat and bulky the Brooklyn Bridge towers seem. Stone is simply not as efficient as steel as a supporting, compressive material, so more stone was required. The steel cables are under tension, and the stone towers are under compression. In this way, all suspension bridges find their **equilibrium**. Many believe that the modern suspension bridge is among the most beautiful objects in the built world.

Tensile Strength and Load Bearing

Spider webs **(C)** are structures under tension and tension alone. These engineering marvels are incredibly strong and super lightweight. Webs must support their own weight as well as that of anything in it (engineers call this a dead load). In addition, webs, as traps for insects, need to withstand the sudden, moving forces of their prey. Any such load that involves moving forces (wiggling insects in a web or cars driving over a bridge) is called a live load. All structures need to deal with dead and live loads. The spider's silk has a very high **tensile strength**, as does steel. In fact, pound for pound, spider silk is stronger than steel. Stone, concrete, and wood have low tensile strength. When designing and fabricating, one must be aware of material properties. On small-scale structures, casual testing is usually sufficient to get an understanding of material strength. Large projects require research and a more rigorous approach to material testing.

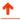 **B**

Brooklyn Bridge. John A. Roebling, designing engineer. New York.

 C

Spider web.

STRUCTURAL CONNECTION

Joinery refers to how parts of a form are held together, how elements are attached. If you have ever built anything, you already know how challenging joinery can be. A common method in antiquity was simply tying things together with rope or cord. Even more basic is the use of gravity. Many ancient structures, such as masonry walls and monumental forms, were made with carefully cut stone—no mortar; just weight and a close fit held everything together. Both methods are still in use today.

Nails, screws, staples, bolts, rivets, clamps, binding, tape, adhesives, welding, soldering, brazing, heat-sealing, and mechanical splicing are just some of the many joinery methods now available. One of the challenges of the designer or artist is to find the appropriate method for the task at hand.

Joinery was considered so important at the Bauhaus that it was the subject of numerous projects. In **A**, Josef Albers had his students build structures with extremely unusual (and dangerous) materials, double-edge razor blades and wood dowels only. The students were forced to be inventive. The tension of the flexed razor blade and its two holes were harnessed to become efficient connectors.

Rivets, however basic, are still used in steel construction **(B)**. They are perhaps your fundamental fastener. Each end of a small steel rod is pounded flat, serving to clamp two pieces of steel together. Rivets have been wtidely replaced by welding, a process in which two pieces of metal are melted together, usually by a bead of applied molten metal. Welding has revolutionized steel construction, allowing for fabrication of almost any configuration.

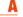 **A**

Construction from Josef Alber's preliminary course at the Bauhaus. Detail on left; 9' high construction on right. 1938. © 2011 The Josef and Anni Albers Foundation/Artists Rights Society (ARS), New York.

Woodworkers utilize many kinds of joints: miter, spline, dovetail, tongue and groove, and dado are just a small selection. Some joints require glue, and some can do without. The dovetail joint in **C** that is being fitted in place will be held together by the logic of its design (which is purely mechanical) and the precision of its artisanry (along with a little glue).

Richard Deacon, a master fabricator, used epoxy to join slabs of wood in his sculpture *Kiss and Tell* **(D)**. Epoxy adhesives are increasingly valuable in art and design. Different kinds of stone are being epoxied together to form new, layered materials; and epoxied composite materials are routine in airplane and boat construction.

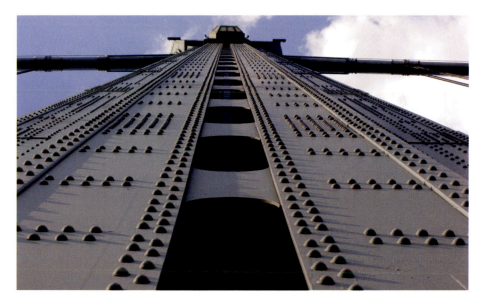

← **B**

Ben Franklin Bridge. Philadelphia, PA.

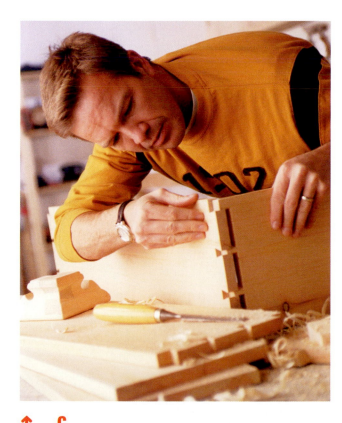

↑ **C**

Woodworker fitting dovetail joint.

↑ **D**

Richard Deacon. *Kiss and Tell.* **1989. Epoxy, plywood, steel, timber, 5' 9$^{11}$/$_{32}$" × 7' 5" × 8' 10$^{11}$/$_{32}$". Collection, Arts Council of Great Britain, London.**

COLLAPSIBLE AND EXPANDABLE STRUCTURE

From simple folding chairs to high-tech tents, objects that transform are increasingly important. Form is not simply a static mass; it can be collapsible, expandable, inflatable, and foldable. Objects that collapse for economical shipping or for carrying in your car or in your backpack are extremely useful. Ikea, the giant Swedish furniture manufacturer, loves flat-pack shipping, and has claimed that this allows them to reduce costs by not shipping air.

The *Blue Heron* decoy **(A)** that we've seen before in its assembled form is shown again here, but this time paired with an image of it in its disassembled state. Hunters could easily carry this decoy disassembled into remote areas where its component parts, three sticks, an oval form, and a ball, could be assembled to create a full-size heron.

Martha Graham, the legendary dancer choreographer, created new forms of movement that often involved an inventive use of costumes. In the performance depicted in **B**, the dancer wears a stretchable tube that becomes the vehicle for the formation of transforming sequences of extraordinary form.

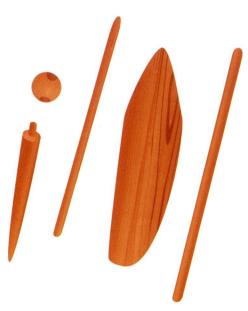

 A

Blue Heron decoy. Assembled, left. A rendering of the decoy unassembled, right.

→ **B**

Herta Moselsio, photographer. *Lamentation.* Choreographer, Martha Graham. c. 1937. Silver gelatin print.

Expandable Structures

The Hoberman Sphere is a toy that expands from nine to thirty inches in diameter **(C)**. Not simply an amusement, the sphere employs ingenious folding mechanisms that have led the designer to major projects involving rapidly deployable tents and adaptive buildings with roofs that open and close and facades that retract.

Nomadic Structures

Portable dwellings such as Bedouin tents, or those built for temporary use, like igloos and huts, are a necessity for **nomadic** people. In today's world of widespread international travel, we are all becoming nomads. Suitcases with wheels, collapsible camping cups and bowls, tents, domes, inflatable structures, mobile homes, and the lunar lander are all contemporary manifestations of nomadic culture.

Consisting of an air-supported membrane and a sustaining trailer, the nomadic pavilion in **D** toured London parks, serving as a temporary, pneumatic event space. With this pavilion, the designers continued to explore what they refer to as "bubbletecture." For sheer ingeniousness, however, it would be difficult to surpass the makers of the "raft" in **E**, who brought their harvest of coconuts to a mill, downstream, using their cargo as its own transporting vessel!

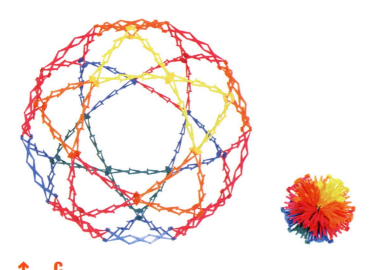

 C

Hoberman Sphere. Toy. Expanded and contracted views. Chuck Hoberman, designer. Plastic, 9"–30".

 D

Raumlaborberlin, Art and architecture collective. *Portavilion 2010: Rosy (the ballerina).* **London, U.K.**

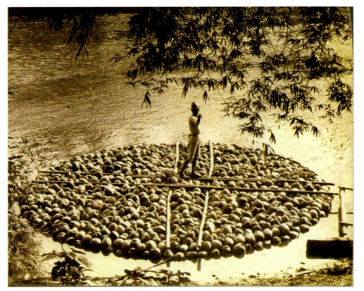

 E

Raft of coconuts. The Philippines.

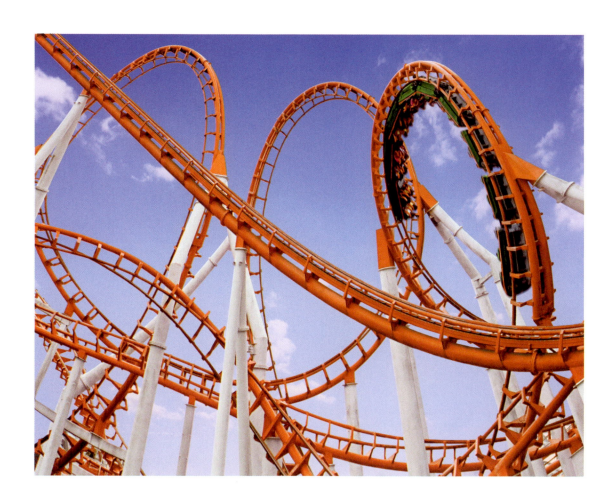

Rollercoaster.

CHAPTER 20 FUNCTION

UTILITY

Beauty rests on utility.

All beauty that has not a foundation in use, soon grows distasteful, and needs continual replacement with something new.

—*Shaker Maxims*

Shaker Design

It would be impossible to discuss utility without acknowledging the Shakers' contribution to contemporary art and design. The **Shakers** created an alternative religious community that flourished in the nineteenth century. They produced tools, furniture, and architecture that embodied their devout religious beliefs. Shaker design is revered for its reductive form, exquisite craft, and its plain and humble focus on use. Shaker furniture has been referred to as "religion in wood."

⬆ **A**

Double Trustee's Desk. Shaker. Mount Lebanon, New York. c. 1840.

"That which has in itself the highest use, possesses the greatest beauty." This Shaker maxim makes objects such as the double desk **(A)**, combining a cabinet and side-by-side fold-down work surfaces, inevitable. If you believe **utility** simulates the order of heaven, as did the Shakers, then what could be better than an object that is multifunctional?

Utilitarianism

Shaker design ideas (and utility in general) relate in interesting ways to the philosophy of utilitarianism, which posits that one should act so as to provide the greatest happiness (and least pain) for the greatest number of people.

The Greatest Good for the Greatest Number of People

There are many designers, architects, and artists dealing with utility. And if you care about utility, why design a new silver-plated wine cork extractor, however functional, when there are more pressing problems facing humanity? Donald G. McNeil Jr. reported in an article in the *New York Times*, "Design That Solves the Problems for the World's Poor":

The world's cleverest designers, said Dr. Polak, a former psychiatrist who now runs an organization helping poor farmers become entrepreneurs, "cater to the globe's richest 10 percent, creating items like wine labels, couture and Maseratis. "We need a revolution to reverse that silly ratio," he said.

"A billion customers in the world," Dr. Paul Polak told a crowd of inventors recently, "are waiting for a $2 pair of eyeglasses, a $10 solar lantern and a $100 house."

One of the products in the Cooper-Hewitt National Design Museum exhibition that McNeil discusses is a simple and elegant design solution, the *Q Drum* **(B)**. It is a 20-gallon water can that is easily towed by an individual, potentially saving millions of people worldwide, mostly women and children, the arduous and dangerous task of carrying heavy vessels.

In **C**, Dean Kamen, inventor of the Segway, operates an iBOT, the motorized wheelchair he designed. The iBOT allows the user to participate in conversations at eye-level, and due to its innovative gyroscopic, self-balancing technology, it can even navigate stairs. All this is extremely valuable, but the design of the iBOT attempts to accomplish more than that, it seeks to provide dignity to the disabled users' experience.

Design as Social Action

Good contemporary, utilitarian design need not involve a product. Socially concerned citizens and designers are finding innovative, alternative methods for creating solutions to pressing problems, as did the group of law students that purchased industrial pollution rights at auction and let them expire unused (preventing the emission of many tons of sulfur dioxide).

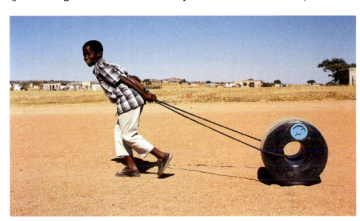

P. J. and J. P. S. Hendrikse, designers. *Q Drum.* 1993.

Dean Kamen riding the *iBOT* motorized wheelchair he invented.

DESIGN AND ART COMPARED

It is commonly believed that the difference between art and design is utility—design has a function and art does not . . . but that is a simplification. While, yes, a great deal of design is clearly about function first and foremost, the difference between art and design can be ambiguous. Let's look at clothing as an example. The production of clothing is a design discipline, and clothing has a clear utilitarian purpose. It conceals and protects our bodies, and keeps us warm in the winter. If this were the entire truth about clothing's purpose, factories would need only produce a few shirt styles for different activities, and we would all be wearing something like white Ts or blue denim work shirts every day. The fact is, there are thousands and thousands of shirt designs produced annually, in every conceivable shape and pattern, and different versions in countries the world over. What is going on here? Whatever it is, it is certainly not all about utility. Clothing design is about so much more than function, and it does not stand alone among the design disciplines.

↑ **A**

Philip Treacy. Hat. Fall/Winter 2001/2002.

We all know that fashion design has a high end, experimental, haute couture faction, but what do you think Philip Treacy is up to with his outrageous, delightful hat in **A**? The cell phone coffin in **B** is from Ghana, where some have opted for burial in playful, custom coffins—beer bottle coffins, lizard coffins, running shoes, pineapples, and automobiles.

The Philip Treacy hat and the coffin illustrate the blurred boundaries of art and design. The hat, like any intelligent, formal sculpture, inventively explores form and structure; and the coffin confronts death with celebratory, pop humor, while both also serve utilitarian objectives, however diminished they may be. To understand the full complexity of the utilitarian–nonutilitarian interface, remember that most things, such as shirts, for example, are also signs, identifying your personal style, social class, subcultural affiliations, and so on.

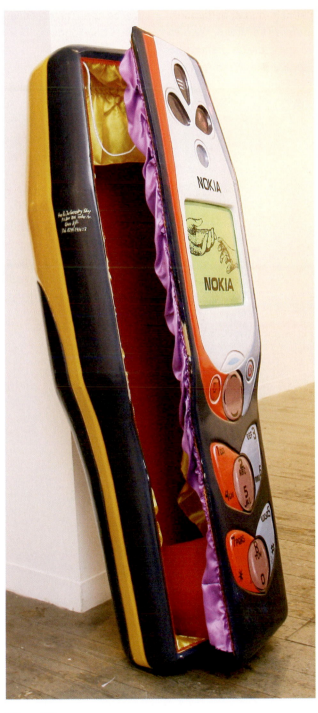

↑ **B**

Contemporary cell phone coffin. Ghana.

ART

Let's consider the notion that art has no utility. Yes, bronze sculpture is really not very good for driving to work in or for opening cans, but if you examine the proposition more carefully, you might agree that art is full to the brim with utility. For its audience, art provides delight, intellectual stimulation, and information; it challenges preconceptions and provokes passionate emotion and even political action. For artists there is a different range of functionality at work. The artist may celebrate or investigate various aspects of phenomena, form and perception, and psychological and social structure, as well as her or his own deepest nature. Art practice remains a quite useful method for self-development. It is a path to self-awareness, often reminiscent of Zen in its approach.

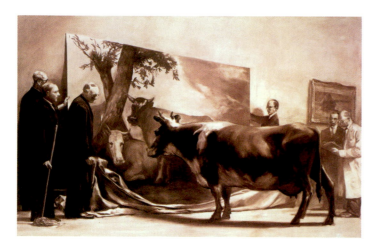

Mark Tansey. *The Innocent Eye Test.* **1981.**

Isomorphism

Humanist psychologist Abraham Maslow describes his idea of **isomorphism** (similarity of structure or form) in this way: you can only know that which you are "up to" (or what you are). We see the sum of our experiences in the world around us and understand and identify with those things that reflect our outlook. Mark Tansey shrewdly comments on such matters in **A**, *The Innocent Eye Test*. To know more, to see farther, requires that we attend to the task of becoming more informed and receptive beings. The practice of art naturally facilitates this process of self-development.

Memes

Richard Dawkins explains that **memes** are similar to genes, and they replicate by being spread from mind to mind. Memes can be ideas, styles, art works, tunes, or theories. Good memes survive for long periods of time because they continue to be spread, and as Dawkins says, they "parasitize" your mind.

The work of Marcel Duchamp and Dadaism turned the art world on its head. After one hundred years, Duchamp remains important because artists continue to explore, spread, and reinterpret his ideas. Duchamp's ready-mades, such as *Fountain* in **B**, are a highly successful meme. His ideas, like certain Web images, have gone viral in art history. Let's get to the studio and make some good memes.

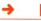

Marcel Duchamp. *Fountain.* **1917.**
© 2011 Artists Rights Society (ARS), New York/ADAGP, Paris/ Succession Marcel Duchamp.

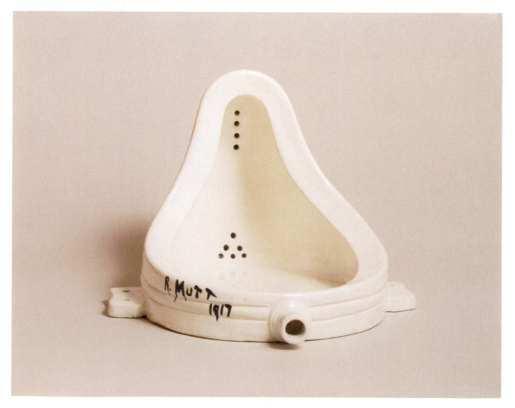

The Gap between Art and Design

The things that exist in the gap between art and design are informative. They make us aware of the richness of human production and the shortcomings of categorization. The finger **prosthesis** in **C** is a utilitarian device—it conceals missing fingers. This prosthesis is successful by virtue of its degree of **verisimilitude**. The maker had to have more than skill; he or she had to carefully observe the form, proportions, color, and texture of the model, as would any good figurative artist.

The trout fishing fly **(D)** speaks eloquently in the languages of both art and design. It has a clear purpose, to assist in the successful capture of a wily trout. The fly must be tied, as the prosthesis was made, by carefully observing actual insects that the trout are feeding on. The more accurate the representation, the better the fly. But in this case things are a bit more complicated—the fly doesn't have to look lifelike to us; it has to look lifelike to trout! Furthermore, it must be realistic when wet, and it must move through the water like the real insect it mimics (it is a behavioral mimic as well as a visual one). The lesson of the prosthesis and the fishing fly is intended to encourage us to remain open to the complexities inherent in the relationship of art, design, and utility.

↑ **C**

Prosthetic fingers. Dianceht Company. Guadalajara, Jalisco, Mexico.

↑ **D**

A trout fishing wet fly known as an Invicta secured in a fly-tying vice.

FORM AND FUNCTION

Form and function is a term used to express the relationship between the form of an object and its use.

Form Follows Function

A closely related notion is **form follows function**—a **dictum** of Modernist architects who, turning their backs on the styles of the past, sought new principles to shape their architecture. It is, however, an idea that has been used throughout history, especially in the creation of tools and structures.

Ergonomic Design

Form derived from function is most evident in objects created for disciplines requiring highly specific uses—air and space travel, medical equipment, transportation, and sports equipment. The handle of the ski pole **(A)** has not been designed to look cool; it has been designed only to function, to fit the hand of the skier and allow him or her to wield the poles effectively and comfortably in all required positions. **Ergonomic** design engages the idea that designed objects must interact compatibly with the user's body.

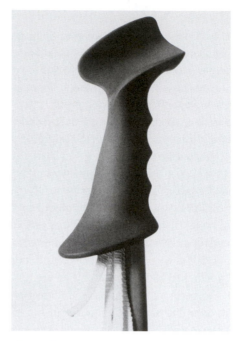

↑ **A**

Peter Stathis, designer. *"Thumb Sparing" Ski-Pole Grip.* **1991. The Museum of Modern Art, New York.**

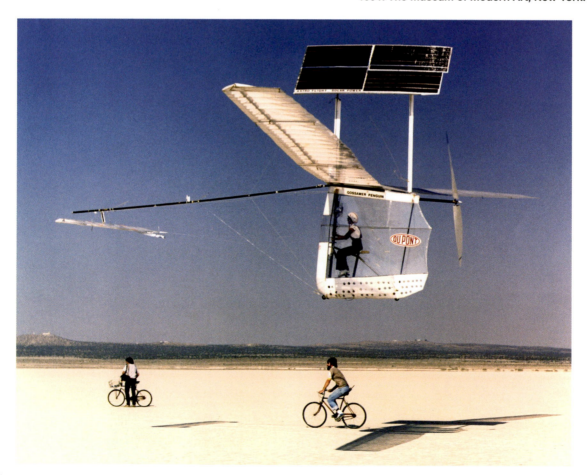

↑ **B**

Paul MacCready, designer. *Gossamer Penguin* **in flight. 1979.**

Functionality Determines Form

In 1980 Paul MacCready's experimental solar-powered airplane, the *Gossamer Penguin* **(B)**, flew a few miles over a dry lake bed. It had a seventy-one-foot wingspan and weighed a mere sixty-eight pounds—it weighed less than its pilot! Every inch of its stripped-down form was determined by its functional requirements. It is interesting to note that the *Penguin's* subsequent iteration, the *Solar Challenger*, integrated the solar panels into the wings, improving its aerodynamics, enabling it to fly across the English Channel.

From the complexities of solar-powered flight to the simplicity of domestic products, functionality determines form. The humble paper clip **(C)** performs its simple task with elegant efficiency. It is even a design icon—an 1899 GEM paperclip has been included in the Museum of Modern Art design collection.

Form and Function in Nature

Evidence of the close relationship of form to function is seen everywhere in nature. Uniquely specialized insects and animals evolve in order to take advantage of specific opportunities in the ecosystem.

While feeding on the nectar of orchids, moths simultaneously pollinate those orchids. Pollen sticks to the bodies of the moths, and when they proceed to other orchids, they unwittingly disseminate pollen. Some orchids have developed longer nectar spurs to guarantee pollination through body contact. The moths in turn must develop longer tongues to reach the nectar. This is an example of the biological concept of **coevolution**, and it illustrates the interaction between function and the development of form in nature.

The Madagascar Star Orchid **(D)** evolved a slim, exceptionally long eleven-inch throat with nectar at the bottom. When Charles Darwin first saw it, he predicted that there must be a pollinating moth that evolved an equally long tongue, though no such moth was known at that time—fellow scientists were extremely skeptical. In 1903, forty years after Darwin's prediction, a hawk moth with a ten-inch tongue was discovered in Madagascar!

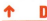

← **C**
Paper clip.

↑ **D**
Madagascar Star Orchid (also known as Comet Orchid). Photo by Pete Oxford.

SIGNATURE AND TYPOLOGY

Style is a simple way of saying complicated things.

—Jean Cocteau

Style, neurologically, is the deepest part of one's being.

—Dr. Oliver Sacks

God is really only another artist. He invented the giraffe, the elephant and the cat. He has no real style, he just goes on trying other things.

—Pablo Picasso

Style as Signature

In art and design, style is usually considered to be a particular manner or technique evident in the work. If you are looking at a work for the first time and its creator is not identified, you will know who made the work if you are aware of the style of the artist or designer. Style can be that unique, like a fingerprint. If you have seen a few Giacometti sculpture's, such as *Man Walking* **(A)**, based on your observation of the artist's signature elongation of the figure and forms built by hesitant accumulation, you will always be able to spot a Giacometti.

Style as Typology

Style is also a type of artwork, object, or architecture with distinguishing characteristics that may be associated with a general concept or historical period. Such classifications are known as **typologies**. The styles of gothic and modernist architecture, for example, are easy to discern. The **streamline style** of the 1930s was based on useful aerodynamic ideas, but eventually this style became a visual *look*, separated from its initial function. Streamlined airplanes and trains make sense, but when toasters are streamlined, you know things have taken a strange turn. The 1935 concept motorcycle in **B** is clearly an example of streamlining. It is, however, a more decorative example of this style, not unlike the toaster; this tendency is often referred to disparagingly as **stylized**. Sacrificing functional design elements (the BMW R7 in **B** is excessively heavy and has purely decorative accessories), the designers of the R7 created a vehicle with high-spirited style, but only the *illusion* of speed.

The young woman in **C** might be included in a typology of style—contemporary Japanese youth street fashion. But she also reminds us of the other uses of the word style—a manner of conducting oneself; popular artifacts *of the moment* (things that are in style); or fashionable elegance. These notions tend to be fleeting, like fads. Does that make them less important?

Dick Hebdige, in a fascinating little book, *Subculture: The Meaning of Style*, explains how style is more than frivolity—subcultures recontextualize commodities "subverting their conventional uses and inventing new ones." The style of the young woman in **C** (like all styles, whether preppy or hip-hop) declares her allegiance to a certain group and her separation from others, at the same time celebrating exuberant color and presenting a dizzying array of pop culture **signs**.

Style usually comes to the emerging artist or designer naturally, as a by-product of a sensibility; simply mimicking a style is not a replacement for genuine discovery. General wisdom suggests: style is not something to be forced.

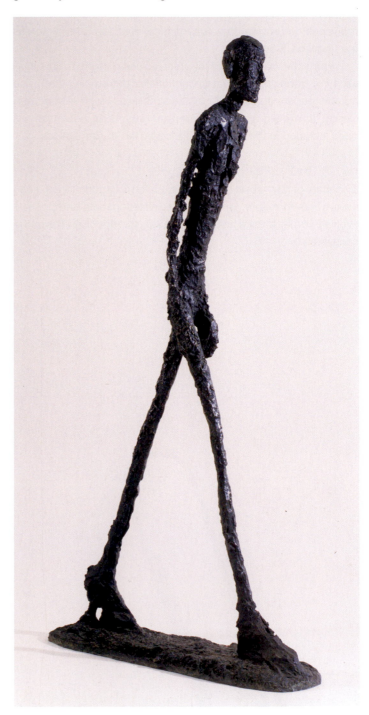

↑ **A**

Alberto Giacometti. *Man Walking (Version I).* **1960. Bronze, overall (with base), 5' 11¾" × 10½" × 3' 2". © 2011 Succession Giacometti/Artists Rights Society (ARS), New York/ADAGP, Paris.**

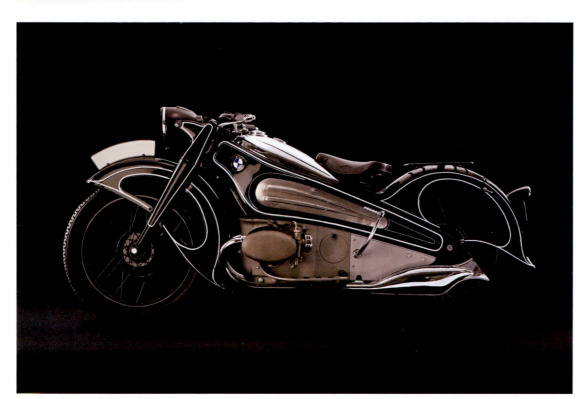

BMW R7 Motorcycle. 1935.

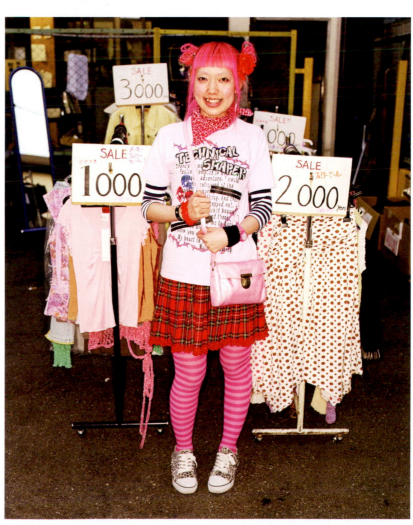

Young woman. Tokyo, Japan

Plastic snowman on suburban lawn.

REPRESENTATION

Representation and Abstraction

To shape material into a form resembling a preexisting thing (object or figure) is to represent it—to make a representation (**representational** art is also commonly referred to as **realism** or figuration). Representational sculpture dates back to prehistory and is one of the principal modes of three-dimensional expression. **Abstraction** (nonrepresentational art) is another major approach to 3D expression. Perhaps all art can be divided into these two fundamental categories: the representational and the abstract.

Abstraction

The abstract realm exists in tandem with the representational, and of course there are countless overlaps, hybrids, and interactions. Like representation, abstraction is a vast category with a wide range of expressions, from preexisting forms that have been altered, simplified, or exaggerated by their creators (an apple presented as a red sphere, or more profoundly Brancusi's *Bird in Space*—see page 300) to the manipulation of pure form for its own sake, also referred to as **nonobjective** or **concrete** art (Anthony Caro sculpture is an example; see page 468). In many ways this book is about abstraction, abstraction as the language of form, and abstraction as the structural basis for representational art as well.

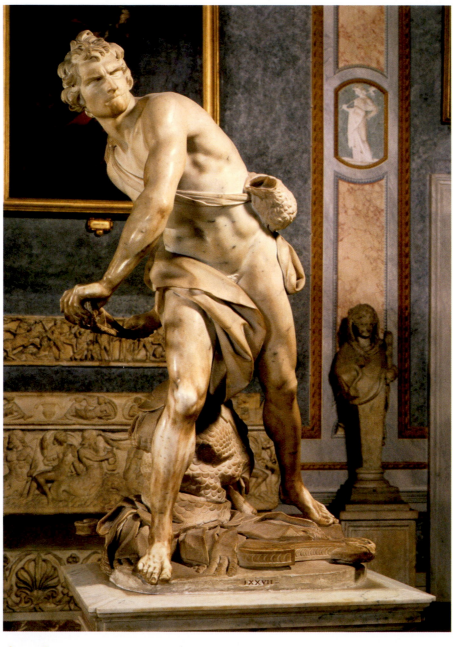

↑ **A**

Gianlorenzo Bernini. *David*. 1623. Marble, approx. 5' 7" high. Galleria Borghese, Rome, Italy.

Verisimilitude

The representational artist attempts to reproduce or express, feature by feature, the essential aspects of the form of the observed subject—often attempting not only to represent the subject in general but to capture its unique and specific features. The more sensitive and skillful the observer, the more convincing the representation.

There are many kinds and degrees of realism. Bernini's *David* **(A)**, for example, represents a high point of verisimilitude. Not only is this sculpture extremely accurate in its depiction of the figure, but the position of the body and the gesture perfectly express that poised moment between winding up and throwing. The facial expression accurately portrays that of a man concentrating intensely.

Ubiquitous Realism

Realism, of course, exists across the cultural spectrum, from the classical artworks of antiquity to present-day **kitsch** artifacts. The plastic **faux** food items in **B** have a high degree of verisimilitude in spite of their simple task of displaying food available in restaurants and stores. These faux meats occupy a very specific niche in the realism universe—they are all life-size, full-color, three-dimensional replicas. It is quite uplifting to see such a high degree of care expressed in the fabrication of such lowly items as individual slices of ham or bologna, for example.

Experiential Realism

A child in central Africa created the wire car in **C**. Not only is it an excellent linear representation of a car (a kind of drawing in space) but it is a representation that *functions* as a car. It is a good example of the category of objects that attempts to represent objects experientially as well as visually. This homemade toy was driven around the streets of Malawi by its maker—its full-size, operational steering wheel allowing the user to push the little car and steer it nimbly. The wire car also reminds us of the expansive range of realistic objects, from high verisimilitude, to those that are abstractions of reality. This car is both a representation and an abstraction.

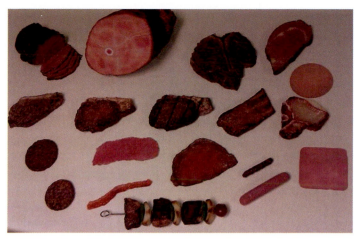

↑ **B**

Faux food. Iwasaki Images of America.

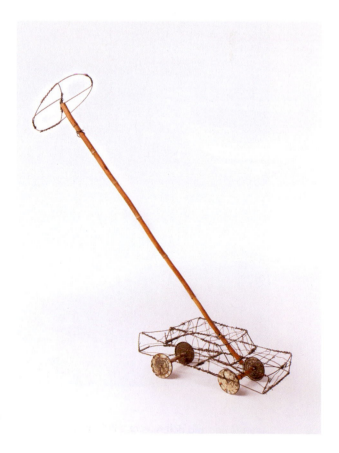

→ **C**

**Wire car. Created by a child in Malawi.
Copper wire, bamboo, tin can lids. c. 1967.
Photograph: Travis Fullerton, 2010.**

CAMOUFLAGE

Illusion may be less prevalent in the three-dimensional realm than on the two-dimensional plane, where it is a seminal issue, but there are, surprisingly, many manifestations of illusion involving 3D form and space.

Camouflage in Nature

Nature is the ultimate master of illusion. Many creatures must hide their form, their dimensionality, in order to be rendered invisible to predators. There are countless examples of camouflage in nature, in which insects and animals assume the color and patterns of their surroundings in order to disappear into the specific environment they inhabit. We are most familiar with this form of camouflage, but there are other kinds such as countershading. Deer, for example, have white bellies and dark backs. This serves to counteract and neutralize the inevitable shadow underneath. Shadows reveal form—obliterate shadow and so will form be obliterated.

Similarly, birds and fish tend to have lighter undersides and darker tops in order to be less visible from below (looking up at them against the light) as well as from above (viewed against the darker ground). In **A**, Atlantic spotted dolphins blend in against the lighted ocean surface. The military often adopts this kind of coloration for airplanes for the same reason nature does—protective coloration offers survival advantages.

Camouflage in the Built World

Camouflage is also used in the built world. Hunters and soldiers do exactly what nature does in order to visually blend into an environment. In some communities, electrical utility boxes are considered unsightly. Well, why not camouflage them? Using digital prints of the surrounding site and adhesive vinyl, this is exactly what an artist did to many utility boxes in California **(B)**.

Yet another category of camouflage, and one also first used by nature, is a kind of hiding in plain sight. The butterfly that mimics a dead leaf remains visible on the plant where it rests, but simply looks like something other than a meal for a bird, and thus it is protected. Similarly, the cell phone towers in **C** and **D** are completely visible, but they no longer look like cell phone towers; they look like pine and palm trees, however out of scale they may be. Still there, still huge objects, but now they are objects that don't offend. Camouflaging utility boxes and cell towers may be a surreal, cosmetic solution to the unwanted elements in our environment; nevertheless, it employs basic forms of illusion.

 A

Atlantic spotted dolphins.

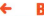
Joshua Callaghan. Camouflaged utility box.

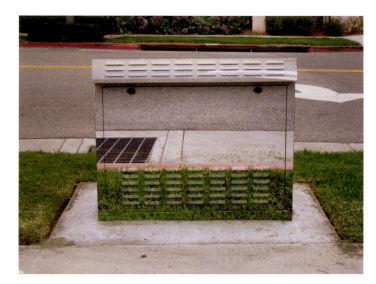

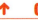
Artificial pine tree concealing cellular telephone tower.

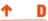
Cell phone tower disguised as palm tree.

ART AND ARCHITECTURE

Impossible Objects

Robert Lazzarini's *Payphone* **(A)** is a compound distortion of an ordinary, life-size pay phone. After the original object was digitally scanned and electronically distorted, 3D models were generated, and the final piece was fabricated with the very same materials used in the original pay phone. The resulting illusion is similar to **anamorphic** projection in which an image is coherent only when viewed from a single, fixed point; from other viewpoints it appears strangely stretched or radically distorted. The end result of Lazzarini's sleight of hand is a paradoxical object that situates the viewer in an impossible place. There is no vantage point from which the viewer of *Payphone* can account for the visual information received; the result: an image that hovers disconcertingly. Like all illusions, *Payphone* is as much about human perception as it is about the image observed.

Reflected Distortion

Looking at *Cloud Gate* **(B)** for a second time in this book—this time a view from below, looking up at its underbelly—we are lost in a maze of reflected distortions, and these distortions are in motion, coinciding with the movement of people below. This disorienting apparition stands in stark contrast to the distant view of *Cloud Gate*: a minimal form with reflected blue sky and clouds.

Defying Gravity

One element in the spectacular and theatrical fountain **(C)** by Isamu Noguchi appears to be a cube propelled skyward by its trail of water, miraculously levitating above the surface of the pool. In reality, pipes support the cube and supply the water cascading downward, hiding the trick. The other cube disperses water from above, becoming as ethereal as a floating chunk of fog.

Representing the Unrepresentable

The Klein bottle is not really a bottle; it is a mathematical concept that cannot exist in real 3D space. As a one-sided construct requiring a fourth dimension, it can only exist theoretically. Nonetheless, mathematicians have created fascinating representations to approximate this theoretical object **(D)**.

↑ **A**

Robert Lazzarini. *Payphone* and two viewers. **2002. 9' × 7' × 4' 8".**

 B

Anish Kapoor. *Cloud Gate,* detail. 2004. 33' × 42' × 66'.
Millennium Park, Chicago.

 C

Isamu Noguchi. *Nine Floating Fountains,*
detail. World Expo 70. Osaka, Japan.
© 2011 The Isamu Noguchi Foundation
and Garden Museum, New York/Art-
ists Rights Society (ARS), New York.

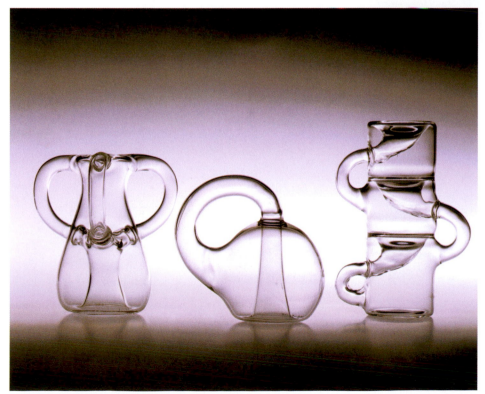

 D

Klein bottles made by Alan Bennett. 1995.

Construction worker releasing concrete from a hopper.

CHAPTER 22 FORMING AND FABRICATION

MAKING

The hand is the window on to the mind.

—Immanuel Kant

From the Stone Age to the present day, the history of objects and structures coincides with the history of making. Today there are numerous fabrication methodologies available, and new processes are continually being invented and utilized. The forming process is important for many reasons. Two especially significant aspects of making involve (1) process (the process of making determines form) and (2) thinking (the making process is a form of thought).

Process Determines Form

The objects you might make while manipulating clay with your hands will always be different than those made by manipulating sheets of steel and welding them together. The making process you use will determine, a priori, a great deal about the resulting object.

Making Is Thinking

One of the most important aspects of making is the fact that it promotes thought; in fact, many today believe that making *is* a kind of thought. The process of manipulating material generates ideas and presents new visual and tactile information for the maker to react to. In addition, the particular process used determines the nature of the ideas generated. To develop ideas, don't just think—do! Start drawing, glue two pieces of wood together, or boot up your computer!

This chapter will examine the principal types of making—additive, subtractive, constructive, **bricolage**, hybrid approaches, industrial methods, computer aided design, replication technologies, and new approaches to replication. Keep in mind, however, that these ways of making seldom stand alone; they are mostly used in combination. Additive clay sculpture (adding clay to clay to make a form) is also used together with subtraction. You add a piece of clay and then you pull or carve off a chunk, and then perhaps you add again. Additionally, you can simply squeeze the humble lump of clay into a desired shape—clay is plastic and malleable.

One contemporary sculptor who raises making and handcraft to a place of extreme thoughtfulness and sensitivity is Martin Puryear. His work **(A)** utilizes a variety of hand fabrication processes. In the sculpture visible on the far right in **A** he employs the very basic materials of tar on wire mesh to create a simple form that is rich with associations from both nature and traditional utilitarian craft. This sculpture uses a process of piecing wire mesh on a wood form—it is made as honestly and directly as a well-built cabin or a birch bark canoe. Puryear has said, "At a certain point, I just put the building and the art impulse together. I decided that building was a legitimate way to make sculpture."

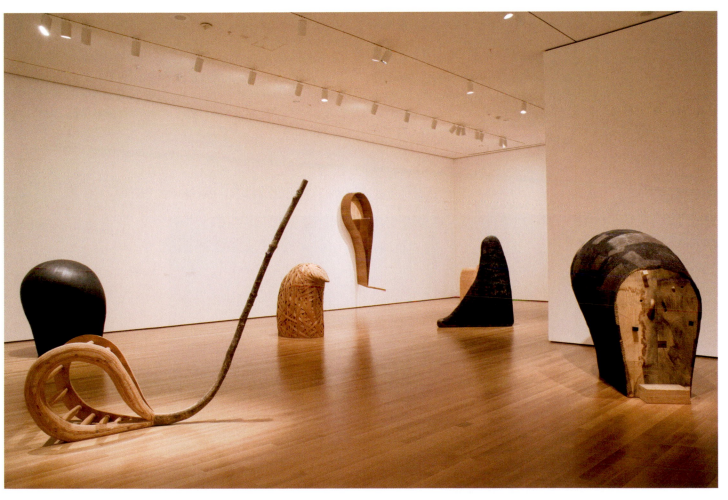

↑ A

Martin Puryear. Installation view of exhibition, "Martin Puryear" 2007. The Museum of Modern Art, New York.

ADDITIVE

Perhaps the most fundamental fabrication process is additive, and clay the oldest and most basic material used to make objects additively. Take a lump of clay and add other small pieces of clay to it, bit by bit, until it takes the desired form—a face, a sphere, or an invented form, for example. You can do the same with wax and plaster of paris.

Welding also suggests the additive. One piece of steel gets added to another and is welded in place, then another, and so on. The process ends when the sculpture—or bridge perhaps—is complete. Brazing, soldering, riveting, and gluing also involve additive processes.

In a film on Henry Moore, the distinguished British sculptor himself, amazingly, gives a very basic but informative demonstration on working with plaster of paris. He is clearly very excited about the versatility of plaster as a medium. He demonstrates how to mix plaster and how to build a form by adding wet plaster to an existing dry plaster, preliminary form, and he continues to trowel on plaster to develop his maquette. Moore then shows how to remove material by rasping and sanding, then adds more plaster, then rasps—continually adding and subtracting until the piece arrives at a satisfactory conclusion.

Alberto Giacometti similarly used the additive process to make *Dog* **(A)**. The sculptor attached small bits of clay to a wire armature to form a representation of the body of a dog. This simple process of **accretion** successfully expresses a very particular dog, following a scent with an ungainly lope, the clay a perfect vehicle for representing the droopy posture. The final work is a bronze cast of the clay original.

In architecture and engineering, the additive process is fundamental. Imagine the construction of a brick building—thousands and thousands of small additions, like the cumulative strokes of an impressionist painting, build the structure. The bridge under construction in **B** was built symmetrically from opposite sides of a river. Concrete was poured into forms that were extended incrementally until the two concrete arches met high over the Colorado River. As the concrete dried and cured, the forms were removed, and ultimately suspension cables and the stable structure of the arch stood to support the weight of the bridge and its traffic.

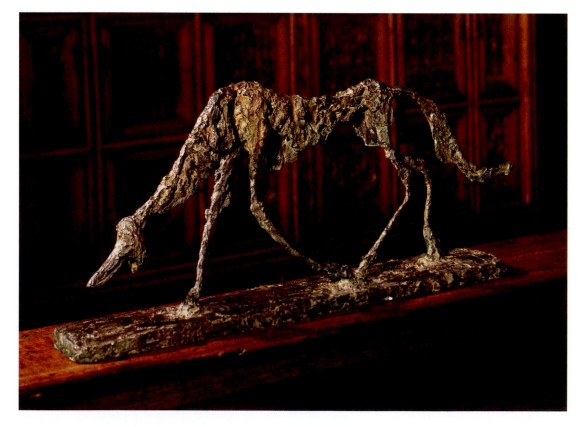

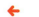 **A**

Alberto Giacometti. *Dog.*
c. 1951. Bronze (cast 1957).
© 2011 Succession Giacometti/Artists Rights Society (ARS), New York/ADAGP, Paris.

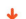 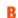 **B**

Colorado River Bridge under construction (Hoover Dam in background).
2009. Design: HDR Engineering, T.Y. Lin International, Jacobs Engineering.

SUBTRACTIVE

The subtractive process allows us to make things not by adding or attaching, but, counterintuitively, by removing material! A dug-out canoe is made by the simple act of hollowing a log. Carving is the most common subtractive fabrication process, but it is not the only one.

To create a figure in stone, stone carvers chip from the block all the stone that is not the figure, leaving behind only the material that resembles the figure they wish to make. Michelangelo imagined the figure within the block and believed his task was simply to release it. Michelangelo's *Unfinished Captive* **(A)** from his series of unfinished slaves is a good example of making by subtraction because he left remnants of the marble block intact, clearly illustrating the relationship of the stone block and the carving process to the "imprisoned" figure.

Similarly Giuseppe Penone carves **(B)** to expose the core of the younger tree contained in the heart of the wood **(C)**. He has said, "My artwork shows, with the language of sculpture, the essence of matter and tries to reveal with the work, the hidden life within."

The installation/**intervention** *Conical Intersect* **(D)**, in which artist Gordon Matta-Clark cut a series of circles out of the shell of an abandoned Paris house, is a subtractive process that doesn't involve traditional carving. Matta-Clark made *Conical Intersect* with industrial saws, creating a kind of poetic, partial demolition that produced startling vistas by literally punching holes in the domestic domain.

In **E** Tom Friedman attacked an ordinary school chair with an electric drill, subtracting so much material that the chair can barely stand. It has been dematerialized to the brink of collapse. Subtraction here equates with loss—this is a chair becoming a poignant memory.

↑　**A**

Michelangelo. *Unfinished Captive.* **1527–1528. Marble, 8' 7½" h. Accademia, Florence, Italy.**

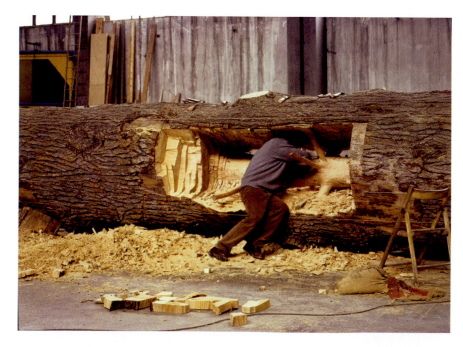

←　**B**

Giuseppe Penone at work on an Atlas cedar weighing 5 tons.

 C

Giuseppe Penone. *Cedro di Versailles* (Versailles Cedar). 2000–2003. 20' 8" × 5' 3". Art Gallery of Ontario. Toronto, Ontario, Canada.

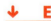 **E**

Tom Friedman. *Untitled.* 1999/2002. Wooden school chair, 2' 11" × 1' 4½" × 2' ½". Courtesy Mary Boone Gallery.

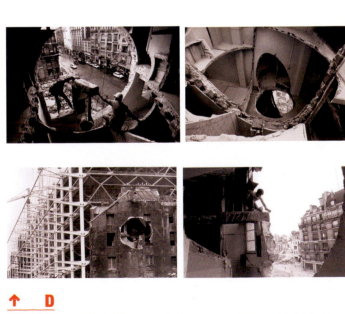

 D

Gordon Matta-Clark. Documentation of *Conical Intersect* in Paris, four detail views. 1975. Paris courtesy of David Zwirner, New York, and the Estate of Gordon Matta-Clark/© 2011 Estate of Gordon Matta-Clark/Artists Rights Society (ARS), New York.

CONSTRUCTIVE

Other then shaping malleable materials, making can generally be explained by the two fabrication processes discussed in the preceding sections—additive and subtractive. The **constructive** process involves addition and subtraction, but it does not involve the traditional methods of modeling and carving. Constructive making involves joinery—it is a process of adding and adjusting elements that are ultimately fixed in place to form a structure. These elements are usually welded, fastened mechanically, or glued together to form a sculpture, product, or building.

The constructive method might best be understood in relationship to its two-dimensional counterpart—collage. The constructive approach was revitalized by modernism, the availability of prefabricated materials, and new methods for joining materials. Constructive method is a combinative idea.

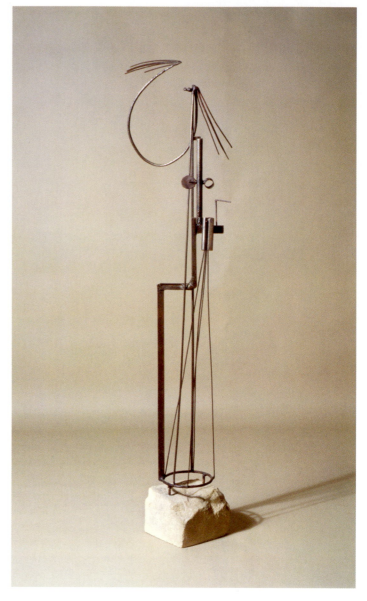

↑ **A**

Julio Gonzalez. *Maternity*. 1934. Steel. 4' 3⅓" × 1' 4" × 9¼".
© 2011 Artists Rights Society (ARS), New York/ADAGP, Paris.

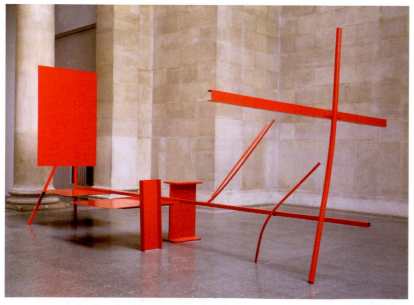

← **B**

Anthony Caro. *Early One Morning*. 1962. Painted steel and aluminum, 9' 6" × 20' 4" × 11'.

The industrial process of welding was quickly adopted by artists. Welding radically altered ideas of what a sculpture can be. Julio Gonzalez **(A)** and Anthony Caro **(B)** used welding to create sculpture that took full advantage of the basic materials of metal rods, beams, and planes, and the newfound freedom of welded joinery. Welding and oxy-fuel metal cutting were perfectly suited to the constructive process and contributed to the growing excitement about abstraction.

Chairs may be carved from wood, heavily upholstered, or cast in plastic. The classic modernist chair in **C**, however, is the product of a constructive approach—wood planes and linear elements mechanically joined.

Most buildings and products are made constructively—consider the suburban house with its wood frame, aluminum siding, sheetrock, and plumbing. The Eiffel Tower is a good example of early constructive fabrication—its iron lattice is held together by approximately 2.5 million rivets. **D** shows the tower under construction.

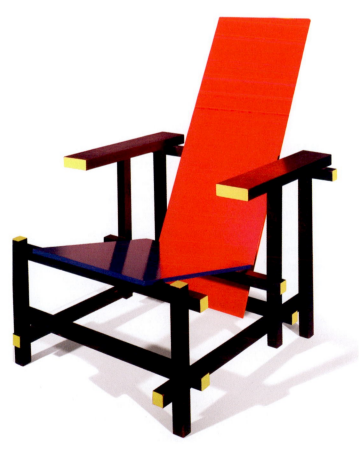

↑ **C**

Gerrit Rietveld. *Armchair Red and Blue.* **1918. Wood, paint.**
© 2011 Artists Rights Society (ARS), New York.

↑ **D**

Drawing by unknown artist. Eiffel Tower during construction.
Designed by Gustave Eiffel. 1889. Paris, France.

THE READYMADE

Dada and Duchamp

In the early 1900s Marcel Duchamp claimed various objects to be works of art. This simple act has dramatically impacted the art world for a century. The Duchamp work in **A** involves the appropriation of an ordinary coat rack. While no physical alterations have been made, a significant change was made to its context. It was removed from its natural place on the wall and placed in a gallery (a site that is accompanied by very specific, viewer expectations) and presented on the floor, robbed of its utility and introduced as a sculptural object. Duchamp and the found objects he referred to as Readymades created fascinating philosophical conundrums; they are puzzles that challenge viewers instead of reinforcing preconceptions. Surrealist painter Rene Magritte would describe this experience as a "crisis of the object." Magritte said an artist could transform the common object and evoke this experience through "isolation, modification, hybridization, scale change, accidental encounters, double image puns, paradox, double viewpoints in one."

Context and the Found Object

One of the most recent and audacious manifestations of the found object is Damien Hirst's thirteen-foot tiger shark in a tank containing 4,360 gallons of formaldehyde, here installed at the Metropolitan Museum of Art **(B)**. Concerning context and the found object, Roberta Smith wrote in the *New York Times*, "On its own the shark looks a bit tamer than usual, though at the Met, of course, it still shocks. If you passed it at the American Museum of Natural History across Central Park, you might not look twice."

 A

Marcel Duchamp. *Trap.* 1917/1964. © 2011 Artists Rights Society (ARS), New York/ADAGP, Paris/Succession Marcel Duchamp.

Precursors

Duchamp and other **Dadaists,** however, did not invent the found object; they just made it central to their art practice. In some sense, most artists have always had an interest in the found object—subject matter and source material, such as objects for still life, are essential to the art-making process. Consider Vincent Van Gogh's view on this subject in a letter to a friend:

> This morning I visited the place where the street cleaners dump the rubbish. My God, it was beautiful! Tomorrow they are bringing a couple of interesting pieces from the garbage pile, including some broken street lamps, for me to admire or, if you wish, to use as models. . . . It would make a fine subject for a fairy tale by Andersen, that mass of garbage cans, baskets, pots, serving bowls, metal pitchers, wires, lanterns, pipes and flues that people have thrown away. I really believe I shall dream about it tonight, and in winter I shall have much to do with it in my work. . . . it would be a real pleasure to take you there, and to a few other places that are a real paradise for the artist, however unsightly they may be.

In his book *The Unknown Craftsman: A Japanese Insight into Beauty*, Sōetsu Yanagi discusses the the Kizaemon Ido tea-bowl, a bowl made in Korea in the sixteenth century and selected by Japanese tea masters in the early seventeenth century to be used as an artifact in the tea ceremony. In Japan today the Kizaemon bowl (a found object) is a national treasure.

> This single Tea-bowl is considered to be the finest in the world. . . . to contain the essence of Tea. . . .

> In 1931 I was shown this bowl in company with my friend, the potter Kanjirō Kawai. For a long time I had wished to see this Kizaemon bowl. I had expected to see that "essence of Tea," the seeing eye of Tea masters, and to test my own perception; for it is the embodiment in miniature of beauty, of the love of beauty, of the philosophy of beauty, and of the relationship of beauty and life. It was within box after box, five deep, buried in wool and wrapped in purple silk.

> When I saw it, my heart fell. A good Tea-bowl, yes, but how ordinary! So simple, no more ordinary thing could be imagined. There is not a trace of ornament, not a trace of calculation. It is just a Korean food bowl . . . that a poor man would use everyday. . .

A typical thing for his use; costing next to nothing . . . an article without the flavor of personality; used carelessly by its owner; bought without pride; something anyone could have bought anywhere and everywhere. . . . The kiln was a wretched affair; the firing careless. Sand had stuck to the pot, but nobody minded; no one invested the thing with any dreams. It is enough to make one give up working as a potter. . . .

But that was as it should be. The plain and unagitated, the uncalculated, the harmless, the straightforward, the natural, the innocent, the humble, the modest: where does beauty lie if not in these qualities? The meek, the austere, the unornate—they are the natural characteristics that gain man's affection and respect.

More than anything else, this pot is healthy. Made for a purpose, made to do work. Sold to be used in everyday life. . . . Only a commonplace practicality can guarantee health in something made. . . .

Emerging from a squalid kitchen, the Ido bowl took its seat on the highest throne of beauty. The Koreans laughed. That was to be expected, but both laughter and praise are right, for had they not laughed they would not have been the people who could have made such bowls . . . The Koreans made rice bowls; the Japanese masters made them into Tea-bowls. . . .

—Excerpts from The Unknown Craftsman *by Sōetsu Yanagi*

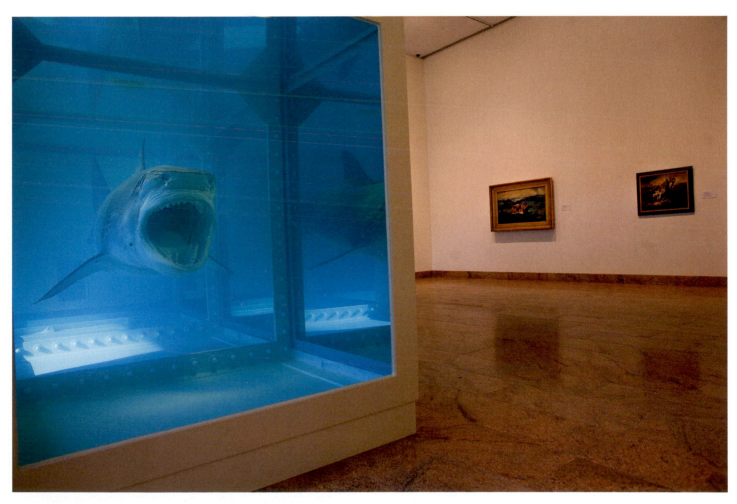

 B

Damien Hirst. *The Physical Impossibility of Death in the Mind of Someone Living.*
Installed at the Metropolitan Museum of Art, New York. 1991.

THE ALTERED READYMADE AND BRICOLAGE

The Altered Readymade

The combination of two or more found objects is often referred to as an altered or assisted Readymade (a term coined by Marcel Duchamp). Earlier in this book we looked at Picasso's *Bull's Head* **(A)**, an assemblage constructed of a bicycle seat and handlebars, in the context of play; here we reconsider it as an example of an altered Readymade (though it preceded such work by Duchamp). In **A** two found, functional components of a bicycle were brought together to form a completely realistic figurative sculpture, a bull's head. What is responsible for a work such as this? It is neither skill nor hard work. It is an intellect that makes creative connections, discovering new meaning in that which has been discarded and overlooked. A later version of *Bull's Head* was cast in bronze from the original objects, complicating its status as found object and connecting it to the tradition of figurative sculpture that is cast from life.

Bricolage

A bricoleur is someone who tinkers or putters about. Bricolage is generally used to describe a constructed object that is made with only materials at hand, regardless of their origin or purpose. The bricoleur is clever, proficient at combining preexisting things in new ways. Makers of Readymades and assisted Readymades are bricoleurs, as are many contemporary artists and designers today (bricolage suits the postmodern temperament).

Collecting

Artists who exhibit collections and who practice art as if they were curators are also bricoleurs. To make art from available material suggests that artist-bricoleurs must harvest material to fuel their combinatorial inventions. Joseph Cornell, famous for glass-fronted boxes containing arrangements of ephemera from art history and popular culture **(B)**, maintained extensive collections of found objects in his Utopia Parkway apartment **(C)**.

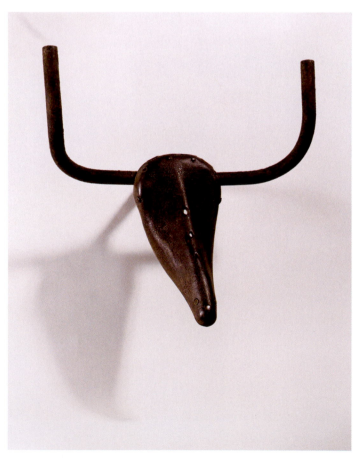

Pablo Picasso. *Bull's Head.* Assemblage, bicycle seat and handlebars. 1' 1½" × 1' × 7½". © 2011 Estate of Pablo Picasso/Artists Rights Society (ARS), New York.

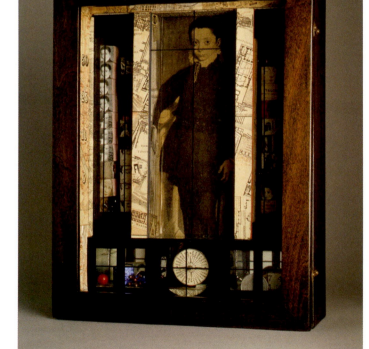

Joseph Cornell. *Medici Slot Machine.* 1942. Mixed media construction, 1' 3½" × 1' × 4⅜". Edward Owen/Art Resource, NY © The Joseph and Robert Cornell Memorial Foundation/Licensed by VAGA, New York, NY.

Joseph Cornell's studio. Utopia Parkway, Queens, New York.

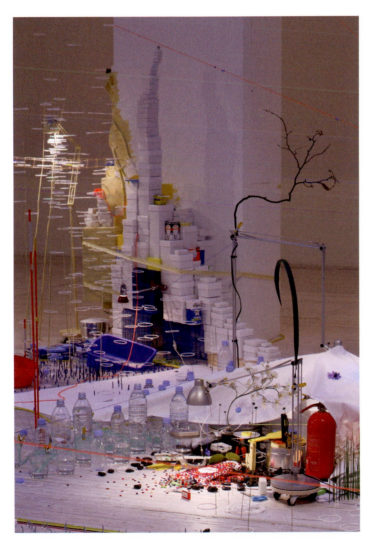

Sarah Sze. *Tilting Planet,* detail. 2008. Mixed media. Dimensions variable.

The sculptor Sarah Sze, a classic bricoleur, creates sprawling installations of found objects **(D)** utilizing material from a vast array of sources. Tree limbs, cardboard gift boxes, electric lamps, water bottles, plastic tubs, and fire extinguishers are just a few of the items used to build her structures, precariously held together with not much more than hardware store clamps. At first glance, the piece in **D** appears to consist of constellations of color/form that utilize the principle of unity and variety as they activate space; upon closer inspection we are delighted to see the quite ordinary materials that have been summoned to perform these formal acrobatics.

Found Objects and Reuse

Contemporary designers are also interested in found objects. The base of the lamp in **E** consists of skewered figurines and ornamental boxes, a vacuum cleaner part, and a faux pear. While found objects in design today are often used humorously, the interest in ordinary and discarded objects is growing, primarily because of the idea of reuse, an aspect of green design. Many designers and D.I.Y. practitioners are repurposing existing objects and utilizing found and discarded materials instead of using new resources.

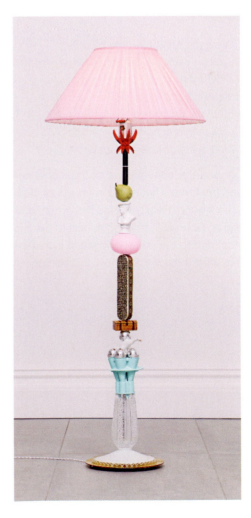

Clare and Harry Richardson. Committee Design. *Surprise* (lamp). 2010.

ART AND EVERYDAY EXPERIENCE

I am for an art that is political-erotical-mystical, that does something other than sit on its ass in a museum. . . .

I am for an art that embroils itself with the everyday crap & still comes out on top. . . .

I am for an art that takes its form from the lines of life itself, that twists and extends and accumulates and spits and drips, and is heavy and coarse and blunt and sweet and stupid as life itself. . . .

—*Claes Oldenburg*

Design and architecture are inherently more actively involved with everyday life than art. We drive cars, live in houses and apartments, and use countless products and appliances daily (and often quite intimately). Art nonetheless has its own passionate and complex relationship with life.

Life as Model

Artists have long desired to create lifelike experience to rival nature. The painter Albert Pinkham Ryder expressed his frustration with painting:

When I grew weary with the futile struggle to imitate the canvases of the past, I went out into the fields, determined to serve nature as faithfully as I had served art. In my desire to be accurate I became lost in a maze of detail. Try as I would, my colors were not those of nature. My leaves were infinitely below the standard of a leaf, my finest strokes were coarse and crude.

Edgar Degas challenged the conventions of traditional figure sculpture by dressing his bronze figure **(A)** in an actual cloth bodice, tutu, and satin hair ribbon. Reality meets the virtual, provoking a complex dialogue. Boundary-blurring is part of the fun of those hybrid works that aim to bridge art and life; it increases the demands on viewers who must decide how to approach a work intellectually.

Happenings and Social Events

Allan Kaprow created **Happenings** in the 1970s, performance-like activities in which the artist gave his full attention to ordinary, ephemeral life experiences, attempting to raise them to a plateau of intensified awareness. According to Kaprow, "nonart is more art than Art art." With a similar mind-set, Tom Marioni created a work titled *The Act of Drinking Beer with Friends is the Highest Form of Art*, and that is exactly what this work consisted of—a social gathering involving the artist, friends, and beer.

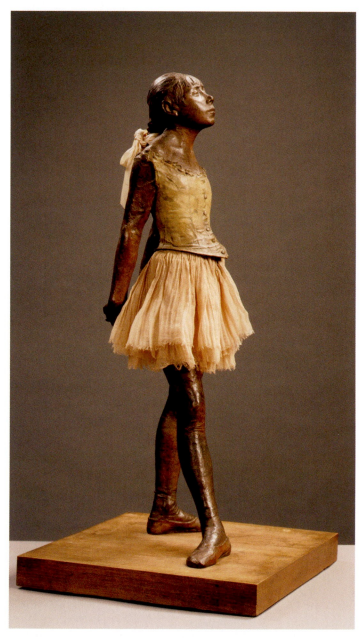

 A

Edgar Degas. *The Little Fourteen Year Old Dancer.* **Bronze (cast 1932), cloth dress and ribbon. Representing Marie van Goethem. 3′ ½″ × 1′ 2″ × 9½″.**

Michael Mercil. *The Virtual Pasture.* **2008–2011. The Wexner Center for the Arts, The Ohio State University, Columbus, Ohio. Photograph by Rachel Heberling.**

Art in the Flow of Life

The Virtual Pasture **(B)** was an artwork installed at the Wexner Center for the Arts on the campus of The Ohio State University. It involved a flock of sheep that visited the campus intermittently as well as virtually, through a live video feed. Less than a hundred years ago cows, sheep, and horses were part of daily life; today they are invisible. The introduction of sheep to a university campus is more than surreal juxtaposition; it is a proposal for a balanced life. Additionally, *The Virtual Pasture* enabled its creator, Michael Mercil, to integrate his life, his job (university professor), and his art.

Artist David Hammons offered snowballs for sale in Cooper Square, New York City **(C)**. To viewers he was just another street vendor; he was not in a gallery that would declare "this is an artwork." This real-life performance was both confrontational and extremely poetic. Titled *Bliz-aard Ball Sale*, Hammons's anti-commodity commodities were presented to everyday New Yorkers . . . in winter. Devoid of institutional structure, labels, and protocol, the artist thrust himself into the unpredictable flow of daily life, challenging his viewers to accept the responsibility for determining meaning. They had no choice but to engage with the work as active participants in its very realization. Today, work like *Bliz-aard Ball Sale* is increasingly being labeled *relational*. In **relational aesthetics** the artist is viewed as a catalyst of social experiences.

David Hammons (left) performing *Bliz-aard Ball Sale.* **1983. Cooper Square, New York. Photograph by Dawoud Bey.**

BLURRING BOUNDARIES

Many contemporary artists, designers, and architects utilize hybrid form. They feel free to use various styles and media within a single work, and they don't worry if the work is called sculpture, painting, or design—in fact, they often combine or hybridize disciplines. It's not that working within disciplinary boundaries is no longer useful; it's just that it is no longer obligatory.

Ann Hamilton's *mattering* **(A)** might be seen as installation, sculpture, or performance—it uses aspects of all these disciplines—or perhaps it is simply a new form, an enveloping environment that is sprawling and complex. A massive sheet of red-orange silk undulates like ocean waves, peacocks strut freely about, and a solo performer sits atop a pole winding typewriter ribbon around his hand, periodically letting the knot of

ribbon drop to the floor. This piece exists in time, appropriates living animals, utilizes a performer, includes recorded sound, and has a powerful formal and chromatic presence—all driven by an otherworldly, dreamlike structure.

The work in **B** is a kind of mammoth musical organ constructed of plastic tubes and huge bladders attached to horns, each playing a different octave. Long scrolls of dots and dashes are interpreted by the organ/artwork to play non-repeating variations of old tunes. It is at once a sculpture, musical instrument, installation, and sound experience.

A very different kind of hybrid object exists in the realm of contemporary electronic products—it involves combining functions that previously existed as separate products. This hybrid

↑ **A**

Ann Hamilton. *mattering* **(four views). Multimedia installation, 16' × 105' × 58'. 1997. Musee d'Art Contemporain de Lyon, France.**

tendency in electronic product design is referred to as convergence. Consider the Apple iPhone **(C)**. It is first of all a mobile telephone but also a computer with e-mail and World Wide Web access. It tacks on numerous additional functions such as GPS, calendar, and calculator; and with its menu of apps it can even serve as a carpenter's level. Many have used its lighted face as an emergency flashlight. Smart phones are the Swiss army knives of the electronic product marketplace.

There are a great many hybrid forms in popular culture as well. Perhaps one of the more interesting and powerful hybrids is Disney World, an amusement park that might easily be considered a work of art, a theatrical production, or in any case, a grand spectacle. Disney World combines installation, live performance, film, sound, animatronic figures, artifacts, and architecture tied together by popular thematic fantasies and completed by interacting viewers.

Hybrid form may become the new norm; in any case, **hybridity** opens doors for artists and designers and expands imaginative possibilities.

→ **C**

Apple iPhone.

↓ **B**

Tim Hawkinson. *Überorgan.* **2000. Woven polyethylene, nylon net, cardboard tubing, and various mechanical components, size variable. Installation in the entrance of the Getty Center. 2007. Los Angeles, California.**

THE MACHINE AESTHETIC

In 1908 the French writer Octave Mirbeau wrote of his admiration for machines:

> *Machines appear to me, more than books, statues, paintings, to be works of the imagination. When I look at, when I hear the life of the admirable organism that is the motor of my automobile, with its steel lungs and heart, its rubber and copper vascular system, its electrical nervous system, don't I have a more moving idea of the imaginative and creative human genius than when I consider the banal, infinitely useless books of M. Paul Bourget, the statues, if one can call them that, of M. Denys Puech, the paintings—a euphemism—of M. Detaille?*

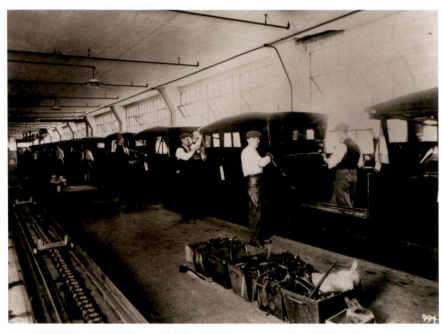

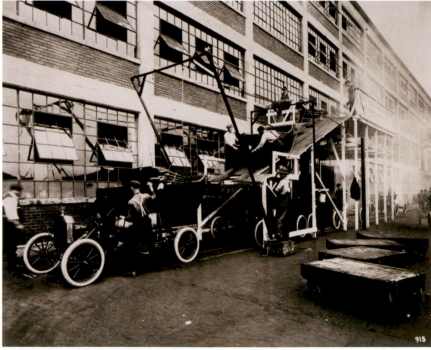

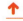

Moving assembly line (top) and assembly line outdoor body drop (bottom) at Ford Highland Park plant, Michigan. c. 1914.

Octave Mirbeau's impassioned statement provides a glimpse of the widespread public enthusiasm for the machines and new inventions of the early 1900s. The automobile, the airplane, radio, the electric light bulb, the skyscraper, and motion pictures were all either invented or came into wider use at approximately this time. The architect Corbusier said, "A house is a machine for living," and product design as we know it today developed then and was widely known as industrial design.

Artists too caught the excitement—the machine metaphor was everywhere. Artists and photographers lovingly depicted the new industrial subject matter of factories, skyscrapers, bridges, locomotives, automobiles, and airplanes, and they began to utilize the materials and fabrication processes of industry.

The industrial assembly line **(A)** replaced the individual craftsperson, a maker of unique products. The assembly line utilized machine-made parts assembled by many workers, each playing a small role in the greater process. Efficiency and mass production replaced handcraft and the pride of the individual maker. But machine-made things have their own kind of beauty, and it is a new beauty for our time—the machine aesthetic has many devotees.

The chair in **B** is a clear example of the influence of industrial fabrication and the assembly line process. Like the Model T Ford, this chair consists of discrete parts that have been joined together to form a whole, and each part utilizes the material most suitable to its purpose and fabrication method; each part can be made more efficiently by a unique fabrication technology and by workers who are specialists in welding or wood-bending, for example.

Many artworks today would never have been conceived or made had there been no Industrial Revolution. Industrial mass-produced forms are the source of countless contemporary artworks. The monumental public sculpture *Sea Change* by Mark di Suvero **(C)** not only employs unadorned industrial H-beams and is installed with heavy-construction equipment, but it takes its very identity and its energy from industrial structures such as the San Francisco-Oakland Bay Bridge visible behind it in image **C**.

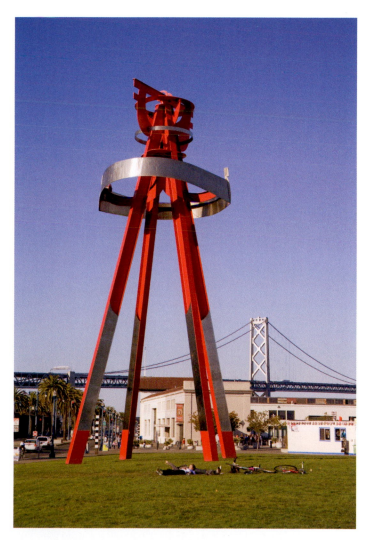

 B
Jean Prouvé. *Antony Chair.* **1950. Enameled steel and molded beech plywood. The Museum of Modern Art, New York.**

 C
Mark di Suvero. *Sea Change.* **1995. Steel, 70' h. San Francisco, California.**

THE FUTURE IS HERE

Today computers are handling an ever-increasing number of tasks in a growing number of disciplines. Art, design, and architecture are not exceptions to the trend toward computer dependency.

It is commonly understood that a great deal of architecture today could never have been made in any other time; that is, a time without computers. Frank Gehry's Guggenheim Museum in Bilbao **(A)** is so complex—consisting of numerous curving and interlocking forms—that its design required an expert group of programmers and an advanced computer-aided design system, CATIA (Computer Aided Three-dimensional Interactive Application), which combines CAD with manufacturing and engineering programs. Every curving beam and custom component had to be drawn in the CATIA program, which was required to keep track of every part and all adjacent parts as well as the whole, determine structural requirements, and monitor all components and their dimensions—a truly herculean task.

The computer rendering of *Embryologic House* **(B)** is an example of the forms achievable using CAD. Not only are complex biomorphic forms possible with CAD, but CAD can provide blueprints (fabrication drawings), structural analysis, and cost estimates.

The artist Karin Sander used a different kind of computer input to realize her one-tenth scale 3D representations of specific people **(C1, C2, C3)**. She used a laser scanner to provide relevant data and a rapid prototyper to transfer that data into actual 3D plastic figures. These portraits, made entirely by mechanical means, are like three-dimensional photographs, and like photographs, they provide us with likenesses that were previously obtainable only by means of an observer who engaged in the act of recreating observed form with skilled hands.

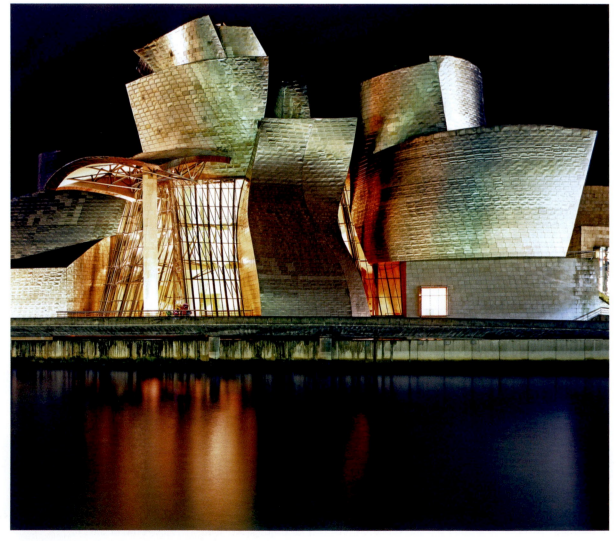

↑ **A**

Frank Gehry. Guggenheim Museum. Bilbao, Spain. 1997.

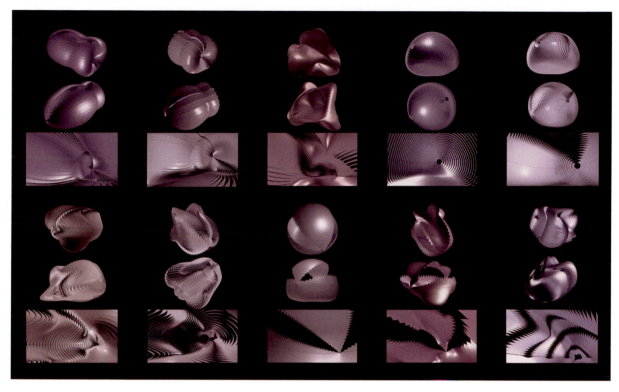

↑ **B**

Greg Lynn. *Embryologic House* [computer rendering]. 1998. Architectural Drawing, inkjet print.

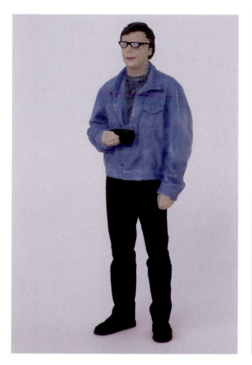

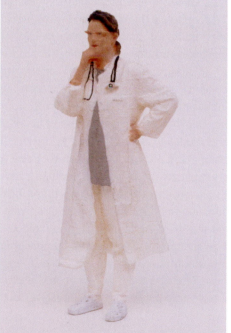

↑ **C1**

Karin Sander. *Annemarie Becker* 1:10, 1999. 3D Bodyscan of the living person. FDM (Fused Deposition Modeling), Rapid Prototyping, ABS (Acryl-Butadien-Nityl-Styrol), Airbrush, Scale 1:10, Size ca. 17 cm.

↑ **C2**

Karin Sander. *Georg Winter* 1:10, 1998. 3D Bodyscan of the living person. FDM (Fused Deposition Modeling), Rapid Prototyping, ABS (Acryl-Butadien-Nityl-Styrol), Airbrush, Scale 1:10, Size ca. 18 cm.

↑ **C3**

Karin Sander. *Dr. Ulla Klippel* 1:10, 1999. 3D Bodyscan of the living person. FDM (Fused Deposition Modeling), Rapid Prototyping, ABS (Acryl-Butadien-Nityl-Styrol), Airbrush, Scale 1:10, Size ca. 18 cm.

BASIC AND TRADITIONAL

2D Replication

If you wish to repeat an element or replicate an image in the realm of two dimensions, on the most basic level you might use a straightedge as a guide to make straight lines, a compass to create circles, or stencils to form letters. On a more advanced level, you can use one of the various printmaking techniques to replicate images, and today, of course, there are cameras and computers as well.

3D Replication

Similar processes exist in the three-dimensional realm. One fundamental tool that allows us to form identical units is the **jig**. Jigs are simple devices that serve as guides for cutting, drilling, and other forming methods. The device in **A** is a rudimentary jig—by virtue of a stop block (here illustrated in red), it allows the user to cut equal-length boards, endlessly, eliminating the need to measure every length of wood.

Casting and Molds in Sculpture and Product Design

The most common process for recreating three-dimensional form involves **casting** and mold making. We are all familiar with **molds**, from cake and Jell-O molds to sand castle molds **(B)**. Molds are useful in daily life. They are also extremely important in industry **(C)**.

Sculptors and product designers have long depended on the technology of casting and mold making to make more durable versions of vulnerable clay or wax originals, and to create duplicate versions of sculpture and products.

Molds are commonly made of plaster **(D)** from original works created in clay, but many other materials such as latex and silicone rubber are also used to make molds. To make a plaster mold, a box-like form is built around part of the original object, the pattern, and filled with plaster and left to harden. This is repeated until all parts of the original have a corresponding mold section. The hardened plaster mold sections are then coated with a release agent to prevent them from adhering to the casting material. The sections are strapped together and filled with plaster or other material that hardens, and finally the mold is removed to reveal the final cast object. The mold for the teapot in **D** had slip (liquid clay) repeatedly poured in and out until a layer of clay formed inside the mold, ensuring a thin-walled, hollow teapot; this mold is a two-part mold—note the negative and positive "buttons" used to align the two halves. Mold making can get very complex, with multiple parts that might be required to avoid undercuts (shapes that would resist removal from the mold). Fine mold making is an art and a science.

There are numerous mold types and variations. Traditional bronze sculpture is often created with a one-piece ceramic shell mold that contains the original wax pattern. After the wax is melted out in an oven, molten bronze is poured into the mold, hardening as it cools. This casting method is referred to as the lost wax process. The ceramic shell is then cracked off the encased bronze, revealing the sculpture. Newer industrial casting methods include plastic injection molding and spin casting.

When designing an object that you intend to replicate as a multiple, it would be wise to understand and carefully consider the casting/mold-making process to which your product or sculpture will ultimately be subjected.

↑ **A**

Sizing board jig.

↑ **B**

Sand castle made with wet sand using a red castle-shaped bucket.

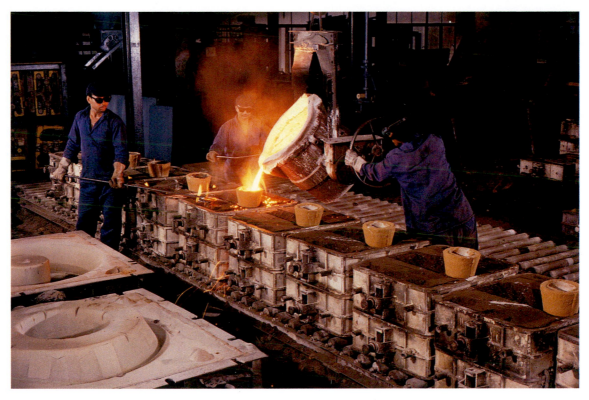

 C

Molten steel being poured into a mold.

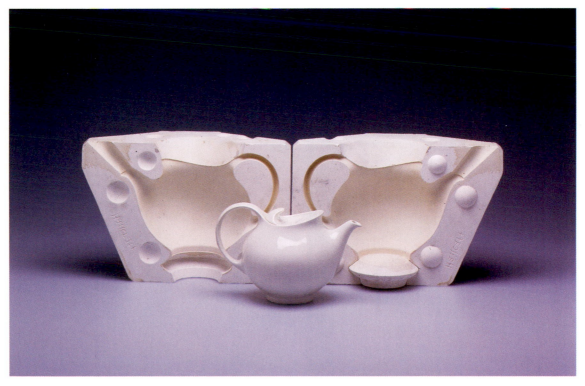

 D

Eva Zeisel. *Tomorrow's Classic.* Hall China teapot and mold. 1952.

REPLICATION TECHNOLOGIES

NEW APPROACHES

The Rapid Prototype

Many new replication technologies are available to the contemporary artist and designer, and they all involve computer technology. Rapid prototyping (also referred to as 3D printing) is an additive process in which digital instructions control a computerized printing device that deposits a material (usually plastic), layer upon layer, until the full three-dimensional object is complete. The initial design input can be either digitally created with CAD software or by laser scanning an original object. The 3D printer illustrated in **A** houses a fabricated duplicate toy horse (green) created by extruding layers of plastic one-hundredth of an inch thick. The black, original horse was first scanned to obtain the information required. In addition to extruding modeling material, this 3D printer lays down a darker material that acts as a support for the object being formed; the supporting material is easily removed after printing.

Laser Cutting

Computerized laser cutters allow for CAD data to control cutting flat shapes in numerous materials. A steel table can be cut from sheet steel and later folded into its final form. The advantages of laser cutting are accuracy and the freedom to fabricate either one table or one hundred at a time, all from the original digital input. Computerized fabrication has contributed to the growth of on-demand manufacturing.

The CNC Router

A CNC (computer numerical control) router is a machine that removes materials such as plastic, foam, wood, and aluminum by virtue of a spinning router bit that moves on three or more axes. The CNC router in **B** is carving a figure in foam.

Two Extraordinary Objects

Two extraordinary objects that were created with new computer-aided replication technologies would not only be all but unbuildable with traditional replication technologies but would also be unthinkable. The *C2 Solid Chair* in **C** is fabricated by means of the stereolithography process, a type of 3D printing in which a computer-controlled laser heats and solidifies a photosensitive epoxy resin. The *Cinderella Table* in **D** was CAD designed, the result of virtually morphing two individual antique pieces of furniture, then fabricated by a CNC router. Fifty-seven individual sections were formed by the router, then pieced together to complete the table. Like the *C2 Solid Chair*, the *Cinderella Table* is endlessly reproducible after the initial data input. Both table and chair are fantasies inspired by technology.

New technologies lead to new thoughts, new forms, and new products.

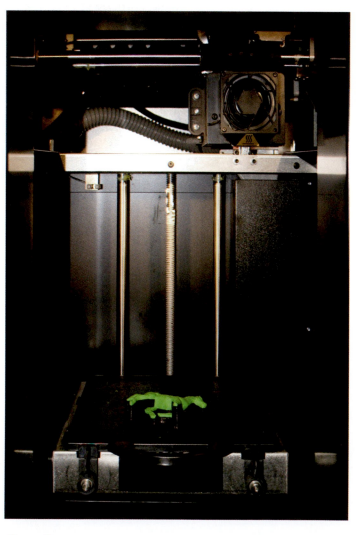

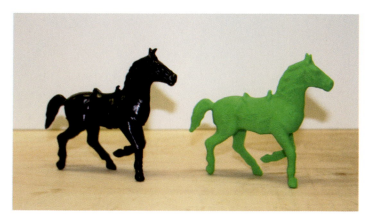

↑ **A**

Toy horse duplicate in a Dimension SST 3D printer at Virginia Commonwealth University, Sculpture Department (left). The SST printer uses a process called fused deposition modeling. Original black toy horse and green duplicate made by 3D printing (right). Photograph: R. Eric McMaster.

← **B**

Shopbot PRS Standard CNC router with foam figure at Virginia Commonwealth University, Sculpture Department. Photograph: R. Eric McMaster.

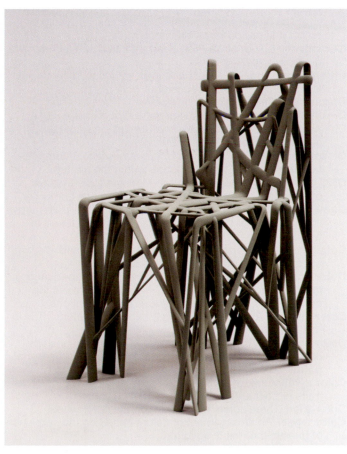

↑ **C**

Patrick Jouin. *C2 Solid Chair.* 2004. Epoxy resin, 2' 6⅞" × 1' 3⅞" × 1' 9¼". Manufactured by Materialise NV. The Museum of Modern Art, New York.

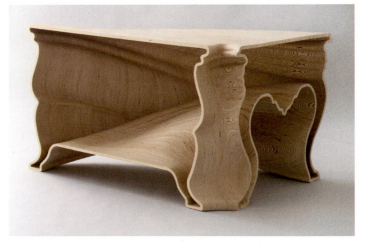

↑ **D**

Jeroen Verhoeven. *Cinderella Table.* 2004. Birch, 2' 7½" × 4' 4" × 3' 4". Manufactured by Demakersvan. The Museum of Modern Art, New York.

GLOSSARY

Abstract Expressionism The abstract art movement of the mid-1900s characterized by energetic mark making motivated by the artist's subconscious impulses.

Abstraction The presentation of form for its own sake, devoid of representation. Abstraction can occur through a process of simplification or distortion in an attempt to communicate an essential aspect of a form or concept.

Accretion Building form by incremental additions.

Achromatic Black, gray, or white with no distinctive hues.

Additive system A color mixing system in which combinations of different wavelengths of light create visual sensations of color.

Aerial perspective The perception of less-distinct contours and value contrasts as forms recede into the background. Colors appear to be washed out in the distance or take on the color of the atmosphere. Also called *atmospheric perspective.*

Aerodynamic Objects designed to move through air or water with the least amount of drag (friction).

Aesthetics A branch of philosophy concerned with the beautiful in art and how the viewer experiences it.

Afterimage Occurs after staring at an area of intense color for a certain amount of time and then quickly glancing away toward a white surface, where the complementary color seems to appear.

Allover pattern A composition that distributes emphasis uniformly throughout the two-dimensional surface by repetition of similar elements.

Alternating rhythm A rhythm that consists of successive patterns in which the same elements reappear in a regular order. The motifs alternate consistently with one another to produce a regular (and anticipated) sequence.

Ambiguity Obscurity of motif or meaning.

Amplified perspective A dynamic and dramatic illusionistic effect created when an object is pointed directly at the viewer.

Analogous colors A color scheme that combines several hues located next to each other on the color wheel.

Analysis A measure of the attributes and relationships of an artwork or design.

Anamorphic Term used to describe an image that has been optically distorted.

Anthropomorphic Form that has human likeness or attributes.

Anticipated movement The implication of movement on a static two-dimensional surface caused by the viewer's past experience with a similar situation.

Appropriate (e-´prō-prē-āt) The act of borrowing images, objects, or styles from pre-existing artworks or from culture in general for one's own creative use.

Archetype An ideal model.

Art deco A decorative style, popular in the 1920s, characterized by its geometric patterns and reflecting the rise of industry and mass production in the early twentieth century.

Art Nouveau A late nineteenth-century style that emphasized organic shapes.

Ash-Can school American realist painters of the early 1900s who glorified daily life and ordinary people.

Assemblage An assembly of found objects composed as a piece of sculpture. See **Collage.**

Asymmetrical balance Balance achieved with dissimilar objects that have equal visual weight or equal eye attraction.

Asymmetry Nonsymmetrical form.

Automatic writing The surrealist practice of writing or drawing without conscious control.

Axis A line of reference around which a form or composition is balanced.

Balance The equilibrium of opposing or interacting forces in a pictorial composition.

Bauhaus Influential German school of architecture, design, and art.

Bilateral symmetry Balance with respect to a vertical axis.

Biomimcry Design that utilizes nature's methods to create new products.

Biomorphic Form derived from nature, often embodying organic growth.

Blurred outline A visual device in which most details and the edges of a form are lost in the rapidity of the implied movement.

Bricolage An assemblage of found materials and objects created by improvising with whatever material happens to be available.

CAD Computer Aided Design. Software programs that assist designers in the conception and execution of products and buildings.

Calligraphy Handwritten letterforms that are generally either geometric or cursive.

Canon A law or accepted code that prescribes a set of standards.

Cantilever A structural overhang that is counterbalanced at the opposite end.

Carbon footprint The amount of greenhouse gases produced by an activity or product, usually expressed in equivalent tons of carbon dioxide.

Caryatid An architectural column in the form of a human figure.

Casting The process of duplicating an original sculpture or object (the pattern) by means of a mold.

Ceramic An object of clay that has been fired at a high temperature, usually in a kiln.

Chiaroscuro The use of light and dark values to imply depth and volume in a two-dimensional work of art.

Chroma See **Intensity.**

Chromatic Relating to the hue or saturation of color.

Classical Suggestive of Greek and Roman ideals of beauty and purity of form, style, or technique.

Closed form The placement of objects by which a composition keeps the viewer's attention within the picture.

CNC Computer Numerical Control. Machine tools that are operated by the programmed commands of a computer.

Coevolution The evolution of two or more species that adapt to changes in each other during an extended period of time.

Collage An artwork created by assembling and pasting a variety of materials onto a two-dimensional surface.

Color constancy A psychological compensation for changes in light when observing a color. A viewer interprets the color to be the same under various light conditions.

Color discord A perception of dissonance in a color relationship.

Color harmony Any one of a number of color relationships based on groupings within the color wheel. See also **Analogous colors, Color triad,** and **Complementary.**

Color symbolism Employing color to signify human character traits or concepts.

Color triad Three colors equidistant on the color wheel.

Color wheel An arrangement of colors based on the sequence of hues in the visible spectrum.

Complementary A color scheme incorporating opposite hues on the color wheel. Complementary colors accentuate each other in juxtaposition and neutralize each other in mixture.

Composition The overall arrangement and organization of visual elements on the two-dimensional surface.

Compression The stresses associated with placing materials or structures under pressure.

Conceptual Artwork based on an idea. An art movement in which the idea is more important than the work's visual structure.

Concrete art Geometric abstraction.

Constancy effect An aspect of human perception that allows us to see size or color or form as consistent even if circumstances change appearances.

Constructive A fabrication process that involves addition and subtraction (but not modeling or carving) by joining (usually welding, fastening mechanically, or gluing) to form a sculpture, product, or building

Content An idea conveyed through the artwork that implies the subject matter, story, or information the artist communicates to the viewer.

Continuation A line or edge that continues, virtually, from one form to another, allowing the eye to move smoothly through a composition.

Continuity The visual relationship between two or more individual designs.

Contour A line used to follow the edges of forms and thus describe their outlines.

Cool color A color closer to blue on the color wheel.

Cradle-to-Cradle design Design that considers sustainability, especially the entire life span of an object, from creation to disposal and ultimately to material recycling and reuse.

Crit An abbreviation of critique. A process of criticism for the purpose of evaluating and improving art and design.

Critique A process of criticism for the purpose of evaluating and improving art and design.

Cross contour Lines that appear to wrap around a form in a pattern that is at an angle to the outline of the form.

Cross-hatching A drawing technique in which a series of lines are layered over each other to build up value and to suggest form and volume.

Crystallographic balance Balance with equal emphasis over an entire two-dimensional surface so that there is always the same visual weight or attraction wherever you may look. Also called *allover pattern*.

Cubist (Cubism) A form of abstraction that emphasizes planes and multiple perspectives.

Curvilinear Rounded and curving forms that tend to imply flowing shapes and compositions.

Dadaists International artists of the early 1900s that reflected the cynicism that followed WWI. They employed irrationality, humor, and irony.

Deformation The formal alteration of established forms or pre-existing elements.

Description A verbal account of the attributes of an artwork or design.

Design A planned arrangement of visual elements to construct an organized visual pattern or structure.

Dictum A short pronouncement that expresses a general rule or principle.

Distortion A departure from an accepted perception of a form or object. Distortion often manipulates established proportional standards.

Draftsmanship The quality of drawing or rendering.

Dynamic Energetic or forceful form, implying physical motion.

Earthworks Artworks created by altering a large area of land using natural and organic materials. Earthworks are usually large-scale projects that take formal advantage of the local topography.

Emotional color A subjective approach to color use to elicit an emotional response in the viewer.

Enigmatic Puzzling or cryptic in appearance or meaning.

Equilibrium Visual balance between opposing compositional elements.

Equivocal space An ambiguous space in which it is hard to distinguish the foreground from the background. Your perception seems to alternate from one to the other.

Ergonomic Design that considers the relationship of the body of the user to the product.

Expressionism An artistic style in which an emotion is more important than adherence to any perceptual realism. It is characterized by the exaggeration and distortion of objects in order to evoke an emotional response from the viewer.

Eye level See **Horizon line.**

Facade The face or frontal aspect of a form.

Fauve A French term meaning "wild beast" and descriptive of an artistic style characterized by the use of bright and intense expressionistic color schemes.

Faux Fake; an imitation.

Fetishism Extravagant devotion. The displacement of erotic interest to an object.

Figuration Realistic depiction in art.

Figure Any positive shape or form noticeably separated from the background, or the negative space.

Focal point A compositional device emphasizing a certain area or object to draw attention to the piece and to encourage closer scrutiny of the work.

Folk art Art and craft objects made by people who have not been formally trained as artists.

Foreshortening A distortion of a shape due to perspective wherein an object appears shorter than we know it to be.

Form and function The design elements that are often coupled because of their co-influence.

Form follows function Design in which the form of a product or building is dictated by its functional requirements.

Form When referring to objects, it is the shape and structure of a thing. When referring to two-dimensional artworks, it is the visual aspect of composition, structure, and the work as a whole.

Formal That which relates to visual form, such as the elements of shape, size, color, and composition.

Fresco A mural painting technique in which pigments mixed in water are used to form the desired color. These pigments are then applied to wet lime plaster, thereby binding with and becoming an integral part of a wall.

Functional The usefulness or utility of an object.

Futurist Pertaining to the Italian art movement of the early 1900s that stressed speed, a machine aesthetic, dynamic form, and the rejection of the past.

Geodesic dome A dome constructed of a lattice of triangular elements that distributes stresses uniformly, creating a structure that is extremely efficient in its use of material.

Gestalt A unified configuration or pattern of visual elements whose properties cannot be derived from a simple summation of its parts.

Gesture A line that does not stay at the edges but moves freely within forms. These lines record movement of the eye as well as implying motion in the form.

Golden mean A mathematical ratio in which width is to length as length is to length plus width. This ratio has been employed in design since the time of the ancient Greeks. It can also be found in natural forms.

Golden rectangle The ancient Greek ideal of a perfectly proportioned rectangle using a mathematical ratio called the Golden mean.

Graphic Forms drawn or painted onto a two-dimensional surface; any illustration or design.

Green design Design that takes into consideration a product's energy consumption in its making, its use, and its disposal or re-use.

Grid A network of perpendicular intersecting lines that divides spaces and creates a framework of areas.

Ground The surface of a two-dimensional design that acts as the background or surrounding space for the "figures" in the composition.

Happenings Informal and spontaneous art events, often involving ordinary daily activities.

Haptic Relating to the sense of touch.

Harmony The pleasing combination of parts that make up a whole composition.

Hieratic scaling A composition in which the size of figures is determined by their thematic importance.

Horizon line The farthest point we can see where the delineation between the sky and ground becomes distinct. The line on the picture plane that indicates the extent of illusionistic space and on which are located the vanishing points.

Hue A property of color defined by distinctions within the visual spectrum or color wheel. "Red," "blue," "yellow," and "green" are examples of hue names.

Hybridity Relating to the phenomenon of composite identity, as when objects embody the characteristics of different genres or combine diverse functions.

Icon A religious image meant to embody the actual qualities of the depicted saint. More generally, a symbol or sign, especially one with strong emotional power.

Idealism An artistic theory in which the world is not reproduced as it is but as it should be. All flaws, accidents, and incongruities of the visual world are corrected.

Ideation The process that aids in the development of early-stage design ideas.

Ideoplastic Drawing what you know, not what you see. Also applies to figuration in general, when ideas eclipse perception.

Illusion A false perception. For example, perspective can create the illusion of deep space on a flat plane.

Illustration A picture created to clarify or accompany a text.

Imbalance Occurs when opposing or interacting forms are out of equilibrium in a pictorial composition.

Impasto A painting technique in which pigments are applied in thick layers or strokes to create a rough three-dimensional paint surface on the two-dimensional surface.

Implied line An invisible line created by positioning a series of points so that the eye will connect them and thus create movement across the picture plane.

Impressionism An artistic style that sought to re-create the artist's perception of the changing quality of light and color in nature.

Informal balance Synonymous with **asymmetrical balance**. It gives a less-rigid, more casual impression.

Installation A mixed-media artwork that generally takes into account the environment in which it is arranged.

Intensity The saturation of hue perceived in a color.

Interpretation A subjective conclusion regarding the meaning, implication, or effect of an artwork or design.

Interstitial The space between two things, usually a small gap.

Intervention In art, an intervention involves the act of altering an existing object, situation, or environment.

Irony The conflict between what seems to be communicated and what is really intended.

Isometric projection A spatial illusion that occurs when lines receding on the diagonal remain parallel instead of converging toward a common vanishing point. Used commonly in Oriental and Far Eastern art.

Isomorphism When objects share a formal resemblance, they are isomorphic.

Iteration The repetition of a process and the different stages that result.

Jig A device that regulates and maintains the relationship of a tool or machine to the work being formed.

Joinery The act of joining parts to form a single unit.

Juxtaposition When one image or shape is placed next to or in comparison to another image or shape.

Kinesthetic empathy A mental process in which the viewer consciously or unconsciously re-creates or feels an action or motion he or she only observes.

Kinetic Structures that move or have moving parts.

Kitsch Low or common art forms that appeal to sentimentality.

Legato A connecting and flowing rhythm.

Line A visual element of length. It can be created by setting a point in motion.

Line quality Any one of a number of characteristics of line determined by its weight, direction, uniformity, or other features.

Linear perspective A spatial system used in two-dimensional artworks to create the illusion of space. It is based on the perception that if parallel lines are extended to the horizon line, they appear to converge and meet at a common point, called the vanishing point.

Lines of force Lines that show the pathway of movement and add strong visual emphasis to a suggestion of motion.

Local color The identifying color perceived in ordinary daylight.

Logo A sign or image that is taken to be an easily recognized symbol representing a company or organization.

Lost-and-found contour A description of a form in which an object is revealed by distinct contours in some areas whereas other edges simply vanish or dissolve into the ground.

Mandala A radial concentric organization of geometric shapes and images commonly used in Hindu and Buddhist art.

Maquette A small-scale model that precedes the actual sculpture.

Medium The tools or materials used to create an artwork.

Memes Ideas that replicate by being spread from mind to mind. Memes can be ideas, styles, art works, tunes, or theories, for example.

Minimalism An artistic style that stresses purity of form above subject matter, emotion, or decoration.

Mixed media The combination of two or more different media in a single work of art.

Modernism The ideas, styles, and ideology of the modern epoch up to the 1960s. In art and design it is commonly associated with abstraction, the grid, and rationality.

Module A specific measured area or standard unit.

Mold An object made by enveloping an original object in a liquid such as plaster or resin that hardens. This hardened form, the mold, is then used to reproduce copies of the original.

Monochromatic A color scheme using only one hue with varying degrees of value or intensity.

Monocular Pertaining to vision from one eye only.

Monolith A single, massive, and discrete form, such as an obelisk.

Montage A recombination of images from different sources to form a new picture.

Multiple image A visual device used to suggest the movement that occurs when a figure is shown in a sequence of slightly overlapping poses in which each successive position suggests movement from the prior position.

Multiple perspective A depiction of an object that incorporates several points of view.

Multipoint perspective A system of spatial illusion with different vanishing points for different sets of parallel lines.

Narrative The story that is told in an artwork.

Naturalism The skillful representation of the visual image, forms, and proportions as seen in nature with an illusion of volume and three-dimensional space.

Negative shape A clearly defined shape within the ground that is defined by surrounding figures or boundaries.

Negative space Unoccupied area or "empty" space defined by objects or figures.

Nomadic A mobile or migratory life style.

Nonobjective A type of artwork with absolutely no reference to, or representation of, the natural world. The artwork is the reality.

Objective Having to do with reality and fidelity to perception.

One-point perspective A system of spatial illusion in two-dimensional art based on the convergence of parallel lines to a common vanishing point usually on the horizon.

Op Art A style of art and design that emphasizes optical phenomena.

Opaque A surface impenetrable by light.

Open form The placement of elements in a composition so that they are cut off by the boundary of the design. This implies that the picture is a partial view of a larger scene.

Optical mixture Color mixture created by the eye as small bits of color are perceived to blend and form a mixture.

Overlapping A device for creating an illusion of depth in which some shapes are in front of and partially hide or obscure others.

Parallax The resolution of two images from binocular (two-eyed) vision.

Patina The color and surface changes resulting from the oxidation of metal, such as the green film that forms on copper. Also, any change in the surface of an object due to use or age.

Pattern The repetition of a visual element or module in a regular and anticipated sequence.

Pentimenti (plural) The artist's changes or corrections sometimes evident as traces in the surface. From the Italian and implying "the artist repents."

Pictogram A simple pictorial sign or group of signs intended to communicate without words.

Picture plane The two-dimensional surface on which shapes are organized into a composition.

Plane The two-dimensional surface of a shape.

Pointillism A system of color mixing (used in painting and drawing) based on the juxtaposition of small bits of pure color. Also called *divisionism* (see **Optical mixture**).

Polychrome Two or more colors occupying the surface of an object.

Polyrhythmic A complex pattern employing more than one rhythm or beat.

Pop art An art movement originating in the 1960s that sought inspiration from everyday popular culture and the techniques of commercial art.

Positive shape Any shape or object distinguished from the background.

Post and lintel A building system in which a lintel (horizontal beam) is supported by two posts (columns).

Postmodernism The style and ideology of the current era, characterized by pluralism, appropriation, and irony. The idea of collage has come to be known as the signature structure of postmodern design.

Primary colors The three colors from which all other colors theoretically can be mixed. The primaries of pigments are traditionally presented as red, yellow, and blue, whereas the primaries of light are red, blue, and green.

Progressive rhythm Repetition of a shape that changes in a regular pattern.

Proportion Size measured against other elements or against a mental norm or standard.

Prosthesis A device to replace a missing or impaired part of the body.

Prototype A full-size working version of a product, created to test appearance and function through use, before general production.

Proximity The degree of closeness in the placement of elements.

Psychic line A mental connection between two points or elements. This occurs when a figure is pointing or looking in a certain direction, which causes the eye to follow toward the intended focus.

Quotidian Everyday activity; ordinary objects.

Radial balance A composition in which all visual elements are balanced around and radiate from a central point.

Radial symmetry Symmetry of an object or organism around a central main axis. Such objects can be divided into identical halves by any vertical cut through its central axis.

Rapid prototyping Machine reproduction of objects by means of digital information and the layering of material. Also referred to as 3D printing.

Readymade An art object selected (appropriated) from the world of "ordinary" objects of daily use.

Realism An approach to artwork based on the faithful reproduction of surface appearances with a fidelity to visual perception.

Recontextualize Transforming the meaning of an object by transporting it from its natural environment to a new site.

Rectilinear Composed of straight lines.

Reductive An aesthetic of reduction that produces objects stripped of all but the necessary.

Relational aesthetics The artist is understood to be a catalyst of social experiences.

Repeated figure A compositional device in which a recognizable figure appears within the same composition in different positions and situations so as to relate a narrative to the viewer.

Repetition Using the same visual element over again within the same composition.

Representation The depiction of an object by approximating its characteristic physical attributes. Also, realism or figuration.

Representational An image suggestive of the appearance of an object that actually exists.

Retinal fatigue Fading perception due to overexposure and resulting in an afterimage effect.

Rhythm An element of design based on the repetition of recurrent motifs.

Saturation See **Intensity**.

Scale The relative size of an object or a volume of space in relationship to the viewer, to other objects in the vicinity, or to the object's environment in general.

Secondary color A mixture of any two primary colors.

Shade A hue mixed with black.

Shading Use of value in artwork.

Shakers An alternative Christian religious community that flourished in the 19th century; the Shakers produced tools, furniture, and architecture that embodied their devout religious beliefs.

Shape A visually perceived area created either by an enclosing line or by color and value changes defining the outer edges.

Sign A fundamental visual or linguistic unit that designates an object or idea.

Silhouette The area between the contours of a shape.

Simultaneous contrast The effect created by two complementary colors seen in juxtaposition. Each color seems more intense in this context.

Site specific A work of art in which the content and aesthetic value is dependent on the artwork's location.

Source A place where creators seek information and inspiration. The source for many artists and designers is other art and design, but nature, geometry, and culture at large are also sources of special interest.

Spectrum The range of visible color created when white light is passed through a prism.

Spherical symmetry Symmetry around a central point. Any slice through the center of an object possessing spherical symmetry will produce identical halves, mirror images, such as when one bisects an orange.

Staccato Abrupt changes and dynamic contrast within the visual rhythm.

Static Still, stable, or unchanging.

Streamline style The style associated with industrial design of the 1930s, inspired by the aerodynamic demands of the airplane and the automobile.

Stylized The application of stylistic elements to an object, usually associated with cosmetic as opposed to functional design considerations.

Subject The content of an artwork.

Subjective Reflecting a personal bias.

Subtractive system A color mixing system in which pigments (physical substances) are combined to create visual sensations of color. Wavelengths of light absorbed by the substance are subtracted, and the reflected wavelengths constitute the perceived color.

Suprematism A Russian art movement of the early twentieth century that emphasized nonobjective form.

Surrealism An artistic style that stresses fantastic and subconscious approaches to art making and often results in images that cannot be rationally explained.

Sustainability Relating to the efficient use of resources, so as to sustain them, preventing depletion.

Symbol An element of design that communicates an idea or meaning beyond that of its literal form.

Symmetry A quality of a composition or form wherein a precise correspondence of elements exists on either side of a center axis or point.

Tactile texture The use of materials to create a surface that can be felt or touched.

Tenet A principle or belief held true by members of a group or discipline.

Tensile strength The ability of a material to withstand the pulling force of tension.

Tension Structurally, the stress resulting from stretching or pulling.

Tertiary color A mixture of a primary and an adjacent secondary color.

Texture The surface quality of objects that appeals to the tactile sense.

Tint A hue mixed with white.

Tonality A single color or hue that dominates the entire color structure despite the presence of other colors.

Transparency A situation in which an object or form allows light to pass through it. In two-dimensional art, two forms overlap, but both are seen in their entirety.

Triadic A color scheme involving three equally spaced colors on the color wheel.

Trompe l'oeil A French term meaning "to fool the eye." The objects are in sharp focus and delineated with meticulous care to create an artwork that almost fools the viewer into believing that the images are the actual objects.

Truss A framework, typically consisting of triangulated struts, supporting a roof, bridge, or other structure.

Two-point perspective A scene that is viewed through an angle, with no objects parallel to the picture plane and with edges receding to two points on the horizon line.

Typology Classification by type or style.

Unity The degree of agreement existing among the elements in a design.

Utility The functionality or use-value of an object.

Value A measure of relative lightness or darkness.

Value contrast The relationship between areas of dark and light.

Value emphasis Use of a light-and-dark contrast to create a focal point within a composition.

Value pattern The arrangement and amount of variation in light and dark values independent of any colors used.

Vanishing point In linear perspective, the point at which parallel lines appear to converge on the horizon line. Depending on the view, there may be more than one vanishing point.

Verisimilitude Accuracy or faithfulness in depiction or representation.

Vernacular A prevailing or commonplace style in a specific geographical location, group of people, or time period.

Vertical location A spatial device in which elevation on the page or format indicates a recession into depth. The higher an object, the farther back it is assumed to be.

Vibrating colors Colors that create a flickering effect at their border. This effect usually depends on an equal value relationship and strong hue contrast.

Visceral Relating to deep inner feelings, as if experienced by the gut.

Visual color mixing Placing small units of color side by side so that the eye perceives the mixture rather than the individual component colors.

Visual texture A two-dimensional illusion suggestive of a tactile quality.

Volume The appearance of height, width, and depth in a form.

Warm color A color closer to the yellow-to-red side of the color wheel.

Wash drawing A technique of drawing in water-based media.

Zeitgeist The spirit of an era.

Zen A Japanese adaptation of Mahayana Buddhism that aims at enlightenment.

General

Anderson, Walter Truett, ed. *The Truth About the Truth.* New York: G.P. Putnam's Sons, 1995.

Bachelard, Gaston. *The Poetics of Space,* trans. Maria Jolas. Boston: Beacon Press, 1994.

Battcock, Gregory. *Minimal Art: A Critical Anthology.* New York: E. P. Dutton & Co., Inc., 1968.

Barrett, Terry. *Criticizing Art: Understanding the Contemporary,* 3rd ed. New York: McGraw Hill, 2011.

Bayer, Herbert, Walter Gropius, and Ise Gropius, eds. *Bauhaus 1919–1928.* New York: The Museum of Modern Art, 1938.

Berger, John. *Ways of Seeing.* London: British Broadcast Corporation, 1987.

Buser, Thomas. *Experiencing Art around Us.* Belmont, CA: Wadsworth/Thomson, 2006.

Canaday, John. *What Is Art?* New York: Alfred A. Knopf, 1980.

Chipp, Herschel B., ed. *Theories of Modern Art.* Los Angeles, CA: University of California Press, 1971.

Dondis, Donis A. *A Primer of Visual Literacy.* Cambridge, MA: MIT Press, 1973.

Drexler, Arthur. Introduction to *Twentieth Century Engineering.* New York: The Museum of Modern Art, 1964.

Faulkner, Ray, Edwin Ziegfeld, and Howard Smagula. *Art Today: An Introduction to the Visual Arts,* 6th ed. Fort Worth, TX: Harcourt Brace College Publishers, 1987.

Grosenick, Uta, and Burkhard Riemschneider. *Art Now.* London: Taschen, 2009.

Hall, Edward T. *The Hidden Dimension.* New York: Anchor Books, 1969.

Hebdige, Dick. *Subculture: The Meaning of Style.* London: Methuen & Co. Ltd, 1979.

Judson, Horace Freeland. *The Search for Solutions.* New York: Holt, Rinehart and Winston, 1980.

Koomler, Sharon Duane. *Shaker Style: Form, Function, and Furniture.* London: PRC Publishing Ltd., 2000.

Kostelanetz, Richard, ed. *Esthetics Contemporary.* Buffalo, NY: Prometheus Books, 1982.

Mau, Bruce, and the Institute without Boundaries. *Massive Change.* London: Phaidon Press Ltd., 2004.

McCann, Michael. *Health Hazards: Manual for Artists,* 6th ed. Guilford, CT: The Lyons Press, 2003.

McCarter, R. William, and Rita Gilbert. *Living with Art,* 2nd ed. New York: McGraw-Hill, 1988.

Morrison, Philip and Phylis Morrison and The Office of Charles and Ray Eames. *Powers of Ten.* New York: Scientific American Books, 1982.

Nervi, Pier Luigi. *Aesthetics and Technology in Building.* Cambridge, MA: Harvard University Press, 1965.

Oka, Hideyuki. *How to Wrap Five Eggs.* Boston & London: Weatherhill, 2008.

Patin, Thomas, and Jennifer McLerran. *Artwords.* Westport, CT: Greenwood Press, 1997.

Preble, Duane, and Sarah Preble. *Artforms: An Introduction to the Visual Arts,* 5th ed. New York: HarperCollins, 1993.

Rader, Melvin, ed. *A Modern Book of Esthetics.* New York: Holt, Rinehart and Winston, 1962.

Reps, Paul, ed. *Zen Flesh, Zen Bones.* Garden City, NY: Anchor Books, 1989.

Rossol, Monona. *The Artist's Complete Health and Safety Guide,* 3rd ed. New York: Allworth Press, 2001.

Roth, Richard, and Susan Roth. *Beauty Is Nowhere: Ethical Issues in Art and Design.* Amsterdam: Gordon and Breach, 1998.

Rudofsky, Bernard. *Architecture without Architects.* Garden City, NY: The Museum of Modern Art, 1965.

Silk, Gerald. *The Automobile and Culture.* New York: Harry N. Abrams, 1984.

Thompson, D'Arcy Wentworth. *On Growth and Form: The Complete Revised Edition.* Mineola, NY: Dover Publications, 1992.

Tufte, Edward R. *Visual Explanations: Images and Quantities, Evidence and Narrative.* New Haven, CT: Graphics Press, 1996.

Yanagi, Sōetsu. *The Unknown Craftsman.* Tokyo: Kodansha International Ltd., 1972.

Art History

Arnason, H. H. *History of Modern Art,* 3rd rev. ed. New York: Harry N. Abrams, 1986.

Janson, H. W. *History of Art,* 4th rev. and enl. ed. New York: Harry N. Abrams, 1991.

Kleiner, Fred S. *Gardner's Art through the Ages,* 13th ed. Boston: Cengage Learning, 2009.

Nelson, Robert S., and Richard Shiff, eds. *Critical Terms for Art History.* Chicago: The University of Chicago Press, 1996.

Reimschneider, Burkhard, and Uta Grosenick, eds. *Art at the Turn of the Millennium.* Köln, Germany: Taschen GMBH, 1999.

Smagula, Howard. *Currents,* 2nd ed. Englewood Cliffs, NJ: Prentice-Hall, 1989.

General Design

Bacon, Edmund. *The Design of Cities.* New York: Viking Penguin, 1967.

Bevlin, Marjorie Elliot. *Design through Discovery,* 6th ed. Fort Worth, TX: Harcourt Brace College Publishers, 1994.

Bothwell, Dorr, and Marlys Frey. *Notan: The Dark-Light Principle of Design.* New York: Dover, 1991.

Collier, Graham. *Form, Space and Vision: An Introduction to Drawing and Design,* 4th ed. Englewood Cliffs, NJ: Prentice-Hall, 1985.

De Lucio-Meyer, J. *Visual Aesthetics.* New York: Harper & Row, 1974.

De Sausmarez, Maurice. *Basic Design: The Dynamics of Visual Form.* Blue Ridge Summit, PA: TAB Books, 1990.

Hoffman, Armin. *Graphic Design Manual.* New York: Van Nostrand Reinhold, 1977.

Hurlburt, Allen. *The Design Concept.* New York: Watson-Guptill Publications, 1981.

Hurlburt, Allen. *The Grid.* New York: Van Nostrand Reinhold, 1982.

Hurlburt, Allen. *Layout: The Design of the Printed Page.* New York: Watson-Guptill Publications, 1989.

Itten, Johannes. *Design and Form: The Basic Course at the Bauhaus,* 2nd rev. ed. New York: Van Nostrand Reinhold, 1975.

Kepes, Gyorgy. *Language of Vision.* Chicago: Paul Theobald, 1969.

Kerlow, Isaac Victor, and Judson Rosebush. *Computer Graphics.* New York: Van Nostrand Reinhold, 1986.

Maier, Manfred. *Basic Principles of Design.* New York: Van Nostrand Reinhold, 1977.

Mante, Harald. *Photo Design: Picture Composition for Black and White Photography.* New York: Van Nostrand Reinhold, 1971.

Margolin, Victor. *Design Discourse.* Chicago: University of Chicago Press, 1989.

Mau, Bruce. *Life Style.* New York: Phaidon Press, 2005.

McKim, Robert H. *Thinking Visually.* New York: Van Nostrand Reinhold, 1980.

Murphy, Pat. *By Nature's Design.* San Francisco: Chronicle Books, 1993.

Myers, Jack Frederick. *The Language of Visual Art.* Orlando, FL: Holt, Rinehart and Winston, 1989.

Stoops, Jack, and Jerry Samuelson. *Design Dialogue.* Worcester, MA: Davis Publications, 1983.

Wilde, Richard. *Problems, Solutions: Visual Thinking for Graphic Communications.* New York: Van Nostrand Reinhold, 1989.

Wong, Wucius. *Principles of Three-Dimensional Design.* New York: Van Nostrand Reinhold, 1977.

Wong, Wucius. *Principles of Two-Dimensional Design.* New York: Van Nostrand Reinhold, 1972.

Zelanski, Paul, and Mary Pat Fisher. *Shaping Space.* Belmont, CA: Thompson Wadsworth, 2007.

Visual Perception

Arnheim, Rudolf. *Art and Visual Perception: A Psychology of the Creative Eye, the New Version,* 2nd rev. and enl. ed. Berkeley: University of California Press, 1974.

Bloomer, Carolyn M. *Principles of Visual Perception,* 2nd ed. New York: Van Nostrand Reinhold, 1989.

Ehrenzweig, Anton. *The Hidden Order of Art: A Study in the Psychology of Artistic Imagination.* Berkeley: University of California Press, 1976.

Gombrich, E. H. *Art and Illusion: A Study in the Psychology of Pictorial Representation.* Princeton, NJ: Princeton University Press, 1961.

Köhler, Wolfgang. *Gestalt Psychology: An Introduction to New Concepts in Modern Psychology.* New York: Liveright Publishing Corporation, 1947.

Space

Carraher, Ronald G., and Jacqueline B. Thurston. *Optical Illusions and the Visual Arts.* New York: Van Nostrand Reinhold, 1966.

Coulin, Claudius. *Step-by-Step Perspective Drawing: For Architects, Draftsmen and Designers.* New York: Van Nostrand Reinhold, 1971.

D'Amelio, Joseph. *Perspective Drawing Handbook.* New York: Leon Amiel, Publisher, 1964.

Doblin, Jay. *Perspective: A New System for Designers,* 11th ed. New York: Whitney Library of Design, 1976.

Ivins, William M., Jr. *On the Rationalization of Sight: With an Examination of Three Renaissance Texts on Perspective to Which Is Appended "De Artificiali Perspectiva" by Viator (Pelerin).* New York: Da Capo Press, 1973.

Luckiesh, M. *Visual Illusions: Their Causes, Characteristics and Applications.* New York: Dover Publications, 1965.

Montague, John. *Basic Perspective Drawing,* 2nd ed. New York: Van Nostrand Reinhold, 1993.

Mulvey, Frank. *Graphic Perception of Space.* New York: Van Nostrand Reinhold, 1969.

White, J. *The Birth and Rebirth of Pictorial Space,* 3rd ed. Cambridge, MA: Harvard University Press, 1987.

Texture

Battersby, Marton. *Trompe-l'Oeil: The Eye Deceived.* New York: St. Martin's Press, 1974.

O'Connor, Charles A., Jr. *Perspective Drawing and Applications.* Englewood Cliffs, NJ: Prentice-Hall, 1985.

Proctor, Richard M. *The Principles of Pattern: For Craftsmen and Designers.* New York: Van Nostrand Reinhold, 1969.

Wescher, Herta. *Collage.* New York: Harry N. Abrams, 1968.

Color

Albers, Josef. *Interaction of Color,* rev. ed. New Haven, CT: Yale University Press, 1975.

Birren, Faber. *Creative Color: A Dynamic Approach for Artists and Designers.* New York: Van Nostrand Reinhold, 1961.

Birren, Faber. *Ostwald: The Color Primer.* New York: Van Nostrand Reinhold, 1969.

Birren, Faber. *Principles of Color,* rev. ed. West Chester, PA: Schiffer Publishing, Limited, 1987.

Birren, Faber, ed. *Itten: The Elements of Color.* New York: Van Nostrand Reinhold, 1970.

Birren, Faber, ed. *Munsell: A Grammar of Color.* New York: Van Nostrand Reinhold, 1969.

De Grandis, Luigina. *Theory and Use of Color.* New York: Harry N. Abrams, 1987.

Fabri, Frank. *Color: A Complete Guide for Artists.* New York: Watson-Guptill, 1967.

Gage, John. *Color in Art.* New York: Thames & Hudson, 2006.

Gerritsen, Frank J. *Theory and Practice of Color.* New York: Van Nostrand Reinhold, 1974.

Itten, Johannes. *The Art of Color,* rev. ed. New York: Van Nostrand Reinhold, 1984.

Kippers, Harald. *Color: Origin, Systems, Uses.* New York: Van Nostrand Reinhold, 1973.

Pentak, Stephen, and Richard Roth. *Color Basics.* Belmont, CA: Wadsworth/Thomson, 2003.

Porter, Tom, and Byron Mikellides. *Color for Architects.* New York: Van Nostrand Reinhold, 1976.

Rhode, Ogden N. *Modern Chromatics: The Student's Textbook of Color with Application to Art and Industry,* new ed. New York: Van Nostrand Reinhold, 1973.

Varley, Helen, ed. *Color.* Los Angeles: Knapp Press, 1980.

Verity, Enid. *Color Observed.* New York: Van Nostrand Reinhold, 1980.

Zelanski, Paul, and Mary Pat Fisher. *Color.* Englewood Cliffs, NJ: Prentice-Hall, 1989.

Frontmatter: v *t* Courtesy of the School of Visual Arts; *c* Image © Estate of Charles Harper. Photo courtesy of Charley Harper Art Studio; *b* Photograph by G.R. Christmas, courtesy The Pace Gallery © Thomas Nozkowski, courtesy The Pace Gallery; **vi** *t* Glen Holland and Michelle Herman; *c* Erich Lessing/Art Resource, NY; *b* Niklaus Troxler; **vii** *t* © Ellsworth Kelly and Maeght Editeur, Paris; *c* Courtesy of Elliot Barnathan; **viii** *t* © Richard Meier, Licensed by SCALA/Art Resource, NY; *c* © Ellsworth Kelly. Collection of the artist; *b* Lola Moreno and Ramon Rosanas; **ix** *t* Ardine Nelson; *c* Alan Cote; *b* William Wegman; **x** *t* Andrea Jemolo/Scala/Art Resource, NY; *b* © Prisma/SuperStock; **xi** *t* Russell Mountford/Lonely Planet Images/Getty Images; *c* Morey Milbradt/Brand X Pictures/Getty Images; *b* Morey Milbradt/Brand X Pictures/Getty Images; **xii** *t* Francesco Chinazzo/Shutterstock; *c* Scala/Art Resource, NY; *b* Stockbyte/Getty Images; **xiv** © Charles E. Burchfield, The Burchfield Penney Art Center. Munson-Williams-Proctor Arts Institute/Art Resource, NY.

Chapter 1: 1 (from top to bottom) Courtesy of the School of Visual Arts; Image © Estate of Charles Harper. Photo courtesy of Charley Harper Art Studio; Photograph by G.R. Christmas, courtesy The Pace Gallery © Thomas Nozkowski, courtesy The Pace Gallery; Glen Holland and Michelle Herman; Erich Lessing/Art Resource, NY; Niklaus Troxler; **2** © Bruce Eric Kaplan/The New Yorker Collection/www.cartoonbank.com; **4A** © 1983 John Kuchera; **4B** Steve Mehalo, http://www.anotherposterforpeace.org; **5C** Marty Neumeier, http://www.anotherposterforpeace.org; **6A** Poster for Amnesty International. Stephan Bundi, Art Director and Designer; Atelier Bundi, Bern, Switzerland; **7B** Andy Goldsworthy; **7C** Paul Breitzmann; **8A** Copyright Claes Oldenburg and Coosje van Bruggen, 1993; **8B** Courtesy of the School of Visual Arts; **9C** Collection of Daryl Gerber Stokols and Jeffery M. Stokols, Chicago; **10A-B** Raymond Loewy, Industrial Design (Woodstock, NY: Overlook Press). Copyright © 1988 Raymond Loewy; **11C** Chris Rooney; **11D** © Museum of Fine Arts, Boston. Gift of Governor Carlton Skinner and Solange Skinner, 2002 Accession number: 2002.789; **12A** By permission of Aerospace Publishing Limited, London; **12B** By permission of Dorling Kindersley Ltd., London; **13C** Reproduced by permission of the American Museum in Britain, Bath; **13D** Rune Hellestad/Corbis; **14A** © Copyright The Estate of Arthur Dove, courtesy of Terry Dinenfass, Inc. Image: Munson-Williams-Proctor Arts Institute/Art Resource, NY; **14B** © 2010 Georgia O'Keeffe Museum/Artists Rights Society (ARS), New York. Photograph courtesy of The National Gallery of Art, Washington, DC Alfred Stieglitz Collection, Bequest of Georgia O'Keeffe; **15C-D** Collection © 2010 Her Majesty Queen Elizabeth II; **16A** Photography by Jeffery Nintzel 2008. Hood Museum of Art; **16C** Lauren Orr, Dartmouth College '08. Hood Museum of Art; **17C-D** © Nancy Crow; **18A** Réunion des Musées Nationaux/Art Resource, NY; **18B** © 2010 Estate of Pablo Picasso/Artists Rights Society (ARS), New York. Digital Image © The Museum of Modern Art/Licensed by SCALA/Art Resource, NY; **19C** © Robert Colescott. Image courtesy, Phyllis Kind Gallery, New York and Andrea Coos; **19D** Betty Crocker Through The Years, Courtesy of General Mills Archives; **20A** © The Estate of Eva Hesse. Hauser & Wirth Zurich, London; **20B** Sarah Weinstock, Untitled Drawing. 2006. Ink and soap bubbles on paper; **21C** Art © Estate of David Smith. Licensed by VAGA, New York, NY. Courtesy Gagosian Gallery. Photography by Robert McKeever; **21D** Art © Estate of David Smith//Licensed by VAGA, New York, NY Image copyright © The Metropolitan Museum of Art/Art Resource, NY; **22A-B** © 2010 Succession H. Matisse/Artists Rights Society (ARS), New York. Photograph: © The Baltimore Museum of Art; **23C** Meredith Reuter; **24A** Courtesy of the Author; **25B** Courtesy of the Author; **25C** Courtesy Gagosian Gallery, New York, with permission from the estate of Mark Tansey.

Chapter 2: 26 © 1959 Peter Arno. The New Yorker Collection/cartoonbank.com; **28A** Art © Wayne Thiebaud/Licensed by VAGA, New York, NY; **29B** Damon Winter, Communication Arts, May/June 2005; **29C** Art © Alex Katz/Licensed by VAGA, New York, NY; **30A** © 2010 Karl Blossfeldt Archiv/Ann u. Jürgen Wilde, Köln/Artists Rights Society (ARS), NY; **31B** Photograph © 2008 Museum of Fine Arts, Boston, 19.124; **31C** Hoefler & Frere-Jones; **32A-D** Cengage Learning; **33E** Courtesy Gagosian Gallery, New York. © Richard Prince; **33F** Alex Bartel/SPL/ Photo Researchers, Inc; **34A-B** Cengage Learning; **35C** Amon Carter Museum, Ft Worth, Texas. Purchased by the Friends of Art, Fort Worth Art Association, 1925; acquired by the Amon Carter Museum, 1990, from the Modern Art Museum of Fort Worth through grants and donations from the Amon G. Carter Foundation, the Sid W. Richardson Foundation, the Anne Burnett and Charles Tandy Foundation, Capital Cities/ABC Foundation, Fort Worth Star-Telegram, The R.D. and Joan Dale Hubbard Foundation and the people of Fort Worth. 1990.19.1. **35D** © 2010 Artists Rights Society (ARS), New York/VG Bild-Kunst, Bonn. Digital Image © The Museum of Modern Art/Licensed by SCALA/Art Resource, NY; **36A** © 2010 Artists Rights Society (ARS), New York/ProLitteris, Zurich. Photograph courtesy of Kunstmuseum Bern; **36B** Joe Miller's Design Co; **37C** Don Bachardy UNTITLED II, AUGUST 19 1985. Courtesy the artist and Cheim & Read, New York; **38A-B** Cengage Learning; **38C** © 2010 Artists Rights Society (ARS), New York/ADAGP, Paris. The John R. Van Derlip Fund and the William Hood Dunwoody Fund: The Minneapolis Institute of Arts; **39D** Janet Borden, Inc; **39E** 2004 BMW of North America, LLC, used with permission. The BMW and logo are registered trademarks; **40A-B** Cengage Learning; **41C** Wood/Phillips; **42A-C** Cengage Learning; **43D** © 2010 Artists Rights Society (ARS), New York/VG Bild-Kunst, Bonn. Photograph courtesy of the Solomon R. Guggenheim Museum, New York; **43E** Art © Robert Rauschenberg/Licensed by VAGA, New York, New York. Digital image © The Metropolitan Museum of Art/Art Resource, NY; **43F** Smithsonian American Art Museum, Washington, DC./Art Resource, NY. With permission from the family of Alfonso Roybal, aka Awa Tsireh, San Idelfonso Pueblo, New Mexico; **44A** Image © Estate of Charles Harper. Photo courtesy of Charley Harper Art Studio; **45B** Albright-Knox Art Gallery/Art Resource, NY; **45C** Eva Zeisel Classic Century produced by Royal Stafford, England; **46A** Reza, National Geographic Services; **47B** Irises (folding screen), Korin, Ogata (1658-1716)/ Nezu Art Museum, Tokyo, Japan/The Bridgeman Art Library International; **47C** © 2010 Artists Rights Society (ARS), New York/VG Bild-Kunst, Bonn. Photograph Courtesy of the Artist and Yossi Milo Gallery, New York; **48A** Erich Lessing/Art Resource, NY; **48B** © Copyright Elizabeth Murray. Digital Image © The Museum of Modern Art/Licensed by SCALA/Art Resource, NY; **49C** Norton Simon Museum, Pasadena (gift of Molly Barnes, 1969); **50A** Michael Dwyer/Stock Boston; **51B** Tom McHugh/Photo Researchers, Inc; **51C** Courtesy of Gehry Design, Santa Monica, CA; **52A** Réunion des Musées Nationaux/Art Resource, NY; **53B** © 2010 Estate of Pablo Picasso/Artists Rights Society (ARS), New York. Digital Image © The Museum of Modern Art/Licensed by SCALA/Art Resource, NY.

Chapter 3: 54 © 1946 Whitney Darrow, Jr. The New Yorker Collection/cartoonbank.com; **56A** Tibor de Nagy Gallery, New York; **57B** © 2010 Succession H. Matisse/Artists Rights Society (ARS), New York. Photograph © St. Louis Art Museum, Missouri, USA/The Bridgeman Art Library; **57C** Photo courtesy Chase Manhattan Bank Collection; **58A** Yale Center for British Art, Paul Mellon Collection, USA/The Bridgeman Art Library; **58B** © 2010 Artists Rights Society (ARS), New York/SABAM, Brussels. Photo: A.K.G., Berlin/Superstock; **59C** Columbus Dispatch, Columbus, Ohio; **59D** Photograph by G.R. Christmas, courtesy The Pace Gallery © Thomas Nozkowski, courtesy The Pace Gallery; **60A** Luca Vignelli; **60B** Courtesy of the University of Pennsylvania Art Collection, Philadelphia, Pennsylvania. (1889.0001); **61C** Réunion des Musées Nationaux/Art Resource, NY; **62A** Courtesy of Susan Moore; **62B** © The Samuel Courtauld Trust, The Courtauld Gallery, London; **63C** HIP/Art Resource, NY; **64A** Lino/AGoodson.com; **64B** © 2010 Estate of Pablo Picasso/Artists Rights Society (ARS), New York. Digital Image © The Museum of Modern Art/Licensed by SCALA/Art Resource, NY; **65C** Reactor Art and Design; **65D** Christopher Sturman; **66A** © 2010 The Pollock-Krasner Foundation/Artists Rights Society (ARS), New York. Photo © 2004 The Museum of Modern Art/Art Resource, NY; **66B** Mark Keffer/Esopus Magazine; **67C** Chaz Maviyane-Davies.

Chapter 4: 68 © James Stevenson/The New Yorker Collection/www.cartoonbank.com; **70A** © 1993 Richard Roth; **71B** Glen Holland and Michelle Herman; **71C** Photograph © 1992 The Metropolitan Museum of Art/Art Resource, NY; **72A** Photograph © 1997 The Metropolitan Museum of Art; **72B** Réunion des Musées Nationaux/Art Resource, NY; **73C** © Board of Trustees, National Gallery of Art, Washington; **73D** Photo Researchers; **74A** © Howard Hodgkins, Christie's Images/CORBIS; **75B-C** © 2010 Andreas Gursky/Artists Rights Society (ARS), New York/VG Bild-Kunst, Bonn. Image courtesy of the Matthew Marks Gallery, New York; **76A** Cengage Learning; **77B** Nicolo Orsi Battaglini/Art Resource, NY; **77C** Statens Museum for Kunst, Copenhagen, KMS 6202. photo © and by permission of Stiftung Seebull Ada & Emil Nolde, Neukirchen, Germany; **78A** Mark Fennessey. Yale University Art Gallery (transfer from the Yale Art School); **78B** Courtesy Gilbert Li; **79C** From the series Landscapes of the Future Communist spared Station "Jupiter", erected in the year 2737, watercolour & black pen on paper, 17.5 x 25 cm, 2009. © Copyright Pavel Pepperstein; **79D** JOHN MOORE Blue Stairway, 1998 Oil on canvas, 28 x 24 in. Image courtesy of Hirschl & Adler Modern; **80A** © 2010 C. Herscovici, London/Artists Rights Society (ARS), New York. Location: Private Collection. Banque d'Images, ADAGP/Art Resource, NY; **80B** Courtesy New York-New York Hotel & Casino LLC, Las Vegas; **81C** Courtesy Regen Projects, Los Angeles, CA; **81D** Fernando Botero, courtesy Marlborough Gallery, New York; **82A** Cengage Learning; **82B** Board of Trustees, National Gallery of Art, Washington; **83C** Réunion des Musées Nationaux/Art Resource, NY; **83D** © 2010 Estate of Pablo Picasso/Artists Rights Society (ARS), New York. Digital Image © The Museum of Modern Art/Licensed by SCALA/Art Resource, NY; **84A** Cengage Learning; **84B** Réunion des Musées Nationaux/Art Resource, NY; **85C** Scala/Art Resource, NY; **85D** Timothy Remus.

Chapter 5: 86 David Lauer; **88A** Paris, Bibliothèque Nationale de France, Cabinet des Estampes; **88B** © 2010 The Josef and Anni Albers Foundation/Artists Rights Society (ARS), New York; **89C** Cengage Learning; **89D** © 2010 Estate of Pablo Picasso/Artists Rights Society (ARS), New York. Digital Image © The Museum of Modern Art/Licensed by SCALA/Art Resource, NY; **90A** Smithsonian American Art Museum, Washington, DC/Art Resource, NY; **90B** Réunion des Musées Nationaux/Art Resource, NY; **91C** Sheldon Museum of Art, University of Nebraska-Lincoln, UNL-Gift of Wallis, Jamie, Sheri and Kay in memory of their parents, Joan Farrar Swanson and James Hovland Swanson. Photo Sheldon Museum of Art; **91D** Advertisement for Betty Cunningham Gallery. Art in America, April 2005; **92A-B** THE KOBAL COLLECTION/Picture Desk; **93C** Art © Alex Katz/Licensed by VAGA, New York, NY. Courtesy Timothy Taylor Gallery; **93D** The Bridgeman Art Library/Getty Images; **94A** © Ed Ruscha. Courtesy Gagosian Gallery. Photograph by Robert McKeever; **95B** Photograph courtesy the artist and The Pace Gallery © Hiroshi Sugimoto, courtesy The Pace Gallery; **95C** Courtesy of the artist and Jean Albano Gallery, Chicago; **96A** © Nan Goldin 1994; **96B** Courtesy Haim Steinbach; **97C** Vision/Cordelli/Photodisc/Getty Images; **98A** Cengage Learning; **98B** © The Metropolitan Museum of Art/Art Resource, NY; **98C** Illustration by Kristian Russell/Art Department. Published 2000 by Harry N. Abrams, Inc, NYC, 100 5th Ave , New York, NY 10011; **99D** Offrant le Panal au Torero, 1873 (oil on canvas), Cassatt, Mary Stevenson (1844-1926)/Sterling & Francine Clark Art Institute, Williamstown, USA/The Bridgeman Art Library International; **100A-B** Cengage Learning; **100C** © 1991 The Metropolitan Museum of Art/Art Resource, NY; **101D** The Art Institute of Chicago; **102A** Cengage Learning; **102B** The Granger Collection, New York; **103C** The Annunciation, 1442 (fresco), Angelico, Fra (Guido di Pietro) (c.1387-1455)/Museo di San Marco dell'Angelico, Florence, Italy/The Bridgeman Art Library International; **104A** Digital Image © The Museum of Modern Art/Art Resource, NY; **104C** Erich Lessing/Art Resource, NY; **105C** Courtesy of Estate of Garry Winogrand, Center for Creative Photography, University of Arizona; **106A** Jerold & Linda Waldman/Bruce Coleman/Photoshot; **106B** Courtesy Donald Yound Gallery, Chicago and Andrea Rosen Gallery, New York; **107C** © Nancy Crow, published in Nancy Crow: Quilts and Influences (American Quilters Society); used by permission;

by SCALA/Art Resource, NY; **223C** Agnes Gund Collection, New York. Photo: Jim Strong; **223D** Art © Alex Katz/Licensed by VAGA, New York, NY; **224 A-C** Cengage Learning; **225D** Designer: Jennifer C. Bartlett. Design firm: Vickerman-Zachary-Miller (VZM Transystems), Oakland, California; **225E** Art © Al Held Foundation/Licensed by VAGA, New York, NY. Photo: Oeffentliche Kunstsaammlung Basel, Martin Buhler; **226A** The Metropolitan Museum of Art/Art Resource, NY; **227B** Réunion des Musées Nationaux/Art Resource, NY; **227C** Addison Gallery of American Art, Phillips Academy, Andover, Massachusetts.

Chapter 11: 228 © 1995 Sam Gross. The New Yorker Collection/cartoonbank.com; **230A** Erich Lessing/Art Resource, NY; **230B** Réunion des Musées Nationaux/Art Resource, NY; **231C** Harold & Esther Edgerton Foundation, 2003, courtesy of Palm Press, Inc; **231D** Henri Cartier-Bresson/Magnum Photos; **232A** © 2010 Artists Rights Society (ARS), New York/VG Bild-Kunst, Bonn. Digital Image © The Museum of Modern Art/Licensed by SCALA/Art Resource, NY; **232B** © 2010 Artists Rights Society (ARS), New York/VG Bild-Kunst, Bonn. Digital Image © The Museum of Modern Art/Licensed by SCALA/Art Resource, NY; **233C** Yellow Dog Productions/Getty Images; **234A** V&A Images/Victoria and Albert Museum; **234B** Lola Moreno and Ramon Rosanas; **235C** AP Photo; **235D** Calvin and Hobbes. © 1985 Watterson. Reprinted with permission of Universal Press Syndicate. All rights reserve; **236A** Courtesy of Elliot Barnathan; **236B** © The Metropolitan Museum of Art/Art Resource, NY; **236C** Siena College Athletics; **236D** National Football League; **237E** Gizmachine, Inc. 1989. All Rights Reserved; photo: Timothy Remus; **238A** © The Metropolitan Museum of Art/Art Resource, NY; **239B** Feng Li/Getty Images; **239C** © 2010 Artists Rights Society (ARS), New York/ADAGP, Paris/Succession Marcel Duchamp. Photograph © The Philadelphia Museum of Art. The Louise and Walter Arensberg Collection, 1950/Art Resource, New York; **239D** John Baldessari; **240A** Photo by John Houston; **241B** Niklaus Troxler; **241C** From the collection of Faith and Stephen Brown; **241D** © 2010 Estate of Pablo Picasso/Artists Rights Society (ARS), New York. Digital Image © The Museum of Modern Art/Licensed by SCALA/Art Resource, NY.

Chapter 12: 242 © 1967 William O'Brian. The New Yorker Collection/cartoonbank. com; **244A** Cengage Learning; **244B** Ardine Nelson; **245C** Susan Moore; **245D** Courtesy: jointadventures.org photo: Stephan Köhler; **246A** Judith and Holofernes (panel), Gentileschi, Artemisia (1597-c.1651)/Museo e Gallerie Nazionali di Capodimonte, Naples, Italy/The Bridgeman Art Library International; **246B** Réunion des Musées Nationaux/Art Resource, NY; **247C** © 2010 Estate of Pablo Picasso/Artists Rights Society (ARS), New York. Digital Image © The Museum of Modern Art/Licensed by SCALA/Art Resource, NY; **247D-E** © 2010 Succession H. Matisse, Paris/Artists Rights Society (ARS), New York. Digital Image © The Museum of Modern Art/Licensed by SCALA/Art Resource, NY; **248A** Portland Museum of Art, Portland, Maine (bequest of Charles Shipman Payson, 1881.1); **249B** © The Metropolitan Museum of Art/Art Resource, NY; **249C-D** Andy Goldsworthy; **250A** Courtesy: ACA Galleries, NY; **250B** Collection of North Carolina National Bank; **251C** Edward Burtynsky/Toronto Image Works; **251D** 1984 Sue Coe. Courtesy Galerie St. Etienne, New York; **252A** Walter Hatke; **252B** © 2010 Artists Rights Society (ARS), New York/SIAE, Rome. Photo: Luciano Calzolari, Bologna, Italy; **252C** Arkansas Arts Center Foundation Collection: Purchased with a gift from Helen Porter and James T. Dyke, 1993 (93.035); **253D** Yale University Art Gallery, New Haven (Everett V. Meeks Fund); **253E** Art Director: Alan Aboud. Photographer: Sandro Sodano. Computer Manipulation: Nick Livesey, Alan Aboud, Sandro Sodano.

Chapter 13: 254 © 2004 Jack Ziegler/Cartoonbank.com; **257A-B** Cengage Learning; **258A** Tate, London/Art Resource, NY; **258B** The Philadelphia Museum of Art/Art Resource, NY; **259C** Cengage Learning; **260A** Cengage Learning; **261B** Courtesy of Gretag Macbeth, New Windsor, NY; **262A** Cengage Learning; **263B-C** Cengage Learning; **264A-B** Cengage Learning; **264C** Domus Design Collection, New York; **265D** Giraudon/The Bridgeman Art Library; **266A** © Adobe Systems; **267B-D** Gamblin Artists Colors Co; **268A** Photograph by Ellen Page Wilson, courtesy The Pace Gallery © Chuck Close, courtesy The Pace Gallery; **268B** Photograph by Ellen Page Wilson, courtesy The Pace Gallery © Chuck Close, courtesy The Pace Gallery; **269C** House of Tartan Ltd. Perthshire, Scotland; **270A** Photo by Michael Moran Courtesy P.S.1 Contemporary Art Center; **270B** Cengage Learning; **271C** Neil Welliver, Courtesy Alexandre Gallery; **272A** Cengage Learning; **272B** Glide Dental Floss Campaign. Saatchi & Saatchi, New York. Creative Director: Tony Granger, Jan Jacobs, Leo Premutico. Art Director: Menno Kluin. Copywriter: Icaro Doria. Photo: Jenny van Sommers; **273C** Andy Goldsworthy; **274B-C** © 2010 Successió Miró/Artists Rights Society (ARS), New York/ADAGP, Paris. Digital Image © The Museum of Modern Art/Licensed by SCALA/Art Resource, NY; **274A** Art © Wayne Thiebaud/Licensed by VAGA, New York, NY; **275E** Réunion des Musées Nationaux/Art Resource, NY; **275D** © 2010 Estate of Pablo Picasso/Artists Rights Society (ARS), New York. Digital Image © The Museum of Modern Art/Licensed by SCALA/Art Resource, NY; **276A** Courtesy Crystal Bridges Museum of American Art, Bentonville, Arkansas; **277B** Alan Cote; **277C** 1980 David Hockney; photo © 2006 Museum Associates/LACMA; **278A** Mark Tansey, Collection of Emily Fisher Landau, New York; **279B** Natural History Museum of Los Angeles County (William Randolph Hearst Collection, A.5141.42–153); **279C** © Elizabeth Peyton. Image courtesy of Gavin Brown's Enterprise; **280A** Art © Estate of Stuart Davis/Licensed by VAGA, New York, NY. Digital Image © The Museum of Modern Art/Licensed by SCALA/Art Resource, NY; **280B** Van Gogh Museum, Amsterdam, The Netherlands/The Bridgeman Art Library; **281C** Scala/Art Resource, NY; **282A-B** Cengage Learning; **282C** Art © Estate of Wolf Kahn/Licensed by VAGA, New York, NY; **283E** Deborah Pentak; **284A** © 2010 Artists Rights Society (ARS), New York/SIAE, Rome Photo: Luciano Calzolari, Bologna, Italy; **285B** The Ohio State University Department of Theatre; **285C** © 2010 Milton Avery Trust/Artists Rights Society (ARS), New York. Image copyright © The Metropolitan Museum of Art/Art Resource, NY; **286A** © 2010 Estate of Pablo Picasso/Artists Rights Society (ARS), New York. Photograph,

courtesy Staatsgalerie Stuttgart; **286B** Chicago Historical Society; **287C** Art © Estate of Leon Golub/Licensed by VAGA, New York, NY. Photo, Courtesy Ronald Feldman Fine Arts; **287D** © 2010 Estate of Hans Hofmann/Artists Rights Society (ARS), New York. Photo © The Art Institute of Chicago; **288A** Goal AG; **289D** Euro RSCG Zurich, Frank Bodin.

Chapter 14: 290 Andrea Jemolo/Scala/Art Resource, NY; **292** S. Department of Defense/Photo Researchers, Inc.; **294** Dimitri Vervitsiotis/Getty Images; **294** Just One Film/Getty Images; **294** Image Source/Getty Images; **295A** hammernet; **296A** Vanni/Art Resource, NY © 2011 Artists Rights Society (ARS), New York/VG Bild-Kunst, Bonn; **297B** © 2011 The Josef and Anni Albers Foundation, Artist's Rights Society (ARS), NY. Photo © Art Resource, NY; **298** William Wegman; **299A** Courtesy of Stephen Pentak; **299B** Courtesy of Stephen Pentak; **300A** Digital Image © 2009 Museum Associates/LACMA/Art Resource, NY © 2011 Artists Rights Society (ARS), New York/ADAGP, Paris; **301B** Historic New England; **302A** Tom McHugh/Photo Researchers, Inc.; **302B** IndexStock/SuperStock; **303C** NASA, Hubble Heritage Team, (STScI/AURA), ESA, S. Beckwith (STScI). Additional Processing: Robert Gendler; **303D** Exactostock/SuperStock; **304A** Comstock Images/Jupiterimages/Getty Images; **305B** BMW PressClub; **306A** Haim Steinbach; **307** Fred Wilson/The Pace Gallery; **308A** Art Resource, NY © 2011 Frank Lloyd Wright Foundation, Scottsdale, AZ/Artists Rights Society (ARS), NY; **309B** Wolfgang Volz © 1983 Christo; **309C** Wim Delvoye; **310A** Virginia Commonwealth University Art Foundation Program, photo: Matt King; **311B** Virginia Commonwealth University Art Foundation Program, photo: Matt King.

Chapter 15: 312 Jessica Hilltout; **314A** Russell Stewart; **314B** Courtesy of Cervèlo; **315C** Courtesy of Cervèlo; **315D** Natalie Jeremijenko/Massachusetts Museum of Contemporary Art; **316A** Digital Image Photo credit: The Museum of Modern Art/Licensed by SCALA/Art Resource, NY; **316B** Digital Image © The Museum of Modern Art/Licensed by SCALA/Art Resource, NY; **317C** © Owen Franken/CORBIS; **317D** Joe McNally/Getty Images Entertainment/Getty Images; **318A** © Heritage Images/Corbis; **318B** Louie Psihoyos/Science Faction Jewels/Getty Images; **319C** Image copyright © The Metropolitan Museum of Art/Art Resource, NY; **319D** Photo: Marco Melander. Copyright Stefan Lindfors; **320A** Mike Quinn, National Park Service Photo; **321B** Bruce Barnbaum; **321C** Richard Barnes; **322A** Steve Gorton/Dorling Kindersley/Getty Images; **323B** The Peck Tool Company; **323C** Yoshikazu Tsuno/AFP/Getty Images; **324A** Scala/Art Resource, NY; **325B** Photography courtesy The Pace Gallery © Tara Donovan, courtesy The Pace Gallery; **325C** Photography courtesy The Pace Gallery © Tara Donovan, courtesy The Pace Gallery; **325D** Allen Memorial Art Museum, Oberlin College, Ohio; Gift of Philip Droll, and the direction of Donald Droll, In Honor of Richard E. Spear, Director. © 2011 Estate of Scott Burton/Artists Rights Society (ARS), NY; **326A** Digital Image from The Museum of Modern Art/Licensed by SCALA/Art Resource, NY © 2011 Succession H. Matisse/Artists Rights Society (ARS), New York; **326B** Digital Image from The Museum of Modern Art/Licensed by SCALA/Art Resource, NY © 2011 Succession H. Matisse/Artists Rights Society (ARS), New York; **326C** Digital Image from The Museum of Modern Art/Licensed by SCALA/Art Resource, NY © 2011 Succession H. Matisse/Artists Rights Society (ARS), New York; **326D** Digital Image from The Museum of Modern Art/Licensed by SCALA/Art Resource, NY © 2011 Succession H. Matisse/Artists Rights Society (ARS), New York; **327E** SITE | architecture, art & design; **327F** SITE: architecture, art & design; **327G** Collection of the Ohr-O'Keefe Museum of Art; **328A** © 2012 The LeWitt Estate/Artists Rights Society (ARS), New York; photo courtesy San Francisco Museum of Modern Art; **329B** Courtesy the artist and James Cohan Gallery, New York/Shanghai; **329C** Mike Kemp Images/The Image Bank/Getty Images; **330A** © 2012 The LeWitt Estate/Artists Rights Society (ARS), New York; photo courtesy San Francisco Museum of Modern Art; **331B** Wim Delvoye; **332A** © Andrè Kertesz—RMN Photo: National Portrait Gallery, Smithsonian Institution/Art Resource, NY; **333B** Photo: R. Notkin; **333C** Rèunion des Musèes Nationaux/Art Resource, NY © 2011 Estate of Pablo Picasso/Artists Rights Society (ARS), New York; **334A** © Donald Judd Photography by Ellen Wilson, courtesy The Pace Gallery. © Judd Foundation. Licensed by VAGA, New York, NY; **335B** © Caste/SoFood/Corbis; **43C** Digital Image copyright The Museum of Modern Art/Licensed by SCALA/Art Resource, NY; **336A** © Photos 12/Alamy; **336B** © Estate of David Smith/Licensed by VAGA, New York, NY; **337C** © Estate of David Smith/Licensed by VAGA, New York, NY; **337D** Eva Zeisel Archive; **338B** Farrell Grehan/CORBIS; **339C** Courtesy of Intel®; **340A** Susan Spann/The New York Times; **341B** Jessica Hiltout; **342A** Digital Image © The Museum of Modern Art/Licensed by SCALA/Art Resource, NY © 2011 Artists Rights Society (ARS), New York/ADAGP, Paris/Succession Marcel Duchamp; **343B** The Art Archive/Galerie Caron-Lestringant Louvre des Antiquaires/Gianni Dagli Ort © 2011 Artists Rights Society (ARS), New York/ADAGP, Paris; **343C** firstVIEW; **344A** Henry Moore Foundation © 2011 The Henry Moore Foundation. All Rights Reserved/ARS, New York/DACS, London; **345B** Henry Moore Foundation © 2011 The Henry Moore Foundation. All Rights Reserved/ARS, New York/DACS, London; **345C** Andrea Jemolo/Scala/Art Resource, NY; **346B** Flirt/SuperStock; **347C** Cengage Learning; **347D** Exactostock/SuperStock; **347E** from "Illustration from On Growth and Form" by D'Arcy Wentworth Thompson, Courtesy of Dover Publications; **348A** The Museum of Modern Art/Licensed by SCALA/Art Resource, NY © 2011 The Andy Warhol Foundation for the Visual Arts, Inc./Artists Rights Society (ARS), New York; **349B** Photo Credit: William Watkins; **349C** Photo Credit: William Watkins; **350A** Digital Image © The Museum of Modern Art/Licensed by Scala/Art Resource, NY; **351B** Collection Walker Art Center, Minneapolis Gift of Kenneth E. Tyler © 2011 The Willem de Kooning Foundation/Artists Rights Society (ARS), New York; **352A** Tate, London/Art Resource, NY © Judd Foundation. Licensed by VAGA, New York, NY; **353B** © Eames Office, LLC (www.eamesoffice.com) Eames House: 1997, photographer, Eames Demetrios; **353C** Digital Image © The Museum of Modern Art/Licensed by SCALA/Art Resource, NY; **354A** Daniel Clowes/Fantagraphics Books Inc.;

355B Harry Melchert/dpa/Corbis; **355C** Jenny Holzer/Art Resource, NY © 2011 Jenny Holzer, member Artists Rights Society (ARS), New York; **355D** Jason Miller Studio.

Chapter 16: 356 © Dan McCoy—Rainbow/Science Faction/Corbis; **358A** Photography by Richard Roth; **359B** Smithsonian American Art Museum, Washington, DC/Art Resource, NY; **359C** Kohler Wolfgang/Liveright Publishing Corporation; **359D** The Museum of Modern Art/Licensed by SCALA/Art Resource, NY © 2011 Richard Serra/Artists Rights Society (ARS), New York; **360A** Ali Jarekji/Reuters/Corbis; **360B** Collection Walker Art Center, Minneapolis Gift of the T.B Walker Foundation, 1971 © Judd Foundation. Licensed by VAGA, New York, NY; **361C** © 1992 Janine Antoni. Courtesy of the artist and Luhring Augustine, NY; **361D** Koichi Kamoshida/Getty Images; **362A** Photograph by Richard Roth; **362B** Digital file from Getty Images. Maman, 2005 © Louise Bourgeois Trust/Licensed by VAGA, New York, NY; **362C** JPooreCollection/Cengage Learning; **363D** Nicolas Sapieha/Art Resource, NY © 2011 The Henry Moore Foundation. All Rights Reserved/ARS, New York/DACS, London; **363E** Courtesy of Rachel Whiteread and Luhring Augustine, New York. © 1994, Rachel Whiteread; **364A** © Charles Ray, Courtesy Matthew Marks Gallery, New York; **364B** The Museum of Modern Art/Licensed by SCALA/Art Resource, NY © 2011 Calder Foundation, New York/Artists Rights Society (ARS), New York; **364C** MARKA/Alamy; **365D** CNAC/MNAM/Dist. Rèunion des Musèes Nationaux/Art Resource, NY; **365E** Chad Ehlers/Stone/Getty Images; **366A** Digital Image © The Museum of Modern Art/Licensed by SCALA/Art Resource, NY; **367B** Xavier Florensa/age fotostock/Photolibrary; **367C** © Prisma/SuperStock; **368A** Robert J. Lang; **369B** Ufuk Keskin and Efecem Kutuk (efecemkutuk.com and ufukkeskin.com); **369C** Open Library; **369D** Google SketchUp; **370A** Diego Azubel/epa/Corbis; **370B** © Dennis Gilbert/VIEW/VIEW/Corbis; **371C** Richard Roth; **371D** © Clive Nichols/Corbis; **372A** Marie Mauzy/Art Resource, NY; **372B** © Clark Dunbar/Corbis; **373C** Fabrice Coffrini/AFP/Getty Images; **373D** Nicolas Sapieha/Art Resource, NY © 2011 Barragan Foundation, Switzerland/Artists Rights Society (ARS), New York; **373E** Tapio Wirkkala/Venini spa Fondamenta Vetrai; **374A** © Terry Harris PCL/SuperStock; **374B** Albright-Knox Art Gallery/Art Resource, NY © 2011 Stephen Flavin/Artists Rights Society (ARS), New York; **375C** Courtesy of the artist; neugerriemschneider, Berlin, Tanya Bonakdar Gallery, New York; and Gallery Koyanagi, Tokyo © 2009 Olafur Eliasson; **375D** Elisabeth Pollaert Smith/Photographer's Choice/Getty Images; **376A** Digital Image © The Museum of Modern Art/Licensed by SCALA/Art Resource, NY; **376B** Harvard Art Museums/Busch-Reisinger Museum, Gift of Sibyl Moholy-Nagy, BR56.5 Copyright: Photo: Junius Beebe © President and Fellows of Harvard College; **377C** Courtesy Tony Oursler and Metro Pictures; **377D** Getty Images; **377E** Chris Helgren/Reuters/Corbis.

Chapter 17: 378 Elliot Barnathan; **380A** Courtesy Modern Art Museum of Fort Worth; **380B** Portia Munson; **380C** Portia Munson; **381D** Portia Munson; **381E** Schroeder House, built in 1923-24 (photo), Rietveld, Gerrit (1888-1964)/Utrecht, Netherlands/The Bridgeman Art Library © 2011 Artists Rights Society (ARS), New York; **382A** Courtesy of Tom Friedman, Luhring Augustine, New York and Stephen Friedman Gallery, London; **382B** Bettmann/CORBIS; **383C** © imagebroker/Alamy; **383D** Russell Mountford/Lonely Planet Images/Getty Images; **384A** Paul D. Slaughter/Photographer's Choice/Getty Images; **384B** Allan McCollum; **384C** Photo: Richard Roth; **385D** Musée d'Orsay; **385E** Joel Shapiro; **386A** © Ian Griffiths/Robert Harding World Imagery/Corbis; **386B** Vanni/Art Resource, NY; **387C** Gregory Wrona PCL/SuperStock; **387D** © Gunter Marx Stock Photos; **387E** Tomoyuki Sugai/ Getty Images; **388A** kokoroimages.com/Flickr/Getty Images; **388B** Bill O'Connell/Workbook Stock/Getty Images; **389C** A. Barrington Brown/Photo Researchers, Inc.; **389D** Safdie Architects photo by Timothy Hursley; **390A** Erwin Hauer; **390B** Courtesy of: Arte en la Charreria/Luis González Cárdenas; **391C** Mihrab [Isfahan, Iran] (39.20), Heilbrunn Timeline of Art History, The Metropolitan Museum of Art; **391D** Laura Wickenden/Dorling Kindersley/Getty Images; **391E** Ar.Shakti Nanda/Flickr/Getty Images; **392A** Copyright The Cleveland Museum of Art. Gift of the John Huntington Art and Polytechnic Trust 1928.856.a; **392B** Eva Hild © 2011 Artists Rights Society (ARS), New York/BUS, Stockholm; **393C** Erich Lessing/Art Resource, NY © 2011 Artists Rights Society (ARS), New York; **394A** Handout/Reuters/Corbis; **395B** Michael Lawrence/LonelyPlanet; **395C** © imac/Alamy; **395D** © Rubin Museum of Art/Art Resource, NY; **396A** Jean-Louis Blondeau/Polaris Images; **396B** Calder Foundation, New York/Art Resource, NY © 2011 Calder Foundation, New York/Artists Rights Society (ARS), New York; **397C** Flak, 1981 (felt, glass and wood) (see also 195073), Mucha, Reinhard (b.1950)/Hamburger Kunsthalle, Hamburg, Germany/The Bridgeman Art Library; **397D** Dancer looking at the sole of her right foot, 1919-21 (bronze), Degas, Edgar (1834-1917)/Art Gallery of New South Wales, Sydney, Australia / The Bridgeman Art Library; **397E** Art Resource, NY © Estate of David Smith/Licensed by VAGA, New York, NY; **398A** Design concept Philip Wright body engineer James Hughes. Pierce-Arrow Motor Car Company. Photograph by Stephen Pentak; **398B** © WWD/Condè Nast/Corbis; **107C** De Agostini/SuperStock; **399D** Science Faction/SuperStock; **400A** Studio Daniel Libeskind & © Bitter Bredt; **401B** DeA Picture Library/Art Resource, NY © 2011 Calder Foundation, New York/Artists Rights Society (ARS), New York; **401C** © Inigo Bujedo Aguirre/Arcaid/Corbis; **402A** © Condè Nast Archive/CORBIS; **403B** The Metropolitan Museum of Art/Art Resource, NY; **403C** SSPL/Getty Images; **404A** Ronald Zincone VWPics/SuperStock; **405B** Peter Willi/SuperStock; **405C** Ulf Sjostedt/Photographer's Choice RF/Getty Images; **406A** JPooreCollection; **406B** Courtesy of Roy McMakin; Matthew Marks Gallery; **407C** Werner Forman/Art Resource, NY; **407D** Courtesy L.A. Louver, Venice, CA; **408A** Jonathan Poore/Cengage Learning; **408B** Image Source /Getty Images; **409C** firstVIEW; **410A** Staton R. Winter/Redux Pictures; **411B** © Eames Office, LLC (www.eamesoffice.com); **411C** JPooreCollection; **412A** © Lebrecht Music and Arts Photo Library/Alamy; **412B** © Jeremy Sutton-Hibbert/Alamy; **413C** Charles Lewallen; **413D** Willard Wigan; **414A** Dinodia Picture Agency; **415B** REUTERS/Andrew Wong/CORBIS; **415C** Nik Wheeler/CORBIS; **415D** Gavin Brown's enterprise.

Chapter 18: 416 Camille Seaman; **418A** Scott Richter; **419B** Jeff Koons; **419C** AFP/Getty Images; **420A** Photo by Gjon Mili/Time Life Pictures/Getty Images; **421B** Henry Moore Foundation © 2011 The Henry Moore Foundation. All Rights Reserved/ARS, New York/DACS, London; **422A** Chicago Natural History Museum; **422B** John Lund/The Image Bank/Getty Images; **422C** Stuart Westmorland/Science Faction/Getty Images; **423D** Zen Shui/SuperStock; **423E** Paul Schraub; **424A** NASA/JPL; **424B** Guido Trombetta/Alinghi/NewSport/Corbis; **425C** Permission granted by Integra LifeSciences Corporation, Plainsboro, NJ; **426A** El Anatsui/NY Times; **426B** Photo by Richard Roth; **426C** John Habraken; **427D** © Cook+Fox Architects; **427E** Hoang Dinh Nam/AFP/Getty Images.

Chapter 19: 428 © Dennis Hallinan/Alamy; **430A** Comstock Images/Jupiterimages/Getty Images; **431B** Shigeru Ban Architects; **431C** Morey Milbradt/Brand X Pictures/Getty Images; **432A** © Chris Stelly/2006 225BatonRouge.com; **433B** Jean-Pierre Lescourret/Corbis; **433C** Apic/Hulton Archive/Getty Images; **434A** Josè Miguel Hernández; **435B** Nick Delaney/Axiom Photographic Agency/Getty Images; **435C** Felix Labhardt/Taxi/Getty Images; **436A** MoMA publication. © 1938. © 2011 The Josef and Anni Albers Foundation/Artists Rights Society (ARS), New York; **437B** Paul Marotta/Flickr/Getty Images; **437C** Jim Craigmyle/Corbis Edge/CORBIS; **437D** Richard Deacon; **438A** Historic New England; **438B** Herta Moselsio photographer. Lamentation. Choreographer Martha Graham. ca. summer 1937. Silver gelatin prints. Music Division Purchase, 2001 (233.2, 234.2). Library of Congress; **439C** Hoberman; **439D** Up Projects; **439E** Rob Oechsle Collection.

Chapter 20: 440 Lester Lefkowitz/Getty Images; **442A** Collection of Hancock Shaker Village, Pittsfield, Massachusetts/Photo by Michael Fredericks; **443B** Q Drum; **443C** Roll Call/Getty Images; **444A** © Orban Thierry/CORBIS SYGMA; **445B** AFP/Getty Images; **446A** © Mark Tansey. Courtesy Gagosian Gallery; **446B** Jerry L. Thompson/Art Resource, NY © 2011 Artists Rights Society (ARS), New York/ADAGP, Paris/Succession Marcel Duchamp; **447C** Copyright Diancehct, S.A. de C.V. www.manosydedos.com; **447D** John Warburton-Lee/JAI/Corbis; **448A** Peter Stathis Digital Image © The Museum of Modern Art/Licensed by SCALA/Art Resource, NY; **448B** NASA; **449C** Francesco Chinazzo /Shutterstock; **449D** Pete Oxford/Nature Picture Library; **450A** Albright-Knox Art Gallery/Art Resource, NY © 2011 Succession Giacometti/Artists Rights Society (ARS), New York/ADAGP, Paris; **451B** BMW Motorcycle Magazine; **451C** Ryan McVay/Stone/Getty Images.

Chapter 21: 452 Finn O'Hara/ Getty Images; **454A** Scala/Art Resource, NY; **455B** Iwasaki Images of America; **455C** Photographer: Travis Fullerton, 2010; **456A** Daniel Mcculloch/Digital Vision/Getty Images; **457B** Joshua Callaghan; **457C** Hans Georg Roth/Corbis; **457D** Nivek Neslo/Riser/Getty Images; **458A** Gustavo Caballero/Getty Images Entertainment/Getty Images; **459B** Photo: Richard Roth; **459C** The Noguchi Museum © 2011 The Isamu Noguchi Foundation and Garden Museum, New York/Artists Rights Society (ARS), New York; **459D** SSPL/Getty Images.

Chapter 22: 460 Lester Lefkowitz/ Getty Images; **463A** Digital Image © The Museum of Modern Art/Licensed by SCALA/Art Resource, NY © 2011 Succession Giacometti/Artists Rights Society (ARS), New York/ADAGP, Paris; **464A** Scala/Art Resource, NY; **465B** FHWA Central Federal Lands; **466A** Nimatallah/Art Resource, NY; **466B** Penone, Dèvoiler l'invisible; **467C** Giuseppe Penone/Art Gallery of Ontario; **467D** Paris courtesy of David Zwirner, NY, and the Estate of Gordon Matta-Clark; **467E** Image © the artist and courtesy of the artist and Stephen Friedman Gallery, London; **468A** Tate, London/Art Resource, NY © 2011 Artists Rights Society (ARS), New York/ADAGP, Paris; **468B** Barford Sculptures; **469C** Erich Lessing/Art Resource, NY © 2011 Artists Rights Society (ARS), New York; **469D** SuperStock/Getty Images; **470A** CNAC/MNAM/Dist. Rèunion des Musèes Nationaux/Art Resource, NY © 2011 Artists Rights Society (ARS), New York/ADAGP, Paris/Succession Marcel Duchamp; **471B** Rorbet Caplin for the *New York Times;* **472A** Rèunion des Musèes Nationaux/Art Resource, NY © 2011 Estate of Pablo Picasso/Artists Rights Society (ARS), New York; **472B** Edward Owen/Art Resource, NY © The Joseph and Robert Cornell Memorial Foundation/Licensed by VAGA, New York, NY; **473C** Harry Roseman; **473D** © Sarah Sze, Courtesy Tanya Bonakdar Gallery, New York; **473E** Gallop Workshop; **474A** Photo Credit: Rèunion des Musèes Nationaux/Art Resource, NY; **475B** Photo by Rachel Heberling. Reproduced with permission of Michael Mercil; **475C** Dawoud Bey; **476A** Ann Hamilton; **477B** © David Kennedy/Alamy; **477C** © David J. Green—technology/Alamy; **478A** Henry Ford Museum; **479B** The Museum of Modern Art/Licensed by SCALA/Art Resource, NY; **479C** © Ambient Images Inc./SuperStock; **480A** Allan Baxter/Photographer's Choice/Getty Images; **481B** SFMOMA; **481C** Image 1: courtesy: © Karin Sander, VG-Bildkunst, Bonn photography: © Studio Karin Sander. Image 2: courtesy: © Karin Sander, VG-Bildkunst, Bonn photography: © Studio Karin Sander collection: Sammlung LB-BW, Stuttgart, Germany. Image 3: courtesy: © Karin Sander, VG-Bildkunst, Bonn photography: © Studio Karin Sander collection: Private Collection, Aspen, USA; **482B** Steve Gorton and Gary Ombler/Dorling Kindersley/Getty Images; **483C** Stockbyte /Getty Images; **483D** The Schein-Joseph International Museum of Ceramic Art, photograph by Brian Oglesbee; **484A** Photos by R. Eric McMaster; **485B** R. Eric McMaster; **485C** Digital Image © The Museum of Modern Art/Licensed by SCALA/Art Resource, NY; **485D** Digital Image © The Museum of Modern Art/Licensed by SCALA/Art Resource, NY.